THE SELECTED PAPERS OF
CHARLES WILLSON PEALE
AND HIS FAMILY

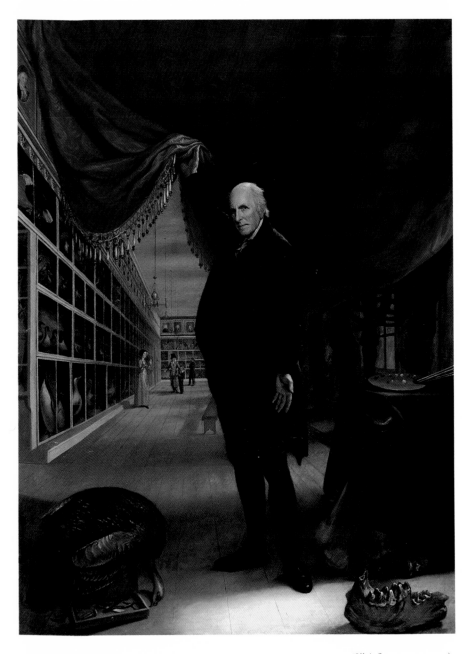

The Artist in His Museum. C.W. Peale, 1822. Oil on canvas, 103 3/4 x 79 7/8" (263.5 x 202.9 cm). Pennsylvania Academy of the Fine Arts, Philadelphia. Gift of Mrs. Sarah Harrison (The Joseph Harrison, Jr., Collection).

THE SELECTED PAPERS OF

Charles Willson Peale

AND HIS FAMILY

VOLUME 4, *Charles Willson Peale: His Last Years, 1821–1827*

LILLIAN B. MILLER, *Editor*
Historian of American Culture, National Portrait Gallery

Sidney Hart, Senior Associate Editor
David C. Ward, Associate Editor
Leslie Reinhardt, Editorial Assistant

Published for the National Portrait Gallery,
Smithsonian Institution, by
YALE UNIVERSITY PRESS
NEW HAVEN AND LONDON

The Selected Papers of Charles Willson Peale and His Family has been generously supported by the National Endowment for the Humanities, the Andrew W. Mellon Foundation, the National Historical Publications and Records Commission, and the Smithsonian Institution. Publication of this book was assisted by a grant from the National Historical Publications and Records Commission of the National Archives.

Set in Baskerville Roman types by The Composing Room of Michigan, Inc., Grand Rapids, Michigan. Printed in the United States of America by Edwards Brothers, Inc., Ann Arbor, Michigan.

Library of Congress Cataloging-in-Publication Data
(Revised for vol. 4)

The Selected papers of Charles Willson Peale and his family.

Vol. 2– : David C. Ward, research historian.
Includes bibliographical references and indexes.
Contents: v. 1. Charles Willson Peale, artist in revolutionary America, 1735–1791 — v. 2, pts. 1–2. Charles Willson Peale, the artist as museum keeper, 1791–1810 — v. 3. The Belfield Farm years, 1810–1820. 1. Peale, Charles Willson, 1741–1827—Archives. 2. Peale family—Archives. 3. United States—Civilization—To 1783—Sources. 4. United States—Civilization—1783–1865—Sources. I. Peale, Charles Willson, 1741–1827. II. Miller, Lillian B. III. Hart, Sidney. IV. Appel, Toby A., 1945– V. National Portrait Gallery (Smithsonian Institution)
ND237.P27S37 1983 759.13 82-20155
ISBN 0–300–02576–9 (V. 1 : ALK. PAPER)
ISBN 0–300–06180–3 (V. 4 : ALK. PAPER)

A catalogue record for this book is available from the British Library.

♾ The paper in this book meets the guidelines for permanence and durability of the Committee on Production Guidelines for Book Longevity of the Council on Library Resources.

10 9 8 7 6 5 4 3 2 1

Editorial Advisory Board

Contents

Chapter 1. Restructuring the Museum: January 4, 1821–December 3, 1821 · · · · · · 1

Chapter 2. A Time to Change:
January 2, 1822–June 11, 1822

Chapter 3. An Effort at Dentistry:
June 14, 1822–February 13, 1823

Chapter 4. Lectures on Natural History: February 26–August 26, 1823 — 222

Chapter 5. Portraits for the Public: September 19, 1823–July 2, 1824

Chapter 6. Lafayette's Return to America: July 16, 1824–December 7, 1825 — 427

Chapter 7. "Journeying through a Long Life." Charles Willson Peale's Autobiography: December 9, 1825–April 20, 1826 500

Chapter 8. Full Circle. The Relocation of the Museum and the Death of Charles Willson Peale: April 25, 1826–April 27, 1827

Illustrations

Acknowledgments

This edition of *The Selected Papers of Charles Willson Peale and His Family* has been sponsored by the National Portrait Gallery of the Smithsonian Institution, with financial assistance in its early years from the National Endowment for the Humanities and the Andrew W. Mellon Foundation. We are grateful to these organizations for their generous support and encouragement. At the Smithsonian Institution, we especially wish to thank S. Dillon Ripley, secretary emeritus, Robert McCormick Adams, secretary emeritus, and I. Michael Heyman, secretary, for their interested efforts in our behalf. Ronald F. Cuffe, contracts specialist, was of great assistance to the project. The staff of the National Portrait Gallery has been constantly supportive. We acknowledge in particular the help of Alan M. Fern, director; Cecilia Chin, librarian, and her staff; Rolland White, senior photographer, and his staff; Linda Thrift, keeper of the Catalog of American Portraits, and her staff; Robert Stewart, senior curator emeritus, and the staff of the curator's office; and Margo Kabel, the Portrait Gallery's computer specialist, for her assistance in devising print codes and the placement of the manuscript on the computer.

We are grateful to the members of our editorial advisory board for their encouragement and assistance. We are appreciative of the cooperation offered by the staffs of all the institutions listed under Lending Institutions who helped in our research and granted us permission to publish their documents. The staffs of the American Philosophical Society, the Library Company of Philadelphia, the Historical Society of Pennsylvania, the Library of Congress, and the Friends Historical Library at Swarthmore College were especially helpful during the time this volume was being researched, as was Dr. John Sanders of the Institute of Government at the University of North Carolina at Chapel Hill.

The labors of our staff were augmented at various times by the efforts of fellows, volunteers, and interns who came to this office to study the art of editing and remained to make valuable contributions: Ellen Grayson, Frank Duncan, Deborah Waller, and Mary Ann Hardy.

We are pleased to acknowledge the assistance of the staff of the Na-

tional Historical Publications and Records Commission, who generously researched in the National Archives for relevant materials.

To the director and staff of Yale University Press, we reiterate our appreciation of their efforts on our behalf. We are especially grateful to Judith Calvert, Susan Laity, and Jane Zanichkowsky for their expert attention to this volume.

To all these institutions and individuals, and to the many who assisted in smaller but equally important ways, we extend our thanks and deep appreciation.

Introduction

CHARLES WILLSON PEALE: THE LAST YEARS OF AN AMERICAN MASTER

Volume 4 of *The Selected Papers of Charles Willson Peale and His Family* takes the aging artist full circle, as he moves back to the city where almost half a century earlier he had established his reputation as an artist and had begun the work that would result in the Philadelphia Museum, an institution that in his lifetime became a significant force in Philadelphia's cultural development.[1] The 1820s were not to be Peale's golden years; indeed, the golden years were behind him, interred in Belfield's fields and mills and gardens, now a deteriorating monument to the bucolic ideals of another era. Belfield as an agricultural experiment had never realized full success, although some of Peale's agricultural reforms and mechanical innovations deserve notice. As a result of Peale's restless experimentation the farm never became self-sufficient,[2] and the artist's inexperience in agricultural production and marketing of crops resulted in the incurring of mortgages and debts that were to trouble him for the rest of his life. Long before the end of the decade he spent there, Peale lost his enthusiasm for "enlightened agriculture" and turned his gaze back to Philadelphia and his beloved museum, then being administered by his son Rubens. When in 1821 his third wife, Hannah Moore Peale, died, and he was left weak and rudderless after a severe bout of yellow fever, he was ready to abandon the less-than-idyllic life of a farmer and resume his management of the museum.

These were difficult years for Peale and his sons, each of whom had his own agenda and each of whom was dependent financially on the success of his father's institution. The panic of 1819 and the ensuing depression created a credit shortage that drove up interest rates and adversely affected business enterprises. Neither artists nor museums prospered. Faced with mounting debts, the demands and squabbles of his children, difficulties with a city government that had other uses for the building in which his museum was located, deafness, and loneliness, Peale nevertheless was indefatigable. He continued to plan projects for the museum and to paint portraits, such as his famous self-portrait, *The Artist in His Museum*

(1822), in order to attract further commissions as well as to increase the museum's income. He composed and delivered lectures and even wrote a full-scale autobiography. Always interested in mechanics, he developed a method for making porcelain teeth and attempted to set himself up—none too successfully—in the dentistry business.

Meanwhile, Peale's children, married and with families to support, continued to cause their father anxiety as they tried to establish themselves financially and professionally. Dissatisfied with the role of museum keeper, Rembrandt readily abandoned his Baltimore enterprise when Rubens, displaced by his father at the Philadelphia Museum, became available to take it over. Rembrandt also suffered in the financial depression of these years: unable to find sufficient patronage for his portraiture to maintain himself and his family, he was forced to travel from New York to Boston and back to Philadelphia in search of fame and fortune. In the course of his travels and despite his difficulties, he continued to develop artistically and during these years produced some of his finest work, including the grand manner portrait of George Washington, the "standard likeness." He also perfected his skills in lithography and deepened his aesthetic philosophy.

Rubens remained the loyal son, ever responsive to his father's requests and needs. He also proved to be the best businessman in the family, managing to keep the Philadelphia Museum and, later, Rembrandt's museum in Baltimore (which he took over in 1822) and his own New York institution (established in 1825) afloat despite the depressed economy. Raphaelle, on the other hand, gradually succumbed to the disorder that had marked his life since 1805, but like his father and brothers, he also produced his best work—some beautiful still lifes—despite disabling pain and illness.

Peale's younger children—the offspring of his second marriage—had now also entered adulthood and were seeking satisfactory professions. Rebelling against his father, Linnaeus attempted a navy career, only to encounter such hardship that he was content finally to come home and resume his efforts in manufacturing and politics. Franklin and Titian, rivals for the top position in the Philadelphia Museum, found it necessary (with their father's prodding) to settle their differences and seek their own—separate—careers. Peale's daughters, all married, pursued their domestic activities; but James Peale's daughters, not as comfortably situated as Charles's, while assisting their father in his artistic activities became artists themselves.

This volume brings to a close the multivaried and impressive life of Charles Willson Peale. Lafayette's visit to America in 1824–1825 and the deaths in 1826 of John Adams and Peale's old friend Thomas Jefferson

symbolically marked the end of the era that had fostered Peale's talents and given meaning to his efforts. With Peale's death, and with the advent of Andrew Jackson to the presidency, a new social vision and a new generation of Americans with different expectations emerged. Peale's children would participate in this new society, but they would not divest themselves of their father's values and philosophy even as they responded to new social demands and new cultural influences. Although their world would be markedly different from their father's in many respects, some of Charles Willson Peale's Enlightenment philosophy would continue to guide their paths and permeate their work. He was too strong a force, too dominant a personality, not to have left his impress.

1. Sidney Hart and David C. Ward, "The Waning of an Enlightenment Ideal: Charles Willson Peale's Philadelphia Museum, 1790–1820," in Lillian B. Miller and David C. Ward, eds., *New Perspectives on Charles Willson Peale* (Pittsburgh, 1992), pp. 219–36.

2. David C. Ward, "Charles Willson Peale's Farm Belfield: Enlightened Agriculture in the Early Republic," in ibid., pp. 283–301.

EDITORIAL METHOD

For history of the Charles Willson Peale Papers project, description of the collection, Peale Family genealogy, and full explanation of Editorial Method, see *The Selected Papers of Charles Willson Peale and His Family*, volume 1 (New Haven, Conn., 1983). Correspondence, diaries, and documents have been presented in this volume, as in the entire series, exactly as they came from their authors' pens, showing significant crossouts, phonetic spelling, and inconsistencies in punctuation and usage. We have not silently emended the text or changed grammar or spelling. All editorial clarifications appear in square brackets, empty for missing words. We have printed all significant crossouts in italics within angled brackets ⟨*italics*⟩ so that the reader may easily skip over them to maintain an uninterrupted narrative flow. In deference to printing costs, however, we have incorporated interlineations into the sentence body unless there seemed a reason for noting them in a footnote; for the same reason, we have brought down superscripts in abbreviations.

Peale's letters included in this volume are, for the most part, copies made with his polygraph—a copying machine he co-invented in 1803 (see *Peale Papers* 2:475–78). These he bound into letterbooks at the end of each year. Whenever the recipient's original letter has been located, we have used that rather than the polygraph copy.

Individuals named in the documents have been identified in footnotes at the first mention, but cross-references have not been given to subsequent mention. The index provides the reader with that kind of informa-

tion. We have cross-referenced events or situations if it seemed to us that guidance to a previous or later document would be useful. Such cross-references are indicated by the document number provided in the Table of Contents; where a reference is to a note only, that note appears in the same document. Document numbers are printed in boldface (e.g., **100**).

Lending Institutions

CtY Yale University Library, New Haven, Connecticut
DLC Library of Congress, Washington, D.C.
DNA National Archives, Washington, D.C.
DSIA Smithsonian Institution Archives, Washington, D.C.
DSIAr Archives of American Art, Smithsonian Institution, Washington, D.C.
MH-H Houghton Library, Harvard University, Cambridge, Massachusetts
MHi Massachusetts Historical Society, Boston
MWA American Antiquarian Society, Worcester, Massachusetts
NIC Cornell University, Ithaca, New York
NJP Mudd Library, Princeton University, Princeton, New Jersey
NN The New York Public Library, Astor, Lenox, and Tilden Foundations, New York City
NNF Fordham University Library, Bronx, New York
NNMor The Pierpont Morgan Library, New York City
NNMu Museum of the City of New York
PHi The Historical Society of Pennsylvania, Philadelphia
PPAFA Pennsylvania Academy of the Fine Arts, Philadelphia
PPAmP The American Philosophical Society Library, Philadelphia
PPC College of Physicians at Philadelphia
PPL Library Company of Philadelphia
TxU Harry Ransom Humanities Research Center, The University of Texas at Austin
ViU Library, University of Virginia, Charlottesville
Philip H. and A. S. W. Rosenbach Foundation, Philadelphia

Short Titles of Sources

Works cited more than once in a single chapter have a full title in the first mention.

APS, *Early Proceedings*
 American Philosophical Society, *Early Proceedings of the American Philosophical Society . . . Manuscript Minutes of Its Meetings from 1744 to 1838* (Philadelphia, 1844).

A(TS)
 Horace Wells Sellers, Transcript of Charles Willson Peale's manuscript autobiography, 1826–27. Peale-Sellers Papers, American Philosophical Society, Philadelphia. F:IIC.

Appleton's
 James Grant Wilson and John Fiske, *Appleton's Cyclopedia of American Biography*, 6 vols. (New York, 1887).

BDAC
 U.S. Congress, Joint Committee on Printing, *Biographical Directory of the American Congress, 1774–1989* (Washington, D.C., 1989).

BDML
 Edward C. Papenfuse et al., *A Biographical Dictionary of the Maryland Legislature, 1635–1789*, 2 vols. (Baltimore, 1979–85).

CAP
 Catalog of American Portraits, Washington, D.C., a national reference center administered by the National Portrait Gallery, Smithsonian Institution.

Current Expenditures
 Peale's Museum, "Current Expenditures, 1808–19," PHi. F:XIA/5B2–12.

CWP
 Charles Coleman Sellers, *Charles Willson Peale* (New York, 1969).

DAB
 Allen Johnson and Dumas Malone, eds., *The Dictionary of American Biography*, 10 vols. and supplements (New York, 1928-36).

DNB
Leslie Stephen and Sidney Lee, eds., *The Dictionary of National Biography*, 22 vols. and supplements (Oxford, 1963–64).

DSB
Charles Coulson Gillispie, ed., *Dictionary of Scientific Biography*, 16 vols. (New York, 1970–80).

D(TS)
Horace Wells Sellers, Transcript of Charles Willson Peale's manuscript diary. This notation includes a serial number and a page number: D7(TS):47 means diary 7, page 47, of the Horace Wells Sellers transcript. Peale-Sellers Papers, American Philosophical Society, Philadelphia. F:IIB.

Daybook 1
Charles Willson Peale, "1806–1822 Daybook," PPAmP. F:IIE/4–5.

Daybook 2
Charles Willson Peale, "1810–1824 Daybook," PPAmP. F:IIE/6–7.

F
Microfiche edition. Lillian B. Miller, ed., *The Collected Papers of Charles Willson Peale and His Family* (Millwood, N.Y., 1980). This notation includes a series designation, a card number, and a location letter and number: F:IIA/7D12–14 means Series 2, Part A, card 7, line D, spaces 12–14.

Falk, *Annual Exhibition Record*
Peter Hastings Falk, ed., *The Annual Exhibition Record of the Pennsylvania Academy of the Fine Arts 1807–1870: Being a Reprint with Revisions of the 1955 Edition of Anna Wells Rutledge's Cumulative Record of Exhibition Catalogues Incorporating the Society of Artists, 1810–1814 and the Artists' Fund Society, 1835–1845* (Madison, Conn. 1988).

Four Generations
Maryland Historical Society, *Four Generations of Commissions: The Peale Collection of the Maryland Historical Society* (Baltimore, 1975).

Groce and Wallace, *Dictionary of Artists*
George C. Groce and David H. Wallace, *The New-York Historical Society's Dictionary of Artists in America, 1564–1860* (New Haven, Conn., 1966).

IAP
Inventory of American Painting, Washington, D.C., a national reference center administered by the National Museum of American Art, Smithsonian Institution.

MHM
Maryland Historical Magazine

Malone, *Jefferson*
Dumas Malone, *Jefferson and His Time*, 6 vols. (Boston, 1948–81).

Mathews, *Americanisms*
Mitford McLeod Mathews, *A Dictionary of Americanisms on Historical Principles* (Chicago, 1956).

Memorandum Book
Charles Willson Peale, "Memorandum Book," PPAmP. F:IIE/2F7–3E4.

Miller, *In Pursuit of Fame*
Lillian B. Miller, *In Pursuit of Fame: Rembrandt Peale 1778–1860*. With "The Paintings of Rembrandt Peale: Character and Conventions" by Carol Eaton Hevner (Seattle and London, 1992).

Museum Accessions Book
"Memoranda of the Philadelphia Museum, 1803–1842," PHi. F:XIA/3A1–5A6.

NCAB
The National Cyclopedia of American Biography, 63 vols. and supplements (1893–1919; reprint ed., Ann Arbor, Mich., 1967).

NUC
Library of Congress and American Library Association, *The National Union Catalog* (London and Chicago, 1968–).

Notable Americans
Rossiter Johnson, ed., *The Twentieth Century Biographical Dictionary of Notable Americans*, 10 vols. (Boston, 1904).

OED
The Oxford English Dictionary. Second Edition. Prepared by J. A. Simpson and Edmund S. C. Weiner (Oxford, 1989).

PMHB
Pennsylvania Magazine of History and Biography.

P&M
Charles Coleman Sellers, *Portraits and Miniatures by Charles Willson Peale*, American Philosophical Society, *Transactions*, n.s., 42, pt. 1 (Philadelphia, 1952).

P&M Suppl.
Charles Coleman Sellers, *Charles Willson Peale with Patron and Populace: A Supplement to Portraits and Miniatures by Charles Willson Peale with a Survey of His Work in Other Genres,* American Philosophical Society, *Transactions*, n.s., 59, pt. 3 (Philadelphia, 1969).

P-S
Peale-Sellers Papers, American Philosophical Society, Philadelphia.

Peale Papers, 1
Lillian B. Miller, Sidney Hart, and Toby A. Appel, *The Selected Papers of Charles Willson Peale and His Family*, vol. 1: *Charles Willson Peale: The Artist in Revolutionary America, 1735–1791* (New Haven, Conn., 1983).

Peale Papers, 2
Lillian B. Miller, Sidney Hart, and David C. Ward, *The Selected Papers of Charles Willson Peale and His Family*, vol. 2: *Charles Willson Peale: The Artist as Museum Keeper, 1791–1810*, Part 1 and Part 2 (New Haven, Conn., 1988).

Peale Papers, 3
Lillian B. Miller, Sidney Hart, David C. Ward, and Rose Emerick, *The Selected Papers of Charles Willson Peale and His Family*, vol. 3: *The Belfield Farm Years, 1810–1820* (New Haven, Conn., 1991).

Philadelphia Directory (1821)
The Philadelphia Directory and Register, for 1821 (Philadelphia, 1821).

Philadelphia Directory (1822)
The Philadelphia Directory and Register, for 1822 (Philadelphia, 1822).

Philadelphia Directory (1823)
The Philadelphia Index, or Directory, for 1823 (Philadelphia, 1823).

Philadelphia Directory (1824)
The Philadelphia Directory for 1824 (Philadelphia, 1824).

Philadelphia Directory (1825)
The Philadelphia Directory and Stranger's Guide for 1825 (Philadelphia, 1825).

Philadelphia Directory (1828)
Desilver's Philadelphia Directory and Stranger's Guide for 1828 (Philadelphia, 1828).

Prime, *Arts and Crafts in Philadelphia*
Alfred Coxe Prime, *The Arts and Crafts in Philadelphia, Maryland, and South Carolina*, 2 vols. (1929; reprint ed., New York, 1969).

ReP Catalogue Raisonné, NPG
Catalogue Raisonné files of Rembrandt Peale, Peale Family Papers, National Portrait Gallery, Washington, D.C.

RuP, Letters
Letters (copies) and notebook for the Philadelphia Museum, PPFA. F:XIA/7C1–14.

Scharf, *Baltimore*

John Thomas Scharf, *History of Baltimore City and County*, 2 vols. (1881; reprint ed., Baltimore, 1971).

Scharf, *Maryland*

John Thomas Scharf, *History of Maryland*, 3 vols. (1879; reprint ed., Hatboro, Pa., 1967).

Scharf, *Phila.*

John Thomas Scharf and Thomas Westcott, *History of Philadelphia, 1609–1884*, 3 vols. (Philadelphia, 1884).

Sellers, *Museum*

Charles Coleman Sellers, *Mr. Peale's Museum: Charles Willson Peale and the First Popular Museum of Natural History and Art* (New York, 1980).

WMQ

William and Mary Quarterly.

Descriptive Symbols and
Other Abbreviations

ACP	Anna Claypoole Peale (1791–1878)
AD	Autograph Document
ADS	Autograph Document Signed
AL	Autograph Letter
ALS	Autograph Letter Signed
AN	Autograph Note
APR	Angelica Peale Robinson (1775–1853)
APS	American Philosophical Society
BFP	Benjamin Franklin Peale (1795–1870)
CLP	Charles Linnaeus Peale (1794–1832)
CPP	Charles Peale Polk (1767–1822)
CWP	Charles Willson Peale (1741–1827)
DS	Document Signed
EDP	Elizabeth DePeyster Peale (1765–1804)
EPP	Elizabeth DePeyster Peale Patterson (1802–57)
HMP	Hannah Moore Peale (1755–1821)
JP	James Peale (1749–1831)
JPjr.	James Peale, Jr. (1789–1876)
MsD	Manuscript Document
MsDS	Manuscript Document Signed
NPG	National Portrait Gallery, Smithsonian Institution
n.s.	New Series
o.s.	Old Series
PAFA	The Pennsylvania Academy of the Fine Arts
PrD	Printed Document
PrDS	Printed Document Signed
PrLS	Printed Letter Signed
RaP	Raphaelle Peale (1774–1825)
ReP	Rembrandt Peale (1778–1860)
RuP	Rubens Peale (1784–1865)
SMP	Sarah Miriam Peale (1800–1885)

SPS Sophonisba Peale Sellers (1786–1859)
SyMPS Sybilla Miriam Peale Summers (1797–1856)
TRP[1] Titian Ramsay Peale [1] (1780–98)
TRP Titian Ramsay Peale [2] (1799–1885)

Peale Family Abbreviated Calendar, 1821–1827

1821	January 14	CWP begins to paint *Our Saviour Healing the Sick at the Pool of Bethesda.*
	January	TRP returns from Long Expedition; RaP paints in Annapolis.
	February 21	Pennsylvania legislature incorporates Philadelphia Museum; RuP remains as manager.
	March 5	CWP appoints trustees of Philadelphia Museum.
	March 20	TRP's Long Expedition specimens placed in Philadelphia Museum.
	March 24	CWP exhibits *Our Saviour* at Belfield.
	March	CWP plans sale of Belfield or its exchange for a city lot on which to construct a museum building; ReP paints *Death of Virginia.*
	April 11	Philadelphia Museum Trustees and RuP petition city of Philadelphia to lower museum rent and grant use of "lower" room in Statehouse; Dr. John D. Godman lectures at Philadelphia Museum.
	April 13	Philadelphia City Councils grant three-year lease to museum and lower rent to $600 per year.
	April 17	ReP and *Court of Death* travel to Boston; ACP also travels to Boston to paint miniatures.
	April	CWP paints portrait of Joseph Heister, governor of Pennsylvania; CWP makes teeth for APR.

	June	TRP expresses dissatisfaction with position at Philadelphia Museum; CWP constructs mill dam at Belfield.
	July	CLP returns to cotton manufactory at Belfield; *Court of Death* is exhibited in Boston and Salem; RaP paints in Maryland; CWP inquires about DePeyster estate.
	August 7	RaP visits CWP at Belfield; CWP preserves elk.
	August	CWP seeks depositions declaring Eliza Greatrake (Mrs. BFP) legally insane before marriage; CWP considers spending part of year in Philadelphia; RuP seeks information about establishing a museum in Washington, D.C.; TRP seeks position on Commodore Charles Stewart's expedition to the Pacific.
	September–October	CWP and HMP ill with yellow fever; HMP dies October 10; CWP moves to Philadelphia.
	October 6	ReP's daughter Angelica (1800–1859) marries Dr. John D. Godman.
	November	CWP renews attempt to sell Belfield and boards with RuP; distributes portraits to family members.
	December	JP applies for Revolutionary war pension.
1822	January	*Court of Death* is exhibited in Charleston, S.C.; ReP exhibits *Mother and Child* in Baltimore Museum; ReP proposes selling museum to RuP.
	February	Alexander Ricord, of the Muséum National d'Histoire Naturelle in Paris, proposes exchange of specimens with RuP.
	March	RuP purchases ReP's Baltimore Museum; CWP takes over management of Philadelphia Museum and employs BFP and TRP.
	April	RuP puts his Philadelphia house on sale; TRP is engaged to marry Eliza Laforgue.

May 2	CWP paints portraits of Laurent and Elizabeth Clerc.
May 9	James Peale, Jr., and Sophonisba Peale (1801–78), RaP's daughter, marry.
May 10	RaP exhibits nine works in PAFA exhibition.
May 21	CWP exhibits portrait of Edward Burd in PAFA exhibition.
May	CWP experiences financial problems and decides to sell his farm.
June 9	ReP, in New York City, exhibits portraits of Duke of Wellington and Charles Willson Peale at American Academy of Fine Arts; CWP paints portraits of Robert Hare, Elizabeth Williams and Deborah Logan; BFP arranges new coin display; TRP makes new arrangement of shells at the Philadelphia Museum.
June 11	Perpetual motion machine is displayed in Baltimore Museum.
June 21	CWP decides to manufacture porcelain teeth; CWP offers to buy ReP's portraits of Samuel Latham Mitchill and David Hosack.
June 23	Sophonisba Sellers Patterson (d. 1883) born to EPP and William Augustus Patterson.
July 10	RaP, unemployed, sends paintings to Baltimore Museum for sale.
July 23	CWP begins painting *The Artist in His Museum* on commission from Philadelphia Museum Trustees.
July	RuP postpones first art exhibition at Baltimore Museum.
August 2	CWP achieves success in manufacturing porcelain teeth.
August 4	Coleman Sellers appointed to state commission to construct Philadelphia penitentiary.
September 10	CWP completes *The Artist in His Museum*; BFP

		and TRP feud over management of Philadelphia museum.
	October 4	CWP's *The Artist in His Museum* exhibited in Philadelphia museum's Long Room.
	October 10	TRP and Eliza Cecilia Laforgue (d. 1846) marry.
	October 17	RuP opens first annual painting exhibition at Baltimore Museum.
	October 29	CWP repairs Thomas Jefferson's polygraph.
	October	Conflict continues between BFP and TRP over management of Philadelphia museum; museum income low and CWP in debt.
	November 4	CWP manufactures porcelain teeth for family.
	November 5	CWP paints *James Peale by Lamplight*.
	November 8	BFP and TRP come to agreement; John Godman lectures in Philadelphia.
	November 21	RaP's son, Edmund, attempts suicide.
	December 7	ReP sends his portrait of Charles Mathews to London; RaP paints miniatures in Baltimore; CWP completes *James Peale by Lamplight*; CWP begins making porcelain teeth for APR and SPS.
	December 8	Cold weather harms RuP's live animals at Baltimore Museum; Edmund plans trip to South America; ReP paints portrait of Willet Hicks.
	December 12	William Gilmor purchases RaP's *Venus Rising from the Sea*.
1823	January 1	TRP redesigns interior of Philadelphia Museum quadruped room; BFP makes a large magnet.
	January 19	RaP paints fruit pieces for vendors.
	January 23	ReP determines to go to London.
	February 8	CWP sends Thomas Jefferson silver springs for his polygraph.

February 9	In New York City, ReP advertises half price portraits for first twenty sitters.
February 20	CWP begins writing lecture on natural history.
March 23	Indians visit Philadelphia Museum.
April 6	Russia and France invade Spain.
April 9	CWP delivers first Lecture on Natural History at the Philadelphia Museum.
April 13	CWP seeks his children's shares of the De-Peyster estate.
April 19	*Court of Death* is exhibited in Philadelphia.
April 24	ReP moves family to West Point, N.Y.; Henry Robinson criticizes RuP's management of Baltimore Museum.
May 17, 19	CWP delivers second lecture in two parts at the Philadelphia Museum.
May 22	CWP determines to purchase RuP's Philadelphia house.
May 24	CWP delivers his first lecture at Baltimore Museum.
May 25	RuP exhibits Henry Sargent's *Christ Entering Jerusalem* (ca. 1817) at Baltimore Museum; CWP paints portrait of Charles Carroll of Carrollton; CWP visits Annapolis.
June 3, 4	CWP delivers second lecture in two parts at Baltimore Museum.
June 7	CWP offers to paint portraits of six early governors of Maryland in exchange for Herman van der Myn's portrait of Charles Calvert (ca. 1730).
June 14	In Philadelphia, CWP agrees to paint *Staircase Self-Portrait* for RuP.
July	Edmund Peale, imprisoned in Havana, Cuba, escapes and returns to Baltimore.
August 7	*Court of Death* is exhibited in Boston.

	August 25	"Devil Fish" exhibit is mounted in Philadelphia Museum.
	August	CWP works on *Staircase Self-Portrait*.
	September 19	In Philadelphia CWP works on the governors' portraits and self-portraits. ReP, in New York City, plans his Washington portraits.
	October 4	Problems with BFP's divorce re-emerge.
	October 5	*Staircase Self-Portrait* is sent to Baltimore; CWP plans to travel to Maryland to paint governors' portraits; CWP attempts to organize his finances.
	October 22	CWP in Baltimore.
	October 23	Baltimore Museum's annual art exhibition opens.
	November 16	CWP back in Philadelphia, preoccupied by his financial problems and those of RaP. RuP manufactures and markets artist's pigments.
	November 30	ReP's paintings are destroyed by fire in New York City. RaP travels to Charleston to paint.
	December 18	ReP exhibits his portraits in Philadelphia.
	December 28	CWP completes portrait of Gerard Troost.
1824	January 8	ReP proceeds with Washington portraits, plans campaign to obtain a government commission; seeks endorsement from national figures.
	January 14	CLP's son dies.
	January	CWP continues to paint portraits of Maryland governors; single edition of *The Philadelphia Museum* is published.
	February	RaP continues painting in Charleston; TRP is ill with pleurisy. ReP's campaign to obtain a government commission continues in Washington; he proposes that Congress reform copyright laws so that artists may profit from the reproduction of their work; bill is killed in committee.

March 1–18	Purchase of *Patriae Pater* is debated in Congress; purchase of a portrait of Washington for $5,000 is approved but no action is taken before the next Congress and the resolution dies. ReP solicits testimonials to the accuracy of his portrait from prominent Americans.
March 20	To honor him and the organization he helped to found, the PAFA requests CWP to paint a self-portrait.
March 31	ReP completes visit to Washington, exhibits *Patriae Pater* in Baltimore on return trip to Philadelphia.
April 18	CWP completes two self-portraits for the PAFA, the second done in response to amateur criticism of his effort.
May 10	ReP back in Philadelphia.
May	CWP exhibits two self-portraits and four portraits at the PAFA; also exhibited at the PAFA are two still lifes by RaP; two still lifes by JP; and nine miniatures by ACP.
June 14	CWP in Baltimore working on governors' portraits.
July 1	CWP in Annapolis working on governors' portraits.
July 2	English naturalist Charles Waterton introduces TRP and CWP to new method of taxidermy.
July 25	TRP draws illustrations for C. L. Bonaparte's *American Ornithology*.
August 18	ReP seeks commission from New York City to paint portrait of the Marquis de Lafayette.
August	CWP takes a "ramble into the country" in suburban Philadelphia and makes sketches.
August–September	Philadelphia and the Peales plan reception for Lafayette.
September 5	RuP has financial and organizational difficulties with Baltimore Museum.

	September 13	ReP in New York city deals with controversy over his *Patriae Pater*.
	September 28	Reception for Lafayette is held in Philadelphia.
	October	Baltimore Museum Annual Exhibition.
	Winter 1824–1825	CWP concentrates on making artificial teeth. TRP undertakes collecting trip to Florida for Bonaparte's *American Ornithology*.
1825	March 5	RaP dies.
	May	ACP exhibits six miniatures at the PAFA.
	October 16	RuP opens New York Museum on day celebrating the completion of the Erie Canal.
	December 9	CWP begins to write his autobiography.
1826	January 27	Belfield is sold for $11,000.
	January–February	ReP solicits state governments to purchase replicas of his *Patriae Pater*.
	February 11	CLP has joined the Colombian navy.
	February 12–23	CWP involved in his financial problems.
	March 14	Hints arise that CLP is in trouble in the Colombian service.
	March–April	Baltimore Museum in financial trouble.
	April 20	CLP has money stolen.
	ca. April 20–ca. May 15	CWP in New York City.
	April 25	RuP disengages himself from the Baltimore Museum and plans to establish museum in New York City.
	May 30	CWP solidifies plans to move Philadelphia Museum to new building (the Arcade); CWP deals with discontent from TRP and BFP about their roles at the Museum; CWP begins to consider remarrying.
	May	JP exhibits one portrait and five still lifes at the PAFA; ACP exhibits two miniatures at the PAFA.

June 27	CWP advertises dentures; family is unhappy at his decision to concentrate on dentistry. After a series of misadventures in South America, CLP is released from Colombian jail.
July 4	Thomas Jefferson dies, as does John Adams.
July 18	CWP broaches plan of moving Museum to Philadelphia Arcade.
July 19	ReP has few portrait commissions in New York City.
July–August	CWP receives inquiries about his false teeth, states that it is the most important work that he can do.
September 19	ReP in Boston, establishes studio at 2 Graphic Court.
September–October	CWP begins actively to seek a fourth wife.
December	CWP visits New York City to court Mary Stansbury; she refuses his offer of marriage; Peale endures difficult return trip to Philadelphia that contributes to his final illness.
1826–28	John D. Godman publishes *American Natural History*.
1827 January 4	CLP back in Philadelphia.
January	CWP ill.
February 22	CWP dies; is buried at St. Peter's Episcopal Church February 24.

THE SELECTED PAPERS OF
CHARLES WILLSON PEALE
AND HIS FAMILY

VOLUME 4

Charles Willson Peale: His Last Years, 1821–1827

1 Restructuring the Museum: January 4, 1821–December 3, 1821

In December 1820, on the recommendations of his sons, Peale decided to incorporate his museum and issue stock in order to protect the family's interests in the enterprise and assure his children a share in its income. Confronting the dilemma of obtaining public support for a private organization, Peale expected that incorporation would give the museum a quasi-public character that would recommend it to the city authorities as being important to both the city's economy and its culture and therefore deserving of assistance.

The Philadelphia Museum Company, established formally on February 1, 1821, by the Pennsylvania state legislature, was a stock company valued at $100,000, with authority to issue five hundred shares of stock at two hundred dollars a share. Peale assumed ownership of all the shares and received 100 percent of the museum's gross income. In the deed of trust that preceded the formal incorporation, Peale provided that on his death the stock would be distributed in equal shares to his six sons and created a trust providing five hundred dollars per year to his widow. Under the terms of the legislation, the stockholders—which during his lifetime meant Peale alone—rather than the proprietors and trustees were "liable in their individual capacities for the debts and engagements of the body corporate." The stockholders were empowered to elect a board of five trustees, who would be entrusted with the overall management of the company. The act of incorporation also stipulated that neither the museum nor any part of it could leave Philadelphia without its stockholders paying twice its value to the city, a provision designed to reassure government officials and potential donors that although the museum was still privately owned, it was responsible to the public and acccountable to the city of Philadelphia.

The incorporation of the museum did not end Peale's efforts to establish his enterprise on a more solid footing and, in particular, to persuade the Philadelphia City Councils to lower the rent for the rooms he occupied in the Statehouse. A more welcome alternative was to find a well-situated

1

lot of sufficient size and low enough cost on which to erect a suitable building, but such a purchase proved beyond his means. In the wake of the Panic of 1819 and the economic depression that followed, the museum suffered reduced income and Peale was faced with heavy debts.

Peale's financial problems were heightened by the competition of his sons for jobs in the museum. Titian returned from the Long Expedition confident of his capacity to preserve and mount specimens and anxious to establish himself in the museum world; he also wished to marry, which necessitated an adequate income. As a result of the economic downturn, Franklin abandoned the possibility of manufacturing cotton and also sought employment in the museum. Rubens, who had successfully managed the museum since Peale's formal retirement in 1810, had married; he required a larger income at a time when museum profits were diminishing. Rembrandt was struggling to keep his museum afloat in Baltimore, and Linnaeus was facing unemployment at Belfield after the closing of his and Franklin's cotton manufactory. Raphaelle's inability to find employment for his artistic skills in Philadelphia propelled him to try his luck in Annapolis and Marlborough, Maryland, but his family continued to call on Peale for financial assistance. Approaching his eightieth birthday, the elderly artist still felt vigorous and confident in confronting the economic problems that beset him and his family. At his farm in Germantown, he planned new pictures and new museum programs. His confidence was to be shaken, however, before the end of the year, when tragedy struck and he found himself alone once again and weakened by an almost deadly bout of yellow fever.*

*Philadelphia Museum, Deed of Trust. Charles Willson Peale to Raphaelle Peale et al., December 11, 1820, P-S, F:IIA/65B3–12, C1–6; "An Act to Incorporate the Philadelphia Museum," in Philadelphia Museum Minutes, 1821–1827, P-S, F:XIA/6F5-G13; *Peale Papers*, 3:784–86, 858–60; *Poulson's*, January 10, 1821; below, **3, 22**.

1. CWP to Thomas Jefferson[1]
GERMANTOWN, PA. JANUARY 4, 1821

Belfield Jany. 4th. 18⟨20.⟩ 21.

Dear Sir

Yours of 28th. Ult.[2] received, yesterday, and coming home last night, I thought of my small Polygraph, which was made for a traveling conveniency, I find are exactly what you want, therefore it gives me pleasure to send them.

I have long thought on the means to preserve health,[3] and have made many experiments to assertain what would be the best food, as well as drink— and as I enjoy perfect health, many of my acquaintance ask me, what I eat &c my answer is, that it is not so much the quality as the quantity, yet a choise is to be made, and that which is not so easily digested I use very sparingly. And although I drink only water, I do not take great draughts of it—but sip of it on going to bed, when I rise in the morning, and after every thing I eat—because it helps digestion better than any other liquid—therefore a cure for colick, if colick is caused by indigestion. I masticate well all my food, by which much saliva is thus mixt with it.

All this is only a preamble to what I wish to say to you, About 14 years past, I was waken'd by severe pain in my foot, as I had frequently removed triffling pains by rubing the part effected— I now determined to make tryal of rubing although at the moment the pain was Tormenting to touch it—however I began to rub, first ligh[t]ly, Then more violently, (I mean with my hand) and continued it so long that all the pain was driven away, and I sleep the remainder of the night. in the morning I found my foot alittle swelled with redness on the Skin and totally free of pain. This was so satisfactory, that ever since I have been in the practice of driving away pain, when ever I have felt it, on my limbs or Body. As I observe that as Animals grow old, that their teeth become more Solid, the cavities where the nerve or marrow is, it becomes very small, and thus perhaps may be the case with all our bones in extreme old-age. I have not examined the bones of various ages for want of opertunity, and leisure, nor have I read any author on the subject. This is however alittle foreign to my subject, that of rubing. Many People complain of Rheumatic pains, ⟨and⟩ The rubing as I direct, I have prooved in some instances to be an effectual cure— Not with a flesh brush, that only frets or irritates the Skin—but with one or both hands, pressing and rubing the Mustles and all the internal structure togather, by which not only the circulation of the blood is promoted, but also obstructions in the smaller fibers is removed, and a warmth of the parts are obtained of an agreable nature. Exercise we all know is of vast importance to obtain health, especially in the open air. But at times we can rub our limbs or Body, more especially when stripted of our garments. therefore before I get in Bed I rub my feet, leggs, thighs, hips, Body, Shoulders & Arms. with one hand, but where I can with both hands, the harder the better, as it warms me. rubing the abdomen while in Bed, And as often as I get up in the night, I have recourse to the same exercise. Now my Dear Sir may not such a practice be servicable to you— Your wrist I hope would be made better—[4] This is more than passive exercise, it is real exercise, or rather active exercise, that will give

3

energy to the whole System. A perseverance in rubing must be practiced with complaints of long standing—I hope what I [have] written may induce you to a tryal with your wrist. as I conceive you must lament the loss of using it. I cannot help believing that much of my present abilities to do any kind of work or exercise may have been from the above practice—for I do assure you that I feel as active as I have ever been in my younger days. can this be a delusion?

My Son Rembrandt on reading your letter on the receipt of the drawing from his Picture, conceived it would be useful to him, therefore I let him have it, and at New york he had it put into a news paper, and I am inclined to think that it drew the attention of the Corporation for since the publication of it the Mayor & Corporation in a body visited his exhibition, paid him high compliments, and it has led to an important Visitation to him—I had some reluctance in parting with said letter, yet I hope you will not regret my giving it to him, since such has been his benefit.[5]

<div style="text-align: right">

I am as ever your obleged friend
CWPeale

</div>

PS. My next will be to give you some account of my Museum
 Thos Jefferson Esqr.
 Monticella

ALS, 2pp. & end.
DLC: Thomas Jefferson Papers
Copy in PPAmP: Peale-Sellers Papers—Letterbook 17

1. During his years of retirement at Monticello and Poplar Forest, Virginia, Thomas Jefferson (1743–1826) devoted much of his time to the planning and development of the University of Virginia. The friendship of CWP and Jefferson began in Philadelphia during the 1790s when Jefferson was serving as secretary of state in the Washington administration. Active members of the APS, both men served on the committee appointed by the society to obtain information on America's paleontological remains. During Jefferson's presidency (1800–08), CWP occasionally acted as a liaison between Jefferson and the Philadelphia scientific and cultural community. Jefferson's enthusiastic support for John Isaac Hawkins's and CWP's polygraph, a machine that made copies of letters, strengthened their friendship and provided a firm basis for their future correspondence. See *Peale Papers*, 2: 5, 595, 1001, 1029, 1030, 1151; 3: 99, 197, 332–33, 430, 475, 485, 564–65, 577, 770; Malone, *Jefferson*, 1:162; 6:365–97.

2. In his letter of December 28, 1820, Jefferson asked CWP to exchange a pair of ink-glasses, which CWP had sent him, for a smaller pair that would fit the small polygraph he used at Poplar Forest. TxU—Hanley Coll., F:IIA/65E2–4.

3. See CWP, *An Epistle to a Friend on the Means of Preserving Health* (March 1803), in *Peale Papers*, 2:489–513.

4. In his letter to CWP of December 28, 1820, Jefferson wrote that his "stiffening wrist . . . gets worse, & will ere long deprive me quite of the use of the pen." TxU—Hanley Coll., F: IIA/65E2–4.

5. See Jefferson to CWP, August 26, 1820, *Peale Papers*, 3: 845. The letter first appeared in the *New York National Advocate* of December 19, 1820, and was republished almost verbatim in *The National Intelligencer* (Washington, D.C.), December 23, 1820. It contained praise of ReP's *Court of Death*.

2. Rosalba Peale[1] to TRP

BALTIMORE. JANUARY, 1821

Baltimore January[2] 1821

Let me congratillate you my dear Uncle on your safe return once more to the civilized world. I am quite delighted at papas account of your improved health, he says you are as tall and as straight as an Indian, and your cheaks quite plump and rosy. Oh! My dear fellow how I long to see you. We were sadly disapointed when papa told us that you had liked to have [come] down with him but were detained on account of buisiness, I hope you may settle that soon and that it will not be long before we shall have the pleasure of seeing you

I have suffered a great deal since your absence with sickness but thank *God* and good *nursing* I am now perfectly restored to health and happiness. I Shall always feel gratefull to Uncles family for their kind attention to me while sick at their house their attention was that of kind sisters[3]

There has been great changes in the family Who would ever have thought of Uncle Rubens taken to himself a wife[4], and Betty to be married before her niece[5] but wonders will never cease. I expect yet I shall have to dance attendent on Angelica in My stocking feet, but as her Marriage will not take place untill next fall perhaps in the cource of that time I may see some *one that* will please my fancy for I ashure [you] it is not one of the every day men that I will select. *by* the *by*, how comes on you and Eliza[6] you are a sly dog never to say any thing to me about her but lelled [lulled] my suspicions entirely by saying you never would get married or wishing I was not your niece, you are a pretty one but I have found you out and you have my good wishes for your suckcess and happiness provided I still keep the same place in your Affections and you do not for get there is Such a being in istance [existence] as

Your ever Affectionate Rosa

NB Papa Says you did not hear from me while you were absent I wrote to you twice one letter I sent the other Majour Long did not call for[7] Adieu do come down as soon as possible

ALS, 2pp., add. & end.
PPAmP: Peale-Sellers Papers

1. Rosalba Carriera Peale (1799–1874) was ReP's first child.
2. Endorsed as received on January 13, this letter may also be dated by TRP's arrival in Philadelphia after a long absence in the West while serving on the Long Expedition. In his letter to Jefferson (above, 1), CWP did not mention TRP's return; on January 14, he wrote to APR that TRP was home. See below, 4.
3. Between September 1818 and March 1820, Rosalba was ill. In 1818, she came to

Belfield to restore her health, having left Baltimore "emaceated," with no appetite, "in a *decline* and approaching fast to death." At Belfield, according to CWP, she regained her appetite, gained twenty-five pounds, and returned to Baltimore "chearful and in high health." RuP, however, reported from Philadelphia that Rosalba had "recovered her [health] very considerably, but not perfectly." *Peale Papers*, 3:604, 808.

4. RuP married Eliza Burd Patterson (1795–1864) on March 6, 1820. See *Peale Papers*, 3:808.

5. EPP married Eliza Burd Patterson's brother, William Augustus Patterson (1792–1833) on November 2, 1820. Her niece, ReP's daughter Angelica (1800–59), married Dr. John D. Godman (1794–1830) on October 6, 1821. See *Peale Papers*, 3:808; *CWP*, pp. 441, 443; below, **15, 16**.

6. TRP had been courting Eliza Cecilia Laforgue (d. 1846) before he left Philadelphia to join the Long Expedition in March, 1819. They would be married on October 10, 1822. *Peale Papers*, 3:715n; *CWP*, p. 443; below, **105**.

7. Both letters are unlocated. Major Stephen Harriman Long (1784–1864) led the expedition to Yellowstone and the Missouri River (the Long Expedition) on which TRP served. During the winter of 1819–20, Long returned to Philadelphia to consult with Secretary of War John C. Calhoun and make new staff appointments. See *Peale Papers*, 3: 696, 787.

3. CWP to RaP

GERMANTOWN, PA. JANUARY 14, 1821

Belfield Jany 14th. 1821.

Dear Raphaelle

If I remember right, you went ⟨went⟩ with me to Revd. Mr. Bakers,[1] when I borrowed the Print of Christ at the Pool,[2] I am prepairing to make a copy of it, on a canvas 8 feet long and 6 feet 4½ In. high; in that size it will give the figure of Christ between 34 & 36 Inches high. a size sufficiently large to enable me to make an interresting picture, but I shall make it [a] difficult task, as I mean to paint the whole in reverse because the figure of Christ should have his right-hand raised & the Print makes the elevated hand, the Left of the figure. This will bring the light on the Right sides of all the figures—It will be difficult only in the beginning of the Picture, and by a little practice the execution will become familiar—[3] The Deed of conveyance now only wants your signature to be complete—[4]and I expect daily to hear that the Act of Incorporation of the Museum, has passed into a Law—[5] I have still my difficulties with the City Corporation, having visited many of the Members of each board, I find in them a disposition (in each one I have addressed), to do what I want, But the Chairman of the Committee,[6] it appears to me, is the only one, who has been obstinately bent to give us trouble, as I found that he wanted me to pul down the Room over the stair-way, also the Chimney from the Steeple—[7] however it will be extraordinary if one Man should have power to carry a measure when so many among them are convinced of the utility it is to the Museum— It is agree'd in all of them that the rent shall be lowered—But the delay of acting is unpleasant. I have addressed the Boards of late three times, the last was only to assure them that whatever

they in their united wisdom should order, I would obey and I hoped my successors would fulfill their wishes.[8] I have taken some pains to find a situation for the Museum in order to be provided should it in future be necessary to remove the Museum, but as yet have not been able to get a lot within my means of purchasing. in a situation that would be advantageous to place the Museum.

I suppose you may have heard that Titian has arrived here, he looks well and has increased in higth, I believe that he has done himself credit by a persevering industry and obleging deportment to those of his party, at least Major Long gives me this character of him—[9] And I expect he has kept a regular journal from the time he set out, I have only seen the 6th. December, which contains the last of their tour.[10]

I am anxious to hear ⟨with⟩ what success you have at Annapolis—also how you like the tints, for flesh,[11] when in the City, I retouched three of my portraits, the two Mr. Ingersoles[12] & Mr. Burd.[13] all of them I made more pleasing pictures—The colouring not so hard.

The work I have meditated, will keep me fully imployed this winter, perhaps it is more than I can get through, more especially if I paint my portraits, for besides my painting, I have in meditation to form a neat address on the subject of Natural history, in order to show the importance of a Museum to diffuse a knowledge of the wonderful works of an alwise Creator, and by which means the mass of Inhabotants of the City of Philada. may be led from frivolous Amusement. and thus be made wiser and better.[14] This is on the consideration that the Councils do what is proper to encourage my labours.

If I find an opportunity to send my essay on health, and that on Domestic hapiness, by some person going to Annapolis, in such case, you may expect them—[15] I mean to make the enquiry when next I go into the City. Your Mother & Mrs. Morris desires to present their loves. Yrs. Affectionately

CWPeale

P.S. Your Mother reminds of my neglect of presenting our respect to Mr. & Mrs. Brewer[16]

Mr. Raphaelle Peale
 Annapolis

Brother Henry's wife is entitled to a third of the farm you mention [in] your letter to Patty, Mr. Jackson & Steaurts Children to the other 2/3——I have noticed them some time past, and think it probable that Mr. Pussle [Fussell] who married Brother Henrys Daughter Patty will go take possession of [or] settle on it.[17]

ALS, 2pp.
PPAmP: Peale-Sellers Papers—Letterbook 17

1. Unidentified.

2. The large copperplate engraving by Jean Jacques Flipart (1719–82), after the painting by the German artist Christian Wilhelm Ernst Dietrich (1712–74), was published in Paris as *Notre Seigneur à la Piscine*. From this print, CWP painted *Our Saviour Healing the Sick at the Pool of Bethesda* (*unlocated*). Later, CWP wrote to ReP that he had long admired the print because of the "effect of Light and shadow," but had refrained from making a copy while West was alive in order to avoid the appearance of competing with his old teacher's *Christ Healing the Sick*, a replica of which West completed in 1815 and sent to the Pennsylvania Hospital in 1817. *Peale Papers*, 2:1102–04; 3:360, 842–43; CWP to ReP, March 19, 1821, P-S, F: IIA/65G1–2; *P&M Suppl.*, pp. 46–47.

3. CWP reversed the engraving to match Dietrich's original composition, since the elevation of the right hand was more appropriate to Christ's role.

4. See above, p. 1.

5. The bill incorporating the museum as the Philadelphia Museum Company was passed on February 1, 1821. See "An Act to Incorporate the Proprietors of the Philadelphia Museum," in Philadelphia Museum Minutes, 1821–27, P-S, F:XIA/6F5-G13; above, p. 1.

6. William Meredith was the president of the Select Council of Philadelphia. See RuP to William Meredith, Esq., March 22, 1821, informing him that the "requisition of the committee of councils of November 9, 1820 has been complied with." PPFA, F: XIA/7C6.

7. This room, which CWP had constructed over the tower stairwell in 1803, was CWP's workshop; he often referred to it as the "lodge." *Peale Papers*, 3:858; *CWP*, pp. 197, 237.

8. The museum's rent was $1200 a year. CWP appealed to the Select and Common Councils of Philadelphia to lower the rent on November 8, December 14, and December 25 and 26. *Peale Papers*, 3:852–53, 854–56.

9. On March 30, 1819, Major Long appointed TRP assistant naturalist on his expedition to Yellowstone. It is not clear when Long communicated with CWP regarding TRP's work. Perhaps Long arrived at his home in Philadelphia before TRP, who detoured to New Orleans before returning home; or perhaps Long spoke with CWP on his earlier visit to Philadelphia during the winter of 1819–20, while the other members of the expedition remained at Council Bluffs organizing their collections of rocks, plants, maps, and animals for shipment east. See *Peale Papers*, 3:696, 711.

10. TRP's journal entry for December 6, 1819, is no longer extant. The existing manuscript (see *Peale Papers*, 3:729–67) begins with the departure of the Long Expedition from the Allegheny Arsenal on May 3, 1819, and ends on August 1, 1819, when the party reached Fort Osage, near present-day Sibley, Missouri.

The missing portions of the journal cover the period following the winter at Council Bluffs. Long had been instructed to limit the scope of his expedition; rather than attempting to explore the upper Missouri, he was to travel to the Southwest, by way of the Platte River and the Great Plains, and make his way to the Arkansas and Red Rivers. On June 6, 1820, joined by botanical assistant and geologist Edwin James (1797–1861), Long's mission set out, heading west along the north bank of the Platte River. At the end of June, they had their first glimpse of the Rocky Mountains. Continuing along the south bank of the Platte River, they reached Pike's Peak, and on July 18 several members of the expedition became the first party ever to scale the peak. On July 24 Long divided the expedition into two groups for the return trip. One party, commanded by Captain John R. Bell (1785?-1825), a journalist who had joined the expedition as second in command in 1820, and including Lieutenant William H. Swift (1800–79), a former West Point student, who subsequently became a prominent army engineer, Thomas Say (1787–1834), entomologist and naturalist, and Samuel Seymour (fl. 1796–1823), artist, descended the Arkansas River to eastern Oklahoma. The second group, consisting of Long, TRP, and James, crossed the Arkansas River and supposedly headed south to explore the Red River, an important mission because the river was presumed to be the boundary between U.S. and Spanish territory. The party suffered extreme deprivation. The men were forced to subsist by eating the flesh of their own horses, and they continually encountered hostile and suspicious Indians. At the end of their trip, they discovered that they had mistakenly traveled down the Canadian rather than the Red River. Shortly after, they met up with Captain Bell's party, which had encountered similar misfortunes. On October 12 the two groups assembled at Cape Girardeau, Missouri, to head home, only to

have most of the party, except Bell, Swift, and TRP, fall ill with "intermitting fever." Recovering around the first of November, James Duncan Graham (1799–1865), the expedition's assistant land surveyor, Say, and Seymour, together with TRP, decided to voyage to New Orleans before heading home. William H. Goetzmann, *Exploration and Empire: The Explorer and the Scientist in the Winning of the American West* (New York, 1966), pp. 56–61; Edwin James, *Account of an Expedition from Pittsburgh to the Rocky Mountains*, 2 vols. (1823; facsimile edition, Ann Arbor, 1966), 2:321–24; Richard G. Wood, *Stephen Harriman Long, 1784–1864: Army Engineer, Explorer, Inventor* (Glendale, Calif., 1966), pp. 61, 75–76.

11. For a description of CWP's recommended tints, see *Peale Papers*, 3:828–29.

12. It is uncertain whether CWP painted a replica of his 1820 portrait of Jared Ingersoll (1749–1822), prominent Philadelphia jurist and CWP's lawyer from as early as 1806, or a portrait of Jared's third son, Joseph Reed Ingersoll (1786–1868). Joseph Reed Ingersoll read law with his father after graduating from Princeton College in 1804. He was admitted to the Philadelphia Bar in 1807 and quickly established a large practice as well as a reputation as an orator. Only one portrait of Jared Ingersoll has been located (1820: *Independence National Historical Park Collection*), and no portrait of Joseph Reed has been located. *Peale Papers*, 2:835; 3:793, 795n, 814; *P&M*, p. 109; *CAP*.

13. (*Unlocated*; in collection of Mrs. Frederick Carrier of Philadelphia in 1923). Edward Burd (1751–1833), jurist, son of James Burd and Sarah Shippen, married his first cousin Elizabeth Shippen (1754–1828) in 1778. In 1772, he served as king's attorney at Northumberland, but with the Revolution, he enlisted in the American cause, serving as a major in Haller's Pennsylvania Battalion of the Flying Camp. In August, 1778, the revolutionary government of Pennsylvania appointed him prothonotary of the state supreme court, an office filled by his uncle Edward Shippen before the war.

Burd's sister Jean was the mother of Eliza Patterson Peale (Mrs. RuP) and William Augustus Patterson, husband of EPP. An inscription on the back of Burd's portrait indicates that it was intended as a wedding present for RuP's wife. The portrait was exhibited in PAFA in 1822. Randolph Shipley Klein, *Portrait of an Early American Family: The Shippens of Pennsylvania Across Five Generations* (n.p., 1975), pp. 140–42, 147–48, 186, 187; Francis B. Heitman, *Historical Register of Officers of the Continental Army During the War of the Revolution* (Baltimore, 1973), p. 133; *P&M*, p. 44; Pennsylvania Academy of the Fine Arts, *Catalogue of an Exhibition of Portraits by Charles Willson Peale and James Peale and Rembrandt Peale* (Philadelphia, 1923), p. 161; *Peale Papers*, 2:1241.

14. See below, **129**.

15. See *Peale Papers*, 2:489–513; 3:129–47.

16. The Brewers were relatives of CWP's first wife Rachel Brewer (1744–1790).

17. Henry Moore (1753–1829), HMP's brother, was a farmer and blacksmith in Montgomery Square, a village in Montgomery Township, Montgomery County, Pennsylvania. His wife, Priscilla Hill Jackson Moore, died in 1821. "Mr. Jackson" is Richard Jackson, Priscilla's brother, who married HMP's sister, Deborah Moore (b. 1751). The "Steaurts" are unidentified.

Henry Moore's two daughters married brothers named Fussell: Elizabeth married Joseph in 1812 and Milcah Martha (1792–1833), Solomon in 1816. There is no information on the farm. See CWP to Henry Moore, April 6, 1819, *Peale Papers*, 3:712–13; Fussell Genealogy, Peale Family Papers files, NPG.

4. CWP to APR

GERMANTOWN, PA. JANUARY 14, 1821

Belfield Jany 14. 1821.

Dear Angelica

Last evening I finished a set of Teeth,[1] the bottom of which is of pure silver, and the Ivery being well rivited in the place where the pivots should

be placed, in consequence they (I mean the rivits[)] will come over the holes in your gums, and I hope the silver will fit better than could be made in Ivery; and the whole is certainly much stronger I need not tell you, that if they are too long, that you must use your file, and afterwards polish the teeth with a skein of thread in which put wet ashes, and lastly give a finer polish with rubing briskly on the palm of your hand— By your letter[2] I find that you do not like the Idea of my selling the Farm, because it is here that I have improved my health. I am very sensible of the advantages of exercising in a pure air and the enjoyment of having pure water to drink, and therefore I will not sacrifise it, but if I can get a comfortable House & such a lot as may be sufficient to make a better display of the Museum, it is my Interest to do so. however I find that very difficult, at least in such parts of the City, as would be to my liking. I have had the offer of a Number of handsome Buildings, but very few have ground sufficient for my purpose—and some not central.

My [some] time since, I received yours of the 2d. Instant, has been much ingrossed with the business with the corporation, they have long promised to lower the rent. I ans[w]er the Individuals of each board, yet among such a number there is always to be found some who are wanting of liberality, and it is difficult to get public bodies to meet, who receive no pay for their services— honour is a poor reward for the loss of time to men in business. Therefore I am the more anxious to make myself independant of all public Bodies, yet the central situation and general appearance of the Statehouse is important. yet in a few years the Museum must be possessed of more room to display the ever increasing articles, and it is now mortifying that I cannot put any large painting, and those now in the Museum are scattered in the several Rooms, when the Number would be much more respectable if brought into one view.

When I was last in the City I took on myself the trouble of cleaning all the Pictures, and those which I painted in the time of the revolutional War, is now as bright as any that have been lately added. yet was I to remoove the paintings, I should then perhaps improve many of them by retouching the back grounds &c—

I have not heard the progress of the act of Incorporation but I suppose it must take its turn with the other business. yet I daily expect to hear that it has passed both Houses, as it is not like many other acts, having demands for money. Perhaps you may have heard of Titians arrival, he looks well, and has grown to a respectable heigth. I believe he has done himself credit by his good conduct & persevering Industry, but the constant mooving through a dangerous country of Savages, must have prevented him from collecting & preserving many articles worthy of note. but I am much pleased to find that he has kept a journal, which will be interresting to him in future times.

I have in view much to occupy me this winter, at the farm—
prepairing to paint a large picture, 8 feet by 6 f 4½ Inches high—the
Subject, Christ at the pool from the 5 chapter of John.— The picture
contains a considerable number for [of] figures, and I may give a more
particular account of it in a future letter. I have also another task which I
propose to myself. The writing a neat address on the subject of Natural
History, in which I mean to show the importance of a Museum for the
diffusing a knowledge of the works of the Creator, to insure true piety
and lead the public from all frivolous amusements, to their lasting bene-
fit.[3] Your Mother & Mrs. Morris join

in love to you & the Children
affectionately Yrs. CWPeale

Mrs. Angelica Robinson.
 Baltre.

ALS, 2pp.
PPAmP: Peale-Sellers Papers—Letterbook 17

1. CWP had been making teeth for himself and family members for more than forty
years. He sent APR her last set of teeth in July 1820. See *Peale Papers*, 1:194; 2:1204; 3:118,
841.
2. Unlocated.
3. See below, **129**.

5. CWP to RaP

GERMANTOWN, PA. JANUARY 19, 1821

Belfield Jany. 19th 1821

Dear Raphaelle
 As health is the most important of all considerations, I have therefore
desired to write to you, some of my reflections on the means of preserving
it and therefore I hasten to write without more inteligence than my letter
the other day[1] gave you I mean of family affairs— From my practice,
besides what I have read on the subject, it is proved to me beyond a doubt
that *frictions*, that is, a rubing of the Muscels togather & against the bones,
are of the greatest importance as we advance towards old age, Exercise is
ever acknowledged to be allways necessary to promote (especially in the
open air) good health, and often also recommended to us the flesh brush
to cure Rheumatic complaints, but from the tryal of the flesh brush, I
found it a feeble force, it only warmed or iritated the skin, and had but
little effect on mussels—: Now the practice I persue, is when I am un-
dressing I rub the soles of my feet with a wollen stocking in one hand and
the other on the Toes & top of the each foot, untill I produce a glow on my
feet, then put on my socks, then striping of my cloaths, before jumping

into bed, with both hands I rub my legs, knee's thighs, hips & Loins, with my whole strength, And with one hand rumb my abdomen, then my arms, breast, and shoulders—&c. And by this exercise the present cold nights, I produce a glow over my whole frame before getting in bed. and as often as I get up in the night I repeat the same rubing of my limbs & body— This may be called electerising myself.

If at any time I feel a pain on any part of my frame I do not cease to Rub untill the pain is removed. and a further good effect by the above practice, I feel always alert, and capable of any kind of exercise or work.

Your Mother lately had a voilent pain in her back and she was apprehensive that She would be as she had been before, scarcely able to get in & out of bed, & scarcely able to walk, and once I was induced to get medical aid, & she wore a large strengthing plaster for a long time, and another time she was in [the] same way, and she got relief by a fright which made her run up stairs to see what aided [ailed] her Niece, & that voilent exercise gave her intire relief. In this late attack, I told [her] I would cure her, which I did effectually by rubing the part with my hand in fullforce. These pains must be caused by some obstruction what can tend more effectualey to remove such obstruction as the pressing the mustles togather to cause an action within them, and thus pushing forward the fluids, either of blood or serum; and when a due circulation by this means is effected, the muscles will not complain— we know but little of the powers of the Electrical fluids—except that it is every where, more in the living bodies than in the dead. That we have more of it in a cold clear air than at other times, hence we feel more energy, than in moist damp weather. are not all bodies more excited with Electricity by friction?

Now more to the purpose, you have a gouty habit—And you know the cause of the Gout, therefore after taking what care you can to keep clear of it, by avoiding every thing that you know tends to produce it, and in addition as far as you can follow my practice, and I flatter myself that you will find the good effects of it.[2] Your joints that are sore must not be rubed so far as to produce inflamation, but only so far as may help to remove some of that obstructed jucis [juices], that cause a stiffness of your joints. your abdomen and other parts of your body may be rubed pretty frequently and such part of your limbs as can bear it.

I am more particularly induced to urge you to this practice because I find that in former times more attention was paid to this kind of exercise, than in Modern times—the moderns call it *passive exercise*, yet in the mode I point out, it is much more than passive, it is effective exercise. I think I have said enough to induce you to think and make some tryal on yourself. And now I shall only say, that the family are all in health &c

One thing more, my canvis for this big picture is very fine, and having 2

coats on it, this seems intirely hid & the surface charmingly smooth, as it ought to be for small figures. Your Mother Mrs. Morris, and others of the family desire their Love &c to be presented you

yours affectionately
CWPeale

PS. Your Mother wishes you to ask the Gentleman who spoke to you about the land in Chester County, if he knows how many acres it contains & what its quality.

ALS, 2pp.
PPAmP: Peale-Sellers Papers—Letterbook 17

1. See above, **3**.
2. RaP experienced many incapacitating illnesses after his disastrous adventure in Georgia in 1806 (see *Peale Papers*, 2:960–63, 980). In 1807, tremors are mentioned (*Peale Papers*, 2:1021); and in 1809, "delirium" necessitated hospitalization (*Peale Papers*, 2:1218n). CWP attributed these attacks to RaP's intemperance, or alcoholism. From about 1813 on, however, Raphaelle began to suffer episodes of what CWP referred to as "gout," a temporary crippling of his hands that made it impossible for him to work. RaP's last attack of gout was during the summer of 1820. See *Peale Papers*, 3:210, 363–64; 842. For different analyses of RaP's health problems, see Phoebe Lloyd, "Philadelphia Story," *Art in America* 76, no. 11 (1988): 155–202; Phoebe Lloyd and Gordon Bendersky, "Arsenic, an Old Case: The Chronic Heavy Metal Poisoning of Raphaelle Peale (1774–1825)," *Perspectives in Biology and Medicine* 36 (1993): 654–65; Phoebe Lloyd and Gordon Bendersky, "Of Peales and Poison, "*MD* 38, 2 (1994): 27–29; Phoebe Lloyd and Gordon Bendersky, "The Peale Controversy: Guilty," *MD* 38, 4 (1994): 10, 12; Lillian B. Miller, "The Peale Controversy: Not Guilty," ibid., 10, 12; Gerald Weissmann, "Peale's Gout: A Lead-Pipe Cinch," ibid., 9. Weissmann believes that RaP suffered "saturnine gout," the result of lead poisoning from the leaching of lead-lined vessels used for brewing alcoholic beverages. For a discussion of lead poisoning resulting from alcoholism, see Richard P. Wedeen, *Poison in the Pot: The Legacy of Lead* (Carbondale, Ill., 1984).

6. Henry Ploss[1] to RuP

LEIPZIG, GERMANY. FEBRUARY 28, 1821

Leipzig the 28 feb 1821[2]

Sir:

Mr. Vezin von Leugerke[3] had the kindness to give me your directions, and I hear with pleasure that he hath allready received a party of birds from you.

Being informed by Mr. Vezin von Leugerke that you prefer bartering to selling, I am ready to serve you also in such case. I am possessed of a considerable cabinet and can moreover by my connexions procure you by and by all European birds.

Having embraced the science not for gains, but for instructions and entertainment's sake, I also give the preference to bartering; and if you

please, we may exchange bird against bird, and in order to appoint the near value, we could fix it for the little birds a Dollar bill to the size of a Pie.[4]

I expect on this account your kind decision; and after having received it & if the Season makes no impediment to Shipping, I'll make you a sending of inland birds of all Sorts. If you'll acquaint me with what you particularly wish to possess I would be very glad of it.—

In case you prefer birds of a larger Size, they are at your Service. I also would like to have great-ones; in that case the price in bartering must be singly fixed.

By these means we both may considerably enlarge our Cabinets[5] I heartly wish, to be soon favoured with an answer, in which expectation I am respectfully
> Sir

> Your most obed. Servent
> Henry Ploss
> Associe Ploss & Klaebirch

ALS, 2pp., add, & end.
PPAmP: Peale-Sellers Papers

1. Unidentified.
2. This letter, endorsed as having been received May 16, 1821, is a close copy of an earlier letter dated November 24, 1820, which was endorsed "Rec'd March 3d, 1821." F:VIIA(Add.)/1C2–4.
3. Unidentified.
4. Perhaps *magpie*. The most common species in Europe is the black-billed magpie (*Pica pica*), which is twenty inches long, including a ten-inch tail.
5. The Philadelphia Museum, first under CWP and later RuP, had entered into international exchanges almost from its inception. CWP sought specimens from private collectors, such as Thomas Hall of London, and from institutions, such as the Royal Swedish Academy of Science. RuP continued his father's practice of exchanging, or "bartering," rather than purchasing, specimens. *Peale Papers*, 2:31–34, 44–45, 100–01, 154, 156. See also Alexander Ricord to RuP, January 6, 1821, P-S, F:VIIA/3D14-E1; Lewis Lederer to CWP, January 10, 1821, P-S, F:IIA/65E12–14, F1.

7. ReP to John Pendleton[1]
BALTIMORE. MARCH 3, 1821

> Baltimore March 3d. 1821.

Dr. Sir

Since I wrote last[2] I have several times taken up & again abandoned the idea of going with you to Boston. But many of my friends, & among them my wife, think I ought not to doubt of the advantages, to say nothing of the pleasure. I have long looked forward with some satisfaction to a good

excuse for visiting Boston and am willing to be persuaded that my trip would not be unprofitable— Yet I grieve to lose so much time from my eazel.

My Picture of the Death of Virginia[3] I think can be finished in less than 2 weeks, but whether it would be adviseable for me to wait that long I am not sure.—I am informed that the good weather in Boston generally commences about the 1st. of April. But the Snow you mentioned as being 10 Inches deep, was here only enough to whiten the ground & in Boston was 18 inches deep. It will be well for you to make enquiries & let me know. The weather for two weeks past has been delightful here. If the weather should be good with you ⟨could⟩ would it not be well to mention that the Picture which (since the close of exhibition) had been suffered to remain in the Academy because the weather rendered it inadviseable to remove it to Boston will now be positively taken down on (Wednesday) &c.[4]—Submitted to your own judgment.

Mr. Sparks[5] has promised to give me a list of all the Clergymen in & about Boston which I shall probably be able to forward you by Tuesday's mail, in order that you may save time by filling up the Tickets & enclosing them (each with a *handbill*) directing & sealing them. It will then be easy to make any additions to the list.

It will be necessary for me to varnish the Picture as it will be still more dull in Boston, even with all the care you can practise in putting on your *pancake*.[6]

Enquire concerning the Packets to providence & those which go direct from N.Y. to Boston. Time, expense & safety, and insurance.

After your poetical Letters, mine appear very dull & prosaick—— But you must consider that here at home, it is filled with many cares.

<div align="right">

Yours sincerely
Rembrandt Peale
</div>

To Mr. J.P.

ALS, 2pp.
Private Collection

1. In 1816, John B. Pendleton (1798–1866) and his brother William S. Pendleton (1795–1879) assisted ReP in installing gaslights in the Baltimore Museum. Around 1820, John went to France, where he studied lithography. In 1821, ReP hired him and his brother to manage his traveling exhibition of the *Court of Death*. Later, in 1825, the Pendletons established a lithography firm in Boston from which ReP benefited. *DAB*; *Peale Papers*, 3:843; below, **195**.

2. Unlocated.

3. (Destroyed by fire.) On April 4, 1821, ReP explained in a printed "Card" that his *Death of Virginia* was intended as a companion piece to the *Roman Daughter* of 1811 but that he had put it aside in order to paint *Christ's Sermon on the Mount* (which he never finished). However, before he became "entirely engaged in this laborious undertaking," he was persuaded, he wrote, to finish the *Virginia*. He was now advertising its exhibition in the Peale Museum.

The theme of ReP's painting was taken from the Roman legend in which the daughter of

the plebeian Virginius is slain by her father to prevent her being dishonored by the tyranni-cal decemvir (magistrate) Appius Claudius. This episode led to the overthrow of the decem-virate in 449 B.C. ReP may have been stimulated to complete the picture by performances of James Sheridan Knowles as Virginius in September and October, 1820, in New York and Baltimore. In November of that year, copies of the play were advertised for sale in Joseph Robinson's Circulating Library at the corner of Market and Belvidere Streets in Baltimore. ReP's "Card" is in the C. C. Sellers Papers, PPAmP, ReP (uncat.) v. 2. See also *The Century Dictionary and Cyclopedia* (New York, 1900); *Baltimore Federal Gazette*, November 3, 1820; Miller, *In Pursuit of Fame*, p. 112.

4. The *Court of Death*, exhibited at the American Academy of Fine Arts in New York, was advertised as closing on February 10. *Mercantile Advertiser* (New York City), February 6–10, 1821. For a visitor's response to the New York exhibition of *Court of Death*, see the appendix.

5. Jared Sparks (1789–1866), Unitarian clergyman, editor, and historian, was the first minister of the First Independent Church of Baltimore (Unitarian), serving from 1819 to 1823. ReP was a pew holder in the newly built church from 1819 until he left Baltimore in 1822. His association with the Reverend Sparks brought him into contact with prestigious Unitarian circles in Boston and London, resulting in portrait commissions and aesthetic ideas that influenced his art from the 1820s on. See Miller, *In Pursuit of Fame*, pp. 131, 141, 155, 219. (Fig. 1.)

6. *Pancake* was the Peale family term for egg varnish, which was used, according to Thomas Sully, "to prevent the action of stickiness in the paint while the canvas was rolled up." Sully's preparation included alcohol, sugar, and the white of an egg. CWP noted (see below, 20) that ReP was coating his painting with the white of an egg and flour to prevent it from sticking. Thomas Sully, *Hints to Young Painters* (1873; reprint ed., New York, 1965), p. 25.

8. CWP to RuP

GERMANTOWN, PA. MARCH 5, 1821

Belfield March 5th. 1821.

Dear Rubens

My opinion accords with you in the Electing Mr. Patterson, Mr. Zac-cheus Collins, as trustees, and I have added Mr. Vaughan as a third, on the supposition that you will agree that no one that we could get would be more active than he will probably will be to serve the Interest of the Museum— Therefore you will note the holder of the Stock appoints Messrs. Pierce Butler, Coleman Sellers, Robert Patterson, Zaccheus Col-lins & John Vaughan as Trustees for the ⟨new⟩ present year. and that you will accept the office of Manager of the Museum—[1]

I am so much interrested in the completing of this Picture[2] that I do not want to quit it before it is had my last touches, or it would be very agreable to me to celebrate your wedding— It is fine weather & your plants are beautifully blooming. Love to Eliza

Yours affectionately
CWPeale

Mr. Rubens Peale.

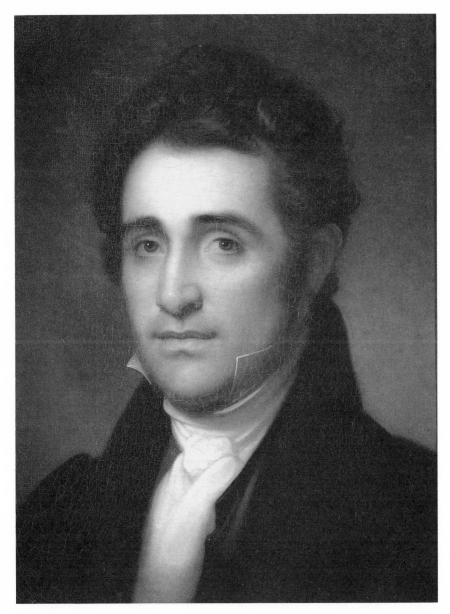

1. *Jared Sparks*. Rembrandt Peale, ca. 1819. Oil on canvas, 20 ¹/₈ × 15 ³/₁₆″ (51.1 × 38.6 cm.). Courtesy of the Harvard University Portrait Collection, Harvard University Art Museums, Bequest of Lizzie Sparks Pickering, wife of Edward C. Pickering.

ALS, 1 p.
PPAmP: Peale-Sellers Papers—Letterbook 17

1. The board of trustees consisted of some of Philadelphia's notable scientists and public figures. Robert Maskell Patterson (1787–1854), physician and educator, was professor of mathematics and natural philosophy at the University of Pennsylvania (1813–28). In 1814 he succeeded his father, Robert Patterson (1742–1824), as vice provost of the university. He was later director of the U.S. Mint (1835) and president of the APS. While studying the physical sciences in Paris from 1809 to 1811, he served as acting U.S. consul-general. It was at this time that he and ReP, also in Paris to study and practice his art, became good friends. See *Peale Papers*, 3:10n, 67; *NCAB*; *Notable Americans*.

Zaccheus Collins (1764–1831), merchant and botanist, was a member of many of Philadelphia's prestigious institutions of culture and learning, including the Academy of Natural Sciences, the APS, and the Pennsylvania Horticultural Society, of which he was elected president in 1828. His botanical expertise was honored and immortalized by Thomas Nuttall, who named a species after Collins in his *The Genera of North American Plants* (1818). *PMHB* 18 (1894):94; Scharf, *Phila.*, 1:621; John C. Greene, *American Science in the Age of Jefferson* (Ames, Iowa, 1984), pp. 58, 270; Maurice E. Phillips, "The Academy of Natural Sciences of Philadelphia," *Transactions of the American Philosophical Society*, 43, pt. 1 (1953): 271; *NUC*.

John Vaughan (1756–1841), merchant and art patron, was also an active member and an officer of the APS. In 1792, he had served as a member of the Philadelphia Museum's Board of Visitors. *Peale Papers*, 1:389; 2:37–39.

Pierce Butler (1744–1822), planter and politician from South Carolina, resigned his seat in the U.S. Senate in 1804 to become a director of the Bank of the United States in Philadelphia. *Peale Papers*, 2:854; *NCAB*.

Coleman Sellers (1781–1834), manufacturer, married SPS in 1805. *Peale Papers*, 2:797, 899, 900; Eugene S. Ferguson, ed., *Early Engineering Reminiscences (1815–40) of George Escol Sellers* (Washington, D.C., 1965), xiv.

2. CWP's painting *Our Saviour Healing the Sick at the Pool of Bethesda*.

9. Rosalba Peale to TRP

BALTIMORE. MARCH, 1821

The last time I wrote to you,[1] I almost made up my mind, I never would write again in such a hurry, for there are a thousand things, *extravagantly speaking*, that one would wish to say that is omitted when writing so fast, I did not entend to write to day but as Mr Sully[2] called this morning to let us know he was going to Philamaclink[3] this afternoon. I thought I must write a few lines to my dearly beloved Uncle hurry or no hurry

How delighted I would be if it were possible for you to come down and stay with us while papa is gone to Boston.[4] he goes in a bout 3 weeks and will be absent fore or five weeks at the furthest, is it utterly out of your power to come down. if you have writing, or drawings to make bring them down, and I will help you. but I expect if the truth was known you are too much engaged with Eliza[5] to make any great effort

I have a commision for you. Papa has given me the portrait of Mama, Now in posesion of Uncle Rubens,[6] I wish you to put several thicknesses of

paper and a bord in front of it and screw it to the picture, and give it to Mr. Sully who will return on Thursday

How are all the folks especialy C W Peale jue⟨nor⟩[7] give my love to them all tell the girls in pine St[8] that I [want] to hear from them soon it is almost five there I must bid you Adieu give my love to Dr. Godman

Your Sincere Rosa

ALS, 1p. & add., end. Recd. 11th: March 1821 Philada:
PPAmP: Peale-Sellers Papers

1. See above, **2.**
2. Thomas Sully (1783–1872), portrait painter, resided in Philadelphia, but had been working in Baltimore since November 1820. He remained in Baltimore, except for frequent trips back to Philadelphia, until July 1821. See *Peale Papers*, 2:1097; 3:819, 819n; Monroe H. Fabian, *Mr. Sully, Portrait Painter* (Washington, D.C., 1983), p. 14.
3. Possibly a humorous term for Philadelphia used by the young Peales. Aware of TRP's restlessness and his urge to be an explorer, Rosalba may have been playfully punning with the word *clink*, as in prison.
4. See above, **7.**
5. Eliza Cecilia Laforgue. See above, **2.**
6. Either ReP's 1803–05 portrait of his first wife, Eleanor May Short (1776–1836) (*private collection*), or the later (ca. 1811) portrait (*Mead Art Gallery, Amherst College*), both of which descended through family members. ReP Catalogue Raisonné, NPG.
7. Probably RuP's first child, born on February 15 (1821–71). RaP's first son (1802–29) was also named after CWP. *CWP.* pp. 440, 442.
8. Possibly RaP's daughters Eliza and Sophonisba, who lived on 99 Pine Street. *Philadelphia Directory (1821)*.

10. RuP to Henry Escher[1]
PHILADELPHIA. MARCH 14, 1821

Philadelphia March 14th. 1821.

Dr. Sir.

My Father Charles W. Peale, who Continues to enjoy good health at the advanced age of 81, desirous of giving to his children a due proportion of the profits of many years labour, has obtained from the State of Pennsylvania an Act of Incorporation, and placed the Museum ⟨under th⟩ on a firm basis, under the Controll of five Trustees, so that the Museum must always remain together and undivided.

Devoting all our efforts to the advancement of the Natural Sciences, we desire with a similar intention to address ourselves to you, as an admirer of the same. We assure you that any subjects of Natural History peculiar to your country, or works of Art you may please to present to our Museum, shall be received with thankfulness and pleasure.

In like Manner we are willing to return or exchange what ever produc-

tions of our country, (that are to be obtained) you may desire, and as your attention has been directed particularly to the department of Insects, it will give us pleasure to commence a mutual exchange of them, therefore you may expect by an early opportunity to receive a box of insects from us as a beginning.[2]

Mean time we shall be happy to hear from you

I have the Honor to be

<div align="center">Your HbS.</div>

<div align="right">R.P manager.</div>

Henry Escher.
 Zurick
 Switzerland.
forwarded by the way of New York.

AD, 2pp.
PPAFA Archives

1. Unidentified.
2. There is no listing in the Museum Accessions Book for an exchange of insects with Escher.

11. Stephen H. Long to John C. Calhoun[1]
PHILADELPHIA. MARCH 15, 1821

<div align="right">Philadelphia March 15, 1821</div>

Sir:

I take the liberty to inclose an application made by Mr. Peale, for the Animal Specimens collected by the Explg. Expedition.[2]—— Considerable expense must necessarily be incurred, in preserving framing & stuffing the skins, and as no public funds are applicable to that as well as other objects of the Expedition not yet accomplished,— I know of no other means of making a suitable disposition of our collections, except thro' some arrangement with an institution like that in which Mr. Peale is concerned.—— By an act of the Legislature of this State Peale's Museum has lately been invested with a corporate capacity, under the title of the Philadelphia Museum Company, which will be likely to secure to it a permanency, to which probably no other institution of the kind in the U. States, has equal claims.

As an immediate attention is necessary to secure the skins, from injury, I have placed them in the care of Mr. Peale, under the condition that they shall be subject to your order whenever you see fit to have them otherwise disposed of.—— Should you deem it proper to have them deposited in the Philadelphia Museum, arrangements can be made for having them

framed without an additional expense to Govt.—— I shall be glad
to receive your instructions upon this subject.—
I have the honour to be Sir: very respectfully

> Your most obt. and
> Humble Sert.
> S. H. Long Maj. U.S. Eng.

Hon. J. C. Calhoun
 Secy. of War.

[enclosure]

Rubens Peale to Maj. Stephen Long
PHILADELPHIA. MARCH 13, 1821

> Philadelphia Museum Company (lately Peale's Museum.)
> March 13th. 1821.

Sir
The Company which I have the honor to represent, desirous of extending the advantages resulting from the late exploring expedition, wish to obtain the Articles of Natural History collected, so as to render them accessible to the Citizens generally.

Actuated by this desire, I am authorized to inquire whether the skins of the Animals procured by the Zoologists may not be obtained for this institution. Untill such grant can be received we shall keep an account of every such article as may be placed under our care.[3]

I have the honor to be

> Your obedt.
> Sert.
> Rubens Peale manager.

Majr. S. Long.

ALS, 2pp., add., enclosure (1 p.)
DNA—RG-107. Secretary of War. Letters Recd. L–81(14)
Endorsed: Phila. March 15, 1821. Maj S. H. Long. Enclosing an application of Mr. Peale for the Animal Specimens collected in the late expedition for the museum.

1. John C. Calhoun (1782–1850), senator from South Carolina (1832–43, 1845–50) and vice president under John Quincy Adams (1825–29) and Andrew Jackson (1829–32), served as secretary of war from 1817 to 1825 in Monroe's administration. CWP had painted his portrait in 1818. *Peale Papers*, 3:623; *DAB*.
2. RuP's application to Stephen H. Long derived from a conversation in December 1820, between John C. Calhoun and CWP. When Calhoun stopped in Philadelphia on his return from a tour of forts and military installations, CWP met with him and requested that the

animal specimens collected by TRP on the Long Expedition be placed in the museum. In CWP's recollection, Calhoun, who as secretary of war had organized the expedition, had responded that such an arrangement would be "most useful." Writing to Calhoun on December 24, 1820, CWP reminded him of the conversation, assured him that TRP would do a careful job of preserving the specimens, and offered to make drawings of them if needed for publication. To reassure Calhoun of the public benefit of such an arrangement, CWP added that the museum had been incorporated by the Pennsylvania legislature. On March 20, Calhoun wrote to Long that he had approved the deposit of the articles in the Philadelphia Museum "subject to the orders of the [War] department." See *Peale Papers*, 3:861–62; W. Edwin Hemphill, ed., *The Papers of John C. Calhoun* (Columbia, S.C., 1971), 5:692.

 3. See below, **14**.

12. CWP to RaP

GERMANTOWN, PA. MARCH 19, 25, 1821

<div align="right">Belfield March 19th:-21.</div>

Dear Raphaelle

Anxious to finish my painting from the print[1] I was not willing to spend any of my time in Letter-writing or you would have heard from me some time past. I get through the painting in reverse much better than you would expect, untill all the picture had the first colouring, I was obleged to work from the mirrer, but in the next colouring I laid aside the Glass—yesterday I put the last touches to the piece, and I am much mistaken if it does not excite a good deal of admiration—It has been a task of seven weeks of the closest application I have risen with dawn of morning, & commonly made my fire, set my pallet and made some progress in my work before breakfast, continuing steadily at the Easel untill night and in all the time lost only 3 days— Reluctantly being obleged then to Visit the City. But what I think very extraordinary, is that having received a hurt that I thought might proove very serious, yet I did not cease from the exercise of my Pensil a single hour on that account.

Standing on a piece of Scantling to reach the upper part of the Picture, the scantling by my reaching on one side turned and I feel [fell] on a Stool on my right side, I felt but little hurt at the time, and I continued painting—towards the evening, finding some uneasiness of my side, I took a steam bath[2] and rubed Vinager and on the part affected, and the following days I found that [I] could not undress, stooping was too painfull and your Mother was obleged to help me to dress & undress, raise and lower the picture I could sit still & paint, but if I sneezed, coughed or blowed my nose hard the pain was extreamly severe, I sent to Germantown to get a Man to put on Leeches, but he had none, therefore I was obleged to go into the City, and none was to be had there and consequently I got cupped,[3] it gave me some relief, but too little blood was taken

away and returning home I took repeated doses of Salts,[4] lived on Gruel, and poulticed my side twice with Cow dung. however by temperate living & frequent bathing with Vinager in 9 or 10 days the pain gradually left me— your Mother was a faithful nurse to me, she constantly watched to aid in all my wants. Had I when the accident first happened, have taken about 12 oz of blood from my arm, I propably should have saved myself much pain & trouble, but knowing my pulse to be good; no fever or even pain without those exertions named above, but at my time of of life bleeding if possible ought to be avoided.

The Picture, being now finished, I shall frame & varnish it, and then invite all the gentell [genteel]company to view the Picture for a few days previous to the removal to the City—[5] by this means I shall get it *talked off* [*of*], which seems to be necessary to get it seen at the Museum—and a spur to drive company there is very much wanted, as of late our income has been very triffling, altho' our expences is not lessened, but rather increased.[6] The Corporation has not yet lowered the rent [illeg] I hope it will be done, as we have complied with the wishes of some members, by pulling down the Room over the Stair-way, also the Chimney in the Steeple. Perhaps you may not have seen the paper that have published accounts of the Incorporation of the Museum[7] and on the 9th. Instant the following Gentlemen was appointed Trustee's to the Philada. Company, for the improvement of the of the Museum, Vizt. Pierce Butler, Zacchius Collins, Robt. Patterson, Coleman Sellers & Rubens Peale. By the Act of incorporation the Museum cannot be removed from the City of Philada. or even an article from it without forfeiting twise its value to the City.

25th. I have got the following memorandom from Mr. Armat who says he believes his Son W. Armat had nothing to do with the land— Purchasers of Lands the property of G. Taylor & Jones. Paul Beck one Tract. Jno. Stoddart 5 Tracts & Mr. Corless one T. Sold by John Connerly. Decr. 15th. 1802. I shall be in Phila. next week and will then of Mr. Connerly who got that of Chas. Polk, Mr. Armat thinks it probable it were amongst the 5 kept—[8] I invited the Germantown folks & yesterday 295 Visitors came to see it, & if the day is good believe more will be here today. The Picture is greatly admired, but praise is cheap; does not cost those that give it any thing. I expect on Monday next to go to Phila. with the Picture provided the frame is ri[ght] [for] it.

I suppose you will shortly come home to see your family, as usial, I must not omit to present your Mother & Mrs. Morris love to you. Rembrandt I hear will be here next week on the way to exhibit his Picture at Boston. Yrs. affectionately

CWPeale

Mr. Raphaelle Peale.

ALS, 3pp.
PPAmP: Peale-Sellers Papers—Letterbook 17

1. *Our Saviour Healing the Sick at the Pool of Bethesda,* see above, **3.**
2. For CWP's invention of a vapor bath, see *Peale Papers,* 2:315.
3. Cupping is the art of taking blood by placing on the skin cups that have been emptied of air. After the blood is drawn to the surface, incisions are made in the skin and the cups are reapplied to collect the blood. CWP had an ambivalent attitude toward bleeding. He believed that such treatments weakened the body, but when other medicines and approaches failed, he resorted to bleeding, cupping, and the use of leeches. See *Peale Papers,* 3:303–05, 315–17.
4. CWP could have taken Epsom, Rochelle or Glauber's salt as a cathartic. *OED.*
5. In a letter to ReP of this date, CWP wrote that he would "invite all the respectable families in Germantown to see it, previous to its going to the Museum, so that my Painting-room & garden will be like a *Jubialia*" (P-S, F:IIA/65G1–3). See also CWP to Mr. Wachmuth & Family, March 20, 1821. DSIAR: Feinberg Collection, F:IIA/65G7–9.
6. Museum receipts had been declining almost steadily since 1816, when they reached a high point of $11,924.50. In 1817 they were $8,232.50; in 1818, $8,411.25; in 1819, $6,046.75; in 1820, $5,317.00; and in 1821, $4,928.99 1/2. The museum's net income also declined from the last quarter of 1820 to the first quarter of 1821. RuP's quarterly "Recapitulation of Receipts & Expences" confirm CWP's characterization of museum income:

```
For the last quarter of 1820:
     October     268,,25.
     November    391,,62 1/2
     December    630,,56.          1290 37  1/2
              Deduct expenses, viz:
     October      82.82 1/2
     November     34.40 3/4
     December     88.20             205 33  1/4
              Nett receipts        1085 04. 1/4
For the first quarter of 1821:
     January     349.75.
     February    236.75.
     March       306.99  1/2        893 49. 1/2
              Deduct expenses &c.
     January      41.94
     February    130,97
     March        34,36             207.27
                                    686 22. 1/2
```

See Philadelphia Museum Account Book, January 1820–July 17, 1824, P-S, F:XIA/6A2-E12, pp. 1, 10, 14.

7. In late February and early March shareholders of the Philadelphia Museum were notified that in accordance with the third section of the Act to Incorporate the Philadelphia Museum a meeting would be held on March 5 "to elect Trustees for the present year." *Poulson's* and *The National Gazette and Literary Register,* February 27 to March 3, 1821. Since CWP was the only shareholder, this announcement was simply pro forma.

8. The individuals mentioned are unidentified. CWP is writing about land willed by his brother, St. George Peale (1745–78) to his nephews RaP and CPP, consisting of two tracts, or five hundred acres, in Frederick County, Maryland. CPP sold his share of the land. In 1810, when RaP neglected to pay taxes on his land, it was seized by the county sheriff and sold at auction. According to CWP, RaP, "knowing that the more sufficient improvement on the land to have prevented them from being sold for Taxes," hired a lawyer and recovered his share of the land. In April CWP wrote to Isaack Lazarus of Caroline County, Virginia, inquiring whether Lazarus still held title to CPP's land. *Peale Papers,* 1:281; CWP to

Nathaniel Ramsay, January 9, 1813, P-S, F:IIA/52A8–9; *Peale Papers*, 3:181, 182n; CWP to Isaack Lazarus, April 3, 1821, P-S, F:IIA/66A9.

13. James Milnor[1] to RuP
NEW YORK. MARCH 23, 1821

<div align="right">New York March 23rd. 1821</div>

Dear Sir,

Your letter on ye. subject of the Esquimaux was received by me at too late an hour to answer by yesterday's Mail. Butler's conduct in regard to these people has been so shameful, and he has shewn such an utter contempt of all decency & regard to public opinion, that so far as I have been able to learn the sentiments of the Gentlemen who were associated with myself ⟨with⟩ in the design of protecting and instructing them, and returning them to their own Country, it is their united determination to sanction no acts of his in relation to these people, & to act no further in their intended trust unless they voluntarily & entirely place themselves under their care. B's departure from New York was secret and concealed & he has falsified all his assurances to the Committee. On the Subject of the exhibition of the Esquimaux it was our resolution had they not been seduced from our care to avoid every thing of the kind, and we should without the least difficulty by individual contribution have possessed ourselves of all the necessary means for their education & support & return home. We thank you for the obliging interest you have taken in the case of these poor people, & shall be happy to hear that the charitable exertions of the philanthropic City, where they now are may be more successful than our own. Butler we have no doubt has sinister designs; for he has given up his whole business for this object, and it is feared that his Tavern has given George[2] such a love of liquor that that temptation alone will be sufficient to enable him to maintain his influence over him, & he will control the women.

<div align="right">In much haste
I remain,
Dr Sir, Yr's Sincerely,
JMilnor</div>

Mr. Rubens Peale

ALS, 2pp. & add., end.
PPAmP: Peale-Sellers Papers

1. James Milnor (1773–1845), rector of St. George's Church (Episcopal) in New York City since 1816, had earlier served as minister of St. Peter's Church in Philadelphia, with which the Peale family was associated and was probably acquainted with RuP. Milnor had also

served as a representative in the United States Congress from 1811 to 1813. On February 23, 1821, Milnor and other New Yorkers formed the "Committee of Benevolent Citizens," charged with the care of three Eskimos, who were being exhibited in the city presumably against their will. Their alleged captor, Captain Samuel Hadlock, Jr., of Cranberry Isles, Maine, was arrested on February 5, and charged with kidnapping the group. Hadlock had met the Eskimos—George Niakungitok, Marie Coonahnik, and her baby son Ekeloak—in Labrador in the autumn of 1820, and had begun exhibiting them in New York City in December. After Hadlock's arrest, the Eskimos were moved to Charles T. Butler's hotel, or "porter house," on 7 Park Avenue, where the baby, Ekeloak, soon died. Butler then exhibited the Eskimos in New Brunswick, New Jersey, and proposed to RuP that they be shown in the Philadelphia Museum, with all compensation from the exhibition going to the Eskimos' aid. On March 21, RuP wrote Milnor to inquire whether his committee would approve the arrangement. Milnor's characterization of Butler's "shameful" behavior led RuP to reject Butler's offer, after which, beginning on March 26, 1821, Butler exhibited the Eskimos at August's Long Room in Philadelphia.

Hadlock was found innocent of the charges against him and obtained a habeas corpus to force Butler to release the Eskimos, who willingly returned to Hadlock on April 24. Hadlock first exhibited them in Baltimore and then took them to England, Wales, and Ireland. In the autumn of 1822, Marie Coonahnik died in England, but Hadlock continued his exhibition tour to Germany, Austria, and Hungary with George Niakungitok. Niakungitok died in Strasbourg in November, 1825. Hadlock was lost at sea on a voyage to the Arctic in 1829.

We are grateful to Dr. William C. Sturtevant, Curator, Department of Anthropology, National Museum of Natural History, who is conducting a research project on Captain Hadlock and his Eskimo tour, for this information. See RuP to the Rev. James Milnor, March 21, 1821, RuP, Letters (copies) and notebook, for the Philadelphia Museum, PPAFA, F:XIA/7C1–14; *Niles Register*, December 30, 1820, February 24, 1821, pp. 296, 482.

2. George Niakungitok.

14. RuP: List of Specimens from Long Expedition

PHILADELPHIA. MARCH 23, 1821

Invoice of Zoological Specimens and Drawings prepared by Titian Peale, Assistant Naturalist for the Exploring Expedition and deposited in the Philadelphia Museum by Majr. S.H. Long. Maj. U.S. Engr. pursuant to instructions of the Secretary of War.

Zoological Specimens &c.

3 Prairie Wolves.	2. Species of Hawks.
1. Black Wolf.	2 do. of Owls.
1. Very large Catfish.65ϖ	2 do. of Swallows.
1. Wild Turkey Cock.	1 Pigeon.
3. Squirrels.	1 Grouse.
1 Gopher.	2 Woodpeckers.
1 Wood Rat.	3 Fishes.
1 Otter.	3 Species of Fly catchers.
2 Sand Hill Cranes.M.&F.	1 Warbler.
1 Whoping Crane	3 Turtles.

2 Prairie Hens.

1 Raven.

4 Magpies.

1 Badger.

1 Black tail Deer.

1 do. Fawn.

1 Mexican Squirrel.

2 New Specimen of Squirrel.

2 Snakes.

4 Lizards.

1 Garmlus cærutea

1 Bunting.

1 Sparrow.

1 Bag of Seeds.

Sundry small Birds, anatomical preparation

1 Box of Small animals.

Drawings. [1]

1 Buffaloe	finished	1 Skunk.	unfinished	
1 Black Wolf.	do.	1 Gopher.	do.	
1 Prairie Wolf.	do.	1 Wood Rat.	do.	
1 Badger	do.	2 Antelopes.	do.	
2 Shrews.	unfinished	3 Black tail		
2 Wild Bats.	do.	Deer	do.	
2 Squirrels.	unfinished	2 Marmots.	do.	
2 Squirrels	do.	1 Oriole M&F.	finished	
1 Pine Grose		2 Sand Hill		
beak.(young)	finished	Crane M.&F.	do.	
1 Magpies.	finished	1 Swallow.	unfinished	
2 Minute	unfinished	2 Buntings.	do.	
Tern.		1 Hawk.	do.	
1 White		1 Owl.	do.	
Pelican.	do.	13 Plants.	do.	
1 Black Hawk.	do.	9 Fishes.	do.	
4 Sparrows.	do.	9 Lizards.	do.	
3 Warblers	do.	3 Snakes.	unfinished	
2 Sand Pipers.	do.	33 Insects.	unfinished	
3 Fly-catchers	do.	6 Shells.	finished	
1 Pigeon.	do.			
1 Woodpecker.	do.			

Received, Philadelphia Museum, March 23d.1821. of Majr. S.H. Long. the several Articles, specified in the above Invoice, as a deposit for safe keeping, preservation and Exhibition; and I hereby promise, as agent for the Institution to hold the said Articles subject to the orders of the War Department, thro the said Maj. Long

Rubens Peale manager

ADS, 2pp.
PHi: Peale Papers

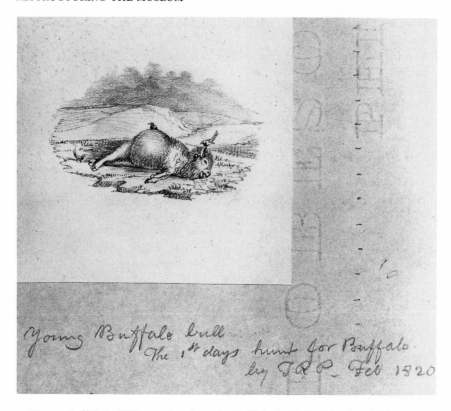

2. *Young Buffalo bull/The 1st days hunt for Buffalo. by TRP, Feb 1820.* Titian Ramsay Peale, 1820. Graphite on paper, 3 ¼ × 3 ⅝″ (8.2 × 9.1 cm). American Philosophical Society, Philadelphia. [B/P31.15d no. 62]

1. TRP's drawings, or sketches, were executed on small sheets of paper in a small sketchbook. They were drawn mainly in pen and ink; a few are in watercolor. TRP later incorporated some of these sketches into lithographs and paintings. See Jessie Poesch, *Titian Ramsay Peale, 1799–1885, And His Journals of the Wilkes Expedition* (Philadelphia, 1961); figs. 2–8.

15. Rosalba Peale to TRP
BALTIMORE. MARCH 26, 1821

Monday March 26th—21

Dear Titian

I thank you most sincerely for your kind letter[1] and Mockasons[2] which I doubly value being made by your orders when so far away from me it

28

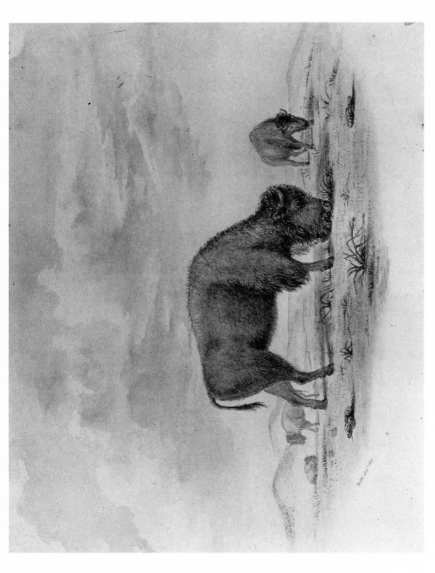

3. Sketch of Bison. *Bulls Feby 1820*. Titian Ramsay Peale, 1820. Watercolor and ink over graphite on paper, 7 ³/₈ × 9 ¹/₄″ (18.9 × 23.4 cm). American Philosophical Society, Philadelphia. [B/P31.15d no. 65]

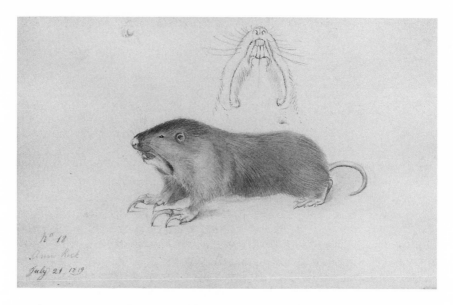

4. Sketch of Pocket Gopher *No 18/ Arrow Rock/ July 21, 1819*. Titian Ramsay Peale, 1819. Pen and ink over watercolor, 4 ⁷/₈ × 7 ⁵/₈″ (12.3 × 19.4 cm). American Philosophical Society, Philadelphia. [B/P31.5d no. 44]

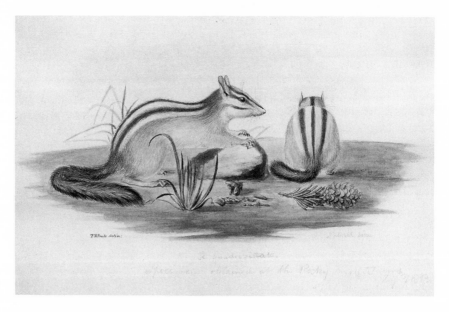

5. Sketch of Chipmunks. *Sc quadravittatus/ Natural size/ Specimen obtained at the Rocky mountains/ by TRP*. Titian Ramsay Peale, ca. 1820–22. Watercolor on paper, 7 ³/₈ × 9 ³/₄″ (18.5 × 24.5 cm). American Philosophical Society, Philadelphia. [B/P31.15d no. 115]

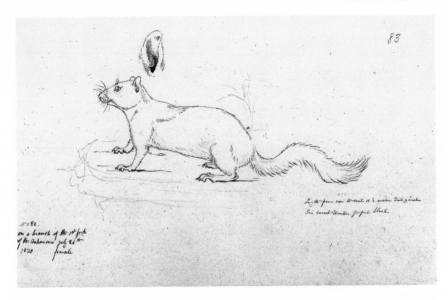

6. Sketch of Line-Tail Squirrel. *No 80/ on a branch of the 1st fork of the Arkansa July 26th 1820 female/ Length from nose to tail 11 1/2 inches. Tail 9 inches. Iris burnt Umber. pupil black.* Titian Ramsay Peale, 1820. Ink over graphite on paper, 5 1/4 × 8 1/8" (13.4 × 20.8 cm). American Philosophical Society, Philadelphia. [B/P31.15d no. 112]

shows that you did not forget me although from not receiving any letters from me you had every reason to suppose I had you. but I would wish my dear Tititan to have sufficiant confidance in my affection to believe my love unalterable weather I write or not

I am very muched pleased to hear of Dr. Godman's Success[3] I believe him worthy of all the attention he can receive I am glad to hear he has made up his mind to live in Philadelphia—— My dear Uncle I cannot help saying I am pleased to find that affair between you and E——[4] almost broken off I think you are sufficiantly young to wait a year or two before you decide upon so serious an[d] awful a thing in which the whole happiness or misery of your future life dipends—do not be to much pleased with the beauty of face or form—for they soon fade—but beauty of mind last forever, *Untill they become Childish* but that is looking rather to far a head. But my dear Titian we have had several lessons in our own family of the disadvantage of marr[y]ing to young before they were capable of determining wether they loved the one they married sufficiant well to put up with all the little inequalities of temper which without loveing most devotedly it is almost impossible to bear or wether they were able to support their wifes as they would wish— My affection for you is

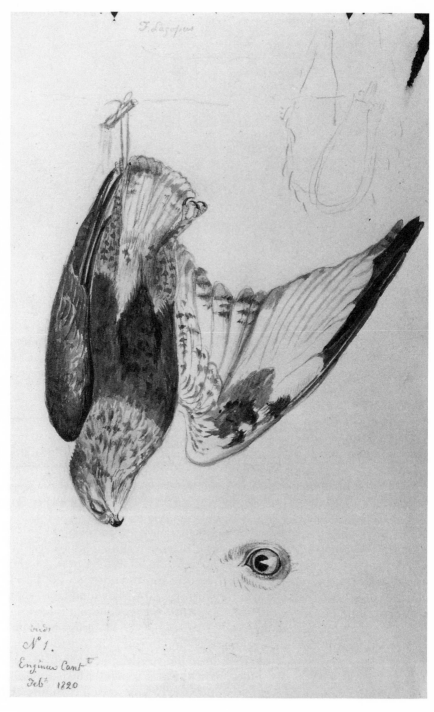

7. Sketch of Grouse. *F. Lagopus birds/ No. 1/ Engineer Cantt/ Feby 1820*. Titian Ramsay Peale, 1820. Watercolor and ink over graphite on paper, 7 7/8 × 5" (20 × 12.5 cm). American Philosophical Society, Philadelphia. [B/P31.15d no. 61]

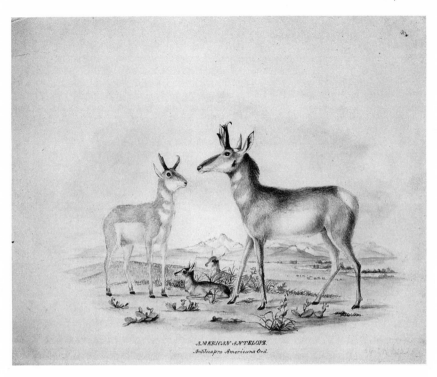

8. Sketch of Pronghorn Antelope. *American Antelope. Antilocapra Americana Ord.*
Titian Ramsay Peale, ca. 1822. Watercolor over graphite on paper, 10 ³/₄ × 13″
(27.4 × 33.2 cm). American Philosophical Society, Philadelphia. [B/P31.15d no.
101]

that of a tender Sister who wether you marry one unworthy of you, or
bring an amiable good girl to be supported by your family would be
unutterably distressed——Are you not quite tired of my surmonizing? I
am sure you are. So I will stop. I am sure you will excuse me knowing it
procedes entirely from a sincere love for you and an ardent wish for your
permanant happiness——I have given up all hopes of seeing you this
summer & hope the Visit being delayed so long when you do come you
will stay a grater length of time with us My love to all retain the
la[r]gest portion for yourself

Yours Rosa

Keep your heart perfectly free untill you come down I think there are
siveral here that you will be pleased with Adieu

ALS, 2pp. & add.
PPAmP: Peale-Sellers Papers

33

1. Unlocated.
2. *Mockasons* is written in pencil.
3. John Davidson Godman (1794–1830), naturalist and anatomist, had been living near Baltimore in 1821, expecting to be appointed professor of anatomy at the University of Maryland. When the appointment failed to materialize, he moved to Philadelphia to lecture in anatomy and physiology. Later, in 1821, he was invited by the Medical College of Ohio in Cincinnati to be professor of surgery. On October 6, 1821, he married ReP's daughter Angelica, and that same day the couple left for Cincinnati. Godman's major works include *Anatomical Investigations* (Philadelphia, 1824), *American Natural History*, 3 vols. (Philadelphia, 1826–28), and articles on natural history that were collected and published posthumously under the title of *Rambles of a Naturalist* (Philadelphia, 1833). *DAB*. (See fig. 9).
4. Eliza Cecilia Laforgue.

16. CWP to APR

GERMANTOWN, PA. APRIL 2, 1821

Belfield April 2d. 1821.

Dear Angelica

Anxious to finish a large picture, which contained about 18 whole figures besides many other parts of figures, a Copy from an old Print which pleased me in its composition and light & shade. The subject Christ at Bethesda, 5th. Chapter of St. John, where he tells the man who had been 38 years an invalid, to take up his bed and walk, and which I believed would excite Admiration, made me neglect my correspondince in toto. The Picture being now placed in the Museum, I shall endeavor to please my friends, by my endeavours to fulfill their wishes—[1] Now with respect to your teeth, if I understand you, they are rather short, do you mean that the teeth are too short or is the piece ⟨*too short to*⟩ composing the several teeth too short to imbrase your natural teeth? If the latter, cannot you put some linner [liner], leather, or pieces of Elastic Gum, sliced very thin, and thus make it sufficiently long to fasten firmly by tying them. Is there any objection to the silver plate? The teeth is much stronger in this mode than without the Silver. As soon as you can answer these queries I shall make you another set and if the fault in these last done is a shortness of the Teeth, it will be well to make these long enough, and let you file them down & give them the finish, as I suppose you are sufficiently enginus to do it to your mind.

After I had finished my large picture, I wished to know the impression it would make in the public mind Therefore I envited the principle inhabitants of Germantown to see it for a few days previous to its removal to the City. and we had an abundance of Company, who were much pleased, as many of them had never seen such paintings— It was quite entertaining to see Men Women & Children coming & going. the weather

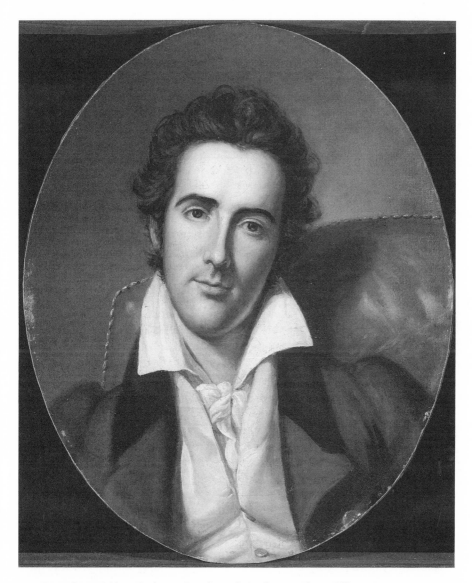

9. *Dr. John Davidson Godman*. Rembrandt Peale, ca. 1821. Oil on canvas, 22 × 18″ (55.9 × 45.7 cm). Courtesy, Museum of Fine Arts, Boston. Bequest of Nellie G. Taylor.

being pleasant, in one day my doorkeeper counted 295. The effect of the Picture cannot be so good in the Museum because we ought not to sacrifise other objects, by concentrating the light only on the picture.

That you may judge of my pleasure in painting this piece, I will relate to you what has not alittle surprised me since— but first I shall say that it made the winter seemingly short by my constant imployment. wanting to reach alittle nearer the top of the picture, I found a piece of scantling in the ajoining room & placing it edgeways, it gave me a good hight, by which means I painted conveniently several days, chiefly on the heads of the upper figueres, but attempting to reach to retouch some of the higher parts of the picture, and reaching to one side overset the scantling and I feel [fell] with my side on a Stool, I felt some pain for a few minutes only, and resumed my work again, but towards the evening I began to feel some unpleasant [illeg] of my side, not in the least alarming, I took [illeg] and rubed my side with vinager & spirits, thinking that in the morning, I would know whether it would be necessary to be bleed; but as I know that persons of my age ought to avoid the loosing of much blood. In the next morning I found myself perfectly clear of fever, but my side more painful Therefore I thought of getting leeches to take blood from the part affected, and I sent to Germantown to a man who follows bleeding cuping &c but he had no Leeches—and on a former occasion having received best benefit from the use of Leeches I determined to go to the City; but no Leeches was to be had there, the severity of the winter in a great measure destroyed them, therefore I submited to be cupped, which I know would answer the same purpose, but is more painful. I found benefit from the cupping, yet too little blood was drawn off. returning home I determined to take salts, live on light food &c. when I was still I felt no pain, but if I coughed sneezed ⟨and⟩ or blowed my nose hard, the pain was very severe, like cutting my heart. Your Mother undressed and dressed me, because I could not stoop without suffering great pain, she raised & lowered the picture for me, for as I said before I am surprised that I should not have lost a single hour from my work, except that of going into the City (1½ day). your Mother often entreated me to leave off painting but I found that out of imployment I was feeling my side and was more uneasey than when my mind was engaged with my work, which required only the motion of my arms, therefore I ⟨did⟩ suffered less while imployed than while idle, this is therefore a striking instance how much people suffer from an idle habit, and I hold it as a divine favor that we are required to gain our support by the sweat of the brow and I do solemnly aver that no man can enjoy happiness without he practices some useful imployment, and manual labour is most condusive to health. Therefore those who do not immerse their hands as well as their mind find trouble from the most

36

triffling occurances—undoubtedly a choise of what kind of labour we select is all important. and I now know that my fondness for a variety of mechanicks has been a great sacrifize of time & money to me, yet I have often found great amusement thereby. The same time spent in painting would have made me very wealthy, & very likely would have given me an exalted estimation with the Public. The extent of my labours in the Museum has excited the admiration of many People but especilly Europeans— Now I have touched on the subject of the Museum, I must inform you that It is now an Incorporated body, known by the name of the *Philadelphia Museum company*, and being made a permanant establishment it will be entitled to a more liberal support, than while it was liable to be divided, as all personal property is by succession. It is now very probable that considerable Legaces will be made to the Museum as it may be considered as City property, as a clause was made in the Act of Incorporation that the Museum should remain in the City of Philada. and no part remooved under the penalty of ⟨*the*⟩ twice the value being paid the City of Philada. Corporation and of course that body ought to be more favorable to the institution than they have been heretofor for I have paid an exorbitant rent for several years—no less than 1200$ annually—[2]a committee is now about to report an abatement of the Rent, which I expect will not exceed half that Sum.

You seem very fearful of my selling the farm, but at present I have very little hopes of doing, as it is my determination that if I part with it that I must have its full value, and these times are very unfavourable to sell lands, I thought when I first advertized it,[3] that my chance was in getting City property for it, and many Houses & lotts have been offered to me, but scarcely any of them such as I wished to possess, because my choice would be only such as was central and possessed space sufficient to extend the Museum to 2 or 3 times the extent it now occupies. then a removal of it would increase the income, as expanded display would be more attractive but the Stadthouse is undoubtably a fine situation and the appearance imposing, with instead of *Peale's Museum*, it is now, *Philada. Museum*. and Straingers will suppose that it belongs to the City and is not private property.

I have now wrote enough about myself & the Museum, and the remainder of the sheet shall be family news. Your Sister Sophonisba appears to me as becomming rather thinner, yet her health is rather mending, tho' slowly, her spirit is always good— I think that Rubens of late is not in such good health as formerly, he is subject to head akes & colick. his Son grows fast and of late is more quiet than in the month [before]. Elizabeth seems to be in a comfortable situation, the family say that she is a fine housekeeper, she grows fat which indicates a contented mind.[4] Franklin

37

from his superior talents as a mechanic has full imployment in the City. Linnius is hanging on his owers [oars] at present, but in expectation of obtaining imployment with a Man who is rich & has a great concern in Lands.[5] Titian is engaged in mounting the subjects collected on the late tour, and also in finishing his drawings. I am inclined to think that Titian may become an expert Surgeon if he applies himself in that branch of Science. he posseses strong nerves and is an expert disector of Anatomy, and has talents of macanism.

We are acquainted with a young man who comes from Baltimore, who is acquiring a great reputation here, for his superior talents in many respects, but more especially in his delivery of lecture on Anatomy,[6] he is a self taught genus of the first magnitude, he is learned in the dead Language beside his knowledge of the living languages he is a fine writer, I don't mean a fine penman, but a good compositor. Doctr Godman tells me that he likes Philada., therefore I expect that he will settle himself here & I shall consider him a great acquisition in our medical schools.

I have nothing further to add, but that your Mother & Mrs. Morris presents their love to you— I have no more complaint of my side,

<div align="right">Yrs. Affectionately
CWPeale</div>

Mrs. Angelica Robenson Baltre.

ALS, 7pp.
PPAmP: Peale-Sellers Papers—Letterbook 17

1. Announcements for the exhibition of CWP's *Our Saviour Healing the Sick at the Pool of Bethesda* in the Philadelphia Museum began appearing in *Poulson's* on March 27, 1821.
2. See above, **3.**
3. CWP first advertised to sell his farm or exchange it for city property in November 1820. *Peale Papers*, 3:853.
4. EPP.
5. Unidentified.
6. John D. Godman.

17. CWP to RuP

GERMANTOWN, PA. APRIL 7, 1821

<div align="right">Belfield April 7. 1821.</div>

Dear Rubens,

My head & Lunges has been much affected with a cold for a week past, and I have not been at my Easel, but amused myself with writing letters, which I enclose, that to Angelica I wish to be put into private conveyance, when sent by the post, she often looses them.[1] That to Coll. Magill I wish you to See Betsey Morris before you put it into the post office. for your

mother says he may not be any connection with the family, and Miss Zane may have only boarded at his House.[2] The other letter is to a Man who purchased Charles Polks part of the tracts of Land which Raphaelle owns the half.[3]

I was reluctantly induced to give an order on you for the poor Tax of last year, the collector had been at much trouble in calling for it, being lame in one of his feet & he came once in a deep Snow and could not get to the House. when I promised him that I would call at his House & give him no further trouble &c. I hope you have been able to pay Mr. Jno. Warder.?[4]

Selser[5] will finish the forebay[6] of the mill today, and if you can spare a few dollars, I would wish to pay him a part if not for the weeks work. & I have only 75 Cents at present.

I wish Franklin to bring out the Cards,[7] as I expect Linneus will put them on the Machines. The forebay is a very complete Job. What is the effect of the picture? I should have been at the Introductory on Minerology but too unwell.[8] however I am now better & I hope my cough is passing away. Love to Eliza.

<div align="right">

yrs. affectionately

CWPeale

</div>

Mr. Rubens Peale
Philada.

ALS, 1p.
PPAmP: Peale-Sellers Papers—Letterbook 17

1. See above, **16**. CWP's reference to lost letters refers to his suspicion that APR's husband Alexander Robinson destroyed letters written to her from Peale family members. In 1815, Robinson claimed that he had "lost" a letter from SPS to APR; and again in 1818, CWP, in enclosing a letter to APR in a letter to ReP, explained that some of his letters had not reached her, and that the enclosed letter was "intended for her only." See *Peale Papers*, 3:313–14, 606.

2. This was CWP's second attempt to obtain Sarah Zane's collection of "Antient Arms." In November, 1807, he had written to her, reminding her of a visit she had earlier made to the Philadelphia Museum and of her inclination then to donate to the museum a collection of "Antient Arms" that had formerly belonged to Lord Dunmore, colonial governor of Virginia. Sarah Zane was the sister of General John Smith and the aunt of architect Robert Mills's wife Eliza. Apparently, CWP believed that there was some connection between Zane, Col. Charles Magill of Winchester, Virginia, and HMP's family. In April, he wrote Magill requesting information concerning the disposition of the collection. Betsey Morris was Rachel Morris's daughter, Elizabeth. CWP to Sarah Zane, November 29, 1807, P-S, F:IIA/42A9–10; CWP to Col. Charles Magill, April 6, 1821, P-S, F:IIA/66A10. We are grateful to Pamela Scott of the Robert Mills Papers for Sarah Zane's identification.

3. See above, **12**.

4. In Daybook 1 (1806–22), CWP noted on April 11: "By order of poor Tax—— 15.75" (p. 149). John Warder (1751–1828), Friend, Loyalist, and shipping merchant, resided in London during the American Revolution and returned to Philadelphia in 1788. In his Daybook, CWP recorded on April 21: "By Interest to Mr. Warder——72" (p. 149). Elaine Forman Crane, Sarah Blank Dine, Alison Duncan Hirsch, and Arthur Scherr, eds., *The Diary*

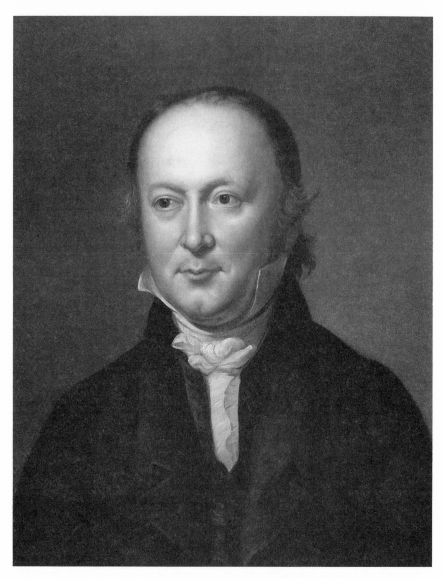

10. *Gerard Troost*. C. W. Peale, 1823–24. Oil on canvas 23 × 19″ (58.4 × 48.3cm). Library, The Academy of Natural Sciences of Philadelphia.

of Elizabeth Drinker, 3 vols. (Boston, 1991), 3:2226; "Extract from the Diary of Mrs. Ann Warder," *PMHB* 17 (1893):444.

5. In Daybook 2 (1810–1824), CWP noted for April [?]: "Mr. Selser was 6½ days making the forebay at the mill—paid him on 11th April 2$^{75}/_{100}$ due him 3.$^{75}/_{100}$" (p. 105). On April 28, CWP noted that he paid Selser "all due him except 1$" (p. 105).

6. A reservoir between the mill race and waterwheel. *OED.*

7. Cards are implements for raising a nap on cloth; carding machines disentangle and arrange fibers of cotton, wool, or flax. *OED.*

8. On Friday evening, April 6, 1821, Gerard Troost delivered his introductory lecture in a course titled "Lectures on Mineralogy." *Poulsons American Daily Advertiser*, April 4, 1821.

Gerard Troost (1776–1850), geologist, was born and educated in Holland and later in Paris where he was a pupil of René Just Haüy, specializing in mineralogy and crystallography. He sailed to Philadelphia in 1810, and soon after arriving became an American citizen. Troost established a pharmaceutical and chemical laboratory in the city, and in 1812 was one of the seven founders of the Academy of Natural Sciences, serving as its first president for five years. In addition to his position as lecturer at the Philadelphia Museum, he was professor of pharmaceutical and general chemistry at the Philadelphia College of Pharmacy. During these years, he also conducted a geological survey of the environs of Philadelphia for the Philadelphia Society for Promoting Agriculture and published the results in 1826. *DAB.* (See fig. 10)

18. The Trustees of the Philadelphia Museum: Petition to the Select Council of Philadelphia

PHILADELPHIA. APRIL 11, 1821

To the honorable, the Select Council of
the City of Philadelphia.
 The memorial of the Philadelphia Museum Company
Humbly Shewith.
 That the Philadelphia Museum having attained to a magnitude unexampled in our own country, and not often exceeded in others——The Trustees of the Institution are desirous of making the same more extensively useful, by procuring Teachers, who by public Lectures shall assist in diffusing knowledge and thereby improve and benefit society.
 That your memorialists have procured and appointed such teachers, and are induced to beg of your honorable body permission to make use of the lower Eastern Room of the State house, as a lecture room, for which your memorialists are willing to give such rent as your honorable body may deem proper, provided it does not exceed their ability to pay. At the same time it may be remembered, that such occupation will not in the

least interfere with the holding of the general Elections in this room, as heretofore.[1]

Of the value which this institution may be and has been to the city, it needs but little reflection to understand. To spread the knowledge of Truth and of Nature, to excite the youth of our country to studies which shall guard them against the seductions of vice, and to give to the City a new attraction for strangers as well as citizens, may be without presumption observed as well worthy the fostering attention of your honorable body; to which we trust we have not addressed ourselves in vain.

<div style="text-align:right">And your memorialists as in duty bound will ever pray.</div>

<div style="text-align:right">Rt. Patterson
Zaccheus Collins
Coleman Sellers
Rubens Peale</div>

Philadelphia April 11th. 1821. <div style="text-align:right">Trustees</div>

DS, 2pp. & end.
PPAmP: Peale-Sellers Papers
Endorsed: April 13. 1821. Read and referred to the
Committee on State House C.C. conars

1. There is no indication that the Select Council gave the museum formal permission to use the "lower" room for lectures. On October 25, 1821, the museum trustees made a similar request, and again there is no formal indication that the museum obtained the use of the room. However, newspaper advertisements of lectures given by the museum faculty and CWP in 1823 suggest that the lower room was used for this purpose. Perhaps an informal arrangement was agreed upon between the city corporation and the Philadelphia Museum.

19. CWP to JPjr.

GERMANTOWN, PA. APRIL 17, 1821

<div style="text-align:right">Belfield April 17th. 1821.</div>

Dear James

Doubtful whether you will recieve this at Boston and should it, you may be surprised at recieving one from me at the time, but my motive is to serve you, & fulfill a duty incumbent on me. My age and experience confirms me in the opinions I mean to dictate as being our interest in evry point of view to follow, to obtain happiness either for the present moment or in future.

Will you patiently and deliberately hear what I mean to advise for your conduct through life? If so, my hope is that I do not write in vain, grant it heaven!

But advice often stinks. it may not in this instance. I have done with preface, now to the subject.[1]

Suppose I am insulted, what ought my first reflection to be. perhaps

something I have said or done, render me deserving of it. have I done to others as I should wish to be done to me? suppose on this inspection of my words & actions I can accuse myself of something wrong, then I ought surely to endeavour to attone for that wrong if possibly in my power, at lea[s]t, humble myself to acknowlege my faults. Every *being* is liable to commit errors. & the first step to honorable and correct behavour, is to acknowledge our faults. The just & honorable will readily forgive us. but even should they be unforgiving, is it not consoling that I proffered my offering? for stronger illustration— Suppose I am called a liar and Scoundril. This you will say is very provoking language. Ought I not to resent it? I answer NO. what good will result from the resenting it? let me first critically examine myself, am I in the least degree deserving of those taunting epithets? If my conscience tells me that I am not entitled to such character, can my shewing resentment give me the esteem of any good man? and certainly the oppinion of fools & mad men, is not worthy of our notice. If we respect ourselves, we will never do any thing that is wrong in word or deed, and the consciousness of doing our duty to our fellow beings is a consoling comfort, but we must not seize the power to correct others who offend us, this is an assumtion of power which will neither give us pleasure nor profit. and may imbitter our whole life. for example, let us suppose, we are insulted in ⟨*grossest*⟩ the most grose abuse of ourselves or family, what satisfaction can it be to me to nock-down the offender can I feel any pleasure in the act? Who gave me the right to execute vengeance on any human being?——only suppose that in my act of revenge I am guilty of Murder, what then would be [the] result of my feelings? tormenting remorse continually goading my conscience—! and by one rash act, I have have made myself a miserable being the remainder of my life. But suppose I am made to bite the ground—where is the satisfaction then. The bold, the strong & even the skillful, may not be the Victor. and now I will tell you how we may be always victorious. It is not a new art, it is an art long known, but I am sorry to say in too little practice. "Never return an injury, it is an Noble tryuph [triumph] to overcome evil by good!"[2] seek for occations to serve those ⟨*that*⟩ who evilly treat you. This conduct will be a consoling comfort, this is persuing true happiness, this is embracing stors of pleasure, this is raising up friends where-ever our actions are known, it is worthy of our utmost exertions to conquer and subdue ourselves to this glorious temper of mind. which will not only make others love us, but also makes us love ourselves. It is the highest attainment of the human mind, and is not difficult if we firmly resolve to undertake the practice, for every moment we sincerely inter this pleasing carier, we shall find encouragement to proceed & subdue our brutal passions, It is a savage passion that harbours revenge. If we truely and faithfully desire to be happy we will not intentionally give offence, yet if

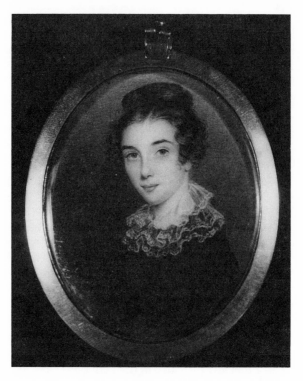

11. *Eleanor Britton (Mrs. William Musgrave)*. Anna Claypoole Peale, 1821. Watercolor on ivory, 2 ⁷/₁₆ × 2″ (6.2 × 5.1 cm). Yale University Art Gallery, Lelia A. and John Hill Morgan Collection.

we offend, endeavour to obtain forgiveness, by shewing a willingness to restore a conceliation and harmony. It is an abominable pride that shew a hautiness of temper; to refuse a return of little civilities, of words & actions.

It is common to hear people say, I wont speak to such a one, because they do not speak to me. This is not justifiable conduct, we ought to give respect to those that do not return it, because the faults of others will not excuse our faults, If we respect ourselves we will be faultless. By humbling ourselves we may be exalted. There is only one kind of Pride that is commendable, that is of doing well. The Pride of Birth, Country, or of Wealth, are only stinking Pride.

Dear James the above is only hints on the most important subject for Man to reflect on, therefore you must know that I have writen with the view and hope that you will weigh, and ponder well on what I have written, and not think me arrogant, harsh or unfriendly in giving such advice. It is a practice that will ensure our happiness here, independantly

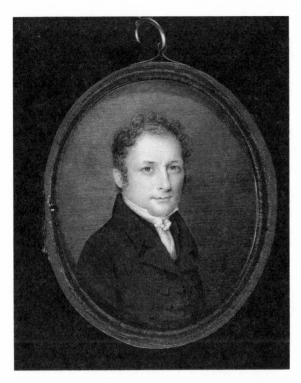

12. *Dr. Oliver Hubbard*. Anna Claypoole Peale, 1821. Watercolor on ivory, 3 ¹/₈ × 2 ¹/₂″ (7.8 × 6.3 cm). Courtesy, Peabody Essex Museum, Salem, Mass.

of a hereafter. And it is what I hope all my future conduct will be—and I very much regret that I have not in all my past long life practiced— love to your Sister and I wish her pleasure & profit yours

affectionately CWPeale

To Mr. James Peale
Boston.

NB. made the superscription of the above to Anna C. Peale, least James might have left Boston

ALS, 3pp.
PPAmP: Peale-Sellers Papers—Letterbook 17

1. CWP's unsolicited advice was intended to heal JPjr.'s anger at ReP's refusal of ACP's request to accompany him to Boston. ReP had planned this trip to supervise the exhibition in the city of his *Court of Death*. Why he refused to take ACP with him is not known. To ACP, still in the early stages of her career as a miniaturist, Boston promised patronage and recognition. Since she probably insisted upon an escort, her brother, JPjr., was forced to take leave from his position as bank clerk to accompany her. While in the city, ACP painted a number of miniatures, including *Eleanor Britton (Mrs. William Musgrave)* (fig. 11) and *Dr. Oliver Hubbard*

(fig. 12), as well as an incomplete *Daniel Webster* (*unlocated*). Information furnished by Anne Sue Hirshorn; CAP. Peale Family Papers files, NPG. See below, **20**.

2. CWP continually repeated this advice to his children and other family members. While living at Belfield, he had an obelisk constructed in the garden bearing this motto. *Peale Papers*, 3:216.

20. CWP to ReP

GERMANTOWN, PA. APRIL 18, 1821

Belfield, April 18th. 1821.

Dear Rembrandt

It would have much gratified me to have seen you either here or in Philada. but I expected the [that] it was your intention to have retouched Mrs. Bettons portrait,[1] therefore I did not immedeately go into the City when I heard of your arrival there, besides having heard your intention of visiting us at the farm. a few days past I was at Doctr Bettons, and I informed them how you was disappointed of coming here, and that you was under the necessity of going to Boston with all possible haste in order to [be at] the Exhibition of your Picture of the Court of Death, And being in the City on Monday last to hear Doctr Godmans 2d Lecture. I then heard that you intended to tarry at Boston only 2 or 3 weeks, and that on your return here you would stay ⟨*here*⟩ sometime, which I have presumed you ment then to work on Mrs. Bettons picture, and on that presumption I will call on the Doctr to give him notice, which will serve as an appology for your not keeping your promise of working on said picture in the present month. The politeness of the Doctr to you, as well as other branches of our family has made me feel much anxiety on this business. Your refusial to let Anna accompany you to Boston, as you hinted to me, has no doubt, caused much bickering in my brothers family, and when I went into the City I went there, expecting it likely that they would speak to me on the subject, if so, I would have endeavored to produce peace & harmony—But some company was present and nothing said on the subject. and knowing how James your ⟨*Nephew*⟩ cousin had behaved to you, I conceived it a duty on me to write to him, a letter of advice[2] respecting how he ought to behave, when any thing offended him, in a hope that my oppinion may influence his future conduct, because I well know his pride & passion has made him swerve from a mode that is most wise & prudent to avoid strife, & promote a self approving conscience; present as well as future happiness. my letter was lengthy without once mentioning any action of his on this late affair, or any former transaction, but simply to state in as strong terms as possible what ought to be our

conduct in case of the grosest insults. Inshort it contained in my own language the duties of the Christain religion—"Never return an Injury, it is a noble tryumph to overcome evil by good!" my advise to him was to reflect, when offended, whether some misconduct intitled the cause of offence— I cited the casses as supposing them to be on myself, and what ought to be the course I ought to persue to promote my own happiness. this mode of reasoning would be less offensive than if applied to him, as I well know that advice is often offencive however well ment, Indeed it must be so as it implies that the person addressed needed reproof. therefore my letter to James required my utmost exertions to make it as accepti⟨ona⟩ble as possible. I directed it to Anna on the outside, least James might not be in Boston, as I suppose he cannot be long from the Bank.

Doctr Godmans introductory Lecture on ⟨Geology⟩ Phisiology was highly gratif[y]ing to a polite audience, of Ladies as well as Gentlemen.[3] they thought it too short, such was it[s] attractions. His 2d lecture was also public, for he had not yet obtained subscribers; I need not say that I think him a young man of superior talents in oratory, and that he will be an acquisition to Philada. and I hope he will meet with due encouragement. I dont know whether the proper mode was persued to gain subscribers to his Lectures, or what is intended, to be done to fill up a class,

The Trustees of the Museum meet last week at the Museum, and organized the Institution, appointed the officers, and began a regular journal of their proceedings.[4] They adjourned to this Evening to settle and regulate the proceedings of the Professors, and make the allowance to the Manager, and designate the duties &c. also making such bye Laws as they may think necessary. I dont know how they can go into the business at the Museum, because this being the week of the General Meeting of the quakers, and the Museum as usial being illuminated every night. This was not thought off at their last meeting of the Trustees. Mr. Pierce Butler was chosen President, Robert Patterson Vice president, and Coleman Sellers their secretary. The Professors also appointed for one year. Doctr Godman named first, then Doctr Troost, Say[5] & Titian. Doctr Troost gave his first private lecture (Minerazogey) [mineralogy] at 5 O'clock A.M. in the Room where Delaplaine pictures is placed in the Room below the Museum.[6] his list of Subscribers appears to be tolerably filled.

The next information I have to communicate is, that the Councils have fixed our Rent at $600. to commence from the time that all arrearages is paid up. It is not pleasant to be under the hatches with any public body. However I shall be very cautious how I undertake to made [make] any other disposition of the Museum, it had better remain statenary than I should be embrarrysed with expence of another Building.[7]

Govr. Heister is now in Philada. and I have wrote to him to request the favor of his setting, that I may place his portrait in the Museum. either to set for me in the City, or if agreable at My Painting-room here & I have offered him my Table & a Bed, that he might see his friends in the neighbourhood of Germantown with little loss of time. I expect an Answer this Evening.[8]

I hope you do not varnish your large picture at every place of exhibition—here I found you had coated it with the write [white] of Eggs and flour to prevent its sticking togather in the package—that washing that off, you gave it a new coat of Varnish, and I suppose you had varnished it previous to its exhibition at Baltimore. If your Varnish is hard (copal) will not repeated coats at last crack and damage the picture?[9]

During the whole winter I never took cold, but since finishing the Picture of Christ at Bethesda, and exposed to cold air & wet grounds, I have had a severe cold, which I strugled hard to get rid off for some time, but now I have almost cured, It does not for a few nights past trouble me—I had recourse to the vapor-bath, herb teas, moderate living, the flowers of Sulphur—[10] and various exercizes in working, riding &c—but having repairs to be made at the fore-bay of the Mill, retaerded the good effect of my remedies, untill at last I found it absolutely necessary to relieve my Lunges—and if the weather becomes mild in one or two days I shall be perfectly well again. The present weather is uncommon, yes[ter]-day with a N E wind it rained the greater part of the day & today Hail & Snow covered the fields— This afternoon the white covering is almost gone & the wind more notherly & cold—with flying clouds—some fruit trees almost in bloom, I hope the cold will not injure them. I have nothing further to add but that your Mother & Mrs. Morris desire me to present their love to you, receive the same from your

<div style="text-align: right">affectionate father CWPeale</div>

Mr. Rembrandt Peale
<div style="text-align: center">Boston</div>

ALS, 3pp.
PPAmP: Peale-Sellers Papers—Letterbook 17

1. (*Unlocated.*) In 1820, ReP painted a portrait of Mary Forrest Betton, daughter of CWP's friend Thomas Forrest and wife of CWP's Germantown family physician, Dr. Samuel Betton. In December, CWP informed ReP that Mrs. Betton was not satisfied with the likeness. It is not known whether ReP reworked the painting. *Peale Papers*, 3:290, 320.

2. See above, **19**.

3. On April 11, John D. Godman delivered his "Introductory Lecture" in the museum; his first lecture in his "course of Physiology" was presented on April 16. *Poulson's*, April 7, 13, 1821.

4. The first meeting of the Museum Trustees was on April 11, 1821. See "1821–1827 Philadelphia Museum Minutes," P-S, F:XIA/7.

5. Thomas Say (1787–1834), entomologist and a founding member and curator of the

Academy of Natural Sciences of Philadelphia, had accompanied TRP on the collecting expedition to the Georgia Sea Islands and Florida in the winter of 1817–18 and on the Long Expedition of 1819–20. See *Peale Papers*, 3:554n. Troost's first lecture for his course on mineralogy was delivered at 5 P.M. on April 16. *Poulson's*, April 13, 1821.

6. Joseph Delaplaine (1777–1824), a Philadelphia publisher, in 1819 opened Delaplaine's National Panzographia for the Reception of the Portraits of Distinguished Americans, a gallery of portraits of American heroes that was located on the corner of Chestnut and Seventh Streets, about one block from the Statehouse. He seems to have used the lower east room in the Statehouse as an office for his publishing ventures as well as an exhibition space. Although Delaplaine was at first averse to giving up his room and threatened to petition the councils to retain it, by December he and CWP were able to compromise their claims, with CWP promising the publisher "remuneration for the inconvenience [he] shall be put to" and "some apartment . . . for the purpose of transacting my little literary affairs." See *Peale Papers*, 3:578; Gordon M. Marshall, "The Golden Age of Illustrated Biographies: Three Case Studies," in Wendy Wick Reaves, ed., *American Portrait Prints: Proceedings of the Tenth Annual American Print Conference* (Charlottesville, Va., 1984), pp. 32–45; Joseph Delaplaine to William Meredith, December 13, 1821, PPAmP: Misc. Ms. Coll., below, **51**.

7. On April 13, 1821 the Select and Common Councils of Philadelphia resolved that "the City Commissioners under the direction and with the approbation of the same committee [the committee appointed "in relation to the State House"] execute a lease . . . to the Trustees of the Philadelphia Museum of the second floor of the State House and the room under the Belfrey for a term not exceeding three years at an annual rent of six hundred dollars . . . provided that all arrears of rent be paid up to the time." Philadelphia Select Council: Extract from Minutes to William Meredith, April 13, 1821. P-S, F:XIA/7B12–14.

8. (Fig. 13.) Joseph Hiester (1752–1832), merchant, Revolutionary soldier, and politician, was elected governor of Pennsylvania in 1820. CWP and his troops served under Lieutenant-Colonel Hiester of the Pennsylvania militia in November 1777, during the skirmishing around British-occupied Philadelphia. CWP to Joseph Heister, April 17, 1821, P-S, F:IIA/66B4; *P&M*, p. 103; *DAB*; *Peale Papers*, 1:252.

9. See above, **7**.

10. Pale yellow powder of sulfur. *OED*.

21. Edwin James[1] to TRP

SMITHLAND, KY. APRIL 18, 1821

<div align="right">Smithland April 18 1821</div>

Dear Sir

Your favor of Feb. 21st.[2] I did not recieve, untill a few days since and I loose no time in returning you an answer. I am gratified with the assurance which your letter gives that you have not so entirely withdrawn your thoughts from the western country as to forget that there is still one of your friends in that qua[r]ter.[3] I believe the prospect is a poor one of our being again employed in duties similar to those in which we were busied so much to our own liking during the last summer. I hope however we shall not be retained merely to lie inactive, and to suffer the inconveniences of poverty, which we are here beginning to find not entirely agreeable. I do not know that those of the party who have returned to the east have shared more largely of the liberality of government than we have, but I

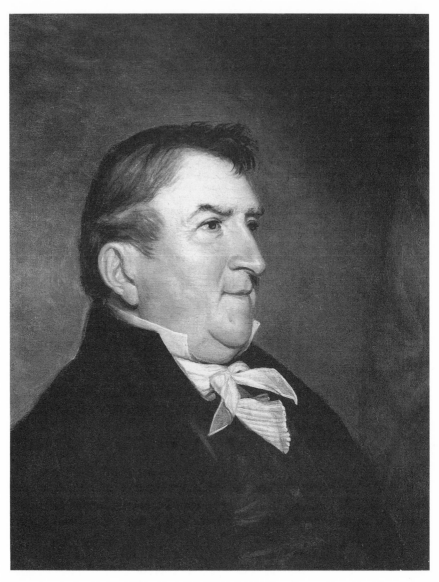

13. *Joseph Hiester*. C. W. Peale, 1821. Oil on canvas, 24 × 20″ (61 × 51 cm). Independence National Historical Park Collection, Philadelphia.

think they can not so sensibly feel the need of assistance, being as they are at home and among friends. We have been spending the winter in one of the least desirable places which could have been found on the Ohio. While we have money we could not procure comfortable accomodations, and now that we have none, you will easily believe we are not much more pleasantly situated. We have been more eagerly longing for the comforts of civilized countries than during our last summers pilgrimage in the wilderness, and I believe should have found the winter less tedious and dreary had we spent it among the savages than we have here.

Little is said here as far as I know or any where else, about the past performances of our party I have heard from the State of New York that those who speak of them at all there speak with little respect. If the impression which our Expedition has had on the public mind has hitherto been unfavorable I should hope that some thing might still be done to make up former deficiencies if such have been believed to exist.[4]

It is now some time since we have heard from Maj. Long, but we are in constant expectation of hearing good news. I cannot as yet persuade myself that the boat will be allowed to remain here and we on it during the whole of the present summer. The sickly season is approaching and I have no hopes of escaping if I should remain in this place untill it commences. I have not yet completely recovered from last falls sickness. nither have Edwards and Kimball who are on board the boat[5] The spring is considerably advanced and I begin to find some amusement in excursions to collect plants &c, but I feel greatly the want of intercourse with some of the intelligent part of the world you know how ridiculous the pursuits of Natural History appear to the stupid and uninformed and you have undoubtedly found that when surrounded entirely by such, our zeal is apt to grow cold.—— By the last mail I sent Maj. Long a paper on the Geology of a part of the country near the Rocky Mountains but I am somewhat afraid he will not recieve it, as the conveyance by mail appears to be entirely uncertain.[6] Tell Mr. Seymour my best wishes always attend him; and th[at I] will take most special care of his drawings which were left on the boat.

Please to remember me to all the gentlemen of the Party who are with you, and accept my most cordial good wishes

<div align="right">Yours &c. Edw. James</div>

Let me hear from you as often as you can find time to write

ALS, 3pp. & add.
PPAmP: Peale-Sellers Papers

1. Edwin James (1797–1861), botanist, geologist, and surgeon, accompanied Long from Philadelphia to Council Bluffs in early 1820 as a replacement for a former member of the Yellowstone Expedition. *Peale Papers*, 3:696n.

2. Unlocated.

3. In early November 1820, TRP and several of the expedition's scientists and artists left Cape Girardeau, Missouri, and traveled by steamboat to New Orleans. James and Lieutenant William Swift remained with the *Western Engineer* at Cape Girardeau. They expected to travel in the steamboat down the Mississippi to the falls of the Ohio at Louisville, where the *Western Engineer* would remain during the winter. On November 22, the river having risen, Lieutenant Swift and the *Western Engineer* began the journey down the Mississippi, while James, on horseback, followed a path alongside the river. James became ill and was unable to keep up with the boat. Reaching Smithland, Kentucky, near the confluence of the Cumberland and the Ohio Rivers, Swift left the boat there for James's use and headed back to Philadelphia on horseback. Arriving in Smithland on December 2, James decided to winter there. He remained in Smithland until mid-May, when he finally took the *Western Engineer* down the river to Louisville. Edwin James, *Account of an Expedition from Pittsburgh to the Rocky Mountains* (1823; reprint ed., Ann Arbor, Mich., 1966) 2:324–29; Maxine Frances Benson, "Edwin James: Scientist, Linguist, Humanitarian," Ph.D. diss., University of Colorado, 1969, pp. 80–84.

4. The series of failures, setbacks, and misfortunes experienced by the Long Expedition led many contemporaries and some subsequent historians to label it a failure. Its inability to achieve its two important goals, building four permanent forts and reaching the Yellowstone River, influenced Congress to curtail funds for the enterprise. The expedition also failed to find the sources of the Arkansas, the Platte, and the Red Rivers—also an important goal. Critics pointed out that with the exception of Long's map, the scientific accomplishments of the expedition were "negligible." The expedition's notebooks were stolen or lost, and most observations were not made with the kinds of precise instruments that were used on subsequent explorations. Long's judgment that the Great Plains were not fit for human habitation subsequently launched the myth of the "Great American Desert" and created an impediment to the progress of Western settlement. *Peale Papers*, 3:694–97; Goetzmann, *Exploration and Empire*, pp. 60–62.

Revisionist historians Roger L. Nichols and Patrick Halley do not agree with this assessment of the expedition. They point out the important influence of the Long Expedition on the establishment of a strong relationship between government and science. According to Nichols and Halley, Long was "the chief promoter of exploration following the War of 1812, and without his persistent efforts there is little indication that the government would have supported scientific exploration for another decade." Not only did the Long Expedition establish "firmly" the role of scientists on such exploring projects, but the actual data accumulated by the scientists accompanying Long to the West "entered directly into the mainstream of American scientific thought of the day." Roger L. Nichols and Patrick L. Halley, *Stephen Long and American Frontier Exploration* (Newark, N.J., 1980), pp. 16–18, 158–180.

5. Benjamin Edwards was the steam engineer of the *Western Engineer*. Isaac Kimball was the vessel's carpenter. Stephen H. Long to John C. Calhoun, April 20, 1819, roster of "the Crew & other hands on board" the *Western Engineer*, in W. Edwin Hemphill, ed., *The Papers of John C. Calhoun* (Columbia, S.C., 1969), 4:31.

6. Edwin James, "Remarks on the sandstone and floetz trap formations of the western part of the valley of the Mississippi." Read to the APS on August 17, 1821, and published in APS, *Transactions* 2 (1825). *NUC*.

22. CWP to Trustees of the Philadelphia Museum

GERMANTOWN, PA. APRIL 30, 1821

Belfield April 30. 1821.

To the Trustee's of the Philadelphia Museum.

Gentlemen,

Having with Rubens examined the neat [net] proceeds of the Museum

at several seasons, we found that ⅓ was nearly equal to the sum he received previous to the Act of Incorporation. When I put the Museum under his care and management, he was to pay me 4000$ yearly, out of which I paid half the Rent, also the expence of such permanant improvements as would meet my approbation. And after he had paid the insidential expences and the above mentioned sum, the surplus was the profit of his labour, care, and management of the Museum.[1]

In the belief that Rubens has the capasity of improving the Museum, disposes me to grant him such encouragement as will call forth his utmost exertions, giving his whole attention to render the Institution valuable to the public, and a credit to the City, therefore it is my wish, provided it meets with your approbation, to allow him as Manager one Third of the neat proceeds of the Museum for the year, commencing from the first of July last. And also if you think it proper to order Tickets of Admission to be given to the annexed Names.[2]

I am really much pleased with the Interest you take to organize the Museum, and I feel my obligations to you for your zeal in fulfilling your appointment as Trustee's of the Museum, and am with the highest respect

<div align="center">Gentlemen your much obleged friend
CWPeale</div>

ALS, 1p.
PPAmP: Peale-Sellers Papers—Letterbook 17

1. Since museum accounts of receipts and expenses are not complete for the year 1820, it is impossible to know precisely how much CWP proposed to pay RuP for managing the Philadelphia Museum. Revenues were declining: in 1820 they amounted to $5,317 (see above, **12**). Museum expenses from July 1820 through June 1821, on the other hand, amounted to $1,028. If RuP paid CWP his usual annual allowance of $4,000 that year, his profit could not have been large, even if CWP paid half the rent and the cost of permanent improvements. Philadelphia Museum Account Book, 1820–1824, pp. 1, 6, 10, 14, 18. P-S, F:XI/6A2-E12.

2. The list is unlocated. However, see CWP to Trustees of the Philadelphia Museum, May 5, 1821. P-S, F:IIA/66B11. Included in the list were all the members of the Peale family and their children, public officials, "Amatures [amateurs] who offer their services," "Donors of articles of value," and "such Strangers of great distinction as the board may deem proper."

23. CWP to Managers of the Pennsylvania Academy of the Fine Arts

GERMANTOWN, PA. MAY 20, 1821

<div align="right">Belfield May 20.1821.</div>

To the Managers of the Academy of fine arts,
Gentlemen,

In my view of the Academy of fine arts, its objects are, to bring forth the

dormant genius of the Pencil; and give the public a true taste of the merrits of Painting.

A Genius in obscurity by exhibiting a good Picture is brought into Notice, and thus meets with Incouragement.

A Painter viewing his pictures in his painting-Room, may think his work faultless, but putting them into a Picture Galery, the Artist then see's his faults, consequently he will improve in some part of his labours.

My motive for troubling you with this address, is simply to state the disadvantage of an Idea going forth that no Exhibition will be made, as it prevents Artists from exerting themselves to produce pictures for Exhibition, therefore I humbly propose that an Exhibition should be made every year, It will yearly shew the state of the Arts, with the other advantages of an Academy.[1]

<div style="text-align: right">

I am Gentlemen with due respect
CWPeale

</div>

ALS, 1p., add., & end.
PPAFA Archives
Copy in PPAmP: Peale-Sellers Papers—Letterbook 17

1. The PAFA held two exhibitions in 1821, the first opening on May 21, a week later than the scheduled date. Perhaps the delay was responsible for the rumor that no exhibition would be held that year. Earlier in 1821, there had been friction between the artists and the managers of PAFA, and CWP appears to be taking the artists' part in his advocacy of yearly exhibits. RaP exhibited two still lifes in the 1821 exhibition, *Still Life—Peaches and Grapes* (possibly the 1815 *Peaches and Fox Grapes* at the Pennsylvania Academy of the Fine Arts, or an unlocated *Fruit, Still Life, Peaches and Grapes* exhibited at PAFA from 1814 to 1824) and *Apples, Grapes, etc.* (fig. 14). Falk, comp., *Annual Exhibition Record*, p. 6; *Poulson's*, April 10, May 25, 1821; Lee L. Schreiber, "The Philadelphia Elite in the Development of the Pennsylvania Academy of Fine Arts, 1805–1842," Ph.D. diss. Temple University, 1977, p. 138.

24. TRP to CWP

BALTIMORE. JUNE 2, 1821

<div style="text-align: right">

Baltimore June 2d 1821

</div>

Dear Father

It is with sincere regret I hear that I am not likely likly to get the Situation at the Museum to which I think myself justly entitled. having laboured so long to make myself competant & worthy of it.[1] you know yourself that it will not do for me to stay long with Remt. he cant give me any thing like a selary but proposes to pay me by an increasing share in his museum this will involving me in his debts and therby preventing my doing anything for my own benefit.[2]

thus even you see I have no prospect of getting a living excepting what I may get by your aid in Phila. Franklin has been proposed to take my place there merely because he is not provided for. Am I not in the same Situa-

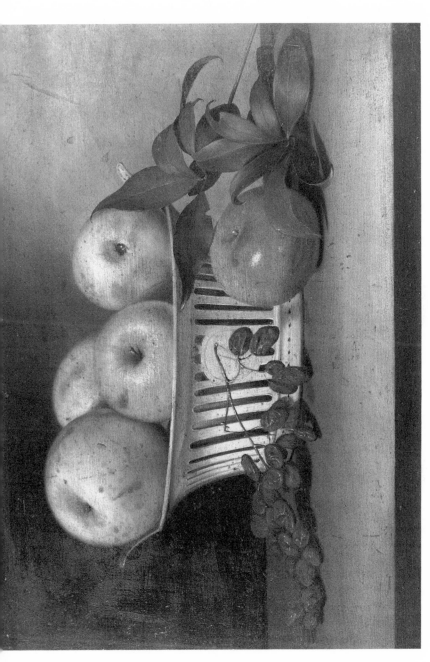

14. *Still Life with Raisins, Yellow and Red Apples in Porcelain Basket.* Raphaelle Peale, ca. 1820–22. Oil on wood, 12 ³/₄ × 19″ (32.4 × 48.3 cm.). The Baltimore Museum of Art, Gift of Mrs. Francis White, from the Collection of Mrs. Miles White, Jr. BMA 1973.76.276.

tion You have already set him up once in buisness me you have not. I have been a long time learning to prepare and arrange Animals. he has neither the taste nor experience. I only ask you now to look for yourself, if you think me unworthy the Situation, let me know it for suspence and dependance are worse than beggary

You expressed a fear that I would become involved with a woman, I am already and have for some time been so—[3]I see nothing unnattural in it, but never suppose sir that I am going to become a dependant on you. I have too many examples before me. I would sooner starve than ask a cent that I do not earn of any body in the world.

If you attend yourself sir to making an arrangment in the affairs of the Museum you may see and keep clear of the interested views of others, and to prevent any Jealousy I wish you to establish a sallary for me on which I may live without interuption, from the interests of others. Rubens and I have always lived in the greatest harmony & can still, when this little jealousey is removed. I shall be glad to hear your views and advice as soon as you can make it convenient.

<div style="text-align: right">

Your affecte Son
T Peale

</div>

ALS, 3pp.
PPAmP: Peale-Sellers Papers

1. TRP had worked for RuP in the Philadelphia Museum during the month of March and through most of April, at a salary of $9.00 a week. TRP had hoped to supplant BFP as RuP's main assistant in the Philadelphia Museum, but after an argument with his father, he decided to try to make an arrangement with ReP in Baltimore. On April 24, RuP noted in his Museum Account Book that TRP had gone to Baltimore. See Philadelphia Museum Accounts 1821–22. DSIA, F:XIA(Add.)/9A7-C6. For TRP's consideration of alternative careers, see below, **34**.

2. TRP's fears that he might be called upon to meet the Baltimore museum's deficits were well founded. During 1819 and 1820, the museum experienced financial difficulties as a result of the Panic of 1819 and the yellow fever epidemic in the city, which reduced attendance. Museum income picked up in 1821, amounting to $3,385, but expenses estimated by ReP at $2,527, "Additions and Improvements" estimated to be as much as $1,000, and a set 8 percent annual interest payment to stockholders rendered this income far below what was necessary for his survival. For income and expense figures for the museum during ReP's tenure as manager from 1814 to 1821, see Baltimore Museum Account Book, 1822–1829, n.p., MdHi, F:XIB/3B1–5C8; also see Miller, *In Pursuit of Fame*, pp. 125–27.

3. TRP had been courting Eliza Cecilia Laforgue. See above, **2**.

25. Philadelphia Museum: "Death on the Pale Horse,"
American and Commercial Daily Advertiser
PHILADELPHIA. JUNE 5, 1821

<div style="text-align: center">

(COMMUNICATION).

</div>

The Philadelphia Museum has lately been furnished with an article

which deserves to be particularly made known; exhibiting at once a very interesting portion of natural history and the singular skill and talent of the preparer.

This deposit consists of a gigantic human skeleton mounted on the skeleton of one of the largest horses that we have yet heard of. The skeleton of the horse is represented as in full action, while his rider is rising to throw his dart, which is poised for this purpose; his left hand which is disengaged, very significantly points to the earth. Those who have not seen, can have very little idea of the awful impression produced on the spectator by this truly poetical arrangement, where all thoughts of the want of living instruments to produce the appearances of swiftness and exertion, are lost in the sublime expression of energy thus given to "Death on the pale Horse."

As for the propriety of representing death by its effects, rather than by personifying the agent which produced it, no excuse need be offered. The causes of death are as frequently negative as positive, and while many might be unable to comprehend a personification of the power, few can behold a skeleton without associating the idea of death. As an instance of the anatomical skill of Dr. R. Harlan,[1] who prepared it, as well as affording a direct comparison between the human osteology and that of the horse, this subject is highly interesting. If it were placed by itself, without any thing to divert the attention, few persons could behold it unmoved; though it is not to be supposed that the preparation is at all calculated to inspire disgust or horror; on the contrary, a large number of ladies and gentlemen have visited it, and expressed their admiration, unmixed with any thing of dislike.

The horse is 20 hands, or six feet eight inches high. The skeleton of the man, six feet two inches high.

PrD. 1p.

1. Richard Harlan (1796–1843) specialized in vertebrate paleontology and comparative anatomy while practicing medicine in Philadelphia beginning in 1818. His major work as a naturalist was *Fauna Americana*, the first systematic treatise of American mammals (1825). See below, **148**.

26. A. R. Perkins[1] to RuP
BURLINGTON, N.J. JUNE 11, 1821

Burlington June 11 1821

Respected Sir.

I have endeavoured to procure for you the living White Rat, which I

mentioned to you when I was down, but the person in whose possession it is at present does not like to part with it, I have however sent you the skin of one which was killed in digging it out of its hole. If you think it Worthy of a place in your Museum, you would much oblige me by placing it by the Side of the Fox.——

Your's respectfully
ARPerkins

PS. I rather think you will receive the living one before long

yours &c—
ARP.

ALS, 1p., add. & end.
PPAmP: Peale-Sellers Papers
Endorsed: accompanying the skin of a white Rat.

1. A. R. Perkins is unidentified. In late April he sent to the museum "a full Blooded Red Fox . . . about one month old living, which is nourished by a Cat, which accompanies it." The animals were presented to RuP in exchange for a ticket of admission to the museum. In early May, the baby fox was killed in a fall, "and the cat pined for it." On June 13, RuP received the "White Rat's skin. shot near Burlington. N. Jersey." Museum Accession Book, pp. 113, 114, PHi, F:XIA/4B10–11. A. R. Perkins to RuP, April 25, 1821, P-S, F:VIIA/3E13–14.

27. CWP to TRP

GERMANTOWN, PA. JUNE 14, 1821

Belfield June 14th. 1821.

Dear Titian

Yours of the 2d Instant[1] received, and a rainey day gives the time to write some letters, which I have long neglected owing to my heavy undertakings— It is now two months that I have done the work of a day labourer, It is a curious experiment, that a Man of 80 years of age can work from sun rise to sun set, at this season of the year, and most of the time at a wet meadow, making a Mill dam—[2] but I must quit this subject to attend to the object of your letter, although it is not in my power to write anything more to the purpose, than what passed in our conversation previous to your departure for Baltimore. and indeed my situation appears more gloomy than at any former period, for my expenses encrease upon me, and my income by the Museum most surprisingly decreased, I went to the City on last Monday, and find by the account of money received for the last year, not yet quite completed; That is to the first of next month (July) is 3 thousand & some hundred Dollars, out of which all the expences, both permanant & current are to be deducted, It is true that the

yellow fever of last summer was cause of great loss of income, this may happen again & again, as alarms are soon spread, & the evil is almost the same, whether given by real danger or false reports.[3]

At the end of the month, as I told you, I shall know more particularly, how to settle the business of the Museum and I must beg of you to be more moderate in your calls for my aid, it only adds to my distress, which I can truely say, is already very heavy on me. I have an earnest desire to to ⟨aid⟩ help all my Children, as they are equally dear to me. You ask a salery, can my present circumstances justifie such a request? You must have patience, & in the mean time practice riged economy, I do not wish to find fault, but think such advice very necessary, more especially to young people.

Now with respect to attachments with the fair sex, it is a business that require much reflection, it is a cruel thing to bring trouble on them, therefore I forewarn you not to expect that my means will be sufficient to bear an Increase of Expences— I am sore now, hence I forbid you thinking that I can bear & suffer more.

Your Mother joins in Love to you.

I will write again when I can write more to the purpose

<div align="right">yours Affectionately CWPeale</div>

To Titian Peale
 Baltimore

ALS, 2pp. & end.
PPAmP: Peale-Sellers Papers
Endorsed: Received 16th
Copy in PPAmP: P-S—Letterbook 17

1. See above, **24**.

2. Daybook 2, pp. 106–07. See "Notes of days work on the mill dam." CWP's efforts to construct a mill dam were designed to ensure a constant supply of power to CLP's and BFP's cotton mill, so that it could resume operation.

3. CWP appears to be referring to museum receipts for the first six months of 1820, which totaled $3,572.87. He also correctly assumed that the yellow fever alarm in Philadelphia in August and September 1820 sharply reduced museum receipts. Museum income actually declined precipitously beginning in July, when it fell to $183.25 (down from June's total of $333.50); to $163.75 in August; and to a low in September of $103.75. Monthly receipts slowly increased during the remainder of the year, but total yearly income was only $5,317. As a general five-year trend, museum revenues declined from an all-time high of $11,924.50 in 1816, to $8,232.50 in 1817, up slightly to $8,411.25 in 1818, and down to $6,046.75 in the economically troubled year of 1819. During 1821 the downward fall would continue, with museum income reaching only $4,928.99. Museum expenses are not known for the first six months of 1820; during the second half of the year they increased from $133.61 (July-August-September) to $205.33 (October-November-December). Expenses continued to increase in 1821, from $207.27 in the first three months to $482.13 (April-May-June). CWP's personal expenses cannot be totaled from his Belfield accounts book. Philadelphia Museum Account Book, PPAmP, F:XIA/6A4-B14; Charles Willson Peale, "1806–1822 Daybook," PPAmP, F:IIE/6–7.

28. Coleman Sellers to TRP

PHILADELPHIA. JUNE 21, 1821

Philada. June 21. 1821—

Dear Titian

I recd. your 2 favours,[1] and should have replied to them sooner if I could have communicated any thing of Value— we have had but I think one meeting since your absence and shall not have any until the 1st. of July—when the Quarterly settlement takes place.[2] I shall then present your Pe[ti]tion and use all my Influence to indeavour to effect something in your favour— Rubens is working hard at your subjects,[3] as soon as you were gone he fell to work and has been quietly and Industriously ingaged ever since. If any thing transpires of consequence you shall receive the earliest inteligence. In the Interim I shall do all that can be done by Your Affectionate Brother

C.Sellers

ALS, 1p., add. & end.
PPAmP: Peale-Sellers Papers
Endorsed: Baltre. Recd. 23d.

1. Unlocated.
2. Trusteeship meetings were held on April 28, May 8, May 22, June 5, and possibly July 2. After his trip to Baltimore on April 24, TRP returned to Philadelphia and remained in the city until at least May 22. Sometime between then and June 2, he returned to Baltimore. In late June or early July TRP was back in Philadelphia. 1821–1827, Philadelphia Museum Minutes, P-S, F:XIA/7A6-B11.
3. See above, **14**.

29. Henry Escher to Unidentified[1]

ZURICH. JUNE 25, 1821

I am very much obliged to you for the letter from Mr. Peale please tell him that i accept with pleasure his proposal respecting an exchange of insects giving European ones for American in equal quantity, variety freshness and perfection; that what i shall send will have the advantage of beeing properly classed according to Lineus, fabricius & the celebrated modern authors,[2] that my sending will be very considerable because it is attended with too much trouble and expence on a/c the difficulties experienced from the french Customhouses to make constantly small sendings, that the Collection i am making up will leave a french port, where i must send it at som expence in April next and consist of at least 4000 Insects all numbered and classed and accompanied with a Cathalogue, that i request an equal number and variety of insects in a fine state of preservation and

well put up in return that making such a collection as i shall send is attended with considerable expence and the ordering of it determining each insect and making up the Cathalogue the work of many months which no one would like to have in vain. I should wish all the butterflies contained in Smith[3] rare insects of Georgia except Cardue, Atalanta & Antiopa of the larger and brillant species 4–5–6 specimens.[4] I am particularly desirious of ½ Dozn. specimens of each of Pha. Luna Cecropia, Polyphemus, Promethea, Io, Imperialis, Regalis Virgo, reared out of the Caterpillar,[5] most of them are common in the neighbourhood of Philada. and Bethlehem.

Zurich the 25 June 1821.

(Signed) Henry Escher.

ALS, 1p., add. & end.
PPAmP: Peale-Sellers Papers
Endorsed: Copy of letter addressed to "Peale Esqr. Philadelphia"

1. The recipient, unidentified, copied Escher's letter and sent it to RuP. Escher's expression of gratitude at the beginning of this letter, thanking the recipient for conveying RuP's letter of March 14 (above, 10) suggests that Escher's letter was sent to the individual in New York responsible for forwarding RuP's letter to him.

2. Johann Christian Fabricius (1745–1808), Danish entomologist, published extensively in the field of "descriptive systematics (taxonomy)." "Celebrated modern authors" in entomology and natural history would include Pierre-André Latreille (1762–1833), Lorenz Oken (1779–1851), and Johann Wilhelm (1764–1845). DSB; NUC.

3. Sir James Edward Smith (1759–1828), The Natural History of the Rarer Lepidopterous Insects of Georgia (London, 1797). NUC.

4. Cardue is an obsolete term for thistle. Escher probably meant the thistle butterfly, the "painted lady," Vanessa (Pyrameis) cardui, whose larva feeds on the thistle (OED); the Vanessa atalanta and the Nymphalis antiopa are Linnaean classifications of butterflies found in North America. We are grateful to Dr. Don R. Davis, curator, Department of Entomology, National Museum of Natural History, Smithsonian Institution.

5. Of the moths mentioned, we have identified the following: Cecropia, a large silk moth (Hyalophora cecropia), belonging to the family Saturniidae and found in the eastern United States (OED); the io moth, a large yellow North American moth (Automeris io) (OED); the "imperial moth" (Eacles imperialis), of the family Citheroniidae (Ency. Am.); the Regalis virgo, possibly the regal moth, any member of the family Citheroniidae, found only in the New World (Ency. Brit.).

30. RuP to TRP
PHILADELPHIA. JULY 6, 1821

Philadelphia July 6th. 1821.

Dear Brother.

Your favour of the 5th.[1] by Mr. Sully[2] has just been received, but too late for this days male. I was sorry that I didnot see you the morning you left the City, as I had letters from Dr. Troost &c for you and the remain-

der of the money due to you from my Father $4. I went to the Museum at 10 o'clock and remained untill after the steam boat left town, for I was sure that you would be there before you left the City.

Major Long once called whilst I was at dinner and I didnot see him and I have not seen him or herd from him since he is still in the country, I understood that he said to moses,[3] that he was astonished that you should leave town without letting him know of it—but why, I cannot say.

I have been amusing myself at leisure times in preparing many of the articles brought by the party,[4] yesterday I mounted seven of the fish and shall finnish them perhaps on sunday next, if the sun shines bright, they look much better than I expected to make them. The Shells form a very handsome case, Mr. Say is delighted with it and is progressing with the Insects, which he finds very tedious this hot weather. I had much difficulty in distroying the Moth and dermestes amongst the skins &c. it took me 2 or 3 days after you left town to accomplish, but succeeded perfectly well. I have just left Mr. Ord,[5] who lately has returned from a tour thro England, France & Italy. he says he should have been delighted to see you—but I donot think him quite so inthusiastic as he was formerly, buisness being dull perhaps depresses his spirits.

It gives me pleasure to say that after my Father has finnished the new dam Linnaeus has consented to commence the Cotton buisness again, but not without much persuasion. And that Andrew Summers[6] has an engagement for two or three mont[h]s with a merchant at twelve dollars a week. I have made a large collection of Insects, for the time, and some are new or very rare. I shall not begin the large skins brought by you, untill next week. I have been expecting my Father in town for the last month to assist in making a begining of them, but the mill dam has occupied all his time.

Tell Rembrandt that I shall write to him in a few days, that I received a letter from John Pendleton[7] in Salem, that the exhibition was to commence the next day for one week, with an excellent light shewing it to great advantage, but that his expectations were not great.

You will find enclosed 4 dollars being the remainder of the amount due from my father and the two to supply the counterfit one received from me, which I hope will be received in good time.

Give our love to all the family and receive the good wishes of your brother

Rubens Peale

ALS, 3pp., add., & end.
PPAmP: Peale-Sellers Papers
Endorsed: Recd. 9th.

1. Unlocated.

2. Thomas Sully.

3. Moses Williams was the son of CWP's former slaves, Scarborough and Lucy. He was manumitted by the Peales after 1803 and earned a substantial living working in the museum and taking silhouettes for visitors with the physiognotrace, the profile drawing machine. Williams accumulated considerable property in Philadelphia and married, or entered into a liaison with, CWP's white cook. *CWP*, p. 109; *Peale Papers*, 2: 248n.

4. For the articles from the Long Expedition that were deposited in the Philadelphia Museum, see above, **14**.

5. George Ord (1781–1866), listed in the *Philadelphia Directory* as a ship-chandler, inherited his father's prosperous business and was able to devote much of his time to the study of natural history and philology. In 1818, he accompanied TRP, William Maclure, and Thomas Say on a field trip to the Georgia Sea Islands and Florida. Ord completed volumes 8 and 9 of Alexander Wilson's *American Ornithology* and, in 1824–25, published a much expanded edition of the work. *Philadelphia Directory*, 1821; *DAB*; *Peale Papers*, 3:554.

6. Andrew Summers III (1795–1843) married SyMPS on November 9, 1815. *Peale Papers* 3:358n.

7. John Pendleton (see above, **7**) was traveling through the eastern United States exhibiting ReP's *Court of Death*. He had shown it in Boston in May, and was now taking the exhibition to several other Massachusetts towns. Carrie H. Scheflow, "Rembrandt Peale: A Chronology," *PMHB* 110 (1986):153; Miller, *In Pursuit of Fame*, p. 137.

31. CLP to TRP

GERMANTOWN, PA. JULY 15, 1821

<div align="right">Belfield July 15th-1821</div>

Dr Titian

I have intended for some time past to write to you but being so very busy with the dam & other affairs have been prevented untill now. The dam has been finished three weeks & now stands very well, I am getting the factory in order for an other trial, if I donot succeed in this treale I dont think I shall troubled it again[1]——Uncle James & Pa' have taken some fine views of the Place, looking across the dam towards my house and the garden &c—and have taken one view of Pattersons mill from the spring on the other side of the Creek[2]— We are are all in good health—Christy[3] desires her love to you. Phoebe[4] was married about two weeks since—Sally is as usuall breaking all the beaus hearts & wont have any of them[5]—James Peale has been promoted & Andrew has got into Bank again at a salary of 700 dolls. Please call on Mr Nightingale[6] and get the amount of what he has sold of my straps—[7]I have allowed him 10 prCt commission

Remember Christy and Me to all Rembs family & those who may enquire after any [of] us.

<div align="right">Your Brother
Linnaeus</div>

NB. I forgot to say that Pa' & family were all well L.

[In left margin]This was written by a lamp without oil.

ALS, 1p. & add.
PPAmP: Peale-Sellers Papers

1. The Panic of 1819 brought to a standstill work at CLP's and BFP's cotton manufactory at Belfield. At the end of July 1819, CWP reported that his sons "are doing nothing now in the Cotton line." *Peale Papers*, 3:723, 725, 728.

2. The landscapes are unlocated. Patterson's mill was a part of the Patterson Woolen Manufactory in Harmony Grove, Germantown. *P&M Suppl.*, p. 47; *Peale Papers*, 3: 798; *CWP*, pp. 392–93.

3. CLP's wife, Christiana Runyon (d. July 1, 1839).

4. Unidentified.

5. SMP.

6. Jason Nightingale was a Philadelphia sailmaker whose business was located on the north side of the Vine Street wharf. *Philadelphia Directory* (*1820, 1821*).

7. CLP began making razor strops in the spring of 1820. CWP judged their "fine edge" "superior . . . to any I have seen before." *Peale Papers*, 3:813.

32. CWP to RaP

GERMANTOWN, PA. JULY 22, 25, 1821

Belfield July 22.1821.

My Dear Raphaelle

It is long since we have heard from you,[1] I fear your sufferings are great. your letter to Eliza[2] spoke of your returning so far to health as to enable you to resume your Pencil, although much debilitated, why do you not write to some of the family or if you are not able, get some person where you are to do it for you? I have been once or twice in the City of late, and going to your House, each time Patty said, that my rap at the door made her expect it was the Postman with letters, and week after week they expect in vain, it is cause of much distress to all the family. This last trip to Maryland I am apprehensive has been unfortunate.— I am interrupted with company & must finish tomorrow. 25th. sundry labours have occured since the above— It is matter of wonder that [at] my time of life that I should be able to bear the fateague of working hard from morning to night, and enjoy my health, this summer I have made full experiment of what may be done by an aged man without the aid of Stimilus. I wanted to make a Mill dam as my Mill was of little value in these late dry seasons without one, and having but little money I determined to work myself, by which I know I should get more work done by those I hired, and allso in the hope that by my examble I might indu[c]e others to do the like, and as water is my only drink, I might induce the men I hired (for I know they loved Whiskey) to do without it. To it I went with vigor, rising by the dawn of day, and I was the first in the morning & the last at night at the Spade. Your Brother Linnius also worked with me as a labourer, his offer of working I thought in case I should not be able to stick

closely to it, or get indisposed, might supply my place—however neither extreame heat, fogg or wett feet prevented me from hard labour one hour, and a substantial Dam is now compleated at a triffling expence by my mode of conducting the labour— The cost to me for wagers being only 73.$ the cost of materials included another artist and this Dam is 125 feet long and of a breadth for a carriage, as I intend it to be a road to bring Stone & Wood from the other side—and my plan is, when the Bank of the Dam is well settled, to put a Bridge across the tumbling-dam[3] (which is 30 feet wide), made of boards according to my invention,[4] & without any Iron in it.

I have worked for upwards 2 months this summer unceassingly, at various labours, and always glad to hear the Bell that called me to meals— and hence I know that labour is not so penible as many suppose. And I know has been condusive to my health. I have not painted more than a few hours this summer, having no time for it. but now I contemplate to resume the Pencil as the more profitable imployment. Your Mother enjoys good health, She & Mrs. Morris desire to present their love to you— I am just about starting for the City & perhaps I may there add a postscript.

Yours Affectionately, CWPeale.

Mr. Raphaelle Peale
Malborough Maryd.

ALS, 2pp.
PPAmP: Peale-Sellers Papers—Letterbook 17

1. CWP's last letter to RaP was written on March 19, 1821 (see above, **12**). Letters from RaP to CWP are unlocated.
2. RaP's letter to his eldest child, Eliza Ferguson, is unlocated. *CWP*, p. 439.
3. The part of the dam over which excess water passes. Mathews, *Americanisms*, p. 1778.
4. For CWP's patent bridge, see *Peale Papers*, 2:178–92.

EDITORIAL NOTE: *The DePeyster Estate*

Peale had been striving to obtain a share of the DePeyster estate for his and Elizabeth DePeyster Peale's five surviving children for many years. Elizabeth's father, William DePeyster, Jr. (1735–1803), had stipulated in his will that his widow, Christiana Dally DePeyster (1748–1813), should receive income from the sale of the estate and the interest on a security bond of $5,000. After her death, the estate and the $5,000 would be divided equally among his surviving children or their heirs. For more than a decade after William's death, John DePeyster, Elizabeth's brother and the executor of the will, acknowledged the estate's obligation to Elizabeth's children by advancing Peale several sums of money against their

inheritance. However, about two years after the death of Christiana, the firm of John DePeyster and his cousin Gerard DePeyster declared bankruptcy. John had invested the money intended for the support of William's widow in the stock of his company instead of in "landed security" as William's will had directed. Until the DePeyster firm could regain solvency, there would be no funds to distribute to William's heirs. Almost immediately, amicable relations among the several families ceased as different members sought control of whatever portion of the estate remained to be distributed.

One of the interested parties was Henry Remsen (d. 1843), president of the Bank of the Manhattan Company in New York from 1808 to 1825 and husband of Elizabeth DePeyster Peale's niece Elizabeth (Eliza) DePeyster (1787–1826). Since Christiana had died intestate, by law her portion of her husband's estate should have gone to her Dally relatives. Remsen persuaded the Dallys to name him administrator of Christiana's estate and, accusing John of mismanagement, instituted a bitter lawsuit to obtain control of the $5,000 bond, promising to distribute it among the various DePeyster heirs. Complicating his proposal was the fact that John and Gerard had incurred bank debts that Remsen had not only authorized but had assumed. Aware that Remsen would use the proceeds from the bond to reimburse himself for the loan, the DePeysters refused to turn over the bond to him, and thus the remainder of the estate was tied up in litigation.*

*Peale Papers, 3:306n, 354–55n, 501–02.

33. CWP to Henry Remsen

GERMANTOWN, PA. JULY 30, 1821

Belfield July 30th. 1821.

Dear Sir

on receipt of your letter[1] I went into the City and waited on my friend Gerard Ingersole Esqr.[2] whose opinion as well as my own accord with you, and I much regret that I did not follow it sooner, but I was flattered with the hope that the settlement would be made in an amicable Manner, and without the expence of a suit at Law. I was also informed that Messrs. John & Philip DePeyster[3] had employed Mr. Anthon[4] as counceller, and expecting that justice would be done to my Children, as I knew you ment to fulfill the Intention of the will of the late Wm. DePeyster

Mr. Ingersole promised to write to Messrs. Sedgweeks,[5] to appear in my behalf, as counsel, which I hope will meet with your approbation and be in

time. It was necessary that I should see my Children who now are all of mature age, and agree ⟨that⟩ on the measures I have taken, or, I would have wrote to you by post last week.

Please to present my respects to your consort & her Mother[6] and except the assurance of the high reguard of

<div style="text-align: right">your friend CWPeale</div>

Henry Remsem Esqr.

ALS, 1p.
PPAmP: Peale-Sellers Papers—Letterbook 17

 1. Unlocated.
 2. Jared Ingersoll.
 3. John B. DePeyster (1765–1846) was EDP's twin brother; Philip DePeyster (1772–1846) was a younger brother. *Peale Papers*, 2:3.
 4. John Anthon was a New York attorney with offices at 95 Beekman Street. *Longworth's American Almanac, New-York Register, and City Directory* (New York, 1821).
 5. Henry Dwight Sedgwick (1785–1831) and Robert Sedgwick, sons of the jurist Theodore Sedgwick, practiced law at 34 Cedar Street in New York City. *NCAB*; *Longworth's American Almanac, New-York Register, and City Directory* (New York, 1821).
 6. Catharine Bancker (Mrs. Abraham) DePeyster (1760–1825). See *Peale Papers*, 3:496.

34. ReP to TRP

BALTIMORE. AUGUST 4, 1821

<div style="text-align: right">Baltimore August 4.1821.</div>

Dear Titian

By your letter of the 1st. Inst.[1] I perceive that you have made no progress in your affair at the Museum—at least to your satisfaction, as it appears you do not like being at the Farm on the terms of my fathers proposition—and indeed in some respects a residence in town would be more advantageous as well as more agreable, altho' the country at times would afford you facilities and leisure for many collections & preparation. You must not treat my fathers proposition with too much neglect as in his situation I do not see that he could have offered any better.[2]

I cannot offer you my opinion concerning your claims before the Trustees, because you have not informed me what you have proposed to them—but I do not think it probable that they will agree to give you a greater compensation as an Assistant, as your expences in town would have to be added.[3] Mr. Collin's recommendation that you should meet your father, Rubens & Coleman & agree upon terms is certainly good— because as Mr. Vaughan says "every thing may be done by a fair wind, Nothing by a foul one"[4] but it is not likely at present that the Trustees would act in opposition to such an agreement.

<div style="text-align: right">67</div>

As to your painting Portraits I believe your talent in drawing would enable you to succeed, provided you would devote your whole soul immediately to it and entirely abstract all your thoughts from Natural History. The two are entirely incompatible with each other—as soon as my father commenced Naturalist he lost all enjoyment in painting—And I know by my own experience that when I attend to Mechanics or for a few days occupy myself with the Museum, it indisposes me to painting. If you can devote your eyes & your mind to the study of colour, countenance character—the general instead of the minute of Anatomical details you may succeed in Portrait painting after a year's preparatory study & practice.

The offer which I made you flowed from the most hearty good will towards you and was founded on the good opinion I had formed of your principles—character, which made me desirous of benefitting you, if I could, without injuring myself—but the severity of your observations about relations has induced me to reflect on the Subject & I confess I am much afraid that in this respect your erroneous judgment will not only render it difficult to meet your wishes, but destroy the confidence which ought to be the foundation of domestic happiness. I frankly assure you that I am extremely sorry at your having indulged such notions, although you have had some reason—because in so doing you are indulging yourself in the same selfishness that you would suspect others of. You must recollect that the happiest moments of your life have been those in which you have been most free from suspecting others & most occupied in endeavoring to do good yourself. It is true you have arrived at an Age when it has become necessary to settle yourself & procure the means of giving happiness to others. But you can scarcely count upon doing this without depending on the honesty & kindness of others & it will be the most injurious idea you can entertain to suppose yourself the only correct man in the world, even whilst you permit your feelings to offend the feelings of others. If the good in the world did not greatly predominate it would indeed be a sad world, only fit to be ⟨supported⟩ governed by a Devil & would not at all agree with the wonderful pefection to be found in the structure & arrangement of all animate & inanimate beings.

Rosalba after two days travelling found [letter torn] her head ache quite relieved—spent part of a day [letter torn] [at] Harpers ferry where she made 3 drawings—[5]visited Berkley Springs & passing through Cumberland arrived well at Pittsburg the 9th. day—whence she wrote a short note.[6] We are satisfied that this journey would establish her health firmly & convince her in the most agreeble manner the advantage of exercise.

Dr. Godman has begun to draw & is determined to persevere till he conquers the difficulty—encourage him in this resolution and assist him if you can.

I & my family will be glad to hear from you especially if you can communicate anything indicating your satisfaction or success.

Yours affectionately
Rembrandt Peale

ALS, 3pp. & add.
PPAmP: Peale-Sellers Papers

1. Unlocated. ReP's letter was carried to TRP in Philadelphia by Dr. Godman.

2. CWP may have offered TRP a choice of positions, either to work with CLP in the cotton manufactory at Belfield or to assist RuP in the Philadelphia Museum if the trustees approved. See above, **27**.

3. The precise request TRP put before the trustees is not known, although it was probably similar to what he proposed to his father (see above, **24**). On October 6, 1821, the trustees met and resolved that "at the desire of . . . Charles W. Peale his son Titian Peale be employed as an assistant Manager at the Salary of Four hundred Dollars per annum to commence from the first day of August last and to continue at that rate until otherwise determined by this Board." Philadelphia Museum Minutes, 1821–1827, P-S, F:XIA/7A6-B11, p. 8; CWP to the Trustees of the Philadelphia Museum, July 8, 1821, P-S, F:IIA/16C6.

4. CWP used John Vaughan's maxim anonymously in his *Essay to Promote Domestic Happiness. Peale Papers*, 1:389; 2:39; 3:12, 132.

5. Harper's Ferry, at the confluence of the Potomac and the Shenandoah Rivers, was well known to contemporaries for its sublime landscape. Thomas Jefferson described the "stupendous" view of the rivers and mountains in 1784 in his *Notes on the State of Virginia*. ReP had painted a small watercolor at the site (1811: *Baltimore City Life Museums, The Peale Museum*) from which he created a five by seven-and-one-half foot canvas for exhibition purposes (*private collection*). According to CWP, ReP had written an interesting account (unlocated) of his 1811 trip to Harper's Ferry, and this may have further stimulated Rosalba's desire to travel there. Rosalba's drawings are unlocated. *Peale Papers*, 3:103–08; Miller, *In Pursuit of Fame*, pp. 107, 293n.18; Adrienne Koch and William Peden, eds., *The Life and Selected Writings of Thomas Jefferson* (New York, 1944), pp. 192–93.

6. Unlocated.

35. CWP to Pierce Butler

GERMANTOWN, PA. AUGUST 7, 1821

Belfield Augt. 7th. 1821.

Dear Sir

Having my Son Raphaelle some days past and on my return from the City last night, found the Elk sick, and this morning rising early, I found him dead, of course I must be deligent to preserve him,[1] these circumstances have prevented my waiting on you as was my desire. please to inform me of the state of your health verbally by my Man Jonas.[2] Enclosed I send the Answer of Captn. Sewart respecting my Son Titian.[3] with sentiments of high reguard

your friend CWPeale

Pierce Butler Esqr.

ALS, 1p.
PPAmP: Peale-Sellers Papers—Letterbook 17

1. CWP brought the year-old elk to Belfield in 1810. He had intended to domesticate the animal and break him "to a Cart," but that proved a dangerous experiment. When the elk tried to run off, CWP came close to being seriously injured. CWP kept the elk at Belfield, carefully recording in his Daybook the animal's growth and horn measurements. In 1819, Hyde de Neuville, the French minister who was also a naturalist and collector, offered CWP five hundred dollars for the animal. CWP did not consider the offer sufficient and determined to try to keep the animal alive for two or three years, "as then he might form an interesting subject for the Museum." *Peale Papers*, 3:58, 61n, 711–12.

2. Jonas was CWP's gardener at Belfield. CWP's account book shows payments to him in 1819, 1820, and 1821. *Peale Papers*, 3:797, 801n, 804; Daybook 1, pp. 137, 138, 139, 141, 143, 147, 149, 152.

3. Charles Stewart (1778–1869), naval officer, served brilliantly during the War of 1812, receiving a sword of honor from the legislature of Pennsylvania and a gold medal from the U.S. Congress. From 1820 until 1824 he commanded a squadron in the Pacific. *DAB*.

TRP had probably written to Stewart seeking to join his expedition to the Pacific, and when his application was rejected sought his father's intervention. In turn, CWP appealed to Butler for help. Later in the month, perhaps on Butler's advice, CWP interceded with Stewart himself (see below, **41**).

36. CWP to Philip DePeyster

GERMANTOWN, PA. AUGUST 9, 1821

Belfield Augt. 9th. 1821.

Dear Philip

My Children having arrived at Mature age, the youngest (Elizabeth) married to Mr. William Patterson a worthy young man, engaged in a manufactory of Cloath, Titian since his return from exploring the Western regions, is also commencing to earn a livelihood—inshort they all I need not repeat them, want what is due to them from our worthy fathers Estate, & have desired me to employ an attorney (Counseller) to act in their behalf—And Messrs. Sedgewick's are imployed to undertake the recovery of their rights, it is therefore necessary and proper that I should revoke my Power of Attorney to you, which I gave many years past. At the same time I must say that I feel my oblegations to you for your indeavors to serve me, and as Mr. Remson has make ⟨you⟩ me a partie adverse or defendant, therefore it became necessary to take this measure, as I am not a defendant but a plaintiff. however I hope this will bring the business to a close in some shape—[1] I hope the delay may not bring distress upon the Widow of Mr. James DePeyster, whose estate is liable to the payment of the legacies— You will do me a particular favor to write me what is the situation of Gerard & his Mother at this time.[2]

And I have another request of you, which is call on Messrs. Sedgewick's and give a clear Idea of the situation of the business and the cause of the long delay of the payment of the Bond, I hope this business in its present train will meet with your approbation, and a help to our worthy sister Mrs.

Stagg,[3] to whom please to present my love as well as that from Mrs. Peale, we both enjoy good health, and jogg on as you have seen in some years past— still at the farm, for I could [not] get property in the City suitable for the Museum, in exchange for it, or I would have done it that I might have saved the payment of an enormous rent in the State-house— however at last the City Corporation have made me an abatement of one half ⟨said⟩ instead of 12.00$ I now pay 6.00$. that is in my Idea rather much for these times, but I have consented to it, as the situation is preferable to any I could get.

I shall be glad to hear that you have profitable employment, my respects to the family, and believe me with sincere reguard your friend and brother

CWPeale

Mr. Philip DePeyster New York.

ALS, 2pp.
PPAmP: Peale-Sellers Papers—Letterbook 17

1. Up to this time, CWP was able to communicate amicably with Philip DePeyster in the controversy concerning the DePeyster estate. In 1816, CWP had conveyed to Philip power of attorney to act in behalf of the Peale family in settling the business. See *Peale Papers*, 3:289–90, 398–99, 600–01
2. Anna (1746–1832), daughter of Gerardus DePeyster, married her first cousin James W. DePeyster (1745–1812), EDP's uncle. They were the parents of Gerard DePeyster (1776–1824). *P&M*, pp. 64–65; Waldron Phoenix Belknap, Jr., *The DePeyster Genealogy* (Boston, 1950), pp. 38–39.
3. Margaret DePeyster (Mrs. John) Stagg (1767–1846) was EDP's younger sister. *Peale Papers*, 1: 618n; 2: 70n; *P&M*, p. 199.

37. CWP to Messrs. Sedgwick
GERMANTOWN, PA. AUGUST 9, 1821

Belfield near Germanton Augt. 9th. 1821.

Gentlemen

My friend Edward Ingersol Esqr.[1] informs me that you have appeared in my favor to obtain the Settlement of the Legassies due to my Children by the Will of the late William DePeyster— There has been a disagreable procrastination of that business, owing to differences between Mr. Remson & Messrs. John & Philip DePeysters—and I have been flattered year after year that an amicable settlement would have been made, and Mr. Remsen has repeatedly declared to me his intention and desire to fulfill the intention of the will of Mr. DePeyster, and assuredly his children are equally intitled to their share of the Estate as the other hiers. But Mr. Philip or John DePeyster will I hope give you a full & proper state of the

Business— Some years past I gave Mr. Philip DePeyster a Power of Attorney to act for me—And, I have to day wrote to him informing him of my revocation of that Power, and requested him to make you acquainted with the state of ⟨the case⟩, all their proceedings. My Children by the Daughter of Mr. Wm. DePeyster are all of mature age, and the property when recovered & divided into five parts, as there are 5 of them, Namely, Linnius, Franklin, Sybella, Elizabeth & Titian, will be a small sum to each—yet that little will be more valuable at this period perhaps than at any other time, as they have not all commenced business for their future support. Like other old men, perhaps I am more prolix than needful— But your advice if you wish further information will oblege your

<div style="text-align: right">friend CWPeale</div>

Messrs. Sedgwick's

ALS, 1p.
PPAmP: Peale-Sellers Papers—Letterbook 17

1. Edward Ingersoll (1790–1841), lawyer, was the son of CWP's former lawyer, Jared Ingersoll. Jared's three sons, Charles Jared, Joseph Reed, and Edward, all practiced law in Philadelphia. Edward's office was at 159 Walnut, just a few doors from his father's at 136 Walnut and his brother Charles Jared's at 130 Walnut. Edward published *A Digest of Laws of the United States from 1789 to 1820* (Philadelphia, 1821) and *Abridgement of Acts of Congress* (Philadelphia, 1825), as well as poems under the pen name of "Horace" for the *Philadelphia Magazine*. Lillian Drake Avery, *A Genealogy of the Ingersoll Family in America, 1629–1925* (New York, 1926), pp. 146, 162; *Philadelphia Directory (1821)*; *NUC*.

EDITORIAL NOTE: *The Marriage and Divorce of Benjamin Franklin Peale*

Franklin married Eliza Greatrake when he was nineteen years old. In November 1813, Peale had sent him to the Brandywine River Valley to work with the Hodgson brothers and learn the operation of a textile machine manufactory. There he met Eliza, the daughter of the manager of Thomas Gilpin's paper mill. Eliza had become a Quaker, joining the Wilmington Meeting on December 3, 1813. Her religious fervency made a great impact on Franklin, and for a time he intended joining the Friends. On April 24, 1815, without his father's consent, Franklin and Eliza were married, the records of the Wilmington Meeting noting that Eliza married a man "not in membership."

Peale claimed and later testified that on his first meeting with Eliza, before the marriage, he believed that "her mind was disturbed by religious enthuseasm." After the marriage, the young couple went to live on the Peales' farm in Germantown. Peale insisted that he treated them, especially Eliza, with "kindness," and that his wife, Hannah, "did every

thing in her power to comfort the deranged Strainger," even preparing meals for her and Franklin after they set up "Housekeeping." On March 26, 1816, Eliza bore a daughter, Anna Elizabeth (d. 1906), and a month later, according to Peale, without Franklin's "consent," went to live with her mother. Mrs. Greatrake, who shared the Peales' anxiety about Eliza and the infant, "saw the necessity of having her daughter confined to save the life of the Child." On May 6, 1816, after only one year of marriage, Eliza was admitted as a "lunatic" to the Pennsylvania Hospital. Peale claimed that Eliza's mother, after promising to pay the cost of hospitalizing her daughter, paid for only two weeks, and that he, who had been "entered as suriety," was forced to pay "several hundred Dollars" in additional costs. "Rather then putting her into the Poor-House" in Philadelphia, Peale brought Eliza to her mother, "on the Brandywine." "In the end," Peale noted, the Friends, who possessed enlightened ideas about the mentally ill and a sense of responsibility for their own, would "maintain Eliza." Franklin and the child returned to live at Belfield, and Mrs. Peale, being "very fond" of the child, took over its care.

According to Peale, Franklin had "determined to have nothing more of the plague of a deranged wife," and he was "determined to take every possible means to obtain a devorse." In December 1819, Peale hired a lawyer to have Eliza declared a "lunatic" prior to her marriage, a step that would annul the marriage and thus free the Peales of any legal and financial responsibility for her. On March 22, 1820, a hearing was held in the Philadelphia Court of Common Pleas at which Eliza was found to have been in a "State of Lunacy" for over five years—that is, prior to her marriage to Franklin—and Franklin was granted an annulment. Eliza's and his daughter, Anna Elizabeth Peale, was, however, granted by act of the Pennsylvania House of Representatives "all the rights and immunities of a person born in lawful wedlock."*

*"Papers relating to Petition of Franklin Peale," PPAmP: J. K. Kane Legal Papers, F:IXA/1A8-G7; [Pennsylvania] House of Representatives, "An Act for the Relief of Franklin Peale," January 14, 1825, F:IXA/1G6–7; *Peale Papers*, 3:291n, 302, 303n, 343n, 356, 408, 539, 553, 782, 793, 794, 801, 807–08, 810–12, 815.

38. CWP to Eli Hilles[1]
GERMANTOWN, PA. AUGUST 18, 1821

Belfield Augt. 18th. 1821.

Dear Sir

When I called on you the other morning I did not know that the Steamboat left Wilmington at 7 O'clock. I had an impression on my mind that

her departure would be at 8 O'clock—or I should not have supposed that you could have time to make the Deposition that you so oblegingly offered—and I am afraid that my friend Mr. McDowal[2] in the commencement of the testament, detained you so long as to indanger the loss of your passage, and by it have obleged you to an exertion of fateague to arrive at the Boat in due time.

My friend Mr. Jones, Mrs. Latimer & Miss Nickols[3] were so obleging as to give testemony that I hope & believe will be of important service to me and Franklin, as in a great measure it will clear up the doubts of the Gentlemen who are Arbitrators in the case of Greatrake & Peale, about the insanity of Eliza previous to her marriage with my Son,

What an immencity of trouble and expence might have been avoided had I received the letter which in friendship to my family you had wrote, if I had received it!

Franklin's sufferings were great while he was trying to hide her follies in the first months of his Marriage. and afterwards his sensibility were such as gave me great apprehentions that he would distroy himself, Mrs. Peale did every thing in her power to lessen Franklin's suffering, and indeed to bring Eliza into better understanding. She acted the part of an affectionate Mother to both of them in providing for all their wants. and from the birth of her child[4] Mrs. Peale has been ever watchful for its happiness, indeed she loves the Child and is anxious to have it well educated—

Franklin has a gloom hanging over him, which I hope will be despersed when this unfortunate connection & its consequences are remooved. He possesses a comprehensive mind and I flatter myself that he will in future days do Credit to the Name given him by the Philosophical Society.

It appears to me that numerous persons who visited the Meeting, must have been convinced by the behaviour of Eliza that she was insane when she attempted to preach. and I have understood that she often disturbed the Meeting— Then why should any one be backward to declare their belief that her mind was not sane at that period? Pardon me my friend for this question, my anxiety is great to relieve my son and myself from the trouble of longer contesting a most unfortunate and very expensive business. I know you wish to serve me, therefore you will excuse my importunity to obtain your testemony as soon as possible, as I have posponed the Meeting of the Arbitrators until the 5th. day of next week (Thursday). they are 3 in Number, Mathew L. Bevan, Joseph Price & Samuel Mifflin,[5] I am informed that they are all men of sense and of good public characters. hence I ought not to doubt that they will be of opinion that Franklin ought not to pay for Eliza's maintainance, The present demand is upwards of 100$ besides cloathing which is to follow.—and surely if we do proove that Eliza was insane before and at the time of her marriage they

cannot recover a cent. With my aid Franklin & his Brother Linnius commenced a Manufactory of Cotton Spinning, but a change of times made them loosers with all their exertions, and since that period Franklin has been with Rubens to aid him in the labours of the Museum, of course in no way to get money, and occasionly he had some employment in making apparatus for Philosophical experiments, merely sufficient to purchase his necessary cloathing. He possesses a corrict knowledge of Mechanicks; and is a neat workman, so much so, that my Son in law Coleman Sellers finds him an excellent aid in making his curious Machinery. But this is only a mere support for himself, he cannot support a craisey wife if he is to be burdened with one.

About 4 weeks after Eliza was delivered of a Child she left her home contrary to Franklins will, and went to her Mother on the Brandywine, during the week she staid there Mrs. Graterake was apprehensive that she would kill the child, and sent one of her daughters to tell me if Franklin would go to Brandywine that she would come up with him and put her daughter into the Hospital, and would pay the expence there, and that she would also maintain the Child— Mrs. Greatrake put Eliza into the Hospital and within two weeks took the Child from her—and she paid only for two weeks of Hospital expences, and a Citizen's note being required previous to a patient being admitted, I gave my signature & therefore made myself liable for all the expences, and was obleged to pay 5$ Pr. week for about 3 years & in the last year the managers made an abatement of one Dollar pr. week— my circumstances with a large family to support has rendered it very difficult for me to fulfill my engagement. some gentlemen of the Law say that I ought to sue Mrs. Greatrake for the expences of the Hospital, but this does not accord with my principle, I am so much of a *friend* as to avoid all Suits at law that I can, and desire to have no contention with any person, and, would rather chuse to suffer some wrongs, ⟨rather⟩ than defend myself.

Mrs. Peale was disappointed at not seeing Mrs. Hillis, but we hope that when you may visit this quarter that you will favor us with your company, either at the farm or in the City, for I contemplate renting a House in the City with the intention of spending a part of the year there, in order occasionally to paint some portraits and attend the concerns of the Museum— since the Incorporation of the Museum my mind is relieved from the apprehension of its division & total loss—my family may receive each their proportions of its profits, and I have provided for the maintainace of my Widow in case I should depart first— The museum being at a nominal Value 100,000$ is divided into 500 Shares— which by my will I mean to distribut amongst my Chi[l]dren in an equal proportion, making some allowance in such cases w[h]ere some have had

greater aid than others. The Share holders by the act of incorporation are to elect annually the Manager & the several Professors— At present I being the only stock holder I must make the those appointments at the stated Periods.

Thus my friend, I have given you many particulars as rested on my mind at the present, and shall conclude with wishing you every blessing, Mrs. Peale joins in respects to the family, accept the assurance of the esteem

<div style="text-align: right">of your friend CWPeale</div>

Mr. Eli Hillis
 Wilmington.

ALS, 4pp.
PPAmP: Peale-Sellers Papers—Letterbook 17

1. Eli Hilles (1783–1863) and his brother Samuel (1788–1873) operated a girls' boarding school in Wilmington, Delaware, which EPP attended in 1814.Hilles was acquainted with the Greatrake family and had written to CWP about Eliza's condition before the marriage took place, but his letter was lost in the mails. *Peale Papers*, 3:289n, 343n.

2. Thomas McDowal was the justice of the peace in New Castle County, Delaware, who took depositions in Wilmington for those testifying in the *Peale vs. Greatrake* arbitration. See CWP to Thomas McDowal, Esq., August 18, 1821, P-S, F:IIA/66C14; Papers Relating to the Petition of BFP, PPAmP, F:IXA/1A8-G7.

3. Ann Latimer (1760-?) was a Quaker who resided in Wilmington. On August 15, 1821, she, together with Quakers John Jones (1758-?) and Margaret Nichols (1793-?) testified before Judge McDowal that Eliza had been "insane" before her marriage to BFP. CWP utilized their testimony to annul BFP's marriage to Eliza. Papers Relating to the Petition of BFP, PPAmP, F:IXA/1A8-G7. Mrs. Latimer may have been related to several of CWP's sitters of the same name: *James Latimer* (d. by 1813) (1788–89: *private collection*); *Sarah Latimer* (d. by 1813) (1788–89: *private collection*); *George Latimer* (1750–1825) (1816: *private collection*); *Margaret Latimer* (1816: *private collection*). *Peale Papers* 2:826–27; *P&M*, pp. 121–22.

4. Anna Elizabeth Peale (1816–1906). *CWP*, p. 439.

5. The arbitration, which was conducted in Philadelphia, was adjudicated by three prominent city merchants: Mathew L. Bevan, of the firm of Bevan & Porter of No. 35 South Wharves, who sold furs and mahogany and was an officer of the Pennsylvania Hospital; Joseph Price, the owner of a feather store at 209 North Second and a director of The Philadelphia Contributionship for the Insurance of Houses from Loss by Fire; and Samuel Mifflin, Philadelphia merchant and officer of the Schuylkill Navigation Company, and a member of the commission appointed to receive subscriptions for stock in the Union Canal Company of Pennsylvania. *Poulson's*, January 11, March 12, April 6, 10, May 8, July 23, 1821; *Philadelphia Directory (1821)*.

39. Philip DePeyster to CWP
NEW YORK. AUGUST 18, 1821

<div style="text-align: right">New york 18 Augt—1821</div>

Dear Sir

I Recd. your letter of the 9th Inst[1] on the 15th— As you have Espoused the Cause of Mr Remsen by becoming a plaintif with him in this Very unpleasant buisiness I thought it Right to Consult Mr Anthon our Coun-

sel wether it would be proper for me to Call on the Messrs. Sedgwicks to give them the Information you Required, and he has advised me by no means to do it, for as your Councel will no doubt be Associated with Mr Remsens, I Might as well Call on him and give him facilities to pursue us with all the Malignity of his Client, you must Excuse my Expressing my astonishment and Regret at the Course you have taken, when this Suit was first Instituted, you Requested me to Employ Councel for you, I Call'd on Mr Anthons and he advised you not to Appear—because if you did not Remsen could not succeed in this Infamous Prosecution without advertizing that his Wife was A party in a Chancery Suit against her Widdowed Aunt and wasting her little patrimony in Useless Costs— Even Such as Remsen is he dared not do this, but would have been obliged to Settle the Estate according to the Acct. Rend. which Acct. from my Soul I Believe to be Just.

John Certainly committed an Error in putting out the $5,000 on Bond Instead of Landed Security— That Error may Saddle him (to the Great Gratification of Remsen) with enormous Costs, which your procedure will augment I fear you have allowed Shylocks to Impose on your unsuspecting Honesty and have become a Tool in his hand to aid in Cutting out the pound of Flesh to Glut his Vengance— You Express some Sympathy for *Mrs. DePeyster*, I believe you may make your Mind Easy on that Subject— In the Settlement of John & Gerards affairs there was a house and Lot appropriated for the payment of that debt—Gerard Sold the property and Vested the funds in Bank Stock which Stock is now worth 10 prCt more than he gave for it, and he has, Since he purchased it Rec'd 9 prCt prAnn Interest on the Amount.

My Best Respects to your Good lady and family and believe me to be Still your friend & well wisher tho I cannot approbate the Step you have taken.

<div style="text-align: right">

Yours Respectfully
Ph DePeyster

</div>

ALS, 3pp. & add.
PPAmP: Peale-Sellers Papers

1. See above, **36**.

40. CWP to John C. Calhoun

GERMANTOWN, PA. AUGUST 30, 1821

<div style="text-align: right">

Belfield Augt. 30. 1821.

</div>

Dear Sir
My Son Rubens is desireous to know what encouragement might be

obtained to establish a Museum in the City of Washington, provided the undertaker was qualified to render it a scientific and well organized Institution for difusing general knowledge.[1]

Whether a building would be given that would be sufficiently large to make a beginning & capable of being extended with an increasing collection of Nature & arts.

Rubens proposes that he might begin with Mr. Delaplanes Collection of Portraits[2] and some subjects of natural History, and he wishes to assertain to [illeg] [w]hat amount of Income might be expected Pr. Annum in the first beginning of such an undertaking, and if it would [illeg] him to an increasing family he would make exertions to accomplish what he conceived would in the Issue be a public benefit.

The parting with Rubens would be a loss to the Philadelphia Museum, but if it [is] for Rubens's interest I cannot withhold my assent, as I have other Children to be provided for and who of course must supply his place. Titian is now in my pay to mount those subjects which he collected in the late tour with Major Long. I did hope to have had them all mounted and in public view before this time, but the labour of mounting in proper form, a variety of Animals which was collected and has been skined and hurried from place to place, under manyfold disadvantages, require more time to put them in order than Subjects freshly obtained. Some of the Small birds are mounted, also some of the small Quadrupeds—all the Snakes of which there is a pretty variety, they are done—but the large birds and Quadrupeds are yet on hand, and I expect that I must lend my aid to complete them.

Since my Museum has been incorporated, the Professors have given their aid to the further improvement of it. The Minerals are splendid and emportantly arranged to give a facil & perfect knowledge to those who incline to persue that study.[3]

My Son Titian yesterday urged me to make application to get an appointment of him as a Naturalist in a tour of discovery that Commodore Steward commands. Mr. Pierce Butler advises me to let Titian go, and he offers to write a letter to the President to obtain his patronage of it.[4] Titian is well qualified to preserve as well as to collect Subjects of natural history generally.

Your occupations allow you very little time to write letters, and therefore unless you can find some occassion which I can serve you I cannot expect a line from you, unless you can oblege me in giving your opinion on the first subject of this Scrole.

I am Dear Sir with much esteem your friend

CWPeale

John C. Calhoun Esqr. Secy. of War.
 Washington

ALS, 2pp.
PPAmP: Peale-Sellers Papers—Letterbook 17

1. On June 3, 1820, RuP had written to CWP to express dissatisfaction with his "arrange-ment" as manager of the Philadelphia Museum. As manager RuP received a percentage of the revenue after expenses and a payment to CWP. The system worked well for RuP while museum revenues were high and CWP remained at Belfield. Now, however, RuP had married and the museum's low revenue in 1819 caused him concern about his future ability to support a wife and family. It also seems probable that RuP knew of CWP's desire to move back to the city—the "great change" that RuP referred to in his June letter. Confirming his intention to move back to Philadelphia, in the fall of 1820 CWP began placing advertise-ments in the Philadelphia newspapers offering his farm for sale or as an exchange for city property suitable for his museum. CWP's response to his son's concerns was to incorporate the museum and place RuP on a fixed salary. RuP's interest in moving to Washington, D.C., appears to indicate that he was not fully satisfied with this arrangement. Above, **22**; *Peale Papers*, 3:824, 843, 845, 853.

2. See above, **20**. RuP did not purchase Delaplaine's collection until 1824. See below, **213**.

3. Gerard Troost, who lectured on mineralogy in the museum, may have assisted RuP in the arrangement of the museum's collection. See above, **20**.

4. See above, **35**; below, **41**.

41. CWP to Commodore Charles Stewart
GERMANTOWN, PA. AUGUST 30, 1821

Belfield Augt. 30. 1821.

Dear Sir

My Son Titian who went the Tour with Major Long to the Missourie, is very capable of Collecting & preserving subjects of Natural History, is very desireous to be imployed in that capacity in your Voiage of discov-eries, It was only yesterday that he told me that he wished to go this long & ardious voyage, yet I hope my application may not be too late. I believe his conduct was such as indeared him to his companions in that hazardous and fateaguing trials they went through in that rout.

If you think his service will be desireable, and going with you will meet your approbation, please to inform me on what terms it may please you to allow him imployment, as early as possible, in order that ⟨my⟩ he may furnish himself with necessaries, as an outfitt for a long voiage.

Mr. Pierce Butler told me to day that he would write a letter to the President in favor of my Son Titian, which I am thankful for,[1] but I presume your approbation may be all that is necessary to be done.

Titian draws correctly & beautifully in which capacity I conceive he will be very usefull.

I am with great respect your friend CWPeale

To Comodore Steward
 New York.

ALS, 1p.
PPAmP: Peale-Sellers Papers—Letterbook 17

1. See above, **35**.

42. Columbian Institute: Dr. William Thornton's Motion to Purchase Peale's Museum[1]
WASHINGTON, D.C. SEPTEMBER 1, 1821

Sept 1. 1821

Read and ordered to lie on the table
 Dr. Thornton's motion
 relative to the purchase
 of Peale's museum.

No. 1

I move that a Committee be appointed to address the Congress of the United States, and to request that they will purchase the museum of Mr. Peale of Philadelphia, which he informed me he would sell to the United States for one hundred thousand Dollars—: or, if it should be considered as not perfectly constitutional for the Congress to advance such a Sum for the purpose contemplated, I should be willing to propose that they would grant the Columbian Institute[2] the liberty of obtaining, by lottery, a sufficient Sum to purchase the Museum which is subject to be sold, & if sold it may depart from the Country, to the great loss of not only this Government but every State of this Union who have for thirty years past contributed very generously towards its establishment: and if the Congress should refuse to grant the advantage of a lottery, I should move that a Committee be appointed to solicit from the People at large one Dollar each for this purpose.
 William Thornton

MsD, 1p. & end.
DLC: Records of the Columbian Institute, Peter Force Papers

 1. William Thornton (1759–1828), longtime friend of CWP's and a man of wide cultural, technical, and scientific interests, was appointed by President Jefferson in 1802 to head the Patent Office, a post he retained until his death. *Peale Papers*, 1:518; 2:690; 3:603; *DAB*.
 2. The Columbian Institute was founded in 1816 by a group of about twenty prominent Washingtonians, including John Quincy Adams, Josiah Meigs, and the navy surgeon, Edward Cutbush. These men hoped that the institute would be a powerful force for "the promotion of the arts and sciences" in the nation's capital, in a way similar to its model, the APS in Philadelphia. Congress incorporated the institute in 1818 and gave it six acres of land for a botanical garden. However, as many of its most important members died or left Washington in disillusionment, the institute slowly declined in influence in the 1820s. Constance McLaughlin Green, *Washington Village and Capital, 1800–1878* (Princeton, N.J., 1962), pp. 69, 103.
 Dr. Thornton's motion does not seem to have been revived.

43. CWP to ReP
PHILADELPHIA. OCTOBER 28, 1821

Philada. Octr 28.1821.

Dear Rembrandt

This is the first attempt at writing with my Polygraph since my fever left me—[1]tomorrow will be 4 weeks since I was taken, and a hard tryal I have had of it, and I can truely say that my life has been saved by good nursing, for I have not taken any Medicine since the first 3 or 4 days of my sickness—the 2d day I took epecasuanna, then Rhiubard, and thirdly I attempted to take a dose of Bark, which would not Stay in my stomack.[2] I began to make what arrangements I could to settle the disposition of such property as I thought most important to promote harmony in my family after my decease, which occupied my mind almost continually—— This business must now have another turn by the loss I have sustained——[3]I will resume the task shortly again. I entend boarding with Rubens this winter—I cannot reside in the Country and therefore shall indeavour to dispose of part of that property in ordur to wipe off my debts——
give my love to Eleoner & children—yours affectionately

CWPeale

ALS, 1p.
PPAmP: Peale-Sellers Papers—Letterbook 17

1. The incidence of yellow fever in the summer and fall of 1821 was not severe and did not follow the usual geographic pattern. Outbreaks occurred in'some of the suburbs of Philadelphia, such as Norristown and Germantown, but not in the city. CWP later noted that "Many were sick, yet it was not fatal except in a few instances, in comparrison to the numbers who was sick." On October 20, *Poulson's* reported: "We are happy to hear that the Fever, which has, for about six weeks, prevailed in Germantown and its neighbourhood, is rapidly subsiding." P-S, F:IIC/19; A(TS):563; *Poulson's*, August 11, October 20, 1821.

2. Ipecacaunha, more commonly ipecac, is extracted from *Cephaelis ipecacaunha*, one of a group of plants that possess emetic properties. The drug causes vomiting, sweating, and purgation. Rhubarb was also used for purgation. Bark, extracted from one of several species of the Cinchona tree, contains alkaloids, such as quinine, and was used as a defense against fevers. *OED*.

3. On October 10, 1821, HMP died at Belfield of yellow fever.

44. CWP to CWP II[1]
PHILADELPHIA. OCTOBER 30, 1821

Philada. Octr 30. 1821

My Dear Charles

Having just recovered from a severe Fever I shall not be able to make a long letter, yet I have much to say, by way of advice, and in the hope you will weigh well, and reguard what comes from me, having no motive but to

promote your happiness in the various situations in which fortune may place you. and we ought to take more care to persue such a course as may tend to leave pleasing reflections afterwards, than to gratify our passions at the present moment; and being possest of an approving conscience will be a continual feast.

You are now amongst strangers, therefore my dear Son be extreemly careful to make no acquaintance but with the virtuous, If you hear a young man use profane language avoid him as you would a rattle snake. For if he has no guard on his words, poison will come from his tongue.

But I cannot help associating the Character of a Gamester to that of a foul mouth Babbler. such characters will endeavor to lead you to places of amusement, thus under pretence as you are a strainger to give you entertainment as an act of politeness, therefore be always on your guard—for one false step will not be easely recovered— One of the best rules I can give you, is, to keep no company that is inferior to you, rather let them be older who may be supposed to have more experiences, and from whom you may hope to obtain improvement.

A Polite carriage is a good passport through life. and it costs as little trouble to be polite as to be rude, and often there is some profit from the former but none from the latter.

The next subject I shall touch on, must be that on Injur[y.] Pride will say I am injured. What is the remedy? This is a most important question. If we reason on it turn it round & round and view it in every point of light, what then will we find the best course to persue? **Never to return an Injury**. On my Oblisk in the Garden is inscribed **"It is a noble triump[h] to overcome evil by Good!"**[2]

In my late ilness I told my my Children, that if I died, to have me buried ⟨and⟩ on that side of the oblisk. This has been an important memento to me, so often reading it and so often reflecting on it has stamp ⟨to⟩ a value on its precept greater than all the riches of the world!

Man cannot be placed in any situation wherein the rule can be dispenced with, but to a disadvantage— suppose I am treated ill, no matter by what manner, can I Revenge it & not be a sufferer by doing so? revenge is a troublesome guest, it will ever torment the breast that harbours it, but if fortune should ever favour me with an occasion to serve the Person whom I thought had injured me, I will then most assuredly make a friend of him, who might not have been a friend before. However we are not always sure that we have not justice done to us—we may by some misconception of things, think a tort was done us, when in reality ⟨when⟩ we may have richly deserved that abuse by words or acts. Since our first reflection should be, how has this come uppon me, have I done anything to deserve it? And, if I find on examination of myself that I have done

what I ought not to have done, let me hasten to make a just acknowledge-
ment of my fault and proper reparation if in my power—but if on the
contrary I cannot find out that I have done wrong, then let me exult and
rejoice in being able to say I am superior to those who evilly treat me.
Others doing wrong, is their fault not mine. It is enough that I conduct
myself as I ought to do towards every one in whatever station they be;
whether rich, dependant or Poor, I cannot be deficient in respect to all, if I
appreciate myself as I ought to do.

This has been no little exertion for me in my present enfeebled state or
perhaps the scrole would have been better concieved & executed, yet I
hope you will accept it such as it is, being ment to excite Reflection to your
proper management of yourself when you cannot have the choise of your
Parents who must always feel great anxiety for your happiness— Yrs
most affectionately

CWPeale

Mr. Charles Peale
 Charleston S. Carolina

ALS, 2pp.
PPAmP: Peale-Sellers Papers—Letterbook 17

 1. Charles Willson Peale II (1802–1829), was RaP's eldest son. Despite his personal oppo-
sition to military service, CWP had spoken with Commodore John Rogers in 1819, while in
Washington, D.C., in order to obtain a position in the navy for the young man. CWP
described young Charles as "well formed, smart . . . a good tempered and well disposed
youth." He praised his grandson's penmanship, but admitted that he was "near sighted,
which incapacitates him from learning some of the Mechanic Arts." It is not known what the
young man was doing in Charleston, South Carolina. *Peale Papers*, 3:642; *CWP*, p. 440.
 2. This aphorism resembles the biblical injunction: "Be not overcome of evil, but over-
come evil with good." Romans 12:21.

45. CWP to APR
PHILADELPHIA. NOVEMBER 1, 1821

Philadelphia Novr. 1st. 1821

Dear Angelica
 The fever which I have had, was of an uncommon grade, yet the com-
mencement with me was exactly a[s] the common Ague & fever——I was
amusing my self in repairing a Watch,[1] and was taken with a violent Ague,
I shook every limb, then succeeded the fever. The next morning I took
Epicucuanna, then Rheubarb, the day after early in the Morning I mixed
and took a portion of Bark, but I could not retain it. and I meditated some
other remidies— About this time Hannah was taken ill, I administered
for her the Epec &c as I had done, my family urged me to send for the

Doctr. this I thought unnessary as I believed I knew what was necessary to be done[2] but my Children anxious that I should send for Doctr Betton[3] urged it before Hannah, when she to second their wishes, said but you will let me have a Doctr? to be sure I will—for I had never refused her any thing that she asked of me— Linnius immedeately post off for Doctr Betton. He came & found me setting in my painting-Room he had seen Hannah in the other Room— I told him what I had taken &c And told him that I had great objections to taking any calomel,[4] that I had seen the most dreadful effects ⟨affected⟩ by it. It distroyed the mind as well body— His Answer was that I did not need it and he would not order me any, but Mrs. Peale's case was very different. her Bowels required it. I could not object,—we were both of us ill, and they found it necessary to have us in seperate beds, and I had mine in the parlour adjoining—I never thought that the mercury was worked off with Hannah— I had much delerium about this period, and therefore I took no account of time— The Doctr proscribed no medecine to be taken by me, but that they must give me as much Whey as I could posibly take, soon after to quit the whey & take Barly water[5] Hannah became worse & the Doctr ordered blisters[6] the night was a long & teagious one to me, but I hoped from the stillness that they had given her an annadine[7] to keep her quiet while the blisters was drawing No the stillness was death— —She died without pain. she was buried in friends burying ground at Germanton— They put me into a carriage on a bed & hurried me into the City and set up with me every night for some time Sybella & my B[r]other James's daughter took turn about they gave me nourishing things every 3 hours—when I became some what better Rubens set up, and then had a small bed to rest on & he would be up, on the least motion I made, and we after a while got into the habet of drinking a dish of Choco-late at about 3 O'clock, and I becoming considerably better I could hardly prevail on Rubens to leave me— I was 4 weeks that my Body was disor-dered. now the 5th. week I have something of caugh which was made worse by my ventering out too soon. I now feel that I shall be in perfect health, my cold has gone off so much since yesterday.

When I was first taken ill, my thoughts was almost wholy ingrossed about making a disposition of my property, and I wrote many particular's of it, and endeavoured to divide such personal property as I thought would be most liable to cause disputes amongst my Children, especially in the division of the Portraits, and for fear I should not be able to finish my will,[8] I read what I had wrote to Hannah & my Children, telling them what further I intended to add, that they might consider this as my Will & what I hoped would be agreable to all, that I considered all of them as

equally dear to me & that therefore my distribution should be also as equal as possible.

I have this business to begin again, and wish to do it shortly. Indeed it is my intention to settle all my concerns without much delay. I have done with House keeping & will give my Children my furniture according to their wants. I shall board with Rubens this winter—and as I can never desire to be long on the farm again, I shall endeavor to sell a part of it, perhaps all except the Mill & buildings convenient to it, with strip of land for improvements, which I shall leave to Linnius & Franklin.[9] Linnius is now spinning Cotton for his support.

Your sister Sophonisba is surprisingly well, yet she looks pale—she is too active, often injures herself,

<div style="text-align:right">

at present [no] material to add but that I wish you health and happiness, yours Affectionately CWPeale

</div>

Mrs. Angelica Robinson

ALS, 2pp.
PPAmP: Peale-Sellers Papers—Letterbook 17

1. As a young artisan in Annapolis CWP had repaired clocks and watches, and he remained so fond of this work that he continued to repair clocks for family and friends for the rest of his life. He expressed his sense of accomplishment in this craft by including "a clock taken to pieces" in the background of his first self-portrait (*unlocated*). A working knowledge of clocks and watches was highly valued in eighteenth-century preindustrial mechanics, and CWP recorded his experiences as a watchmaker with pride in his unpublished autobiography. *Peale Papers*, 1:155, 161, 175, 258, 497, 592; Sidney Hart, "'To encrease the comforts of Life': Charles Willson Peale and the Mechanical Arts," *PMHB* 110 (1986):325; A(TS), pp. 14, 16.

2. CWP had experienced many of the yellow fever epidemics that swept through American cities in the late eighteenth and early nineteenth centuries. In many instances, he treated himself and family members for this dangerous disease rather than call in a physician. In general he believed that "the less we have to do with Physicians the better," and "in all doubtful cases it is safest to let Nature direct to the means of Cure." *Peale Papers*, 3:315.

3. Dr. Samuel Betton. See above, **20**.

4. Calomel (also calamel), a mixture of mercury and chloride, was prescribed for purgation. Because the tendency of mercury was to produce salivation physicians used it in the late eighteenth and in the nineteenth century as an alternative to bleeding. *OED*; *Peale Papers*, 3:305.

5. Whey, the watery part of milk that remains after the curd has been separated, was boiled with sugar and vinegar for treatment of fevers. Barley water, made by boiling grains of barley, was used to soothe and protect inflamed mucous membranes. *OED*; Robley Dunglison, *A Dictionary of Medical Sciences* (Philadelphia, 1845), p. 1170; *Webster's Third New International Dictionary* (Springfield, Mass., 1961).

6. Blisters were used to divert blood from inflammations. Irritants such as mustard were applied to the skin, and the resultant blisters were then opened to let the fluid escape. For CWP's attitude toward bleeding, see above, **12**. Audrey Davis and Toby A. Appel, *Bloodletting Instruments in the National Museum of History and Technology* (Washington, D.C., 1979), p. 17; *Peale Papers*, 3:305, 317n.

7. *Anodyne* refers to any medicine or drug that relieves pain. *OED*; Dunglison, *Dictionary of Medical Sciences*, p. 69.

8. Unlocated.

9. In keeping with this resolve, CWP wrote to his neighbor, the gentleman farmer William Logan Fisher, on November 6, offering the farm for sale "in toto or by a division." No response from Fisher has been located. He also wrote on the same day to another neighboring farmer, Mr. Tharp. On November 27, 1821, CWP inserted an advertisement for the sale of Belfield in *Poulson's*:

<div style="text-align:center">

FOR SALE
A Farm and Mill Seat
HALF A MILE FROM GERMANTOWN

</div>

CONTAINING upwards of 100 acres. It may be divided to suit purchasers. Perhaps there is not a Farm in the vicinity of Philadelphia, that possesses so many natural advantages. The fields are sufficiently level for culture, inclosed in a considerable part with well grown thorn hedges. A proportionate number of acres of wood land—several quarries of building stone—and springs of good water.

<div style="text-align:center">THE BUILDINGS ARE.</div>

[sketch of building at left margin]

A convenient mansion house, farm house, barn, spring and bath house of stone: stable, waggon, house, and carriage house, &c. frame buildings.

The garden, containing about three acres, is beautifully situated, and planted with most choice fruits.

The MILL SEAT is a good stream of 25 feet fall, and the dam may be made near the mill, so that no freshets can injure it. This may be sold with about ten acres of watered meadow, or the meadow may be reserved to the farm. For particulars, enb[q]uire of LINNAEUS PEALE, on the premises, or at the Philadelphia Museum.

<div style="text-align:right">**C. W. PEALE.**</div>

See F:IIA/66E5,E6.

46. CWP to Mr. Royal

PHILADELPHIA. NOVEMBER 7, 1821

<div style="text-align:right">Philadelphia Novr. 7th. 1821.</div>

Sir

under the belief that you will be highly gratified to have a faithful likeness of your Mother,[1] I have as soon as my health would enable me to resume my Pensil, ⟨here⟩ put the finishing touch[e]s to the Portrait—and I believe it is deserving of a handsome frame which doubtless you will order for it.

I have found since I shewed the Portrait that the likeness has been much admired, and much pleasure has been expressed that the Portrait was made— A Lady of your Mothers acquaintance one day visiting Mrs. Peale, said that she would also set, provided your Mother would have her Picture, and your Mother intended to surprise her with the sight of the Picture when finished—Mrs. Peale knew the Name & I have forgot it—

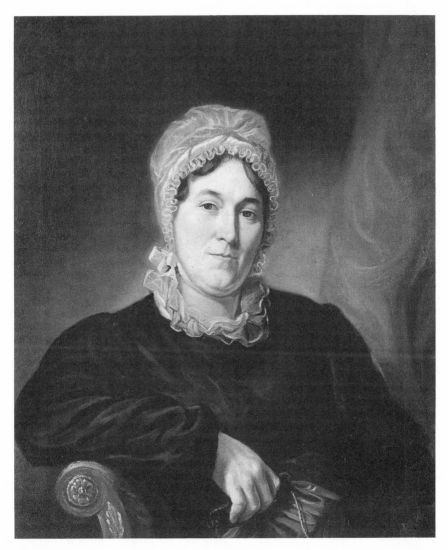

15. *Polly Royal.* C. W. Peale, 1821. Oil on canvas, 29 ½ × 24 ½ (75 × 62 cm).
Philadelphia Museum of Art, Given by Eliza Royal Finckel.

Please to pay to my Son Linnius one hundred Dollars, the price which Mrs. Royal engaged to pay for the Portrait and you will much

oblege your friend
CWPeale

Mr. Royal
 Germantown

ALS, 1p.
PPAmP: Peale-Sellers Papers—Letterbook 17

1. Fig. 15. Polly S. Royal may have died in the yellow fever epidemic in Germantown in which HMP succumbed. Her son is unidentified. *P&M*, p. 186.

47. John D. Godman to BFP
CINCINNATI, OHIO. NOVEMBER 12, 1821

Cincinnati Ohio[1] Novr 12th 1821
my dear Franklin

You should have heard from me before this, but from the peculiar pressure of my engagements no time has been allowed me, for anything besides hard labor in the duties of my new place. My feelings have prompted me a hundred times to write, but besides the hurry in which I must of necessity be continually in, I hoped by a slight delay to render my letter more satisfactory on all accounts. Our voyage down the Ohio was pleasant enough, but insufferably tedious as we were 17 days on the Ohio river—10 of which were passed in an open boat;—from the time we left Wheeling till our arrival here. With the exception of having our boat sunk *once*, and all our clothes and my surgical Instruments wet—together with a few etcetera's—the voyage was by no means disagreable.

We were shocked to heare of your great loss and felt the sincerest sympathy for your father's suffering, in losing at his time of life so cherished a friend. I am sure that both Angelica's feelings and mine were as much excited from learning this unpleasant event as if we had been more immediately concerned.

In relation to this place, I need hardly tell you that for this winter at least I might have done better in Philadelphia. My reception has however been very flattering and I cannot without longer experience speak with much positiveness in relation to it. The class here is not larger than my own class was last March, so that you may believe the school is yet in its infancy. Add to this that the money of this country is depreciated 40 per cent. This leaves me of necessity minus.

Call at Mrs. Wharfes' when you are at leisure and ask her to see the letter I have written to her You will there see the explanation of the

circumstances connected with my leaving unsettled the amt. standing between me and Mrs. W. your brother T. and yourself. As the amt. in the hands of Dr. G. would have been entirely sufficient to have cancelled the two first I had intended as soon as I became fixed to transmit what is coming to you. The reception of Mr. Wharfe's letter informing me that he had not yet received the money for Mrs. W. and for Titian gave me much vexation as I thought they were both paid long ago. As I have been obliged to rend this amt out of the little I received here, it leaves me tolerably slim at present. However nothing but an impossibility of sending seven dollars in *cash* by *mail* induces me to suffer T. to wait longer for this balance of our acct.[2]

To you, my dear Frank who are so well acquainted with my feelings it is unnecessary to say more on this subject. If I have not done as I wished in relation to *you*, it is entirely owing to circumstances I could neither foresee nor prevent. I will be delighted to receive a letter from you, telling me *everything*, as soon as you get this. Give my love to your father, to your brothers, R.T. L. and to James P and the girls. To uncle and aunt Sellers particularly. To Dr. Troost I beg you to say that I wish him much to write to me directly and for yourself be sure that death alone will make me forget that I am your friend

J.D. Godman

P.S. I intended to have told you fifty things that in my eagerness I have no room for. When I write again I shall be more calm and collected. Do remember me to Mr. Say and to *all* our friends.

ALS, 4pp., add. & end.
PPC: William Kent Gilbert Collection

1. Godman was serving at this time as professor of surgery at the Medical College of Ohio in Cincinnati and as editor of the *Western Quarterly Reporter of Medical, Surgical and Natural Science. DAB*.

2. There is no information on the accounts of Godman with the Warfes and Peales. Mrs. Warfe was a member of the Brewer family and a cousin of the Peale children. She was married to a Captain Warfe and, according to Escol Sellers, kept "a fashionable boarding house on Walnut Street." Perhaps Godman boarded with her while residing in Philadelphia. See George Escol Sellers, "Reminiscences," June 24, 1882. PPAmP.

48. CWP to APR
PHILADELPHIA. NOVEMBER 18, 1821

Philada. Novr. 18th. 1821.

Dear Angelica

This is to be a short letter, I am well & hope to gain strength & flesh, by using the means to secure them.

I am about distributing some of my property—and I wish you to say to whom I should give your Portrait and Mr. Robensons, a Copy from that you possess;[1] which of your Children?

Altho' I have always felt pleasure in viewing the Portraits I have taken of my several connections, and shall part with many of my Pictures with regret, yet as I have determined never to keep House again, at least that is my present Opinion—and having attempted to give my paintings by Will, and found it not very easey to do it satisfactory, I have now deliberately weighed the Matter & beleive my friends will be pleased to receive and value what I give them. Therefore I wish you to give your advice without delay, as I want to settle as much as I can, in order that I may have as little worldly care on me as possible.

At present I board with Rubens and have as much comfort as I ought to expect— I have resumed my pencil and shall chiefly employ it for the improvement of the Museum— Sophonisba enjoys more health than I had expected. The Country I hope will be now more healthy as we have had some frost. Love to the family

<div style="text-align: right">Yrs. Affectionately
CWPeale</div>

Mrs. Angelica Robenson.

ALS, 1p.
PPAmP: Peale-Sellers Papers—Letterbook 17

1. A replica of CWP's 1795 portrait of APR and Alexander Robinson (*Reynolda House, Winston-Salem, N.C.*). The original is privately owned. *P&M*, p. 183. See also below, **59**.

49. CWP to Nicholas DePeyster[1]

PHILADELPHIA. NOVEMBER 19, 1821

<div style="text-align: right">Philadelphia Novr. 19th.1821.</div>

Dear Sir

Having passed through a severe tryal of sickness, and desireous to settle all my worldly concerns in such manner that no trouble may fall on those I leave to settle the little I have to dispose off, and also to leave my mind as little to burden it as possible. The first step and most important was to secure the Museum from a division in case of my exit— I have got it incorporated by a law which fixes it permanantly in the City of Philada. and intitled it the Philada. Museum, under the Care & Direction of Trustee's appointed annually by the Stock holders. The Stock being nominally 500 shares, at 200$ Pr. Share, which Stock I shall dispose off by Will to my several Children—but it is my intention not to part with [it] during

my life, by which means I may give the profits to those most in want and most deserving. I have lived on a farm upwards of 10 Years, a place possessing great natural beauties & advantages, which to rid myself of all further trouble I mean to sell & apply the product to more compleatly ridding myself of Care—my furniture I divide amongst my Children and my Pictures which are numerous, to those whom I hope will value them——

In parting with the Portraits I must feel a pang, as in as much as I esteemed the originals, and thinking on their virtues gave me pleasure, but as I do not expect ever to be a Housekeeper again, I esteem it best in the most deliberate manner to distribute them, while I have my mind sound, & free from bodily pain.

Now my Dear Sir, the many favours I have received from you and Mrs. DePeyster at different periods, and when I was in distress calls for my most greatful thanks,[2] and which will never be forgotten by me, and when you look on the Portrait of your Brother, think that the donor has a greatful heart & wishes he could do more than presenting you with that Portrait & the consort[3] accompanying it.

I must make a packing-case to hold sundry pictures, Vizt. Abraham DePeyster which I give to his Daughter—[4]Major Stagg & Sister Stagg to Sister Stagg.[5] John & Philip to them,[6] with those for you— I must hasten to get them sent by Water, while the weather is favorable, and I suppose it will be best to direct them to the care of Brother John DePeyster.

Present my best respects to Mrs. DePeyster and the family and believe me with much esteem your friend

<div align="right">CWPeale</div>

Mr. Nicholas DePeyster
 Bloomingsdale New York.

ALS, 2pp.
PPAmP: Peale-Sellers Papers—Letterbook 17

1. CWP did not know that Nicholas DePeyster (1740–1821), brother of William DePeyster, Jr., and EDP's uncle, had died on September 5 or 6. A merchant, he resided at his estate in Bloomingdale at the time of his death. His second wife was Frances de Kay (1753–1826). Belknap, *The DePeyster Genealogy*, pp. 70–71.

2. The Nicholas DePeysters had helped CWP at least twice, during August and September of 1798, when CWP stayed at their Bloomingdale estate while he was treating his father-in-law, William DePeyster, Jr., for yellow fever, and on June 9, 1801, while in New York searching for a vessel that would take him up the Hudson River to the site of the mastodon bones. At that time, CWP recorded in his diary visiting and breakfasting with the Nicholas DePeysters. *Peale Papers*, 2: 225, 318.

3. CWP took the portraits of EDP's father, William DePeyster, Jr., (*New-York Historical Society*) and stepmother, Christiana Dally (*unlocated*) during his visit to New York City with EDP on their first wedding anniversary in 1792. *P&M*, pp. 67–68; CWP, Diary 12, P-S, F:IIB/13.

4. Abraham DePeyster (1763–1801), a mariner, was one of EDP's brothers. CWP had taken his portrait in 1798 (*private collection*). His daughter, Elizabeth, was married to Henry Remsen. CWP to Remsen, November 27, 1821, P-S, F:IIA/66E11; *Peale Papers*, 2:229n, 318n.

5. (Both, *private collection*). John Stagg, Jr. (1758- 1803) was the husband of EDP's sister, Margaret (Peggy) DePeyster (1767–1846). CWP took their portraits around 1793, when they resided in Philadelphia. *P&M*, p. 199.

6. DePeyster, EDP's twin brother, was taken on the artist's trip to New York City in 1798 (*New-York Historical Society*). Philip's portrait is unlocated. There is no evidence in the Peale documents that CWP actually painted a portrait of Philip DePeyster (1772–1846), EDP's younger brother. As one of his first efforts at portraiture, however, ReP painted Philip's portrait in January 1792 (*unlocated*).In his letter to John DePeyster of November 27, 1821, CWP noted that he was sending seven portraits to be distributed to family members. This number does not account for Philip's portrait. Perhaps CWP realized when he wrote to John the following week that either he did not paint a portrait of Philip or that the portrait of Philip he mentioned in this letter had been painted by ReP and was not his to give. On the same day, CWP also sent to Mr. and Mrs. Henry Remsen the portrait of Mrs. Remsen's father, Abraham DePeyster (1798: *private collection*) and expressed his satisfaction "in knowing it will be preserved to the family." See CWP to John B. DePeyster, November 27, 1821, P-S, F:IIA/66E12; CWP to Henry Remsen, November 27, 1821, P-S, F:IIA/66E11; *Peale Papers*, 2: 3n, 7, 8n, 78n; *P&M*, pp. 64, 66.

50. *Poulson's American Daily Advertiser*
PHILADELPHIA. NOVEMBER 27, 28, 1821

Poulson's, November 27, 1821
MURDER AMONG THE SNAKES!
Mr. Lawrence of Castine (Me.) has recently, while working in his field, together with his workmen, killed 85 snakes, in one hole, and within a short distance of it. They were of a middling size, and mostly of the striped and green kind, though some were black, yellow, brown, &c.

Poulson's, November 28, 1821
CHARLES WILLSON PEALE, of Philadelphia presents his respects to Mr. LAWRENCE, of Castine, (Maine,) and wishes that he had prevented the murder of 85 Snakes, for those Snakes feed on field Mice, and should be considered friends to the Farmer.[1]

PrD, 2pp.
DLC

1. In illustrating the utility of the study of natural history, CWP frequently used snakes as an example. In a 1799 lecture, he noted that farmers should be aware that snakes feed on field mice and moles, "which would otherwise destroy whole field of corn." In 1823, in one of his last lectures, he returned to that theme. In a more philosophical context, he wrote in his discussion of reptiles and other classes of animals that "prejudice has produced too much antipathy" towards these creatures, a hostility "unworthy of a *philosophic mind*, for assuredly, we ought not to indulge the *impious thought*, that any thing has been created in vain." *Peale Papers*, 2:266; CWP, 1823, Lecture 3, p. 13, F:IID/30F9.

51. CWP to John D. Godman

Philada. Decr. 2d. 1821.

Dear Doctr.

A melancoly change has taken place, since I received your obleging letter, an indearing companion is no more, we lived togather more than sixteen years and never a jaring word passed between us, how could it be otherwise, when every thing I wished was done, and very frequently my wishes anticipated. You know how few 2d. mariages, where there are Children of a former wifes, that are free from discontent. I claim some merit for the mode which I adopted, which was always to let Mrs. Peale give to the children what we intended they should receive, If they wanted any thing, it was their interest to apply to her. indeed she was always mindful to provide & advise what ought to be done for their happiness, and thus saved me the troubles of thought. One other rule I invariably followed, treating her with polite attention, she truely deserved it, and the advantages was, that all the family did the same. I have said enough; you have known us. This dreadful fever, has baffled all the Phisicians, their Savouior Medicine (Calomel) did not make cures, of course they had better never to administer it! at least such is my impression. To fill up a void, I have recourse to my Pencil, I cannot live at the farm, and I board with Rubens. his Son now walks across the room, and is a fine hearty fellow.[1]

The Museum has undergone very considerable improvements, Titian has shewn much taste in arranging the numerous messelanious [miscellaneous] articles in the several cases, he keeps each kind togather, and give the whole a fanciful form, thus they attract attention, and each article has its label, Franklin assists in labelling— Rubens is very much occupied in preserving Birds & Quadrupeds and deserves credit for the neatness of mounting them. The Trustee's have made application to the Councils for the eastern Room below, and the committee have made a report in favor of our having it at $200 pr. year rent, but whether we shall get it, is yet doubtful—[2]we wish to have this Room for the advantage of having Lectures from Professors &c.

I wish you could have staid with us, but if you shall have made a better exchange, as where you have gone is a young country, you may have the advantage of a rapid increase of inhabitants, and your interest promoted. it will give me pleasure.

It is my intention to sell the farm, reserving only the mill for Linnius & Franklin, which will leave about 100 ars. As there is another Mill seat & about 20 ars. of Water meadow, perhaps that will be taken seperate, yet I

will not divide it untill I find a certainty of a Sale. Thus my Dr. Sir I have given you all that concernes me at present, I wish you health & happiness

Rubens & Eliza. join in love to you and

Angelica CWPeale

Doctr. Godman
Cincinata

ALS, 2pp.
PPAmP: Peale-Sellers Papers—Letterbook 17

1. RuP's son, Charles Willson, was born on February 15, 1821. *CWP*, p. 442.
2. The museum trustees petitioned the Select Council of Philadelphia on October 25, 1821, for the "use of the eastern room on the lower floor of the State house" at "such reasonable rent as they may be able to pay," so that there would be space "to place their philosophical apparatus" and to be able to "more extensively and conveniently . . . exhibit . . . a course of experiments in Optics, electricity, and other useful and entertaining parts of natural philosophy." The eastern room was at the time occupied by Joseph Delaplaine (see above, **20**). The committee's report in favor of the trustees' request is unlocated. F:VIIA/4A6,7.

52. CWP to John C. Calhoun
PHILADELPHIA. DECEMBER 3, 1821

Philadelphia Decr. 3d.1821.

Dear Sir

When I was last at Washington, I waited on you respecting the application of my Brother James Peale, who was after that placed on the pension list, and under the act of 18 March 1818 received one years pension,[1] but never the additional act of 1820 owing to his having formed a wrong conception of its provisions.[2] My object in now troubling you is to know whether you think he can be continued on the list under the last act. His situation is peculiarly a hard one as he is now past 72 years of age, and has a family consisting of 10 persons: his wife, 5 Daughters one Son and two grand children, all of whom live togather—two of his Daughters paint, one does alittle by teaching Musick, and his Son is a clerk,[3] yet knowing that his Children with great difficulty support even themselves, and that he has not for many years been able to support himself, my Brother wishes to be continued under the additional Act.— His only property (which remains unaltered since the Act of 1818) consists of some old furniture amounting to about $150. He owes debts to the amount of about 600$ leaving out those he owes his Children.

With every apology for thus intruding on you, I shall be pleased if it does not interfere with your many important duties to receive an answer

in a few days. A single line may be sufficient, and you will confer an obligation on Dear Sir,

your friend CWPeale

PS: My Son Rubens meditates the Establishment of a Museum in Washington, but I think it very doubtful whether he will receive sufficient encouragement from Public bodies. If he visits Washington this season its probable that I may accompany him.

The Honorable Jno. C. Calhoun Esqr.

ALS, 1p.
PPAmP: Peale-Sellers Papers—Letterbook 17

1. CWP visited Washington from November 5, 1818, to January 29, 1819. On November 26, 1818, he began a portrait of Calhoun (*private collection*), who was serving as secretary of war in the Monroe administration, and undoubtedly discussed with him his brother James's eligibility for a pension. Under the pension law signed by President Madison on March 18, 1818, JP, who had served in the Revolution as a commissioned officer, was entitled to receive $20 a month for the rest of his life. On December 4, 1818, JP appeared before Judge Richard Peters of the District Court of the United States in the Pennsylvania District and testified that "by reason of his reduced circumstances in life, he is in need of assistance from his country for support." *Peale Papers*, 3:623, 665.

2. The pension law of 1818 required that to receive a pension a soldier had to have served at least nine months in a Continental line (as opposed to the militia), or until the war ended, and had to be in "reduced circumstances." The amendment of the law in 1820 applied a means test—an oath of poverty—to all those eligible for a pension. All payments under the earlier act were suspended, and recipients were required to submit documentation of their poverty to a court of record. The veteran was required to disclose his age, occupation, and health, and to submit a detailed financial account of himself and the members of his household, including an inventory of his property. Initially, 22 percent of those awarded pensions under the 1818 law declined to submit to the new means test, but by the end of the decade nearly all surviving veterans of the Revolution had taken an oath of poverty and received a pension. John P. Resch, "Politics and Public Culture: The Revolutionary War Pension Act of 1818," *Journal of the Early Republic* 8 (1988):154–55.

3. The members of JP's household included his wife Mary Claypoole (1753–1829); his five daughters, Jane Ramsay (b. 1785), Maria (1787–1866), Anna Claypoole (1791–1878), Margaretta Angelica (1795–1882), and Sarah Miriam (1800–1885); and his son James, Jr. (1789–1876), whose first wife, Anna Dunn, had died. Jane Ramsay had three children, Mary Jane, Edgar, and William, and may have returned to live with her parents after the death of her husband, Dr. Samuel Simes, in 1813. *CWP*, pp. 439, 444.

2 A Time to Change: January 2, 1822–June 11, 1822

Hannah Moore Peale's death propelled Charles Willson Peale into making a decision that he had been seriously contemplating but had postponed for both familial and economic reasons, that is, to assume active direction of his Philadelphia museum. Although he had entrusted the management of the institution to Rubens, he had continued to exercise control from his country retreat, especially in matters that involved relations with the city government, such as rent, use of rooms, and space to expand. As he discovered anew the pleasures of painting, he had justified his artistic inclinations with the explanation that his works of art would heighten interest in the museum. His decision to incorporate the institution had stemmed in part from his desire to continue in its active management; to that end, he had made himself the sole stockholder and therefore the sole decision-maker. Without Hannah the farm no longer held his interest. Having been moved to Philadelphia during his illness, he decided to remain, sell Belfield, and, as his health returned, resume his position as head of the museum.

In reasserting his control over his institution, Peale faced the problem of Rubens's discontent at being forced into a secondary position. A resolution to his dilemma was provided by Rembrandt's predicament in Baltimore. A large mortgage on the museum building and heavy obligations to his stockholders imposed intolerable burdens on the artist; in 1821, for instance, the museum had receipts amounting to $3,385, but operating expenses came to approximately $2,500, and another $1,000 were needed for improvements and expansion of the collection. Rembrandt had concluded, moreover, that he could not be both a museum manager and an artist, and the recent success of the tour of his *Court of Death* convinced him that he could sustain himself and his family with his painting alone. Rubens's willingness to assume management of the Baltimore Museum provided Rembrandt with a way out of his troubles. Not only would he be able to resume his painting career, but by offering Rubens management of the enterprise he would in some measure repay his

brother for the money and natural history specimens that throughout the past decade Rubens had given him for his museum.

The brothers made no formal arrangements for the sale of the museum. Eager to run his own institution, Rubens agreed to give Rembrandt "a little cash" to assist him in moving his family to New York and to assume responsibility for Rembrandt's debts—the total of which, together with Rembrandt's earlier debt to him, amounted to $7,500. Rubens thus became the proprietor of a foundering institution, obligated to its business-oriented stockholders during a time of severe financial distress, while Rembrandt resumed a painting career that would subject him to new experiences and influences. And the elderly Peale faced up to new problems involving management of the Philadelphia Museum, housing, and debts that were to plague him for the remainder of his life.*

*Peale Papers, 3:843–45, 858–60; "Memorandums of Rubens Peale and the events of his life &c.," P-S, F:VIIB/1; Miller, In Pursuit of Fame, pp. 125, 138; Wilbur H. Hunter, "The Tribulations of a Museum Director in the 1820s," MHM 49 (1954): 215.

53. ReP to RuP
BALTIMORE. JANUARY 2, 1822

Baltimore January 2d. 1822

Dear Rubens

Now that you have got through with the Hollidays, I presume you may have leisure to attend to business that may draw your attention for a while from home. I have conn'd over the affair of my Museum & my Painting and shall be prepared to confer with you as soon as you please to pay me a Visit, as I believe it was your intention to proceed to Washington unless you could make a satisfactory arrangement with me, which I think you can do if you wish it.

As it will be necessary for you to examine the Museum & the Accounts well, it will require some days of your time here— Besides, I am desirous that if it be done at all, it may be decided without any needless delay. I wish you therefore to answer me & say when we may expect you & whether Eliza will accompany you. The occupation of my time this Winter will very materially depend on this decision & therefore it is very important for me, as well as you, to have it settled.

As it would be disadvantageous to me to have such a report circulated unless I sell, I will thank you not to speak of it out of your own family & to Coleman if you please; & to them with injunctions not to give currency to it.

We have lately received a Letter from Dr Godman, who states that,

although the Class is below what he was led to believe, he has made an excellent beginning in the practice of Medecine & Surgery——and that He & others are publishing a Medical Journal, which will have an excellent tendency to draw them into Notice.

My Picture of the Mother & Child is before the public & appears to please—[1] How much, will be made evident by the amount of Visitors. I perceive by the papers, that my "Court of Death" was opened in Charleston the 24th. Decr. but have not heard from Pendleton.

Since I did not write so before New Year's day, in my name wish a happy New Year to our family & friends, and particularly to our father.

<div align="right">

Yours sincerely
Rembrandt Peale

</div>

ALS, 2pp.
PHi: Stauffer Collection, P. 2342

1. (*Unlocated.*) See Miller, *In Pursuit of Fame*, p. 138. On December 24, 1821, ReP advertised *Mother and Child* in the *American Commercial and Daily Advertiser*:

Mother and Child
REMBRANDT PEALE respectfully informs the public that his last new Painting, taken from the Greek story of "Lysippa and her Child," is just finished, and placed in his private Painting Room, where it will be exhibited for a while to the visitors of the Museum every day, and on the evenings of illumination.

54. CWP to Henry Moore
PHILADELPHIA. JANUARY 4, 1822

<div align="right">

Philadelphia Jany 4th.1822.

</div>

Dear Brother Henry

The loss we have sustained is [ir]reparable, but it [is] the order of an allwise providence, and it becomes our duty to bear i[t] with a Christian fortitude.

I little thought that I should be the survivor, for I wrote part of my will, after I was taken with that dreadfu[l] fever, in which I made provision for my dear Hannah's comfort, for having by a deed of trust when about to incorporate the Museum secured to her five hundred dollars pr. Annum payable from the receipts of the Museum ⟨*payable*⟩ quarterly—[1]it was my intention also to give her such furniture as I knew would be acceptable and necessary for House keeping, but how vain our foresight for future ⟨*hap*⟩ happiness in this transitory world!—

I know that if your sister was living, that she would approve of giving you the note which you made to her of one hundred pounds for that sum lent you on Interest. and it was my intention never to ask of you the

payment of the principal. And believing that none of the survivors would do otherwise, I therefore inclose you the said note, which I hope will be some relief to your mind.[2]

as I feel no disposition to house keeping in future I therefore part with all my furniture, and altho' I feel pleasure in viewing the Portraits which I have painted of the families connected by marriage, yet as I may occasionally have the pleasure of seeing them, I have as judiciously as I could given disposed of them, where I hope they will be valued and preserved to future generations.

Your portrait[3] please to accept, and when you choose to part with it, give it to such of your Children who may ⟨it⟩ esteem it the most valuable. I have it at my lodgings with my Son Rubens, and it will be delivered to your order. I wish you health and happiness and am with high reguard your friend & Brother

CWPeale

Mr. Henry Moore.

ALS, 2pp.
PPAmP: Peale-Sellers Papers—Letterbook 17

1. See *Peale Papers*, 3:858–59.
2. In April 1819, Henry Moore appealed to CWP for help in meeting a debt of $91 plus three years' interest that he owed to a local hotelkeeper, George Weaver. CWP suggested that he apply to his sister Martha Moore for the sum and offer her a mortgage on his farm as security. Probably Martha refused, and HMP, who was "under great suffering on [his] account," provided the necessary funds. *Peale Papers*, 3:712–13.
3. (*Private collection.*) In August 1805, soon after his marriage to HMP, while visiting Henry Moore in Montgomery County, Pa., CWP made a chalk drawing of him (*Peale Papers*, 2:880); later, in January 1807, he urged Henry to make a long visit to enable him to paint his portrait. In 1809, while recuperating from his illness at Moore's farm, RaP made a miniature copy of his father's portrait (fig. 16). *P&M*, p. 145; *Peale Papers*, 2:880; CWP to Henry Moore, January 23, 1807, P-S, F:IIA/40A11.

55. ReP to Robert Gilmor, Jr.[1]

BALTIMORE. JANUARY 5, 1822

Baltimore Jany. 5. 1822

Sir

Constituted as I am I cannot but rightly estimate the consideration which you express for my feelings, which can never be gratified at the expense of others. Educated as I have been to the simplest & purest motives, I could not but suffer from the slightest imputation of wilful error. Unaccustomed to money transactions, I cannot but regret that I should ever have deviated from that punctuality which I am aware they require; but having no commercial connections & never having employed

16. *Henry Moore*. Raphaelle Peale after C. W. Peale, 1809. Watercolor on ivory, 2 ¼ × 1 ¹³/₁₆″ (6 × 4.5 cm). Raymond and Linda White Collection.

any artifices with the banks, it was not easy for me, when my own labours on my reasonable expectations failed, to establish for myself a character of commercial exactness—which could not, however, raise me higher than I have always stood in the estimation of those who know the purity of my motives or the rigour of my principles, which have always prompted me rather to make sacrifices than to involve others by indorsement.

I am not, I assure you, piqued that you should have expressed your disappointment at my not having been punctual. But I must confess that I did feel hurt at any imputation of intentional delay. And I am sorry that your particular mention of the 100 $ should have given me the opportunity of remarking that I have never claimed your fathers[2] voluntary offer to give me that note (which he then held) if I would finish the Portrait of your niece which I found almost impossible from her restless sitting.[3]

When I thanked you for the assistance you have lent me, it was a simple

& sincere expression, as you might have known had you been better acquainted with me— And when I repeated the expression in my last, little as it was, it was meant in justice to the kindness of your intentions. It is true I might have hastened to you with explanations why my first expectations deceived me—instead of which I endeavoured by renewed trials to find the means of more than an empty Apology. The particular efforts which were destined to comply with my engagements with you & others, one after the other disappointed me. The Court of Death, which required a room to be built here & heavy charges elsewhere, besides my time & expenses in travelling to 3 Cities,[4] has, nevertheless, proved an interesting experiment to my fellow Artists & to Men of taste—And has removed something of the uncertainty which might attend their operations.

This exhibition helped to lessen the pressure of the times on me, with a very large family, when many excellent men have failed entirely— And tho' my sanguine spirit perhaps expected too much from it in a limited time & from a scattered population (since *all* our cities & villages scarcely make a London) it probably will yet realize my hopes. But I am convinced that the difficulties attending the exhibition of such large Paintings is at present too great— And that the leisure of an Artist in the precarious (sometimes capricious) employment of Portrait painting, will be better devoted to smaller subjects of History & Poetry.

I must apologize for occupying so much of your time, as I cannot pretend that I have anything like a right, either as a Man or an Artist, beyond the pleasure you may experience in doing good—And to request you not to imagine that any obligations conferred on me can ever be cancelled or friendship forfeited by my own failures in fulfilling engagements with others. And whilst I endeavour to know the good in others, I shall be happy in the enjoyment of friendship founded upo[n] a just estimate of my character & the efforts I have been making to merit the approbation of Men of taste.

Having made the arrangement with the Amount of your loan, I must decline the offer repeated in your last note,[5] whilst I thank you for the polite manner in which you have expressed it.

<div style="text-align: right">

And remain
Your much obliged
Rembrandt Peale

</div>

ALS, 3pp. & add.
PPAmP: Peale-Sellers Papers

1. Robert Gilmor, Jr. (1774–1848) was a Baltimore merchant, rentier, and art patron. The Gilmor family was one of a small group of mercantile and landed gentry who emerged in Baltimore after the American Revolution as the economic and social leaders of the city. During, or immediately following, the War of 1812, the Gilmors, along with other successful

merchant families in Baltimore, retired from most business activities to devote their time to community enterprises. These families soon constituted the city's elite, dominating Baltimore's social and cultural life up to the Civil War. Gary Larson Browne, *Baltimore in the Nation, 1789–1861* (Chapel Hill, 1980), pp. 11–12, 80, 95; Anna Wells Rutledge, "Robert Gilmor, Jr., Baltimore Collector," *Journal of the Walters Art Gallery* 12 (1949):18–39.

2. Robert Gilmor (1748–1822) was born in Scotland and came to Maryland in 1767. He became an extremely wealthy merchant, entering into a partnership with William Bingham, a prominent citizen of Baltimore. In 1788 CWP painted portraits of Gilmor and his wife (both at *Colonial Williamsburg, Williamsburg, Va.*). *Peale Papers*, 1:551; *P&M Suppl.*, p. 64.

3. (*Unlocated.*) The sitter has been identified as Gilmor's niece, Isabel Baron. ReP Catalogue Raisonné, NPG.

4. After the *Court of Death* left Philadelphia in October 1820, it traveled under the management of John Pendleton to New York, Boston, Albany, and Charleston, and then to Savannah in February 1822. ReP claimed that it had been viewed by thirty thousand people and earned more than nine thousand dollars. Although he writes in this letter that it was a pecuniary as well as an artistic success, he later claimed that the costs of the exhibition consumed the profits. Carrie H. Scheflow, "Rembrandt Peale: A Chronology," *PMHB* 110 (1986): 152–53; Miller, *In Pursuit of Fame*, p. 137.

5. Gilmor's note is unlocated. He may have offered to cancel ReP's debt if he finished Isabel Baron's portrait.

56. Alexander Ricord[1] to RuP
PARIS. FEBRUARY 10, 1822

Paris the 10th of February 1822.

Sir

It is only since two days that I have had the pleasure of receiving your letter of the 14th of may 1820—[2] the person that you had given it to having asked for me at the Museum just at the time that I was not there did not take the trouble to return a second time, and it was by the greatest chance that the day before yesterday I saw a bill that he had put at the door of the School of Medicine to let me know that he had a letter for me. when I saw him he told me that since eight months that he was in France he had written several times to you, telling you that I was probably not in Paris, since he had not found me; nevertheless, if that person had had the goodness to put the letter at the post office I would have receved it immediately; but he thought it proper to do otherwise; however I am sure that what he has written has been the cause of my not receiving the birds that you had promised me, and that the collection that you had been obliging to prepare for Mr. Lesueur had prevented you sending sooner.[3]

As a citizen of the United States, and still more as a friend of the inhabitants of Philadelphia, I must approve the wise means that your father has taken to secure your valuable museum to that interesting city.

As for what regards the exchanges that you wish to make for birds of

Europe, Africa, and india, the thing is very easy but you know it is an affair of trust; one must send first; and it is the one that desires the thing. you must then trust in me, and send me a certain number of birds that I shall exchange, either with the museum, where I am employed, or with rich naturalists of the Capital or other cities of France, with whom I am acquainted;[4] by those means I shall be able to let you have very fine birds.

You tell me that I may recollect that your Museum is deficient in many foreign articles: I do remember it; having had the opportunity of frequently visiting its Spacious galeries: I recollect also that your collection of fishes is hardly commenced, and that it has always been very difficult for you to enrich yourself in that part, on account of those preparations been very dear, and that few naturalists attend to them. I can offer you a good bargain that may probably be agreable to you; I have a pretty large collection of fishes from the Mediterranean Sea, from the British channel, and from different parts of the coast of France. I shall sell them to you already mounted with enamel eyes and varnished for one dollar ea for those of one foot long, and two dollars for those exceeding that length. I know that you would prefer exchanging, but as I have been obliged to spend some money for that sort of collection, I cannot do otherwise but giving them for cash. the price is certainly very moderate, and I can assure you that you would not find them so cheap at any naturalist's; it is because I am in want of money for my Medical Studies that I work at such a low price; for in two years of hence, time at which I shall have taken my degrees of Doctor, I would not make such preparations for a price double of that I now ask. I invite you to take at least a hundred of these fishes; those sorts of preparations are ever lasting, the methods I employ to preserve them is that of the King's Museum where I am employed intirely for the preparation of fishes.

As for the exchanges of birds, I shall let you have two birds well mounted with their eyes for three skins of yours not mounted the exchange shall be size for size you would not have the same advantage with the museum but would give you skins unmounted.

When I shall leave Paris (in three years as I expect) I hope I shall continue to be employed for the museum I intend to make then a journey to the south of America, you may be assured that if I can then be agreable to you I shall be much gratified; for I have not forgotten the generosity with which you bought a few birds of me at my arrival in Philadelphia,[5] I shall ever remember the service you did render me for I hadnot then a single dollard. Naturalists are generaly grateful.

I have learned the return of your brother with much pleasure.[6] I do regret that I am not in Philadelphia to admire the numerous curosities

that he has brought. his travels have probably increased your collections of a great many articles. Assure your brother of my friendship tell him that I remember with pleasure our agreable hunting parties.

Do me the favour to write oftener; but above all do recommend to the captain, or passengers to whom you shall give your letters to put them at the post office at their arrival I shall then receive them immediately.

I now expect to receive soon those birds that you [page torn] so long expected. I beg of you that you should not [page torn] to send me two grous. if you have not yet send them to me, you may give them to Mr. Hersant Secretary of my Lord Hyde de Neuville ambassador of France at the United-States, who is going to return to France in the Spring.[7] You may also write a word to his excellency, if you think it proper, to ask him if you may trust in me. it is by his protection that I am employed at the King's Museum, and I think that I may flatter myself that in such a case his excellency would give you a very good opinion of me, if I have not yet the advantage of having inspired it to you.

<div style="text-align:right">

I am with esteem your
obedient Servant Alexandre Ricord
Elève en Médecine, employé au laboratoire
de Zoologie au Museum d'histoire
naturelle au Jardin du Roi à Paris.

</div>

ALS, 3pp., add., end.
DSIA, Record Unit 7054: Philadelphia Museum, 1792 and 1808–42
Endorsed: Recd. 21st Nov:1822/RP

1. Alexander Ricord (1798–1876), physician and naturalist, was born in Baltimore and went to Paris before 1819 to study medicine and natural history under Georges Cuvier. In 1824 he received his degree as doctor of medicine and later became an assistant surgeon in the French navy. He was able to devote a great deal of his time to the study of natural history and to writing articles for scientific journals. In 1845, he was awarded the decoration of the Legion of Honor. *Appleton's.*

2. Unlocated.

3. Ricord had written to RuP on October 22, 1820, indicating that he had sent him "a small box, containing enamel Birds' eyes, to be exchanged for birds." The Museum Accessions Book does not record this transaction. Ricord to RuP, October 22, 1820. PU: Gen. Mss., F:VIIA(Add.)/1B13-C1.

4. Ricord was employed by the Muséum National d'Histoire Naturelle in Paris. This museum was created in 1793 when the French revolutionary government enlarged and reorganized the Jardin des Plantes, which had earlier belonged to the king of France. *Peale Papers*, 2:101, 144.

5. On October 17, 1818, the Museum Accessions Book (p. 95) noted that the museum had received "Thirty Three Birds from South America, and Africa purchased from Mr. Alexd. Ricord for 44.50."

6. A reference to TRP's return from the Long Expedition.

7. Hyde de Neuville, the French ambassador to the United States, was a naturalist and collector who was known to the Peales. In 1819 he had offered to purchase the live elk CWP kept at Belfield. The ambassador had brought with him to America ninety-one European

birds, preserved by Ricord, which he wished to exchange for American birds. Ricord to RuP, October 22, 1820; *Peale Papers*, 3:711.

57. CWP to the Misses Butler[1]
PHILADELPHIA. FEBRUARY 16, 1822

<div align="right">Philada. Feby. 16. 1822.</div>

Respected Ladies

The remembrance of favors confered on my family by my much es-teemed friend can never be effaced from my memory, and as Mr. Butler[2] had consented to set for a portrait,[3] which I very much regret that I did not made [make] a beginning of it in time past, but still looking forward for a moment that should give him the least trouble it was unfortunately posponed. I called yesterday at your house as soon as I had heard the soriful tidings, and mentioned to your servant my desire to make a mask and drawings, and today your servant tells me that you are not willing to have such a thing done. If it is the taking a mask which is most exceptional, although it might be the best mode, yet if drawings[4] will be permitted to be done, it will much oblege your

<div align="right">friend CWPeale</div>

Miss Butlers.

ALS, 1p.
PPAmP: Peale-Sellers Papers—Letterbook 17

1. Most of Pierce Butler's estate was managed by his eldest unmarried daughter, Frances. The two other unmarried daughters living at his Philadelphia home were Anne Elizabeth and Harriet Percy. Francis Coghlan, "Pierce Butler, 1744–1822, First Senator from South Carolina," *South Carolina Historical Magazine* 78 (1977): 111–12.
2. Pierce Butler died on February 15, 1822. The previous August, he had offered to assist TRP in obtaining a place on Captain Charles Stewart's expedition to the Pacific. See above, **35, 41**.
3. See above, **35**.
4. CWP did not make a posthumous drawing of Butler.

58. ReP to John Pendleton
BALTIMORE. FEBRUARY 28, 1822

<div align="right">Baltimore Feby. 28. 1822</div>

Dr Sir

A great press of other writing induced me to delay informing you that your last,[1] enclosing a Draft for 250 $ is received, for which prompt

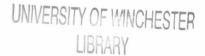

remittance I tender you my acknowledgment Thus has Charleston done its part—less than I originally expected, but very well to compare with New York & Boston. I perceive that you retained the price of 50 Cents to the last. When I exhibited the Mammoth there, I found it advisiable & advantageous to have it the greater portion of the time reduced to 25 Cents.[2] Probably you may chuse to try the experiment in Savannah.

In your former letter you mention the reasons which induced you to give up N. Orleans. I presume you took care to judge correctly— But it renders it probable that N. Orleans will never see the Picture. Do you contemplate Shipping it for Richmond direct or for Norfolk, in order that you may judge then whether it would be well to shew it there. I know nothing of either place & cannot assist in judging, except in the policy of having your choice. The Picture is often enquired for here & I believe would produce even a third good Seasson.

By the papers I perceive that Sully's picture still remains open.[3] You have not said what was thought of it. He has written to Mr. Robinson[4] that he will paint no more for Exhibition, unless on commission. He has very good employment in Portrait painting.

By the papers you will no doubt hear of the death of the great Mr. Pinkney—[5] This is the town-talk—But a distressing one has occurred. Mr. Robinssons family—his favourite little Anna died with 3 days sickness—Quinsy.[6]

I have but little now to say. My family join me in wishing you health & happiness

Believe me Yours sincerely

Rembrandt Peale

[added in pencil]
 For J. Pendleton
 Savannah
 Geo

ALS, 2pp.
Private Collection

 1. Unlocated.
 2. ReP had visited Charleston during March and April 1804, when he and RaP were touring with the reconstructed skeleton of the mastodon. Newspaper advertisements at that time indicate that they charged fifty cents' admission, occasionally lowering the charge to twenty-five cents in order to entice visitors. *Peale Papers*, 2:648–52; Miller, *In Pursuit of Fame*, p. 72.
 3. Probably *The American Troops Crossing the Delaware at Trenton, in December 1776, in a Snow Storm* (1819: *Museum of Fine Arts, Boston*), which was touring eastern cities. Monroe H. Fabian, *Mr. Sully, Portrait Painter* (Washington, D.C., 1983), p. 14.
 4. Henry Robinson (1775–1849), merchant and businessman, was born and educated in England; later he immigrated to America. In 1800, he and his wife, Isabella Maxwell, were living in Baltimore. He was the largest stockholder in ReP's Baltimore museum, and he

appears to have silently supported ReP in his involvement with the Gas Light Company of Baltimore. Later, in 1843, he founded and became the first president of the Boston Gas Works. A close friend of ReP and his family, particularly Rosalba, Robinson contributed to ReP's European travels and commissioned a number of his paintings. In his will Robinson left Rosalba ("my adopted daughter") a twenty-thousand-dollar trust fund and an additional ten thousand dollars in cash. New England Historical Genealogical Society to Peale Family Papers, December 2, 1990; A. I. Bartow, paper presented to the Baltimore Gas and Electric Company, 1978; ReP Catalogue Raisonné, NPG.

5. William Pinkney (1764–1822), lawyer and ambassador to Russia, represented Maryland in the U.S. Senate from 1819 until his death and played an important role in the Missouri Compromise negotiations. ReP painted two portraits of Pinkney (ca. 1818: *The Fine Arts Museums of San Francisco; private collection*). Notice of Pinkney's death appeared in the *American Commercial and Daily Advertiser* on February 27, 1822. *DAB; Peale Papers,* 3:681, 682.

6. A severe inflammation of the throat, or tonsillitis. "Little Anna" is unidentified.

59. CWP to APR

PHILADELPHIA. MARCH 10, 1822

<div align="right">Philadelphia March 10th. 1822.</div>

Dear Angelica

Yours of the 6th. Instant[1] received yesterday, containing the circumstances of the fate of the picture[2] which was detained in a Ware house so long, and which account of it, I received in one of your former letters.[3] Mr. Robensons & your portrait in the same peice, is still at the farm as well as several other pictures, but I intend to have all of them brought to the City as soon as I can conveniently bring them, I have to finish the hands, and propose to have it packed up with Rubens pictures—I suppose you have heard that he has purchased Rembrandt's Museum, and he will be mooving to Baltimore in the latter part of next month, or the beginning of May. of course my plan of travelling for amusement the ensuing Summer is done away because the Interest of my Museum must be attended to, and I propose to spent most of my time in the Museum, and to employ Franklin and Titian to assist me. I offered them each $600 pr. Anm. and thuse I expect the Museum will undergo many improvements, and maintain its Utility and superiority to all others on this Continant.

How I shall live, whether at board or other wise is yet undetermined, but my determination is, to economise as much as possible. Your Sister Sophonisba expects that I will board with them.[4] and I well know that they would do every thing in their power for my comfort, but I must have a Room to paint in, also a Room as a shop, to prepare subjects for the Museum, and this as near the Stadt-house as possible. Therefore it will not suit me to stay at Colemans. I must be where my business is carried on. I enjoy good health, and would rather *ruff it*, to employ my time to most

advantage. The Museum after being incorporated ought to raise in its consciquence with the Public, and it is my duty, as well as my Childrens that are with me to make our utmost exertions to render it an honor to the City and our Country.

You know that I have always believed that a constant employment of our time is essential to our happiness—hence, I have often regretted that more honour was not attached to Mechanical imployments. The most usefull is certainly the most honorable. and a habit of Industry is of the first consequence to the Youthful mind. and to find out some profession to suit the capacities of our children is all important—very often wealth, or the prospect of it, leads the young mind to the though[t]less indifference about the use of money & their time—and if their time is not employed usefully, their mind becomes viciated. I hope that is not the case of your Son Archibald,[5] he is yet young, and is not difficient in mental qualifications. at least as far as I have been able to know in the short periods of my acquaintance with him. Therefore I hope that you will yet receive comfort in him.

It is not often the lott of those who have many children to have all conducting themselves as they ought to do. and where the parents sett a proper example before them of prudence, sobriety, industry and economy—and do the best they can to make them what they ought to be & happy—Such Parents ought to console themselves with having done their duty to their ofspring.

But I must go a little further and say that we should not abandon all hopes of reclaiming them, if they have been ever so depraived, the fostering care of a Parent may awaken at last a feeling of respect for themselves, and being once brought to reflection, hopes may be expected of amendment. Family resentments are very often more bitter than with those unconnected, this I conceive is highly represencible [reprehensible]. we ought to forgive our Enemies, then how much more forbearing ought we to be with our near connections, we are too apt to expect more respect from our relations than from straingers, and therefore feel more hurt in consequence of the want of it

but if we realy were possessed of the true spirit of forgiveness, we certainly would never resent an Injury in any situation whatever. This the situation that I am labouring to accomplish in my habits. how far I may have command of myself, my future behaviour must testifie. My age undoubetably favors that disposition to forgiveness, and another comfort of Old-age; is, that we have less of that restlessness common to the more youthful time of Life.

One other thing about self, & that not a litt[le] of the surprizing. I have painted three Portraits[6] without the use of Spectacles, and all my friends

that have seen them say that they are superior to my former works. And this day I have mended my Penns without Spectacles that is of long focal Glasses. My respects to Mr. Robenson & love to the Children.

Yours Affectionately CWPeale

PS. my Scrole don't savor of good Pen-mending. One important information omited, is, that your Sister Sophoa: looks well & has good spirits, which gives me hopes that she may do well in the issue of her present situation. should that be the case, her constitution may be strengthend.

Angelica Robenson

ALS, 3pp.
PPAmP: Peale-Sellers Papers—Letterbook 17

1. Unlocated.
2. See above, **48**.
3. Unlocated.
4. Coleman Sellers and SPS lived at 231 High Street (presently Market Street), which was approximately four blocks from the Philadelphia Museum. *Philadelphia Directory (1822)*.
5. Archibald Robinson (1798–1848) was the Robinsons' oldest living child in 1822. *CWP*, p. 440.
6. CWP painted ten portraits in 1821 and 1822, including three self-portraits. Four of these portraits were painted after the date of this letter. In spring 1821 he painted Joseph Hiester (fig. 13), and during the fall of that year, he took Mrs. Royal's portrait (fig. 15). Although he collected payment for Deborah Logan's portrait in July 1822, he may have finished it earlier in the year (*unlocated*). See below, **84**.

60. CWP to RuP
PHILADELPHIA. MAY 2, 1822

Philadelphia May 2d.1822.

Dear Rubens,

About one hour after you left here, I received Rembrandt's Letter to you,[1] which informs me that your leaving us was just as it ought to be, so that I expect to see Rembrandt here this morning.

I have not seen Mr. Shipping,[2] but as he has not called on me, it is my intention [to] seek him this afternoon—for I did not present the Notes for discount, as you directed before seeing him. I have had no offers for the House.[3] To day we thought to clean the parlour below, and I find nothing in the large packing Case. I see Beef in salting-Tub and also in the Sellar hams & other meat hanging to the joice Which suppose you wish to have sent with other things left in the Parlour.

I wish to know which rout we shall send them whether by Sea, or in the Union line?[4]

The Dumb Teatcher will sett for finishing his Portrait this Morning.[5] Sophonisba Sellors continues in pretty good health. They expected to

[see] you at parting, all the family expected to have gone to the steam boat with you. Franklin was much mortified to think he had not been with you. Sophonisba had wrote a letter to her Sister to be particulary in your care, I will sent it you, by the first safe hand.

Love to Eliza. Yrs. affectionately
CWPeale

Mr. Rubens Peale
 Museum Baltemore.

ALS, 1p.
PPAmP: Peale-Sellers Papers—Letterbook 17

 1. Unlocated.

 2. Perhaps CWP meant "Dr. Shippen"—Joseph Galloway Shippen (1783–1857), a son of Joseph Shippen, III (1732–1820)—who was a potential purchaser of RuP's house (see below, **70**). Randolph Shipley Klein, *Portrait of an Early American Family* (n.p., 1975), Appendix B, B-3.

 3. From approximately this date until May 1823, when CWP decided to buy RuP's house himself, one of CWP's major concerns was the rent or sale of the property, a difficult assignment given the depression that persisted in Philadelphia as a result of the Panic of 1819. His efforts are detailed in the letters that follow. For his decision to purchase the house himself, see below, **128**, **131**, **132**.

 4. The Union Line was a steam boat service located at 9 South wharves. *Philadelphia Directory (1821, 1822)*.

 5. [Louis] Laurent [Marie] Clerc (1785–1869), educator of the deaf, was born in France and came to the United States in 1815, where he helped to found the American Asylum for the Deaf in Hartford, Connecticut. When CWP took his portrait, he was visiting the Pennsylvania Institution for the Deaf and Dumb. CWP exhibited the portrait at PAFA later in 1822 (fig. 18). *P&M*, p. 55.

61. CWP to Miss Butler[1]
PHILADELPHIA. MAY 3, 1822

Philadelphia May 3d.1822.

Dear Miss

It is far from my wish to intrude on your concerns, yet I hope ⟨I hope⟩ when I explain the motive that induces me now to make this address, that you will have the goodness to pardon the anxiety of a Parent to assist a dutiful and deserving Son.

Without further preface I shall proceed to state the Case.

My Son Rubens has purchased from his brother Rembrandt the Baltemore Museum, and having made the first payment, to complete the second, he offered his House in Walnut Street for sale,[2] in the full confedence that he would get a purchaser for it, he promised his brother Rembrandt a payment of 2500$ on the first of the present month (May). And Rembrandt in consequence made engagements to pay certain sums of

money in Baltemore, and also rented a House in New York, in order to remoove his family there, intending to persevere in his profession of Portrait & Historical Painter—his reputation as an artist standing high in the estimations of the Citizens of N. York—but he cannot well leave Baltemore untill he fulfills his engagements there.

Rubens and his Wife have given me a Power of Attorney to sell his House in Walnut Street, Also to sell other property belonging to his Wife—which is also offered for sale; a Mill on the Wissasicon & a house also in Walnut Street.[3]

I have thought that if you have Money to be disposed off, that this House belonging to Rubens, described in the enclosed advertizem[en]t,[4] will be a safe and I believe a profitable purchase at the price which Rubens allows me to take for it—because it will always bring a good rent, never less that [than] what it now brings & in all probability a much higher rent as the back Buildings are desirable to many Professional Men. May you have the goodness to excuse my giving you the trouble to think on this business, and to believe me desireous to meet with your approbation in whatever I undertake—that it will give me pleasure to do you any service, in the power of your sincere friend

CWPeale

Miss Butler.

ALS, 2pp.
PPAmP: Peale-Sellers Papers—Letterbook 17

1. Probably Frances Butler. See above, **57**.
2. RuP's house was on "Walnut above Sixth." *Philadelphia Directory (1822)*.
3. Eliza's house was located at 206 Walnut Street. See below, **136**.
4. Unlocated.

62. CWP to Bridget Laforgue[1]
PHILADELPHIA. MAY 4, 1822

Philadelphia May 4th. 1822.

Madam,

As a Parent wishing to promote the happiness of my Family, and, as my Son Titian has not the means of supporting a Wife, and the Salary I have proposed to give him is, I fear more than my Income from the Museum will enable me to pay—therefore I think it very imprudent in him to enter into any Matrimonial connection before he can have a prospect of a more permanant support. And, also, believing it is my Duty to inform you, that I disapprove of the family connection, as I am well assured that there cannot be any Cordiallity between your family and mine,[2] of course, you

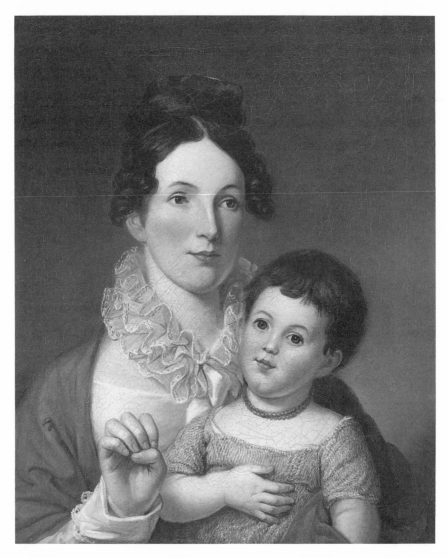

17. *Mrs. Laurent Clerc*. C. W. Peale, 1822. Oil on canvas, 25 × 21″ (63.5 × 53.4 cm). American School for the Deaf, courtesy of the Wadsworth Atheneum, Hartford.

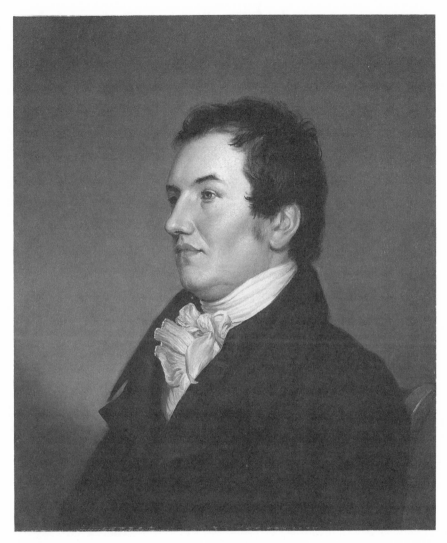

18. *Laurent Clerc*. C. W. Peale, 1822. Oil on canvas, 25 × 21″ (63.5 × 53.4 cm). American School for the Deaf, courtesy of the Wadsworth Atheneum, Hartford.

cannot take it amiss that I have now given you my candid opinion, that the connection of our families will only produce discord and unhappiness

with respect yours &c

☞ CWPeale

To Mrs. LaForgue ⟨[illeg] *Street*⟩

☞ when prepairing to bind these letters, I thought I should obliterate this letter, but as I wish to have all my transactions made known to my posterity I therefore preserved it, and will now say (Augt. 24th. 1824) that Eliza has been a faithful, affectionate wife, and a patient nurse to my Son Titian, and also has been kind and attentive to all my wants; having done every [thing] in her power to make me comfortable since I have lived her[e]—(I have boarded with them ever since their marriage and I have paid 5 Dollars Pr. week having my washing done in the House—and Eliza has mended my cloaths when ever wanting.[3]

ALS, 1p., add. & end.
PPAmP: Peale-Sellers Papers—Letterbook 17
Endorsed: Aug. 24, 1824

1. Bridget Laforgue, Eliza's mother, was a widow who lived at 3 Willow Court. *Philadelphia Directory (1821).*
2. For CWP's objections to the Laforgues, see below, **63**.
3. CWP added this paragraph to his letterbook later in order to correct the record and acknowledge his error. George Escol Sellers (1808–99), CWP's grandson, recalled the ill feeling that had existed between the families, but was not aware of the reconciliation. In a letter written when he was seventy-nine years old, Sellers noted that Eliza had made CWP's home, "unhappy after the death of his third wife." And in another letter to his younger brother Coleman (1827–1907), written when he was eighty-nine years old, he wrote that at the time of CWP's last illness in 1827, their mother, SPS, "was greatly concerned at the want of attention to his [CWP's] personal comforts by Titian's wife." Typescript, George Escol Sellers to Horace Wells Sellers, May 15, 1887; George Escol Sellers to Coleman Sellers, January 21, 1897. "Miscellaneous Reminiscences," PPAmP.

63. CWP to RuP

PHILADELPHIA. MAY 5, 1822

Philadelphia May 5th. 1822.

Dear Rubens

Mr. Robenson[1] no doubt has acquainted you with my indeavors to procure Money with all my discouragements, therefore I need not repeat particulars, and shall only say that I had a long conversation with Mr. Joseph Norris,[2] whose oppinion was that he did not beleive that Money could be had at any of the Banks in Philada. The situation of New York had made it necessary for the Banks here to be very cautious of letting out Money. and one Instance he mentioned to shew me how impossible it

would be to obtain a discount—which was that a Gentlement who owned Bank stock was refused a discount of a Note. The Gentleman was very angry. Having had this oppinion of Mr. Norris and beleiving his friendship for us with his knowledge of Banking Business I have not offered your Notes for discount.[3] But I have some hopes that Mr. Paul Beck[4] may be indu[c]ed to purchase your House, and he promised me that he would call on Doctr. McClelland[5] to see the House within one or two days—I see him on board the Steam Boat, when I went to see Mr. Robenson take his passage, but do not know whether he was going with Strickland[6] & other Gentlemen on the canal business or not—but I will call at his House tomorrow morning.

Mr. Robenson I suppose told you of my writing to Miss Butler as I read to him my Sketch of said letter—[7]Last Evening I received her Answer,[8] in which she made the opology of not writing to me sooner, she intended to have wrote immedeately after breakfast, but company on business prevented her. She says, "It is not Miss Butler['s] wish to make a purchase, but it would have afforded her the greatest gratification, to offer to Mr. Peale the sum immedeately wanted, if it had been in her power. From indisposition of Miss Butler she has not yet made known to those Persons who have funds to remit, to whom they were to remit them, which puts it out of Miss Butlers power to do what would otherwise have given her so much pleasure. No opology was necessary for Mr. Peale's letter. Miss Butler must again express her regret at not having it in her power to remove the anxiety which it is so natural for Mr. Peale to feel." I had a final Settlement with Craiger.[9] yesterday, Mr. Saml. Gibson[10] came to the City for that purpose, and Mr. Joseph Ball[11] was added to the Arbritrators— Craiger brought in a charge for pastering all my Horses ⟨from⟩ the time of commencement—also charge of some time that I had 2 Cows less than he had— The Arbritrators called for the articles of agre[e]ment, and no provision being made for the pastering of my Horses—therefore, as only our Words could be had, they thought it was their business to act only on written evidence, although I beleive they knew that Craiger had brought this charges forward, as indeed he said that Linnius had brought every thing he could against him. yet as they conceived that the former reference with respect to the Hay was made liberally in Craiger's favour they gave a statement that Sammy Craiger was indebted to me 110$ And Coleman after the award was made Coleman told the Gentlemen that as Craiger had twice flew from his engagement in this business he thought it would be proper to draw up an acknowledgment to bind himself to abide by the settlement of the arbitrators, which was agree'd on, and a penalty of 200$ annexed to it. Craiger had signed it and it being sent to me I also put my Signature, which paper is left in Colemans care & the statement of the

award— Craiger was mortified to find that he had not got a greater sum allowed him. Foolish Man—he has lost his charactor of Honesty, which surely ought to be of more value to him than 100$, as every person who may hear of his having brought up such a charge, and nothing of the sort having ever been spooken off in the 5 years that he had the farm, nor any thing of the like nature in the time that John Stump[12] had the Farm. I can never take him by the hand again, nor have thing to do with him, but shall impower Coleman to settle a small acct. of Blacksmiths work & also to receive my Rent from him. I mean to avoid speaking of his dishonesty in future, his own conscience will be punishment sufficient. I am fearful that Linnius will get hold of it, and his enmity to Craiger will probably induce him to say harsh things, and no good will come from it. This letter I am sorry to say will not be a pleasant one, my next subject is of that nature. Titian having still the same disposition to perplex me about his situation which his unfortunate engagement, with the hope of putting an end to further trouble, I have this morning given my oppinion and final determination, by telling him that I disapprove of the Match, that altho' I have agree'd to give him 600$ yet he ought not to depend on it, as the Museum may not give a sufficient income; that he ought to know that If [I] am taken off, the Trustee's might not give him the management of the Museum, and his share of Stock would not support him, and that I find the Family he wants to be connected with, will not harmonize with mine, as I have found that they are bigoted low bred Roman Catholicks, and I told him I would acquaint them that I disapproved of the connection, and a connection of our families would surely produce only discord & unhapiness. And I have since wrote a letter to the Mother[13] giving the above sentiment, except that I did [not] mention religion or character, that I conceived it my duty to state my opinion in candid terms, which letter was delivered into the Hands [of] Bridget Laforgue Widow. Thurse I hope good may come of it. Titian blaims me for not telling him sooner, and says that before he went to Baltemore that he desired me to enquire into the Character of the family, very probably he did so, yet at present I dont remember it. He still harps on Franklins stepping into his place, that I put Franklin above him in giving him the accounts to be keept concerning the Museum, I tell him that I do not put Franklin above him nor one above the other, that I require the constant attendance of both of them and their utmost exertion to improve the Museum, that I am put above both of them, and that if he is desireous to please me he must harmonise with Franklin, if he does not I shall not be pleased with him. Perhaps when the love affair is blown over I shall have peace with him— I told him that while he was to the westward that a Young man was ingaged to her & the match was broke off by the family objecting to the marriage as the young

man was not a Roman Catholick. Sophonisba continues well. I was at Mr. Warfs since dinner, Eleoner & the Children are all well & in good spirits, I told Eleoner that they must whenever in this quarter to take what was going, but only 3 of them at a time, as I had only Six knives & 6 Spoons & Six Cups, that the[y] ought to take their turns to partake of my board.

They all join in Love to Rembrandt, Eliza, yourself and Mr. Robensons family. I have endeavored to make my letter worth its Postage by the length of it, if not by the Matter. My love to Eliza and Rembrandt.

<div align="right">Yours affectionately CWPeale</div>

PS. I mean to write frequently whether I have much to say or little— God grant that I may be able to assist you.

Mr. Rubens Peale
 Museum Baltemore

ALS, 3pp.
PPAmP: Peale-Sellers Papers—Letterbook 17

1. Henry Robinson.

2. Joseph Norris (1763–1841) was president of the Bank of Pennsylvania from 1808 until his death. *Peale Papers*, 3:775n.

3. Scarcity of money as a consequence of the Panic of 1819 and the ensuing depression presented bankers with two alternatives: they could suspend specie payments, as did many western banks, and issue unbacked bank notes liberally, or they could maintain specie payments by contracting loans, which was generally the policy of the more conservative northeastern banks. New York banks were particularly cautious about making loans, especially to individuals. See George Dangerfield, *The Era of Good Feelings* (New York, 1963), pp. 184–89.

4. Paul Beck, Jr. (1760–1844), merchant, philanthropist, and patron of art and letters, served for many years as warden of the port of Philadelphia. In 1822, Beck was involved with the architect William Strickland in the Delaware and Chesapeake canal project. A founder of PAFA, he owned a "considerable and valuable" art collection. His major philanthropic interests, however, were the Institute of the Deaf and Dumb and the American Sunday School Union. In 1834, he served as a trustee of the Peale Baltimore museum. Simpson, *Eminent Philadelphians*; Paul Beck to Baltimore Museum, January 6, August 1, 1834, MdHR, F: XIB/2E1–4, 2E10-F3.

5. George McClellan (1796–1847), physician and surgeon, was the father of the famous Civil War general George Brinton McClellan. In 1816, McClellan graduated from Yale College and, in 1819, received a medical degree from the University of Pennsylvania. McClellan established a surgical practice in Philadelphia, with a specialty in ophthalmology. His residence on the southwest corner of Chestnut and Seventh Streets was about three blocks from RuP's home on Walnut and Sixth. He did rent RuP's house soon after this letter and utilized an upper room for his lectures. See below, **75**; Stephen W. Sears, *George B. McClellan. The Young Napoleon* (New York, 1988), pp. 2–3; *Poulson's*, May 1, 1822; *Philadelphia Directory (1822)*.

6. William Strickland (1787–1854), architect and engineer, was associated with Paul Beck, Jr., and others in a third and successful attempt to construct a canal from the Delaware River to the Chesapeake Bay. *Peale Papers*, 3:90n; Simpson, *Eminent Philadelphians*, q.v. Paul Beck, Jr.

7. See above, **61**.

8. Unlocated.

9. Samuel Craiger had been renting Belfield and farming for CWP since 1817. He also seems to have worked as a blacksmith at the farm. See CWP to Peter Robinson, November

27, 1818, P-S, F:IIA/61C14; CWP to RuP, May 5, 1822, P-S, F:IIA/66G8–10; CWP to Samuel Craiger, June 17, 1822, P-S, F:IIA/67B14.

10. Unidentified.

11. Unidentified.

12. John and Susan Stump farmed for CWP at Belfield from 1814 to 1817. *Peale Papers*, 3: 241, 539.

13. See above, **62**.

64. CWP to RuP

PHILADELPHIA. MAY 9, 1822

<div align="right">Philada. May 9th. 1822.</div>

Dear Rubens

An Old adage, "Those that go a borrowing go a sorrowing."[1] It has been truly so with me, I had an intimation that Richd. Wister[2] was immenisly rich, and I stated to him our situation and asked of him on Interest the small sum of 4 or 500⟨o⟩ $—he said he would inquire and let me know— when I called on him he said he thought his Sister had it, but he found that she had parted with it—and being in trade all his money was required in this business—All fal lall. I applied for advice to Mr. Joseph Norris—also to Mr. Graff—[3]and lastly to our friend Zacheus Collens—who has promised me 4 or 500 Dollars in 3 or 4 days provided a Person who is engaged to pay 900 $ should give him the money, so that this depends on a contingency. I have set other weals to work, and I have put an advirtisment in the Museum, A good house in a beautiful situation to be sold cheap. apply to the Door keeper of the Museum— my mode is get it sold by mentioning the price of $8000—Mr. Graff says it is really cheap at that price— I mean again to put advertizments in 2 papers,[4] saying *to be sold on advantageous Terms*. Rembrandt thinks I should not s[ay] that that the *property will be sacrefied [sacrificed]*. I do not say so, but that the property is realy worth more than 8000 $. that I do so to be more certain of selling it.

I heard last night that Richd. Humphries[5] will give that price in City Stock at 5 Pr. Cent—which Stock he says commands cash—I will see him this morning. He said that he had bid that sum for it, I suppose he means at the public sal[e]. I have painted the Wife of Mr. Laurent Clerc & her interresting Child.[6] finished likeness's in less than 2 days—they leave this [city] to day—my next will give more particulars. Sopa: Sellers was like her time the day before yesterday, it has passed away yesterday, so that I expect she will hold out one week more.[7]

I will probably continue in this House, and will now attend to packing up & sending by Sea your things and ⟨so⟩ shall conclude by saying that I

will turn every Stone I can to ⟨see⟩ serve you & Rembrandt—accept my love to each of you—

CWPeale

PS. David (carpenter)[8] called yesterday, but you have not left his acct. I find that which is paid off, only.

ALS, 2pp.
PPAmP: Peale-Sellers Papers—Letterbook 17

1. The original saying is from Thomas Tusser's (ca. 1524–80) *A Hundred Good Points of Husbandry* [1557]: "Who goeth a-borrowing; Goeth a-sorrowing." Emily Morrison Beck, ed., *Bartlett's Familiar Quotations* (Boston, 1980).

2. Richard Wistar, Jr., son of a Philadelphia merchant and a nephew of Dr. Caspar Wistar, carried on his father's mercantile business. The sister was probably Sarah. *Peale Papers*, 3:114, 115n; *Eminent Philadelphians*; *Philadelphia Directory (1821, 1822, 1823)*.

3. Charles Graff (d. ca. 1856), a wealthy "gentleman" and art patron, served as a PAFA board member for more then twenty years. At the time of his death, Graff owned five of RaP's still-lifes. Nicolai Cikovsky, Jr., *Raphaelle Peale Still Lifes* (Washington, D.C., 1988), p. 71; Rutledge, "Robert Gilmor, Jr., Baltimore Collector," pp.21, 32.

4. CWP inserted an advertisement in *Poulson's* on May 1, 1822. The advertisement indicated that the property consisted of two buildings on a lot 25 feet wide and 130 feet deep. The main dwelling house was described as a two-story brick building, with "two fine parlours with mahogany folding doors, three chambers, and three good garret rooms." The advertisement was repeated on May 3, 6, and 7.

5. Richard Humphreys was listed in the *Philadelphia Directory* for 1822 as a "gentleman" who resided at 32 Sansom Street.

6. (See fig. 17, above). Elizabeth Crocker Boardman Clerc (1792–1880), like her husband (see above, **60**), lost her hearing in childhood. She was one of the first students in her husband's American Asylum for the Deaf. The daughter was Elizabeth Victoria. *P&M*, p. 55.

7. SPS delivered a stillborn baby on May 20, 1822. See below, **68**.

8. David White was employed by the Peales as a carpenter.

65. CWP to RuP

PHILADELPHIA. MAY 10, 1822

Philada. 10th. 1822.

Dear Rubens

I went to Richd. Humphries this Morning, but he ⟨but⟩ was gone out, and I found by Betsey Morris that I should do nothing with him unless I was to give him the House clear of Ground rent—however I told her what to say to him, and if he inclined to purchase he will call on me. I have today gave orders to have the House again advertized in Duanes & Poulsons papers.[1] By Monday I expect to know whether Mr. Z. Collins will have the 500 $ for me.

I put a White canvis lettered on the F[en]ce before you[r] House—the first was not sufficiently bright.

This will be handed to you by Miss Bordley,[2] who promises to call for it tomorrow morning, and I wish you to shew her your Museum. she is fond of seeing Museums. she has been 2 evenings this week at the Stadt House. Sophonisba is bravely this evening— 3 of Rembrandt's daughters dined with me to day. I ought to have requested 3 others for tomorrow but my head is good for nothing—[3] having your business to perplex me, and finishing Mrs. Clerc's picture has keept me very busey. It is very handsome.

our friend George Patterson[4] called on me today and he says that the Germantown Bank makes discounts—should I fail with Zeecheus Collins, I may endeavor to get a note discounted on that Bank. perhaps as I have still the Farm there is a chance of Credit with them. It is expected that there will be many Bankrupts soon in this City. Coleman tells me that their House have lately had a very large importations—(indeed I have seen the Shop filled with Tin casses of wire) and that they are obleged to make large remittance to England and have been obleged to draw largely on Sammy.[5]

I have no reason to complain about the receipts of the Museum, yet the last few days we have fewer visitors and if the night was not adding something it would be bad enough— Raphaelle is still short of work, but he has got something to do within a few days and probably when the Academy is open, he will, at his low price, obtain more to do, as his pictures will do him credit in the Exhibition.[6] I do not think it will be necessary to write to either o[f] you untill monday next. Rembrandt's family dined today at my Brothers. adieu, may God prosper you

<div align="right">Love as usial CWPeale</div>

Mr. Rubens Peale.

ALS, 2pp.
PPAmP: Peale-Sellers Papers—Letterbook 17

1. See above, **64**.

2. Elizabeth Bordley (Mrs. James) Gibson (1777–1863) was the daughter of CWP's friend and patron, John Beale Bordley. *Peale Papers*, 2:36n, 1091n.

3. In 1822 ReP had seven living daughters: Rosalba Carriera (1799–1874); Angelica (1800–59); Augusta (1803–86); Eleanor (1805–77); Henrietta (1806–92); Mary (1812–76); and Emma Clara (1814–?). Peale Family Papers files.

4. George Patterson was Eliza Patterson Peale's brother, who with William, EPP's husband, operated a woolen mill in Germantown. *CWP*, pp. 392–93.

5. Probably the son of Nathan Sellers's brother, David, Samuel Sellers was a wireworker employed by the firm formed by his brother James and cousin Abraham L. Pennock to manufacture riveted fire hose and leather mail bags. Eugene S. Ferguson, *Early Engineering Reminiscences (1815–1840) of George Escol Sellers* (Washington, D.C., 1965), pp. xix, 2; *Philadelphia Directory (1823)*.

6. RaP exhibited nine works in the 1822 PAFA exhibition: "Profile in imitation of Bronze on plaster paris"; *Still Life—Apple, cake and raisins*; *Venus rising from the sea—a Deception* (1822) (fig. 19); *Portrait of an Old Lady* (see fig. 20); *Still Life—Apples, Wine, Cake, &c.* (see fig. 21); *Still*

19. *Venus Rising from the Sea—A Deception (After the Bath)*. Raphaelle Peale, ca. 1822. Oil on canvas, 29 ¼ × 24 ⅛″ (74.3 × 61.3 cm). The Nelson-Atkins Museum of Art, Kansas City, Missouri (Purchase: Nelson Trust) 34–147.

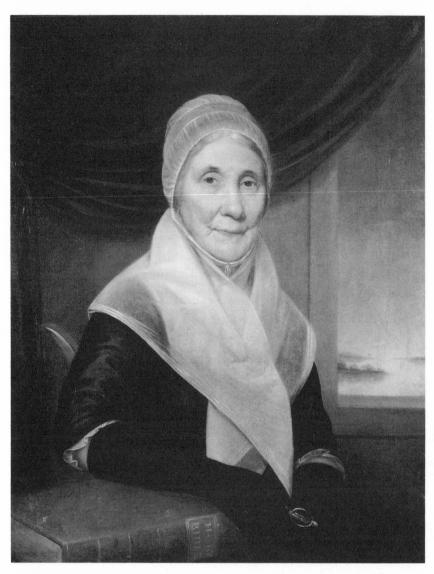

20. *An Old Lady [Martha George (Mrs. Matthew) McGlathery?]*. Attributed to Raphaelle Peale, ca. 1817. Oil on canvas, 29 ³/₈ × 23 ¹/₄″ (75.5 × 59 cm). Private Collection.

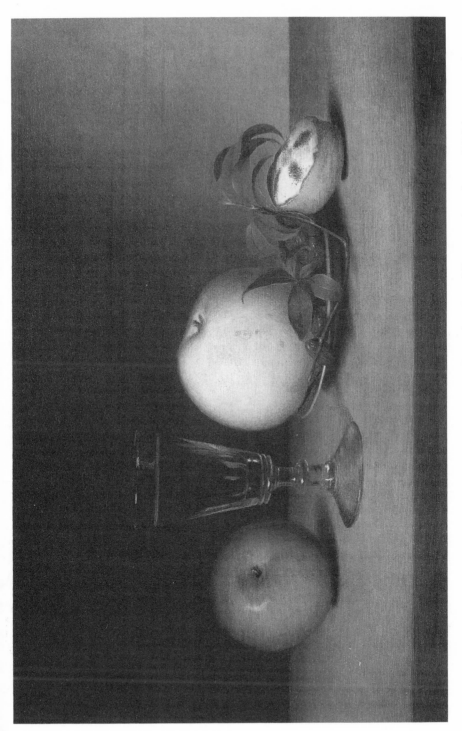

21. *Still Life with Apples, Sherry, and Tea Cake, Jan. 4, 1822*. Raphaelle Peale, 1822. Oil on panel, 10 ½ × 16 ³/₈″ (27 × 42 cm). Collection of Mr. and Mrs. Paul Mellon, Upperville, Virginia.

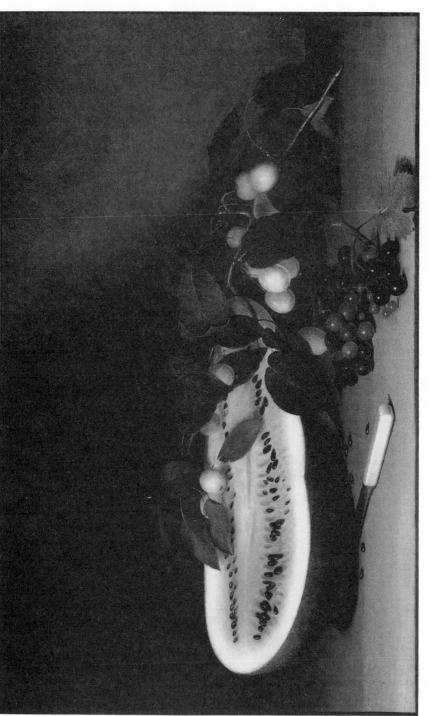

22. *Still Life with Watermelon.* Raphaelle Peale, 1822. Oil on canvas, 16 ¾ × 26 ½″ (42.5 × 67.3 cm). Private collection. Courtesy Berry Hill Galleries, New York.

Life, Oranges, &c. and a miniature portrait of a Lady (ca. 1818: *The Toledo Museum of Art*); *Yellow Peaches and Grapes*; *Still Life—heath peaches and grapes*; *Still Life—Watermelon and Grapes* (see fig. 22). Falk, ed., *Annual Exhibition Record*, p. 166; Cikovsky, *Raphaelle Peale Still Lifes*, pp. 126–32.

66. CWP to RuP

PHILADELPHIA. MAY 11, 12, 1822

Philadelphia May 11th.1822.

Dear Rubens

While Miss Bordley was in my painting-room, I received Mr. Z. Collens letter[1] inclosing the 400 $, and I opened my letter to give you the intelegence, I thought it safest to get an order from the Philada. Bank[2] for the check I had received, as safest mode, also to send it by the Mail as being more certain than any private hand— I have been to the weding of James & Sophia this evening,[3] they set out for Boston tomorrow morning at 7 O'clock. 1/2 past 10 I left them, thus setting the example, but whether the company will take the hint I cannot tell— I see the Parson[4] take a Glass of wine & in a few minutes afterwards the Brides Groom asked him to take another, thinks I to myself you had better let it alone. My Brother, Polly & the Girls all were there, also Rachael,[5] and Mrs. McGlathery. Oh by the by, the Bride said to me, suppose we have another wedding, here is my Mother[5] & the Parson present and we can get Brides maids—my reply was that *I am not yet old enough.* 12th. I may be alittle Childish, as such a State may gradually creap on us, yet it is my hope that if I can possess philosity [philosophy] enough to have complete command of my passions; to eat just sufficient to support the system; sufficient to supp[l]y Brood [Blood] and chyle;[7] to keep the mind in a quiet and tranquil state; to exercise the mussels sufficiently ⟨to prevent⟩ to give them elasticity and prevent obstructions—always prefering the ailement that experience has shewn me as best addapted to give all the necessary secretions—to take a sufficiency of water to promote digestion & supply the waste of perspiration—thus keeping my body from drying up. In short to do⟨ing⟩ nothing that is useless— In this mode of Conducting ourselves, we may *better enjoy life*, and prolong it untill the marrow of bones become bone—and finally go to sleep an everlasting sleep. we are liable to a thousand accidents that may take away life & impair our natural fu[n]ctions, but cool reflections & prudence may prevent many of them, so that man should know that he deserves sorrow if he neglects his duty to himself. you see that I want subjects to fill up my paper or I should not repeat what you so often have heard me express. Sophonisba is still

hearty. none of the Deaf & dumb were at the Museum yesterday, although it is a good school for them, & I suspect that they have the Idea that they are invited to make a show of them & pride keeps the teachers & Pupils away. But I think of getting Mrs. Clerc's portrait framed, & be shewn to them by next saterday.

I expect to have the pleasure to see Rembrandt soon.

<div style="text-align: right">my love to all not excepting Charles
adieu CWPeale</div>

Mr. Rubens Peale.

ALS, 2pp.
PPAmP: Peale-Sellers Papers—Letterbook 17

1. Unlocated.
2. The Philadelphia National Bank was established in 1803 and incorporated the following year. Scharf, *Phila.*, 3:2110.
3. James Peale, Jr., and Sophonisba (1801–78), RaP's daughter.
4. The marriage was performed by the Reverend James Abercrombie (1758–1841), of Christ Church, who also served as an associate rector of St. Peter's and St. James's in Philadelphia. St. Peter's Church: Marriage Records, F:III/5F5; *Appleton's*; Simpson, *Eminent Philadelphians*.
5. Rachel was the Peales' cousin, Rachel Brewer.
6. Sophonisba probably meant "Grandmother"—Martha George (Mrs. Matthew) McGlathery, who was a widow at this time.
7. Chyle: intestinal fluid.

67. CWP to Zaccheus Collins

PHILADELPHIA. MAY 11, 1822

<div style="text-align: right">Philadelphia May 11th.1822.</div>

Dear Sir

"*A friend in need, is a friend indeed.*"[1] The loan you so obleegingly make, I esteem a great favor, my Son Rubens is equally obligated to you, my Son Rembrandt may now come on to take his family to N. york, where he has already rented a House, and he is anxious to commence his labours of the Pencil. I have almost finished an interresting Picture of Mrs. Clerc, consort of the Deaf & dumb teacher—which I wish you to see when you are passing in this quarter—

<div style="text-align: right">I am with great esteem & high respect
your friend CWPeale</div>

Zachius Collens Esqr.

ALS, 1p.
PHi: Daniel Parker Papers. Zacheus Collins Section.
Copy in PPAmP: Peale-Sellers Papers—Letterbook 17

1. See John Heywood, *Proverbs* (1546): "A friend is never known till a man have need." *Bartlett's Familiar Quotations.*

68. CWP to APR

PHILADELPHIA. MAY 21, 1822

Philadelphia 21st.1822.

Dear Angelica

Yesterday morning your sister Sophonisba, was delivered of a dead Child about 3 days deceased, She suffered a great deal of Pain about 2 hours, and pain was severe all yesterday, obleged her to take a good [illeg][1] this morning she is much better, and I hope [&] believe she will do very well. The Phisician advises her to suckle a Child which one of her girls had lately given her. and he is also of the opinion that she will be much benefited by it as Mrs. Wistar was,[2] who never had a child living, until she had given suck to other Children—after which she has had several, who are living & one of them is almost near grown.

I keep the House your Brother Rubens left, and have housekeeper who formerly was housekeeper for him, & my family consists [of] Frank[lin & Titian]. I have 6 Coffee cups, [6 sp]oons, [& 6] knives & forks, & as little furniture as possible— I told my friends that may chuse to take their meals with me, that I can entertain 3 of them at a time— I continue the use of my Pencil & can paint best without spectacles. Having just finished 3 interesting Portraits; Laurent Clerc, teacher of the Deaf & Dumb, he was the first teacher under the Abbe Secar of Paris—[3] His wife a very handsome & highly accomplished Woman, & her child of 2 years of age enjoys her speach, but she also converses with her Consort by [illeg. hand signs?]. These pictures have given me much pleasure in the execution of them

You will find Rubens consort a very agreable woman, and worthy of your acquaintance.

I have exhibited a Portrait of Mr. Burd, uncle of Ruben's Wife[4] and when the exhibition is over I mean to send your Portrait packed up with that belonging to Rubens.

Love to the children yrs. affectionately
CWPeale

PS. I am now manager of the Museum & have Franklin & Titian my [oars?] and mean to sell my farm as soon as [I] can get a reasonable price for it.

Mrs. Angelica Robenson

ALS, 2pp.
PPAmP: Peale-Sellers Papers—Letterbook 17

1. In his letter to RuP the following day, CWP wrote that Sophonisba had been "obleged to take a good deal of opium." CWP to RuP, May 22, 1822, P-S, F:IIA/67A11.
2. Perhaps Elizabeth Mifflin Wistar (d. 1840), Caspar Wistar's second wife, for whom CWP made teeth in 1811, 1816, and 1822. Wistar, whose first wife had no children, had three children with Elizabeth. *Peale Papers*, 2:1234; 3:304; *DAB*.

3. Abbé Sicard (1742–1822) presided over the Institute for the Deaf and Dumb in Paris when Laurent Clerc began his formal education there in 1797. Sicard helped develop a systematic sign language as a medium of instruction for the deaf. *DAB*, q.v. Laurent Clerc; *Encyclopedia Britannica* (1966 ed.).

4. CWP exhibited Edward Burd's portrait in the PAFA exhibition of 1822 as *Portrait of a Gentleman*. See above, **3**; Falk, ed., *Annual Exhibition Record*, p. 163.

69. CWP to Eliza Patterson Peale

PHILADELPHIA. MAY 24, 1822

Philadelphia May 24th. 1822,

My dear Eliza

You may be surprised that I should address a Letter to you instead of Rubens, but [it] will be understood as you puruse it. I had some faint hopes that you would be acquainted with my daughter Angelica, and in a letter I wrote to her the other day[1] to acquaint her of my daughter Sophonisba's situation, I gave you the character you merit in a very few lines & thinking to do what I could to bring you togather, but a letter which she has wrote to Sophoa.[2] contains as follows. "Painful as it is I must say something on a subject to me much distressing, it is my wish never to say any thing to injure my husband but I must lament his prejudices are of such a nature, and so violent as to compel me to neglect a *Brother so dear to me* as Rubens *is*, and *has ever been*. I have made a rule never to do any thing clandestine. I therefore dare not visit them nor can I ask them to my House to be insulted. The pain caused by these circumstances, reconciles me to the thought of visiting Virginea, a visit I have dreaded. we go as soon as I can get ready." Dear Eliza, you must pitty Angelica, She has had a hard time of being tyed to an Ignorant, brutal and miserable being—who by speculations had become rich, with so little sense as to be proud of his wealth.[3] I have said enough on a disagreable topic, and will conclude in saying something on business,— I have visited some ladies whom I thought would be likely to purchase the House, and I wait for them to see & consider whether they will purchase it. one whom I thought a few days past would choose it, as she seemed much pleased with the situation, said she would consult her husband, he is very rich and fond of his young thriving wife, I fear she has not the influence represented to me. The other is a Widow whom a brother has left her many ground rents, by which she may easily obtain cash, far sufficient for our purpose. But, after so long trying every means in my power to bring it into notice, I find it rather discouraging. Mr. Tagart[4] tells me that I ought not to sell it now for it will command a higher price some later time hence. I wish [illeg] much to send your goods to you, but I have not yet got a bed for Re-

beckah[5] to sleep on— I expected Linnius would have sent in Franklins bed—I fear he is sick again—he was taken with chills & fever when in the City two days past.

I wish to hear whether you have many visitors to the Museum? my success is but middling, but as the holydays come next week, I expect it will be a better harvest. I cannot spare time to say more than presenting my love to you both, farewell. I see your brother George the other day, but not your sister[6] since you left us. they are well. CWPeale

Mrs. Eliza Peale

 Baltre.

ALS, 2pp.
PPAmP: Peale-Sellers Papers—Letterbook 17

 1. See above, **68**.
 2. Unlocated.
 3. Alexander Robinson's hostility to his in-laws arose in part from his dislike of their public exhibitions and museum occupations, which he considered "*degrading.*" Soon after marrying APR, he indicated his antipathy to CWP's occupation as a museum keeper. Robinson also opposed ReP and RaP's exhibition of the mastodon in Baltimore in 1804–05, and later ReP's opening of a museum in the city. *Peale Papers*, 2:121, 719; 3:108n, 172n.
 4. Joseph Tagert was president of the Farmers and Mechanics Bank. *Philadelphia Directory* (*1822*).
 5. CWP's housekeeper. See above, **68**.
 6. Mary Patterson. See *Peale Papers*, 3:808, 810n.

70. CWP to RuP

PHILADELPHIA. MAY 29, 1822

Philadelphia May 29th. 1822.

Dear Rubens

I have received your letters of the 26 & 27th.[1] on receipt of the first immediately waited on Mr. Snyder,[2] he refered me to Mr. Ule in the Bank (or some such name)[3] I told him that I did not know that Gentleman, But I was acquainted with Mr. Tagart, he advised me to consult with him I did so, and Mr. Tagart said it was easey to have it settled by Mr. Snyder calling on Mr. Ule or Huyle & he would by letter draw for the note—accordingly I went with Mr. Snyder to the Bank this section this morning, Mr. Snyder told Mr. Tagart that he had not put Rembrandts & your Note in the Bank for collection, but he had drawn the money. Then Mr. Tagart told me that I ha[d] best draw a Note on the Bank & let Mr. Snyder indorse it, but that I would do well to reduce it as much as I possibly could, I told Mr. Tagart that I could only reduce from it $100 I have drawn the note for $821.90 and Mr. Snyder has promised to indorse it for presentation at the Bank tomorrow But whether the directors

will discount the note or not I cannot say, Mr. Tagert has promised me to do what he can for me.　　　　Yesterday I put on board the regular Packet Schooner Argo, two packing cases about an hour before I received your letter—one case packed up before you left us, the other the large Packingcase, which Franklin reduced considerably, it contains Philess's bed, your meat & sundry Kitchen furniture & your Brass plate,—I will look for the Box you describe and send it also by the Argo.

I have not heard from Rembrandt— Sophonisba is better but still very weak. The Museum does tolerably well, better in the nights than by day.　　　　I have paid Shaker[4] for the Oil $135 &c. and just now the Taylor's Bill (O'Neil) 15$.[5] I can't be particular now on such Matters.

I mean to continue House keeping, for I find that I have so many things besides Lumber that I do not know what to do with them. Should I attempt to board out, Perhaps it will cost me about 150$ more than my board @ 6$ Pr. Week. In 2 or 3 days I will cast up my Account of Housekeeping in order that Titian may see that 600$ would not support him in House keeping, we live savingly, yet have a sufficiency of good things at our Table. since writing the above I have drawn another Note instead of having Interest to calculate on 1.30 I make the Note 840 Dollars—Snyder seems to have confiden[ce] that the Bank will discount it. I am fearful that I shall not be able to obtain the 400$ [for] which I gave m[y] Note to my friend Z. Collins, unless I can sell your House, I called yesterday on Doctr Coxe[6] whom I had heard was a bidder for it [at] the sale—he told me that he bid to 6000$. You know the man. Mrs. Wistar yesterday told me that she thought she has found a Purchasher for it in a Doctr Shippen whom she says has married a rich Lady of Virginia—I will ma[ke] some further enquiry who he is, & what change [chance] of the Sale.

I have not been able to find Davids account (the Carpenter) and I wish to pay him, I remember to have seen it, and think it is about 12$. I have paid the Carpenter for making your Packing cases $14.69.

will it not be proper for you to send me the Letters received from Europe wishing an exchange of articles of Natural History.[7] We have duplicates of Birds &c preserved by Titian to make returns for for what has been sent to this Museum, and I wish to shew such of them as may be worth the notice of the Directors. I find that Doctr Godman will in all probability remain in the western Country, and it is proposed to Elect a Young Man now in Paris in his place (I dont recollect his name) he is said to be a man possessing Abilities and fortune, an Acquaintance of Z.Collins. and will it [is] said bring with him such things as may be usefull in his lectures. I see Miss mary Patterson a few minutes last week. she returned in the same day. My love to Eliza, & tell her that I am equally at a loss for her company, at home as in visiting—I now and then visit some Old

acquaintances, Mrs. Powil,[8] Mrs. Wistar, Mrs. Mifflin[9] and Miss Di[c]kinson[10] &c. And have not had the pleasure of seeing the Miss Butlers, altho' I have made two attempts. The servant tells me they are not well. Sophoa. is better, Dr. James[11] tells me that he thinks she will do well.

I will write as soon as I learn the Bank business. Love as usial— adieu

<div align="right">CWPeale</div>

Mr. Rubens Peale

ALS, 3pp.
PPAmP: Peale-Sellers Papers—Letterbook 17

1. Unlocated.
2. Unidentified. Possibly Joseph Snyder, a Philadelphia gilder who made frames for ReP. *Peale Papers*, 3:201n; see below, **156**.
3. Unidentified.
4. Unidentified.
5. In 1822 there were three tailors in Philadelphia with similar names: John O'Neial at Lombard above Tenth; Daniel O'Neil at 246 South Fourth; and Robert O'Neill at 33 Arch. *Philadelphia Directory (1822)*.
6. John Redman Coxe (1773–1864), a member of the APS and one of the first directors of PAFA. Coxe's low bid on RuP's house and CWP's remark, "you know the man," may allude to a residue of bitterness between Coxe and the Peales. In 1816, Coxe opposed CWP's attempt to convey the Philadelphia Museum to the Corporation of Philadelphia. *Peale Papers*, 2:426–27, 434–35, 846, 854n; 3:437n.
7. For letters from Europeans offering exchange of specimens, see Alexander Ricord to RuP, January 6, 1821, P-S, F:VIIA/3D14-E1; Lewis Lederer to CWP, January 10, 1821, P-S, F:IIA/65E12-F1; Henry Ploss to RuP, above, **6**; Henry Escher to Unidentified, above, **29**; Alexander Ricord to RuP, above, **56**.
8. Unidentified.
9. Clementine Ross, the widow of John Fishbourne Mifflin (1759–1813), John Beale Bordley's stepson and CWP's lawyer, who lived at 226 Walnut Street. *Philadelphia Directory (1822)*; *Peale Papers*, 3:10n.
10. Mary Dickinson. See below, **189**.
11. Dr. Thomas Chalkley James (1766–1835) taught obstetrics at the University of Pennsylvania School of Medicine. He was one of the attending physicians at EDP's delivery of a stillborn and at her death in 1804. *Peale Papers*, 2:637, 638n.

71. CWP to RuP

PHILADELPHIA. MAY 31, JUNE 1, 1822

<div align="right">Philadelphia May 31st. 1822.</div>

Dear Rubens

Yesterday morning I met with my friend Z. Collins who told me that he had some money transactions to settle and he was going to Mr. Morris[1] to put my note or transfer it to make a payment on, for collection. I dont know which he said, owing to my deafness; this has alarmed me with the the fear that I shall not have cash to meet it— The rent for this House

must be paid in 14 days, and my reducing the note to Snider 100 $ and also the discount on it, also the discount on note 1550 to be discounted this day, will probably ⟨well⟩ so reduce my money in Bank, that I cannot have much left. how much I shall know to day, as I have a statement of my Bank book with them to prepare against I call for it. much will depend on the visitation of the Museum and I am fearful that the weather becoming warm will be against me. yesterday produced but little, being warm, about 20$. Genl. Williams with his Niece Elizth. is here,[2] they visited the museum last evening. Elizth. and a young Lady he[r] companion are at Colemans. Sophonisba had invited her to stay there, I suppose for a few weeks— The uncle is looking out for a small Country Seat if he finds one to his mind he will purchase it. My farm is too large for him—I wish to Sell it at the price of 16 or 17000 $. the part Linnius holds is alittle more than 6 A. therefore will be left about 98 a. This is reducing the price Pr. acre to about 163$ Pr. Acre, and surely with the mill seat with a fall of 23 feet, it ought to fetch that price. I shall now stop to finish this, when I know the proceedings of Bank business, and have it ready for tomorrows post. 2 O'clock. the note being discounted, I drew a Check to the amount of $109.27 Cts, for Mr. Snyder, and he told me that Mr. Hale[3] would finish the business with the Baltimore Bank.[4] I must confess that I am ignorant in this sort of business, but I suppose it may be in the proper train to relieve you, at least I hope so. June 1st. last night I see Sophonisba, and staided with her about 20 minutes, and since her delivery never before more than 2 or 3 minutes—she was so much better and in good spirits.

I cannot find the Box you wrote for. one No. 4 is I expect that for Rembrandt I raised the lid & found it stuffed with board & paper. I suppose it contains plaster Casts. I dont at present think on any subject that might give you pleasure, and to say any thing which would only give you pain, is not to my mind, my resolution is, to pass on through life and bear with the folly of others silently, unless by speaking I can make a reformation of the conduct & manners of ⟨others⟩ those I must associate with. very few have sense in sufficiency to receive advise— My love to Eliza & Charles, yours

affectionately CWPeale

Mr. Rubens Peale

ALS, 2pp.
PPAmP: Peale-Sellers Papers—Letterbook 17

1. Unidentified.
2. Probably David Rogerson Williams (d. 1830) of South Carolina, who was made a brigadier general in 1813. His niece was Elizabeth Alston Williams (1803–30), daughter of Joseph John Williams II (1775–1808) and Elizabeth Norfleet Hunter, whose portrait CWP

took in 1822 (*private collection*). See below, **84**. Sellers identified the general as William "Pretty Billy" Williams, of Montmorenci, Warren County, North Carolina, but William Williams is not listed in Heitman's register of soldiers. Heitman, p. 1040; *P&M Suppl.*, pp. 82–83.

3. Perhaps Thomas Hale, a broker whose office was at 83 Chestnut Street. *Philadelphia Directory (1822)*.

4. The Union Bank of Baltimore, which is identified in Daybook 1 (p. 161) on May 11, 1822, under "New Accounts" with RuP: "To an order on the Union Bank Baltre 400—." Scharf, *History of Baltimore City and County, Maryland*, 1:455.

72. CWP to RuP

PHILADELPHIA. JUNE 7, 1822

Philada. June 7th.1822.

Dear Rubens

Thanks to Eliza for her obliging letter,[1] and I am happy in hearing that she is contented with her resedence in Baltemore, no doubt she will have as many visitors as she may desire more especily if you give them a plenty of *good chear*, such is the way of the World— My note to My friend Z. Collens date the 11th. May payable in 60 days. Your slides for the magic Lantho[r]n are arrived,[2] and Coleman says that you must send him $80. there is some little cost besides, but you need only to send the above sum. very few ask the price of the H——[House] of late, one person last night at the Museum, demanded your price, no other within a fortnight. My account of expenses of House keeping for the first month is $66.02½ multd. by 12 is $792.30, but I may posibly have omited setting down some Items.[3] I mean to continue keeping a statement, and probably may continue to keep the House. I cannot bragg about the income of the Museum, and may give you a statement of it in a future letter. Sophonisba is mending, Polly Peale[4] has been very ill, bled 4 times, now getting better. James has the gout, also Raphaelle, my love to Eliza & Charles, Yrs. &c.

CWPeale

Mr. Rubens Peale.

ALS, 1p.
PPAmP: Peale-Sellers Papers—Letterbook 17

1. Unlocated.

2. The "New Magic Lanthorn slides" from Europe were first exhibited in the Philadelphia Museum on August 6, 1822. CWP continued to utilize them for evening "Illuminations" in the fall. Among the images projected were "Instructive Astronomical Demonstrations and amusing Grotesque objects." RuP began placing advertisements for "ASTRONOMICAL SHADES" on July 19. His use of the term *shade* and not *slide* may be significant: *slides* usually referred to paintings on glass, *shades* to illuminated transparencies that served as background for exhibitions, such as a demonstration of an eclipse. RuP's advertisement also mentioned "a number of beautiful and instructive illumination[s] in NATURAL HISTORY, MOVEABLE LANDSCAPES, MANNERS and CUSTOMS, &c. &c." These other

133

images may have been on glass slides. *National Gazette and Literary Register*, July 5, August 30, 1822; *American Commercial Daily Advertiser*, July 19, 1822.

The magic lantern worked much as a slide projector works, illuminating and enlarging scenes painted on glass slides and also projecting transparencies. The device became popular in large theaters with the use of strong light sources such as the Argand lamp, invented in 1784. RuP, who may have seen it used in London in 1802 by the famous French showman Paul de Philipstal, began its use in the Philadelphia Museum in 1820. *Peale Papers*, 3:813–14.

3. CWP's accounts for the 1820s are fragmentary and do not include these figures. Daybook 1, p. 158.

4. JP's wife, Mary Claypoole Peale.

73. CWP to RuP

PHILADELPHIA. JUNE 9, 1822

Philadelphia June 9th. 1822.

Dear Rubens

If I remember right you told me that when Doctr McClelan paid his rent, that I was to pay the same sum to Mr. Graff. This is an Idea resting in my mind, but you may suppose that my memory at my time of life cannot be depended on. I beleive so, therefore it will be my indeavor to make memorandons on every occation that I may refer to them in order to be corrected. I find that the Doctrs rent became due on the 6th. ult. did you receive the said rent before you left Philada.? I do not recollect that I have received said rent. you must write to me on this subject. Mr. Worrel[1] meet me the other day, and told me that he had mentioned to you a long time past, his intention that you should pay him one $ pr. day in your future rent, and he asked off me whether you had spoken to me on that subject, my reply was that I had some such recollection, however I told him that shortly I would call on him to pay my rent & then we would talk about it according to the custom of rents. that I was not pleased with my painting-room, and I wished to have one with a north light, and asked him if he had a House with a Room that would suit me better,—this I thought might shew him that I was not very anxious to keep his House, nor would I if I could find one more to my liking in the vicinity of the Stadt-house. this being very doubtfull, very probably I shall remain in it, my lumber[2] is too considerable to be mooved to a lodging House, and by being a House-keeper I have the pleasure occationally of asking a friend or relation to take a meal with me, so far I feel an independance greatful to my failings. some of my friends say that it is too troublesome to me to bring my marketing &c but I prefer carrying my Basket & even going twice to bring all that we may want, rather than being plaged with a servant. If you have the account of David Whit (carpenter) not being able to find his account, which I remember to have seen, and he wanting money I paid him yester-

day $15. and took his receipt in the Book. he says that there is a triffle due him for something done at Eliza's House in Walnut street. but he did not want it at present.　　　　Franklin is making a display of the Coins, & Titian giving a handsome arrangement of the Shells, in classical order. my difficulties for want of Room increases, the Coins ought to have a good light otherwise the heads and devices cannot be seen. by the manner of display that Franklin has adopted they form a tolerable History of the reigns of Kingdoms.　　　　I have heard that Rembrandt was painting a Lady's portrait,[3] by a catalogue of the exhibition I find he has exhibited the portrait of Lord Wellington (a facsimile) he says, also portrait of me,[4] he says I began the study of Painting when 26 years old, that I was a short time a pupil of Wests, for some time one of the first portrait painter[s] in America, that I now paint without Spectacles at the advanced age of 82. Those pictures serve to inform the public that he resides in broad-way, in a fine House which I wish may not have too high a rent to be paid by his success of painting & exhibition of his Historical pictures.[5] I have nearly finished a portrait of Betsey Williams for which I expect $100, and Genl. Williams says that he will has [have] his and his Lady, when he can get them painted at the same time. A cousen of Miss Williams came with them, she also wants me the [to] paint her portrait, and she has wrote to her relations in Carolina to know if she may have her portrait at $100 price, in all probabi[li]ty I shall also have to paint it. I have began the portrait of Doctr Hare,[6] he has given one sitting for the face, it is like. I had then a bad cold and I told him I would call on him when my cold was better, but since I am well have been ingaged with Betsey Williams.

I have this minute received your letter of yesterdays date,[7] and will as soon as I finish this scrole carry the Money to Coleman,—The Ship that brought the slides had not began to unload, therefore it probably wil be some days hence before I can get the slides—but as soon as I receive them, no time will be lost before I send them to you.

You do not say in your letters how the business was finished respecting Snyders $900 business. I was not without my fears that the Bank would give my credit at this time of difficulties in money Matters, and I feel my obligations to Mr. Taggart for his friendly aid.

The monies received in the Museum in May $671.25 expences by the Book, including rent for the month, is 219.73 but oil and probably some other expences are not included, consequently a month statement is an uncertain account, however it is pleasing to find that the income of May in the present year is greater than is [it] was last year, I do not exactly remember to what amount.[8] I hope we may continue to mend—at any rate I will curtail all the expences I can that I may be able to say, that I owe nothing but what I can pay every week. how long before that will be my

situation is not within my power to say. long Bills from Printers are not to my mind very pleasing, I have paid off the National Gazette & discharged the paper, and made some Items charge to you on it.[9] Sophonisba is on the mending, but still weak. Linneus & Wife are better by yesterdays account—Polly Peale mending slowly & James is better, Raphaelle's goutty hand prevents him from doing any thing. Mr. Geo. Patterson & Mr. Buckley[10] dined with me yesterday, they are well at Chesnut hill—

Doctr. Shippen in the City the other day, ready to start in a Gigg—his wife got into it, the Horse started, she was thrown out & her arm hurt, but not broken. so much from a want of care with a spirited Horse—the Chair broken to pieces. I have crowded togather all the news at present.

<div style="text-align:right">Love to Eliza & Charles yrs Affectionately
CWPeale</div>

Mr. Rubens Peale.

ALS, 3pp.
PPAmP: Peale-Sellers Papers—Letterbook 17

1. Possibly Isaac Worrell, deed recorder for the city and county of Philadelphia, or either John or William Worrell, merchants. A Mr. Worrell owned the land at Walnut between 6th and 7th Streets on which ReP had built his house, now owned by RuP. RuP paid ground rent to Worrell, a condition that seemed to hamper the sale of the property. CWP also rented a house from Worrell on 6th Street when he moved back to Philadelphia. *Philadelphia Directory* (*1822*); *Peale Papers*, 2:881, 1183n.

2. A term for old household items.

3. Possibly Joanna Stoutenburgh (Mrs. John) Hone (1765–1838) (*private collection*; replica, *Museum of the City of New York*). John Hone (1764–1832) was a New York businessman and cultural leader who, along with his more famous brother, Philip Hone, mayor of New York City, was active in the affairs of the American Academy of Fine Arts. ReP Catalogue Raisonné, NPG.

4. ReP's paintings were exhibited at the American Academy of Fine Arts in New York City. The catalogue listed two portraits: the *Duke of Wellington*—a "facsimilie copy" after Sir Thomas Lawrence's original, then in the possession of William Caton of Baltimore, which ReP painted in 1818 (*Museum of Fine Arts, Boston*; *Wadsworth Athenaeum, Hartford*) (*Peale Papers*, 3:662–64); and a portrait of his father (1811: *Historical Society of Pennsylvania*). ReP was mistaken about his father's age; CWP was 81 on April 16, 1822. See below, **76**; Daybook 2, February 7, 1811; *Catalogue of Paintings and Engravings. Exhibited by the American Academy of Fine Arts. June, 1822* (New York, 1822), Archives of American Art, roll N510, frames 278–82; CAP.

5. In June 1822, ReP inserted a "CARD" in the New York newspapers to advertise where he lived and worked:

> REMBRANDT PEALE, Portrait Painter, No. 345 Broadway. Ladies and gentlemen are respectfully informed that a room is appropriated for their accommodation in viewing his paintings.

National Advocate, June 6, 1822.

6. (*United Missouri Bank of St. Louis.*) Dr. Robert Hare (1781–1858), professor of chemistry at the University of Pennsylvania Medical School, invented the oxyhydrogen blowpipe, which generated sufficient heat to melt metals previously thought impossible to melt, such as platinum. A device similar to Hare's blowpipe was used in the Philadelphia Museum for demonstrations and experiments. *Peale Papers*, 2:1142; CAP.

7. Unlocated.

8. The museum income for May 1821 was $464.25, and for May 1822, $672.25. Philadelphia Museum Account Book, January 1820-July 17, 1824, P-S, F:XIA\6A3-C5.

9. CWP continued running advertisements in the *National Gazette* in July and August, although not the large columns he had previously used that contained lists of new accessions and donations.

10. Daniel Buckley was a gentleman farmer and a trusted associate of CWP's who had advised CWP on his purchase of Belfield in 1810 and on other matters pertaining to farming. CWP painted Buckley's portrait in 1820 (*private collection*). *Peale Papers*, 3:12n, 816n.

74. RuP to BFP

BALTIMORE. JUNE 11, 1822

<div align="right">Baltimore June 11th. 1822.</div>

Dear Brother.

Mr. I. Lukens[1] has been with me for a few minutes this morning but hadnot time to see the museum but in a very loose manner— He will place in your hands the Model of Red H perpetual motion and I will be much obliged if you will pack it up will [well] and send it by the steam boat, as soon as possible.[2] I shall be very much put to it, to make up my July payment which is to be paid the last of this month 500. I had made calculations on receig. the Magic Lanthorn objects for some time past.

Say to my Father his letter yesterday was very exceptable for its diversity of contents altho it contained the news of the non arival of the articles, from London.[3] Amongst them were to be a balloon, glass figures, Tumbling Man[4] &c. they will be very exceptable here my apparatus is still very small and I have been engaged ever since my arrival in the large operations, so that small articles have been deferred.

Tell my Father that the rent from Dr. McClellan was due the first of may which he said he would receive he complains of his memory not serving him—the anxiety about Raphaelle &c must have affected him very much. I wish he would not place so much reliance of Raphe. promises and fair words, they are like the dust that is now rising, promising a severe Storm but it all ends in dust and but little sprinkling. *or a soap bubble*. When I left Phila. I knew what was to happen and I hinted it to my father.[5]

I had the misfortune to have the globe of the Orry[6] broke last week by the white-washer. And ⟨today⟩ yesterday to loose the Wild Cat I expect his situation was to warm, for on skinning him I found that it was very fat.

Say to my father that I beleave Davids bill was left amongst the other bills as I donot find it. however in a few day I shall have examined all my papers and send all that has any connection with the Museum.

Eliza joins me in love to all, and let this suffice untill my next which I hope will be more satisfactory yours affectionately

<div align="right">Rubens Peale</div>

ALS, 2pp.
PPAmP: Peale Papers

 1. Isaiah Lukens (1779–1846), Philadelphia clockmaker, designer of tools and scientific instruments, and cofounder of Philadelphia's Franklin Institute, was closely associated with CWP, who painted his portrait in 1816 (*The Franklin Institute Science Museum*).

 2. In 1813, Lukens built for RuP a model of Charles Redheffer's perpetual motion machine to demonstrate the fraudulence of Redheffer's claims. A showman, Redheffer created a sensation in Philadelphia when he demonstrated his perpetual motion machine in 1812–13 and again in 1816. The city's mechanics and artisans, who generally believed perpetual motion was a violation of natural law, were nevertheless fascinated by Redheffer's device. Writing about the controversial episode in his memoirs, RuP noted that "the excitement continued for months and increased the income of the museum considerably." *Peale Papers*, 3:182–88.

 3. See above, **73**.

 4. Probably the device that RuP described in his letter to BFP on June 28 (below, **80**), which he referred to as the "chinese tumblers."

 5. Except for comments from CWP that RaP had no work but was planning to exhibit still lifes at the PAFA exhibition, or that his gout prevented him from working, we have no information about RaP's activities at this time. See above, **65**, **73**.

 6. The *orrery* is a mechanical apparatus that demonstrates the orbits of the planets around the sun. *OED*. See below, **242**.

3 An Effort at Dentistry: June 14, 1822–February 13, 1823

In the spring of 1822, Peale had occasion to test the porcelain teeth made by a French dentist, Anthony Plantou, who had settled in Philadelphia and was successfully practicing his profession. His experience with Plantou's teeth renewed his long-held interest in dentistry, and from 1822 to the end of his life much of his time was devoted to developing porcelain teeth, which he believed would contribute to good health and improve appearance. The problem of finding the best materials and learning the art of firing the mixture to achieve the desired hardness and color was a challenge that Peale could not resist, given his lifelong mechanical propensities and concern for health.

In his thirties, Peale had undertaken the manufacture of teeth because dentistry had not yet developed as a profession in America. There were few dentists even in the larger cities, no dental schools and professional associations, and no government regulations. Peale learned to make teeth from a French book on the subject, and he generally followed accepted practice, using ivory and animal teeth, which were available to dentists everywhere. These materials, he soon found, were unsatisfactory, not only because ivory stained and animal teeth broke easily, but because animal substances were prone to decay and produced an unpleasant odor. When he later discovered the possibilities of porcelain, which was beginning to be used by a few dentists in large cities such as Boston and Philadelphia, his interest in attempting to make such teeth increased. Porcelain teeth were expensive and, according to Peale, those that were being made were poorly crafted. He was challenged to meet both problems.

Peale's easy assumption of the dental profession reflected his belief that the human body was a wonderfully built machine that could, however, break down prematurely through abuse and ignorance; when this happened, he was convinced a good mechanic or artisan like himself who had studied the human machine could provide the best treatment. Whether making an artificial hand for a friend, or a truss for another suffering from a hernia, or inventing a portable steam bath to aid in hygiene and

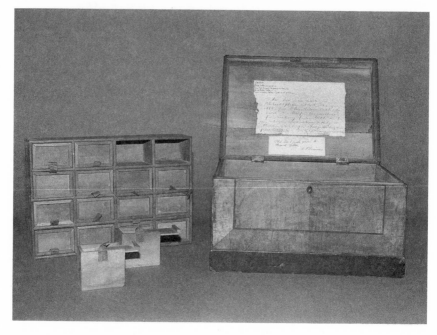

23. C. W. Peale's Dental Box, ca. 1808. The Baltimore City Life Museums. 8 × 13 × 9″ (20.2 × 33.4 × 23.9 cm).

cure colds and fevers, Peale never doubted that with his mechanical ability he could effect bodily cures. In joining his love for mechanics with his concern for health, the repairing and making of teeth appeared as a natural activity for him to undertake and, given his financial problems, a promising source of income—a "business of profit."

Peale's renewed interest in dentistry in 1822 was an aspect of a general resurgence of his creative and intellectual faculties after he had recovered from his devastating illness and the loss of his wife. While grappling with the mechanical problems involved in firing porcelain, he was also experimenting in the effects of light in his portraits, particularly in his self-portrait of 1822 (*The Artist in His Museum*) (Frontispiece) and the lamplight portrait of his brother James (Plate 1). And once again, his thoughts turned to the natural history encapsulated within his museum and to the necessity of developing the museums's programs, both to attract more visitors and to render the institution indispensable to Philadelphia's cultural life.*

75. CWP to ReP
PHILADELPHIA. JUNE 14, 1822

<div align="right">Philada. June 14th. 1822.</div>

Dear Rembrandt,

I wish to hear your progress since you have began in N. York. By the Catalogue of the Academy of fine Arts, I find you have exhibited 2 portraits, have you not made a small mistake of my age? I was 82 the 16th of April last.[1] I hope my Eyes are still mending—I have just finished a Portrait of Miss Betsey Williams and now about a head of Doctr Hare.

I am now diverted alittle from painting, for having a set of Enamel Teeth made by Mr. Plantou[2] that do not altogather please me, and believing that I can make them more to my mind, If I can hitt the composition, and I have some receipts for the purpose, yet I am advised to apply to Doctr. Mead[3] who I am told that he can assist me substancially—and probably he may not be unwilling to let me have the Materials ready prepaired, as the quantity sufficient for my use will be very small, therefore I wish you to call on him & tell him that he will do me a great favor by giving me his advice and aid. I think to set about making a small furnace in my Chimney to burn my essays, on tomorrow, therefore your early attention to this business may shorten my labour provided the Doctr is so obleging as to do me that important service.

I have determined to continue my House keeping because I have too much lumber to be put into a private lodging, a painting Room & a work [room] are indispensable—and Rebeckah is a good House keeper and she does our Washing, Franklin & Titian board with me. It is a saving to them as I only charge each 3$ pr week including the washing.

Sophonisba is beginning to be her self again She walks into the front Parlour.

I have not yet found a Purchaser for Rubens House, and I am trying to get a purchaser for my farm, I offer it for 17 thousand dollars, and the mill seat of eastern meadow is worth 4000$[4]

If I can sell it before I find a purchaser for Rubens's House, I will then pay the price I now demand for that House. I may live in it myself, at any rate retain it on a certainty of its fetch.g a higher price hereafter.

The Academy of the fine Arts have a considerable run of Visitors every afternoon in good weather. and my Museum does tolerably well at present. Franklin & Titian do themselves credit in the display of several departments.

My love to Eleonor & the Children yours

Affectionately CWPeale

Mr. Rembrandt Peale
⟨*museum*⟩ N.York.

ALS, 2pp.
PPAmP: Peale-Sellers Papers—Letterbook 17

1. CWP had previously corrected ReP about his age, and now he himself became confused. He was eighty-one on April 16, 1822, and not eighty-two, as ReP had indicated in the catalogue entry for the American Academy of Fine Arts exhibition of June 1822 (see above, **73**).

2. Anthony Plantou, a "Surgeon Dentist, from Paris" who had settled in Philadelphia, advertised himself as "the only Dentist in the United States who possesses the art of making incorruptible TEETH." Plantou claimed that his artificial teeth were "preferable to all sort of animal matter, which decaying in the mouth creates a bad breath and contributes to the decay of the sound remaining teeth." In July 1822, Plantou reduced the cost of his teeth from ten to five dollars a tooth. In the same notice, Mrs. Plantou advertised herself as a portraitist "in oil and miniature." *National Gazette and Literary Register*, July 6, 1822.

3. Unidentified.

4. CWP posted a notice in the museum offering for sale RuP's house and his farm; it was probably similar in part to an advertisement he placed in the July 5 isssue of the *National Gazette and Literary Register*:

FOR SALE,

A convenient House, corner of Walnut and Swanwick streets, with back buildings that will always command a good rent, independent of the front dwelling.

ALSO,

A Farm containing 98 acres, divided into 6 fields, with a good proportion of woodland and watered meadow—and a mill seat of 23 feet fall—a considerable part of which Farm is enclosed with Thorn Hedges.

Enquire of the doorkeeper of Philadelphia Museum.

76. CWP to ReP

PHILADELPHIA. JUNE 21, 1822

Philadelpa: June 21–22

Dear Rembrandt

yours of 15th. instant received,[1] and I might have wrote an answer sooner, but I waited to see what my prospects would be to comply with my ingagements. I am fearful that I cannot get a purchaser for Ruben's House soon for the Citizens are now going into the Country, and untill their return, the chance of selling is very doubtful, the ground rent has prevented me from succeeding with several applicants. The 400$ had of

my friend Z. Collens would be paid, on the 11th. of next month, besides interest on several renewed notes, that ought to be lessened at each renual. The affair of Snider note imbarrased me very much, but by my advancing 100$ I got the remainder discounted— having finished Miss Eliza Williams Portrait I expected to have received my 100 $ but behold the Genl. her Uncle, meet with disappointments in the payment of monies due to him- here & in N.York. therefore he promises me to send it on from Richmond in about a week or 10 days. It has been fortunate for me that the month of may was favorable by visitations to the Museum, I had a quarters rent in this House besides a numbers of Bills for Rubens & sundry for expenses of the Museum that were pressing, and I am slowly getting rid of them, June is not productive. the Museum income is decreasing fast as is usially the case at this time of the year. Franklin wants me to advertize the closing of the evening elluminations after the 4th of July, but I am sick of Printers bills, they have been very expensive, and I am labouring to wipe of some old scores of them.

anough of complaints—I wish to write more to your satesfaction, and as soon as can make my way with the present demands on me, I will send you 50.$ for the Portrait of Doctr. Michel.[2] I wish you may make good and pleasing portraits of Hosack[3] & Michel, have you a convenient and spare room to shew your portraits in?

I am well convinced that the exhibition of Portraits *free of expense to visitors* is the best means to obtain imployment of the Painter, some will have their portraits painted on purpose to have them seen, not unfrequently I have had portraits left with me for a great length of time that they might be seen. It is a vanity of human Nature which Painters ought not to dislike.

Wm. Dunlap's large picture of *Christ rejected* is now in exhibition here,[4] I have seen it, but he has placed his rail at too great a distance from the picture to suit my Eyes, I have told him so—and he was so complisant as to invite me to see it closer. I cannot yet learn whether it is much visited. The Academy of the fine Arts is now the place of resort in the afternoons for Ladies of fashion. it never was visited so well for years past.

I am riding a new Hobby—I [am] making essays at porcilain Teeth, have built a furnace in my working-room and commence burning charcoal, but have not yet been able to raise heat sufficient to melt fleltspar and clay, my last letter requested your aid, and I suppose you received that letter after you wrote to me. Plantou is not a good Mechanic, yet he has succeeded in making some good porcelain teeth. he has I believe been aided by Doctr Mead. The price demanded for work by Mr. Planteau is very extravegant, he has attempted a sett for me on the Bottoms I gave him, and not done them to my mind. I want to pay him for what he has

done, but he avoided it by saying when he has done another set we will then settle. I must get rid of him as well as I can, by shewing him that I cannot use these teeth without they are altered & that I am still obleged to have recourse to my Hoggs and Cows teeth to be comfortable.

I have again made an attempt to sell my farm, having drawn the line, which leaves to the Mill, now occupied by Linnius, alittle better than 6 acres, hence the parcel I now offer for sale is 98 ars. which I put at 17000 $ and I have employed Mr. Gerymiah Warden to find a purchaser, who is perhaps the best hand in such business in Philada.[5] My fault before was by saying my price was 200$ Pr Acre. when lands almost every were, in a moderate distance from Philada: were offered for less Pr. Acre— But my improvements with the advantage of a good mill-seat & Water Meadows—besides its vicinity to Germantown, & at equal distances between the York & Germantown turnpike's renders it of more considerable value. Should I suceed in the sale of it, it is my intention to pay off all old scores, also have a surpluss to purchase the Walnut Street House.

Sophonisba has been able to take a short ride in a Carriage, and I hope she will gain strength daily.

Rubens proposes to collect what pictures he can to make an exhibition of them on the 4th of July, requests me to send those I have for him, also what Raphaelle has for sale.[6]

I beleive I have now given you my thoughts at the present Moment and conclude as usial with love to Eleoner & the Children— I was alittle indisposed for 2 days past, but lessening my meals I feel tolerably well to day. yours affectionately

CWPeale

Mr. Rembrandt Peale
N.York

ALS, 3pp.
PPAmP: Peale-Sellers Papers—Letterbook 17

1. Unlocated.

2. (Fig. 24.) Dr. Samuel Latham Mitchill (1764–1831), physician, naturalist, and former senator and congressman. For CWP's earlier relationship with Mitchill, see *Peale Papers*, 2:318. Carol Eaton Hevner, *Rembrandt Peale, 1778–1860: A Life in the Arts. An Exhibition at the Historical Society of Pennsylvania, February 22, 1985 to June 28, 1985* (Philadelphia, 1985), p. 62; Miller, *In Pursuit of Fame*, p. 140.

3. (Fig. 25.) Dr. David Hosack (1769–1835) was a famous New York physician noted for his innovations in medical treatment and surgery. He was also a professor of materia medica and botany at several colleges in the New York area. CWP visited Dr. Hosack when he was in New York City in the spring of 1817. At the time of ReP's first portrait Hosack was engaged in the founding of Bellevue Hospital and was serving as the president of the New-York Historical Society and vice president of the Literary and Philosophical Society of New York. ReP painted a second portrait in 1826 (*Princeton University Art Museum*). *Peale Papers*, 3: 25, 511, 531; ReP Catalogue Raisonné, NPG; Miller, *In Pursuit of Fame*, p. 140.

4. William Dunlap (1766–1839), writer and artist, based his large (eighteen by twelve

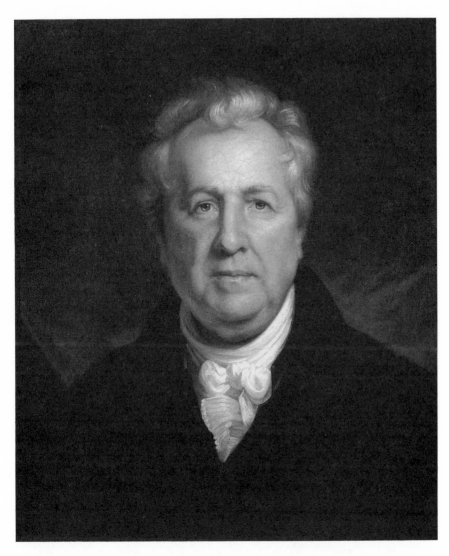

24. *Samuel Latham Mitchill*. Rembrandt Peale, 1822. Oil on canvas, 23 ¹/₂ ×
19 ¹/₂″ (59.7 × 49.5 cm). Library, The Academy of Natural Sciences of
Philadelphia.

25. *Dr. David Hosack*. Rembrandt Peale, ca. 1823. Oil on canvas, 24 ¹/₄ × 22″ (61.5 × 56 cm). Columbia University in the City of New York.

feet) exhibition painting *Christ Rejected* (*unlocated*) on prints of details from Benjamin West's painting of this subject (1814: *Pennsylvania Academy of the Fine Arts*), together with printed descriptions of the work. He acknowledged his debt to West in a small pamphlet that accompanied the painting's exhibition in Philadelphia, Boston, New York, and other cities. For an admission charge of twenty-five cents, CWP was able to view the painting at "Sully and Earle's Gallery, Chestnut Street, opposite the State House." *Peale Papers*, 3:498; *National Gazette and Literary Register*, June 14, 1822; William Dunlap, *A History of the Rise and Progress of the Arts of Design in the United States*, 3 vols. (Boston, 1918), 1:335–62; Helmut Von Erffa and Allen Staley, *The Paintings of Benjamin West* (New Haven and London, 1986), p. 359.

5. Jeremiah Warder (1780–1849) was a Philadelphia merchant who had been involved in real estate ventures in Ohio with his father, John Warder (above, **16**). Elaine Forman Crane, Sarah Blank Dine, Alison Duncan Hirsch, and Arthur Scherr, eds., *The Diary of Elizabeth Drinker*, 3 vols. (Boston, 1991), 3:2226.

6. RuP postponed this exhibition until October. See below, **86**.

77. CWP to RuP

PHILADELPHIA. JUNE 25, 1822

Philada. June 25th.1822.

Dear Rubens

We expect to get the Pictures you want from Academy of fine Arts today,[1] the weather being drisley prevents our getting them early to day. I want to have a packing case made which shall contain the whole, including that of Angelica & Robinson.[2] As soon as I can pack them up I mean to send them by the Union line. As soon as I received your last letter I waited on Doctr. McClannen [McClellan] and told him your proposition i,e, that of delivring up the House on the first april should it be sold. he made again appologies at not having paid the rent, he said that a Gentleman then in the country, would give it to him the next day—several days have since passed. I do not much like the man. I have imployed Jeremiah Warder to sell my farm and if I get a purchaser before I can sell your House it is my intention to purchase it, altho' the price, ground rent Taxes &c price may not be paid by the rent of it. however it is adding another chance of getting money for you—and in some future day the House will I doubt not fetch a better price, thus, I am warranted to take the chance.

Elizth. last sunday morning was delivered of a daughter & she was very well.[3] I went to see them from Linnius's) after dinner sunday. Linnius & family are well, and Sophonisba continues to mend.

I am now succeeding in making Enamel Teeth I have a good composition in *Buisquit*,[4] and have now only to try the glaizing (Enamil) And a receipt, nay several, is given me for this part of the business, I have not yet tryed any of them, but shall make the essays soon—as I have a furnace built in my Shop up stairs. built in the form of that in Mr. Clouds essay room at the mint.[5]

The visitation to the Museum is falling off very considerably in this month, it was fortunate for me thant [that] June was good— Franklin wanted to advertize to close the Evening illuminations after the 4th. of July—I put him off by saying that I was sick of the cost of Newspapers, that I thought by this time that the exhibitions of the Museum ought to be well known by the public.

The fact is that if the evenings will pay better than the daylight, I find it absolutely necessary to get all I can to meet with my engagements. It is true that Franklin & Wilson are much confined by the evening entertainments— What is your oppinion on this subject? I am very fearful that your Brother Rembrandt will not get the encouragement he promised himself in N.York. He has no demand for portraits when I heard from him not long since— He has finished Dr. Michel & about to begin a portrait of Doctr. Hosack, which pictures he expects will attract company to visit him—*the* former he intends for me, and requests me to send him 50$ which I mean to do as soon as I can find it in my powers, I mean after getting through the immediate demands, for which I am making every exertion.

But if Genl. Williams fails in his promise of sending from Fredericksburgh the price of Elizths. portrait it will much mortifie me.

Franklin is making some tryals at a new discovery made in England— Motion given to a wheel by a combination of Galvanic & Magnetizm[6] I am not sufficiently acquainted with what is said on the subject, but I find that Mr. Lukens & Franklin have twice suceeded to obtain the motion described in an English Magazine (I believe). more of this [in] my next—love to Eliza & Charles. yrs. Affectionately

<div style="text-align: right">CWPeale</div>

Mr. Rubens Peale
 Baltre.

ALS, 2pp.
PPAmP: Peale-Sellers Papers—Letterbook 17

1. These may have included CWP's *Self-Portrait* of 1822 (fig. 26), and two of SMP's still lifes (see fig. 27). Baltimore Municipal Museums, *Rendezvous for Taste. Peale's Baltimore Museum 1814–1830* (Baltimore, 1956), p. 34; Falk, *Annual Exhibition Record*, pp. 163–70.

2. See above, **48**.

3. On June 23, 1822, Sophonisba Sellers Patterson (d. 1883) was born to EPP and William Augustus Patterson. *CWP*, p. 443.

4. Unglazed ceramic.

5. Joseph Cloud (1770–1845) was the chief assayer at the United States Mint in Philadelphia. In 1808 RuP had made use of Cloud's simplified oxyhydrogen blowpipe in his chemistry demonstrations at the Philadelphia Museum. *Peale Papers*, 2:1137, 1142–43n.

6. There is no information on the specific experiments involving galvanism and magnetism performed by BFP and Isaiah Lukens. BFP wrote a short article about his interest in the similarities between magnetism and "its sister" science, "Galvanic and common electricity," for the single published issue of *The Philadelphia Museum*. In the article he noted that his

26. *Self-Portrait*. C. W. Peale, 1822. Oil on canvas, 29 ¹/₂ × 24 ¹/₂″ (75 × 62 cm). The Fine Arts Museums of San Francisco, Gift of Mr. and Mrs. John D. Rockefeller 3rd, 1993.35.22

27. *Still Life.* Sarah Miriam Peale, 1822. Oil on panel, 15 ³/₈ × 21 ⁵/₈″ (39 × 55 cm). Private Collection. Photograph courtesy Richard York Gallery, New York.

experiments were aided by "the well directed talents of an ingenious member of the Academy of Natural Sciences," probably Isaiah Lukens, and that they performed experiments on "polarity," which BFP believed was an important characteristic common to both phenomena. "Natural Philosophy. On Magnetism," *The Philadelphia Museum, or Register of Natural History and the Arts* (January 1824), DLC, pp. 11–13, F:XIA/17B5–8. See also "Description of an instrument by which electrical attraction and repulsion are illustrated in a new and striking manner. By the inventor, Mr. Franklin Peale," in *The Franklin Journal and American Mechanics' Magazine* 3, 1 (1827): 1–2.

78. RuP to BFP

BALTIMORE. JUNE 25, 1822

<div style="text-align:right">Baltimor June 25th. 1822.</div>

Dear Franklin.

I received yours of the 18th. and also the Model in good order but not untill yesterday morning,[1] and with respect to closing after the 4th. of July I am decided as to the propriety of keeping it open all the summer as I did intend to do if I had remained in Phila. and mean to do here altho some evenings bring in but little yet on the whole I am much benifited by it, I have published a small bill[2] to be sent to all parts of the City and cost but little, I must acknolledge that it is very confining but in these hard times it becomes our duty to do everything in our power to aid in the great work.

Yesterday morning I received a very impertinent letter from Mr. John Butterworth[3] respecting those birds from England that I have, and which I requested you to ask Titian to let him have a few common birds for me in exchange for them, it appears that he didnot get any from you, I therefore have forwarded on to him the Engh. Birds again.

I should like you to send me the exact measurement of the different parts of the Profile Machine that I shall have on[e] made like it except rather smaller.

Tell my Father that Mr. Worrel cannot expect an increase of Rent untill after the lease of the year is up, and this Mr. W. always told me and what I expected to pay, but that I had taken it for one year at 350, but at the end of the year it was to be 365 if I remained in the house.[4]

I received in the month of May during the day time 85.62 and at Night 248.12. and this month in the day untill this date 53.77. and night 157.58. Those odd cents are from mineral water & fruit.—— I have purchased the two living Wolves at 20 dollars.[5]

I have collected all the letters recvd. concerning the Museum and if Mr. Robinson can take them I shall be pleased.[6]

Give our love to all the family and beleave

<div style="text-align:center">me ever sincerely</div>

<div style="text-align:right">Rubens Peale</div>

ALS, 2pp.
PPAmP: Peale-Sellers Papers

1. BFP's letter is unlocated. The model was the perpetual motion machine made by workers in the Philadelphia Museum. See above, **74**.

2. Unlocated.

3. Unidentified.

4. Worrell was raising the price of ground rent for RuP's house at Walnut and Sixth Streets. See above, **73**.

5. The appearance of the "two living Wolves" in the Baltimore Museum was advertised on June 29, 1822, in the *American Commercial Daily Advertiser*. RuP claimed that the animals were "caught when quite young and domesticated" and that they were "full grown and remain quite gentle," but that "visitors are prevented from a near approach to avoid accidents."

6. RuP was sending via Henry Robinson papers and bills relating to the business of the Philadelphia Museum that his father needed in order to pay workmen. See above, **74**.

79. CWP to APR

PHILADELPHIA. JUNE 27, 1822

Philadelphia June 27th. 1822.

Dear Angelica

Yours of the 24th.[1] the moment after I read it I commenced a letter to you to inform that your Sister Sophonisba is recovering her health, although still weak, yet she is chearful, and occasionally dines with the family below, but when the weather is damp she keeps up stairs. She rode out in a Carriage last week but not without some fateague, and she has thought it was servicable to her.

Your sister Elizabeth Patterson was delivered on sunday Morning last, a fine daughter, that morning I intended to have taken the Stage to Germantown, but when I arrived at the Stage office I found the Stage full, and not being willing to let Linnius be disappointed of my company, as he expected me, I took the walk and a very hot walk it was, for I had on a thick cloath Coat, for you must know that I am still so much of a Patriot, that I will not wear cloathing that is not manuf[act]ured in my Country. and that I have a pride when I can say this American Manufacture ⟨that⟩ does credit to our Artists.[2]

I wish such sentiments universally prevailed, than we might be truely independant, but while we import more then we can pay by the production of our Country we cannot expect the times to mend. so much for Politicks— I am glad to hear that Archibald[3] is becoming industrous and pleased with farming, it is a pleasant occupation provided the professor will live within the income of his farm, he must not go in debt, for it is not easey to get money by farming to pay debts. foreign Luxeries must not be indulged in. Nature does not require such indulgences. health is

promoted by simple food and the pure spring water is the most valuable of all fluids. and we need no other, but to indulge a depraved taste. I do not approve of Cyder making, if the farmer has it, more than probable he will drink of it, or give to those that do not need it. I have made yearly, barrils of wine, yet I cannot say that I have for a long time past pressed my friends to drink it. I have still some for sale & shall rejoice when I see no more of it in store—as it gives me pain to see young men take a glass, so useless if not hurtful to them. you must not think that I am complaining of any of my children with me. they very sildom touch wine, the fault if any is in myself, as I cannot see any strong drink without reflecting how much Misery the use, or rather abuse, brings to families. Why do I ramble on in this strain, some people might suppose that I ment it as advice to you, not so, you need not any reproof, but I must write, as I do it with a hope that I may give some pleasure to you, by shewing that my affections for my children does [not] abate by the coming on of old age. Some of my friends tell me that I am the greatest curiosity belonging to the Museum, to see me still active, producing good works, even Painting without Spectacles better pictures that [than] at any other period of my life.

The fact is I put my best foot foremost. I wish to be an example worthy of being followed by being temperate in all things, and indeed as I advance in years my only pleasure must consist in contributing all that is in my power to render happiness to others. I cannot expect any other gratifications.

I keep a House, for I have yet much lumber, although I have been continually getting rid [of] what I do not want, and rightly understood our real wants are few, but it requires time to makes a judicious distribution of the useless. And absolutely requiring a work shop & a painting-room, I find that I cannot board out and have such conveniences, and although it must cost me something more by Housekeeping, yet I am more independant, and my Sons Franklin & Titian living with me, lessens their expense as well as mine. I have a House keeper who keept house for Rubens,[4] she knows our ways, is an excellent cook, does our washing & keeps all things neat & clean, and what is important, she stays at home & has but few visitors. Her health is not very firm, and I am fearful of her not holding out for considerable length of time.

I have made some progress in making porcelain Teeth, having built a furness in my Work shop, I shall in a few days make tryal whether I can raise a heat sufficient to burn the hardest ware, if I succeed in this I may serve you more effectually than heretofore, which will give me much pleasure—but they must be made quite perfect, for they cannot be altered by any edge tool, and if once correct in form, they are valuable as incor-

ruptable. My Sons Franklin & Titian are improoving the Museum in several of its departments.

Love to the children yrs. Affectionately
CWPeale

Mrs. Angeleca Robenson
 Shepherdstown
 in Virginea

ALS, 2pp.
PPAmP: Peale-Sellers Papers—Letterbook 17

 1. Unlocated.
 2. CWP's economic nationalism may be traced back to the influence of his early patron and closest friend, John Beale Bordley, Maryland planter and agronomist. During the American Revolution, Bordley had argued that agricultural self-sufficiency was crucial to independence and a necessity for the survival of republican government. CWP picked up this theme again in the first decade of the nineteenth century in support of Jefferson's nonimportation and embargo acts. *Peale Papers*, 1:167–68; 2:1164–65, 1176–77.
 3. Archibald Robinson.
 4. Rebeckah. See above, **75**.

80. RuP to BFP

BALTIMORE. JUNE 28, 1822

Baltimore June 28. 1822.

Dr. brother.

In the discription you sent to me, I could not understand whether the Mercury bath was dug out of the mahogany or a metal vessel to contain it, placed on the stand, and if the bath was made in the mahogany stand does not the acid affect the wood? and how in this case do you get the magnet in contact with the mercury? or whither it is nesesary to be in contact? Or if the mercury is contained in a seperate vessel placed on the stand in this case how do you place the magnet to permit the circulation? And also the size of the Magnet? and ⟨if none can be obtained of the size and kind⟩ can one be obtained in Phila.? if so to be sent on by Mr. Robinson or an earlier opportunity would be well, I think it not probable that it can be obtained here. And the next thing not understood is, what size battery, have you used, or made in what manner, all this I must do, as it is my intention to shew ⟨magnet⟩ galvanic experiments in the fall. Therefore if you have made or use any other than what we had (Porcelain Troughs) I shall be pleased to know the number and size of the plates &c. And what do you mean by amalgamating the pivots? Answer all these queries as soon as you can, mean time I will go on with the other parts of the instrument.[1]

Last evening I commenced with the Electrical experiments and they

pleased very much altho I have but very few to exhibit yet.　　　When I shall commence on mechanics and speaking of gravity &c. I shall exhibit my chinese tumblers they are made thus. A. tubes partially filled with

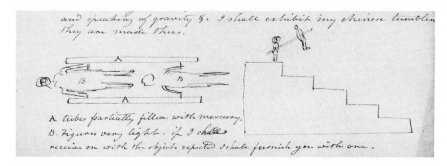

mercury. B. Figures very light. if I shall receive on[e] with the object expected I shall furnish you with one.

I would like you to see Dr. Hares small instrument for lighting a candle by Galvanism and also send me the discription and measurements of it.

I shall use those Blue glass tubes in this manner to make them look well, place the spots inside of each and then connect them together by a brass ferrel and cement with a Ball at each end. it is a most splendid experi-

ment.[2]

I have just placed the Model of R.P.M.[3] in the museum a mahogany case will be ready for it this evening but few have seen it and all are pleased with it.

I will be very much obliged to Mr. Lukens if he will finish the Hydrogen star and the two cuppling screws for I wish to fix anew my blow pipes &c.

You must remember that Dr. Troost has the quarto Voll. of Haüy on mineralogy ever since last winter.[4]

Has Coleman done anything to the singing Bird yet?

Give our respects to James and Sophonisba, and hope they are as happy as they expected to be.

I would be pleased to receive our canary birds by some acquaintance for none but an acquaintance would be troubled with them. Mary Patterson will be coming on in August　　　if not sent before she will bring them.

My next will be to my father, present our love [to] all of the family and beleave me ever yours

Rubens Peale

ALS, 2pp.
PPAmP: Peale-Sellers Papers

1. The devices RuP described were intended to demonstrate chemical reactions produced by an electric current from a voltaic pile or battery and referred to as *galvanism*. As early as 1809 RuP had been performing such public exhibitions in the Philadelphia Museum. While ostensibly demonstrating the new phenomenon of electricity, many of these "experiments" were designed to produce spectacular pyrotechnical effects—"philosophical fireworks"—in order to attract large popular audiences. While exhibiting the mastodon in London in 1802, RuP may have attended such demonstrations, presented by popular scientific lecturers such as Humphry Davy at the Royal Institution; or, he may have familiarized himself with these experiments through his association with chemists James Woodhouse (1770–1809) and Robert Hare, both of whom performed electrochemical experiments with voltaic piles in Philadelphia. *Peale Papers*, 2:1199–1201; 3:699–700, 702.

2. There is no specific information on the experiments that RuP and BFP performed. More than seventy years later, CWP's grandson, George Escol Sellers (1808–1899), remembered assisting his uncles in electrical demonstrations in which there would be a "great electrical machine" that caused effects with "dancing dolls" or produced "lightning flashes over glass plates sometimes arranged to display portraits." A more elaborate setting included clouds and a model of a "many-jointed and hinged house . . . with a pointed rod . . . capped with a brass ball." The clouds would descend over the house and send a "lightening flash" to the house's lightning rod. A cork would then be blown out of a gas bottle, "and with its thunderclap the house would fall to pieces." George Escol Sellers to Horace Wells Sellers, May 2, 1895, quoted in Sellers, *Museum*, pp. 243–44; see also Eugene S. Ferguson, ed., *Early Engineering Reminiscences (1815–1840) of George Escol Sellers* (Washington, D.C., 1965), p. 70 & n.

3. Charles Redheffer's perpetual motion machine. See above, **82**.

4. In 1808 the French mineralogist Abbé René-Just Haüy (1743–1822) presented the Philadelphia Museum with a small mineral collection and two publications, one of which was his *Traité elementaire de physique*, 2 vols. (Paris, 1806). The museum may also have owned a copy of his *Tableau comparatif des resultats de la cristallographie et l'analyse chemique, relativement à classification des minéraux* (Paris, 1809). *Peale Papers*, 2:1175; *NUC*.

81. RuP: Draft of Form Letter to Collectors[1]

BALTIMORE. 182 [1822]

Capn.
Sir,

 To advance the interest of the Baltimore Museum and Gallery of the Fine Arts, and render a service to this rising city, you are earnestly requested to collect or preserve such articles as may fall in your way, during your voyage or stay at any foreign Port or country, and since it is from the science, zeale and liberality of individuals that we must be indebted for the developement of natures boundless stores, as well as the inginuity of art, of which this valuable collection consists; it shall always be my indeavour so to dispose of such articles brought or sent by you, as may insure their preservation and publick utility.

<div style="text-align: right">

Sir, with respect I remain your
obedient servant
Rubens Peale.

</div>

Baltimore Museum, Holliday
Street, __ __ 182__.

Quadrupeds, or Beasts, may be opened on their back from their tail to their sholder, and skinned as you would a Rabbit except it is always desirable that the ⟨head or⟩ skull, as well as the leg bones, should be left in, having removed all the flesh, as well as brains and eyes &c. The skin thus prepared may then be thrown into a pickle of salt, and allum if convenient.

Snakes, Lizards, Turtles, &c may all be served in the same manner.

Birds may be opened from the anus to the middle or upper part of the breast bone, and skinned, the legs and wing seperated from the body and then the neck, and after the body is removed the head skinned by turning it inside out and removing all the flesh, Eyes & brains, and then turned having rubbed a little brown soap with some Allum, and the parts filled with cotton or other substance, where the flesh was—and the wings and legs served in like manner and the bird laid smooth in an airy place to dry⟨;⟩—and when dry may be packed between cotton.

Small Fish, Snakes, Lizards, Insects, Turtles, or *Quadrupeds*, may be put into common whiskey or spirits.

Butterflies must be stuck through the body with a pin and and placed in a box to prevent it being rubbed, all other insects may be served in the same manner.

Star-fish, Sea-Eggs, Corrals &c *shells*, may be washed with fresh water and dried.

Direction how to Collect Specimens of Natural History

Rubens Peale

182 __

Quadrupeds may be opened either on the back or belly as soon after their death as convenient, and the Skin taken off, as you would a rabbit, and leaving in the head and bones of the lower joints of the legs, after the flesh is removed from them, and the brains, eyes &c are removed. The skin may be then thrown into a solution of salt and alumn, in this pickle they may remain any length of time.

Snakes, Lizards and Turtles may all be cured in the same manner.

Birds may be opened along the breast bone, as high as the upper part, and all the flesh removed leaving in the Skulls, as well as the legs and wing bones, the eyes, brains &c. The inside of the Skin may then be washed with a strong Solution of alumn and Salt, (or corrosive sublimate alone) Then place in the Skin, Some cotton to keep the Skin from touching or shrinking; then lay the bird as smooth as possible in the air to dry, then they may be packed in cotton.[2]

Small Fish, Snakes, Lizards, Insects &c. may all be thrown into common Spirits except butterflies, and they should be stuck with pins through their

⟨*body*⟩ bodies and care taken not to rub them, as their delicate plumage is easily removed.

Corals, Sea Stars &c may be washed in fresh water, and dried.

Snells, Sea Eggs &c may be dipped in hot water to kill the animal, and then it may be removed with the greatest ease, with a point, then placed to dry, and packed in cotton.

Minerals, such as [line lost in crease of paper] to be wrapped in paper to prevent their being p[].

N.B. Warlike Implements—Agricultural Instruments, Articles of dress, antiqu[i]ties &c

Attention to the above will much oblige

<div align="right">

Your Friend
Rubens Peale.

</div>

ALS, 4pp.
PPAmP: Mills Collection.

 1. The editors have dated this document 1822; it exists in draft form only. It is not known whether RuP ever circulated the letter to ship captains and travelers.

 2. RuP's directions for preserving museum specimens are similar to those drafted by CWP in 1789. The utilization of such substances as corrosive sublimate and cotton for stuffing the animals was standard practice among naturalists at this time. *Peale Papers*, 1:486–89.

82. RuP to CWP and BFP

BALTIMORE. JULY 6, 1822

<div align="right">

Baltimore July 6th. 1822.

</div>

Dear Father and Brother

Franklins of the 2d[1] came to hand yesterday morning for which I am much obliged, I am delighted at the intelligence of the arrival of my philosophical apparatus, I shall be much obliged to you if they could be put into the hands of some acquaintance in the steam boat, they will arrive 2 or 3 days sooner and not injoured by jolting the two last cases recd. were almost tumbling to pieces on their arrival—(Mr. Robinson expects to return about wednesday). I have announced their arrival in my address to the Publick[2] The live animals now in possession are Two Wolves—Grey Fox—Horned Owl—Fishing Hawk—White Rat—Alligator—Four Gold Fish—and Java sparrow. They excite much interest but everything in this city is dull at present but by advertisg. the Museum has done tolerable well. May gave in the day and night 333.75—June gave 253.28. My wednesday evening gave me 4.25—Thursday 7.12—Friday 3.62—Saturday 6.00——And in this month Viz. 1st. 2.62—2d—nothing as it

rained—3d. 3.62.—4th. day 20.62 . Night 56.75—5th. 12.50. Although it is very fatiguing to be kept so constantly engaged yet I find it necessary to keep the museum open every evening, for the days yeald scearce anything.

On the 3d. I hoisted a pole on top of the House and on the 4th.

Mounted a flag thus which costs about 25$ made of Bunting. I shall mount it again on monday and continue it every fine day—as the house is rather out of the way and in a low part of the City I thus make it conspicuous to many points of view, and every stranger on the exchange[3] or monument[4] or even on board of the steamboat will naturaly enquire what flag is that if at too great a distance to read it, the letters are 3 feet high, the flagg is upwards of 25 feet long and perhaps 13 wide—there being no lightening rod to the house I took this opportunity to place one up the flag staff &c—which I am much pleased with—Sarahs Washington was very conspicuous.[5]

The box of Pictures has been received and not much injoured by rough usage. I shall begin to display them on Monday.[6]

How have you arranged the Coins—I thought of first displaying the English Coins, and then the Meddals and lastly the provinceals and tokens—My cases are nearly ready for their reception. did you place them on cards as I proposed containing the History or name &c? or on the back of the case? They are very few in this collection but some are very handsome.

Present our love to all and beleave us ever

affectionately
Rubens Peale

ALS, 2pp.
PPAmP: Peale-Sellers Papers

1. Unlocated.
2. See below, **83**.
3. Designed by Benjamin Henry Latrobe, the Board of Trade and Exchange building at Gay Street and Exchange Alley opened on June 1, 1820. At the time it was one of the largest and most impressive commercial structures in the United States, standing four stories high, with east and west fronts 256 feet in length. It was located about four blocks south of the museum. Scharf, *History of Baltimore City and County*, I:437–38.

4. Either the Battle Monument on Calvert Street (about three blocks southeast of the museum), which was built between 1815 and 1827 to commemorate the Battle of Baltimore (September 12–14, 1814), or the Washington Monument on Mt. Vernon and Washington Place (about five blocks northeast of the museum), built between 1815 and 1829. Edward C. Papenfuse, Gregory A. Stiverson, Susan A. Collins, and Lois Green Carr, eds., *Maryland: A New Guide to the Old Line State* (Baltimore, 1976), pp. 369, 380–81.

5. SMP painted a transparency of Washington, based probably on a CWP image, for the front windows of the museum. It is no longer extant.

6. See above, **77**.

83. RuP: "To the Public," *American and Commercial Daily Advertiser*

BALTIMORE. JULY 8, 1822

TO THE PUBLIC

RUBENS PEALE from Philadelphia, having succeeded his brother in the proprietorship of the MUSEUM and GALLERY OF PAINTINGS, in Holliday st. Baltimore, and, being determined to make it a place of recreation worthy of the polite and intelligent world, apprises the public that he has begun, and will continue henceforth to devote to it, all his *time, attention,* and *resources.*

Many additions have just been made to the department of *Paintings* and *Natural History,* and with the correspondence that he has established, he can promise a continual augmentation hereafter.

He is preparing as fast as circumstances and the season will admit. to open an ANNUAL EXHIBITION, after the manner of that at Summerset House, in London and at the Academy of Fine Arts in Philadelphia. The first exhibition will commence the first of October next and continue six weeks.

He has already fitted up a large cool and pleasant lecture room, with *seats* like an Amphitheatre, where the company can be accommodated far more agreeably than heretofore.

He would further apprize the public that henceforth the museum will be illuminated every evening, instead of three time a week as hitherto— the experiments hereafter mentioned will be exhibited every evening, *however small the company,* and *whatever may be the weather*—as he is exceedingly solicitous of making the MUSEUM (now that the theatre is closed) a place of innocent and rational recreation, worthy of all ages and dispositions.

The experiments alluded to will be continually diversified, and explained in as familiar and intelligible a manner as possible, so that children themselves may understand them—at present they will consist of multiplied demonstrations in PNEUMATICS (the phenomena of air) ELEC-

TRICITY and CHEMISTRY—and hereafter, of a variety, in other branches of NATURAL PHILOSOPHY, such as *Galvanism, Magnetism, and Mechanics, &c.*

He would further inform those who are interested in the education of children, and sufficiently sensible of the advantages to be derived from a continued course of amusement and instruction, that he is preparing, and shall be able in the course of eight or or ten days, to commence a display of ASTRONOMICAL ILLUMINATION, or SHADES, of a remarkable beautiful and popular character, which he has just imported from Europe, where they have been lately a matter of great interest to the wise and benevolent.

He has engaged a Band of Music, to play on MONDAY, WEDNESDAY & FRIDAY EVENINGS, of every week. They will commence on MONDAY the 8th inst.

PrD, 1p.
DLC

84. CWP to RuP
PHILADELPHIA. JULY 9, 1822

Philadelphia July 9th.1822.

Dear Rubens

I have been so busy with the Porcelain Teeth as to exclude all other affairs from my mind, but now I have all things in train so as to succeed I think perfectly, having now in my mouth teeth which I rivited to the bottoms, which fitted my Gums perfectly, and these new teeth with some alterations will I hope be equally easey as was the old rotten ones. I was some time under difficulty to make the Glaising, several receipts was given me, and perhaps they were good, but my materials perhaps not well choosen, but finding you had purchased enamil in Powders I made tryal of them by different mixtures, and I have very nearly obtained a natural colour, and I find my furnace will even give too much heat for the Enamil, for in my first essay the heat was so great as to re[s]tore the lead to its natural colour, this I was obleged [to] grind off with a lapidary's mill; and in 2d firing, I fired the Enamil without changing the colour. My next tryal will be to know if my heat will be sufficient to melt the Buisquit sufficiently, which I shall do either to day or on tomorrow— The weather is now in the extreeme of heat, of course not perfectly agreeable for this sort of work, but as I now know the management of the furnace, there is no need to expose myself to much of its heat, and I find in the first place I must bring on the heat slowly, but after the subjects arrive at red heat, that then a quick heat is best, it required a white heat to melt the Feltspar which is

indespensible to give the necessary hardness. I was apprehensive that in riviting these Teeth that I would break some of them, yet I did not brake a single tooth,—It will be better to solder them, but Platina is scarce,[1] with some difficulty I have obtained a small piece, and no other metal will bear the heat necessary to fuse the Feltspar. enough on this subject.

By getting my money from Mrs. Logan,[2] and to day I expect Coleman will get me the price of Elizabeth Williams Portrait, which will enable me to pay the 400$ borrowed of my friend Z. Collens, It is put into the North America Bank I suppose for Collection.[3]

I wish the exhibitton of pictures may have answered your purpose. let me hear on it in your next. some of your mooving slides are handsome, particularly the moovement of boats. The Horses-leggs do not answer to well.

I might [write] more on the subject of Visitation of the Museum, but I trust Franklin has done that for me

therefore present Love to Eliza & Chas.

yrs. affectionately

CWPeale

Mr Rubens Peale

ALS, 2pp.
PPAmP: Peale-Sellers Papers—Letterbook 17

1. Crude native platinum.
2. Deborah Logan (1761–1839) paid in advance for her yet unfinished portrait in response to CWP's request (*destroyed*; copy owned by the *Fairmont Park Commission, Philadelphia*). Mrs. Logan, widow of George Logan (1753–1821) and CWP's Germantown neighbor, was a historian who collected and edited her family papers and donated them to the APS. The Logans had supported CWP's efforts to obtain aid from the state of Pennsylvania for the Philadelphia Museum. *P&M*, p. 130; *P&M Suppl.*, p. 70; *Peale Papers*, 2: 280–81; 3: 7, 12; CWP to Deborah Logan, July 6, 1822, P-S, F:IIA/67C12.
3. The North American Bank, established by Robert Morris in 1781, was rechartered by the state of Pennsylvania in 1814. Scharf, *Phila.*, 3: 2089–92.

85. RuP to BFP

BALTIMORE. JULY 9, 1822

Baltimore July 9th. 1822.

Dear Franklin

Mr. Robinson has arrived without the Slides, altho you gave him to understand that they would be sent with him, yet he says that you didnot place them in his care or on board the Boat didnot say anything about them—he therefore concludes that you didnot bring them on board, yet he examined every package and did not find any directed to me— I

then thought proper to visit this days boat and donot hear any thing of this—so that if you have sent them, I should like to know by whom and when, so that they may be obtained—if Mr. R. had forgotten then they will be on board the boat in the Delae [Delaware].

I commenced last evening with a small band of music, and expect to continue it every Monday, Wednesday, and Friday, the evenings that I exhibit the Magic Lanthorn the other 3 evenings are devoted to other branches of Natural Philosophy—[1]

I am surprised to learn that the museum is closed for the summer, altho but little can be expected, yet it will shortly increase— In your next give a continuation of the income, as it is always agreable to compare notes &c— My 4th. of July Gave during the day 20,62—and Night 56.75.—. 5th. 5.50. Night 12,50. 6th. 2.50 Night 212. very cloudy.—8th. 1.00 night 12.12½ so that you see I should do but little if it were not for the nights.

Give our love to all and beleave me ever yours senserly,

Rubens Peale

ALS, 1p.
PPAmP: Peale-Sellers Papers

1. RuP mentioned the appearance of a "Band of Music" in the Baltimore Museum in his address, "TO THE PUBLIC." See above, **83**.

86. CWP to ReP

PHILADELPHIA. JULY 10, 1822

Philada. July 10.1822.

Dear Rembrandt

Yesterday I paid the 400$ which I borrowed of my friend Z. Collens, which I was enabled to do by the receipt of the price of Mrs. Logans Portrait, with a part of the rent of the last quarter of the Walnut Street House. The Museum at this season as usial is falling off on visitations, and so few attended of late in evenings that we have suspended the ellumina-tions for this season, of course I cannot expect for some times but alittle more than my current demands, independant of what I must give to aid Raphaelle who is without employment, I cannot let the family suffer. He has not been difficient of industry, but no sales for his still-life— He has sent nearly all his pictures to Rubens with the hopes of selling some of them, but Rubens postpones his exhibition to (I believe) October next. I received a short letter from Rubens yesterday inclosing a flaming adver-tisment, which I suppose you will see by looking at the Baltre. Papers,[1]

I am in a fair way of succeeding in making Porcelain Teeth, I have a sett

now in my mouth that is tollerably easey but not yet finished, I can rivet and unrivet them and some are now cooling in my furnace, experiments in glaizing & also a tryal to know if my furnace will effectually melt the Feltspair. I expect Mr. Planteau will not be pleased with me, yet he cannot suppose I would not try to help myself & family, I do not desire to take from him any of his custom, and if he will do them in such a mode as will render them useful, I shall certainly advise those you [who] want teeth to employ him.

I want much to know how you go on, whether Hosack is finished and whether you have Visitors & your prospect of employment— I understand that Mr. Pendleton has arrived at New York, with the picture of the *court of Death*, what next is to be done with it? All the news & prospects will be very acceptable.

<div style="text-align:right">

Love to Eleoner & Children yours
Affectionately CWPeale
</div>

PS. I thought that sunday was your day of letter writing? I have not lately heard from you.— this is intended by a Gentleman of your acquaintance. Name out of my mind at this moment.
Mr. Rembrandt Peale
 N.York

ALS, 2pp.
PPAmP: Peale-Sellers Papers—Letterbook 17

 1. See above, **83**.

87. CWP to ReP

PHILADELPHIA. JULY 23, 1822

<div style="text-align:right">

Philada. July 23d.1822.
</div>

Dear Rembrandt

As you proposed to devote sundays to letter writing I am disappointed in not receiving a line from you this Week, being very anxious to know how you come on with the Citizens of N. York. Have you any portraits engaged in this discouraging season of warm weather? what is to be done with the court of Death? &c &c

My next object in writing is [to] try your invention of a composition of a large whole length portrait. The Trustee's at their last meeting, directed me to make a whole length Portrait of myself for the Museum,[1] which I have promised to perform without delay, and I have bought canvis, which I mean to prepare in my method using fish Glue.[2] I think it important that I should not only make it a lasting Monument of my art as a Painter, but

also that the design should be expressive[3] that I bring forth into public view, the beauties of Nature, and art, the rise & progress of the Museum. My canvis is $2^{1}/_{4}$ yards wide, I have 3 yards of it—it appears to be a fine Russia-sheeting—[4]sold by [illeg] Market Street.

My last letter I think, told you that I am succeeding with Porcelain Teeth. I am more comfortable than I have been for years past, although those I use are not so handsomely Glaized as I expect to do in future. we possess materials for Porcelain equal to the Chineaes Chinia[5] in the vicinity of Philada. I expect to find its locallity by inquiry.

I have just got rid of a bowel complaint, chiefly by the the flax-seed injections. The complaint is very general here. I wish our Drs. would adopt the french method of curing.

<div align="right">love to the family. Yrs. Affect
CWPeale</div>

Mr. Rembrandt Peale.

ALS, 1p.
PPAmP: Peale-Sellers Papers—Letterbook 17

1. (Frontispiece.) At a meeting of the trustees on July 19, it was resolved that "C W Peale be Requested to paint a full length likeness of himself to be placed in the museum." Philadelphia Museum Minutes, F: XIA/7A6-B11; *P&M*, pp. 160–62.

2. CWP had been using fish glue, or isinglass, to prepare his canvases since at least 1778, when he noted in his diary its resistance to water. See *Peale Papers*, 1:268–69; 3:698.

3. For a discussion of the painting and CWP's use of the term expressive, see Roger B. Stein, "Charles Willson Peale's Expressive Design: *The Artist in His Museum*," in Miller and Ward, eds., *New Perspectives on Charles Willson Peale* pp. 167–218.

4. A coarse, heavy cotton cloth imported from Russia that CWP had utilized in the past. *Peale Papers*, 3: 541–42.

5. In 1822, Thomas Haig, Sr., David G. Seixas, and George Bruorton were three prominent pottery manufacturers in the Philadelphia area producing china ware, or porcelain. Scharf, *Phila.*, 3:2297–98.

88. CWP to ReP

PHILADELPHIA. AUGUST 2, 1822

<div align="right">Philada. Augt. 2d.1822.</div>

Dear Rembrandt

I had become uneasey at not receiving a letter from you & relieved to day by yours of the 30th ult. I could not account for your silence about a design for this whole lenth Portrait of self. I waited to hear what you would say before I would begin it, and did not mention what I might have done, I mean my first thoughts, which I now give you, and written too late to alter my design. My dress a suit of Black Breeches and silk Stockings—holding up with my right hand a a dark crimson Curtain, to give a view of

<div align="right">165</div>

the Museum from the end of the long room, thus shewing the range of Birds, the revolutionary Characters, and instead of the projecting casses behind me, I contemplate as much & as conspicuous as possible the Skeleton of the Mamoth & perhaps some of the quadrupeds more distant, I may have some Mamoth bones &c at my feet, My Pallet & Pencils near at hand, My left hand in form & view of expaciating & being open & turned alittle back to express as I conceive *fullness* Bringing the beauties of Nature into public view—this is perhaps telling the Story, simple & plain to be understood.

Now for the likeness, I make a bold attempt—*the light behind me*, and all my features lit up by a reflected light, beautifully given by the Mirror! the top of my head on the bald part a bright light, also the hair on each side. That you may understand me, place yourself between a looking-glass & the window your features will be well defined by that reflected light a dark part of a curtain will give an astonishing [illeg] to the catching Lights, and thus the whole figure may be made out with strong shadows and [illeg] catching lights. With this mode I can paint a faithful likeness—as I have prooved by taking a small canvis, the likeness I have made it is said to be better than those I painted for Rubens & Sophonisba.[1]—— Titian is finishing a drawing, which I made the lines by the drawing machine, his drawing looks very handsome seen through the *Lens*, and will be a good object to place there occasionally.[2]

On reconsidering what I have wrote about the head being seen by a reflecting light, I wish you to write me if it is only a few lines to give me your opinion on that, as well as the design generally, and I will waite for it, in the mean time I can do some other work which I want out of the way.

I have just received the account from the City Treasurer in which is stated that I owe $767.67Cts. due the July 1st.[3] I have paid for Rubens several bills besides the 400$ sent them—and reduced the note of Snyders to 200$ which is renewed in the Bank. and I have several large notes in the Bank which I can not reduce in renewing them—withall the Museum produces little at this season, and I am also under the necessity of supporting Raphaelle with money for the support of his family, He is striving hard to get ⟨to get⟩ along he cannot sell his pieces of still-lifes, and he has no portraits to do that gives him Cash, he has just finished 3 Portraits for a bricklayer, who is to pave his Yard, and make him steps &c.[4] I will send you some Cash as soon as can I know how I shall fare with the City Treasurer & pay some Intrest due soon to ⟨ *Jeremiah* ⟩ John Warden; 72$.

I have got through all my difficulties in making Porcelain Teeth, and can even burn the *Buisquets* to sufficient hardness in my furnace, the afterwork, that of Glaising require less heat. and a few more experiments will proove the collouring most natural, & the variety neccesary.

Sophonisba is greatly mended in her health. she can now go shoping, & visit her friends. I have not shewn your letters nor will I shew them to any one. let me hear from you as soon as possible— Love to Eleoner & the Children. yrs. Affectionately

CWPeale

Mr. Rembrandt Peale.
New York.

ALS, 2pp.
PPAmP: Peale-Sellers Papers—Letterbook 17

1. CWP's self-portraits of ca. 1821–1822 require clarification. Two were exhibited at PAFA in May 1822, both dated 1822 and described in the catalogue as "painted in the 81st year of his age without spectacles." These were probably the two portraits CWP painted for SPS and RuP, both showing the artist with palette (fig. 26; *private collection*). On the basis of Peale's statement that these self portraits were painted in his eighty-first year, Sellers dates them 1821. The painting described in this letter as "being better done than those . . . painted for Rubens and Sophonisba" was probably the one sent to the Baltimore Museum for Rubens to exhibit, since it descended in Rubens's branch of the family (fig. 28). This portrait would not have been finished in time to be exhibited in May 1822. Peale's full-length (*The Artist in His Museum*) was not commissioned until July 1822. The trustees, and particularly Joseph Hopkinson, may have conceived the idea of the commission after seeing Peale's earlier self-portraits in the PAFA exhibition. *P&M*, p. 160; Falk, *Annual Exhibition Record*, 1:163; CAP.

2. TRP, *The Long Room, Interior of Peale's Museum* (fig. 29). CWP was continually experimenting with perspective and with drawing machines. In the 1770s, he referred to one such device as a "painter's quadrant" and used it, as one would a surveying or a navigational quadrant, to achieve better perspectives of altitudes and distances. In 1788, he utilized a more complex device in "taking perspective Views" from the Statehouse in Annapolis. This device either transferred points or traced lines from actual views to paper. In 1816, ReP introduced him to a new type of drawing machine that utilized a magnifying lens and produced a reversed image. CWP used this device in an initial attempt to take HMP's portrait (1816: *Museum of Fine Arts, Boston*), but was unsuccessful in obtaining "the minute markings, so essential to a well finished portrait"; he completed the portrait "in the common mod[e]." However, ReP's "New Method" stimulated him to experiment once again with drawing machines. In 1819, he wrote to ReP that he had "finished a drawing machine to make larger drawings." Later that year, he wrote RuP in Baltimore requesting that he ask ReP what he thought "would be the effect of a light through a lens, such as are now fixed in Ships decks, to paint by."
Always interested in optical effects, CWP frequently experimented with unusual lighting, lenses, and mirrors. In earlier years this interest manifested itself in the design of eyeglasses and in an effort to achieve in his paintings a realism of likeness based on shadows and light. He considered the greatest interest of *The Artist in His Museum* the capturing of the strange effect produced by light coming from behind him and reflecting off a mirror in front of him onto his features. *Peale Papers*, 1:118–19, 493–94, 502, 523; 2:1006–07; 3:61, 390, 400, 457–58, 470, 539, 564–65; *P&M*, p. 165.

3. The account from the city treasurer is unlocated. The rent paid by the Philadelphia Museum to the city corporation for the use of the upper rooms in the Statehouse had been lowered to $600.00 a year. The additional $167.67 billed to the museum may have been back rent plus interest. Philadelphia Select Council, Extract from Minutes to William Meredith, P-S, F:XIA/7B12–14; see above, **20**.

4. Unidentified.

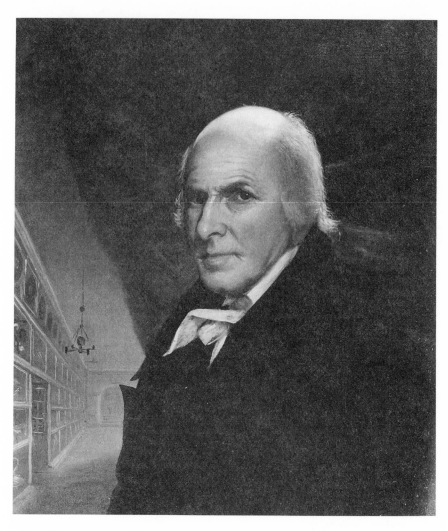

28. *Self-Portrait*. C. W. Peale, 1822. Oil on canvas, 26 × 22″ (66 × 56 cm).
Private Collection.

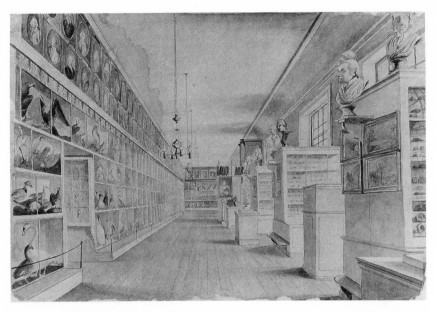

29. *The Long Room, Interior of the Front Room in Peale's Museum.* Titian Ramsay Peale, 1822. Watercolor, 14 ¼ × 20 ⅞″ (36 × 53 cm). The Detroit Institute of Arts, Founders Society Purchase.

89. CWP to RuP

PHILADELPHIA. AUGUST 4, 1822

Philadelphia Aug 4th.1822.

Dear Rubens

It gives me pleasure to find your exertions to entertain the Public produces a reward. I fear it is not the case with Rembrandt? he has a large and expensive family and a high rent to pay, I am doubtful of his success in getting Portraits, the season he says is against him for *in hotest weather of summer which covers the face with greasy perspiration is not the season to be chosen for the purpose* of representation. He wrote to me some time in June to send him 50$ as payment for Doctr Michel's portrait. I would most willingly have sent it, but fearfull of not be:g able to meet the demands on me, I have yet posponed it and must see what I can do to obtain time untill ⟨my⟩ more income is produced by the Museum I have just received a Bill from the City Treasurer in which it states the Ballance due July 1st. $767.67, and if possible I must lessen that sum in the hope that I may be favoured with some time to complete the payment in full.

169

I have renewed my note to Snyder & reduced it to $800. that is paying 41$ and a discount of $8.53 cts. I paid Geo. Widdefield[1] for your packing cases $14.69. O'Neal's (Taylor) 15$ your Rent 31.25. Shermon Bill for fraimes $16.50[2] Interest to Jacob Copia[3] $18.00. Websters[4] Bill for milk $10.80. and some other Bills for you. And I think myself very fortunate in getting payment from Mrs. Logan & for the Portrait of Betsey Williams, otherwise I do not know what might be the consequence to me as Mr. Z. Collens had negociated my Note & it was put into the Bank of North America for collection. I might say more on these disagreable subjects, but this enough for the present, and if I can fill the remainder of this scrole with the agreable, it will accord better with my feelings——

At the last meeting of the Trustee's of the Museum they passed a Vote that I should paint a Portrait of myself for the Museum—a whole length—I promised to do it, but I told them that I could not find room for smaller Pictures and valuable subjects of Natural history.

I have now my canvis before me studying the composition. The design which I have thought best, as simply shewing that I have brought subjects of Natural History into view, is by representing myself putting a Curtain aside to shew the Museum, on my right the Birds with the revolutionary Characters; and extended room, The light is on my back, of course my face is only lighted up by the reflected light of the Mirroir, but the light is extreemly bright on ⟨the⟩ my bald pate & grey hairs— you may try the effect of such a light by placing yourself between a looking glass and the window, and you will find that the features are thus well defined—to make a tryal of it I took a small canvis & painted a portrait which is said to be more stricking than that I painted for you ⟨and⟩ or for your sister Sophonisby. My right hand to be raised high holding up a dark Crimsom Curtain, the dark shadow of that arm as high as my right Eye, with the light on the upper & outer part of said arm. my black Suit contrasted to the light of the long room, with all the shadows inclineng to the front of the picture, my left hand in a position of address; the extended forward arm and hand open turned alittle back. at my left side a Table covered with green baise, Pallet & Pencil, and some dissecting & other tools, below some Mammoth Bones and if I can make it out to my mind, the Skeleton of the Mammoth beyond the Table & Curtain, & perhaps some other animals may be seen in the greater distance. To make tryal of the effect in the perspective of the long room, I drew the lines with my Machine, & I set Titian at work to fill it up with his Water Colours, and he has nearly finished an admirable representation of the long room, the minutia of objects makes it a laborio[u]s work, it looks beautiful through the magnifiers.[5] Coleman seeing it yesterday, says that it deceived him, he thought he was viewing the Museum in the looking

Glasses at the end of the Museum. he thinks it might be a good deception, to see it in another room and would have a good effect on Visitors.

We have at present but few Visitors, and I tell the Boys that I must commence the illuminations in Sepr.

William Patterson was with us yesterday, he tells me that Mary does not incline to visit Baltemore——of course I am relieved from a breach of complisance, for realy I cannot see my way clear, to pay you a Visit, although it would much gratifie me to take the trip. If I could sell my farm and thus pay off all bank debts, I might venture from home.

Raphaelle is deligent at work, yet he gets nothing that brings him Cash,[6] of course I am obleged to aid him in the support of his family.

Sophonisba is wonderfully recovered, she now goes out to the shops, and also visits her friends.

Coleman & the Company have full imployment, yet he must still persevere to get the Penitentionary made according to Mr. Haveland's plan. Govr. Heister is here & encourages Coleman to go on, he will not consent to receive his resignation.[7] Thus I have now given you all the news I can think of at present. I have suceeded tolerably well with my Porcelain. Love to Eliza and Charles.

<div style="text-align:right">

Yrs. affectionately
CWPeale

</div>

Mr. Rubens Peale
 Baltre.

ALS, 3pp.
PPAmP: Peale-Sellers Papers—Letterbook 17

1. A carpenter at 171 High Street. *Philadelphia Directory (1822)*.
2. Unidentified.
3. Jacob Copia may have been the coachtrimmer listed as residing at 183 Pine Street. In 1823 CWP borrowed once again from Copia ($600) when he purchased RuP's house. *Philadelphia Directory (1822)*; RuP, *et ux.*, Deed to CWP, July 29, 1824, PPDR, F:VIIA/4F13-G2.
4. Unidentified.
5. It is not clear exactly what the magnifiers were; perhaps they were used somewhat as the later stereoscope was, to produce realistic effects of spatial depth.
6. RaP submitted nine works to the 1822 PAFA exhibition, four of which were marked "for sale." See above, **65**.
7. John Haviland (1792–1852), architect, was born in England and came to the United States in 1816, settling in Philadelphia. The Eastern State Penitentiary at Cherry Hill, Philadelphia, was his most famous work. Haviland's concept of a central vertical structure for the prison guards, with blocks of cells radiating from this building like spokes from a wheel hub, was viewed as a major reform in prison design and became the architectural model for penitentiaries in the United States and Europe.
On March 20, 1821, the Pennsylvania legislature voted to erect a penitentiary for the eastern district of the commonwealth. Appointed by the governor to the building commission to supervise the prison's design and construction, Coleman Sellers found himself in the middle of a rancorous debate. A majority of the commission, including Sellers, favored Haviland's concept, but a minority preferred a plan submitted by William Strickland, Phila-

delphia architect and designer of the Pittsburgh penitentiary, then under construction. Amidst charges of fraud and waste against the majority and furious attacks of the majority against the minority, the commission decided to appoint a committee to meet with Governor Hiester in Harrisburg. Coleman was a member of the committee. Hiester approved the Haviland plan on August 22, and although the minority faction continued its opposition, the commission finally approved it on September 27. Negley K. Teeters and John D. Shearer, *The Prison at Philadelphia: Cherry Hill* (New York, 1957), pp. 33–44; *DAB*; Scharf, *Phila.*, 3:1834–35; *Poulson's*, August 27, 1822.

90. CWP to ReP

PHILADELPHIA. AUGUST 10, SEPTEMBER 9, 1822

Philada. Augt. 10th. 1822.

Dear Rembrandt

I thank you for your invitation to [visit] New York, but the sight of Sir Thomas Laurance's picture[1] or any other, would be off no service to me to go on with my Picture already once coloured over, of course I care not to alter my design, but to go on, and finish every part I can from nature. your caution of not making the face too dark was attended to in my commencement of it, & altho' it not yet has a second colouring, it is so like that every eye knows it—— I have only a few minutes to write by the bearer,— I would willingly visit you, it would be very agreable to me, and to help you in obtaining Visitors to see your works, yet my acquaintance didnot extend much farther than the DePeyster family & their intimates. I found that I could not be in time for the Gentleman I intended to send this by, therefore I may make it a longer Letter. I have had some difficulty about the point of sight in the picture—to shew the length of the Room necessarially placed the Horizon higher than I conceive is pleasing. [Illeg] after much study of the several objects to be represented placed rather above the middle of my figure—the Mammoth then placed behind me the lower part only seen the curtain covering [it] above. This Curtain is a dark crimson Colour with damask flowers. it makes a fine relief of the head—I could not bring the base line of the bird casses to the bottom of the Picture, because it would make the room too narrow, but to fill up that vacant space, a measure of about 3 feet, I shall place there one of the 2 steps Stools of the Museum with a fine specimen of our wild turkey, brought by Titian on the Missourie expedition, painted in its full size,[2] and a few of the birds & perhaps one or two of the Portraits of revolutionary characters September 9th. It is as you see a full month since I began this letter, you may wonder the reason of my silence my only excuse is that I could not write any agreable [page ripped][news] I have had so many calls on me for money that I have felt very disagreable and have not had it in my power to

send you what I ment to have done. The Museum has not produced much income, indeed very little since the hot weather set in. We have in the beginning of this week commenced the illuminations but the Circus having reduced their price to 25 Cents draws most of the company from us, & this I expect will be the case for a few weeks,[3] I came from the Museum this evening because there was only 2 boys visitors, & thus I have come to this scrole, with the intention to finish it—— My anxiety about you is great, never for a long time hearing from you. I wrote once to Rubens since since I received your letter of the last month & I have found that he has sent you two letters.[4] His exertions to please the Public has been profitable to him——I wish it may continue so.

Raphaelle is diligent at his pieces of still life, but of portraits he had nothing to do for sometime past, & he very sildom can get any thing for what he does, of course I am obleged to find him market money——

Titian for a long time past give me trouble, he thought that Franklin ought to leave the Museum & go to the Cotton business, he was jealous of his being in his way to the obtaining the whole management of the Museum. & he wanted to get married, this he thought would not be prudent to do without I would increase his salory—which my income could not afford—at last I have at least for the present satesfied him, by agreeing to give him 10$ pr. week for my board, and retaining my work shop & painting room & bed room. But I tell him that he must harmonize with Franklin as the Museum require the labour of both of them.[page rip][I shall] now give you some account further on my portrait, It is now in train to be finished in a few days—And I wish it may excite some admiration, otherwise my labour is lost, except that [it] is a good likeness. I have introduced a few figures at the further end is a figure of meditation, a man with folded arms looking at the Birds, next a father instructing his Son. he holding his book & lesson open before him & looking forward as attentive to what the Parent says—and a quaker lady, we may suppose entered at the further opening & passing along by the Cases of Birds turns round and seeing the Mammoth Skelleton, is in the action of astonishment, her right foot forward & both hands lifted up—she is dressed in in plain rich silk & black Bonnet— I dont know that more figures are necessary these seem to [be] sufficient for the perspective of the room. I mentioned the Wild-turkey to be on a stool—I have placed it on a Mahogany ⟨[illeg]⟩ box with the drawer drawn out contain[in]g Tools, Vise Plyers &c. behind me is a table covered with green baise, on it my Pallet & Pensils, This is the best I can give you without a drawing, but when Titian has got through his present work, he may give you a sketch of the Picture—He has taste & draws very handsomely with dispatch.

I hope as soon as you receive this you will write to let me know your

situation, it I fear is bad enough through the misfortunes of the fever.[5] many of yours friends have enquired of me about you.

My Nephew James Peale & his Wife boards at lodgings, they stoped some time with his father. She is at this time very much indisposed, it is said to be Gout. I am told that she will eat Pickles—so much for imprudent eating—very few People think of the use of eating & drinking. Your Sister Sellers is likely to become a well woman again, altho' at present she is getting rid of Broken bone fever &[?] she[?] went on a visit to Wilmington; on her return she took cold by the wet deck of the Steam-boat. Love to Eleoner & the Children. yrs. Affectionately

CWPeale

Mr. Rembrandt Peale.

ALS, 3pp.
PPAmP: Peale-Sellers Papers—Letterbook 17

1. Probably Sir Thomas Lawrence's (1769–1830) full-length portrait of Benjamin West (fig. 30), commissioned in 1818 by the American Academy of Fine Arts, New York, and completed in 1820. The portrait was exhibited at the Royal Academy in 1821 before being sent to New York. It remained at the American Academy until that institution closed in 1842. *Peale Papers*, 2:663; Kenneth Garlick, *Sir Thomas Lawrence: A Complete Catalogue of the Oil Paintings* (New York, 1989), p. 280, no. 807c; Algernon Graves, *The Royal Academy of Arts: A Complete Dictionary of Contributors and their work from its foundation in 1769 to 1904*, 8 vols. (London, 1906), 5:5.

2. The turkey, one of the specimens that TRP had collected on the Long Expedition, was accessioned into the Philadelphia Museum on March 20, 1821. See above, **14**. Philadelphia Museum, Records and Accessions, Invoice of Zoological Specimens and Drawings prepared by TRP.

3. Probably the circus of Pepin and Brechard, which occupied a large building on the corner of Walnut and Ninth Streets. Remodeled and designated in 1810 as the "Olympic Theatre," the building was designed similarly to Sadler's Wells in London. Included in the interior were a riding course, a large stage with a separate orchestra section, and "rooms for refreshments." James Mease, *The Picture of Philadelphia* (Philadelphia, 1811), p. 29.

4. See above, **89**. ReP's letter to CWP is unlocated, as are RuP's letters to ReP.

5. In early August, reports of cases of yellow fever in New York City prompted the Philadelphia Board of Health to issue an order interdicting persons or goods from New York from entering the city, despite assurances from Dr. David Hosack that the cases were few in number and localized. *Poulson's*, August 16, 19, 1822.

91. RuP to BFP

BALTIMORE. AUGUST 26, 1822

Baltimore Aug. 26th. 1822—

Dear Brother.

Being rather indisposed I could not think on the subject of the gas holders, before this, my indisposition was a billious head ache, and after one dose of saltz, and two of antibillious pills and yesterdays rest from duty, I have quite recovered.

I approve of the 3 gasometers[1] under one table and from experience I

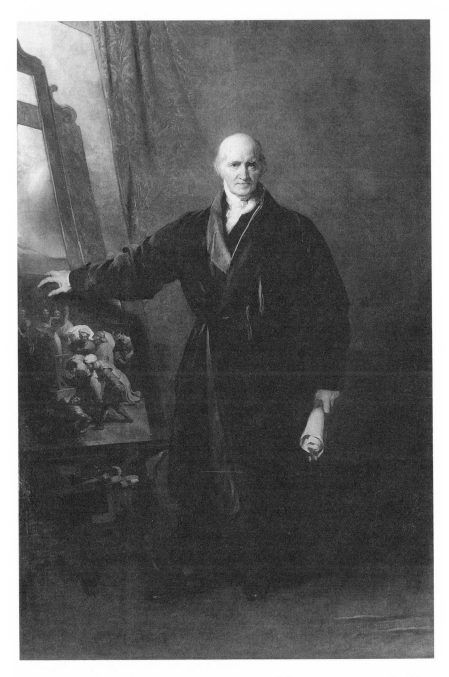

30. *Benjamin West.* Sir Thomas Lawrence, 1820. Oil on canvas, 107 × 69 ½″ (272 × 177 cm). Wadsworth Atheneum, Hartford.

cannot say whither these gasometers are as good as our old one or not, I rather suspect that my combined blow pipe[2] is not well constructed, I have not yet succeeded perfectly with the Melting of the mettals, I think it will be well to get Mr. Lukens to make another for me and send it on, there are no small blow pipes to be had in Balte. or I should make it myself, or if a convenient opportunity should shortly occur, perhaps it would be well to send ours ⟨here⟩ to make trial of, and then to return it before you will want it—if you think best to have one made I send the distance of the pipes from each other Mr. Luken said he would make for me a set of pipes with cuppling screws *&c. I have the brass cocks made by him already. If he can do them im-

ediately I should be pleased. I think my failure in the melting of the mettals was entirely in the defect above mentioned and not in the gasometers. I think the lead pipes left at the museum will answer perfectly well for the gas to come from the holders and connect to the brass cock **A**. and the blow pipes, and other instruments connected to the cock by means of a cuppling screw **B**. When in Phila. I had intended making the gas holders seperate and the cisterns like those formerly in the steeple—so as to be light, and easily removed, for during the severe part of the Winter they cannot always remain in the Lobby or they would freeze. The gasometers left by Rembrandt are made of tin, and I found several small holes rusted

through them, altho they were painted painted, I soldered them up, and gave them another coat of paint.[3] I would recommend you to have a sheet iron stove made at the east end of the long room as the drawing directs I would have it square resting on an iron plate, and the sheet iron to be filled in, with fire bricks &[c]—the top without brick, and it to be hinged with a door in the front, so as to put the coal in rather than to lift it or having the door in the body of the stove. This you could make the oxygen in perfectly well the iron tube from the retort would pass through the small door in the top or cover. the draft I think sufficient, to receive

* a simple pipe—the compound pipe—the wreathe or whorle—and a cock for Bladder.

it from under the floor, which would be much better than from the museum—but if not sufficient, the drawer or ash pan might be left a little ways open. The Susquehannah coal[4] to be used in it. and the inner part to hold about a half bushell of coal which will serve the day, so that the coal being put into it at night it will be hot the next morning, and also perfectly safe from fire owing to its being enclosed in sheet iron. I am now trying to obtain this coal here but shall find much difficulty in getting it, wood is now 3$ per cord, which is very cheap. I have augmented my number of Living animals, and if I go on in this man-

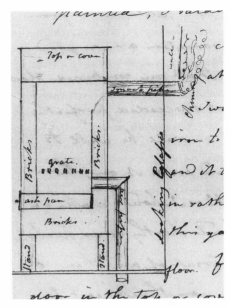

ner my room will soon be too small for them it being now almost fool [full].

I have not hird anything about the magnettic whirl[5] that you have been engaged about? And I have been too much engaged to do any thing with it. Many enquiries are made of me whether I will introduce the galvanic apparatus of Dr. Hare's,[6] which I am much at a loss how to answer. I am rather afraid of the expence.

Will you ask my father or some one of the family to send me on a sketch of the profile of Dr. Franklin[7] for my Electrical expt. about the same size of yours? When I shew the Guinea & Feather Expt. with air Pump,[8] I generally introduce the double cone assending the inclined plane,[9] and also the Chinese tumbler, the first surprises, and the latter delights—

I should like you to obtain for me some Nitrate of silver and Oxymuriate of Potash, and some of the french Æther from Mr. Leman's ⟨& smith⟩[10] corner of 2d. and the Bank of Penna. he promised to let me have it at a reduced price, he only had about 8 bottles left I would like to [have] 4 or 5, and I think you ought to seccure some of it, if you would let me know, what all will come to I will forward the amount &c———

Tell Anna that I expect to send this by Mr. Shepherd,[11] her admirer whom we had as a companion to, and at Bethlehem and that he is still unmarried, and has made many enquiries about her and the others of the party; that I yesterday sent my letter to Sarah,[12] and in it, one from Eliza, which she hadnot finished writing, so that I expect she will have to em-

agine some words and guess at others, and the conclusion of it—some words were left to consult the dictionary.

I have been taken off so frequently, that I scarcely know what I have written to you. If you have any information ask it in your Next, and I will answer it—then.

Gum Guyaccum[13] when disolved in Alcahol and a small portion put into a Wine glass and emptied out, and then held over the *oxiynuriatic Acid Gas*, it will form a *Blue* colour—Add to a weak solution of it some Sulphuric Acid, a fine *purple* is produced. The powdered gum, when needed with flour that has no gluten in it, no change takes place, but if it contains glutin it formes a *blue* colour. *Amoniacal Gas*, when placed over mercury in a tube, will be totally disolved when a small piece of Ice is thrown up into it—this is easily done for the Ice rises to the surface of the Mercury so easily.

Give my love to all the family and beleave me yours Sincerely

Rubens Peale

August

Day.	Night
19— 3.00.	11.87:
20— 2.62:	15.—
21— 4.37:	16.12:
22— 1.62:	6.75:
23— 2.37:	6.87:
24— 87:	4.00.

The last 3 days have been very close and sultry scarcely any body moving—And the Williames are playing at the Pavillion at 25 cents each visitor, giving them a play and dancing on Slack and tight ropes &c &c &c———

ALS, 4pp.
PPAmP: Peale-Sellers Papers

1. A tank or reservoir holding gas. *OED.*

2. Probably Joseph Cloud's version of Robert Hare's oxyhydrogen blowpipe (above, **73, 77**).

3. For ReP's gasworks in the Baltimore museum, see *Peale Papers*, 3:387–487.

4. Probably Pennsylvania anthracite coal, which sometimes was referred to by the name of the river on which it was transported. Anthracite coal was shipped in flat boats on the Susquehanna river. In 1818 the Peales began using this coal in special stoves invented by CWP's friend, the Philadelphia mechanic Jacob Perkins. *Peale Papers*, 3:559–60; Ferguson, ed., *Early Engineering Reminiscences (1815–40) of George Escol Sellers*, p. 20.

5. Probably a "whirling table," a device that showed the planets in their orbits; it was used by schools in nineteenth-century America to demonstrate the laws of gravity in the solar system. Benjamin Pike, Jr., *Pike's Illustrated Descriptive Catalogue of Optical, Mathematical, and Philosophical Instruments*, 2 vols. (New York, 1856), 1:207; assistance for this note and notes 8 and 9 was provided by Deborah Jean Warner, Curator, History of Physical Sciences, National Museum of American History, Smithsonian Institution.

6. See above, **80**.

7. There is no information as to how a "profile" of Benjamin Franklin (*unlocated*) was used in the electrical experiment in the Philadelphia Museum. In 1785, CWP painted a life portrait of Franklin for the museum, and two years later he produced a mezzotint from that painting. *P&M*, pp. 81–82.

8. In this experiment a coin equivalent to a guinea and a feather were placed in a glass tube from two to four feet long. When the tube was turned, the feather took several seconds longer than the guinea to fall. When air was pumped out of the tube and the tube was turned over again, the guinea and the feather fell at the same rate. The demonstration, which became a common school experiment in nineteenth-century America, was used to prove that bodies of a different weight will fall at the same rate of speed. Pike, *Pike's Descriptive Catalogue*, 1:207.

9. The "inclined plane" consisted of two rails sloping downward toward a narrow end. A double cone placed at the narrow end initially rolled upward toward the wider end and then eventually rolled downward. The device was utilized in nineteenth-century American schools to demonstrate the "natural law that the centre of gravity of a body always tends to the lowest station." Pike, *Pike's Descriptive Catalogue*, 1:160.

10. W. Lehman and A. S. & E. Roberts, druggists, at 76 South Second Street. The Bank of Pennsylvania was located at 36 South Second. *Philadelphia Directory, Suppl. (1822)*.

11. Unidentified. Anna is ACP.

12. RuP's letter to SMP is unlocated.

13. The resin from a tropical American tree (*Fam. Zygophyllaceae*), gum guyaccum is now used in various tests because of the formation of a blue color on oxidation. *OED*.

92. CWP to RuP

PHILADELPHIA. SEPTEMBER 10, 11, 1822

Philada. Septr. 10th 1822.

Dear Rubens

I began a Letter to Rembrandt the 9th. Ult expecting to send it by a private hand but finding I was too late by that opportunity I left it unfinished for a whole month, and yesterday I sent it by the Post,[1] The reason why I had did not write was having nothing pleasing to communicate to him—but thinking that he would not write to let me know his situation because I had neglected to answer his letters, I became, and am very uneasy about him, and if he gets my letter I hope he write immedeately. I am just on the finish of my Portrait and anxious to know what will be the Public oppinion on it— The likeness I know is good, and cannot be found fault with, but whether the design will excite admimeration is all important. The small figures I have made are a Man with folded arms as meditating at the further end of the Museum, the next is a father instructing his Son, and nearer is a quaker lady in the action of astonishment. She looks toward the Mammoth with *up lifted hands*.

The Skelleton of the Mammoth a part which is seen under the Curtain which I am lifting up and beyond it are a number of Quadrupeds; Grisly Bears, Antelopes, Lama, Buffalos, and Elks. These I have choose, in the

179

place that is occupied by the Casses of Minerals. On my left hand is a Table Covered with green base on which is my pallet and Pensils, Mammoth bones on the floor & one resting against the Table; on the opposite corner is a Large Wild Turkey laying in a Mahogany box, and its drawer drawn out with sundry tools in it. only one of Portraits over the Bird Casses is connoisable. [illeg] 11th. I think that I shall have little occasion to work again on my portrait, since I began this letter I have retouched the Head & finished the drapery. This latter part brings out the effect of great relief. The few who have seen it since praised the work. I have invited Joseph Hopkinson to see the picture, and he being a Critick, whatever manner in which he views it, will in some measure determine what will be said by others, as many are governed by the opinion given by men who are esteemed learned in the art.[2] I quit this subject to enter on one more disagreable. The difficulty I have in management of my Children: Titian not long since had determined to go on an expedition with some company to collect furs on the Missourie, he could not advance two thousand Dollars, so they would not take him as a partner, but he had determined to go as a trapper—In short it was not only an expensive but a dangerous undertaking, and what is more, not in the least likely to enable him to get married. It was proposed to him to undertake a short apprenticeship with a dentist, say of 6 months, and then with the advantage of my knowledge in artificial teeth, he would with his knowledge of the anatomy of the human frame, become conversant in that line of business—It is a business that now commands a vast income to several Dentists, and who cannot get through with the demands on them, Opperations are bespoke months & months before; or in advance— However Titian at last told me that he did not like the business altho' profit might follow—and he said if I would give him $10 Pr. Week for my board, and he said he thought that it would not be more expensive to me than my keeping House, and on my calculation I found with deducting Lins & Franklins board at $3 Pr. Week; the amount in the end would be nearly the same to me, but I told him that he must harmonise with his brother Franklin, as the Museum required the services of both of them, I thought as their Work in it was well defined, that they ought to pull togather without grumbling about their appointments as Managers, My being Manager they were employed to assist me, and it would be my study to so divide their labours as not to interfere with each other, but all my endeavours to make them harmonise seems in vain. [Franklin asked][illeg] this morning what had passed between Titian & me. he resented my not telling him what passed before I consented to Titian's proposition, I told him that I had made it a condition with Titian to harmonize with him, and I asked him if he would board with Titian on the same lay as with me, but he said that he must seek some other imploy-

ment, that he must try to get into the Cotton business, and he asked me to assist him in the settlement with his brother Linnius. He has been a sufferer with his connection with Linnius, I gave them 4 Bales of Cotton; Franklin got nothing for his labour at the mill & as in partnership with his brother he is involved in a debt to the Merchant with whom they [illeg] [transacted] business of about 6 & 7 hundred $ and whether Linnius paid any of that Debt since I left the farm I know not or even whether he has made money or not.[3]

I desired Titian to ask Franklin if he would board with him but whether he will put the question or not is at least doubtfull I told Franklin that his determining to leave the employ, was just coming into Titian's view. I find that Rebeckah cannot stay much longer with me, She looms big, and Sophonisba says I ought to be careful not to get in the same situation as she was with her girl.

I cannot yet find a purchaser for your House, the ground rent is the bug-bear. but as I have said before if I can sell my farm, that in such case I would take it on my own shoulders and reduce the costs of Morgages—as it now stands to attempt to sell by auction would only be adding loss without any chance of getting any profit to you as it would not sell for more than the Morgages— I have had some trouble to get the rent from the Doctr—but at last obtained it, which by necessity I must apply to pay my rent with my Landlord in 2 days hence

What is the dates to pay Interest to John Warder? I must provide for it, and also try to keep Bank business in proper train to avoid difficulties. I am really sick of Banks & other debts, and never can enjoy my peace of mind while I am in debt.

You have said something about selling your lotts, what are your views of them, when I am informed I will follow your advise—[4] I am summoned to the Museum so conclude with love to Eliza &c yrs. affectionately CWPeale
Mr. Rubens Peale

ALS, 3pp.
PPAmP: Peale-Sellers Papers—Letterbook 17

1. See above, **90**.
2. Joseph Hopkinson (1760–1842), Philadelphia lawyer and man of letters, was among the first to propose the founding of the PAFA and actively engaged in its development during its early years. *Peale Papers*, 2:846; 3:70.
3. BFP began preparing to manufacture cotton as early as November 1814. It was not, however, until the spring of 1816 that he and his brothers, CLP and TRP, actually began to manufacture cotton. *Peale Papers*, 3:286, 322, 396.
4. In his "Memorandum's", RuP wrote that before he moved to Baltimore, he "had accumulated some little property of my own." On January 17, 1811, RuP bought a lot in the Northern Liberties of Philadelphia for $50. In 1813 and 1814, he purchased two other lots, each for one dollar, but each encumbered with yearly ground rents. He appears to have erected a brick tenement on the lot he purchased in 1813. On October 24, 1821, he sold this

lot and the tenement to a John Nisbet for $900.00. There is no additional information on RuP's other Philadelphia land holdings. Rubens Peale, Memorandum's, p. 28, P-S, F:VIIB/1A2-G13; Edward Haley & wife, January 17, 1811, Deed to RuP, PPDR, Deed Book, EF 12, pp. 274–75, F:VIIA/2A7-B3; Solomon Wiatt & wife, Deed to RuP, July 26, 1813, PPDR, Deed Book I C 26, p. 288, F:VIIA/2C1–6; Branch Green, et ux., Deed to RuP, January 14, 1814, PPDR, Deed Book GS 18, pp. 555–59, F:VIIA/2D3- E4.

93. RuP to BFP

BALTIMORE. SEPTEMBER 11, 1822

<div style="text-align:right">Baltimore Sep. 11. 1822.</div>

Dear Brother.

Will you take the trouble, and oblige me by calling on as many of the artists in Phila. as you can, and obtain from them, the pictures which are to be exhibited in my Annual Exhibition,[1] and pack them in a secure and safe manner so as to prevent injury, and forward them as soon as possible.

1——C. W. Peale's I have

2——T. Sully, I have several, but I should like his opinion whose portrait he prifers—

3.——Shaw's[2] I have.

4.——William Birch,[3] I should like to have several of, particularly his view of Phila. or on the Schuylkill &c tell him I think they may sell—

5.——James Peale Senr. I should like to have of his Landscapes I think they will Sell &ccc

6.——Tho Birch Senr.[4] I have (enamel)—

7——Wm. McMurtry—[5] I should like to have of his work.

9——Mr. Cridland—[6] I should like to have of his work.

10.——Mr. Douty[7] ? who lives in 10th. below Mr. McMurtry's Mr. Sully will tell you. I should like his work. I think they will sell.

11. Miss Shetkey's[8] work—

12. Miss S. & A. Peale's are expected, with them.

13. Titian Peale. I should like a specimen of his work—

14. Seamore's.[9] I should like a specimen of his work. And ask Mr. Sully if there are any others that would be well to call on, I am now engaged in making the cattalogue which must be published and ready for delivery of the first of Octr., therefore the sooner I can obtain the pictures or a list of them, the better, I therefore will be much oblige to you if you will give your mind to it for a little while, and it will be very thankfully acknowledged by your affectionate

<div style="text-align:right">Brother
Rubens Peale</div>

N.B. I have enumerated all the artists that I at present recollect, (I have all of Raphaels hanging up.) but if you can learn of any others I should be obliged to you to call on and request specimens of them. And I must repeat that no time aught to be lost in your attending to it, I am sure my father will give it with much pleasure, my prospect of a good collection is very fair.

Present my love to all

<div style="text-align:center">Your</div>

<div style="text-align:center">Rubens Peale</div>

ALS, 2pp.
PPAmP: Peale-Sellers Papers

1. On September 30, 1822, a notice in the *Baltimore Daily & Commercial Advertiser* announced the "FIRST ANNUAL EXHIBITION OF Sculpture, Paintings, Drawings, Engravings, &c." at Peale's Baltimore Museum, to open on October 1 and continue for six weeks.

2. Joshua Shaw (ca. 1777–1860), landscape painter and inventor, was born in England and immigrated to America in 1817, settling in Philadelphia. He exhibited frequently in Boston, New York, Philadelphia, and Baltimore. Groce and Wallace, *Dictionary of Artists*.

3. William Russell Birch (1755–1834), miniaturist, enamel painter, engraver, and etcher, immigrated with his son, Thomas, from England to America in 1794 and settled in Philadelphia. He and his son published *Views of Philadelphia* in 1800. In 1822 he was living on his country estate, Springland, near Bristol, Pennsylvania. Groce and Wallace, *Dictionary of Artists*.

4. Thomas Birch (1779–1851) was a marine, landscape, portrait, and miniature painter. Groce and Wallace, *Dictionary of Artists*.

5. William B. (or P.) McMurtrie, portrait and landscape painter, resided in Philadelphia, and exhibited at the Artists' Fund Society in the late 1830s and early 1840s. He sold at least one landscape to the PAFA. Groce and Wallace, *Dictionary of Artists*.

6. Unidentified.

7. Thomas Doughty (1793–1856), landscape painter and lithographer, had been a leather currier in Philadelphia until 1820 when, in a career shift not unlike CWP's, he turned to art. He was one of the first artists in America to devote his career almost totally to landscape painting, and he won praise immediately for his views of the rivers and mountains of Pennsylvania, New York, and New England. He was elected a member of PAFA in 1824, and in 1825 he exhibited ten landscapes at the Academy's annual exhibition. His later lithographs were published in the Philadelphia periodical *Cabinet of Natural History and American Rural Sports* (1830–34), which was edited by his brothers. He remained a resident of Philadelphia until 1832, when he moved to Boston. Thereafter, he traveled in Europe and resided in New York City. Groce and Wallace, *Dictionary of Artists*; Falk, *Annual Exhibition Record*, 1:62–65.

8. Caroline Schetky (1790–1852), landscape, flower, miniature, and still life painter, came to Philadelphia from Scotland in 1818 and remained in the city until her marriage to Samuel Richardson in 1825, after which she moved to Boston. While working in Philadelphia, she regularly exhibited her work at PAFA. In Boston, she exhibited paintings at the Boston Athenaeum under her married name. Groce and Wallace, *Dictionary of Artists*.

9. Probably Samuel Seymour (fl. 1796–1823), engraver and landscape painter, who served as a naturalist and artist along with TRP on the Long Expedition. See *Peale Papers*, 3:730n.

94. Eliza Patterson Peale to BFP with note from RuP to BFP; Eliza Patterson Peale to Maria Peale

BALTIMORE. SEPTEMBER 29, 1822

Baltimore September 29th—1822

Dear Franklin.

I have retired from noise and confusion to write to you. Rubens Joans[1] and Street[2] have been busy all day fixing pictures and have made use of my parlors so that I am not very comfortable for the present including my two sons who do there share to add to the general confusion,[3] The exhibition is going on well, Rubens will have a great deal to tell you about it. The second exhibition of the flower done well,[4] Mr. Robinson who has just gone says Dr. Godman and Lady will be here in two weeks with a son that weighed fourteen pounds when born, so that I must put my eight pound fellow out of the way[5] I was pleased to hear that you and dear little Anna are to board at uncle Jame's, as I think you will be comfortable there I still feel as if you belong to our family and you cant think how strang it appeared when we set down to our meals without you and your father, However, I hope the change which has and is to take place may all turn out for the best[6] As your father has given up house keeping I will have to trouble you to send on our Stove and other things as I am in want of the stove, I dont like to trouble you as I know you are very much engaged at this season, perhap your father may have some time to spare, I will write a few lines to Maria Peal[7] in this and get her to put our things together. then it will not be so much trouble to you. Rubens has Let to Mr. Street his Larger front room down stairs to paint portraits in. he will put in the exhibition four Large pictures,[8] I wish you would write to me as I feel pleased to hear from you—even if you have no great information to communicate

[Eliza Peale]

I regret very much that the pictures you named have not arrived yet. nearly all the paintings are arranged and not knowing the different sizes we cannot leave spaces for them and the Cattalogue is in consiquence deferred until 12 tomorrow.

Rubens Peale

Dear Maria. I have been looking for your sisters for some time, and when the bell rings early in the morning I think it's them. I think during the exhibition is the best time for them to be here. I recieved Anna['s] Letter[9] and asked Mr. R. if the fruite Pieces should be sent. he wishes[?] they were here now, but he will be in Phila. soon. he will then bring them.

Rosa Peale intends meeting her sister in Baltimore. I feel as if I could say a great deal, but paper will not admit. dear Maria I am sorry that I will be oblige to trouble you to collect a few articles of ours left at the house. I have been oblige to buy several things, and still am in want of many, You will please to put the articles together that I will mention below A cooking Stove and apparatus, A new dripping pan. Three flat irons. some pans to bake bread in. Large market basket. One close basket. Tubs. I allowed Aunt[10] to have some stone Jars. oil cloth and mat at front door, if worth any thing. one Toilet table for Sopha. Peale and one for you and some demijons with some wine and cherry bounce for aunt to make vinigar in the garret, perhaps some old chairs that will do for your kitchen, and a flour barrel with a good cover. The entry Lamp perhap you can sell as I dont think it can be sent. Aunt may have a new wash board also a wooden bucket. There is a tin plate stove under the step going into the yard. I dont know what R. will do with it. Our black tin coffee pot aunt may have. I dont know if Brother William[11] has taken the kitchen Tables, as he was to have them. I have not heard when Mr Peale is to give up keeping house but I suppose soon. Then our stove will not be wanted, Tell Sarah that I am not pleased with her for leaving me in suspence about some unexpected news. I should not have said anything about these things if I had not sent for the stove

 Give my Love to aunt and family.

<div align="right">

I remain your affectionat Cousin
Eliza Peale

</div>

ALS, 4pp., add. & end.
PPAmP: Peale Family Papers

 1. Mr. Jones was probably a museum assistant; he was complimented by the reviewer in the Baltimore *American and Commercial Daily Advertiser* for the "handsome style" of the exhibition that he had arranged. Quoted in Baltimore Municipal Museums, *Rendezvous for Taste*, p. 13.

 2. Robert Street (1796–1865), portrait, historical, religious, still life and landscape painter, began exhibiting his work in Philadelphia in 1815, and remained in the city for most of his career. Between 1822 and 1824, however, he seems to have worked in Baltimore at the Peale Museum. Groce and Wallace, *Dictionary of Artists*; CAP.

 3. RuP and Eliza's two sons were Charles Willson, born February 15, 1821, and George Patterson, born August 15, 1822. *CWP*, p. 442.

 4. In August and September RuP placed advertisements in the Baltimore newspapers announcing a second expected blooming of the "CACTUS TRIANGULARIS," or "*Night-blooming Ceres*." Proud of his abilities to cultivate plants, RuP explained that the "second crop" of twenty-two "gigantic flowers" in the same season was "a singular fact . . . [which] can only be accounted for from a new mode of treatment which it has received since its first flowering." The plant, donated to the museum on July 22, 1822, was about twenty years old. In full bloom, the "snowy white" blossoms measured twelve and one half inches. *American and Commercial Daily Advertiser*, July 27, August 3, 5, September 12, 16, 1822; for RuP's botanical interests, see *Peale Papers*, 2:419, 422, 427, 653.

 5. ReP's daughter Angelica and Dr. John D. Godman, who were married on October 6,

1821, had their first child, Steuart Adair, on September 8, 1822. The boy would become an author of romantic fiction, publishing such novels as *The Slaver* (1847) and *The Ocean-born, a Tale of the Southern Seas* (1852). *CWP*, p. 441.

6. BFP moved with his daughter Anna Elizabeth (1816–1906) to his uncle James's house as a result of his and TRP's conflicts over the management of the Philadelphia Museum.

7. Maria Peale (1787–1866) was JP's daughter.

8. There is no extant catalogue of RuP's 1822 exhibition. Newspaper reviews of the show noted two of Street's works: *Christ Crowned* and *Maniac*, both unlocated.

9. Unlocated.

10. Probably JP's wife, Mary Claypoole Peale.

11. William Augustus Patterson.

95. CWP to RuP
PHILADELPHIA. OCTOBER 4, 1822

<div align="right">Philadelphia Octr. 4th. 1822.</div>

Dear Rubens

By a letter from Eliza to Franklin[1] I find some offence is given to Titian, by requesting the articles you left for my use to ⟨send⟩ be sent to you, at the moment that Titian is providing for housekeeping. I wish the demand had not been made while he is finishing a very handsome drawing of this Museum for you.[2]

I have put my Portrait in the Museum in the place where you left the Battle of Paul Jones,[3] not a very good light, but I have put one breadth of green baise to keep off the reflection of the Glass-case, the baise placed in an oblick [oblique] position does not hide the articles in the case & wards of[f] the reflection from all the surface of glass. The Picture is much approved off. Mr. Joseph Hopkinson & his lady see it yesterday and seem delighted with its effect, and strength of likeness. At the last meeting of the Trustee's they required me to make out a statement of the debts of the Museum, also the probable means of payment, this report I have drawn up to day, and the income of the last quarter is less than the expences of the Museum and my support.[4] I must sell some part of the farm in order to get rid of Bank debts. I am very anxious to have done with Mr. Snyder, though he behaves very well to me, I have not been able to reduce the note in the discount of it this day, and I have paid the discount of renewance $8.53 cts. have you been able to send Rembrandt any money for his support When I heard from him last, he was living on Money borrowed. It has hurt my feelings to find that I could not send him $50 which he asked as a payment for his Portrait of Doctr. Michel. I have not been able to pay any part of the rent of the State-House, and the City is incuring heavy expences & in want of money. I told Mr. Baker[5] that I would endeavor to pay him in small payments as fast as I could command the

means. Franklin intends to board with my brother also his daughter Anna.

I am succeeding with making Chinea Teeth, my last essay ended unfortunately, on Saterday last I put a considerable number in the muffle,[6] and commenced [illeg] [firing?] with Charred Coal, but finding that I should not have sufficient heat to vitrify the Feldspar, I added a half peck of Lehigh coal, and it was well ignited I see that the top of the Muffle had fallen in, and the teeth in a fine state of vitrification, had I then stoped the fire I might have saved many of the teeth, but at this time I was putting my Portrait in the Museum, and I thought there would be no further damage done by the fire as it was, but behold the black lead muffle melted on the teeth and sunk all togather in a mass, melted the feltspar cemented all to entire ruin, and I got only one Tooth, yet the satisfaction of knowing the composition to be excellent comforted me, in the loss of teeth & furnace and I have now a good number in a Potters kiln foundry and succeeding in the ⟨burning⟩ fireing of them, they will be perfect with-out the additional trouble of glaising as the composition is of the true colour and so hard that were I maybe obleged to grind them to fitt to the shape desired—I can afterwards polish them with emery.

Sybella is keeping house for me, and prepairing things necessary for Titian whom I understand intends to be married next week.

Burd Patterson[7] was at the Museum last night, his family in health, and he says that he has had all this dry season plenty of water at his mill, and never lost an hour for want of it.

Sophonisba continues to enjoy good health. Franklin in his letter to you hinted that I had not confided in him. this was doing me injustices, but he was angry that I had consented to Titians Marriage, what right has a parent to attempt to controle a child arrived at full age? I found that I must send Rebeckah away, and I knew that I could not get another housekeeper to suit me at least I did not chuse to try a strainger. I have told you all the news in my remembrance—. My love to Eliza & Children

yrs. Affectionately CWPeale

Mr. Rubens Peale
 Baltre.

ALS, 3pp.
PPAmP: Peale-Sellers Papers—Letterbook 17

1. See above, **94**.
2. TRP's drawing of the Long Room that CWP described to RuP on August 4 (see above **89**; below, **97**).
3. Perhaps a scene from CWP's "moving pictures" exhibition of 1786, which included the capture of the British ship *Serapis* by John Paul Jones on September 23, 1779. *Peale Papers*, 1:441; *P&M*, p. 114.
4. When the museum trustees met on July 19, 1822, they resolved "that the manager be

requested to provide at the next quarterly meeting an a/c of all debts from the museum and the means contemplated to extinguish them." CWP's report of October 4 is unlocated. His quarterly report to the trustees indicated receipts of $893.89 and expenses of $351.35. After he deducted his salary of one-quarter of the museum's net receipts—$135.64—he reported a balance of $406.91. CWP's assertion that the museum's income was less than the total of its expenses and his salary as manager would have been true only if the museum's debt came to more than $406.91 and debt repayment was factored in as part of the museum's expenses. Philadelphia Museum Minutes, 1821–1827, P-S, F:XIA/7A6-B11; CWP, Quarterly Report of the Manager of Philadelphia Museum, September 30, 1822, P-S, F:XIA/7F3–5.

 5. Unidentified.

 6. An oven used in a furnace to protect pottery and enameled wares from the flame.

 7. Burd Patterson was Eliza's (Mrs, RuP) third brother. *Peale Papers*, 3:810.

96. CWP to RuP

PHILADELPHIA. OCTOBER 17, 1822

Philadelphia Octr. 17th. 1822.

Dear Rubens

your exertions to obtain so handsome an exhibition of Paintings, must have been great, and I hope the profit will be equally great, in a pecuniary way as well as your acquiring favor with the Citizens of Baltemore, who are proud off splendid improvements of their City.[1] I wish I could spare the time paying you a visit before your exhibition closes, but I fear that I shall not have it conveniently in my power, as I have many things to prepare me for doing what I wish on such a Visit. In the first place I must provide for payments as they become due, wood for the Museum &c. But I do not allow any expence that can well be avoided, therefore nothing but our united labours can be expected for its improvement. Titian seems to have got over his resentment about your sending for your articles left to oblege me this morning at breakfast he said that he must finish the view of the Museum for he wished to send you this ever advancing proof of the improvement in his disposition. It was the character of [his mother] and her children like her are soon are brought to a forg[iveness] after being offended—therefore as soon as Titian can provide some few articles for the Kitchen, I will have your Stoves and what I can find of yours sent by some conveyance. My Portrait in the Museum is much admired, but more especially by Artists. The Trustee's mett last Monday and after going through their business of examining the accounts they went to the Museum to see my Portrait, and although it was rather too near the close of the day, they pronounced it an admirable likeness, but some of them thought my left arm not quite as it ought to be, I told them that I would take it again to my painting-room & try what improvements I could make, Oh no said Mr. Pratt, I have know[n] many pictures spoiled by

attempts of alterations, his father as a painter had found it so by experience—[2] and Mr. Stewart had painted a Portrait of Law[y]er Lewis,[3] a portrait evrey Eye would know even if placed amongst a thousand Pictures. in Short says he it was the best portrait he ever saw. but some persons seeing it had said that it only wanted the Segar to complete the likeness, and Stewart then painted the Segar & Smoak assending, but the family coming to see it was offend'd, and Stewart said he could in less than 2 hours restore it to its former state, yet Mr. Pratt said that Stewart could not make it equal to what it was before—therefore says he you must not touch this picture again. However I am sensible that I can not only mend the left Arm, but other parts of the picture, which I know is not correct, though nearly so, And yet the labour of altering what I allude to will cost me very considerable trouble, therefore as I can never look on the picture without wishing I had made the alterations I allude to, I must not reguard any trouble to complete a picture to remain a Monument of my Talent in the Art, in so public a situation, altho no one that has seen the picture have made the least remark on what I know is not quite correct. My next business of importance is that I must persevere in my next object, that of Porcelain Teeth. as I find that my daughter Sophonisba will in a very short time require a considerable work from me to make her comfortable. for myself I have nearly done all that is really necessary. I will now relate a tryal I made with Lehigh coal—I had my furnace in firing about 60 teeth, and although I had made a very considerable heat with chared-coal yet it was not sufficient to vitrifiy feltspar, and finding that I should fail in making the teeth as hard as I wished them, Mr. Millar[4] said, I wish we had some lehiegh-coal, I instantly ran to Colemans and took a half peck, and puting them in the furnace, in a short time after they had become ignited I found that the teeth was glissening by the fusion, but that the top of the Muffle had fallen in——but I thought to my self, that I could not help it, and by letting the fire remain as it was nothing further would happen, in this I was mistaken, for the heat continued to melt the black-lead muffle & finally when I came to examine it after the fire was done, I found that the bottom was sunken down and all the teeth stuck togather with Melted black lead, and I obtained only one tooth whole and not firmly fired with others, however on the whole I was pleased with the accident as it gave me the satesfaction of knowing my composition of mixture of feltspar & clay was good, and that I could in future increase my heat as far as would be necessary for my purposes—And I am now rebuilding my furnace and shall make it on an improved plan, and a muffle failing I can take it out & supply its place without pulling down my furnace. so much for Porselain teeth & I could say a great deal more on that subject, but I will now say something about the wedding. on this day week Titian asked me in the

morning if I would be disengaged in the evening, for he said that he intended to be Married in the Church, if they would permit him and he said he would enquire in the afternoon, he told me that he wished me to be at home at ½ past 7 O'clock.[5] In the afternoon I dressed myself as is common when I expect to be in company. The evening appeared lowering, and some small rain had fallen. I went home at the time appointed and found Mr. Fisher[6] and other young men, we then were to go to wait on the Bride and I found that Carriages were provided, I had expected to walk, no I must get into a Carriage, so we were carried to the Mothers, where the Bridesmaids was in readiness, and I was introduced to the Mother, the Bride & ladies—then we drove to the back of the Church of Forth Street,[7] went through a door and dark passage into the Church which had a few lights in front of the Alter— The Priest soon began the ceremony which I thought rather long more so perhaps because I ⟨ ⟩ could not hear a single word—for he read in a low voice. we then returned home, and I found that a long table was garnished with the Tea & Coffee apparatus in the center of the Table a Waiter on which a large Cake ornamented with coloured Sugars, on the Top of the cake a round white Pedestal, on it two red coloured hearts—and this covered with an elegant network Temple made of sugar candy, glissennng by its transparancy and humid ⟨illeg⟩ surface. In the first place the Candy was made hard in order to give it strength, then covered with a softer substance to give it splender. But I am loosing myself in this description, when I should tell you that as soon as I entered the House I kissed the Bride calling her my daughter and wishing her happy and a long life. The next day I took the opportunity of finding her alone, I told her that I supposed she knew that Titian & Franklin was not on such terms as I could wish, and that both their service was necessary to me, therefore as Franklin was found [fond] of musick, and she possessed such talents, that it would be for her happiness as well as mine to do her best to harmonise between them, she promised she would &c.[8] drawing to the close of my paper, she just now desired me to make her best respects or love I dont know which, to Eliza & yourself. In which I join yours affectionately

<div style="text-align: right">CWPeale</div>

Mr. Rubens Peale.
 Baltre.

ALS, 3pp.
PPAmP: Peale-Sellers Papers—Letterbook 17

1. No catalog for RuP's first exhibition has been located. Ten articles commenting on different works in the exhibition appeared in the *American and Commercial Daily Advertiser* from October 19 through October 31; earlier four articles appeared in the Baltimore *Morning Chronicle and Daily Advertiser*. Most comments were favorable. On October 11, one re-

viewer noted that Baltimoreans were, "indebted to Mr. Peale for the first effort made among them to promote a taste for the Fine Arts, by a public exhibition of the works of artists of talents and celebrity." Among the 299 pieces in the exhibition, which ranged from "Ancient Painting" to drawings and watercolors, were works by forty living artists "of great respectability." See Municipal Museums of Baltimore, *Rendezvous For Taste*, pp. 13–14, 16, 17.

RuP's accounts indicate some increase in income during the run of the exhibition. Museum revenues had been $604.75 and $705.62 in July and August, and had fallen to $458.75 in September. They increased to $749.75 and 833.37 in October and November (during the exhibition), and then fell to $255.75 in December. Baltimore Museum Account Book, 1822–29, MDHi, F:XIB/3B5-C10.

2. Henry Pratt (1761–1838), son of the painter Matthew Pratt (1734–1805), was a Philadelphia merchant. He was appointed a trustee of the Philadelphia Museum after the death of Pierce Butler (see above, **57**). Sellers, *Museum*, p. 240; Crane and Dine, eds., *Diary of Elizabeth Drinker*, p. 2200.

3. Gilbert Stuart (1755–1828), American portraitist. His portrait of William Lewis (1751–1819) of Pennsylvania, prominent lawyer, member of the state legislature, U.S. attorney, and federal judge for the eastern district of Pennsylvania, is unlocated. An engraving of the portrait by C. Goodman and R. Piggot appeared in the *Analectic Magazine* (1820). John Neagle's copy (1834) is at the Law Library, Philadelphia. *DAB*; Lawrence Park, comp., *Gilbert Stuart: An Illustrated Descriptive List of His Works* (New York, 1926), p. 478.

4. Unidentified.

5. A notice of TRP's wedding appeared in *Poulson's* on October 11:

> **MARRIED**, on Thursday evening last, by the Rev. Mr. Heyden, Mr. **TITIAN R. PEALE**, to Miss **ELIZA CECILIA LAFORGUE**—both of this city.

6. Unidentified.

7. There were three Catholic churches located on Fourth Street: St. Joseph's, in Willing's Alley between Third and Fourth Streets; St. Mary's, on Fourth Street north of Spruce; and St. Augustine's, on Fourth Street between Race and Vine in the northern section of the city. *Philadelphia: A Guide to the Nation's Birthplace*, W.P.A. Guide Series (1937; rep. ed., St. Clair Shores, Mich., 1976), p. 166.

8. CWP also presented Eliza with copies of his two pamphlets, *Epistle to a Friend, on the Means of Preserving Health, Promoting Happiness; and Prolonging the Life of Man to its Natural Period* (Philadelphia, 1803), in *Peale Papers*, 2:491–513; and *An Essay to Promote Domestic Happiness* (Philadelphia, 1812), in *Peale Papers*, 3:129–45. CWP wrote a similar description of TRP's and Eliza's wedding ceremony to ReP, October 11, 1822. P-S, F:IIA/67E9–11.

97. Thomas Jefferson to CWP

MONTICELLO, VA. OCTOBER 23, 1822

Monticello Oct. 23. 22.

Dear Sir

I could never be a day without thinking of you, were it only for my daily labors at the Polygraph for which I am indebted to you.[1] it is indeed an excellent one, and after 12. or 14. years of hard service it has failed in nothing except the spiral springs of silver wire which suspend the pen-frame. these are all but disabled, and my fingers are too clumsy to venture to rectify them, were they susceptible of it. I am tempted to ask you if you

have ever thought of trying a cord of elastic gum.[2] if this would answer, it's simplicity would admit any bungler to prepare & apply it.

It is right for old friends, now and then, to ask each other how they do? The question is short, and will give little trouble either to ask, or answer. I ask it therefore, observing in exchange that my own health is tolerably good; but that I am too weak to walk further than my garden without suffering, altho' I ride without fatigue 6. or 8. miles every day, and sometimes 20. I salute you with constant and affectionate friendship & respect.

Th:Jefferson

Mr. Peale.

ALS, 1p.
TxU: Hanley Collection
Copy in DLC: Thomas Jefferson Papers
Published in Horace Wells Sellers, "Letters of Thomas Jefferson to Chas. Willson Peale,"
PMHB 28 (1904):136–54, 295–319, 403–19

1. Thomas Jefferson was one of the first supporters of the polygraph, a copying machine invented by the English inventor John Isaac Hawkins, with CWP's assistance. In late 1803 or early 1804, Jefferson, who had long sought a means that would enable him to preserve copies of his papers, borrowed one of the first models of the polygraph that CWP had sold to Benjamin Latrobe, and was immediately impressed with it. He purchased several polygraphs from Peale, and during the years when Peale was seeking ways to make the machine more reliable and efficient, he helped Peale eliminate some of the problems with the invention. *Peale Papers*, 2:595, 638–42, 676–77.

2. India rubber. *OED*.

98. CWP to Thomas Jefferson
PHILADELPHIA. OCTOBER 29, 1822

Philadelphia Octr. 29. 1822.

Dear Sir

Your favor of the 22d instant I recieved yesterday,[1] and devolving in my mind what I could best do to serve you, determined to take the springs from my traveling Poligraph, made of Brass wire, which perhaps are better than those made of Silver, unless the silver should have considerable of Alloy, and the wire drawn very hard. I believe I have some of the Wire left of which your springs are made, perhaps sufficient to make a sett for your Poligraph, which I promise myself to do as soon as I can make the apparatus for winding the wire, as in the revolution of things in the Stadthouse; the work-shop pulled down to please some discontented members of the Corporation (I should not blame more than two of that body, at least all the others appeared friendly to my labours) all my tools are scattered and many lost. so much for being under oblegations to public Bodies, but I forbear to trouble you with my complaints and suffering—[2]

The Elastic-Gum hardens with the change of weather, but what is worse, it becomes very hard by age, otherwise it might be cut into a long string by circular cut of an Elastic bottle. The brass wire springs will last a great length of time provided no crease touch it. If by accident the springs are stretched too long, by giving the whole band a turn or two the evil is remedied, but why should I be thus particular to a gentleman of your mechanical resources. it's unnecessary. I am rejoised to hear of your good health, I remember that when you gave me your Pedometer,[3] you told me that you should not use it, on account of a complaint of you[r] *hip*. I am a poor Phisician, yet I want no aid of Medical men, I trust to the aid of nature, giving her fair play, to cure every evil happening to me. I must tell you that for the good use of my limbs I make it my constant practice to rub all my mustles togather *with all my strength*, not with a Brush, but with my hands. this I conceive removes all obstructions. for the purpose I take this exercise Naked. and I am at this moment as active as ever I have been when younger,— I never miss a meal, but eat only what I concieve is best to promote good health. My Eye sight is improving. I paint without spectacles—but my hearing is bad, perhaps injured by some of my experiments to get relief. although I loose some enjoyments, yet I need not hear any thing disagreable.

Having obtained an Act of Incorporation of the Museum my mind is releaved about the disposal of it at my decease. it cannot be divided, but the profits of Income I can give to my Children as I please— All of them are Married, I board at present with my youngest Son, Titian. And my Son Rubens having purchased Rembrandts Museum at Baltimore, the Management of the Philada. Museum (such I have named it) devolves on me, and I have taken the aid of my Sons Franklin & Titian to make it deserving of public favor.

The Trustee's of the Museum having requested me to paint a whole length Portrait of myself ⟨*for*⟩ to be placed in the Museum, I have made the design as I have conceived appropriate. with my right hand I raise a Curtain to shew the Subjects of Natural history arranged in the long Room of the Stadt-house— Standing at the east end of the room, the range of birds westward in their classical arrangement, The Portraits of the revolutionary characters over them. My Pallet & pencils on a table behind me. As the bones of the Mammoth first gave the Idea of a Museum, I have placed a number of them on the floor by the Table, and instead of the Mineral Casses on the North side of the Room I have given a faint Idea of the Skeleton of the Mammoth, beyond it quadrupeds—

A large Wild Turkey (dead) laying on a tool box, with an open drawer showing preserving tools, this in on the foreground, the bones & this in my best finish, at the further end of the roòm is a figure with folded arms

in meditation. nearer is a gentleman instructing his Son, who holds a book, still nearer is a quaker lady in asstonishment, looking at the Mammoth Skeleton; with up lifted hands.

The light I have choosen for my Portrait is novel, and before I made a beginning of the large picture, I made a tryal on a small canvis to know if I could make the likeness sufficiently stricking. My back is towards the light, so that there is no direct light except on my bald-pate, the whole face being in a reflected light. you may readily conceive that it required a considerable knowledge of middle tincts to make a striking likeness. and whether it is Novelty of this mode of Portrait painting that capitivates the Connoisours of the Art, but so it is, that I have great encomions on the Work from Artists as well as others.

The springs I have enclosed with the hope that they will relieve your [w]rist of its burden—and let me add that I shall ever be happy to assist you by any thing I can do to make you comfortable as I well know that you freely give your labours for the benifit of Mankind— believe me with very great respect yr.

<div style="text-align: right">friend CWPeale</div>

Thomas Jefferson Esqr.
 Virginea

ALS, 3pp., add. & end.
DLC: Thomas Jefferson Papers
Endorsed: Peale CW. Oct.23.22
Copy in PPAmP: Peale-Sellers Papers—Letterbook 17

 1. CWP meant Jefferson's letter of October 23, 1822. See above, **97**.
 2. See above, **3**.
 3. CWP made a distance measurer, or odometer, for his *Draisine*, or velocipede, but this is the first reference to Jefferson's gift of a pedometer, which measures distance by strides or steps, as in walking. See *Peale Papers*, 3:717, 718.

99. CWP to RuP

PHILADELPHIA. NOVEMBER 4, 1822

<div style="text-align: right">Philada. Novr. 4th. 1822.</div>

Dear Rubens

I have wanted to send your articles of furneture, but as Titian had not a supply, and I had no money so plenty as to furnish all his wants—and besides I have been uncommonly hurried by having a variety of labours to perform but having again placed my Portrait in the Museum, I have thus got rid of a tedious work. This afternoon I went to the warf to inquire about a Vessel going to Baltemore, and I find that if I can send your goods tomorrow afternoon on board, which I hope to do, and when done I will

write to you again to inform you of what I have done— As I shall send the Cooking Stove & its apparatus, it will be necessary to provide a Tin plated stove for Titians use, therefore I have thought of detaining that which is under the Stairs. if it is complete for the use of the Kitchen, and to allow you the Value—but if you want it, I may send it by the next opportunity; I have not had the time to examine the said stove, I shall look at it in the morning. Franklin is of the opinion that I need not have any packing cases, except one for the Lanthorn, indeed I cannot tell what articles are to be sent, however by the aid of Franklin I shall endeavor to comply with your wishes. My Portrait being painted in an uncommon light excites the admiration [of] connoiseurs & Painters—and several have said that it is the best portrait that they have ever seen—so much for novelty.

I suppose that Mr. Robenson[1] has told you what passed between us, about your property and therefore I need not repeat it— occasionally enquiries are made about your House, one person called this morning, Titian gave him the price &c. I think its situation is so desirable, although some may think the price too high, yet some one will be found that will give the sum we have fixed on it. I dont think I can sell my farm untill next spring, then I expect to sell a part if not the whole togather: Sell I must for I am sick of it. Titian will shortly finish the drawing of the Museum intended for you, he has nearly gone through an immence work; the Classification and arrangement of the fossils and shells. Franklin seems to take pleasure in his experiments, and I believe he is better in his delivery,[2] but of that I cannot well judge, as I am more deaf than I was formerly, indeed so much so, that I can have but little pleasure in any company; and only with those with whom I can take the liberty of setting close to them. I sometimes think that I will absent myself from all society, and amuse myself with my work, painting and reading. I have succeeded in the composition of Porcelain teeth, and now believe that I shall make them in future very handsome and highly servisable to those I work for. Some time past I was trying to fire about 60 of them of excellent materials but finding that my fire of Chared coal would not give sufficient heat to vitrify this feltspar, for my furnace was not so Well constructed as it ought to be to produce the best effect of heat, but as an experiment I added about $\frac{1}{2}$ peck of Leheigh coal, the consequence was, that my Black lead Muffle melted and I lost the whole of my teeth excepting one single tooth. the accident was mortifying but the result will I hope be an important benefit—as now I have rebuilt my furnace on a better plan, for knowing I can give what heat I please, I have so contrived the furnace that I can draw out the Muffle when I see the proper degree of heat is effected.——I am anxious to do some for your Sister Sophonisba, her

mouth is now in a Critical situation, if one tooth gives way, and that very loose, she cannot masticate her food. I have also on hand for my old friend Mrs. W——-r[3] a new sett of enamal teeth, which I hope will [be] the end of all my labours for her, for once succeeding, they will not wear & decay they cannot.

I have advised Raphaelle to lower his price for his portraits this from necessity, for he cannot otherwise get a sufficient imployment to support his family, and I can very illy at present spare the money which I am obleged to do to give him the needfull.

Sarah can tell you that I enjoy good health, except that I have a cold which I am in hopes will pass away in one or two days by my taking exercise in the open air. a walk to the Sculkill bridge & back has in part remooved it, another walk as far as the Penetentionary[4] will perfect the cure. Altho' I have but little to say worthy your perusial yet I have given a long letter. My love to Eliza & Kiss to Charles, yrs.

CWPeale

Mr. Rubens Peale.

ALS, 2pp.
PPAmP: Peale-Sellers Papers—Letterbook 17

1. Henry Robinson.
2. Beginning on September 2, the museum resumed its evening programs with "Popular Lectures illustrated by experiments . . . on the evenings of Tuesday, thursday and Saturday, and Instructive Astronomical Demonstrations, the remaining evenings of the week." *Poulson's*, September 2, 1822.
3. Probably Elizabeth Mifflin (Mrs. Caspar) Wistar. See above, **68**.
4. The new penitentiary under construction on Francis Lane (Fairmont Avenue) between Schuylkill Third (Twentieth) Street and Schuylkill Front (Twenty-second) Street (see above, **98**; Scharf, *Phila.*, 3:1834–35; *Poulson's*, August 9, 1822).

100. CWP to ReP

PHILADELPHIA. NOVEMBER 5, 1822

Philada. Novr. 5th. 1822.

Dear Rembrandt

The greatest inducement I have to write at present, is, to repeat my ⟨ever⟩ wish that you would try the benefit of puting your Eyes open in cold water once a day at least. since you left me I have I believe discovered the dificulty you have in doing of it. Put your face under Water without shuting your Eyes—the difficulty must arrise from your putting your face under the water before opening your Eyes.

I thought I had finished my Brothers portrait,[1] and it has been highly praised, but I see some faults, and knowing them I cannot think of having

those faults flashing in my face every time I look at the picture—therefore James must set again. A Painter ought never begrudge his labour to amend His work, the correction of drawing in particular.

I am in considerable hopes that Doctr Godman will make a good beginning with his lectures. his talents intitle him to encouragement and once getting into public Notice he must succeed.[2]

I expect I have found a purchaser for Rubens House. The [Brewer] in George Street (Mr. Sickle)[3] went with his wife to see it yesterday— he told me that he would call on me. I anxiously wait to see him—

Love to the family yrs. &c
CWPeale

Mr. Rembrandt Peale

ALS, 1p.
PPAmP: Peale-Sellers Papers—Letterbook 17

1. (Plate 1.) *P&M*, p. 166.
2. Godman had returned to Philadelphia from Cincinnati, where he was professor of surgery at the Medical College of Ohio. See above, **15**.
3. Probably Lawrence Seckle or Sickle, wine merchant, at 162 North Fifth Street. *Philadelphia Directory (1822, 1823)*.

101. CWP to RuP

PHILADELPHIA. NOVEMBER 8, 9, 10, 1822

Philadelphia Novr. 8th. 1822

Dear Rubens

on board of the Sloop Anna Captn. Chance I have put your Cooking Stove and all its apparatus, also a Case containing you[r] Glass Lamp, left in the passage, the Brass lamp fitting to it, the Captain put into the harness tub,[1] I found there was two Tubs for salting meat in the Cellar, I have sent you the largest—and this Leather for carr[y]ing Wood. I did [not] see any thing else worthy of paying freight for. The Ten [tin] plates Stove which was left under the Stair-way, we have put up in the Kitchen, and you must sett your price for it—but in case you determine that you will want the use of it, we must send it to you by the next opportunity, of course you will give me notice in time.

I wrote you so long a letter the last[2] that I have not much to say at present. one piece of news that is more like *tea table talk*, is, that Rebeckah is lately delivered of black twins in the birthing House. one of them is dead. I heard that she said that the father was a dark Spanard. we suspect that the father is an American, and very probably the father of that she had when in your service before. *I find Moses is of the same oppinion.*[3]

finding my Lunges rather stuffed too much, I have taken a dose of Salts; and if this does not intirely relieve me I shall have recourse to the Vapour bath, and active exercise in the open air. Doctr Godman will deliver his introductory lecture in Court room[4] at the corner of 6th. & chesnut, on Saterday next at 4 O'clock P.M. He says that this will be the best lecture he ever delivered.

this moment Amos Roberts (Collector) brought a bill of Taxes for south ward for 1822.[5] amounting to $22.30—I told him that I wanted to sell, he asked the price, 8000$, why says he "I can get you that price before night, but I do not want any advantage from the sale of it. I have just come from the brewer[6] back of your House, and he told me that he would give that price for go[ing] into it immediately." My reply was that he could not go into the House before the 1st. of April next, the present Tenant is to keep it untill that period, but I can sell & give a good title with it—by a power of attorney from you & your wife—Mr. Roberts promised me to call on the Brewer & tell him this much.

I have not known any discontent between the Boys, since Titian is married & at house keeping, Eliza as well as Titian is very attentive to all my wants—but today Titian told me that I ought to get some person to aid Wilson in cleaning the Museum, that it was shamefully dirty—my reply was that I could not afford any further expence, he said the Museum would suffer injury— In one word, I will not incur any other expence than my present charge, for I must suffer if I do, therefore I want to hear no more of it. Wilson certainly can fill & dress the lamps in about 2 or 3 hours, the attendance of Visitors takes some of his time, and I know he can clean the Glasses occasionally, and the regular rotine of sweeping & dusting is no very great labour—the fact is we ought not take him from the Museum only when necessiated to do so, and then he will not be too hard worked.

Titian then proposed to ellumenate the Museum only 3 nights in the Week. This I objected to, as we get some thing more than the expence of oil &c even in the worst nights and I would make no alteration, save all I can get as much as I can, in the hopes at last to pay off all debts.

I am glad to be rid of the trouble of House keeping, but on seeing Doctr Godman I then felt a loss, not having it in my power to invite him to board with me. I told him that I would give him part of my bed. He is at present with Coleman 9th. This forenoon has been devoted to repair some locks of your house, I hope the Doctr. (McClelan) will not call on me for other repairs, he was not at home when I finished my works. I must now prepair to attend Doctr Godmans lecture, and finish the remainder of the sheet tomorrow. 10th. very small was the audience to hear the Doctr., of course I am fearfull that he will not be able to obtain a class,

he gave them notice that he would deliver another to which he invited them—Titian tells me that he intends to deliver two more. his next will be delivered in the German Hall[7] on tuesday next. I very much suspect that many of the Phisicians are jealous of this Doctrs Abilities, he certainly possesses greater powers of oratory than any of them, and I have little doubt of his abilities as an anatomist, he has to contend against a host of opponants. Doctr McClelan called last evening for me to repair other locks, I was not well and therefore I went into the Steam-bath, and feel much better today. had I done this sooner, I should most certainly have cured a cough that has been troublesome some time, but I neglect myself more than I ought to do, depending too much on the strength of my constitution, knowing this, I hope for amendment. The Museum is pretty well Visited considering the attraction of the Circus and other places of amusement. and what is pleasing to me, is that there appears more harmony between Franklin and Titian of late. Franklin['s] Child is boarded at Mrs. Warfs, and much under the management of Sybella. My love to Eliza & children.

<div align="right">yrs. affectionately CWPeale</div>

Mr. Rubens Peale
Baltre

ALS, 3pp.
PPAmP: Peale-Sellers Papers—Letterbook 17

1. A rimmed tub or cask used on ships usually to keep salted meats. *OED*.
2. See above, **99**.
3. Moses Williams (b. ca. 1775) was CWP's manumitted slave and a worker in the Philadelphia Museum. In mentioning his name in this connection, CWP may have been aware that Williams knew the father of Rebecca's child in Philadelphia's African American community; or, CWP may have been drawing an analogy to Williams's own interracial marriage, if we can accept the Peale family's story of their former slave. In his "Reminiscences" published in the *Crayon*, ReP described Williams as a "lazy" slave until he was taught how to use the physiognotrace and allowed to earn money with it in the museum. "In a few years," wrote ReP, "he had amassed a fund sufficient to buy a two-story brick house, and actually married my father's white cook, who during his bondage would not permit him to eat at the same table with her." Sellers repeated ReP's version of the story, noting that Williams was twenty-seven years old when CWP manumitted him in 1802.
 As David Brigham has noted, the timing of CWP's manumission of Williams and the former slave's success at cutting profiles in the museum was more than coincidental. The manumission of slaves in Pennsylvania during this time period was viewed as more than an act of individual benevolence; it was an action with social and economic consequences for the community. Upon manumission, both the former slave owner and the community assumed responsibility for the slave becoming a member of the city's free labor force. CWP had to be confident that Williams would be able to survive as a freedman; his slave's successful work as a profile cutter in the museum demonstrated that ability. ReP, "The Physiognotrace," *The Crayon*, 4, 10 (1857):307–08, F:VIB/14C13–14; Sellers, *CWP*, p. 306. For Williams's manumission, see David Rodney Brigham, "'A World in Miniature': Charles Willson Peale's Philadelphia Museum and Its Audience, 1786–1827," (Ph.D. diss., University of Pennsylvania, 1992), p. 177.

4. The county court building became known as Congress Hall when it was used by the U.S. Congress in the 1790s as a meeting place. With the move of the government to Washington, D.C. in 1800, the building reverted to its original function, but retained the name Congress Hall. *Peale Papers*, 2: 282.

5. Amos Roberts, tax collector for the city of Philadelphia, resided at 64 South Eleventh Street. *Philadelphia Directory (1822)*. In 1800 Philadelphia was reorganized into fourteen uniform, or rectangular wards. RuP's house at the corner of Walnut and Swanwick Streets was in the South Ward, which began at Fourth Street and extended to the Schuylkill, and was bounded by Chestnut and Walnut Streets. James Mease, *The Picture of Philadelphia* (Philadelphia, 1811), p. 29.

6. Lawrence Seckle. See above, **100**.

7. The "German Hall" probably refers to the building occupied by the German Incorporated Society, "a neat hall in seventh street." Mease, *Picture of Philadelphia*, pp. 263–64.

102. CWP to RuP

PHILADELPHIA. NOVEMBER 21, 1822

Philadelphia Novr 21.—22

Dear Rubens

I should have posponed writing untill I had a final answer from Mr. Seikle, for it is my intention to prevail on him to go with me to see and examine the House, under an impression that seeing it will induce him to become the purchaser. but Edmond going to Baltemore tomorrow, I think it advisable to give you some account of his situation——[1] Coleman told me this afternoon, that the cause of his ilness at his House, was his having took a dose of Arsenic & Laudanum, and it was fortunate for him that a puking took place by which he must have thrown up much of the Poison—yet enough was left to make him extremely ill, almost unto death. And by good management he recovered—but since he made another attempt to destroy himelf by taking Laudanum, his Mother went into the Room and found him in a fitt, the vial clinched in the hand—

Raphaelle immediately called a Doctr, who gave an immectic which saved him. Some young girl had jilted him, which has so effected his Spirits that made him guilty of the folly of desiring to distroy himself. Therefore if you will exert yourself to get him into some place of active employment, it may be the means of preventing him from taking such rash steps in future, for if he attempts it again, most probably will be fatal.

I had a cold some weeks past and neglecting it at first, I found my Lungs much oppressed, my breathing rather short if I made the least exertion at first I thought horehound candy, Spanish Liquorish & such trifles would remove it, but finding my body in pain, I took some Salts, this not being sufficient I took a Vapour bath, this gave me great relief, yet my intestines seemed sore, I then determined a tryal of taking sulphur, which I did for 3 days successively and staid in the House—this valuable medi-

cine iffected a perfect cure—[2] while taking the sulphur I began a Portrait of my Brother by Lamp-light[3] it will do me much credit, all that have seen it are pleased with the likeness & effect. Tomorrow I shall probably put the finish to it. Doctr. Godman has begun his lectures, at present only 12 pupels, his manner of lecturing will I hope increase his Class. Angelica[4] sett out this morning for N york. Miss Shippen[5] is in the City, she intends to pay Eliza a Visit.

<div style="text-align: right">my love to Eliza & Charles
yrs. affectionatly
CWPeale</div>

Mr. Rubens Peale
 Baltre

ALS, 2pp.
PPAmP: Peale-Sellers Papers—Letterbook 17

1. In 1822, Edmund Peale (1805–1851), RaP's second son, was living with his aunt SPS and her husband Coleman Sellers, perhaps as an apprentice in Coleman's manufactory. Little is known about the seventeen-year-old boy, but apparently his love of dancing had persuaded his uncle and aunt to send him to dancing school and to give dancing lessons in their house. He fell in love with one of his pupils, a Mary Ann Smith, but when the young girl's father, a "fancy grocer" objected to the match, the relationship ended. Distraught, Edmund attempted suicide. RaP took his son to Baltimore, hoping that RuP would find him employment. *CWP*, pp. 405, 440.
2. Horehound, an extract of the plant *Marrubim vulgare*, was used as a remedy for coughs. Spanish licorice was a medicinal preparation made from the evaporated juice of the root-like stem of the plant *Glycyrrhiza glabra*. The "Salts" Peale referred to were probably Epsom salts, or hydrated magnesium sulfate, used as a cathartic for sufferers of constipation. Refined sulphur was also used as a laxative. *OED*; *The American Heritage Dictionary of the English Language*; *Encyclopedia Brittanica*; *Century Dictionary and Cyclopedia*.
3. Plate 1.
4. Angelica Peale Godman.
5. Probably Margaret Shippen (1786–1853), daughter of Dr. Edward Shippen V (1758–1809) and Elizabeth Footman Shippen (1762–1848) of Burlington, New Jersey; and grand-daughter of Edward Shippen IV (1729–1806) and Margaret Francis Shippen (1726–93), whose portraits CWP painted in the early 1770s. She was a Philadelphia friend of RuP's wife. Randolph Shipley Klein, *Portrait of an Early American Family: The Shippens of Pennsylvania Across Five Generations* (n.p., 1975), genealogical chart B-3; John W. Jordan, ed., *Colonial and Revolutionary Families of Pennsylvania*, 3 vols. (1911; reprint ed., Baltimore, 1978), 1:105; *Peale Papers*, 1:126; *Peale Papers*, 3:808.

103. CWP to William Thornton

PHILADELPHIA. DECEMBER 4, 1822

<div style="text-align: right">Philada. Decr. 4th. 1822.—</div>

Dear Sir

The bearer Mr. James Griffiths[1] goes to your City to make tr⟨y⟩ial to obtain encouragement to establish a Museum, he lived many years with

me, & in my service he learned to preserve and mount Animals. I dont know what number of articles of Natural history he possesses, but I expect a much greater collection than has been heretofore exhibited in Washington, He is a Welshman & inherits the character of that people, Noted for their honesty, He is a Married man & has some children and I hope this will be a good opening for them to make an Establishment that will procure them support & with that a benefit to the City of Washington. I have once more resumed my Pencil and I now can paint without Spectacles, it is my hope that I shall execute some pieces that may please the Public, & support the name of a Portrait-painter some few years longer.

Please to make my respects to your Lady & her Mother and accept my thanks of former attentions

to your friend CWPeale

Doctr Thornton
 Washington

ALS, 1p.
PPAmP: Peale-Sellers Papers—Letterbook 17

1. James Griffiths had been a cabinetmaker and museum assistant at the Peale museums since 1802. In 1819, he purchased the "Mechanical Museum" in Philadelphia, to which he added a collection of "self-moving" machines, and opened his museum to the public in "rented Rooms in Market, between 4th and 5 Streets." CWP was doubtful about Griffiths's chances of success. Although acknowledging that his former employee was "not deficient in his knowledge of Mechanics," he worried whether Griffiths could "avoid all use of spiritous Liquors."

Apparently Griffiths did not succeed with his Philadelphia museum, nor did he find encouragement in the District of Columbia. Shortly afterwards, he returned to Philadelphia and resumed his work at the Peale Museum. *Peale Papers*, 2:473, 874, 892; 3:10, 798, 803.

104. CWP to ReP
PHILADELPHIA. DECEMBER 7, 1822

Philadelphia Decr. 7th—22.

Dear Rembrandt

Your letter[1] received too late to answer by the return post, but to-morrow Morning I shall get a 20$ note to enclose, I sent Titian out after the Banks had closed to get one, none of those he applied to could help him. I hope now you will get imployment—undoubtably you will provided you do not make too high a charge for your Portraits. Raphaelle at last is now (since he lowered his Price) getting work in oil as well as in Miniature. It is a Pitty that he cannot acquire a more rapid execution, indeed it appears to me very important to get effect speedily in Portrait painting—some of my best pieces where [were] those which I had but little

time allowed me to paint them. But to finish as perfectly a[s] possible those who will have pa[t]ience to sit long enough to obtain a perfect work. I am much pleased with the Idea of your Portrait of Mathews[2] being carried to England for I am much inclined to beleive that there is as much talent with us as can be found in London— And to shew that proud Nation that we will vie with them in any thing that requires genus. But the misfortune is, we have not men of fortune that are disposed to encourage Native genus. To me you have passed through a very Gloomy period, but you may thank fortune that your family escaped the Yellow fever—this ought to be a comfort to you. I hear with pleasure Rosalba['s] improvements and I have no objection that she should assist you for a time, as a reward for your exertions to do every thing in your power to bring her to this stage of life—Yet if she can obtain a husband deserving of her, and who will fulfill the duty of such an engagement, than you with me will rejoise at the event. do you not agree in this sentiment?[3] I am much pleased to hear that you think you are improving in the Art, for while that is the case you will love it in a greater degree. Mr. Robenson might in a very few words have told you, that the picture which I painted of my brother is a Candle light piece. he is looking at a Miniature picture by an argand lamp. the brightest light is on the end of his Nose downward, the forehead has only the light through the shade of the Lamp, a miniature pallet & Pencil on the Table, this to shew that he is a Painter. on the shade of the lamp I shall put that he ⟨*fought*⟩ served in the Battle of long Island, White plains, Trentown, Brandywine, Germantown, & at Monmoth. You know it is common to ornament the shades of Lamps with the English coat of Arms—I think this is noting that my brother has deserved well of his country—[4] I must say something of self. I enjoy very good health, and very industrous at present in making a good Stock of Porcelain teeth. because I have the desire of serving several of my family, to enable them to masticate their food well, that being essential to health. My Boys are making improvements of the Museum, Franklin will soon finish a Magnet that will support a heavy Man &c Titian has preserved some ellegant subjects &c—The day gives us very little, the Night is most visited. Love to

<div align="right">Eleanor & the Children yrs. Affecty.
CWPeale</div>

Mr. Rembrandt Peale
 N. York.

ALS, 2pp.
PPAmP: Peale-Sellers Papers—Letterbook 17

 1. Unlocated.
 2. (Fig. 31.) Charles Mathews (1776–1835), British actor and comedian, began a tour of

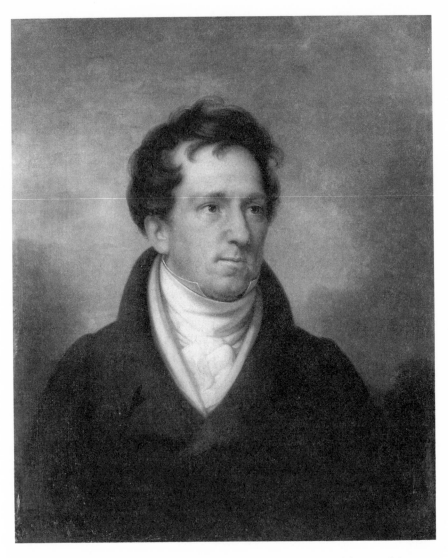

31. *Charles Mathews*. Rembrandt Peale, 1822. Oil on canvas, 28 ³/₄ × 24″ (73 × 61 cm). National Portrait Gallery, London.

American cities on September 5, 1822. On November 2, Mathews arrived in New York and shortly thereafter sat for ReP. Mathews did not mention ReP or the portrait in his letters to his wife. Whether he took the portrait back with him to England, or whether ReP, who had been contemplating returning to London, planned to carry it there for exhibition purposes, is not clear from CWP's statement here. The history of the portrait between 1822 and 1914 is not known. In 1914, it was purchased by the British National Portrait Gallery as a work by the British painter George Clint (1770–1854). On the basis of style, it has been reattributed to ReP, and documentary evidence confirms this attribution. John Neal mentioned the portrait once in 1824, without having seen it; then, after viewing it, he reviewed it critically in the *Atlantic Monthly*. See David Meschutt, "Rembrandt Peale's Portrait of Charles Mathews, British Comedian, Identified," *The American Art Journal* 21,3 (1989):74–79; John Neal "Our Painters," *The Atlantic Monthly* 22, 134 (1868):644, repr. in Harold E. Dickson, ed., *Observations on American Art: Selections from the Writings of John Neal (1793–1876)*, Pennsylvania State College Studies, 12 (State College, Pa., 1943), p. 28. ReP Catalogue Raisonné, NPG. For ReP's contemplated trip to England, see below, **112**.

3. Rosalba Peale did not marry until 1860. She painted some still lifes that are unidentified and unlocated, and for a time helped her father by teaching students in his studio. *CWP*, p. 441.

4. (Plate 1.) In September 1775, JP enlisted as an ensign in the seventh company, first regiment, Maryland line. He resigned with the rank of first lieutenant on June 1, 1779. *Peale Papers*, 3:665.

105. RuP to CWP

BALTIMORE. DECEMBER 8, 1822

Baltimore Decr. 8. 1822.

My Dear Father.

Your letter by James Griffith of the 4th.[1] was duly received. And I am quite dissapointed that Mr. Sickle didnot consent to purchace the house, as my pay day is the last of this month.

I have hird several speak in high terms of Uncles portrait,[2] it would give me much pleasure to see both it and your own. I hope by this time, that you have supplied yourself with as many teath as will supply yourself and all your friends, for I am sure they have cost you more ⟨than⟩ anxiety and trouble, than you ever expected they would and even more money than if they had been made by Mr. Plantou.

With respect to the duplicates, I have not yet examined what is in the house, but I know this, that all those in the Museum want my attention, for many are getting eat up, and now that I have nearly got all the stoves up and in a way to have warm rooms, I must apply myself to preserving, I have purchaced some beautiful South American Birds and a fine collection of insects,[3] therefore shall send some duplicate insects and perhaps a few of the birds. I will forward a plan of insect preservation to Titian in a few days, which I think he will be very much pleased with.

The cold week was a scene of distress amongst my live animals—The Alligator died, and I have preserved it in fine condition—The Goffer

Turtle[4] also died—The Otter wore his feet on the brick floor un[t]il they bled, And before I was aware of it he bled to death.—The Eagle broke his chain and in passing the Tiger Cat was caught by him and was instantly killed. Also a chicken which stood perpendicular faired the same fate.

I have just completed a furnace for the purpose of warming the Animal room, lecture room & Gallery. It is constructed in this manner, I pur-

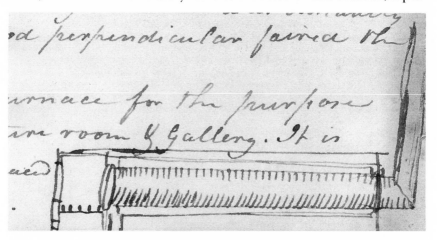

chased a waterworks pipe, of the large size. and made a case of brick work all around it leaving a space of the thickness of a brick, in which I have placed bricks dry all around it leaving interstises for a circulation of fresh air, which I obtain from the Cellar and after having circulated all around the pipe, is thus heated and assends to the rooms above, whilst [t]he brickwork and the smoak pipe, sufficiently warms the Animals room.

I was much surprised that Dr. Godman and others should advise Edmond to go to sea, they knowing that his sight would totally unfit him for the seafaring life—[5] but he said as even his father advises it he would go— —I have given him this idea that by taking a voyage, to S.America, he might make it turn out advantagious to him, and proposed going with Cap. Brown, who will deliver this to you—he is to act as clerk, for the Captain and aid in sale of the cargo &c &c. will be found[6] and receive 10$ pr. month. Both Edmond and my self have looked in vain for a situation in Baltimore.

On the receipt of the drawing by Titian,[7] I placed it in the optic case instead of the *Tyger hunt*, and it gives very great satisfaction.

Mr. Robinson has just received a letter from Rembrandt,[8] who has got to work at last and is painting several pictures— I requested him to paint for me the portrait of Willet Hicks, the celebrated quaker preacher, and he has sat twice and his family are much pleased with it.[9]

Give my love to all, Eliza joins me.

I remain your affectionate Son
Rubens Peale

ALS, 2pp.
PPAmP: Peale-Sellers Papers

1. See CWP to RuP, December 4, 1822, P-S, F:IIA/67G12.
2. (Plate 1.)
3. RuP did not itemize this purchase in his account book. Baltimore Museum Account Book, 1822–1829, P-S, F:XI/B/3B5-C10.
4. The *Testudo carolina*, a tortoise twelve to fifteen inches long, is common in the southern Atlantic states. *Century Dictionary and Cyclopedia.*
5. RuP's concern with Edmund's eyesight prompted him to write to BFP on December 9 to have John McAllister, the Peale family optician on Chestnut Street in Philadelphia, make Edmund a pair of glasses "such as I use" and like those used by "Charles Peale," either RaP's son Charles Willson (1802–29) or SPS's son Charles (1806–98). P-S, F:VIIA/4C10–11; *CWP*, pp. 440, 442; *Peale Papers*, 2:1006–08; 3:62.
6. That is, receive room and board.
7. See above, **99**.
8. Unlocated.
9. (*Private collection.*) Willet Hicks (1765–1845), New York merchant and Quaker minister, achieved wide recognition while traveling and preaching in the United States and Great Britain during the second and third decades of the nineteenth century. He was related to the prominent Quakers Edward and Elias Hicks. "Dictionary of Quaker Biography," typescript, Haverford College Library; genealogical information, Friends Historical Library of Swarthmore College; ReP Catalogue Raisonné, NPG.

106. RuP: Receipt to William Gilmor[1]

BALTIMORE. DECEMBER 12, 1822.

Baltimore December 12 1822
Received of William Gilmor Esqr Twenty-five Dollars in full, for (No. 120 Venus Rising from the Sea) (painted by Raphael Peale) purchased Oct. 1 1822 at the 1st Annual Exhibition of the Fine Arts in the Balte. Museum[2]
Rubens Peale

ADS, 1p.
NN: Theodorus Bailey Myers Collection. Rare Books and Manuscripts Division. Myers no. 2164

1. William Gilmor (1775–1829), Baltimore merchant and partner with his brother, Robert Gilmor, Jr., was a minor literary figure. He published at his own expense *The Pains of Memory with some other Poems* (New York, 1807) (copy at Maryland Historical Society). See Anna Wells Rutledge, "Robert Gilmor, Jr., Baltimore Collector," *The Journal of the Walters Art Gallery* 12 (1949):35n.4.
2. (Fig. 19.) This painting was presumed lost, but Dorinda Evans has argued that it was the original title of RaP's trompe l'oeil *After the Bath*. William Gerdts, however, raises the possibility that *After the Bath* is RaP's replica of the *Venus*. See Dorinda Evans, "Raphaelle Peale's *Venus Rising from the Sea*: Further support for a Change in Interpretation," *The American Art Journal* 14, 3 (1982):62–72; William H. Gerdts, "A Deception Unmasked; An Artist Uncovered," *The American Art Journal* 18, 3 (1986):23.

107. RuP to BFP
BALTIMORE. DECEMBER 12, 1822

Baltimore Decr. 12th. 1822

Dear Brother.

I take the oportunity by James Griffith of saying a few words, I send with him a bottle containing a Draco Volans[1] for the Museum, and I donot remember any other duplicates in this Museum that are wanted in my Fathers, if Titian remembers any thing else, I will forward them—

I want two Knives with Glasses in the handles, they may be had at McCalisters.

Since the opening of the Circus I have been completely deserted. all run mad after Mr. Hunter and as soon as the genteel part quit it, they have taken to the small Theatre which is quite a snug Bandbox,[2] but the last 3 days my company begin to return to me.

Eliza joins in love to all the Family and except the love of your affectionate

brother
Rubens Peale

ALS, 1p. & end.
PPAmP: Peale Papers

1. The "flying dragon" (*Agamidae*, genus *Draco*), which inhabits the forests of Southeast Asia, and is capable of gliding horizontal distances of up to sixty-five yards. On April 3, 1806, the Peale Museum in Philadelphia had accessioned a "*Draco Volans*, Flying Dragon, from the East Indies," but perhaps that specimen needed to be replaced. Harold G. Cogger and Richard G. Zweifel, eds., *Reptiles & Amphibians* (New York, 1992), p. 136; assistance on this note was provided by Dr. Roy W. McDiarmid, Curator of Amphibians and Reptiles, U.S. Fish and Wildlife Service, Interior Department, and the Museum of Natural History, Smithsonian Institution.

2. Perhaps the "frame theatre" near the intersection of Pratt and Albemarle Streets, later known as the Olympic Theatre. "Mr. Hunter" was described in circus advertisements as "one of the first horsemen in England" to ride "without saddle or briddle . . . at full speed." *American and Commercial Daily Advertiser*, January 2, 13, 1823; Scharf, *Baltimore*, 2:689–90.

108. CWP to Edmund Peale
PHILADELPHIA. DECEMBER 16, 1822

Philadelphia Decr. 16. 1822.

Dear Edmond

Hearing that you intend to go with Captain Brown to South America induces me to write a few lines to wish you health and happiness, if you do not get much money by the Voiage, yet if you improve the opportunity you may acquire a knowledge of the Spanish Language, which may in a

future time be of vast advantage to you.—therefore let me request you to endeavour to get some of the passengers to give you some lessons in your outward voiage, since it may be necessary for you to get a Spanish gramer if you can obtain one in Baltemore. Most probable we shall have a considerable commerce with South America, in which case you may readily conceive the advantages you may have by early acquiring a knowledge of that toungue— I will not attempt to give you any lesson how you should conduct yourself, your good understanding and a clear conscience will direct you—let me only say that you will ever find it your interest, *never to return an Ingury*. for if you do, you will heap coals on your own head.

If you meet with any thing that may add to the stor[e]s of the Museum no doubt you will aid us.

<div align="right">
Accept my best wishes for your prospperity—

farewell CWPeale
</div>

To Edmond Peal
Baltre.

ALS, 1p.
PPAmP: Peale-Sellers Papers—Letterbook 17

109. CWP to APR
PHILADELPHIA. JANUARY 1, 1823

<div align="right">Philadelphia Jany. 1st. 1823.</div>

Dear Angelica

I wrote to you on the 30th. of November[1] & gave the letter to the care of Mr. Robenson[2] I dont remember his Christian Name (but I believe he is concerned in a Lottery office) and he promised me that you should receive it, [but] by yours of the 19th Ult.[3] I find you have not received it. I wished you to inform me whether the teeth to which you fastened the artificial was still sufficient, also if I made springs to go round those teeth, would it be firm enough for some I am now prepairing for your use. The teeth I now make are incorruptable, and as hard as flint; of porcelain composition, I have some months been whooly occupied to discover the best mode of making them & now have the pleasure of informing you that I have nearly overcome all the difficulties of producing fine enameled Teeth. I have begun a piece for your use, yet I think that I ought not to proceed with it untill I hear from you, in answer to the above enquiries.

Your sister Sophonisba Sellers is in good health, & I am making some Enamil Teeth for her use, to supply some which I made for her of Ivory. (Sea Coral teeth). The situation of her mouth makes it one of the most

difficult to supply the dificiencies, she has only 3 teeth in her upper, and one of them very loose, the other two being firm, I have undertaken to make up all the dificiences and fasten them to the 2 firm teeth. but if I cannot succeed in this, I must then make another plate to pass round her gums of the under Jaw and connect this by springs to the upper piece. as I cannot have the pleasure of seeing you, and making these teeth to your wishes, by having the advantage of measuring &c. therefore you must be very particular in your directions, because no file will cut my Porcelain Teeth, of course you cannot alter them, the bottem on which they are soldered may be alittle altered, as also the springs, but nothing further.

I suppose you have heard my success in painting a whole length Portrait of myself, which I did by the request of the Trustees of the Museum, I have since painted a Portrait of my brother by lamplight also for the Museum. I am anxious to get through my labours of Enamel Teeth, in order to resume my Pencil again.

You need not fear that my labours will injure my health, having Franklin & Titian to do the work & business of the Museum, leaves me at leasure to persue what ever pleases me most. therefore my greatest pleasure is in serving my family & friends. And you must know that there is no true happiness without having imployment, The Idle suffer more than those who work at hard labour! I beleive you always have full employment, otherwise you would suffer much misery.

My love to the Children, yourself, the same from your father

CWPeale

Mrs. Angelica Robenson
 Baltre

ALS, 2pp.
PPAmP: Peale-Sellers Papers—Letterbook 17

 1. CWP to APR, November 30, 1822. P-S, F:IIA/67G10.
 2. Henry Robinson.
 3. Unlocated.

110. CWP to RuP

PHILADELPHIA. JANUARY 1, 1823

Philada. Jany. 1st.1823.

Dear Rubens

My letter to Angelica which Mr. Robenson promised me that he would deliver it himself, I find she has not recieved it, it was to inquire about her teeth, and required [a] direct answer, I have wrote on the same subject

and inclose it to your care, expecting that you will not fail to have it conveyed to her, as I wish to go on to finishing my labours in that way with all possible deligence, in order to return again to my brush. Titian is making alterations in the quadrupide room—making high railing of wires when the railing is low the Boys injure the animals, these railings are to form an oblong square in the middle of the Room. Leaving 5 feet passage round it, and the larger Animals in pairs on high pedestals in the middle of the square, and the smaller animals on each side below them, by this mode we can only gain room within the square for one additional animal, and that will be a Sea Lyon (seal) but it is a fine subject, handsomely mounted. But the taking the Animals from the windows is important, for there they were much injured by a bleaching Sun. We then can place glass cases at the end of the Room & between the windows— And Franklin has been employed in making a large Magnet, it was supposed that it might lift a heavy man—at present it does not support more than 65℔—Mr. Lukens is making a magnet to charge it better, by experiance it is found the [that] it requiers several days to get fully charged, and that it will acquire greater power by standing some time untouched with the Keeper[1] on it. we are but little acquainted with this subject, and perhaps shall never know much about it. It is certainly interresting to know magnet properties as far as experiance has yet developed

I paid the other day 20$ for your lot[2] & in July next must be paid the like sum. this I fear [is] a loosing speculation. And I cannot see any prospect of getting any of your costs. The times are such that you will not find a purchaser.

I have promised to pay the taxes on your House next week about 26$ including the Water Tax. also the cost of your cooking stove & apparatus $48 we had a good run on Xmas day & night, but the present being very bad weather our receipts are small. I believe it best to conclude my Scrole as I have nothing of an agreable nature to communicate at present— I have the blessing of good health, and keep myself fully imployed to drive away the Blue devils—

<div style="text-align:right">

Love to Eliza & Children
yrs. Affectionately
CWPeale

</div>

Mr. Rubens Peale
 Baltre.

ALS, 2pp.
PPAmP: Peale-Sellers Papers—Letterbook 17

1. An iron bar placed across the poles of a magnet to prevent loss of power. *OED.*
2. See above, **92.**

111. CWP to RuP

PHILADELPHIA. JANUARY 19, 1823

Philada. January 19th.1823

Dear Rubens

Yours by Mr. Nagle[1] I received but I did not see him, it was brought to me from the Museum, but I intend to wait on him tomorrow if a fair day— I have been very much engaged in making your Sister Sophonisba some of my Porcelain teeth and completed them this evening, I could not attend to any thing while she wanted my labour.

Her situation of mouth is one of the most difficult—in her under Jaw she has only 4 front teeth, and in the upper she had 3, one far back & 2 near the canine, but one of them so loose as to be troublesome. I thought I could keep it steady by plates going round it—however it was painful to her & she had it drawn out, then I was obleged to fill up the hole with a plate to fix a tooth to make up the deficiency. If I was to tell you the different alterations & changes of teeth that I made it would fill up my sheet——enough of this subject—

You complain of lack of Visitors, the season of the year is the worst for us—today being rainey I dont get including the night my expenses—

And poor Raphaelle with every exertion he cannot get a support— He is now painting some fruit-pieces to send to Venders— He tells me that he has wrote to you to propose to get a sale of his fruit pieces you have by a raffle[2] & he thinks that painting some smaller pieces that each person according to their lott may each have a picture, and he says it may save expence & when you write to me, mentioning your Ideas on the subject.

Titian has now put the Quadrupeds in the center of the Room forming an oblong square of high wire railing, they look much better, & we have gained considerable room for Glass casses—besides getting the use of the two clossets, usefull to put the Books belonging to the Library.

Franklin has nearly finished a large Magnet he found it very difficult to face the ends to complete a close contact of the keeper. as yet the greatest power is only 150 ℔ but looses of that considerable, I suppose caused by want of the full contact of the Keeper.

Col[e]man has made what they call a *Cap*, i e, a plate of Lead to grind by the aid of Emery, This he has fixed in his lathe, therefore this Magnet being put on a slide, by which mode it will be kept steady while it is ground.

I much approve of the change of place of the Skeleton of the Mammoth, it was what I urged Rembrandt to do.

But why do you expend money in makeing Purchases, your 50$ birds, &c, are perhaps like some of my purchases of cheap things, very dear, because not much wanted. I hope you will excuse me as I make this

remark in the hopes that it benefit you. Love to Eliza & children. yours
affectionately

CWPeale

PS Mr Pendleton will tell you more than I can say in this scrole.
Mr. Rubens Peale
 Baltre.

ALS, 2pp.
PPAmP: Peale-Sellers Papers—Letterbook 17

 1. Probably John Neagle (1796–1865), portrait painter. Born and trained in Phila-
delphia, Neagle had tried establishing a career in Lexington, Kentucky, and in New Orleans,
but was not successful in either location. He returned to Philadelphia, where he had previ-
ously won the praise of Bass Otis, his former painting teacher, Thomas Sully, and CWP, and
established himself there by initially charging very low prices and gradually increasing his
price to $100 a portrait. *DAB*.
 2. RaP's letter to RuP is unlocated.

112. CWP to ReP
PHILADELPHIA. JANUARY 23, 29, 31, 1823

Philada. 23d. 1823.

Dear Rembrandt
 Your letter[1] not alittle surprised me when I see your determination to
go to London, and I must confess that your reasons are of a convincing
nature—as founded too well on facts—that in America there is less incou-
ragement for the fine arts than in England.
 Most certainly I am willing to give you all the aid in my power, but I
realy fear that my means will be small therefore I will now state to you
my situation with respect to Money Matters— In the first place my farm
is Morgaged in two In[s]truments, the first is on my purchase of it,
$2400—and afterwards, when I wanted money for improvements, I was
offered 1600$ I did not want that amount, yet to obtain what I then
wanted, I took that sum, which [made] my debt on that score 4000$.[2] In
the next place, the high rent demanded by the corporation obleged me
with Rubens to take Money of the Bank. one note 1900$ one 1350$ one
1150$ and the notes to Snyder for Rubens 800$ not having been able to
reduce it more. To an old maid in Germantown[3] a bond of 300$—now
sum up all this which I must pay interst for, Vizt. 8700$ the intrest
amounts 522$ pr. Anm.[4] besides this I have many accounts yet to pay
which Rubens left unpaid, against him & the Museum. My present debt
for rent of the State-House amounts to several hundred Dollars of ar-
rearage which I am exerting myself to reduce by one hundred at a time.
The present establishment of of the Museum Cost me, in the first place

600$ pr. year rent to Franklin, Titian, & Wilson, 1464$ so that adding the Interest which I must pay to the yearly saleries makes 2286$ pr. Year,[5] besides oil, firing and Incidental expences for the improvement of the Museum, I cannot at this moment give you any certain amount. But I may had [add] that I pay Titian for my board $5 p.Week for my board & $5 for my work shop and Painting-room. from all which you see that my expenses exceeds four thousand Dollar Pr year.

I cannot yet sell my farm, nor Rubens House, or I would reduce my debts, nay I most anxiously wish to pay all that I owe, as my mind is not alittle harried when I think that should any accident happen to prevent me from meeting with my engagements, what distress I might be plunged into.

I cannot get the rent of my farm altho' I put it at a low price $250 pr.Anm. I have not received the money which Mr. Craiger owes me on the Sale of my Stock, but he is also a sufferer for he had on board men belonging to the factory of Mr. Tharp,[6] and he gave me orders for 78$ drawn by Tharp on the Company, & they have become Bankrups and I expect Mr. Craiger will loose that money, or myself eventually as I do not expect that Craiger will be able to pay it. I will take the best means to obtain my due, yet I cannot distress the family by putting the Law in force. I can only hold a rod over him. altho' in my settlement he made a rascally charge, & I suppos he will always feel a stinging remorse for the same.

29th. Although the sum noted which I am indebted you will say is more than I can with much difficulty manage, but I have not given you the total. I owe to Betsey Morris 600$ on Interest besides some money to her Mother,[7] these being in the family escaped my recollection. Doctr. Godman I expect has wrote to you the substance of this letter therefore I did not hasten to finish it.

If I can ⟨dispose⟩ sell the farm for a sum that will free me from my present burdens, I will do it at a sacrifice of one or two thousand Dollars. otherwise I may [be] obleged do it pr force. If I could now and then get a portrait to paint it might thuse enable me to pay some Interest money. I suppose it is not necessary for me to detail the circumstances that has produced my present situation.

31st. It is high time, to finish this unpleasant letter, as you may want to know my sentiments on your proposed plan. I had thought of stating the all the causes which have brought [me] into my present situation, but too much of it might attach blame on Rubens, yet it is a fact that he had what was just, and what he [t]hought was for my Interest as much as for himself, and on my own score, I can only say, that if I had not been willing to accomodate him, I might have prevented him from incuring expences which have turned out to be bad speculations. I allude to his purchases of

lotts in the Nothern liberties—he might also have done less to improve the Museum & thus had more Money to pay the Rent. however if I can sell my property, I will then keep clear of debt in future.

I have been a long time whooly occupied with porcelain Teeth, and have now nearly completed my work in that line—and will again resume my pencil— I have only two ladies to furnish them, and will have in store as many of different sorts as I may for a long time have occasion for.

Titian has completed a handsome arrangement of the Quadruped-room—by placing all the large quadrupeds in the middle of the Room with Wired frames of an oblong square, it gives us room for a number of Glass Casses for small quadrupeds, the light is better by taking the Animals from the Windows—They are better seen, and a space of 4 or 5 feet width of walk round the room.

Franklin has nearly completed a large Magnet, it will lift 200ω at present the Bomb-shell is suspended to it—but when Mr. Lukens has finished a large Magnet Franklin will again charge this, at which time he will try what power can be given to it. the weight of this Maget is 32ω.

I have nothing further to add except love to Eleonor and children. your affectionate father,

CWPeale

Mr. Rembrandt Peale
 N. York
No.345. Broad way

ALS, 3pp.
PPAmP: Peale-Sellers Papers—Letterbook 17

1. Unlocated.
2. For the Belfield mortgage, see *Peale Papers*, 3: xxvi, 6–7, 33, 47. No document has been located to explain the additional mortgage of $1,600.
3. Unidentified.
4. CWP's figures are correct if the $800 note to Snyder is not included. Since the Snyder note was already discounted, it may not have earned interest and therefore was not included. CWP was paying interest at a rate of 6 percent.
5. CWP's calculations were off by almost a hundred dollars.
6. Probably Thorp, Siddall & Co., a textile manufactory located six miles outside of Philadelphia, just north of Germantown. *Peale Papers*, 3: 221, 240, 241.
7. Rachel Morris, HMP's sister.

113. CWP to Thomas Jefferson
PHILADELPHIA. FEBRUARY 8, 1823

Philadelphia Feby: 8th.1823.
Dear Sir
 Herewith I send your silver springs for your Pollygraph according to

my promise in my last letter,[1] I ⟨dont⟩ do not know whether they are of the proper length, but I know your talents to render them what they ought to be.

By the public papers I find the accident you meet with in a fall, I hope by this time that a cure is made of your arm.[2] and, I have read with pleasure your letter to Mr. Adams[3] in which I find that you do not like the winter season so well as the warmth of summer, now in my situation I feel comforts in the bracing air of this season. I am apprehensive that you have too much company in summer and too little in the winter. we Citizens have some advantages in this season from the circumstance of paved walks; as much company as we chuse to enjoy, but what is more important Science & Arts in progress. I shall conclude my scrole in giving you some account of my Museum. Having employed my two Sons Franklin & Titian. The first makes the Experiments of the evening entertainments, and the latter in preserving Animals and arranging them in the Museum. Franklin attends to the mineral arrangements & also makes all the apparatus for his lectures, and, he is a very neat & excellent Mecannic; a studious turn, and probably will become an excellent Lecturer. Titian also arranges the Shells & fossils, and bids fa[i]r to be learned in Natural History— He is fond of Classical arrangements and takes care of the subjects to be exchanged for foreign subjects, & I have given him the charge of corrispondence abroad. I have only the survey of the whole & aid them with my advice. occasionally I paint for the Museum, but of late I have been much engaged in making Porcelain Teeth & now I believe I shall make them very perfect. Franklin has made a Magnet that promises to be very powerful, its weight is 32 ℔—and at present it has suspended to 85 ℔ but it will lift 200 ℔, and when fully ma[g]netized considerably more.

<div style="text-align: right">I am with much esteem your friend
CWPeale</div>

Thos. Jefferson Esqr.

ALS, 1p. & end.
MHi: Coolidge Collection of Thomas Jefferson Manuscripts
Endorsed: Peale, C.W. Phila. Feb. 8. 23 recd. Feb. 16.
Copy in PPAmP: Peale-Sellers Papers—Letterbook 17

1. See above, **98**.
2. An article on Jefferson's broken wrist appeared in *Poulson's* on January 30, 1823.
3. Jefferson's letter to John Adams of June 1, 1822, on the subject of old age, bodily decay, and death was printed in *The National Gazette and Literary Register* on December 14, 1822. In his next letter to Adams, Jefferson asked his permission to reprint the letter. *Calendar of the Correspondence of Thomas Jefferson. Part 1: Letters from Jefferson* (1894; reprint ed., New York, 1970), p. 9.

114. CWP to ReP

PHILADELPHIA. FEBRUARY 9, 1823

Philada. Feby. 9th. 1823.

Dear Rembrandt

I have been fearful to mention your intention of going to London, least your friends should think you of too roaming a disposition an unsettled mind as is the common expression, "that a roling stone gathers no Moss." however as you have published it by your notice of painting at a lower price 20 portraits,[1] I can now speak of it to those I am acquainted with and per adventure it may produce some demand; Also since your lecture on my shewing your letters I have been very carefull never to shew them or speak of their contents.

I have hunted for the Notice of your receiving the hundred dollars of Mr. John DePeyster.[2] amongst my copies of my letters and also amongst the family letters to me, and cannot as yet find any notice of it, but in the account against you is the charge of that sum received of Jno. DePeyster without date. Now I do not conceive that there will result any difficulty in the accounts of the dividends to heirs, if Mr. Jno. DePeyster presents testimony of the payment. I have wrote to Mr. Philip DePeyster[3] giving him the same Idea's, for when I stated what I believed to be the sums I received of the Estate I had no knowledge of the above article. and if it is necessary I will write to Mr. Sedgwick on the subject. Your reasoning on your chance of doing well by going to a country where more incourage-ment is given to the fine arts appears to me correct w[h]ere excellince in the art meets with due reward—And I do think that you possess an excellence of drawing & colouring—the only objection I know in your work is that you make too long settings your setters get tired of the business. This you may get over by a run of much business, and I hope your plan of cheap portraits will give you that necessary pra[c]tice

I can supply you the means of speaking, and also of masticating your food by my knowledge and practice making of Porcelain artificial Teeth, and they shall not be thus useful but also handsome. I have had consider-able trouble in making a sett for your sister Sophonisba. She has only 2 teeth in her upper Jaw, and four front teeth in the lower. The trouble I allude to was caused by some carlessness, first in taking the mould of her mouth. first attempts to take the mould, by taking the wax from her mouth, the back ends were made too narrow—and on the next the Brass founder in moulding the piece for the under Jaw, made the front teeth too wide by a single tooth this was done by his tapping the patern too forciably sideways in order to take it from the sand. The consequence was

that I made the connecting plate of the sides of the jaw too long. Sophonisba persisted in the oppinion that the plate was long, & I thought that it was not so, but at last measuring with a pair of compasses her teeth & the mould I discovered the error—now where a person has all the teeth of the under Jaw, and none in the upper, my remedy is to make a small plate to pass round the lower Jaw alittle below where the gums imbrace the teeth, to which plate I put pivots, or rather small buttons and thus connect springs to suppor[t] the teeth of the upper Jaw. If you examine your mouth, & put a bent wire there you will find it not inconvenient. at least this is my impression on this business. I was long making experimention the enamel and a few days since I have been very successful and now I am making myself a store of teeth of every size which I think I shall have need for some time to come—but Platina is not to be had here & my stock is rather small for somehow I have put some which I was very choise off into some hole or corner so safe that I have in vain rummaged for it. my friends tell me that I shall find it when not looking for it. I wish it may turn out so, but it appears very doubtful as my search has been often repeated. Doctr Godman has not been well of late I apprehand that his lecture room is not sufficiently warmed by his stove. his room now an open loft to the roof. I do not remember whether I wrote to you my experiment of sleeping with my window partly open, I thought I might do it from summer into winter, but early in the cold weather I had a troublesome cold and trying to get rid of it by the common means, I found tempory relief at last I determined to take flour of sulphur and stay in the House, and also to shut my window at night, I then commenced a portrait of my brother in a candlelight piece, in the week I was thus employed I got rid of my troublesome gest and ever since I have enjoyed perfect health. Sulphur you may remember was always a favorite medicine with me.

An offer has been made for the walnut street House of 7000$ but whether Rubens will accept the offer, I cannot yet tell, I have wrote to him for his determination I have not advised either way, but that sum makes so little profit to him that I have my doubts, as what I have paid and engaged for will leave little or nothing for Rubens.

at present I have nothing to add but love to Eleoner and Children and as ever your affectionate father

CWPeale

Mr. Rembrandt Peale
　　　N York.

ALS, 3pp.
PPAmP: Peale-Sellers Papers—Letterbook 17

1. In 1805, when unemployed, ReP made a similar offer to Philadelphians, charging half price for the first thirty sitters. His plan was highly successful at that time, undoubtedly suggesting its repetition now. His proposal offered the first twenty sitters portraits at half price—$50 a head. See Miller, *In Pursuit of Fame*, p. 79; *Peale Papers*, 2:839–40, 841–42; below, **122**.

2. Between 1803 and 1805 CWP recorded three DePeyster payments against the estate: $200 in November 1803; $500 in June 1804; and $200 in April 1805 (*Peale Papers*, 2:725–26). However, Philip and John DePeyster probably included with those earlier payments the $100 they gave ReP and his family when they were almost shipwrecked off New York on their return from Paris in 1810. *Peale Papers*, 3:71, 73, 94, 95.

3. See CWP to Philip DePeyster, February 8, 1823, P-S, F:IIA/68B10; also see CWP to Messrs. Sedgwick Esqrs., February 13, 1823, P-S, F:IIA/68C1.

115. CWP to RuP
PHILADELPHIA. FEBRUARY 13, 1823

Philadelphia Feby.13th.1823.

Dear Rubens

On receiving your letter in which you leave the sale of your House to my judgement, it being your wish to relieve me from my imbaressments, determines me to strugle with those difficulties as long as I can rather than you should be a looser by the sale of the House, and when I called on Mr. Wilson[1] to know the amount of your debt to him, which before your letter arrived I did not know that you owed any Money, on mentioning the circumstances to him, he very liberly said that he would not wish you to sell the House to the least disadvantage on his account. This good and friendly reply has much raised my esteem for him. I then went to Mr. Taggerts House with the intention of telling him that I would not sell your House for less than 7500$—but was informed that Mr. Taggert was gone to Harrisburgh and would return in less than a week. I therefore took my advertizement to the Printers & had it published this morning,[2] refering to Mr. Bonsel for conditions, Mr. Bonsel called on me this evening saying that 2 or 3 persons had called on him, and he wished to know the lowest price for it. I told him that the above sum I must have, and if I could sell my farm (it is also in the same advertizement) that I would give you 8000$—and that I hoped the farm would be in demand in the Spring & that I would sell it for less than its real Value, in order to relieve me from care and trouble. If on the return of Mr. Taggert I find it necessary to inform you of the result of his opinion, I will write to you again. In my transactions with [the] Bank, I always lack a sufficiency of cash to pay all the Interest of the several notes when renued. Therefore I hope that my credit with them will remain good as they obtain their support by obtaining Intrest on discounts. but realy when I can make myself independant of them, it will be a great relief to my mind.

I have had a disagreable business with Craiger— I heard that he was about to leave the farm as soon as he could finish thrashing out his Oats, & that he was working hard to accomplish it. And having only received from him 20$ in payment of his rent, I was advised to distrain for my rent, in consequence I went to Germantown and drew up my account for 9 Months rent & gave him credit for the 20$ with directions to the magistrate to deputize two Persons to take a Inventry of the effects of Craiger, but at the same time I told him that my object was only to prevent the stock from being removed from the farm before the rent was paid.

Craiger had given me an order from Mr. Tharp for $78–70 drawn on Mr. James Potter[3]—but Potter would not pay it & of course I returned it to Mr. Craiger. last evening Coleman told me that Mr. Craiger had called on him complaining of the ill treatment which he received from Linnius, that he had spread about Germantown an unfavorable report of him, that Craiger in consequence had obtained from sundry persons their certificates of his just & upright character, and said that he never intended to leave the farm without giving me notice of it. and that he went to Mr. Tharp to state his difficulties and that Mr. Tharp paid him the money due, and Mr. Craiger promised Coleman to bring the money on saterday next. Thus much good is done, for without I had proceeded thus, that sum would not have been paid for Tharp has become a Bankrupt. By holding a rod over Craiger I may in the end get what is due to me of rent as well as what is also due to me by an arbritration, of which he has paid 30$ out of 110$ due me.

We have the same complaint as with you—our visitors are very few, either in day or at night, but this season of the year it has been usially so. I am told that the Theature have very little company.

I think the glass shashes [sashes] around the Mammoth are unnecessary—therefore you might use them for other purposes

My love to Eliza & Children—yrs. affectionately

CWPeale

Mr. Rubens Peale

ALS, 2pp.
PPAmP: Peale-Sellers Papers—Letterbook 17

1. Unidentified.
2. CWP placed his newspaper advertisement in *Poulson's* on February 13, 17, 21, and 25:

Philadelphia Museum.

IMPORTANT and numerous additions have lately been made to this Institution, as well as improvements suited to facilitate the study of Natural History, which increase its interest and usefulness.

The Subscriber

Wishes to sell, or exchange for City Property, a Farm near Germantown, containing 98 acres of good land.— There are several good Stone Buildings, with a beautiful falling

garden and excellent Fruit Trees. There is on the farm, a Mill Seat of 23 feet fall, a due proportion of Watered Meadow, and Wood sufficient for fuel. A large part of the Farm is enclosed with thorn hedge.

ALSO, FOR SALE,

That pleasant and commodious House, corner of Walnut and Swanwick streets, now in possession of Dr. M'Clellan. This will be a cheap purchase to any one wishing an agreeably situated dwelling. Apply to Mr. BONSALL, No. 3 Carpenters' Court, or at the Museum, to

C. W. Peale.

3. Unidentified.

4 Lectures on Natural History: February 26–August 26, 1823

In the winter of 1823, Peale decided once again to present public lectures on natural history. His last series of lectures on this subject (in 1799 and 1800) had evoked some interest in the museum, and now, for several reasons, he decided to present his understanding of natural history once again. His sons wanted him to popularize the museum's programs; Peale, however, wished to emphasize the institution's serious educational purpose. When the museum was incorporated in 1821, the trustees had appointed four professors representing various branches of natural history—John D. Godman, Richard Harlan, Thomas Say, and Gerard Troost—and had instituted a program of lectures. It soon became apparent that the lecturers were not attracting large audiences and were becoming discouraged. Peale hoped that his lectures, which had been so successful twenty years earlier, would create a larger audience for such presentations and stimulate the professors to make greater efforts.

Moreover, Peale hoped that his lectures would convince the Corporation of Philadelphia that the museum was an important educational institution deserving of its support. In past years, his personal efforts to influence the council members had resulted in decisions favorable to the museum's interests, and he expected that the museum trustees would assume a similar lobbying function. In early 1823, however, he realized that the trustees were not going to challenge the decisions of existing city councils, which hesitated to support the museum's petition to extend its rooms over the fireproof offices of the Statehouse and reduce its rent; rather, the trustees preferred to wait for a change of membership in the councils before pressing their suit. Peale was unwilling to wait. His decision to present lectures was thus an indirect way of pressuring the city government to act more favorably toward the museum. He hoped that he could convince eminent citizens of the museum's utility and that they, in turn, would influence the councillors. Perhaps, also, Peale realized that these lectures would be his last, and that if successful, they would add to his stature as a naturalist and museologist as well as to the fame of his Philadelphia institution.

In late February 1823, Peale began to compose his lecture. He completed it by March 5 with the assistance of his son Raphaelle and his granddaughter's husband, the naturalist John D. Godman. On April 9, he delivered the lecture to a small audience. Disappointed at the absence of public interest, he nevertheless repeated the lecture on May 7 and wrote a second lecture, which he delivered in two parts on May 17 and 19 (see below, **129**). He then traveled to Baltimore, where on May 24 and on June 3 and 4 he delivered both lectures in Rubens's museum.

Although Baltimore's audiences were larger and more receptive than Philadelphia's, Peale had to acknowledge that his lectures were a failure. He attributed the poor attendance to Philadelphians' being surfeited with lecturers on all kinds of subjects, but he also suspected that he was too old and lacked the requisite abilities to be popular. No contemporary accounts exist either to confirm or to deny his suspicions, but his lack of success may also have been due to his subject. There were many lectures, as he knew, being presented in Philadelphia, but these were specialized, "useful" lectures or courses on such topics as bookkeeping, memory, English grammar, oratory, and "the Science of Elocution." Even lecturers on science emphasized practical applications of their disciplines to, for instance, agriculture or the arts. Some lecturers relied on spectacular effects or "entertaining experiments," or demonstrations with a comical effect, such as the lecture on "Carbonic Acid Gas," which promised that in the course of the evening the nitrous oxide or "Exhilarating" gas would be "respired by several gentlemen."

Peale's decision to resume lecturing was unfortunate in its timing. By the second and third decades of the nineteenth century, the sciences were becoming more specialized and scientists more professionally oriented. Peale's generalized approach to knowledge, which had been appreciated at the turn of the century by amateur naturalists and "philosophers" such as the members of the American Philosophical Society, was old-fashioned. Ironically, only a few years after Peale lectured, the lyceum movement in America began, helping to create large audiences receptive to generalized educational lectures, but Peale would not be alive to take advantage of this new development.*

*Peale Papers, 2:259–72; Poulson's, March 5, 1821, June 30, 1823; National Gazette and Literary Register, December 19, 1821; American and Commercial Daily Advertiser, January 1, 11, March 8, 1823; George H. Daniels, Science in American Society: A Social History (New York, 1971), pp. 152–65; Donald M. Scott, "The Popular Lecture and the Creation of a Public in Mid-Nineteenth Century America," Journal of American History 66, 4 (1980):791–809; Carl Bode, The American Lyceum: Town Meeting of the Mind (1956; 2d ed., Carbondale, Ill., 1968); Sidney Hart and David C. Ward, "The Waning of an Enlightenment Ideal: Charles Willson Peale's Philadelphia Museum, 1790–1820," in Lillian B. Miller and David C. Ward, New Perspectives on Charles Willson Peale (Pittsburgh, 1991), pp. 219–35.

116. CWP to RuP

PHILADELPHIA. FEBRUARY 26, 28, MARCH 2, 1823

Philadelphia Feby.26th.1823.

Dear Rubens

To meet your wishes I now commence the corrispondence which you are desireous I should make to you, yet when I think on the things I mean to undertake for the advancement of the Interests of the Museum, I am realy fearful that I cannot write so much as my inclination inclines me to do at this period. I have now completely succeeded in making handsome Porcelain Teeth, and having yesterday finished a tolerable stock I shall rest a short time from that labour I think it is now about 4 months since I have done little else. I must set some of them for some of my friends, chiefly of the family.——I have advertized this farm and your House for sale—but I would much rather sell the farm even at 16000$ than the House at 7500$ as I find that sum is not sufficient to pay Samuel Sellers in the addition of Wilsons and the monies I am engaged for. I have not yet seen Mr. Tagart on the business under the impression that he has not returned from Harrisburgh I have ⟨called⟩ not enquired for him, either at his House or the Bank.

Maria Peale called on us to day and told me of an oppor[t]unity of sending by a private conveyance of Saterday next. Therefore I shall endeavour to croud as much as possible in this sheet. Franklin has contrived a hansome cloud for the House of the electrical experiment; its a piece of Glass cut in an erregular form: thus, & painted clouds,

then some metalic Brunze [Bronze]-powder spread over the clouds, the Glass suspended by a fork (a) to ballance it, to avoid the trouble of drilling a hole through the Glass, he has made a piece like a button and semented one on each side of the glass, an easey joint. The electric fluid beautifully represents the lightening passing through the clouds. Our income by the museum isvery small for some weeks past, and I have very little expectation of increase before the Steam-boats commence running and better

wheather. I inten[d]ed to send this before stated—but I find that person would not stop in Baltemore.　　　28th. The plan of the glass for a cloud on other tryals, is found uncertain, and therefore Franklin has made of two pieces of paste-board the same forms, and put Tinfoil between them, and clouds painted on each side of the cutout pasteboard.　　since I began this letter I have wrote an Address which I intend delivering myself on the subject of natural history as connected with the Museum,[1] and this morning have finished it—perhaps not entirely so, as I have sent for Doctr. Godman who will be with me this afternoon, who may, probably give me some more trouble in copying it. When I first conceived the Idea of writing the lecture, my plan [was] to only give an outline, and then with his aid to polish the language— but on enquiry for him I found he was under some difficulty about the room he had rented, for the owner of the house would not let him keep it longer than this week, and that he was hunting for some other place to continue his lectures. This is an unfortunate case, for the Doctr had been at considerable expence to fix up the room, and it will be difficult for him to find another place to suit him so well.

finding that I ought not to trouble him, I proceeded in my task and with the aid of Raphaelle to correct my grammer & not appear to me that by giving my own language that the delivery will be easier and peradventure a better work.　　I found that many of the Citizens were not acquainted with the constitution of the Museum, and that I had no hopes of getting the Trustee's to be very active for its advancement, they are so obleging as to meet at the quarterly meetings, but they pospone making any application to the councils to obtain permission to extend it over the fireproof offices; or to lower the rent—[2]and say there must be a change of the members of the councils, and it will be best to wait until another year comes round— my expence is great & I find that some exertions must be made that will have a chance of increasing the income. Yesterday afternoon the City hall caught fire,[3] and while I was writing my lecture I see the flames rushing through the dormant [dormer] wi[n]dow next to the Philosophical Hall. I continued my work as I well knew that the Hose & fire engines would soon arive and stop the fire. I had taken some sulphur in the morning & thought it prudent not to expose myself to the cold air. The flames was soon extinguished, but the roof must be rebuilt. I have not heard how this fire happened, whether by an incendinary or not. 2d. This morning we were called on to know if we would purchase the shark improperly called the Sea-serpent, the owner will call on you.[4] In my situation I would not give 10 $ for it—in the first place, I have no room for it, and 2dly my principle is to purchase nothing untill I can free myself of debts, that this ought to be my resolution, unless the subject could only cost a triffle and promise by its exhibition to bring a considerable profit—

yet in every such case, it is a matter of consideration, whether by some excitement of curosity it brings numbers of Visitors and afterwards there is a preportionable falling off. so that it appears, at present moment to me, that a steady course of giveing pleasing amusement with Instruction, will in the end be more profitable.

Doctr. Godman read my essay last even:g and seems to be pleased with it, and he thought he could connect some of the introductory, into more harmony & render some parts more easy for delivery—which he undertakes to do for me. afterward it was read by Raphaelle for my hearing of it. Coleman present who is pleased with it, as he says it is rich in subjects. I read it to Mrs. Powel[5] this morning, she told me that she was fully of opinion that it would be well received by the Citizens, & would benefit the Institution.

I cannot yet give you any information about the northern libberties lotts. George[6] brought the young man who wished to know the size of the lott—since I have not heard from him.

Having just heard that Mr. Allen Roberts[7] is going to Baltemore I will conclude my letter— Raphaelle received a letter today from Edmond by the way of N. York. They had a short but stormy passage. 25 days he describes the country as sickly—and a very indolent people living in Houses made of [illeg]— The young man (Spannard) passenger found his parents were dead, he intended to begin business on his own bottom, and Edmond says he intends to live with him, Edmond also says that he can now converse in the spanish Language,

If any thing occurs with your notice I will write to send by a daughter of Mrs. D[Silva?] who is married to a Baltemorian and I am told they leave this early next week.[8]

<div style="text-align: right;">

Love to Eliza & children
Yrs. Affectionately
CWPeale

</div>

Mr. Rubens Peale
 Baltre.

ALS, 3pp.
PPAmP: Peale-Sellers Papers—Letterbook 17

1. Peale advertised "a Public lecture connected with the Museum," to be delivered at noon on April 9, 1823. *Poulson's*, April 7, 9, 1823; *National Gazette and Literary Register*, April 7, 1823.

2. On March 24, 1812, a bill was signed into law by the governor of Pennsylvania providing for the construction of fireproof offices on the east and west wings of the Pennsylvania Statehouse. CWP had unsuccessfully lobbied the state government in Lancaster for an amendment to that bill providing for the extension of his museum over those offices. After the offices were constructed, CWP still urged his plan and believed it to be the most efficient way of expanding his museum. *Peale Papers*, 3:1–2, 149–51.

For an explanation of CWP's preoccupation with the rent of the Philadelphia Museum, see *Peale Papers*, 3:404–06.

3. Contemporary newspaper accounts of the City Hall fire state that it occurred on Thursday, February 27, between three and four o'clock in the afternoon. The fire, which supposedly originated from a burst chimney, consumed the building's cupola and damaged its roof and rafters. *Poulson's*, February 28, 1823; *National Gazette*, February 28, 1823.

4. The Baltimore Museum Account Book of 1823 shows no expenditure for a shark or a "sea-serpent." P-S, F:XI/B/3C11-E8.

5. Unidentified. Perhaps Mrs. Samuel Powell, widow of the former mayor of Philadelphia and a wealthy property owner.

6. George Patterson, Eliza's brother.

7. Unidentified. See *Peale Papers*, 3:635.

8. See below, **119**.

117. Thomas Jefferson to CWP
MONTICELLO, VA. FEBRUARY 26, 1823

Monticello Feb. 26. 23.

Dear Sir

Your favor of the 8th. has been recieved with the Polygraph wire you were so kind as to send me. your friendly attention to my little wants kindle the most lively sentiments of thankfulness in me. the breaking of an ink-glass, the derangement of a wire, which cannot be supplied in a country situation like ours, would render an instrument of cost and of incalculable value entirely useless; as both of my Polygraphs would have been, but for your kind attentions.

It must be a circumstance of vast comfort to you to be blest with sons so capable of maintaining such an establishment as you have effected. it has been a wonderful accomplishment, is an honor to the U.S. and merits their patronage.

The fractured bone of my arm is well reunited, but my hand and fingers are in discoraging condition, rendered entirely useless by a dull oedematous swelling, which has at one time been threatening, and altho' better, is still obstinate. it is more than three months since the accident, and yet it indicates no definite term. this misfortune with the crippled state of my right hand also renders me very helpless, and all but incapable of writing. ever and affectionately yours

Th:Jefferson

ALS, 1p.
TxU: Hanley Collection
Copy in MHi: The Coolidge Collection of Thomas Jefferson Manuscripts

118. CWP to RuP

PHILADELPHIA. MARCH 5, 7, 10, 1823

Philada. March 5th. 1823.

Dear Rubens

As I wrote in my last,[1] your house has been in the papers for sale, and as I wrote to you that I thought ⟨that⟩ we ought to get at least 7500$, Mr. Taggart is still at Harrisburgh, and I suppose will not return untill the Bank business is done with in the Legislature. I called this morning on Mr. Bonsel to know what prospect we had in the sale of the farm & your House— he told me that one gentleman he had conversed with would [pay] 7000$ but no more, because he would make additions—a bow window in the back room, & also build Kitchen of 3 stories high, therefore with such additions, the House would come too high price— However Mr. Bronson[2] told me that if Mr. Taggarts friend would give the $7000 that he thought that I might not expect a higher price, and by selling it Mr. Taggerts friend I would save the commission which he should receive if he sold it. he said the present time was realy bad, for a considerable number of whole sale grossers had failed in the City and that there would be distress for a long time. and he also remarked that it even went on in the country, this I believe is owing to the facility of getting money at the Country lands that farmers are brought into difficulties. There is a disposition in the Legislature to put down some of the nest of 40 banks, yet it is a difficult business, to call in all the debts would distress many. I told Mr. Bronsen that I would wait alittle longer to try if I could not get a better price—he advised me to consider on it.

I have now completed my composition of the Address on Natural history connected with the Museum[3] and it is much approved off by all that has yet seen it— My intention is now to read it amongst my friends I ⟨only⟩ mean privately that is small parties amongst the Ladies in particular—for I tell them that ⟨I⟩ having them in my favor, I shall cary all the world before me. by reading it thus, I shall acquire a better manner of delivery— Doctr Godman put the finishing dress to it. the sentements totally of my composition, and I am complimented by those that have heard it saying it is rich in subject—

This morning I called on the Revd. Mr. Videl[4] to ask of him to read it for me—as I was informed that he is perhaps the best reader in Philada. He is at present the popular preacher that all the Lawers & persons of taste go to hear, and he has overflowing houses whenever he preaches. We have had another fire near the Museum the City court House roof was set on fire by an incendiary last week I was writing my lecture and the flames blazing out of the dorment [dormer]

Window, it being at the noon time of day, I know that as soon as the hose & fire Engines could begin, I was confident that they would soon put it out. by the appearance of flames & wind setting towards the Philosophical Hall, there appeared some danger, but when I see several men upon the roof of the Hall putting carpets & blankets over it, I knew it would be safe— The Hose was first put to the hydrant, but the force of the water was not sufficient to carry it that hight but the aid of an Engine, they then threw the water from the Top of the Hall directly into the fire throw [through] the dormant window. & thus in less than 2 hours the fire was extinguished.

I have just heard that a duel was fought today in the Jerseys[5], a Son of Doctr. Mungies passing an Officer in the street, they jostled and the docter son made the appology and asked pardon, but words followed and the consequence was the cause of challenge, it is said the officer is badly wounded, and it is also said that the whole party are taken into custody— more I know not at present.

⟨I have⟩ Mr. George Patterson told me last evening that the person that wants your lot, wishes also to take that belonging to Moses, and he asked Moses what he would take for his lott, Moses said that he ought to have more than he had paid for it— I ask him how much that was, he replyed that he had it 12 years, amounting [to] $240—he said that he would take a little time to consider on it, as he would like to see if he could get another lott— George is of the opinion that the young man will give 500$ for the 2 lotts— Therefore I am inclined to think that he will get the half of that sum, as Moses complained to me some time past that he had paid the ground rent and that he wished to get rid of it.

Raphaelle has no work at present, yet he is not Idle, he paints some fruit pieces—also he paints such persons as will give him any thing for his painting, he engaged to take carpenters work for a Portrait, thus he get what is wanting in repair of his house, streching frames &c. he hopes that when the Steam boats run & people travel more that he may then get some work for the support of his family— It appears wonderful that the Artists should in Baltemore get so much employment.

In my last letter I told you that now I had succeeded in making the Porcelain teeth—I thought them very perfect, yet I now believe that I shall yet improve— as soon as I have done with my lecture, I will again Model & fire them, I was under great fear that I could not get Planina [Platina]—however Mr. Lukens to day has obleged me with 1½ oz of it This is precious article, yet if we could get ore, we can have it made maliable.

7th. conversing with Moses yesterday I find that he does not like to take the offer of 250$ he says lotts in that neighbour-

hood is worth as you say 2$ pr. foot. but he says he will go to know the oppinion of some one in that neighbourhood (I don't remember the name, and then he will give his answer.

10th. yesterday an attempt to brake jaol.[6] It is said that there is 400 prisoners in confinement— When they went into the jaol church, 2 of the keepers went in with them and locked the door, they (the prisoners) demanded the Keys and th[r]eatened them with instant death if they gave the least alarm. they then began to work to brake through the Wall with some implements which they had previously provided, and all began loud singing in order to drown the noise of their pounding, and they had nearly succeeded, but some boys heard the pounding within and run and told the jaoler of it, and the alarm was given—& a multitude of Citizens collected round the prison, & some Marine guards came with their Muskets, and thus the prisoners were secured in their cells. Passing along 6th. St. this morning I see a hole that would receive 2 or 3 of my fingers, so that in a few minutes the outer stones would have been bursted out.

I have read my lecture at Miss Dickenson's to a small party This evening I mean to read it at Mr. Richd. Morris's[7] to company composing several of the Elders of the Meeting (quakers)—and tomorrow at Colemans when all that family and their intimates will be collected. and in this manner it is my hope that the sentiments of my address will be defused pretty generally among socities that may have influence, and may call forth thereby some deliberations amongst the wealthy to get something done in favour of the Museum. By repeatedly reading it, the matter is made better and I shall read it better in the public Meeting of Citizens— When that will take place is not yet determined. but by thus proceeding I believe the inf[l]uential Citizens will begin to talk on the subject.

Moses tells me this morning, that on consulting his friend (mentioned before) that he is willing to sell his lot, if he can get what it has cost him. and he even will take the 250$ which is 35$ less than it has cost, This I entend by letter to acquaint Mr. Geo. Patterson with, as the final result of Moses's opinion. I have nothing further to add, but that your sister Sophonisba is uncommonly well. This will be given to some private conveyance said to leave here tomorrow morning. I shall give it to Maria Peale this evening.

<div style="text-align:right">Love to Eliza & children, yrs. affectionately
CWPeale</div>

Mr. Rubens Peale
Baltre.

ALS, 3pp.
PPAmP: Peale-Sellers Papers—Letterbook 17

1. See above, **116**.

2. CWP may have meant to write "Mr. Bonsall," who was acting as his "conveyancer" in the sale of RuP's house.

3. P-S, F:IID/30E11-G5.

4. Gregory Townsend Bedell (1793–1834), ordained in 1814, achieved great popularity as a preacher at St. Andrew's Episcopal Church. *NCAB*

5. A specific account of this duel has not been located. The doctor was probably Dr. Jean Armantère Monge, or his son. Monge had accompanied Lafayette from France to fight in the American Revolution. He later returned to Philadelphia and changed his name to Monges. The *Philadelphia Directory (1823)* lists a Dr. John R. Monges, the full name taken by Monge or the name of one of his descendants. On March 8, 1823, "Remus" published a letter in *Poulson's*, complaining that citizens from states such as Pennsylvania were able to kill men in duels in New Jersey and escape prosecution in their home states. There were no references to Dr. Monges's son or the officer killed. *NCAB*.

6. The jail was the Walnut Street Jail. A short article in *Poulson's* praising the passage of a bill appropriating $40,000 for a new penitentiary may have been a response to the attempted escape of prisoners described by CWP: "The necessity of finishing that Prison with all possible dispatch is but too clearly shown by the actual condition of the Walnut street Jail. The public security demands, the ends of justice require it" (March 21, 1823).

7. Possibly Richard Hill Morris (1762–1841), a Quaker judge. See below, **119**; Elaine Forman Crane, Sarah Blank Dine, Alison Duncan Hirsch, and Arthur Scherr, eds., *The Diary of Elizabeth Drinker*, 3 vols. (Boston, 1991), 3: 2189.

119. CWP to APR

PHILADELPHIA. MARCH 10, 1823

<div align="right">Philadelphia March 10th. 1823.</div>

Dear Angelica

I wrote to you the 4th. Ult. acquainting you of my success in making Porcelain Teeth, also my desire to supply you with such as are incorruptable, of course more healt[hy] in the use of them ⟨*than*⟩ than such as are made of Animal substances— But how to make them for your use is the difficulty, as it would be out of your power to alter them, as no file will cut what may be too promanant—I have prepaired the silver bottom, but further I do not expect to proceed before I can have the pleasure of seeing you.

I have lately amused myself with writing a lecture on Natural history which I intend to deliver when the weather becomes more settled, and ladies can be a part of my Audience. Natural history embraces an immence field, and I have enriched this discourse with considerable veriety of subject, and what pleases me most is, that I have lanched forth to prove that the female sex has been absurdly called "the weaker Vessel" by which *Old Adage* much injustice has been done to the fair sex. It is very probable that this lecture will get into print in which case I shall not fail to send you one.

Your Sister Sophonisba is remarkably well, she will have all her friends

with her tomorrow evening to hear me read my lecture. And this evening I shall read it at the House of a friend of my lost companion,[1] where I expect to find some of the elders of friends meeting. I suppose the delivery of a public lecture by one of my time of life may excite some curiosity from which I hope that audience will [be] more numerous and also I hope respectable, if it is to be in the Museum it shall be so, for in that case I must send tickets of admission, which will be rather troublesome as well as expensive. but if its delivered in any public building a public notice in the news papers will be sufficient. We have had and still have so many pub[lic] lectures that it becomes difficult to make numerous visitors to attend a lecture be it what it may.

I have not used my *Pallet* for some months, my last picture was of my brother, a portrait by candle light, my desire to have his likeness in the museum induced me to do it in that iffect, as no picture of the kind was in the rooms. Almost the whole winter I have been making experiments on enamil teeth, and yet I can find some tryals for further improvements and have begun to make some alittle different in the composition. those I made for Sophonisba is very useful to her, but the next sett I make shall be not only highly useful, but also very handsome.—— This I expect will [be] presented to you by the late Miss Desilver, now married to some gentleman of Baltemore, I am just told his name is Naff.[2] I have nothing further to add expect [except] presenting my love to the family, yours Affectionately

<div align="right">CWPeale</div>

Mrs. Angelica Robenson
 Baltre.

ALS, 2pp.
PPAmP: Peale-Sellers Papers—Letterbook 17

 1. Richard Hill Morris; see above, **118**.
 2. Miss Desilver may have been the daughter of Robert Desilver, a printer and proprietor of a bookstore at 110 Walnut Street. Her husband was possibly John H. Naff, a Baltimore book and stationery auctioneer at 4 North Charles Street. *Poulson's*, February 16, 1822; *Baltimore Directory (1822, 1823)*.

120. CWP to ReP

PHILADELPHIA. MARCH 10, 12, 17, 1823

<div align="right">Philadelphia March 10th. 1823.</div>

Dear Rembrandt

I am anxious to know how you come on with your portraits at the reduced price, having much to do is often a very great advantage, as it

produces a facility of execution which is all important, especially in portrait painting, because it often happens that we painters are sometimes much plagued with impatient setters, I have very often had the advantage of poor Hannahs aid by her converse with my setters—my deafness preventing my holding conversation with them, she supplied my defects.

I have not taken my pallet in hand a long time, the making experiments in Porcelain teeth has engrossed all my time most of the winter, and still I am in the train of producing of what I hope will be of superior quality.

but what do you think of me, when I tell you that I am about to deliver a lecture on Natural History? I have wrote it and with the aid of Doctr Godman I believe it will be much approved off. It is rich in subject as you know natural history gives an amaizing field— my object is to draw the attention of the public to the improvement of the Museum. It will shew the Citizens that they possess the foundation of a noble structure, which if they heartely join to aid me it will soon become a Magnificient Institution, and an honour to any country.

The want of room is a great misfortune to me at present and if I can call forth the exertion of the lovers of Natural history something of importance may follow. knowing the difficulty of getting a numerous respectable audience to hear a lecture, I have on tryal to interest some of the Citizens by getting some of my friends to collect their acquaintance to hear me read the lecture at their homes, by that means I shall get it spoke off by numbers. this evening I shall read it at friend Richard Morris's and I expect he will get some of the elders off the meeting to hear it, and tomorrow evening I shall read it to a company which Sophonisba and Coleman will collect at his house— In this way I shall the better quallify myself to appear before a large audience, if I should be able to attract public notice. at least I shall give information of the real situation of the Museum to numbers who at present think that I have sold the Museum.

Doctr. Godman will deliver an introductory lecture in the courtroom below the Museum this evening,[1] and I shall now leave off to inquire about the room &c. 12th. This morning I waited on the Mayor,[2] and obtained permission for the Doctr. to deliver his lecture in the court room at 7 o'clock this evening. last evening I read my lecture to a company of quakers about 15 in number—some of whom thanked me for ⟨my⟩ the respect which I made in favor of the female sex. I find that by reading it frequently that I am getting it by heart, without intending it, and new Idea's are creeping in—as the mind dwels on the subject. yet I must be careful not to be prolix so as to trespass on the patience of my audience. Send me a mould of your mouth where teeth are wanting by which I may when moulding teeth to be fired, have in view such as will be of the size you require. I wish I could see your paintings lately done,

but ⟨realy⟩ really my affairs are not in such a situation as would justifie me to be absent even for a short time, independant that I ought not to spend a dollar before all my oblegations are fulfilled. Love to Eleoner & the Children with my best wishes for their and your hapiness

CWPeale

17th This morning ½ past 4 I see the flames of Washington hall[3] high above all the Houses. I expect that the Ma[n]tion-House much damaged if not reduced to ashes. This probably the work of Incendries.

Enquire if Harrison engraver[4] is in N.Y. if so, to try to get from him 61$ which he owes Raphaelle for painting Hogans portrait.[5]

Mr. Rembrandt Peale.

New York.

ALS, 2pp.
PPAmP: Peale-Sellers Papers—Letterbook 17

1. Godman's "Introductory Lecture" to his "Course on Popular Anatomy" was delivered "in the Court Room under the Philadelphia Museum" on the evening of March 11. "Clergymen, the members of the bar, and literary and scientific gentlemen in general" were "respectfully invited to attend." *National Gazette*, March 10, 1823.

2. Robert Wharton (1757–1834). Crane, Dine, Hirsch, and Scherr, eds., *Diary of Elizabeth Drinker*, p. 2229; *Philadelphia Directory (1823)*.

3. The Hall of the Washington Benevolent Society was located on Third Street, above Spruce. Incorporated in 1813, the society was considered the "largest . . . Beneficial Society in the United States." Its hall caught fire on Monday, March 17. *Poulson's*, March 18, 1823; *Philadelphia Directory (1823)*.

4. Probably Charles P. Harrison, born in England in 1783, son of the English engraver William Harrison, Sr., who brought him to Philadelphia in 1794. From 1806 until 1819, Charles P. Harrison worked as a copperplate printer in Philadelphia. In 1820 he began executing engravings, and by 1823 was working in New York City, where he remained until at least 1850. There is no listing of a Hogan engraving by Harrison. David McNeely Stauffer, *American Engravers Upon Copper and Steel*, 2 vols. (1907; reprint ed., New York, 1964), 1: 120; 2: 214–15.

5. RaP's portrait is unlocated. There is a John Neagle painting of William Hogan, a Catholic priest who immigrated from Ireland (1823: *Historical Society of Pennsylvania*). CAP.

121. CWP to RuP

PHILADELPHIA. MARCH 23, 1823

Philada. March 23d.1823.

Dear Rubens

since I wrote you last I having nothing to add respecting your property, it stands just as then in doubt whether I sell or keep the House longer, Mr. Taggart is still at Harrisburgh, when he returns I will advise with him about the continuation of my credit with the Bank & whether it is safe to continue a debtor to them, I always keep money sufficient there to pay my

Intrest as it becomes due. I have not yet heard from Mr. George Patterson since I sent word that Moses would sell.[1]

The Indians came to the Museum yesterday and sent for me, I found Cornplanter[2] alittle intoxicated, I went with them to the Indian Queen[3] where he gave me your letters, they were to leave this [city] in the Steamboat this day—they declined visiting us last evening. He spoke very highly of your attention to them, Cornplanter told me that you was a very good friend to him.

Doctr Godman wants the account of the Pictures in the Museum which he says he began to write additions, we cannot yet find it, and not improbably you may have it amongst your Books or papers. He is anxious to proceed with it.[4]

I have insisted on Mr. Say to commence his duty as a Professor of Zoology in the Museum— I tell him that when I deliver my lecture on Natural history connected with the Museum, I will give notice that he will deliver a lecture at a given time, also that Doctr Troust will also give his introductory lectures, I intend also to get Doctr Godman to repeat his lecture— It is also in meditation to announce that the Professors will give either one or other of them also a lecture every week in the Museum, and if it produces an increase of company, it is my intent to give them part of the product but that must depend on the encouragement we have to go on. It may bring the Museum into some reputation of its usefulness in diffusing Scientific knowledge. Our visitation is in some degree improving, I expect Franklin will, when he writes to you will give the Statement of the late & present income.

What you say about the rent of your House paying the Intrest, is not so clear, for I assure you that I have been much plagued with the Doctr——

After dunning him some time he came and gave me a Check on the Camden bank & I gave him a receipt for the payment which became due the 1st. of febuary. I sent Titian over the River in a bitter cold day to go to the Bank, when behold the Check was drawn with the date of the 9th. of March, neither Titian or myself looked at the date, about 2 weeks in advance. 4 times Titian crossed the river & no money had been deposited to meet the Check, I was promised that he would get the money elsewhere. time after time elapsed and no Mony. At last I called on him & said that Mr. McCallister[5] would seize on the property if payment was delayed any longer, This had the effect, & yesterday he made payment, in the same hour I paid it away. I suspect that the Doctr. has but little practice, And I have understood but few pupels to his lectures, even when he lowered the price of Tickets—this being the case, I have but little dependance of his paying much longer the rent. I hear that Rembrandt has his hands full of work, and therefore declines taking a

House in Philada. for the present. My oppinion is that his lowering his price for his portraits is a wise measure, and in consequence of his having full employment, that he will acquire a more expeditious manner of pencilling, and of course it will be less fateaguing to his Setters— I shall write to you again after I see Mr. Taggart.

<div align="right">my love to Eliza & Children affectionately yrs.
CWPeale</div>

Mr. Rubens Peale.
 Baltre.

ALS, 2pp.
PPAmP: Peale-Sellers Papers—Letterbook 17

1. See above, 118.
2. Cornplanter (ca. 1732/40–1836) was a Seneca chief who visited Philadelphia in 1790 and may have toured the museum. He resided on 1,300 acres of land in Pennsylvania (640 of which had been granted to him by the state in recognition of his "many services to the whites"), and for a time received a pension of $250 per year from the United States government. Cornplanter and two other Seneca chiefs, Red Jacket and Colonel Barry, were returning from Washington, D.C., and had visited the Peale Museum in Baltimore on the evening of March 18, 1823. *American and Commercial Daily Advertiser*, March 18, 1823; Frederick Webb Hodge, ed., *Handbook of American Indians North of Mexico*, 2 vols. (Washington, 1907–10), 1:349–50; *Peale Papers*, 2: 409.
3. The Indian Queen was an inn where George Patterson frequently stayed when he visited the city from Chestnut Hill. See CWP to George Patterson, May 20, 1823, P-S, F:IIA/68D5.
4. Godman was probably assisting CWP in the preparation of a new edition of the *Historical Catalogue of the Paintings in the Philadelphia Museum*, which contained biographical sketches for each subject of a museum portrait. *Peale Papers*, 2:1207–08.
5. Unidentified.

122. ReP to CWP

NEW YORK. APRIL 1, 1823

<div align="right">New York April 1. 1823.</div>

Dear father

Pendleton will be obliged to you if you will assist him in getting permission from the Mayor to creat a temporary wooden building or shed for the exhibition of our Picture in—[1]and likewise the consent of the owner of such lot as he may prefer to build on, because a great deal will depend on the situation. The Picture, Pendleton informs me is very dull & must either be *moistened all over with Spirits of turpentine* or *very thin Mastic varnish*, after being well washed. I would not ask you to take the trouble of assisting him in this job, if I could be spared to go on myself—but I am very busy with my 50 dollar heads, which I cannot paint fast, as I am studying to do them in a style that may do me some honour in London I shall not be

obliged to paint any more than I have engaged at this price, if I can succeed in filling up a scheme for the sale of my Roman Daughter— Godman will shew it to you & perhaps you may be able to find me a few names.[2] No money is [to] be paid till the list is full.

⎡page cut out, ⎤	[surp]rised at your being again
⎢perhaps to obtain⎢	engaged in
⎢signature on ⎢	like to know how you have
⎣the reverse side⎦	have produced any advantageous
	you cannot.

 into quite a New style of painting Portraits & should like you to see them— It is probable I may bring on several of them to Pha—besides the one of Governor Clinton which I have painted for you & which is in my New Manner—-[3] I must paint several more before it becomes quite familiar to me.

Rubens has written to me that without a little Capital to have begun with he is afraid he cannot surmount his difficulties—— He ought to have taken at least 2000 dollars to begin with——For very [few] businesses would success well without some funds. Yet his income has exceeded his expectations very much. & I hear him much commended for his improvements & exertions.

We are all improving a little from severe colds, contracted in this variable climate.

Excuse my dullness——I shall endeavour to be better next time. Love to Eliza & families

 Your affectionate Son
 [signature cut out]

AL, 2pp., add. & end., mutilated
PPAmP: Peale-Sellers Papers

 1. For Pendleton's arrival with ReP's *Court of Death* in Philadelphia, see below, **124**.

 2. ReP was obviously hoping to hold a lottery for the disposal of his *Roman Daughter*, a fairly common method of selling an expensive painting. The plan was not carried through; in early November, ReP sold the *Roman Daughter* to a Boston collector. The painting is now in the collection of the National Museum of American Art, Smithsonian Institution, Washington, D.C. See Carrie H. Scheflow, "Rembrandt Peale: A Chronology," *PMHB* 110 (1986): 155.

 3. (Fig. 32.) DeWitt Clinton (1769–1828), a nationally admired and respected New York statesman and prominent man of letters, achieved distinction also as a naturalist and patron of the arts and public education. He resigned his senatorial seat in 1803 to become mayor of New York City, an office he held with great effectiveness to 1815, with the exception of 1807–08 and 1810–11. In 1812, as one of the most popular political figures in New York State, he was nominated by the state's Republicans to run for president against Madison. He lost in a close election. He was elected governor of the state in 1817. Although intense party strife led to his decision not to be a candidate in 1823, he was reelected in November 1824, and appropriately was serving in that office when both the Erie and the Champlain canals were completed. *DAB*; ReP Catalogue Raisonné, NPG.

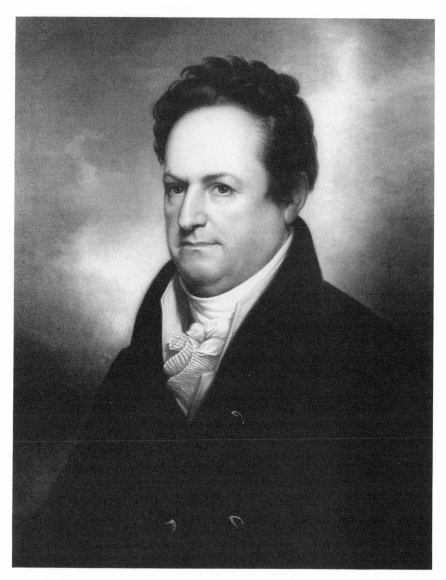

32. *De Witt Clinton*. Rembrandt Peale, 1823. Oil on canvas, 28 ⁵/₈ × 23 ³/₈″ (71.7 × 59 cm). Historical Society of Pennsylvania.

For a description of the Clinton portrait as expressive of ReP's "New Manner," see Carol Eaton Hevner, "The Paintings of Rembrandt Peale: Character and Conventions," in Miller, *In Pursuit of Fame*, pp. 266–67.

123. CWP to RuP

PHILADELPHIA. APRIL 5, 6, 1823

Philadelphia April 5th.1823.

Dear Rubens

I have not seen the gentlemen you mention in your last letters.[1] Not knowing where to find Mr. Wagner[2] prevented me from waiting on him. Letters are brought to Museum, and as my attendance is not absolutely necessary there, I persue my labours at home—and don't receive the letters until the bearers have left the Museum, some regulation should be adopted to prevent the recurrance of such events. I am willing to make some tryal to employ Mr. Helene,[3] say one or [two] weeks, but further I cannot justifie myself to engage. As you think respecting Mr. Nichols,[4] accords with my Idea's. and it also appears to me that very little advantage is obtained by any if such additions of excitement to obtain visitors to the Museum, for suppossing a croud is obtained for a few evenings, less company comes at other seasons, so that with the expence additional and afterwards a falling off, no advantage is in reality of obtained thereby. but also another consideration of no little consequence, should be put into the sack— Is the reputation of a museum of natural History thereby benefited? But I must not have Signor Helena untill the quacker meeting is past, which you know is the 3d. Sd.day of 4th. month

I have a few minutes past seen Mr. Sully, who tells me that he brings me a letter,[5] which [he] could not then deliver, therefore I shall not conclude this as soon as I intended, for I may add to it.

Raphaelle desires me to ask you if you wish him to paint the Mayer picture,[6] and what Portraits in the Museum to paint from (if you desire it) perhaps, he says, you would like old Mr. Chas. Thompson,[7] Doctr. Rush[8] to please medical students—Size of the pictures two feet 5 or 6 Inches 25$ each also to request you of a Mr. Howard[9] concerning the taxes on his lands, he says that he has forgot the street he lives in—but he is the receiver of Taxes in Baltemore—if they are not paid by the Tenant or Mr. Beale Howard[10] of Cumberland, who has rented the same for Raphaelle in order to secure them in possession— The taxes are published in some of the Baltemore Papers——Raphaelle being out of work is in need of support—he requested you to send to him the pictures remaining with

you as soon as you can conveniently do it—as he must try to sell some or all of them by some means to get money to meet expences. He declines going to the point under the view you have given of the situation of the Inhabitants there.

I propose to deliver my Public lecture on Natural History connected with the Museum on wednesday or thursday next at 12 O'clock A.M. and shall invite ladies & gentlem, by advertizment to hear it, in the Room below the Museum.[11]

Some time past you have said "that I had better pay Mr. Planteau, to serve all my friends, than plague myself with them— You would alter that opinion if you knew how many I should have to supply with teeth. It would amount to upwards of 1000 $ at least, and perhaps my friends would not be so well fitted as I hope to do them. at least you will agree with me, we must receive pleasure if we can oblige by our labour those whom we esteem.

I cannot fail at last to do them perfectly well, and although I have spent several months to acquire this knowledge with some cost of materials, yet it is at least a comfortable reflection that I shall have acquired a profession that is essential to the health & happiness of our fellow mortals, and if it should become necessary may be a means of support if I chuse to make it a business of profit.

Mr. Pendleton is here, and we are trying to get a lot to build on it a temporary building to exhibit the Court of Death. Rem.t is very busy in painting portraits at 50$ each. but he says that he cannot help taking so much pains with them that it is not very profitable work.

Having advised with Mr. Tagart and others, I found it was a general opinion that I ought to take 7000$ for your House they said that much better Buildings a little higher up the street could be had for ½ that sum, and trying all I could to get a few 100 $ more, and not finding much company at the Museum of late with many Bills pressing for payment, I consented to take that sum— The Gentleman went to see it with Mr. Strickland,[12] in the result was that he refused to take it. Therefore I must wait to know if a War takes place in Europe, in which case property here, will immediately appreciate.[13] Mr. Bonsel told me that he could find me a purchaser, but I must allow him 2 pr.Ct. I prefer waiting alittle longer. 6th. since dinner the Sheakspeare Building was on fire, the fire blazed high through a hole in the Roof—In about one hour it was extinguished— Franklin went on the top of the Roof and was completely soaked with Water.[14]

On wednesday next at 12 O'clock A.M. I intend to deliver a lecture partly on Natural History connected with the Museum and by advertizment appearing tomorrow I invite Ladies & Gentm. to attend in the Room

under the museum. I flatter myself that I may gain some friends to be active to promote the interests of the Institution. Mr. Sully speaks highly on your tastes & good management of your Museum. When the weather becomes more settled I hope I may be able to visit Baltre. after first paying off some important Bills— The Museum is now becoming better & perhaps I may accomplish my wishes after the Meeting of friends. my lectures will I hope earn me friends in that Society. Mrs. Bend[15] is not well she is subject to an intermitting fever.

The Carpenter that was to take your lot, is now building a Church and for the present probably will not purchase—

<div style="text-align:right">

Love to Eliza & Children yours affectionately

CWPeale

</div>

Mr. Rubens Peale

ALS, 3pp.
PPAmP: Peale-Sellers Papers—Letterbook 17

1. Unlocated.
2. Possibly Jacob Wagner, who had been chief clerk at the State Department under James Madison. CWP wrote to Wagner in 1804 seeking to sell polygraphs to the department. Wagner had resigned as clerk in 1807 to publish a Baltimore newspaper. From 1812 to 1816, he published newspapers in Georgetown, District of Columbia. He returned to Baltimore in 1823. CWP to Jacob Wagner, July 22, 1804, P-S, F:IIA/31D6; *Baltimore Directory (1822–23)*; Robert J. Brugger, Robert Rhodes Crout, Robert J. Rutland, Jeanne K. Sisson, and Dru Dowdy, eds., *The Papers of James Madison: Secretary of State Series* (Charlottesville, 1986), 1:383n; Clarence S. Brigham, *History and Bibliography of American Newspapers, 1690–1820*, 2 vols. (1947; reprint ed., Westport, Conn., 1975), 2:1497.
3. Signor Hellene performed as a one-man "Pandean Band" from Italy, playing on five different instruments simultaneously. Although CWP disdained such performances, RuP believed that the musician attracted visitors, and Hellene had appeared in the Philadelphia Museum for five dollars a night on and off since the spring of 1820. For a description of Hellene's performance, see *Peale Papers*, 3:808–10; Sellers, *Museum*, p. 237.
4. Unidentified.
5. Unlocated.
6. RaP may have been referring to two portraits of mayors done by ReP: *Edward Johnson* of Baltimore (1767–1829) (1816: *Baltimore City Life Museums—The Peale Museum*) and *Robert Wharton* (1757–1834) of Philadelphia (ca. 1823: *Historical Society of Pennsylvania*). Later in 1823 (see below, **153**), CWP also painted a portrait of Wharton (*unlocated*). *P&M*, p. 246; ReP Catalogue Raisonné, NPG. There is no record of RaP's making copies of these paintings.
7. CWP painted two museum portraits of Charles Thomson (1729–1824), secretary of the Continental Congress—in ca. 1781–82 and in 1819, both in the *Independence National Historical Park Collection*. There is no record of RaP's making a copy of either of these paintings. *P&M*, p. 209.
8. CWP painted two portraits of the famous physician Benjamin Rush (1745–1813)—in 1782–83 at *Winterthur* and posthumously, in 1818, now in the *Independence National Historical Park Collection*. There is no record of RaP's making a copy of these paintings. *P&M*, pp. 186–87; *Peale Papers*, 1:378.
9. Unidentified.
10. Beale Howard acted as RaP's legal representative when RaP transferred title of his Cumberland land holdings to his son, Charles Willson, Jr. See RaP, deed to Charles Willson Peale, Jr., October 18, 1823, PPDR, F:V/1E3–10.

11. On April 7 and 9, advertisements appeared in *Poulson's* for CWP's noontime lecture on April 9.

12. William Strickland.

13. CWP was responding to several months' worth of reports and rumors of an imminent war between Spain and the nations constituting the Holy Alliance—Russia, Prussia, Austria, and France. The Alliance threatened to invade Spain, overthrow its constitutional monarchy, and restore the absolutist rule of King Ferdinand VII. Many Americans feared that the Alliance would also attempt to subjugate the newly-independent Spanish American colonies, thus spreading the war into the western hemisphere. On March 15, 1823, American newspapers reported that events appeared "to place it beyond doubt that *war must inevitably ensue between Spain and the 'Holy Alliance.'*" The report indicated, as CWP observed, that a war in Europe "will undoubtedly tend to enhance the value of American products."

Secretary of State John Quincy Adams believed that American involvement in a European war could result either from a maritime conflict in the West Indies, in which British vessels would attempt to impress American seamen, or, more likely, from a demand from Great Britain—as its price for coming to the aid of Spain—for possession of Cuba or Puerto Rico, an event that would pose a threat to American security. In response to the fear of European intervention in the affairs of the western hemisphere, President Monroe delivered later that year (December 1823) the famous message to Congress that has come to be known as the Monroe Doctrine. The invasion of Spain by the armies of Russia and France occurred one day after CWP wrote this letter, April 6, 1823. *American and Commercial Daily Advertiser*, March 15, 1823; Arthur Preston Whitaker, *The United States and the Independence of Latin America, 1800–1830* (1941; reprint ed., New York, 1962), pp. 338–99; Samuel Flagg Bemis, *John Quincy Adams and the Foundations of American Foreign Policy* (1949; reprint ed., New York, 1965), pp. 363–81.

14. The Shakespeare building was located at the northwest corner of Chestnut and Sixth Streets. The fire was reported in the *National Gazette* and *Poulson's*, April 7, 1823.

15. Elizabeth Polk Claypoole Bend.

124. CWP to ReP

PHILADELPHIA. APRIL 6, 1823

Philadelphia April 6th. 1823.

Dear Rembrandt

I was under much anxiety about your picture of the Court of Death untill I met Mr. Pendleton it was very fortunate that the Vessel had not sailed before the late Storm happened— tomorrow I wait on General Cadwa[la]der[1] with hope of getting a lot on the side of the Academy of fine arts for your use, and have very little doubt of obtaining it, but whether soon enough to give you notice of the result in this letter is not quite certain.[2] I shall advise Pendleton to sleep in the building of Exhibition, as fires too frequent happens, and may be the work of Incenderies. To-day in [the] roof of the Shakespeare Building was on fire. by the activity of our hose & fire-companies it was in alittle more than one hour extinguished, although it had blaized in collumn through the Roof. On wednesday next at 12 O'clock I intend to deliver a lecture partly on Natural History connected with the Museum. by advertizement I invite Ladies & Gentlemen to attend in the Room

under the Museum, by this attempt I hope to bring the Museum into more notice & I hope to raise friends to it—for the Public generally do not know its constitution— I wrote the lecture and Doctr Godman has dressed it much to my satisfaction, and I promise myself that it may be the means of bringing forward the several Professors into public notices.

It would give me much pleasure to see you in N York but realy cannot at the present time leave the Museum, not that my Sons require my aid, but the necessity of my exertions to keep those in good humour to whom I owe money. I may by my present exertions with the aid of Franklin & Titian to put the Museum in elegant order with also additional objects attract company at the quaker meeting. Signore Helena will be done with Rubens on wednesday next and I mean to try him for one or two weeks, yet I do not promise myself much for such exhibitions, and if more company come at times, less follow after, and what is worse such exhibitions rather degrade a Museum of Natural History.

If a war with Spain takes place, property will rise in Value here, in which case I may get a purchase for the House belonging to Rubens, I thought I had a purchaser for it at 7000$ but he took Mr. Strickland with him to view it, and afterwards declined the purchase, Houses much better than this a little further westward can be bought for half that sum. It is a great pitty that it had not been another Story higher. Altho.' Doctr Mcclelan gives 600$ rent, yet I doubt whether he can keep it much longer—I have found him very tardy in payments. I much doubt whether his practice will warrant such expense.

Cadwalader has fought a Duel with Patterson[3] of Baltemore, and a Ball entered his wrist and run up his arm, a bad wound. Doctr Phisick[4] went to him yesterday (New-Castle) so that I have nothing to add at present except I shall try every means in my power to to get that [lot] or another near it—and will write again,

<div align="right">Love to the family yrs. CWPeale</div>

Mr. Rembrandt Peale.

ALS, 2pp.
PPAmP: Peale-Sellers Papers—Letterbook 17

1. Thomas Cadwalader (1779–1841) served as a lieutenant-colonel in the War of 1812 and later became a major-general in the Pennsylvania militia. A recognized business and cultural leader of Philadelphia, Cadwalader served as an agent for the Penn family and the Bank of the United States, later becoming that institution's chief director. Nicholas B. Wainwright, "Affair with Professor Pattison," *PMHB* 64 (1940):331–44; Simpson, *Eminent Philadelphians*; *NCAB*, q.v. George Cadwalader.

2. See above, **122**. ReP's painting was advertised in *Poulson's* on April 12, and the exhibition opened on April 19:

Peale's Court of Death,
Is now open to the public for a short season previous to its departure for Europe, in a house erected for the purpose, in Tenth, near Chesnut street, South of St. Stephen's

Church. To become acquainted with an original picture of great extent, composed of many figures, the result of much study and thought, it is necessary to examine it more than once. It is therefore deemed advisable to fix the price of a ticket at 50 cents, which will admit the purchaser at any time during the season. Admittance 25 cents—Children half price.

The exhibition site was next to PAFA, which in 1823 was housed on Chestnut Street, between Tenth and Eleventh Streets. WPA Guide Series, *Philadelphia: A Guide to the Nation's Birthplace* (1937; reprint ed., St. Clair Shores, Mich., 1976), p. 454.

3. The duel was fought between Granville Sharp Pattison (1791 or 1792–1851), professor of anatomy, physiology, and surgery at the University of Maryland at Baltimore, and Thomas Cadwalader. Several years earlier, Pattison had challenged Cadwalader's brother-in-law, Dr. Nathaniel Chapman, to a duel. In March 1823, Cadwalader, in his capacity as a manager of the Philadelphia Assemblies, had written to the other managers to prevent them from giving Pattison a ticket to the Assemblies. In turn, Pattison challenged Cadwalader to a duel. There is no description of the duel itself, but it was, as CWP noted, fought at New Castle, Delaware. Pattison was not injured. Cadwalader's wound, described by his second as "but a scratch" on his arm, was, as CWP described it, far more serious. He is believed never to have recovered the use of his right arm and to have suffered a general decline in his health. Wainwright, "Affair with Professor Pattison," pp. 331–44; *Peale Papers*, 3:796.

4. Philip Syng Physick (1768–1837), professor of surgery at the University of Pennsylvania Medical School. *Peale Papers*, 2:1039.

125. CWP to RuP

PHILADELPHIA. APRIL 13, 16, 1823

Philadelphia April 13th.1823.

Dear Rubens

I don't recollect whether I wrote you that Mr.Taggarts friend declined taking your House, he told Titian that if he bought it that he must pull down the House & he thought it was paying too dear for the ground. I called on Mr. Bronsel & asked him if he could not get his commission besides the 7000$, he replyed that the person who had made him the offer had now declined purchasing, he said it was the same Man that Mr. Taggert had spoken off, and he thinks that we cannot sell soon as property had greatly depreciated, as an instance, he said a gentleman had refused 40,000$ some years past, since then he has refused 20,000$ and now he cannot get 16,500 for the same property. I told him, if a war took place in Europe, property would rise here— he shewed me a newspaper & pointed to the figures of Houses for sale in every collum.

I hear nothing yet from the Doctr. but every day I expect to hear that he must seek another House of less rent.

I expect the Court of Death will shortly arrive, and I obtained a lot in 10th. street between Chesnut & Market streets, & the building will be finished tomorrow or next day— Mr. Burd Junr.[1] was so obleging as to let us have a place on his lot opposite the S.W. corner of Mr. Gerrards square.[2] I had made application to a Mr. Brown[3] for a lot in Chesnut near

7th. St. and went through some curious menouvering & finally failed, Brown being a singular character, rather much of a Miser. though immensely rich, and *neither chick or child* to heir his property.

I delivered my lecture last wednesday at 12 O'clock. my audience was respectable of Ladies & gentlemen, but not so numerous as I expected— some of my friends say that I had choosen a bad hour. but I believe the fact is that we have so many public lectures that the citizens are tired of them.

Doctr Troust delivered his introductory lecture in french last evening. his audience was not numerous, it was rather long 3/4 hour. a well wrote lecture also well read.[4] my hearing is too indifferent for me to form any judgment of public speaking or readings. I shall wait for Mr. Sully's return to send by him, so that I will leave the remainder of this sheet for what may occur.

Mr. Samuel Sellers some time past desired me to write to you about the house at the point belonging to Peggy Coleman[5] and I fear that I have neglected to mention that he wishes you to make enquiry for a purchase of it, for he says it says it will go to ruin if not tenanted or sold— Sammy asked me a few days past whether I mentioned to you, I thought I had but turning over my copies of my [letters] I do not find that I had wrote about it.

I find by Mr. Sully that Rembrandt had gone up the north river to seek lodgings for his family.[6] he speaks highly in praise of the improvement of the Roman daughter but Mr. Sully will tell you all these things.

The building for the Court of Death will be finished today, but the Vessel bringing the picture had not arrived last evening. I think the situation of exhibition in 10th. Street near the Church of Gothic Tours [towers][7] is good at this season, when the ladies are taking their walks in that fashionable part of the city. I had no Idea of the numbers of churches built and building here, untill Mr. Pendleton shewed me the number of tickets he had made out for the ministers—the 2 tours of gothic order is not quite finished & is handsome, and the inside is the most superb finish, as fine as a roman Catholic chapel. do not suppose that any church in America can be half so showey. The 2 archetecks Strickland & Havyland are vieying with each other in the extravagance of their art. a Gentleman remarked to me yesterday that we shall have more churches than hear[er]s. It is time to end my scrole since I have no better matter to write on— Raphaelle can get no employment, and Mr. Birch[8] told me yesterday that he has nothing to do, This morning I shall make a tryal at a bronze head of Genl. Washington in the hope of improving Raphaelle in that mode of work.[9] he now talks of going to Charlestown,

<div style="text-align: right">Love to Eliza & children, adieu.
CWPeale</div>

Mr. Rubens Peale.

16th. while working on Raphaelle's physiognatrace to render it complete to take small profils for likenesses in brunze, the time passed so quickly that I lost the opportunity of sending this by Mr. Sully. This morning I hear that the Vessel bringing the Court of Death has arrived, and delivering Gun powder, in the afternoon perhaps we may get it (the painting) and if I can soon get through my part of the labour of cleaning, varnishing & putting up the picture tomorrow, very probably I may the next day start for New york, because I want to get Rembrandts improvements in colouring, and also to put a finish to the settlement of the Estate which entitles my Children by Elizabeth to their share of 5000$ so long detained from them, A chancery suit have terminated in their favor & the Bond of Gerard DePeyster is ordered to be given to Mr. Remson and by him to be paid Heirs of Wm. DePeyster as agreable to his will.[10] I dont expect to be in N. York more than 2 days, as I must be home in the latter part of the week of friends meeting. Helena delivered me your letter, and he says that you did not tell him that I would not employ him, untill the quaker meeting was over—he said that he could not stay so long on expences & that he must go on to N York & Boston the next day—afterwards, yesterday I meet him coming from the Museum & I asked him if he intended to go, he said that [he] would stay here 2 or 3 days—and it is probable that he means to wait for my imployment—in fact, as I said before, I cannot think his exhibition of much advantage or credit to the Museum. I am also meditating a Visit to you as soon as I find I can be prepaired to be of any service to you, and in what mode I may communicate in my next. but do not expect by this hint that I can bring any money with me more than will pay my expences, I must away to get a conveyance for this.

<div align="right">CWP———e.</div>

ALS, 3pp.
PPAmP: Peale-Sellers Papers—Letterbook 17

1. Probably a son of Edward Burd, uncle of William Augustus and Eliza Burd Patterson (Mrs. RuP). Peale painted Edward Burd's portrait in 1820. See above, **3**.

2. CWP may have been referring to the location of Stephen Girard's house, at Ninth and Chestnut Streets. *Philadelphia: A Guide to the Nation's Birthplace*, p. 77.

3. Unidentified.

4. An advertisement for Troost's "Geological Lectures in the French Language in the Court Room under the Philadelphia Museum," appeared on April 10, 1823 in the *National Gazette*.

5. Unidentified. Probably a relative of Elizabeth Coleman (Mrs. Nathan) Sellers.

6. See below, **126**.

7. The building occupied by St. Stephen's Episcopal Church (admitted in 1823) originally belonged to St. Thomas's Methodist congregation. It was substantially rebuilt according to plans drawn by William Strickland, who designed a Gothic front for it. Scharf, *Phila.*, 2:1351.

8. William Russell Birch (1755–1834), painter and engraver. *DAB*.

9. Unlocated.
10. See H. D. and R. Sedgwick, Memorandum for Mr. Peale, April 19, 1823, P-S, F:IIA/68E4–6.

126. CWP to RuP

PHILADELPHIA. APRIL 24, 1823

Philadelphia April 24th.1823.

Dear Rubens

I returned here yesterday from N. York. left Rembrandt packing up his furniture, in order to store it and to morrow he carries his family to board at a farm-house, opposite West point,　　I received a letter from him,[1] this morning, in which he says, that he received a letter from Mr. Robenson[2] directly after I left N. York. And I believe it to be my duty to give you the following extract from Mr. Robensons letter, in order that you may do what on serious consideration you may think best.　　Whether we like a person or not, I think it is best to give them what they may think is due to them in every respect, for by so doing we may be no losser, and perhaps may gain favor by it, at least we shall have an approving conscience. Have you respected the opinions and advise of Mr. Robenson? do not let me have blame for giving this extract, I hope you will be able to get through all your difficulties, by a steady perseverance of industry and economy, if you suffer injuries do not return the evil, but good, if possibly in your Power and in the end you will be rewarded.

"Something is wanted to give spirit to the Museum here——　Neither ground rent or dividend has been paid since Rubens has had it——and I am not only tiezed by the stockholders, but by Mr. McKim. (the land lord).[3] Robt. Gilmor (who owns a few shares) has hinted to me that it would be best to take it out of Rubens hands.—and Mr. McKim says that he must sell for the ground Rent. I do not speak to Rubens on this subject now—I have said very much, too much. He does all he can to improve the Museum, but has not appeared sufficiently anxious to raise funds to relieve it from the present *dangers*——　I say *has not appeared*, for I cannot know how much he may suffer, or what may be his anxiety on that account.——　It has you will be certain, [been] with difficulty I could bring my mind *at this time* to say so much on this subject　　I have now done with it, perhaps for ever"——　I cannot say what you ⟨might⟩ ought to have done but Rembrandt says that you *ought to do any thing and every thing that Mr. Robenson should require, or recommend to you.* he says that Mr. Robenson holds nearly half the stock, therefore if the Museum is sold at a loss that he (Mr. Robenson) will be the greatest looser.

247

There is a reflection made, and by one of Eliza to me, that Eliza's property ought to be sold in order to aid you to get through your difficulties in the purchase of the Museum, as an equal interest to her. I do not know that Eliza has in reality been adverse to do this, and I cannot tell whether there has been a chance of selling with the consent of her sisters who are also equally interes[ted] in the property.[4] These are delicate subjects, you are each of you to do every thing in your power for your mutial happiness and the maintainance of your Children. you have industry and a disposition to fulfill every Moral and religious duty. [illeg] same opinion of Eliza. I have also received yours of 21st. instant,[5] and I will follow your advice, when Mr. Branch Green[6] calls on [me].

I will retain your House as if it belonged to me, with the hope that some time hence it may be in my power to sell it more advantageously than can be done at this time, and for your advantage—Doctr McCleland has not of late said any thing about leaving it, of course his rent goes on at 600$, yet should he leave it I cannot expect an equal rent, but less would be more agreable than nothing, so much dunning business as I must have with him.

As I wrote to you in my last that I would pay you a Visit, it is my intention to do so, yet I find that the wheather is not ⟨yet⟩ sufficiently settled to secure me from the danger of changes, I am now hoarse from a cold occasioned by my passage from N York, whether caused by riding in the night, or the cold air in the steamboat I know not, my system to restore health, will soon rid me of this, as I have begun to use the best means, I have [w]rap[p]ed myself up, and made some walks of excercise, with a proper attention to diet. I have done wrong in mentioning this triffling complaint, but I must write to you again, when I may get leisure & find something more worthy your notice. I am summoned to a concert. Love to Eliza &c

<div align="right">CWPeale</div>

Mr. Rubens Peale.

ALS, 2pp.
PPAmP: Peale-Sellers Papers—Letterbook 17

1. Unlocated.
2. Henry Robinson's letter is unlocated.
3. Either John McKim, Jr. (1766–1842), a Baltimore merchant who was named a trustee of the Baltimore museum by the Maryland legislature when ReP encountered financial difficulties in 1817, or Alexander McKim, who was also a merchant engaged in the import trade. See *Peale Papers*, 3: 260; Miller, *In Pursuit of Fame*, p. 116; Wilbur Harvey Hunter, *Rendezvous for Taste, Peale's Baltimore Museum. 1814 to 1830* (Baltimore, [1956]), p. 11.
4. See above, **61**.
5. Unlocated.
6. Branch Green was the proprietor of a stoneware factory on North Second Street. Green appears to have owned several of the lots that RuP purchased in Philadelphia. *Philadelphia Directory (1823)*; Branch Green, et ux., Deed to RuP, January 14, 1814, PPDR, F:

VIIA/2D3-E4; RuP et ux., Deed to Branch Green, September 3, 1840, PPDR, F:VIIA/9E9-F4; Correspondence and Miscellany Pertaining Chiefly to the Baltimore and New York Museums (copy of letter from RuP to Green, September 22, 1838), P-S, F:XIC/1B8-G3.

127. CWP to ReP

PHILADELPHIA. APRIL 25, 1823

<div align="right">Philadelphia April 25 1823</div>

Dear Rembrandt

Either riding in the night or by the chilly damp air in the Steam-boat, I have taken cold, and am very hoarse, soon as I got home I bathed my feet, put on my surtout & walked to several parts of the City on necessary business & was nothing better at night, then I took sulphur, and exercised considerably yesterday, at night went to a concert of the musical fund society in the new Theater,[1] finding my place rather cold I left it before the concert was half finished, and took on going to bed a bowl of Molasses Tea—and this morning more sulphur, have been twice to the Court of Death, then to the Mayors & other parts of the City, thus exercising enables me to persue any work I may want to do & in one or two days expect to be again in perfect health. In the Delaware steamboat I meet with Otis,[2] that man possesses very extraordinary talents, he entertained me by his inventions of several sorts. he told me that while he was at trentown he wanted to make a sketch of a View, that he went to a House painter & got some burnt Terre de ciene, prusian Blue & white lead[3] and made his sketch very much to his satesfaction.

I wrote to Rubens yesterday and gave him a statement of your situation, also the best advice I am able to give, and put a question to him, whether he had paid the attention which is due to Mr. Robenson, and also said to him as Mr. Robenson held so large a proportion of the stock of the Museum that he ought to do every thing, & follow his advise in all things. You know my opinion of Gilmor[4] and I am sorry that any of my family should be under oblegations to him. I am anxious to go to Baltemore as soon as the weather and my affairs will permit it. and if by my advice I can help my Children you may believe it will be adding much to my happiness. I shall as far as I can prudently advise that Eliza's property shall be sold in order to enable Rubens to comply with his engagements to you, and I hope that Rubens will economise as much as possible, and not spend money for improvements which ought to go towards paying the debts of the Museum, that 8 pr. Ct. business is an abominable moth, and if Rubens can save any money it is of the utmost necessity that such a debt should be his first care to wipe off.[5] to get out of debt especially where interest is added, is an ardious task

But I talk of a concern on which I have known but little about it—I shall probably know more about the difficulties Rubens has to contend with when I go to Baltre.

Pendleton will write by Mr. Robenson, of course you will know more particulars about the Court of Death than I can give you— The Museum was visited last evening by a numerous & genteel company ⟨*last evening*⟩ but I fear they were not sufficiently attended, as both Franklin & Titian was engaged at the Concert—Franklin as an amatur sang the first song (behind a screen) he did not open his throat sufficiently, at least I could not hear him but very imperfectly, but I do not think a talent for singing is any advantage to a young man, and very often it is a hurt of no little moment. I will now quit writing & go to Mr. Earls to see Wests portrait.[6]

I think the picture of less merrit than I expected, but it is too distant for my Eyes, I cannot see the likeness so far off I intend seeing tomorrow in closser view—The scrole in his left hand is a white spot, the breadth of light in the curtain advances well, and the calm below is pleasing, but the Easel is slanted back too much the extention of his right arm is masterly, the figure has too clumsey an appearance even for an old man. The colouring of the face especially on the left is cold, perhaps when I see it nearer I may like it better, but at this moment I realy think it is far below nature, and the price of 900 £ ster.g ought to have produced a more living representation of West. I think you have a better chance of success in London than I had before seeing this picture, even now in my advanced time of life I would not fear gaining a reputation of an Artist with such competition as Lawrence if he paints no better portraits than this of West. so that you may conclude that if I resume my pencil and enjoy my usial health, that I shall gain an increase of reputation as an Artist, if I can practice your lessons on colouring, Seeing bad pictures when I followed the Saddlers business, induced me to think that I could do them equally well therefore to furnish rooms I began painting, had I first seen good pictures in all probability it would have discouraged me from making the attempt.[7]

I think I can see that the tide in favour of my museum is beginning to flow. The Idea that at my death it would be divided and lost, had taken deep root in the minds of many Citizens, the Mayor the other day said he was rejoiced to hear that its use is secured to the City, and it now was the duty of every citizen to contribute all in their power for its increase and improvement.[8] I have thought to give notice by advertizement that I will repeat my lecture in the museum—and with all despatch I can prepair the other which I mentioned to you, and which I mean to deliver in the Museum in Baltemore.[9]

I have nothing to add except my love to the family, and to Doctr Mumford.[10]

Yrs. Affectionately
CWPeale

Mr. Rembrandt Peale

ALS, 3pp.
PPAmP: Peale-Sellers Papers—Letterbook 17

1. The Musical Fund Society of Philadelphia was founded in 1820 as a benevolent organization for the relief and support of "decayed musicians." The focus of the organization rapidly changed, however, from charity to musical performances, with the society holding yearly concerts in the early 1820s in the Chestnut Street Theatre, which had been rebuilt on the same location at Chestnut above Sixth Street, according to a design by the architect William Strickland. The program for the concert that CWP attended on the night of April 24, 1823, included "Mozart's overture to *Figaro*," a "Haydn Sinfonia," concertos for violin and for violoncello, and "songs by English composers." BFP was the society's secretary in 1823, and TRP was a later member. Louis C. Madeira, comp., *Annals of Music in Philadelphia and History of the Musical Fund Society*, ed. Philip H. Goepp (Philadelphia, 1896), pp. 59, 89, 189; *Poulson's*, December 30, 1823; Scharf, *Phila.* 2:970–73.

2. Bass Otis (1784–1861) was a portrait painter, engraver, and innovator in the development of lithography in the United States. *Peale Papers*, 3: 579.

3. Probably burnt sienna, an earth color with a red-brown tone; Prussian blue, or ferric ferrocyanide, a deep blue pigment first used by artists around 1770; and white lead, or lead carbonate, which was usually made by corroding the metal with a mild acid. Ralph Mayer, *A Dictionary of Art Terms and Techniques*, (New York, 1959), p. 53; *Peale Papers*, 3:356, 599.

4. CWP painted portraits of the elder Robert Gilmor and his family in 1787 (*Colonial Williamsburg*), but made no mention either at that time or later of Robert Gilmor, Jr. See *Peale Papers*, 1:551.

5. When ReP first issued stock in his Baltimore Museum, stockholders were assured of a "fixed interest of 5% or 6%." Later, when ReP found himself in financial difficulties, he issued more stock that paid dividends of 8 percent on income after expenses. The Act of Incorporation of the Baltimore Museum Company stipulated that the dividends over expenses were to be paid semiannually and were not to exceed 8 percent, but, according to RuP, the stockholders "all had the impression that it was an 8 percent stock he had been paying at that rate." RuP, "Memorandums," P-S, F:VIIB/1, n.p.; Wilbur Harvey Hunter, *The Peale Museum, 1814–1864: The Story of America's Oldest Museum Building* (Baltimore, Md., 1964), pp. 8–9; Miller, *In Pursuit of Fame*, pp. 116, 294n.11; Scharf, *History of Baltimore City and County*, p. 176.

Moth, in an archaic definition, is a thing or person that gradually eats away at, wastes, or consumes something. *OED*.

6. Sir Thomas Lawrence's portrait of Benjamin West, painted for the American Academy of Fine Arts in New York City in 1820 (above, **90**; fig. 30), was exhibited at Sully and Earle's Gallery for a "short time" beginning April 24. On the following day an adulatory review of the painting appeared in the *National Gazette*, quoting "eminent" London artists who described the portrait "as one of the finest specimens ever produced in the art of portrait painting." The article concluded by praising "the remarkable closeness and force of the resemblance," and found the work "a masterpiece of the pencil, worthy to draw, as such, crowds of spectators, besides being adapted fully to gratify those who feel an interest in the person and fame of the illustrious original." *Poulson's*, April 24, 1823; *National Gazette*, April 24, 25, 1823.

7. See A(TS):15. CWP was referring to his visit to Norfolk, Virginia, in 1762, when he first saw portraits painted by "a brother of Mr. Joshua Fraizers" and decided that he could do better. This experience marked the beginning of his artistic career.

8. Mayor Robert Wharton's comment encouraged CWP to once again seek public support to expand his museum over the Statehouse. On April 29, an article appeared in *Poulson's*, highly complimentary to CWP personally and urging that the City Corporation allow the museum to construct "a range of rooms over the fire proof offices which adjoin the State House." *Peale Papers*, 3:1–28, 149–51.

9. On May 5 and 7 CWP advertised in the *National Gazette* a lecture for the evening of May 7 "on the advantages of the **STUDY of NATURAL HISTORY**." On May 17 he delivered at the Philadelphia Museum a different lecture, "Embracing a general view of the parental affection of the animal creation." He delivered one lecture in Baltimore on May 24 and a second lecture in two parts on June 3 and 4. *National Gazette*, May 5, 7, 16, 1823; *Poulson's*, May 17, 1823. See below, **139**.

10. Unidentified.

128. CWP to RuP

PHILADELPHIA. MAY 6, 1823

Philadela: May 6th.1823.

Dear Rubens

The letter[1] that you will receive from Eliza with this, I intended to have sent this day but having my mind very much engaged, the time of going to the Steam-boat, slipt my memory, and I am doubtfull whether Eliza will be in the City untill the Steam boat has left us—here is two letters for her, at her parting with me she concluded that if letters were sent by the stage, that she might loose and therefore desired me to retain such untill she returned on to morrow. I mention this least you might expect an immedeate answer. I am much concerned at my neglect of sending that letter, as no doubt you expected one and must be under anxiety.

Your Sister Sophonisba is so busy that she required me to write to Angelica, which I herewith enclose,[2] wishing you to have it delivered into her hand, as I should be fearfull that if Robenson got it—the devil might councel him to disapoint the two Sisters I am as bussey as possible in order to be prepared to leave this in the latter part of next week. I fear that Mr. Pendleton will not make out even tolerable well—the appearance of the House he built has detered many I believe from going to see the picture. I advised him to have it white washed—but the Carpenter said it would render the boards of no vallue— McCellan has left the House & I have paid the rent to Mr. Graff. a Bill on the door, *for sale or rent*. The House is left not very clean—And the windows of the exhibition room 8 panes broke—I will endeavor to make the docter pay for mending them. two offices are about to be built in front of the School House, to be let to to lawers—

In haste, yrs. affectionately
CWPeale

Mr Rubens Peale.

ALS, 1p.
PPAmP: Peale-Sellers Papers—Letterbook 17

1. Unlocated.
2. The letter enclosed was CWP to APR, May 6, 1823, P-S, F:IIA/68F1. CWP informed his daughter that he and SPS would arrive in Baltimore in a little more than a week.

EDITORIAL NOTE: *Peale's 1823 Manuscript Lectures*

No printed or final texts exist for the two public lectures in natural history that Charles Willson Peale delivered in Philadelphia and in Baltimore in the spring of 1823. Five separate manuscripts of lectures, drafts, or fragments of lectures are extant in the Peale-Sellers collection at the American Philosophical Society; a variant by Peale of the first lecture is in the Simon Gratz Collection at the Historical Society of Pennsylvania in Philadelphia. Of these, two match Peale's descriptions of those he delivered. The first, which was copied for the Gratz Collection (F:IID/32A11-C6), is entitled "Lecture on natural history and the Museum" (F:IID/30E11-G5). Peale described this lecture as being "on the subject of natural history as connected with the Museum" and began it with the expression of his "desire to render the museum a lasting benefit." Peale also noted that this lecture contained a section on women in which he challenged the "Old adage" that they were "'The weaker Vessel,'" an assumption that, he believed, did "much injustice . . . to the fair sex." Two manuscript fragments, entitled "Lecture on natural history in connection with the Museum" (F:IID/30D10-E10) and "Lecture" (F:IID/31C8-D6), appear to be drafts for this lecture.

Peale's second lecture (below, **129**), which he described in a newspaper advertisement as "Embracing a general view of the parental affection of the animal creation," probably utilized the text headed "Lecture on Natural History" (F:IID/30G6–31C7); this contains large sections on the parental affection of insects, birds, and polar bears. One other draft entitled "Lecture [on] the Use of the Museum" (F:IID/30B1-D9) contains in its first three pages information similar to that in Peale's first lecture, and then closely follows the second lecture.

The editors' decision to publish the second lecture is in part a response to Peale's own preference for that work. Believing that his first presentation had not successfully engaged the attention of a large enough audience, he composed the second not only to improve on the first but also to generate greater public support. In a letter to Jefferson in 1825, he characterized his second lecture as "more inlarged," representing his "views on Natural [History] more fully."*

*American and Commercial Daily Advertiser, January 1, 11, March 8, 1823; Poulson's, May 17, 1823; CWP to APR, March 10, 1823 (above, **119**); Charles Willson Peale, Lectures on Natural History, P-S, F:IID/30; CWP to Thomas Jefferson, September 10, 1825 (below, **234**).

129. CWP: Lecture on Natural History
MAY 17, 1823

The reasoning faculties of Man, are subservient to his happeness, in proportion as they are correctly employed & properly exerted. Next to the high concerns of moral and religious ⟨duties⟩ duty, the objects which surround us in the infinitely varied and prefect works of creation, always demand our attention and are capable of repaying us for our toil. By acquiring a knowledge of the beings which nature has so profusely scattered over the earth, we are enabled to judge of their qualifications, and employ them for our advantage. We can render harmless such as are noxious; We can trace the modifications of life and structure, which distinguish them from one another & from our own race, while, throughout we perceive the links of connection which pervade the whole. While the study of astronomy fills our minds with sublime conceptions of the immense power, which called into existance, and sustains in order, the living lights of the planitary system, natural history lays before us the unequivocal evidences of a wisdom too glorious for human comprehension; a puissance almighty! a cause omniscient! If the former shews us worlds, which revolve eternally in undeviating orbets round their proper centre, surrounded by atmospheres which refract the rays of the Sun at his decline or rising, to prevent the sudden return of total darkness or day, the latter shews us the *Infinite,* equally plain in the myriads of living things with which the earth is supplied and adorned, from the Elephant and Whale, down to those to whom a single blade, of grass, is a wide extended domain.

The study of Natural History will aid us to escape from the prejudices of ignorance, and convince us that nothing was made in vain. We shall discover that, what at first sight appeared unnecessary or injurious, is really of the greatest utility. We shall find that the very discords tend to preserve the harmony of the System, and that throughout, the order of nature, is, the order, of unerring, and unchanging, wisdom. The shores of our sea coast at certain seasons are covered with the spawn of the horse-shoe crab,+[1] and innumerable quantities of birds, chiefly of the wading tribe, then flock there and feed togather in peace. It is a pleasing sight, that such a Multitude of animals of every difference of size

and form, should be feeding and sporting togather in perfect harmony: no battles or wars are seen among them,+ This provision is in abundance, and if not taken away, might taint the air with putrid effluvia, and although, so much of this spawn is devoured, yet a sufficiency always remains within reach of the tide, for continuing the species. It is said that fishes are the most prolific of all animals; their multiplication is astonishingly great: The pike deposits above 300,000 eggs; the Carp 200,000, and the Mackerel near half a million. To the mind that does not consider the end, this increase would appear superfluous; but, we must recollect that many animals must necessarily feed on others, and that therefore the increase of some should be greater in proportion. so that the happy equilibrum is maintained.

The Insect tribe displays a beauty, splendour, and variety greater than that bestowed by the hand of nature on any of her other productions; yet being among the most minute, they do not so readily catch the eye of the observer; and when they do, mankind, in general, are apt to estimate the worth and importance of things by their bulk, Yet Insects appear to have been natures favorite production, as having combined and concentrated almost all that is either beautiful and graceful, curious or singular, and to these her valued miniatures, she has given the most delicate touches and highest finish of her pencil. With respect to religious instruction, Insects are far from being unprofitable. In the larger animals, though we admire the consummate art and wisdom manifested in their structure, and adore that mighty power and goodness, which, by wonderful machinery, kept in motion by the constant action and reaction of the great positive and negative powers of nature, maintained in full force the circulations necessary to life, perception, and engoyment: yet, as there seems no disproportion between the objects and the different operations that are going on in them; and we see that they afford sufficient space for the display of their systems, we do not experience the same sensations of wonder and astonishment that strike us when we behold similar operations carried on without interuption, in animals scarcely visible to the naked eye. That creatures, which in the scale of being are next to nonentities, should be elaborated with so much art and contrivance, have such a number of parts internal and external, all highly finished and, each calculated to answer the end; that they should include in the evanesant form, such a variety of organs of perception, and instruments of motion, exceeding in number and peculiarity of structure those of other animals; That their nervous and respiratory organs should be complex, their secretory and digestive vessels so various and singular, and that these minims of nature should be endowed with instincts in many cases superior to all our boasted powers of intelect, truely these wonders and miracles declare to every one who

attends to the subject, "the hand that made them is divine;["] that Of the innumerable species of these beings, many of them beyond conception fragile and exposed to dangers and enemies without end, no link should be lost from the chain, but all be maintained in those relative proportions necessary for the general good of the system; That, if one species for a while preponderates, and instead of preserving seems to distroy, yet counter-checks should at the same time be provided to reduce it within its due limits; and further, that the operations of Insects should be so directed and overruled as to effect the purposes for which they were created and never exceed their commission: if we reflect on all this beautiful economy nothing can furnish a stronger proof of this, that an unseen hand holds the reins, now permitting one to prevail, and now another, as shall best promote certain wise ends; and saying to each, "hither shalt thou come and no further."

So complex is this earthly system, and so incessant the conflict between componant parts, as observation which holds good particularly with regard to Inse[c]ts, that if instead of being under such control, they were left to the agency of blind chance, the whole must inevitably soon be deranged and go to ruin. This study, in truth, is a book in which whoever reads, under proper impressions, cannot avoid looking to the cause from the effect, and acknowledging *his* eternal power and Godhead, thus wonderfully displayed and irrafragably demonstrated: and whoever beholds these works with the eyes of the body, must be blind indeed, if he *cannot*, and perverse indeed if he *will* not, with the eye of the soul behold in all this the glory of the almighty Creator, and feel disposed to praise and to magnify every power of his nature.

The sight of a well-stored cabinet of Insects, will bring before every beholder, not conversant with them, forms in endless variety, which hitherto he would not have thought it possible could exist in nature, resembling nothing that the other departments of the animal region exhibit, and exceeding even the wildest fictions of the most fertile imagination. Besides prototypes of beauty and symmetry, there, in miniature he will be amused. But this along will not bring you to the end of your pleasures; you must behold insects when full of life and activity, adorned with every beauty and grace, borne by radiant wings through fields of oether, extracting nectar from every flower, giving some idea of the blessed inhabitants of happier worlds, of angels, and of the spirits of the just arrived at their state of perfection.

In ancient times the butterfly was made an emblem or representive of the soul, as prepaired in the *larva* (or catterpillar state) for its future state of glory; and if it is not distroyed by the Ichneumon, or other enemies to which it is exposed, symbolical of the vices that destroy the spiritual life of

the soul, it will come to its state of repose in the *pupa*, and in its perfect state; The butterfly, bursts forth with new powers and beauty to its final glory and the reign of love. It is worthy of remark, that in the north and west of England, the moths that fly into candles are called *saules* (souls), perhaps from the old notion that the souls of the dead fly about at night in search of light. For the same reason, probably, the common people of Germany call them ghosts (geistchen).

The idea that God is love, is a pleasing thought, and is verified by all his works, for to whatever part of creation we direct our view, we may find something to gratify our senses, imagination or reason, even the smallest insects on grains of sand or leaves, offer subjects of admiration: And he who is not struck with the infinite diversity, and does not acknowledge in it, the goodness of God, must be blind indeed; and little are his feelings to be envied, whose heart does not throb with pleasure at the sight of natures beautiful objects.

Early impressions frequently afford such a stamp to the future character, as to render the proper introduction of them a matter of the utmost importance.

That thoughtless cruelty which we now so frequently observe toward the inferior orders of created beings (if such I may call them), would scarcely be known, could we but teach mankind that the same God "who gives lustre to an Insects wing" ordains with it a right to life and happiness as well as ourselves; and that wantonly to deprive it of these, is an offence against his works, who formed nothing in vain.—an attention to nature from childhood would also contribute greatly to the happiness of mankind in general, and to females in particular, by enabling them to overcome all those fears, and vulgar prejudices, which have commonly attached to some of the smaller quadrupeds, and the reptile and insect tribes. They would then possess no greater repugnance towards handling a Lizard, a Beatle, or a spider, than they now do in that of a bird, or a Flower.

It is necessary however to inform them, that they must not be contented merely with reading:

The principal use of this, is, to direct them to contemplations on the subjects themselves, and to induce a taste for more minute investigation: But it is from this investigation only that they will be enabled to reap the advantages of the science, and such advantages as books alone do not always bestow. To illustrate some of the advantages of the study of natural History we may refer to some of the evils we suffer for want of such knowledge, as a striking instance is given in Pennants zoology. "In new England,["] he says, ["]a reward was offered of three-pence a dozen for the heads of the purple Grackle (black birds), and the inhabitants soon

found, to their cost, that they had at one time nearly extirpated them; for they then discovered that providence had not formed even these seemingly destructive birds in vain. It is true that they made dreadful havoc among the grain, but they amply recompensed the injury by clearing the ground of the larvae of noxious insects. As soon as the birds were destroyed, the insects increased in such multitudes, as, in the year 1749, to cause a total loss of the grass; and the inhabitants were, in consequence, obleged to obtain hay for the cattle, not only from Pennsylvania, but even from Great Britain."[2]

Few birds are more execrated by the farmers, in Great Britain, nor perhaps more unjustly [so], than the sparrows. It is true they do some injuries in our rural economy, but they have been fully proved to be much more useful, than they are noxious. Mr. Bradley,[3] in his general treatise on husbandry and gardening, shews, that a pair of Sparrows, during the time they have their young to feed, destroy on an average every week 3360 caterpillars. This calculation he founded on actual observation.

But the utility of these birds is not limited to this circumstance alone; for they likewise feed their young with butterflies and other winged insects, each of which, if not destroyed in this manner, would be the parent of hundreds of Caterpillars.

one of the most important ends for which Insects are gifted with such powers of multiplication, giving birth to myriads of Individuals, was to furnish the feathered part of the creation with a sufficient supply of food. The number of Birds that derive the whole, or a part of their subsistance from Insects, is, as it is universally known, very great, and includes species of almost every order, that hence, have their support, and these, in their turn, add to *our* happiness. connecting every part of creation together, for if some parts are destroyed, others fill up their place and thus complete the whole system of harmony of the world, a contemplation of the minutest part must create in us, the most exalted idea of that wonderous power that preserves in equal ballance; the great and the small, in perfect symmetry. However vast the disproportion between the whale and the shrimp, the Ostrich and humming bird, the mammoth and the mouse!— Yet the space between them is filled with living Creatures; but, however great the number may appear which come under our observation, they are few compared with those which are so small as to elude our penetration: every shrub, every leaf and tree is filled with living creatures, each as perfect in its internal and external structure as man, and we may presume that they are as tenacious of life, that they have the same affection for their young, and also enjoy as much happiness in their several stations, as any other created beings. Therefore to direct our thoughts occasionally to such subjects, must be beneficial in several points of view, as might be

enumerated, but this would be intruding on your time and patience. It will be better to cite such curious instances related in natural history, as I believe will be more agreable, and I hope more useful to the younger part of my hearers.

It is stated, that in 1553 a vast multitude of Butterflies swarmed through a great part of Germany and sprinkled plants, leaves, buildings, cloths and men with bloody drops, as if it had rained blood. A like event took place in the suburbs of Aix in July 1608, when a considerable extent of country round it, was covered with what appeared to be a shower of blood. It may easily be conceived the amazement and stupour of the populace upon such a discovery, the alarm of the citizens, the grave reasonings of the learned. All agreed however in attributing this appearance to super-natural powers, and in reguarding it as the prognostic and precursor of some direful misfortune about to befal them. Fear and prejudice would have produced bad effects upon some weak minds, had not Mr. Peiresc,[4] a celebrated Philosopher of that place, paid attention to insects. A chrys-alis, which he preserved in his cabinet, let him into the secret of this mysterious shower. Hearing a fluttering, which informed him, his insect was arrived at its perfect state, he opened the box in which he kept it. The animal flew out and left behind a red spot. He compared this with the spots of the bloody shower, and found they were alike. Thus did this judicious observer dispel the ignorant fears and terror which a natural phenomenon had caused. The metemorphosis of the Butterfly is truly curious, it amuses us with its aërial executions, now extracting nectar from the tube of the honeysuckle, and then, the very image of fickleness, flying to a rose, as if to contrast the hue of its wings with that of the flower on which it reposes —It did not come into the world as you now behold it. At its first exclusion from the egg, and for some months of its existance afterwards, it was a worm-like caterpillar, crawling on 16 short-legs, greedily devouring leaves with two jaws, and seeing by 12 Eyes so minute as to be nearly imperceptible without the aid of the microscope. And having ceased to eat, it weaves itself a covering, and becomes a chrysalis; having remained in this dormant state its alotted time, it bursts its prison; of its 16 feet only 6 remain, in most respects wholy unlike those to which they have succeeded; its jaws have vanished, and are replaced by a curled-up proboscis suited only for sipping liquid sweets; The form of its head is entirely changed,—2 long horns project from its upper surface; and, instead of 12 visible eyes, you behold two, very large, and composed of at least twenty thousand convex lenses, each supposed to be a distinct and effective eye.

Almost every insect we see has gone through a transformation as singu-lar and surprising, though varied in many of its circumstances. That

active little fly, so often an unwelcome guest at your table, whose delicate palate selects your choicest viands, one while extending his proboscis to the margin of a drop of wine, and then gaily flying to take a more solid repast from a pear or Peach; now gamboling with his comrades in the air; now gracefully currying his furled wings with his laper feet,—was but the other day, a disgusting grub, without wings, without legs, without eyes, wallowing, well pleased, in the midst of a mass of filth.

The grey coated gnat, whose humming salutation, while she makes her airy circles about your bed, gives terrifick warning of the sanguinary operation in which she is ready to engage, was a few hours ago the inhabitant of a stagnated pool, more in shape like a fish than an insect.

Then to have been taken out of the water would have been speedily fatal; now it could as little exist in any other element than air. Then it breathed through its tail; now through openings in its sides.

Its shapless head, in that period of its existance, is now exchanged for one adorned with elegantly tufted antennae, and furnished, instead of jaws, with an apparatus more artfully constructed than the cupping glasses of the phlebotomist—an apparatus, which, at the same time that it strikes in the lancets, composes a tube for pumping up the flowing blood.

To quote from good authority some instances of the affection of Insects for their young, may be acceptable and have its use, for nothing is more certain, than, that Insects are capable of feeling quite as much attachment to their offspring, as the largest quadrupeds. They undergo as severe privations in nourishing them; expose themselves to as great risk in defending them; and at the very moment of death exhibit as much anxiety for their preservation. Not that this can be said of all insects. a very large proportion of them are doomed to die before their young come into existence.†

When you witness the solicitude with which they provide for the security, and sustenance of their future young, you can scarcely deny to them, *love* for a progeny they are never destined to behold. Like affectionate parents in similar circumstances, their last efforts are imployed in providing for the children that are to succeed them.

The Ichneumon (an insect like a wasp or small fly) that darts its eggs into caterpillars, is curious—the larvae hatched from eggs thus deposited, find a delicious banquet, in the body of the caterpillar, which is sure to fall a victim to their ravages. So accurately, however is the supply of food proportioned to the demand that this event does not take place, untill the young Ichneumons have attained their full growth; when the caterpillar

† But in these the passion is not extinguished, it is merely modified, and its direction changed.

either dies, or, retaining just vitality enough to assume the pupa state, finishes its existance; The pupa disclosing not a moth or a butterfly, but one or more full grown Ichneumons. I have seen this worm come out of the side of a caterpillar, and weave in a very little time, a web round itself, and become a chrysalis, and after one or two days, lying dormant, burst from its prison a perfect fly.

You may find caterpillars every summer with white appendages on their sides; these appendages are the cocoons of the Ichneumon.

In this strange and apparently cruel operation one circumstance is truely remarkable. The larva of the Ichneumon, though every day, perhaps for months, it knaws the inside of the caterpillar, and although at last it has devoured almost every part of it, except the skin and intestines, carefully all the time, *avoids injuring the vital organs*, as if aware that its own existance depends on that of the insect on which it preys. Thus the caterpillar continues to eat, to digest, and to move, apparently little injured, to the last; and only perishes when the parasitic grub within it no longer requires its aid.

In the variety of the Ichneumon tribe, numerous, curious and surprising things are developed—two long to be quoted at present.

No circumstance connected with the *Storgé*, (or natural affection) of Insects, is more striking than the herculean and incessant labour which it leads them chearfully to undergo. Some of these exertions are so disproportionate, to the size, of the insect, that nothing short of ocular conviction, could attribute them to such an agent. A wild Bee or a Sphex, for instance will dig a hole in a hard bank of earth some inches deep, and five, or six, times, its own size, and labour unremittingly, at this arduous undertaking for several days, scarcely allowing itself a moment for food or repose. It will then occupy as much time in searching for a store of food; and no sooner is this task finished, than it will sett about at repeating the process, and before it dies will have completed five or six similar cells, or even more. If you would estimate this industry at its proper value, you should reflect what kind of exertion it would require in a man to dig in a few days out of hard clay or sand, with no other tools than his nails and teeth, five or six caverns twenty feet deep and four or five wide—for such an undertaking would not be comparatively greater than that of the insects in question. At the first view I dare say you feel almost inclined to pity the little animals doomed to exertions apparantly so disportioned to their size. You are ready to exclaim that the pains of so short an existance, engrossed with such arduous and incessant toil, must outweigh the pleasures. Yet the inference would be altogether erroneous. What strikes us as wearisome toil, is to these little agents a delightful occupation. The kind author of their being has associated the performance of an

essential duty to feelings evidently of the most pleasurable description; and like the affectionate father whose love for his children, sweetens the most painful labours, these little insects are never more happy than when thus actively engaged.

We are so accustomed to associate the ideas of cruelty, and ferocity, with the name of spider, that to attribute parental affection to any of the tribe, seems at first view almost preposterous. Who indeed could suspect that animals which greedily devour their own species, whenever they have the oppertunity, should be susceptible of finer feeling? Yet such is the fact.

There is a spider common under clods of earth (Aranea saccata,) which may at once be distinguished by a white globular silken bag about the size of a pea, in which she has deposited her eggs, attached to the extremity of her body. Never miser clung to his treasure with more tenacious solicitude than this Spider to her bag. Though apparently a considerable incumbrance, she carries it with her every where. If you deprive her of it, she makes the most strenuous efforts for its recovery; and no ⟨personal⟩ danger to herself can force her to quit the precious load. When her efforts are ineffectual, a stupefying melancholy seems to seige [seize] her; and when deprived of this first object of her cares, existance itself appears to have lost its charms. If she succeeds in regaining her bag, or you restore it to her, her actions demonstrate the excess of her joy. she eagerly seizes it, and with the utmost agility runs off with it to a place of security. Bonnet[5] put this wonderful attachment to an affecting and decisive test.

He threw a spider with her bag into the cavern of a large ant-lion, a ferocious insect which conceals itself at the bottom of a conical hole, constructed in the sand for the purpose of catching any unfortunate victim that may chance to fall in. The spider endeavoured to run away, but was not sufficiently active to prevent the ant-lion from seizing her bag of eggs, which it attempted to pull under the sand. She made the most voilent efforts to defeat the aim of her invincible foe, and on her part struggled with all her might. The *gluten*, however, which fastened her bag at length gave way, and it separated: But the spider instantly regained it with her jaws, and redoubled her efforts to rescue the prize from her opponant. It was in vain. The ant-lion was the stronger of the two, and in spite of all her struggles dragged the object of contest under the sand. The unfortunate mother might have preserved her own life from the enemy: she had but to relinquish the bag, and escape out of the pit.

But wonderful example of maternal affection! she prefered allowing herself to be buried alive along with the treasure, dearer to her than her existence; and it was only by force that Bonnet at length withdrew her from the unequal conflict. But the bag of eggs remained with the assassin; and though he pushed her repeatedly with a twig of wood, she still per-

sisted in continuing on the spot. Life seemed to have become a burthen to her, and all her pleasures to have been buried in the grave which contained the germe of her progeny! The attachment of this affectionate mother is not confined to her eggs. After the young spiders are hatched, they make their way out of the bag by an orifice, which she is careful to open for them, and without which they could never escape; and then, like the young of the Surinam toad (*Rana pipa*) they attach themselves in clusters upon her back, belly, head, and even legs; and in this situation, they present a very singular appearance, She carries them about her and feeds them untill their first moult; when they are big enough to provide for their own subsistance.

I have more than once been gratified by a sight of this interesting spectacle; and when I nearly touched the mother, this covered by hundreds of her progeny, it was most amusing to see them all leap from her back, and ⟨run⟩ scatter away in every direction.

Having thus given a few examples of parental love in Insects, a field so extensive that with our utmost exertions of sight, we cannot see but a small part of its extent, for what I have said is merly an opening to the view of it, and wishing to draw your attention to the habits and dispositions of other Animals, to shew the beneficent Creator's Equal hand, giving blessings to each and all his creatures, I will proceed to mention some of the manners of Birds also that afford ⟨lessons⟩ examples which man might advantageously imitate. But mans lofty ideas ought not to tempt him to imitate their aerial flights, for however great our Mechanical invention may be, our physical powers forbid success. **X**[6]

Birds *respire* by means of air-vessels in the under surface of the bones. These, by their motion, blow the air through the true lungs, which are very small, (somewhat of the shape of the human lungs) and seated in the very uppermost part of the chest, closely braced down to the back and ribs. The latter, which are never expanded by air, are destined for the sole purpose of oxydating the blood. Mr. John Hunter[7] made a variety of experiments to discover the use of this general diffusion of air through the bodies of birds; and from these we find, that it prevents their respiration from being stopped or interrupted by the rapidity of their motion through a resisting medium. The resistance of the air increases in proportion to the celerity of the motion; and were it possible for man to move with a swiftness equal to that of a Swallow, the resistance of the air, as he is not provided with reservoirs similar to those of birds, would soon suffocate him.

The nests of birds are, in general, constructed with astonishing art, with a degree of architectural skill and propriety that would foil all the boasted talents of man, to imitate.

We have nests that have a sort of door at the entrance which the Bird lifts to enter, and on returning, with its bill shuts it again, to keep out intruders.

Other nests are made with the entrance below, and then the passage assending turns into the bed where the eggs are deposited. And the whole nest suspended by long threads of grass to the extremeties of the branches of Trees, by which construction and situation the bird ⟨prevents⟩ protects its ofspring from being distroyed by Snakes and other enemies. The ingenuity of our beautiful little humming-birds is remarkable; they build their nests on limbs of trees, and with the bark of the same tree glued on the outside of the nest, gives it exact resemblance to a knot of the same trees and thus eludes our sight. some others, such as kingfishers and hawks excavate long and deep passages in perpendicular banks of rivers, of very difficult access. In short, the variety of expedients to propagate and protect their species are wonderful, & the affection of the feathered tribe for their young, truely great and pleasing. A Gentleman in maryland in the early part of my labours to form a museum, presented me a Virginea sorie, that suffered herself to be taken by his hand, rather than leave her young. We know the arts practised by several birds to allure from their nest or young, by fluttering just before us, as if unable to fly, thus tempting us to pursue them, still crippling on, untill ⟨she⟩ they think⟨s⟩ we have lost sight of their offspring, when they exultingly fly⟨s⟩ out of our reach. Can we view these pleasing traits of affection of this beautiful part of the creation, and not esteem them? and through them adore, him to whom adoration is due? The more we see and know of these things, the greater and more energetic ought to be our exertions to render ourselves worthy of our station here. ⟨And when we see good qualities in other beings, let it emulate us to follow all such good examples.⟩

Last summer a Boy took a Wrens nest & young from the Woods, a considerable distance back of Camden and brought it to the town, placing the nest in a Cage, near to a box, where a pr. of wrens had their young, those parents hearing the cries of the young straingers, constantly fed them, as well as their own young, apparently with the same affection.

The description of the European redbreast, makes that bird almost an associate of man; it is said that when thick snow covers the ground, it approaches the houses, and taps on the window with its bill, as if to entreat an asylum, which is chearfully granted; and it repays the favour, by the most amiable familiarity, Gathering the crumbs from the table, distinguishing affectionately the people of the house, and assuming a warble, not indeed so rich as that of the spring, but more delicate. This it retains through all the rigours of the season, to hail each day the kindness of its host, and the ⟨comforts⟩ cosyness of its retreat. There it remains tranquil,

till the returning spring awakens new desires, and invites to other plea-
sures: it then becomes uneasy, and impatient to recover its liberty.
Thompson[8] has charmingly described the annual visits of this little favor-
ite, in lines that have been often quoted.

> The Redbreast, sacred to the household gods, wisely regardful of
> th' embroiling sky, In joyless fields, and thorny thickets, leaves His
> shivering mate, and pays to trusted man his annual visit. Half afraid,
> he first Against the window beats; then brisk alights on the warm
> hearth, then, hopping o'er the floor, Eyes all the smiling family
> askance, and pecks, and starts, and wonders where he is; Till, more
> familiar grown, the table crumbs attract his slender feet.

⟨*It is not uncommon to hear people say to those who do some foolish thing; you Goose
as an epithet of ignorance. But from my observations it appears to me at least
doubtful, whether those birds have not as much understanding as most of the
feathered tribe*⟩— I had a swan presented to me on condition that the
Woman who used to feed it, should come every day to see it—this, she
practiced for some time, but after a while her visits became less frequent,
however the bird at each visit shewed its affection for her, by its soft
cooing notes, and frequent flapping its wings round her. at one time, the
visit was neglected for two weeks—and the instant that the bird heared
her voice and before he had a sight of her, he expressed his joy by ⟨*loud
accents*⟩ his usial sounds of pleasure; and when she entered, it was a novel
and pleasing sceine, to see the Swan run after her into the garden, and
back into the house several times repeatedly carressing with its wings, and
as it were laughing with excess of joy by its melodeous voice. on another
occasion one of my friends gave it a small stroke with a switch, and was
afterwards on sight of him it remembered the insult and would not be
friendly with him.

I have heard and personally know several other instances of the attach-
ment of Birds to the human race, but what I have related, is sufficient to
shew our obligations to treat them with kindness, and be thankful for the
harmony with which they salute the spring season, filling our groves with
melodious songs—independant of the vast importance they are in pre-
serving our fruit and fields of grain by their destruction of noxious In-
sects. Our obligations to swallows particularly are very great, for their
lessening the number of mosquitoes and gnats, the pests of summer
nights.

So great and numerous are the blessings bestowed by a bounteous
hand, that to whatever side we turn, we may find virtues exhibited in some
shape, that deserve our attention; and are worthy of our admiration.

Look at the affection of the dog; no animal has hitherto been found so

intirely adapted to our use, and, even to our protection, as this. His diligence, his ardour, and his obedience, have been truely observed to be inexhaustible; and his disposition is so friendly, that unlike every other animal, he seems to remember only the benefits, he receives; he soon forgets our blows, and instead of discouvering resentment while we chastise him, he exposes himself to torture, and even licks the hand from whence it proceeds. The numerous instances of their fidility, and sagacity, amounts to something more than mere instinct, and surely may be called reason. how can we see a combination of facts produced by reflection, amounting to ⟨such⟩, what they do, without feeling this conviction.

Some years past I had a large dog that constantly followed me to market; by some neglect, I lost my basket, I presumed it was stolen, and I bought a new one. Two weeks afterward being in market, a croud of people drew my attention to the spot, where I found my dog in possession of my lost property; and he would not suffer the person that had made use of it to come near it; the dog sat in the basket, snarling at every one who approched it, to the great amusement of the populace.

I have seen some other instances of their care of whatever they think is commited to their trust, proving their sagasity, as well as tenacity of memory. So much has been published elucidating their important services to us, that I deem it unnecessary to enlarge on this subject.

Cats, it is known, are more attached to habitations than to persons, yet in some few instances, they may shew a regard to their posessors, though I cannot give credit to some historians who relate things done by them, which indicated a mind of reflection, for I have generally found that animals having small cavities for brains, were generally deficient in intellect. Now the Beavor and Otter have capacious skulls, and are equally remarkable for their inginuety in constructing their habitations, and the Otter, when taken young is capable of instruction, and is made useful in catching fish. The account given of the affection which the Polar Bear has for its young is so interesting, that I an induced to quote a passage from a late work.

While the Carcase frigate, which went out some years past, to make discoveries toward the north pole, was locked in the Ice, early one morning the man at the mast-head gave notice that three Bears were making their way very fast over the frozen Ocean, and were directing their course towards the ship. They had no doubt, been invited by the scent of some blubber of a sea-horse that the crew had killed a few days before, which had been set on fire, and was burning on the Ice at the time of their approach. They prooved to be a she bear and her two cubs; but the cubs were nearly as large as the dam.

They ran eagerly to the fire, and drew out of the flames part of the flesh

of the sea-horse that remained unconsumed, and eat it voraciously. The crew from the ship threw great lumps of the flesh of the sea-horse, which they had still left upon the Ice, which the old bear brought away singly, laid every lump before the cubs, gave to each a share, reserving but a small portion to herself. As she was bringing away the last piece, they leveled their muskets at the cubs, and shot them both dead; and, in her retreat, they wounded the dam, but not mortally. It would have drawn tears of pity from any but unfeeling minds, to have marked the affectionate concern expressed by this poor beast in the dying moments of her expiring young.

Though she was herself dreadfully wounded, and could but just crawl to the place where they lay, she carried the lump of flesh she had brought away, as she had done others before; tore it in pieces, and laid it before them; and when she saw that they refused to eat, she laid her paws first on one, and then upon the other, and endeavored to raise them up: all this while, it was pitiful to hear her moan. When she found she could not stir them, she went off, and when she had got at some distance; looked back, and moaned; and that not availing her to intice them away, she returned, and smelling round them, began to lick their wounds. She went off a second time as before; and, for some time, stood moaning. But still her cubs not rising to follow her, she returned to them again, and signs of inexpressible fondness, went round one, and round the other, pawing them, and moaning. Finding at last, that they were cold and lifeless, she raised her head towards the ship, and uttered a growl of despair, which the murderers returned with a volley of musket balls. She fell between her cubs and died licking their wounds.[9]

Concluding my observations on the affection of the Brutes for their young, it is now my wish to do ample justice to the highest grade of animal creation, by remarking on the human species. It is a subject on which I enter with trembling hesitation, as on a path ornamented and enlivened by the sweetest flowers, which spring up in the midst of *rocks*, *brambles* and *caverns*. Though the temptation to advance be great, the dangers and difficulties are such, as to deter the timid, and even impress the hardiest with a sense of dread.

If we compare man in the natural state with man in a state of civilization, we do not at first sight percieve as great a superiority of happiness belonging to the latter as we might expect. Men in the natural condition have the *same bodily wants*, and the *same fear of suffering* as the brutes. A very little suffices for their real wants, and when this supply is obtained, the future causes them no uneasiness. Civilized men have similar necessities, and are

obleged to make equal exertions to obtain the means of satisfying them; thus it would seem, that the degree of happiness is nearly equal. But then *imaginary wants are to be satisfied*, which would turn the scale against civilization, did not these wants *excite a love of industry and labour*, which are productive of the best effects, by keeping up that anticipation of happiness, frequently productive of more enjoyment, than the actual attainment of the end desired.

Learned anatomists say that the human race possess a greater number, and more perfect organs of sensibility and perception than other animals—if this is true, then they must possess more mental energy. This, if not put in motion by moral considerations in acts of Virtue;—in a constant imployment of these powers, we must suffer a listless and uncomfortable state of idleness, or else *our minds will be turned towards vice.* Divine wisdom has assuredly decree'd that we should labour for our support, as we cannot, without exertions of the body & mind, either obtain *health or hope for happiness.* The constant desire of changing place common to youth and manhood, subsides in old age; and might be thought a happy circumstance for the latter, were it not that *apathy* is carried often too far, and the desire of *rest* becomes so great, that we then *neglect the exercise essential to the preservation of health* & its attendant comforts. Man either in the savage or civilized state, is a social being. In the state of nature he delights in the sports of his children, takes considerable pains to instruct them in their games, part[i]cularly the boys, to hunt and make their rude implements for the chace, & is happy in the society of his nation, and especially so at their councils, whilst relating his feats of valour.

In the civilized state man *enjoys the society of his friends and family*; to *gratify them*, he will often go greater lengths than *prudence* dictates; these may become lessons to teach him caution; and such trials should produce *reflection*, and call for a *corrected exercise of his reason.*

In the natural, there is more equality among Persons than in the civilized state; in the latter his exertions must be greater to become *distinguished*; this is ever desirable in human nature, and the more these *energies are brought into action, the more his powers will be enlarged*—and, by the improvements thus made, he will acquire an emmense number of advantages over the uncultivated mind.

Practice produces excellence, and, by repeated essays, perfection is obtained in either the useful arts or abstract science, and thus his knowledge is exceedingly augmented.

An instructed man calculates the revolutions of heavenly bodies, and know the exact time of the eclipses of the Sun or Moon at any distant period; If he should be placed in the wilderness, he could know the exact measurement of time by the appearance of stars. The Philosopher knows

the nature of electricity and lightening to be the same, and hence understands how to make his situation safe during a thunder storm. *Thus superstition flies away before the light of reason*—and he sees in natural productions, the *wisdom, infinite power, and bountious provision of the creator*, who *still continues to support* and *preserve them!* The Mineralogist knows the valuable mineral by the external appearance of the ore; the engenious mechanic knows how to make machenery, to fabricate with facility & dispatch the *most delicate, rich*, or *comfortable dresses* to adorn the lovely daughters of Columbia. The magic pencil can represent the *beauty of virtue*, the *horrors of vice*, the *torments of a bad conscience*, in colours and light and shade, *so strong*, as to convict the evil-doer, and fill him with *shame and remorse*, and thus, bring him to *repentance*.

The civilized condition however vindicates its claims to *entire superiority* in these results by which the *kindly and excellent emotions of the mind*, are *awakened, cherished and prolonged*. Thus the *faithful portrait* of a *lost friend* will constantly remind us of the *amiable qualities, endearing friendship*, and *filial* or *parental affection*, so consolatory to the feeling of an *affectionate heart*; and I may say, that it is a seal of affection never to be broken by absence, or length of time. The *ornamental productions of art*, to *superficial observers, appear useless*; and they say that no encouragement ought to be given to such ingenious labours, as being *totally unnessary to our happiness*; but they do not consider how many *virtuous families earn their bread* by their labours in the production of such *unjustly called usless things*. A multitude of articles which we are too apt to call vain luxuries, are in fact a *scource of infinite benefit to numerous descriptions of people*, who would otherwise be left, without the means of purchasing the necessary supports of life, or of obtaining instruction for their children.

How much better it is to give employment to those who are willing to work to obtain a living, however triffling or insignificant we may deem the object of their industry, than to give our alms to those who prefer Idleness to labour,

It is the *encouragement of industry* that constitutes the *merit* of the *liberal donor*. Hence it is, that many imaginary wants, instead of being an abridgement of our happiness, in the result, really become a blessing, by calling forth the energy of the human faculties, to obtain what fashion, that fickle goddess contrives to impose on her voteries. That what is lost by some, becomes a profit to others, who otherwise would be left to starve, or be necssitated to steal to satisfy the cravings of hunger, *a power that even stone walls cannot restrain*.

In a large and mixed society, we shall ever find that wealth is not equally divided, nor is it necessary that it should be so. And although riches will have their influence, yet this is not too great, if the people are *industrous*

and *virtuous*, as they are equally dependant of each other; Those who pay their money for an article, are as much obliged to the *artizan for his work*, as the other is obliged to the purchaser for his *cash*; and the respectability of persons ought to be in proportion to their moral character for *honesty, sobriety, industry,* and *strict virtue.*

It is to be ranked among the *choicest blessings of this country* that these qualifications are the only requisites to respect. Every profession that has a tendency to *improve the morals of the people*, to entice them from a *dissipated life*, and to make them feel their *dependance on each other*, deserves our highest consideration.

Man has many obligations to fulfill—. we are taught to *love our neighbour as ourselves*, this, as most of our other actions we must practi[c]e, *through a self interest,*—as it produces that heartfelt satisfaction from doing to others as we desire they should do unto us. But should we suppose ourselves injured, let us then *pause; meditate* and *weigh* well all circumstances that may have actuated, in producing this supposed injury, then perhaps, we may find, that we would have done the *same thing in a similiar situation*—By this mode we call to our aid *reflection and reason*; and, by a prudent investigation, will, probably save ourselves much trouble and vexation. But let us suppose we are really injured; ?shall we through a *revengeful disposition* return injury for injury? "an eye for an Eye", *certainly not*, nor can such a return give us *peace of mind*? can we *feel comfort* in doing what our conscience *cannot approve*? We are not *accountable for the faults of another*, but merly for our own actions;—or so far, only, as we may have done wrong. And, if we have offended, let us *hasten to acknowledge our transgression* and make *full and ample compensation* as far as we are able. We are all liable to error; therefore it becomes our *particular duty to examine ourselves*; To gain self knowledge, was a favorite pursuit of the ancient Philosophers of Greece—and they *had written* on the entrance of their Museum, or temple of the muses, *Know Thy self.* This generally, is a proper study, but we must scrutenize ourselves in every case, more especially, when a *jaring interest embroils us with our fellow beings*, otherwise, how shall we know whether we may not have been guilty of some imprudent or wrong action that has given offence?—The *inward examination, if frequently practiced*, will ever have a Salutary effect; It will guard us against *unruly passions*, and thus *increase our wisdom. Conscience* as being the *touchstone*, bearing witness of the goodness or sinfulness of our actions, will guide our steps in paths of virtue.

If we should ask ourselves this question, ?*for what purpose have we been placed here*?—The Naturalist would answer, to fulfill every duty to our associates, exercising all our powers to promote *love* and *harmony* with those, to whom we are connected in domestic life; to sustain the salutary

measures of civil government, designed to protect our lives, liberty and property.—to use the *creatures* permitted for our service, with a *tender regard to their comforts* consistant with humanity; and to consider them, as the whole creation is, a manifestation of the *wisdom and goodness made by that being to whom adoration is our first duty.*

The comforts of domestic life are numerous and truly charming to *both sexes,* especially when *affection is the foundation of their union,* this alliance is *santioned by divine laws,* as well as by those of nature, for the *increase, support, and perpetuety of creatures,* said to be the last and most perfect work of creation; the image and likeness of God.

Men and women have each their share in all the concerns of the married life, they are bound by *mutual obligations to study how they can best promote the happiness of each other*—hence they ought to *consult and reason togather* on every subject, whether of great or even of little import, as such a course will be a *powerful means of consolidating their friendship; increasing their mutual confidence,* and thus securing coequal operation of their power in every measure deserving attention.

in comparing the relative situation of the sexes, it is commonly said, that Man is the head which may be admitted, as he exercises the sovreign power, yet, woman is the *heart.* Her feelings are *more sensible,* her spirits *more sprightly,* her conversation more lively, and, more animating than that of her companion, whose frame of body is made strong, and his mind bold and inflexible.

We ought to honour, love, and give comfort to the beings troubled and charged with our *helpless infancy,* who so willingly undergo privations to ward off thousands of dangers to which thoughtless childhood, is perpetually liable. To Woman who takes on herself *willingly,* the care of instructing us in the thoughtless time of our youth; *ever ready to comfort us in manhood,* and, when disease attacks us, *watches with sleepless eyes, the moment to present the cup of nourishing food,* prepaired by her fostering care; full of anxiety for our return to health, and constantly offering her fervent prayers for our preservation. He must be thoughtless indeed, who sees, and reflects on these amiable qualities of this lovely part of the creation, and does not *feel his obligations to respect and honour her,* to whom so much is due.*

Let us also reflect that such are the perfections of creation, that life is a blessing *even to the meanest worm that crawls on the earth;* then what must we feel on seeing an immence variety of microscopic objects of minute per-

* I shall conclude by observing, that we must know that we are animals under obligations to treat other beings with due respect, as **all** are of the same estimation by our Creator; and in our meditations,

fection, the beautious forms and variegated colours of numberless Insects, birds and fishes; the vast variety of Qudrupeds of various regions; the splendour of chrystals & minerals, and the organic remains of former ages; and each department of natural objects arranged in methodical order in a spacious Museum, *to please the sight and inform the mind.*

Should we not be anxious to employ correctly our time in the *acquisition of a knowledge of the beautious works of nature,* which are sufficiently numerous to offer perpetual variety, and delight the minds of every age, and in every condition of life.

MsD, 41pp.
PPAmP: Peale-Sellers Papers

1. CWP inserted a mark at this point and below, perhaps intending to change the order of these sentences.
2. This quotation has not been located in Pennant's two volumes on birds. Thomas Pennant, *British Zoology,* 4 vols. (London, 1812).
3. Richard Bradley (d. 1732), English botanist, published *A General Treatise on Husbandry and Gardening* in 1724. *DSB.*
4. Nicolas Claude Fabri de Peiresc (1580–1637), French astronomer and patron of science, earned a degree in law and in 1604 obtained a seat in the parlement of Provence. Peiresc's travels to Italy, Switzerland, and England and his exposure to men of wide learning and scientific background provided him with a model of the Renaissance virtuoso, a man of intelligence and curiosity who desired to share his knowledge with individuals of similiar taste. His explanation for the "rain of blood" in July 1608 is regarded as an illustration of his method of interpreting natural phenomena. *DSB.*
5. Charles Bonnet (1720–93), Swiss scientist and philosopher, is considered one of the founders of modern biology. Bonnet's greatest discovery was the parthenogenesis of the aphid. His interest in experimental entomology led him to study the breathing of caterpillars and the locomotion of ants; he published the results of his research in 1745 in the *Traité d'insectologie.* Because of failing sight, Bonnet published little in zoology after 1750, turning instead to the study of plant physiology and theoretical biology. *DSB.*
6. CWP's mark appears to be an indication of the end of the first part of the lecture, which was read on Saturday, May 17. He read the second part on Monday, May 19.
7. John Hunter (1728–93), British anatomist and surgeon. *DNB.*
8. James Thomson (1700–48), English poet and author. CWP quoted from "Winter," in *The Seasons* (1730; reprint ed., London, 1859), pp. 191–92.
9. It seems probable that John Godman, who assisted CWP with this lecture, supplied him with this account. Godman, who began his work on natural history in the spring of 1823, also utilized the story in his section on polar bears. *American Natural History,* 3rd ed. (Philadelphia, 1860), pp. v, 110–11.

130. CWP to ReP

PHILADELPHIA. MAY 18, 20, 1823

Philadelphia May 18th.1823.
Dear Rembrandt
Since I left you I have been very closley engaged in reading, and com-

posing a lenthy lecture on Nateral history and porcelain teeth for your sister Sophonisba & others. and now nearly on the wing for Baltemore. Rubens wife is here she says that she came up to carry me to Baltemore—

that is not her principle object—it is to try to sell her property in order to aid Rubens in his difficulties. But selling it appears to me almost impossible at the present time, and she is trying to get mony by morgaging, and in this case I fear that she can get but little as the property is undivided. however I hope she will carry some with her— her elder sister will be here on tomorrow & they will act togather—further on this business I am unable to add at present.

yesterday afternoon at 5 O'clock I delivered one half of my lecture and gave notice that I would conclude it at the same hour on Monday next. I was about 3/4 of an hours in the reading—off course you find that my Lecture is lenthy. but it is much more interesting than my last. I ended yesterday with the filial affections of Insects, and gave the audience notice that I should commen[c]e the other part with Birds, quadrupedes, and close with moral reflections on Man. My audience were not numerous but respectable, the people of Philada. are tired out with lectures, so many on every subject has been given of late in this City.

This is not the case in Baltemore, and therefore I may, perhaps, help a little to gain a few [illeg] dollars for Rubens— I cannot say that my qualification as a Lecturer will excite much Interest, yet my age, and those of my old acquaintance may have some desire to hear me. It would add much to my [ha]ppiness had I the means to do more for my Children than I can in my present situation accomplish. but while I have life and health I will never cease to do my best to promote their happiness and to equal justice to each of them. and having delivered my Lecture, which I had devided for 2 afternoons, I had pospond the closing this letter untill I might be able to say something on the subject. 20th although I had given notice in 3 news papers of the time & place yet I beleive that I did not get by Visiters who paid for the entrance to Museum the amounts of costs of advertizements in addition to the common receipts. so that I have full proof that I cannot attract the attention of the public by my exertions which I am able to make by lecturing— The Philadelphians are I believe completely sick of Lectures of late. I wish it may answer better in Baltemore for Rubens—for I composed this lecture on purpose to serve him with the impression that in Maryland an attempt of the sort might excite some curiosity among those who has known me so many years past The result of my tryal here should make me believe that neither my composition or delivery possess any merit—and yet my private friends seem very much pleased with it—some have complimented me highly. but this may

be in the view to please me. Yet surely this last lecture is much more interesting than the former—it cost me much reading and close study & so long that I found it would to take nearly 1 1/2 hour to read it & therefor I divided it. Your Sister Sophonisba—My Brother James & Polly—Sophonisba's daughter Elizth. and Mr. Samuel Sellers, make our party for Baltemore & we go with the Steamboat today.

I have looked over the old accounts between us, and made the charge of 100$ for each of the last pictures you painted for the museum—[1]and find that the a ballance against you amounts to upwards of two thousand dollars, and I would have sent you a coppy of all the articles did I think it necessary—at some future time when we meet, if you think proper you may examine the particulars—but in case of any accident to me, I have inclosed a Receipt in full to this date.[2] It is my Wish to help all my Children as far as I am able and I very much regret that I have not the means to assist you at the present moment. I have determined to purchase of Rubens the House in Walnut street, allowing him 6000 dollars for it—the morgages on it, ground rent & taxes amount to 500$ yearly and I cannot rent it for that sum at this time. nor wi[ll] it sell for the sum I mean to offer, besides repairs are now wanting—I tryed hard to sell also to rent it, in vain. and the monies I have pa[id?] and what I have assumed amount considerable above that I allow him, but if he does not chuse to accept my offer, it will involve him in more debt—and he cannot, or rather ought not to have additional debts to those of the Baltre. 8 pr.ct debts. Eliza. has tryed to raise money on her property here but cannot do it at present & the property will not sell. Yrs.affecy. CWPeale
Mr. Rembt.Peale N. York

ALS, 2pp.
PPAmP: Peale-Sellers Papers—Letterbook 17

 1. The three portraits ReP painted for the Philadelphia Museum were of Samuel Latham Mitchill, David Hosack, and DeWitt Clinton. See above **85**, **122**.
 2. Unlocated.

131. CWP to Coleman Sellers
BALTIMORE. MAY 25, 1823

Baltimore May 25th. 1823.
Dear Coleman
 I wrote to Franklin and Titian, to acquaint them of my purchase of Rubens the Walnut St. house, and to give Mr. Worrel notice as usial of

Titians leaving his House ⟨*as is usial*⟩ (3 months notice) and also to put up a Bill to offer it to be rented—that Titian should inform Mr. Worrel the offers as tenants, in order to obtain his approbation—by which method, very probably some tenant might offer that would meet Mr. Worrels aprobation, in which case Titian may have no responsibity for the remainder of the 3 months after his removal. I requested Titian to have my painting room window raised to its original situation, and I thought I need not order any thing to be done at present.[1]

I have repeated the substance of my letter least that to them may have miscarried. I would like to hear from one of them on this subject.

I have made alterations in my first lecture to suit for delivery here, and shall read it at 9 O'clock tomorrow night.[2] I find that Rubens has chief of his income by visitors to the Museum at night.

Yesterday he made a bargain to exhibit a large picture painted by a Mr. Sergeant of Boston—Christ riding on an Ass, S. Luke XIX Chapt & 30th. V.[3] The picture is large and full of figures— The design good but the execution very indifferent. Rubens cannot loose by taking the picture; as by agreement the profits of the Exhibition are to be equally divided, after Rubens shall have received his usial income—this is calculated at 400$ pr month.

Our time of going to Annapolis is not yet settled, probably it will be on Wednesday next—the Steam boat going there twice a week at 8 O'clock on wednesday & Saterday.[4] Sophonisba dines here to day & is quite well. I have nothing to add, best love to the family

<div style="text-align: right;">Yrs. Affectionatly
CWPeale</div>

ALS, 1p.
PPAmP: Peale-Sellers Papers—Letterbook 17

1. See CWP to BFP and TRP, May 22, 1823, P-S, F:IIA/68F4. TRP was able to find another tenant for Worrel's house, and CWP and his sons were soon able to move into RuP's house which CWP had purchased. See below, **137**.

2. On May 23, 1823, a notice appeared in the *American and Commercial Daily Advertiser* that CWP "intends in a few days delivering several discourses or lectures in the Baltimore Museum, Holliday-street, on the subject *Natural History*."

3. Henry Sargent (1770–1845), of Boston, painter and Revolutionary officer, studied in London with Benjamin West between 1793 and 1797. Along with portraits, he painted several large historical and religious canvases, such as *Christ Entering Jerusalem* (ca. 1817: unlocated). On May 27, RuP began advertising the exhibition of the "fifteen feet high, by eighteen ft. wide" painting. Sargent also painted two large scale genre works, *The Tea Party* and *The Dinner Party* (ca. 1815–20: *Museum of Fine Arts, Boston*). Dorinda Evans, *Benjamin West and His American Students* (Washington, D.C., 1980), pp. 11, 113–15, 184; E. P. Richardson, *Painting in America From 1502 to the Present* (New York, 1965), pp. 129, 149; *American and Commercial Daily Advertiser*, May 27, 1823.; *DAB*.

4. CWP finally left for Annapolis on May 30. See below, **133**.

132. CWP to RaP
BALTIMORE. MAY 25, 1823

Baltemore May 25th. 1823.

Dear Raphaelle

I went this morning to the french jeweler[1] you directed me to and he had none of the foil, but he directed to another shop where I shall obtain it, and perhaps I may send it by my friend S. Sellers[2] at any rate I shall get it—the jeweler told me that he must clean it, which he could easily do.

I delivered my lecture last night to considerable audience of Ladies & Gentlemen—who seemed pleased with it as far as I could judge— The other lecture, last written, I have ready prepaired, but think it advisable to wait a few days, to let my first be spoken off— I have agree'd with Rubens & Eliza for the House, and I wrote to Franklin & Titian to request notice to be given to Mr. Worrel, that by a written notice that Titian leaves his house in 3 months, also to put a Bill on the door to obtain a Tenannt first, and when any offered, to acquaint Mr. Worrel, who they were, in the hopes that he might approve of them in which case, Titian would moove on the day the present quarter is paid. I have expected to hear from some of the family, to know if my letter was received, and the result, and since I have wrote to Coleman, to the same purpose, thinking thereby I might hear from some of them.[3] we have not yet fixed on the day to go to Annapolis, may probably determine on it this evening, as shall all meet at Mrs. Brandons[4] to take tea togather— It is my intention to visit Mr. Carrol at his country Seat 15 miles distant, and if I can have the opportunity to paint a portrait of him, by borrowing canvis & colours from Sarah, my niece, I will like to do it.[5] Rubens has done himself much credit by his arrangement of this Museum, the Company come chiefly at night, and as I see some of the wealthy families are on the way to the country, I am apprehensive, that there will be a considerable falling off at the Museum. I ought also to mention that in my letter to your brothers, I desired them to have the painting-room window raised to its former situation— I have some thought that I may paint the portrait of old Mr. Carrol. He is 86 years old—one of the commissioners that was sent to Canada in the beginning of revolutionary troubles, to try to engage the Canadians to join us—

Mr. Sellers is waiting to carry this— Love to all the family—— Yrs.
Affectionately
CWPeale

Mr. Raphaelle Peale

ALS, 2pp.
PPAmP: Peale-Sellers Papers—Letterbook 17

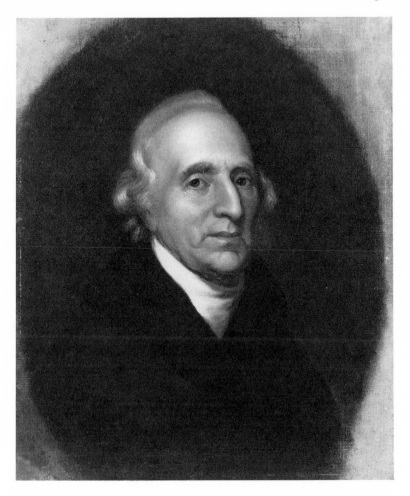

33. *Charles Carroll of Carrollton.* C. W. Peale after Rembrandt Peale, 1823. Oil on canvas, 20 × 24″ (51 × 61 cm). Independence National Historical Park, Philadelphia.

1. Unidentified.
2. Samuel Sellers.
3. See above, **131**.
4. Unidentified.
5. (Fig. 33.) Charles Carroll of Carrollton (1737–1832), Revolutionary leader, member of the commission appointed by the Continental Congress in 1776 to seek Canadian aid for the colonial cause, and later U.S. senator from Maryland, retired from politics in 1800, devoting himself to the maintenance of his estate and his commercial railroad interests. He was the last surviving signer of the Declaration of Independence. *DAB*; *P&M*, p. 50.

133. CWP to Coleman Sellers
BALTIMORE. MAY 29, 1823

Baltimore May 29th. 1823.

Dear Coleman

I have just received a letter from Franklin, in which he states that Doctr Godman is sued for rent in the House he rented in Market Street, and he is applied to be his surity[?], and he requests me to lay my injunctions on him not to do it, this is immediately making Doctr Godman my enemy, which I do not like, indeed it gives me very disagreable sensations, as I most earnestly desire to serve Doctr Godman, by many obligations, family connections; a young man of wonderful talents; and ⟨h⟩is willingly doing whatever I have required of him.

I have often told all my Children that they ought not to be suerty [surety] for any one— That I will never do it, for I have suffered 3 times by it, the first cost me 96£ the 2d 16$ and much trouble, & the last I thought desperate, but by a lucky hit I escaped a considerable loss.

I know your friendship for Godman, and if I mistake not you are intimate with the persons to whom the debt is due, and my hope is that you may persuade him not to prosecute the suit, as it will not be any advantage to him, for Godman going to jail will not pay the debt—it will distress his wife & Rembrandt's family— Godman's talents may perhaps get him a chance of rising, if those to whom he is indebted will labour him. I have said enough on this subject.we go tomorrow morning to Annapolis & I expect to return on Monday—Tuesday & Wednesday deliver my 2d lecture, and if all are agreed return to Phidia. by Thursday Steamboat— yrs.

Affectionately
CWPeale

Mr Coleman Sellers.

ALS, 1p.
PPAmP: Peale-Sellers Papers—Letterbook 17

134. CWP to BFP
BALTIMORE. MAY 30, 1823

Baltemore May 30th. 1823.

Dear Franklin

When I wrote to Titian yesterday[1] I forgot to mention the retort—
Rubens advises you to get those Iron bottles in which the apothecaries import quicksilver (mercury) they are somewhat larger than the com-

mon retort, and a little different in shape, but he thinks you will find them very convenient, they have a screwed stopper. I expect you will find them readily in Philada. otherwise I would buy one here they will cost about 50 Cents.

On Saterday Sophonisba, Elizabeth[2] & self go to the City of Annapolis— My brother says that all his Old acquaintances that lived there, are now dead, therefore he declines going with us, I intend to return on Tuesday, or sooner if I can,[3] And on that evening I deliver here my last lecture, to be concluded the following evening, And I shall as soon as possible after return home.

Sophonisba and Elizth. spent the day (yesterday) with Rubens's family and is very hearty.

Business is dull in Baltemore, some of her first characters having disgraced themselves by cheating the U. S. Bank have caused a want of confidence amongst those in trade—and the widow and orphan have suffered great losses—[4] Betsy Bend tells me that she has been a sufferer, and now is left with only a sufficiency to pay her board.

Some engagements prevents me from ading only that you shall hear from me again shortly yrs. Affectionately

CWPeale

Mr. Franklin Peale.

ALS, 1p.
PPAmP: Peale-Sellers Papers—Letterbook 17

1. See CWP to TRP, May 29, 1823, private collection; copy in P-S, F:IIA/68F9–12.
2. Elizabeth Coleman Sellers. See above, **130**.
3. CWP, SPS, and Elizabeth received such a "hearty welcome" in Annapolis that they remained three days longer than they had planned. CWP delivered a lecture to "a polite audience there, who expressed much satisfaction & approbation of sentiments contained in it." See CWP to BFP and TRP, June 5, 1823, P-S, F:IIA/68G4.
4. In 1819 the Bank of the United States incurred heavy losses at its Baltimore branch, in part due to its redemption of inflated paper currency issued by southern and western banks for specie. Additional losses resulted from fraudulent activity among its officers, including bank president James A. Buchanan, cashier J. W. McCulloh, and parent board member George Williams. The total loss to the Baltimore bank was estimated at $1,671,221.87. Buchanan's successor, Langdon Cheves, presided over an investigation of the matter, which by late 1822 had become highly controversial. *American and Commercial Daily Advertiser*, October 7, October 28, 1822.

135. CWP to Nicholas Brewer[1]
BALTIMORE. JUNE 7, 1823

Baltemore June 7th. 1823.
Dear friend & relation
Under the impression that you have [illeg; sufficient acquaintance?]

with the governor as to mention to him, that I esteem the old portrait of Lord Baltemore as a good picture,[2] although I never had a close examination of it, and wishing to add as many as I can of the first proprietors of the soil to my collection of Portraits—therefore I wish to offer what I conceive will be memorable in the eye of the Public for that pictures, nay what posterity will be more interested in ⟨not only now but⟩ in future. The proposition I make is to paint Six portraits in a handsome head size, of the Governors elected since the change of Government, some of them I presume will be copies of Portraits which I painted in former times— Thomas Johnson Esqr. I believe was your first Governour, whose portrait I have painted for his family.[3] It is my wish to paint as one of the portraits your present Governor as a specimen of my art at my advanced period of life and if my proposition is acceptable I will return to Annapolis at such time as it may be convenient to his Excellency to set—[4] The other portraits to be choosen by your executive, and which I think should be done without loss of time when it is considered that I am now in my 83d year. If this proposition is acceptable, I propose that the picture in question should be sent to my son Rubens's Exhibition in Octr next, and that it remain with him untill I complete the number of portraits which [I] engage to paint for it.

It is in my opinion, making a foundation of a collection of Portraits that will at some future day be a most important work, as I should hope that succeeding Governors will leave their portraits in the collection and I would also hope that they should be painted by the best artists of the time, which also will be adding much value to the Gallery— It does not require much judgement to conceive how interresting it will be to see a spacious room embracing excellent portraits of a procession of men esteemed the best members of society in republican Government—

I will thank you to write me when it is convenient ⟨of⟩ your oppinion on this subject—

We propose to leave Baltemore by the Steam boat on Tuesday next.

Accept my sincere thanks for your polite & friendly attention to us. My daughter continues in good health— make my respects to our friends and

love to your consort Yrs. CWPeale

Nicholas Brewer Esqr. Annapolis

PS. having missed the time of sending this by the steam-boat, I may add a few lines— I have considered the advantages of the head size for making a collection of Portraits— In the first place, many of those may be placed in one room, and the good portrait in that size, is of more value than large pictures indifferently done, a uniform size is also a consideration, in the next place being of less cost will more certainly be increased in

numbers— I have in my collection about 240 portraits, and these portraits of revolutionary character, are greatly esteemed by the public generally. It will give me pleasure to lay the foundation of such a collection, and surely no succeeding Governor will refuse giving his portrait in addition to a collection once brought into existance.

Coleman Sellers has just arrived here/ the husband of my daughter, we expect to leave Baltemore tomorrow—provided my Son in law shall have finished some business.

<div style="text-align: right">adieu CWPeale</div>

ALS, 3pp.
PPAmP: Peale-Sellers Papers—Letterbook 17

1. Nicholas Brewer (1771–1839) was the son of Jane Brewer, sister of CWP's first wife Rachel, and her husband Joseph Brewer. Nicholas was a member for many years of the Maryland House of Delegates and served two terms in the state senate. Joshua Dorsey Warfield, *The Founders of Anne Arundel and Howard Counties, Maryland* (1905; reprint ed., Baltimore, 1973), p. 321. See *Peale Papers*, 3:374.

2. (Fig. 34.) Herman van der Myn's portrait of Charles Calvert, the Fifth Lord Baltimore (1699–1751) and Lord Proprietary of Maryland (1715–51), was painted expressly as a gift to the city of Annapolis and brought to the capital city in 1732 by Lord Baltimore when he visited his American domain. With its provincial coat of arms and representation of an Indian who has laid down his instruments of war, the painting symbolizes the Lord Proprietary's peaceful reign over his grant of lands. CWP first saw the painting in the rooms used by the Annapolis city government when he was working in the city as a saddler before undertaking his artistic career. See Wilbur Harvey Hunter, *The Peale Museum 1814–1964* (Baltimore, 1964), pp. 22–23; *CWP*, pp. 79, 480.

3. *Thomas Johnson* (1732–1819) *and Family* (1772: *private collection*). See *Peale Papers*, 1:112–15.

4. Samuel Stevens (1778–1860) served as Maryland's governor from 1822 to 1826. CWP did not paint his portrait. *Biographical Dictionary of the Governors of the United States 1789–1978*, 4 vols. (Westport, Conn., 1978), 2:656–57.

136. CWP to Eliza Patterson Peale

PHILADELPHIA. JUNE 14, 1823

<div style="text-align: right">Philada. June 14 Sunday 1823.</div>

Dear Eliza

Our passage to French town was pleasant, where I left Coleman & family—they went to Elktown, and I carried my Box of Insects in my lap all the way to N. Castle with scarcely a Nod!

The want of Sleep made me feel somewhat stuped the day of my first arrival here. Titian had got the House in very excellent order he said that he was fearful that I should come home to soon for him to get things in any decent order, the remooval was a heavy job to him for both Houses was to be cleaned. I have in the first place put stove plates across the flue just above the arch of well of dead bones and then filled the chimney with

<div style="text-align: center">281</div>

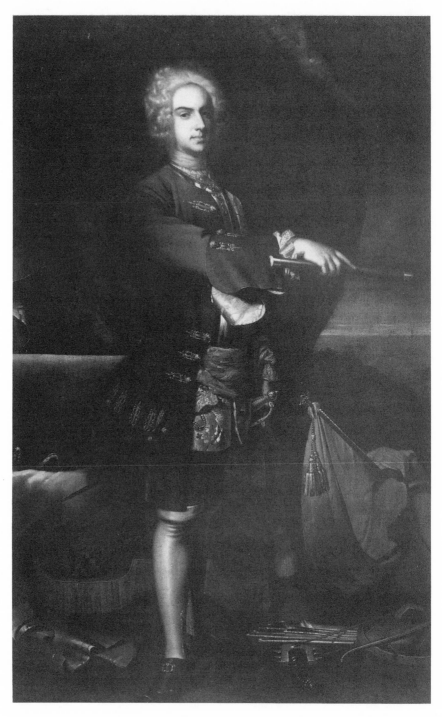

34. *Charles Calvert, Fifth Lord Baltimore*. Attributed to Herman van der Myn, ca. 1730. Oil on canvas, 93 × 57 ¼″ (236 × 145.5 cm). The Peale Museum, Baltimore City Life Museums.

clay 5 or 6 feet, poured some water to settle it down to prevent the stench from rising through it, then made a Wall across the sump hole and ramed clay round the Chimney as high as the level of this of the Yard. Then took the door from the chimney flue above (used to throw the flesh into the vault) and bricked it up closely & also plastered the out side, thus I thought I had secured from all stench ⟨ *from* ⟩ in that quarter. but yesterday I set Mr. Wilson to scour the floors this brought a horrible smell again, so much so that I was affraid to go into that part of the building in the evening—I suppose from the blood in the boards mixing with the water became active, it smelt offensive at the Stable door 1/2 after 9 O'clock last evening when I went to shew Raphaelle what I had done. I have said enough and more than enough on this filthy affair.[1] My painting Room is painted with Spanish brown & white, of a light brick-colour, and the few unfinished pictures in it look well, and I hope to make a good use of this room particularly.　　　　Now for your affairs—　Your Sister Mary called on me yesterday, and says that she has had a great deal of trouble to get a tenant for her & your House,[2] it has cost her 3 trips to the City. She was very fearful of putting a bad tennant in possession of it but she believes that at last [s]he thinks the person will pay the rent as he has a farm (I don't remember where) and appears to be a clever man.

"Memorandom of agreement made June 13.1823 between Mary Patterson of the one part and Thomas Dow[3] of the other part— The said Mary Patterson hath demised and the said Thomas Dow hath taken from her— all that brick Messuage No. 206 Walnut St., Philada. for the term of one year from this date at the yearly rent of 270 Dollars payable quarterly— the sd Mary Patterson to do all the outside repairs necessary to keep the house tenatable in repair. and the said T. Dow to do whatever painting & papering he may want, and particularly the 2 rooms down stairs & entry at his own expence. and at the expiration of the term to render peaceable possession of the premises in as good order & repair as delivered to him reasonable wear, decay, & unavoidable accident excepted—whatever wood will want repairing to be done by sd lessors. Witness my hand the day & year aforesaid,

　Witness

　Caleb Carmott"[4]　　　　　　　　　　　　　　　　　Thomas Dow"

　　　　I have thus given the agreement, which I conceive is a good precept, if such are wanting. my next business give a statement of an acct. & monies to be sent you

"Five months rent at $260 per annum	108.33
paid Taxes &c	70.–8
Ballance due	38.25
paid miss Patterson 31st May 1823	15.

remains due to Miss Patterson	23.25
Ground rent to 1st. April 1823	30.00
Taxes as pr. receipts	29.75
Lauderbacks Bill	1.75
Mrs. Eliza Peale	1 —
Miss Pattersons in advance last quarter	2.18
	65. 8
Water Tax	5.—
	$70.80["]

Mary paid to Caleb Carmott for you $6.00 and she gave me $6.75 which she says is a triffle more than your due, which she will account for at the next settlement.

In order to enclose in my letter I will add the other 25.ct to make-up seven dollars which I enclose in this and try to get a safe conveyance by the Steam-boat tomorrow.

By the time I can get a frame made for my large picture this picture Gallery will I hope be sweetened sufficiently for me [to] work in it. I shall then have the stairs made for me to paint my representation,[5] I suppose a large picture will best please Rubens, the Canvis is rather more than 6 feet wide & I will purchase 3 yds. of it—by which size I shall have ample room to display all my art, and I mean to enter on the study of it, as soon [as] I can get rid of my other ingagements, as such a work ought to be well digested before I begin to colour in the picture.

we have a living Madagaster Batt of full grown-size, given to the Museum by a Brother of Mr. Gibson that married Miss Bordley.[6] I am sorry to find that he died in 3 days after he made this donation to the Museum. James & Polly arrived in good health yesterday Morning— Coleman & his charge also yesterday.

I did intend to have gone to the farm & Chesnut hill at this period, but having seen William, Linnius & your Sister Mary, and having to write this letter made it necessary to stay at home, and on other accounts it is best— for the carpenter promises me to work on the back building early tomorrow— I bought 2 sashes of 12 lights each 11 by 9—for 2$ & 7cts one pane only wanting. Strong & good sashes.

Coleman has just left me, we had a consultation on what would be best for me to do with the floor, and it appears to us, as the floor in many places has large plaches of Ink, and blood, to plain it out would be a labourous job, we think it is best to cover it with yellow oker, and I believe 28℔ will be sufficient to cover the whole floor; this will fill up all the crevices and retain

284

water from passing through it—prevent future disagreable smell, as ever would otherwise be the case, at each time that it should be wett. I hope by putting it in decent order that I may rent it occasionally for exhibition of pictures, it may be well for Rubens to assertain what I may expect as rent from the owner of Christ going to Jerusalem—7 Coleman says that he thinks that I might rent it for the meetings of fire companies—as to School Masters, they very rarly are able to pay Rents, if I remember right Rubens lost by one School Master. But supposing that I cannot lesson my expences, I ought to be content, for already I feel a comfort in having convenient rooms for my own use, and Titian will have the advantage of keeping his subjects that he mounts to better order, and the office a comfortable room to work in. He has very often complained at the other house that my dust injured his birds & Insects. I have as much at present as my memory affords that may in the least be interesting to you, only that I wish you to tell Mr. Sully that I have fulfilled my promise to him on my first arrival here.

<div style="text-align: right">I am your affectionate father,
CWPeale</div>

PS inclosed Seven Dollars
Mrs. Eliza Peale
Baltre.

ALS, 3pp.
PPAmP: Peale-Sellers Papers—Letterbook 17

1. The former tenant in RuP's house, Dr. George McClellan, who during this time lectured on "surgical anatomy and operative surgery," must have prepared his dissections in these rooms. See *Poulson's*, November 1, 1823.

2. Eliza's properties are discussed above, **61**.

3. Unidentified.

4. Caleb Carmalt, Jr., conveyancer, 298 North Third Street. *Philadelphia Directory (1823)*.

5. *Staircase Self-Portrait* (*unlocated; possibly destroyed by fire.*) The decision to paint this work must have been reached during CWP's Baltimore visit, probably at RuP's request. Having witnessed the popularity of CWP's earlier deception showing TRP[I] and RaP on the staircase (1795: *Philadelphia Museum of Art*), RuP probably hoped that a similar work by his famous father would entice visitors into his museum. CWP sent this picture to RuP's museum in Baltimore on October 5, 1823 (see below, **157**). In 1825, RuP brought it with him to his New York museum, the contents of which were later sold to Barnum. Sellers believes it was "almost certainly destroyed by fire" in Barnum's American Museum in 1851. *P&M*, p. 162; Sellers, *Museum*, pp. 312–14.

6. John Gibson (d. 1823) is unidentified beyond what is noted by CWP here. On June 6, 1823, the Museum Accessions Book (p. 123) noted John Gibson's donation of a living bat from "Calcutta." Newspaper advertisements described it as "a Bat of the largest kind, commonly known as the JAVA or MADAGASCAR BAT." TRP's Sketchbook (*American Philosophical Society*) contains a watercolor of the bat, inscribed on the upper left, "Pteropus Edulis/ Geoff=" and on the lower right, "From Batavia/living in Phila. Museum." TRP Sketchbook, PPAmP, F:XIII/4B4; *Poulson's* and *National Gazette*, June 30, 1823 (fig. 35).

7. See above, **131**.

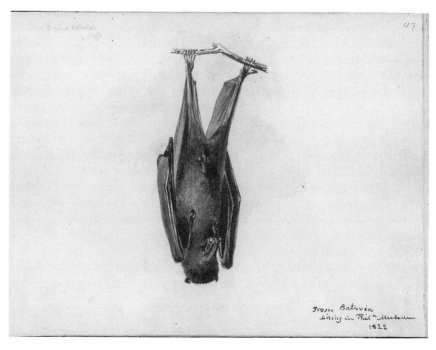

35. *Pteropus Edulia/Geoff. From Batavia/Living in Phila Museum/1822*. Titian Ramsay Peale, 1822. Watercolor on paper, 7 ¹/₈ × 9 ¹/₂″ (18.2 × 24.3 cm). American Philosophical Society, Philadelphia. [B/P31.15c].

137. CWP to ReP

PHILADELPHIA. JUNE 19, 1823

Philadelphia June 19th, 1823

Dear Rembrandt

I found that Rubens had very much improved the Museum, not only by his industry, which is indefaticable, but also at considerable expence, and as he has now made all the important and costly expences, I have advised him to avoid any further expence for the present, in order to pay as much as he possible can to get rid of the arrearages. This he feels is absolutely necessary, and Eliza is truely a valuable wife to him, as she does every thing she can to aid him out of his difficulties, and Rubens appears to be much respected by the Citzens generally, he has a very good sum of visitants, but more especially at night, the income in the day small but at night much better than I expected. He has now exhibiting a large picture

painted by Mr. Sergant of Boston on a lay that he cannot fail to make money by it, it is to be exhibited 2 months, and all monies received over a certain sum—the usial receipts of the Museum, are to be equally divided between the owner of the picture & Rubens— I cannot correctly state what is the sum stated, but it is in my Idea's of it a full allowance. Baltemore is much in the suds,[1] their first men having been found dishonest in bank business, has caused an almost total loss of confidence in each citizen and a great many of the Inhabitants have lost their property by such dishonesty, Betsey Benn amongst others,

Rubens intends to make another Exhibition of Pictures in october, although it is a work of a troublesome nature yet he disregards labour when in prospect of any profit, and the last year the[y] obtained the loan of more pictures than he could find room to put them— There is a shot tower building[2] on the lot back of the Museum, and the proprietors offer to Rubens a passage through to Gay street for some small consideration with 20 feet adjoining the Museum lot, and on consideration of his taking that lot, they will give him the priviledge of shewing the shot tower, to Rubens solely, by his passage to it. We believe the money arrising from shewing the shot tower will fully pay the rent of the lot, the tower to be 160 feet high (I am not certain of the higth) but it will be a Beacon to direct persons to the Museum— The stairs to go up the tower will be commodious —& Rubens wanted to consult Mr. Robenson before he would make a positive engagement but Mr. Robenson had expressed his opinion in favor of it previous to his going to Pitsburgh. I have said all that I particularly remember on this subject of the Museum, except that Rubens will try every means in his power to obtain monies to redeem the 8 Pr.Cent stock.[3] I visited Annapolis and find it much improved within the last 4 years, the Brewer's family[4] are amongst its most valuable inhabitants they have shewn great industry in the cu[l]tivation of the vast grounds there and thus given the Citizens a good market of vegetables.— — I have bought the House you built[5] and now board with Titian in it. and making several alteratins to suit my purposes, The Stable & Chaise-house converted into work shops &c. I cannot at present give you particulars and I must now close this scroll. Altho' you complain that you cannot slight your work, yet I am firmly of the opinion that having many pictures in demand will finally greatly improve your manner. My next will be to tell you more of my own affairs

<div align="right">God bless you—
CWPeale</div>

Mr. Rembrandt Peale
 N York

ALS, 2pp.
PPAmP: Peale-Sellers Papers—Letterbook 17

1. In embarrassment, undone, or in disgrace. *OED*. For Baltimore's bank problems, see above, **134**.
2. A shot tower was a high round tower used to make shot, or projectiles for firearms, by dropping molten lead from the top of the building into water. The stream of lead would break into drops, which become spherical in the water. *Century Dictionary and Cyclopedia*.
3. See above, **127**.
4. The family of CWP's first wife, Rachel Brewer, had significant land holdings in Anne Arundel County, Maryland. *Peale Papers*, 1:37.
5. ReP built his house on the north side of Walnut Street at the corner of Swanwick's Alley between Sixth and Seventh Streets in 1805 (*Peale Papers*, 2:881n); he sold it to RuP in 1814 when he decided to build a museum in Baltimore. Unable to sell the house, as detailed in the letters above, CWP decided to buy it himself.

138. CWP to RuP

PHILADELPHIA. JUNE 20, 1823

<div align="right">Philada Wedy. June 20.1823.</div>

Dear Rubens

By a Mrs. Brown[1] going to see her daughter in Baltre. I wrote to Eliza, enclosing 7$, also stating the particulars of the business of the House as transacted by her sister Mary, which I hope you have received.[2] The other day I received a letter from Rembrandt by Dr. Richards,[3] a young man engaged to be married to a daughter of Rembrandt, and who proposes to engage in business with Doctr Godman— Rembrandt is diligently employed in painting portraits at 50$ but he complains that [he can]not get forward with them in finishing with few and short settings, and says he is afraid that [he] shall never succeed except by having a good price & being permitted to make each portrait as good as possible—his family enjoys good health in the mountain air—and Doctr. Richards tells me that he he has not been to see them since he left them, which was before I visited you. I am told that Eleoner dont like living in the country, this I have learned from Angelica.

I am progressing to put the back Buildings in proper order but much slower than I could wish, as David White is my Carpenter and he is on Jury business, and finds it difficult to get a hand to keep on with the work. The dung hole is now a good room to manufacture my Porcelain teeth, & only wants the front to be put up, and some other triflers to be done, and then I shall proceed to finish some of my engagements in that line, previous to my resuming my pencil. I have bought my canvis for the Staircase[4] 3 yds. long & more than 6 feet wide. will that size be too large? I must have the stretching frame made to prepair the canvis on it The gallery will be

very convenient for this work. the windows being constantly open to carry off offencive air.

The window of the chaize House will afford light to all that part, the petitians being remooved and soon as the white washing is done the printing apparatus will be put up. My carpenters bench is placed on the south-side, and the lath for turning with the large vice will be under the window— there is no door to go into the alley on that side—and the chaize house large [ap]rons have made a complete front with one additional board to the teeth-room

It is perfectly natural for us to write on such subjects as we are engaged in, therefore you are neccissiated to read things of a triffling nature.

Harvey Lewis[5] was married to Betsey sellers yesterday by a Magistrate. off course there will be the folly of punch drinking today.

I have a living Madadagacar [Madagascar] Batt in the Museum presented by Mr. Gibson brother to James who married miss Bordley.[6] It is exceedingly curious in its manners, perfectly harmless, constantly hanging by its hind leggs, eats out of your hand, and cannot bite to hurt your fingers. as soon as it is done eating it rapts itself with its leather-like wings as the human figure would do with a cloak, and to ease itself, it turns up by taking hold of the netting at the top of the box, with its fore claw. & when done generally shakes itself, and then folds his wings round his body and looks very like a black hanging nest.

I have advertized it as curious and interresting I think it ought to bring a considerable run of company to the Museum, but whether any thing can moove the Philadelphians to come in crouds, like with you, I cannot at present say, my next letter may more fully inform you.

My love to Eliza & the Boys. yours affectionately
CWPeale

ALS, 2pp.
PPAmP: Peale-Sellers Papers—Letterbook 17

1. Unidentified.

2. See above, **136**.

3. Unidentified. Either CWP is mistaken about the name or there was a broken engagement. ReP's daughter Eleanor (1805–77) married Thomas H. Jacobs on October 22, 1825; her sister Augusta (1803–86) married Dr. Charles Otis Barker in 1827. *CWP*, p. 441; *Peale Papers*, 2:602n.

4. See above, **136**.

5. Harvey Lewis was perhaps a silversmith and jeweller whose shop was located on 143 Chestnut Street. He was probably a long-time friend of Coleman and SPS, who named a son after him in 1813. Betsey [Elizabeth] Sellers was undoubtedly a relation of Coleman's, but is otherwise unidentified. *Philadelphia Directory (1823)*; Ferguson, *Early Engineering Reminiscences*, xix (genealogical chart).

6. See above, **136**.

139. CWP to RuP

PHILADELPHIA. JULY 2, 1823

Philadelphia July 2d. 1823.

Dear Rubens

last sunday I visited the farm and had my fill of rasberries & cream. in the afternoon went to Chesnut hill, drank tea with Mary &c.[1] she gave me a commission to purchase her a Watch, @ 20$. yet not limited to that sum, I obtained an excellent gold one, a new one, with recommendation of it by Mr. Droz[2] for 23$ which he says will last as long as the Lady lives. Returned to the farm in the evening, and took the afternoon stage on monday— I did not feel very comfortable on seeing the place that had occupied my attentions for a series of years—The Garden running wild, the fences and other wood work going into decay. Mars[3] in a late storm blown down—. I took a turn on the Velosopede[4] up & down the long walk, no other part of the Garden fit for that exercise. Thomas[5] had the best corn in the neighbourhood he paid me a quarter rent, and I sold him the rye which I took of Craiger for one quarter's rent @ 62½$ and I let Bowen have it for 40$. this it is said is a fair price, and it is better to let Thos. have it than any other person, as the straw will thus be keept on the farm— Thos. is an industrous hard working man, and will pay the rent regularly, which will enable me to pay the Taxes and also the Interest which the farm is subjected to. I am still progressing to put my painting room and shops in order, and by my new furnace I have fired the Teeth with much better effect & in half the time that I did before. of course so much less expence of Coal. Most of them is perfectly glazed in the first burning. the spar being perfectly vitrified, if there is any fault in them, it is that they [are] rather too white. some more experience may enable me to give them a little tinge of yellow.

The income of the Museum for April 561.12½ for May 515.89, and June 373.27. I have advertized the illumination to cease after the 4th Instant.[6]

I send the Deed[7] for you & Eliza to execute—it would have given me pleasure to have sold for your advantage but as it is, I beleive you are satisfied since I shall find myself more comfortable than being in a rented House altho' subject to higher cost.

The frame is making to stretch the canvis on to prepair it for the Staircase. This picture will require much study, and I hope to make it better than any picture I have yet painted. I expect to commence the painting in the ensuing week.

I hear that Miss Shippen[8] intends to visit the falls of Nigara.[9]

Raphaelle is now beginning to mend from a severe fit of the Gout. Sophonisba is in good health.

<div style="text-align: right">

with love to Eliza & the Children I subscribe
your affectionate father
CWPeale

</div>

Mr. Rubens Peale.
 Baltre.

ALS, 2pp.
PPAmP: Peale-Sellers Papers—Letterbook 17

 1. Mary Patterson.

 2. Charles A. Droz, clock and watchmaker, at 118 Walnut Street. *Philadelphia Directory (1823)*.

 3. When CWP developed his garden at Belfield in 1814–15, he included in it figures on pedestals—perhaps cut from some kind of board—that conveyed symbolic meaning. One of these was the figure of Mars, which he designed to represent the aphorism that "a wise Policy will do away with wars, hence Mars is fallen." As he described it in his autobiography, "the figure of Mars was made on the end of shed roof to hide it. The making of this is rather of the Political cast, yet he [CWP] had long given over being active in Politics, but choose by it to show his dislike of war." *Peale Papers*, 3:300; A(TS):392.

 4. The velocipede, or draisine, was an early form of bicycle invented in Germany around 1817. In 1819, after viewing such a machine in Baltimore and reading several descriptions of European models in the newspapers, CWP built one at Belfield. *Peale Papers*, 3:717–18.

 5. Thomas Bowen, who was employed as a farmer at Belfield. *Peale Papers*, 3:237, 241.

 6. See advertisements in the *National Gazette*, June 30, 1823, and *Poulson's*, July 2, 4, 1823.

 7. Unlocated.

 8. Margaret Shippen.

 9. By the 1820s Niagara Falls was quickly becoming one of America's most famous landmarks and tourist attractions. James Fenimore Cooper's novel *The Spy* (1821), travel narratives, and gift books included descriptions and engravings of the falls. John Trumbull and John Vanderlyn had visited the falls and had produced paintings and engravings of the stupendous phenomenon. Miller, *In Pursuit of Fame*, p. 211.

140. CWP to RuP

PHILADELPHIA. JULY 6, 7, 1823

<div style="text-align: right">

Philadelphia July 6.23

</div>

Dear Rubens

 finding no one going to Baltemore to whom I would entrust the package containing the deed so that you will find my letter of an earilier date than this

 Last night Eliza was delivered of a Son, and she is *as well as can be expected*.[1]

 I have stretched my canvis ready for sizeing & laying on the Paint, I dont know how you will like it to be so large as it is 9 feet 6 I. by 6 feet 6

Inches and the frame of the door cannot be well less than 9 Inches—and add to this 2 real steps, and if the Schrole hand-rail is added to it, it must take a considerable space of your room.

I shall have a capital room to paint in, by raising the North Window of the gallery about 2 feet— It will not be difficult to darken the skey-lights as I suppose the curtains will be sufficient for that purpose. all the lines are wanting to them.

The smell is nearly gone of[f], as I have constantly keept all the windows open, yet I am fearfull that I shall be obleged to take down the Muslin, on which the paper is pasted, yet I would wish to retain it, as on enspection it appears pretty strong, except in some spots— A carpenter has made me a ladder 11 feet high, one foot highter than necessary, the Hooks are yet wanting, therefore not safe for me to mount, but tomorrow I shall have them, and try to raise the muslin & paper, that is now detached in several places, of course it bags, and forms a ruenous appearance, if the boards beneaf were not very rough, I would not hesitate to take all the papering down, but as it is, if I can make the whole of an even surface (I mean the papering) I can past on any kind of paper on vacant spots and then give the whole a wall colouring of Spanish-brown & white, which forms a good tinct for a painting-room and for shewing paintings.

Do you remember Lerebour,[2] the young frenchman that was familiar with us in the Philosophical hall? he often said that "*those high seillings gave the mind more lofty Ideas*" a Painter should possess a lofty immagination, but if he has not a like sufficiency of knowledge in the execution of his art, his works after all will be only of a mediocrity effect.

The 4th. Instant gave me upwards of 70$ the exact sum above I cannot say, for I have not yet made note of it. Yesterday Franklin sett off for the neighbourhood of Bristol,[3] he will be absent about one week.

7th last night at my Brothers I heard of your success of a run of company on the 4th. Instant, an anonimous letter[4] was sent to me previous to that period—saying it is a common thing in London on memorable days, such as the Kings birth day, to make shows of coloured lamps and tra[n]sparencies—at Public buildings, the author supposed that I could designate some works, as Independance or Liberty etc. Franklin thought is [it] was not proper for me to go to any expence, and Titian thought it degrading to pay any reguard to an opinion of any anonomous letter—he supposed it was written by some person who wanted to sell some lamps, and must be an English-man such are the Idea's of my aids,—I was willing to accept the hint and to make the word Liberty by means of a number of small lamps—and I now think that the effect it would have produced would have justified some expence.

How is it with your agreement for the exhibition of Sergants painting? that you give the ow[n]er of it half your profits when you exhibit the night flowering Ceries? If so he will probably make out very well by an exhibition of an inferior piece of art. I shall conclude and go to the Steam-boat to seek a conveyance. Love to Eliza. I hear that the Children has been sick I hope not much so. Yrs.&c

<div align="right">CWPeale</div>

Mr. Rubens Peale.
 Baltre.

ALS, 3pp.
PPAmP: Peale-Sellers Papers—Letterbook 17

1. Eliza Cecilia and TRP's first son, Bertrand, whose birthdate is mistakenly given by Sellers as January 5, 1823. The baby died on October 22, 1823. *CWP*, p. 443.
2. Alexandre Lerebours briefly resided in Philadelphia in the mid-1790s and became a close friend of the Peale family. He was elected to the APS on April 15, 1796, and attended meetings until May 26, 1797, when he returned to France. Lerebours may have been an associate of Etienne Geoffroy Saint-Hilaire, the French naturalist with whom CWP corresponded in the 1790s. *Peale Papers*, 2:204, 206.
3. A borough in southeast Pennsylvania, about twenty miles north of Philadelphia.
4. Unlocated.

141. CWP to Commodore David Porter[1]

PHILADELPHIA. JULY 8, 1823

<div align="right">Philadelphia July 8th.1823.</div>

Dear Sir

My grandson, Edmond Peale, I understand has been taken a prisoner in a Vessel carrying arms to South America, he was only a passenger in that Vessel, and did not know the objects of her Voyage. The fact is, that he thoughtlessly went to take leave of My Son Rubens and family, and was too long with them, for the Vessel in which his cloaths and some few articles of merchandize sailed without him and by accidently hearing that a Vessel was going to south America in which Rubens obtained a Passage for him—[2]

I hope you will find no difficulty in obtaining his release and probably he may be useful to you, if so I shall be well pleased, as his father by his letter accompanying this[3] expresses his desire of your taking him into your service. I need not dwell on this subject, and shall only say that I will esteem it a favor done me if you will befriend him. I am with much esteem your

<div align="right">friend CWPeale</div>

PS. I am once more resuming my Pencil, in the hope that I may be able to

produce better portraits than I had formerly done, as now I can see to execute my works without Spectacles. enjoying good health in my 83d year of age, and I believe with an improved knowledg of Colouring—
Comodore Porter

on the west Indea station.

ALS, 1p.
PPAmP: Peale-Sellers Papers—Letterbook 17

1. In 1823, Commodore David Porter (1780–1843) was appointed commander-in-chief of the West India Squadron, which had been assigned to suppress piracy and privateering in the region. CWP had made his acquaintance and taken his portrait in Washington, D.C., in 1818. *Peale Papers*, 3: 635; *DAB*; Whitaker, *The United States and the Independence of Latin America, 1800–1830*, p. 294.

2. In late December 1822, Edmund left Baltimore on a trading voyage to South America. On March 2, RaP received a letter from his son with news of his safe arrival in an unnamed locality and his intention to remain (see above, **116**). No documents other than this letter and below, **142**, **143**, exist to tell Edmund's story. He probably returned to Baltimore sometime between March and July, and then set out again for South America. When the ship on which he was sailing was captured by the Spanish, according to Sellers, Edmund was imprisoned in Morro Castle, Havana, Cuba, and sentenced to death. While being escorted along the sea wall of the prison to the place of execution, Edmund presumably "leapt into the water among the tumbling whitecaps and swam, still chained as he was, to a small schooner." Fortuitously, the schooner was bound for Baltimore with a cargo of fruit. By the middle of July, Edmund was home, recovering from the arsenic poisoning he had suffered in his earlier suicide attempt (above, **102**). *CWP*, pp. 405–406.

3. See below, **142**.

142. RaP to Commodore David Porter
PHILADELPHIA. JULY 8, 1823

Philada: July 28th.[1] 1823

Commodore Porter
Dr Sir

I have a Son, by the name of Edmund Peale—who was bound on a trading voyage to La Guirà[2] from thence to Puerto Bello[3] &c on board the schooner [illeg] of Baltimore, but by his delaying too long in taking leave of his friends in Baltimore, the vessel sailed without him— Exertions were used to get him a Passage to the nearest Port in that Country & he obtained a Passage to Chagres[4] on board the Schooner Hunter——which Vessel, I find by the Papers, is taken in Latitude 12 & carried into the Havannah—he was but a Passenger & I hope will not be considered as a prisoner— He is among strangers & without money & to attempt joining his vessel is now impracticable—I therefore, as you are acquainted with our family, request the Favor, that you will take him into the employment of the united states, in your squadron, in *any* Capacity you may think

Proper—he is a smart young man & may be of some service to you & be renderg a service of an afflicted mother—

It is with the greatest exertion that I write, having been confined for twenty one days with Gout in my hands—which I hope will be a sufficient appolegy for this scrawl Depending upon your feelings for some attention in this Business I subscribe myself your

<div style="text-align: center">Obedient Servant</div>

<div style="text-align: right">Raphaelle Peale</div>

P.S. in the Hands of the Consul you will find documents to prove his Nativity Enclosed is his profile. R P.

ALS, 2pp., end.
PHi: Gratz Collection, Case 8, Box 3

1. This letter is misdated; the "2" has been inserted in another hand. The letter has been endorsed, on the bottom of page 2, "July 8. 1823. From R. Peale on the subject of his son."

2. La Guaira, a port on the Caribbean Sea in northern Venezuela, seven miles north of Caracas, is Venezuela's principal port for exports and second largest for imports; nearly all trade for the central part of the republic passes through its harbor. *Columbia Lippincott Gazetteer.*

3. Portobelo, a Panamanian port on the Caribbean Sea founded in 1597, became a thriving Spanish colonial port as a result of being joined by a transisthmian highway with Panama City for transshipment of riches from the Spanish colonies. *Columbia Lippincott Gazetteer.*

4. The remains of the old town of Chagres, which flourished until the rise of the city of Colon in 1850, are found at the mouth of the Chagres River in the Panama Canal Zone. *Columbia Lippincott Gazetteer.*

143. CWP to RuP

PHILADELPHIA. JULY 11, 1823

<div style="text-align: right">Philadelphia July 11th. 1823.</div>

Dear Rubens

By desire of Raphaelle I write to request you to get the *role of equipage*[1] of the Schooner Hunter, the vessel in which Edmond took his passage for South America.

That Vessel carrying arms & amunition was taken soon after leaving our capes, and carried into Havana, have it certified that he was only a passenger—and the Spanish Consul[2] to put his seal to it— Raphaelle has wrote a letter to Comodore Porter requesting him to assist Edmond and take him into his service—[3] I wrote also to the Comodore recommending Edmond to his attention.[4] This business ought to be done as soon as possible, least serious consequences may happen to Edmond. some papers are now going by a Vessel from this port—, a description of his person, depositions of his Babtizm, &c. but the Spanish Consul here[5] says that nothing will avail him, except it is proved that he was only a

passenger—as in the above mode.[6] I sent by Mrs. Clemens of Bal-
temore[7] the Deed for this House, drawn up by Mr. Nathan Sellers [she]
has 2 letters. have you received them?

I have about 24 of the most choice & curious of Plants which Mr. Pratt[8]
has loaned me, among them 2 or 3 of the night blooming Cereus—[9] The
day before yesterday his Gardener, told me that he thought that the
flower the most forward would not bloom before thursday night, of
course it was not noted in the papers—however it blossomed on Wednes-
day night, but at 4 o'clock I found it was opening, and I hurried to get [it]
painted on a transpar[en]t canviss *that it was in blossom* &c and hung this in
front of the lamp at the state-house door. and it produced company to the
amount of 10$ independant of my gratefiing some few friends, such as I
could has[t]ily notice.

I have advertized that Mr. Pratt had deposited these plaints and when
the precise time of the night blooming Cereus would take place, notice will
be given in the Morning & evening papers.

I hope one will bloom tomorrow night—yet I am fearfull that it will
happen on Sunday night. of course we will have a[n]xiety about it. Yester-
day I undertook a dirty job, that of taking off the paper from the walls
of the Gallery. I have raised the north window, and think I shall have a
charming painting-room to paint your Stair case— The canvis is pre-
pairing— I think that I will put the paper with the musseling[10] attached
to it on the floor—instead of painting the floor as I had intended— If
the paper is will secured on the [f]loor and a coat of strong Vernish in which
I will put some Verdigrease ground in oil—that colour being transparent,
will tinge the flowers of the paper of green colour—it dries hard. This I
think [will] not cost me so much as would the painting of the floor, and it
will have a handsome appearance. The boards on the Wall are not plained,
of course many of them are rather rougf to recieve the colouring—

I will advise with the Carpenter to know if some of the roughness may
be taken off with a plain.

I have had a tegisous job, the puting my shop into use, the worst I hope
is over & I shall now begin to dress & complete the arrangement. Titians
wife & child are doing very well. Raphaelle is able to walk out but his hand
not yet sufficiently recovered to permit him to handle his Pencil—

My love to Eliza & children, yrs. Affectionately
CWPeale

Mr. Rubens Peale
 Baltre.

ALS, 2pp.
PPAmP: Peale-Sellers Papers—Letterbook 17

1. Stores, ship tackle; also apparatus of war. *OED*. RaP presumably wished to obtain an accurate listing of the cargo and the accoutrements of the *Hunter* in order to prove that Edmund had unknowingly boarded a smuggler's ship.

American merchants had been supplying Spain's rebellious South American colonies with arms since Venezuela's declaration of independence in 1811. The Spanish government denied American claims of neutrality and prohibited exports of war materiel to their rebellious colonies. Edmund's vessel, disguised as a legitimate merchant trader, had attempted to smuggle wartime contraband into Latin America. It was captured by the Spanish navy and its passengers imprisoned in Cuba, one of Spain's few remaining loyalist possessions in the Caribbean. Charles Carroll Griffin, *The United States and the Disruption of the Spanish Empire* (New York, 1937), p. 98.

2. Unidentified.

3. See above, **142**.

4. See above, **141**.

5. In 1823, Don Juan B. Benabeo was the Spanish consul in Philadelphia. *Philadelphia Directory.*

6. See above, **141**.

7. Unidentified.

8. Henry Pratt. "Pratt's Garden," known as Lemon Hill, is located near the canal and water works in Fairmont Park. In July 1820, CWP and JP painted several landscape views of the Schuylkill River including a CWP painting (*unlocated*) of the "South View of Pratt's Garden formerly the residence of Hon. Robert Morris . . . with the Mansion House, Conservatories for Exotic Plants." *P&M Suppl.*, pp. 45–46; *Peale Papers*, 3:842–43.

9. A plant of the family Cactaceae, usually classified as *Selenicereus* or *C. grandiflora.* CWP's transparency is unlocated. CWP announced the blossoming of the plant on July 24. RuP presented a similar exhibition in the Baltimore Museum the previous summer. See above, **94**; *Poulson's*, July 24, 1823.

10. A variant of *muslin*, a delicately woven cotton fabric used for curtains and hangings. *OED*.

144. RuP to BFP

BALTIMORE. JULY 19, 1823

Baltimore July 19th. 1823.

Dear Franklin

It has been sometime since I have herd from you, I am desirous of knowing what you are all about in the [s]cientific world, especially at the museum. by this mornings papers, it appears that notwithstanding you have a mode of *boxing the compass with the statehouse Bell.*[1] yet you have lost a large portion of a square of buildings. with the great advantage of Hose and engine dissipline, besides so powerful a force of Water added to superior Engines and Hydrolians, surprises us much.

I wrote to Raphael yesterday[2] concerning his son Edmond and sent it by Dr. Staughton[3] and I find Anna also wrote to Margaretta this morning[4] he is rather better, but complains most of excessive burning & heat of the throat, and not much of his stomach. I think he will pay dearly for this frolick. he didnt calculate on arscenic being of so corosive a nature, he thought he could trifle with it, but he sees his error.

I suppose my Father has described my fixtures of gas holders to you—as you well know they would not do as they were before. My gas holders

are placed under my counter (a) with the tube rasing above so as to screw on my pipes B. at the lower part I have a tube conveyed to Coppers the size of my Gas holders, so that when they are are full of water, the other is full of Gas. I fill it through the tube C. &c. Mr. Ingersol is now here and will take this; therefore I must close with saying that I sat down with the intention of making a long letter. Eliza is in the country with george who is much better than he has been.

Give my love to all and beleave me ever your affectionate brother

Rubens Peale

ALS, 2 pp.
PPAmP: Peale-Sellers Papers

1. RuP's meaning here is obscure. Perhaps he meant a system whereby the statehouse bell provided fire engines with the direction of fires by ringing according to some number sequence representing points of the compass. *Boxing the compass* is a nautical phrase meaning running through the points of the compass in order to make a complete turn around. *The Century Dictionary and Cyclopedia.*

2. Unlocated.

3. Either Dr. James Staughton, who attended Edmund after he had swallowed arsenic in his suicide attempt (see above, **102**); or James's father, the Reverend Dr. William Staughton

AUGUST 5, 1823

(1770–1829), first minister of the First Baptist Church in Philadelphia and recently elected president of Columbian College (now George Washington University) in Washington, D.C. (1821–22). In 1821, the Reverend Dr. Staughton delivered a course of lectures on zoology to his pupils in the Philadelphia Museum; in 1829, he became president of Georgetown College in Kentucky and married ACP. *CWP*, p. 439; *NCAB*; S. W. Lynd, *Memoir of the Rev. William Staughton, D.D.* (Boston, 1834); Anne Sue Hirshorn, "Anna Claypoole Peale and Sarah Miriam Peale: The Artists and Their Circle," unpublished ms. in Peale Family Papers files, NPG; RuP, Letters and Notebook for the Philadelphia Museum Company, May-July 1821. PPFA. Entry dated July 10, 1821.

4. Unlocated.

145. CWP to ReP
PHILADELPHIA. AUGUST 5, 1823

Philadelphia Augt. 5th. 1823.

Dear Rembrandt

My time has been fully occupied since I wrote last to you with making arrangements and putting the variety of things of some value as well as much that perhaps might as well be burned, yet waste hurts my feelings, so that I may not regret the loss of what paradventure, I may have some future call for— Then the getting my engagements in the making the highly useful means of Mastication completed, and having partly accomplished this part, my next was to put the Galery into a good painting-room, and have raised the N. window, taken down the muslin & with its paper covering, I spend[?] 6$ to have a brown-red Wall-colouring; got ladders to reach the sky-lights which I have closed and let down the curtains to keep out the light—had my door or rather entering of a staircase—with 2 steps on the front and 2 painted on the canvis— I have painted 2 steps on the canvis with carpeting on them & also on the permanent steps—and on the floor the same carpeting extended as in Room which I shall call my painting-room. after much cogitation I have at last determined to represent myself as discending with my right foot on the bottom step of the picture the left on the upper step (thus the leg foreshortened) my Pallet in my left hand & moll-stick in my right. Thus I shall have a front view of face & figure, yet not ungracefull line by the proper inclination of the head. My first Idea was to make a broken pedestal collom with the bust of Linneus,[1] on which I intended [to] lean, the next Idea was to represent myself in the act of decorating the bust with a reath of flowers; as my indeavor to honor that great Naturalist by my labours, Either of these last designs must naturally place me some distance in the picture and would be more modest than as I have at last determined it— I have had some repugnance on the subject. however the Idea of advertizing myself as a painter, which if the picture is painted as well as I

299

hope to do it, may induce some persons to desire the labour of my pencil. this may be an allusion, for I have now learned to doubt my abilities, and think that I rate myself above my abilities—as a proof of which is verified by my late attempt at lecturing on Natural history. At any rate I shall try my utmost to make this picture in all its parts a real deception, but like Apple's, I may make the grap[e]s to deceive the birds, but the *painted boy* was not natural enough to protect the grap[e]s.[2] An Easel with a picture on it behind me & other appendages of a painting-Room then assending from this 2 steps more leads to an extended Gallery, in which I mean to reverse the light of the picture—This pictorisk of a Museum. Now for business

You may have as occasion may require my painting-rooms, and I hold your former painting-room, as being more commodious for the winter season, for it will be a difficult thing to make the picture Gallery painting-room comfortably warm, without too great a waste of fuel. The window is raised on the north side to its former higth. The room is rather smaller than it was formerly. however for portraits of common size it will do tolerable well.

I hear tolerably frequent from Rubens, he is now prepairing to advertize artists to send their works to his exhibition of October next. There is at present very little prospect of his being able to sell Eliza. property, for there are no purchaser's at present; Eliza is very anxious to sell or even to borrow money on them—and it is with some hope we are looking out for some moneyed person who will loan at 6 pr. Cent—on the House in Walnut street or on the Mill or both I have not been very well of late, yet not seriously complaining, for I can yet moove with ease yet not with so much energy I was wont to do. My friends advise me to labour less & indulge more. It is easey to advise, but not so easy to follow. I must still insist that painting at a low price is better than little work at a high price, too much mending often spoil work. Love to the family

<div align="right">from your affectionate father
CWPeale</div>

Mr. Rembrandt Peale
 n.york.

PS. Today I had a Bricklayer changing the Windows of the Galery—that at the N. end, being very wide, as have 2 sashes hinged to meet a stile in the center, when both sashes was shut it made a broad bar in the middle of the light & formed a line of darkness on the objects in the room, and I thought that one sash of only 2 lights wide, was too narrow. 3 glasses was certainly better besides the auked [awkward] manner of opening, instead of lowering or raising the sashes—determined me to make the change of sashes—

With so fine a painting room if I cannot make good portraits, it will be time to burn my brushes, and seek some other employment.

This picture for Rubens is large; 8 ½ feet high & 6 ½ wide. this higher than that I last painted of myself.[3] but about 7 Inches narrower. I now and then see Doct Godman not so oftain as I could wish— he says that he very much engaged with his pen. The child can walk alone. has cut several teeth without pain. Angelica is harty.

ALS, 2pp.
PPAmP: Peale-Sellers Papers—Letterbook 17

1. Carl Linnaeus (Carl von Linné, 1707–78), Swedish naturalist, whose major achievement was a systematized classification of plants and animals. CWP, a great admirer of Linnaeus, organized his museum on Linnaean principles. In 1802 he asked RuP and ReP to acquire a bust of Linnaeus for him in London, to replace the bust of Cicero that crowned his "Smoke Eater" stove in the museum, but there were none available. *Peale Papers* 1:517, 517n; 2:219–22, 630–31n.

2. CWP is describing his *Staircase Self-Portrait* (above, **136**). He here confuses Apelles (the most famous Greek painter, fl. second half of the fourth century B.C.) with Zeuxis (Greek painter, fl. last quarter of the fifth century B.C.). Both artists are discussed by Pliny the Elder (Gaius Plinius Secundus, 23 or 24–79 A.D.), a Roman scholar and historian and author of *Historia Naturalis*, Book 35 of which constitutes an important source of information on artists of antiquity. The legend CWP refers to related the story of Zeuxis's painting of a boy with grapes that was so realistic that birds tried to eat the fruit. Zeuxis was dissatisfied, however, because he realized that the boy was not realistic enough to deter them. Pliny, *Natural History* 35:66; *Oxford Classical Dictionary* (New York, 1970). For the Peales' knowledge of Pliny, see Dorinda Evans, "Raphaelle Peale's *Venus Rising from the Sea*: Further Support for a Change in Interpretation," *American Art Journal* 14, 3 (1982):62–72; *Peale Papers* 3:852n.

3. *The Artist in His Museum* (frontispiece).

146. CWP to RuP

PHILADELPHIA. AUGUST 5, 6, 1823

Philada. Augt. 5. 1823.

Dear Rubens

Having completed my engagement for mastication at least so far as to enable me to begin your picture of the Stair-case— The frame has two steps and looks very well without the rail ling, nay I think better then it would be with it—It [is] a bold, and good work, cost about 20$. I have painted 2 steps within the picture and painted a carpet on the outer steps, as also on the inner steps—at first I thought to paint a pedestal of the base of collom, with the bust of Linnius, on which I intended [to] rest my left arm—then I had a thought I would be putting a reath of flowers on the bust, meaning to do honor to the father of natural history by my

labours. then I must be put some distance in the picture this would [be] more modest than as I now have determined it. I shall be descending the steps; my right foot on the first step in the picture, my left on the upper

step, with a foreshortened leg. a front face, the head alittle inclined to make a gentle curve of my figure By this I give my exact higth, with my Pallet on the left & Moll-stick in my right hand—behind me my Easel with a picture on it and other apparatus of a painting-room— from which I meditake making 2 steps to enter a Gallery of great length

I borrowed a handsome Carpet from Mr. Rhea,[1] and contrary to usage I paint the bottom of the picture to a finish or nearly so before I sketch in any other part of the picture I mean to make the whole piece a deception if I can.

But I may be mistaken in my abilities, as of late I find it the case, instance, lectures on Natural history— The steps will certainly be a true ellusion, and why not my figure? It is said that Apelles painted Grap[e]s so natural that the Birds came to pick them, that he then painted a Boy to protect them, but the Birds still came to take the Grapes.—[2] I am again altering the window of the Gallery, taking that from the East and puting it at the N. end—The double folding sashes made too broad a light with both open and one of 2 lights was too narrow, more especially when the sash was shut, another ilconvenience was the opening the sashes to let in air with the sliding blind that lessens the light or lowers to admit more light, necessary when the atmosphere becomes darkened. 6th. This forenoon this work will be completed and then I resume my pencil. Your notices to artists received yesterday afternoon, Franklin is now distr[ib]uting them, they are *stilish*.[3]

Rembrandt in a letter[4] says he has not heard from you a long time. He asks if I can let him paint a large picture in the Gallery-painting-room, My answer is he can occasionally use either that or the old painting-room, which I have also reserved for the purpose of painting in it when about common portraits. You say you have a parshality for this House, I feel myself at home in it and would not leave it for any other dwelling in this City. my work shops are convenient—and the dung-hole is my favorite retreat and store-room, I always carry the Key of it in my money pocket. Carmac called the day before yesterday for his rent, I told him that I had no money at present for him— I wish you could get rid of such burdens, how can it be done? I am much troubled with Raphaelle's bad conduct, and his difficulties are encreasing on him, Charles is out of his apprentise-

ship, and cannot get employment, Edmond was cuped in the head the day before yesterday by Franklin, who says that he is liable to inflamation of the brain if he is not keept quite & on low diet. Patty wants to get the property secured ⟨ *from*⟩ to her support and payment on the debts—a Law of Pennsyla.[5] enables the nearest relations of a drunken spenthrift—to apply ⟨*to a cou*⟩ and have appointed two persons to act as trustee's— I was applyed to [do] this business—my reply was that I would not have any thing to do in such business, The breaking up of a family is a serious thing. I some time past told Patty that I would not give her money, that what they got of me must be through Raphaelle. this I did in order to oblege her to be more attentive to his comforts. and finding some time of late that he was getting into his old habits, I told him that he displeased me, nay deceived me by saying that he drank nothing but water, at the same time I was ⟨*not*⟩ supplying the family, but also giving him the means to indulge a vile habit. and I have determined that he shall work for what I must give him—and if he will not do it I cannot be longer a sufferer, except in my sorrow for an unfortunate Son. Patty's violent temper I conceive is a principle cause of his bad habits.[6] I have said enough on a disagreable subject. I find I have a cast in plaster of Teeth in which one is wanting, and my memory, I find fails me, I dont know if this cast is of your mouth or of your brother Rembrandts, if for you, can you file down a little of the projecting stump. and whether space can be had for a gold spring to imbrace the adjoining teeth, the hole in the Stump I see is very large; off course a fastener seems necessary independant of plug which may be of wood with a silver pin or screw alittle bottom of the artificial tooth. I find that Mr. Planteau makes the bottom of the front of his teeth long which rests on the outside against the gum. this is a means of making his teeth appear as if growing out of the Gums. And in my last modeling I have made some teeth of such form—they are not yet fired. I find my furnace excellent and my late firing of Teeth renders them more perfect, even without any glaissing—The body of the teeth being perfectly vitrified. Titian['s] Son grows fairly, but Eliza seems weakly, she begins to take exercise in the open air. I am passing off the remains of a cold— and if I feel any debility while I am working at the picture, I shall endeavor to divide my time between painting & exercise. but it is now generally agree'd that it is more healthy in Philada. than in ot[her] parts of the country——Chesnut hill[7] may I hope be an exception to it—in which case I may make a short visit there. say two or 3 days occasionally—you shall hear from me as I advance with the picture. Love to Eliza & children yrs. Affectionately.

CWPeale

Mr. Rubens Peale
 Museum Baltre.

ALS, 3pp.
PPAmP: Peale-Sellers Papers—Letterbook 17

1. Possibly David Rhea, gentleman, of Frankford Road. *Philadelphia Directory (1823)*.
2. See above, **145**, n.1.
3. On August 8, 1823, RuP placed a "circular" in the *National Gazette* inviting artists to contribute their "pictures, busts, models, engravings, drawings, and other specimens of art" to his "SECOND ANNUAL EXHIBITION AT BALTIMORE," beginning October 20 and continuing for six weeks. He promised that "All specimens of Art" arriving in Baltimore before October 14 would be "entered in the catalogue, where such as are for sale will be particularly mentioned." RuP also promised to pay transportation costs for all items in the exhibition.
4. Unlocated.
5. In the nineteenth century, under common law, a married woman could not make contracts or retain her own earnings (which were considered the property of her husband), unless she had been granted legal status as a *feme sole trader*. Until 1855, this designation was conferred only upon working women whose husbands had gone to sea. Furthermore, intemperance did not constitute an acceptable excuse for divorce, which in the state of Pennsylvania could only be granted on the grounds of desertion, cruelty, or personal indignity. Thus Patty would have encountered innumerable obstacles, including CWP's personal disapproval, in seeking control of Raphaelle's assets. Abraham L. Freedman, *Lectures and Cases in Domestic Relations* (Philadelphia, 1933), pp. 297–98; Abraham L. Freedman, *Law of Marriage and Divorce in Pennsylvania*, 2 vols. (Philadelphia, 1939), 2:635–36, 717, 789.
6. CWP had previously blamed RaP's wife, Martha (Patty) McGlathery (1775–1852), for his son's problems, and in his *Essay on Domestic Happiness* he wrote about a wife's pivotal role in either aiding or harming a husband prone to intemperance. *Peale Papers*, 3:6, 129–46.
7. A suburb northwest of Philadelphia where Eliza's sister Mary and brother George lived.

147. ReP to the Reverend Mr. John Pierpont[1]
NEW YORK. AUGUST 7, 1823

New York Aug. 7. 1823.

Dear Sir

My Picture of the Court of Death pays your city its farewell visit, before it ventures across the atlantic, to be tried before the British Peers.[2] I hope its reappearance in Boston will not be considered impertinent, especially as a great many thousand persons, who perhaps intended to, did not, see it, & others who did may like to see it in a better light.

Mr. Pendleton takes with him my Roman Daughter[3] & other paintings for sale. This picture was painted *con amore* & was not intended for sale— but my purposes have changed, And it will now be convenient for me to part with it, especially if some Gentleman of fortune & taste should do me the honour to become the possessor. I feel assured that if it be in your power to promote my views in the sale of these pictures, it will afford you pleasure—and with a more comprehensive motive when you consider that I am not selfish in this, but that the benefit will extend to my numerous family.

It is true something depends on the merit of the works offered for sale—but very much depends on the fashion of talking about them, in proper places & to the right persons. This it may be in your power to promote ⟨*yourself &*⟩ without doing any injury to your taste or feelings. The laudable plans which have amused my fancy & promised to employ my talent & feed my ambition will either be encouraged or defeated by the fate of these Pictures.

Twenty times have I concluded that I would try my strength in England & twenty times abandoned the idea & determined that I would retire from the world into rural Simplicity, without vanity or vexation of spirit— But, as soon as I have done something a little better than common, then London has again risen to my view & a favourable moment appeared for another American to claim some distinction— Alston, Lesly, Newton,[4] rank higher in England than at home, where there is not so much wealth to reward them, knowledge & taste to discriminate between their excellencies & defects and fashion to render it necessary for them to be employed.

Pendleton likewise takes on two of my Portraits—One of Mr. Schaeffer[5]—the other Dr. Mitchell. These will give some idea of my stile of Painting Portraits. Although I am now quite uncertain how it may be best to employ my time before Winter, I think it not amiss to ascertain whether my pencil can gain any friends in Boston, instead of adventuring there without encouragement.

In consequence of having given up the Museum in Baltimore to my brother before your Portrait[6] was finished, I did not feel myself under the necessity of putting it into the Gallery—It therefore remains in my possession and although it was my intention to have retained it with the Airs of Palestine, it now occurs to me that I have a very good excuse for presenting it to your family, if you will receive it as an evidence of my friendship and as a partial return for the service you can render to my Boston enterprise, without impeaching your own reputation as a Man of taste & judgment. Mr. Pendleton will deliver you the Portrait, after he has stretched & varnished it.

<div style="text-align: right">

Present my respects to Mrs. Pierpont
And believe me
With great respect & esteem
Yours &c.
Rembrandt Peale

</div>

ALS, 3pp., add., & end.
NNPM
Endorsed: Recd 20 Augt. 1823; ansd 26.

1. John Pierpont (1785–1866), Unitarian clergyman, poet and reformer, and grand-father of the financier J. Pierpont Morgan, was ordained in 1819 as minister of the Hollis Street Church in Boston. Before attending Harvard Divinity School, Pierpont practiced law unsuccessfully in Newburyport, Massachusetts. In 1814, he joined his brother-in-law and John Neal in the retail dry goods business in Boston and Baltimore. When his business collapsed in 1815, Pierpont remained in Baltimore, where he published a volume of his poetry, *Airs of Palestine*. In Baltimore, Pierpont was a founder in 1816 of the Delphian Club, a social and literary society similar to the Tuesday and Homony Clubs of eighteenth-century Annapolis. ReP may have made Pierpont's acquaintance during what was probably an informal association with the society. *DAB*; Francis F. Beirne, *The Amiable Baltimoreans* (New York, 1951), p. 356; Robert J. Brugger, *Maryland: A Middle Temperament, 1634–1980* (Baltimore, 1988), pp. 190–91.

2. *Court of Death* was exhibited in Boston from August 21, 1823, to September 20, 1823, at Doggett's Repository, 16 Market Street. From August 19 to September 15 it was advertised in *The Boston Daily Advertiser and Repertory*, and from August 21 to September 18, in the *Boston Commercial Advertiser*. The advertisements were much the same; the first read:

PEALE'S
COURT OF DEATH

This Picture is now open to the public for a short season previous to its departure for Europe, at *DOGGETT'S REPOSITORY*, 16 *Market street*.
To become acquainted with a large original picture, composed of many figures, the result of much study and thought, it is necessary to view it more than once; it is therefore deemed advisable to fix the price of a Season Ticket at 50 cts., which will admit the purchaser any time during its stay.
Admittance 25 cents—Children half price

Boston Daily Advertiser and Repertory, August 21, 1823.

The second advertisement to appear, beginning August 23, announced evening openings:

Illumination of Peal's
C O U R T
O F D E A T H

AT DOGGETT'S REPOSITORY
No. 16 Market-Street
THIS Picture from the nature of the subject, appearing to advantage by a judicious illumination, the public are respectfully informed that the Exhibition will open for that purpose THIS EVENING, To continue during its stay. Open Day and Evening.
Season Tickets, 50 cents. Admittance 25 cents

3. ReP's controversial and sensational *The Roman Daughter* (1811: *National Museum of American Art, Smithsonian Institution*) was painted soon after he returned to Philadelphia from Paris. This work and three other large historical canvases were intended for his new Apollodorian Gallery of Paintings, which opened in Philadelphia in 1811. *Peale Papers*, 3:153–55; Miller, *In Pursuit of Fame*, pp. 108–109; William T. Oedel, "After Paris: Rembrandt Peale's Apollodorian Gallery," *Winterthur Portfolio* 27, 1(1992):1–27.

4. Washington Allston (1799–1843), American artist and author, studied in London from 1801 to 1803 with Benjamin West and in Paris and Rome from 1805 to 1808. After returning to Boston briefly, he revisited London in 1810 and remained there until 1818, when the mismanagement of his patrimonial estates in South Carolina forced him to return to America. Settling in Cambridgeport, in ill health and in debt, he continued to paint for an admiring Boston audience, but was unable to complete his large painting *Belshazzar's Feast. DAB*

Charles Robert Leslie (1794–1859), painter and author, born in London, was the son of CWP's friend the Philadelphia watch- and clockmaker Robert Leslie, who had taken his family to England in 1793. The family returned to America, but in 1811 Leslie traveled to London with the assistance of the Pennsylvania Academy to study painting

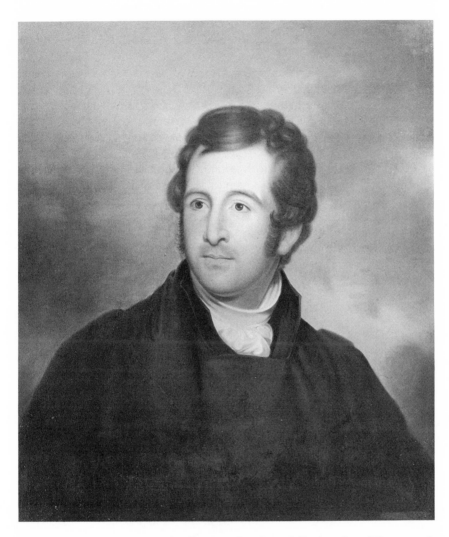

36. *Rev. Frederick Christian Schaeffer, D.D.* Rembrandt Peale, 1823. Oil on panel, 28 × 24″ (71 × 61 cm). Courtesy of Holy Trinity Lutheran Church, New York City.

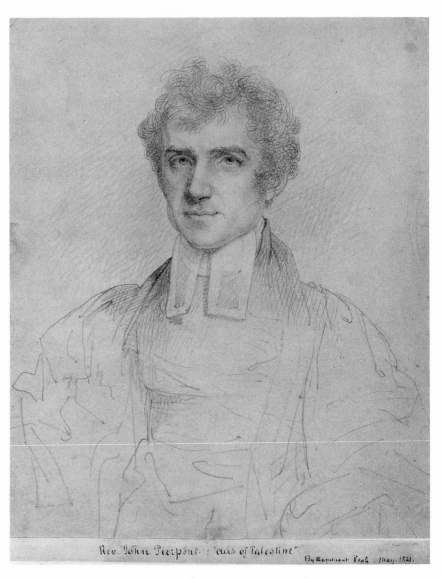

Rev. John Pierpont. ; "oaks of Palestine"

By Rembrandt Peale . May. 1821.

37. *Rev. John Pierpont*. Rembrandt Peale, 1821. Graphite on Paper, 8 × 5 ½″ (19.7 × 16.2 cm.). The Pierpont Morgan Library, New York 1954.21.

with Benjamin West and at the Royal Academy. His genre paintings were successful in London, and except for a brief stint in the U.S. Military Academy at West Point as a drawing teacher, Leslie remained in England for the rest of his life, in 1847 becoming a professor of painting at the Royal Academy. *DAB.*

Gilbert Stuart Newton (1794–1835), painter and a nephew of the artist Gilbert Stuart, was born in Halifax, Nova Scotia, and resided for a time near Boston. After studying briefly in Italy and Paris, he settled in London and continued his studies at the Royal Academy, becoming an associate and academician at that institution. Newton was considered to have had a very successful career in London, initially painting portraits of such celebrities as Sir Walter Scott, Washington Irving, and Henry Hallam, and moving on to larger anecdotal works such as *The Duenna, The Lute Player, The Adieu,* and *The Dull Lecture.NCAB*

5. (Fig. 36.) Frederick Christian Schaeffer (1792–1832), Lutheran clergyman, preached at Christ Church in New York City from 1815 to 1823. In 1823 he formed St. Mathew's English Lutheran congregation. In addition to his religious duties, Schaeffer pursued literary and scientific interests. In the 1820s he became a counsellor to the New York Literary and Philosophical Society, associating with such other ReP sitters of this period as DeWitt Clinton, David Hosack, and Samuel Latham Mitchill. Family tradition indicates that ReP painted the Rev. Schaeffer "for his [ReP's] pleasure," which may explain the painter's sending this portrait to Boston. ReP also painted, probably on commission, a matching portrait of Martha Wagner (Mrs. Frederick) Schaeffer. *Appleton's*; ReP Catalogue Raisonné, NPG.

6. ReP made at least three portraits of Pierpont: a sketch in graphite on paper (fig. 37); an oil portrait (1836: *Unitarian Universalist Church, Boston*); and this portrait (1816–23: *unlocated*). The only located image of the last is a photograph in Abbie A. Ford, *John Pierpont: A Biographical Sketch* (Boston, 1909). ReP Catalogue Raisonné, NPG.

148. RuP to BFP
BALTIMORE. AUGUST 14, 1823

Baltimore August 14th. 1823.

Dear Brother.

In my last communication and dispatch to you[1] I neglected the enclosed invitation for Robert Sully,[2] therefore you will oblige me by delivering it— Also give the enclosed order to my Father.[3]

Will you make enquiries of Mr. Sully, if he thinks it likely that I could obtain a few paintings from the following gentlemen if I should make application to them by letter? *Joseph Bonaparte. Mr. Mead, Dr. Dewese* or others.[4] Be so good as to answer the above questions as soon as possible, and you will much oblige me.

Dr. Harlan promised to furnish me with a skeleton for the museum. I have therefore written a few lines to him.[5]

You have never yet furnished me with the income of the following months, to complete my table of comparison.

1822.	February	November	My July was 625.50.
	March	December	

April	1823.	By attending to the above
May	January	you will much oblige
June	February	your affectionate brother
July	March	Rubens Peale
August	April is furnished by my Father.	
September	May	do.
October	June	do.
	July	——

ALS, 1p.
PPAmP: Peale-Sellers Papers

1. Unlocated; perhaps above, **144**.

2. RuP probably meant to write "Thomas Sully," the portrait painter. The invitation (unlocated) was for RuP's second annual art exhibit, to be held in October at the Baltimore museum.

3. Unlocated.

4. All three men mentioned by RuP owned art collections. Joseph Bonaparte (1768–1844), known also as the Comte de Survilliers, was the elder brother of Napoleon and former king of Spain. After Napoleon's defeat at Waterloo, he sought refuge in America and settled on an estate near Bordentown, New Jersey. CWP took his portrait in 1824 (see below, **204**).

Richard Worsam Meade (1778–1828) was a Philadelphia merchant whose collection of Old Masters was well known in the urban centers of the country. *DAB*; CAP.

William Potts Dewees, physician and obstetrician, had his portrait painted by John Neagle about 1815 (*Mütter Museum, College of Physicians, Philadelphia*). *DAB*; CAP.

5. See above, **25**. On April 11, 1821, the Board of Trustees of the Philadelphia Museum, at their first meeting, appointed Dr. Richard Harlan, a founder of the Academy of Natural Sciences (1812), to the lectureship of comparative anatomy. RuP's letter to Harlan is unlocated. *DAB*; Sellers, *Museum*, pp. 234, 239; Philadelphia Museum Minutes, p. 5, P-S, F:XIA/7A10.

149. CWP to ReP

PHILADELPHIA. AUGUST 25, 1823

Philadelphia Augt. 25 1823.

Dear Rembrandt

Yours from Broklan [Brooklyn] recieved,[1] to answer your question respecting the large painting room, the House north is a two Story-stable with the end next the Street. I have taken the window on the east side side of the Galery and placed it high on the North side, so that over the roof of the Stable I have a full view of the Sky, before I advance to the middle of the room, the window which was in this plan I have placed in the east side. Doctr. Richards will tell you my progress with the Stair-case picture for Rubens, but the design is simply this: I am desending the steps with my pallet in my right hand the Moll stick in my right as having left my picture

on the Easel of Your Mother looking on her naked child who sleeps; a picture I painted about 1772 which was much admired and handsome scrols wrote on it—[2]my Saddelers hammer I have laid on the steps and commenced the Painter, from the painting-room one step enter a grand museum in which are seen cases of Birds the skeleton of the Mammoth at the extreme end, and I intend a group of figures is viewing the Museum— The light on the steps is from the left, but in the Museum from the right—thus you must understand that I defy criticks, My face ⟨in⟩ is an intire front face alittle inclining to the left—so as to give by my standing on my left foot a gentle

The number of portraits in the Museum is 35 all of which I hope to paint to day—therefore you must not expect me to make this a long letter. besides I have engaged to write by James Griffiths (who is

about to Establish a Museum in Washington) a letter to Rubens.[3] aprepos—Sarah is prepairing to paint a large stransparency of the Battle at Baltemore & the fall of Ross to be exhibited in the front of the Museum.[4] I must say something on painting which has employed some of my thoughts, as essential to its painters—which I hope you will take no offence at. Truth is better than a high finish. The Italians say give me a true outline & you may fill it up with Turd. Steward [Stuart] is remarkable for giving a good character in his portraits, a gentill air—& good drawing of the Heads, hands bad enough. Dispatch is absolutely necessary in the painting of portraits, otherwise a languor will sit on the visage of the setter. and very few persons will set for portraits if they hear that they must sett long and often. therefore I am of the opinion that the portrait painter must dispatch his work as quick as possible, by aiming at good character, truth in drawing & colouring—effect at a proper distance if not so hightly finished may be acceptable with the multitude. I deem it essential for the durability of painting to lay on a good body of Colour, glaising to inrich may please from the present, but paint with only the bonding vehicle will last longer with a good effect. therefore I wish to dispence with lake as much as possible & all other glaising colours.[5]

The fish will be mounted in a few days, and I shall try to get the east-room below the Museum to exhibit it, it weighed 2044 ℔ without the intestines, is 15 feet across & 12 feet long, from the head to the end of the tail, the usial mode of meas[ur]ing animals, the body about 8 feet long. we are obleged to make it in 2 pieces—as the size would not permit it other wise to be mooved. It costs me much, in the first cost 315$ & many other expences since. but I hope to be repaid by the exhibition of it before I

place it in the Museum— Titian has had a hard job of it. but his genius & ambition will carry him through with whatever he undertakes—[6]

Love to Eleoner & Children.

I hope Doctr. Godman will get an employ in the lecttering house;[7] an Election takes place today, to fill a vacancy by the death of a young Doctr.

with much affection yrs.

CWPeale

Mr. Rembrandt Peale

ALS, 2pp.
PPAmP: Peale-Sellers Papers—Letterbook 17

1. Unlocated.

2. *Rachel Brewer (Mrs. Charles Willson) Peale, with Daughter* (1770: *unlocated*). Verses praising CWP's painting appeared in the "Poet's Corner" of the *Maryland Gazette* on April 18, 1771, and July 8, 1773. *Peale Papers*, 1:92–94; *P&M*, pp. 163–64.

3. See below, **150**.

4. (*Unlocated.*) The Battle of Baltimore, or North Point, was fought by the Baltimore City Brigade against British troops during the War of 1812. On September 12 and 13, 1814, city militia confronted the British at the narrowest point of Patapsco Neck and delayed the enemy's advance on Baltimore. The following day Fort McHenry withstood an intense bombardment by the British fleet. Impressed by the stiff resistance of the Baltimore troops the British retreated, and the city was spared a fate similar to the burning of Washington on August 24 and 25. General Robert Ross, commander of the British troops, was critically wounded in the battle. *Peale Papers*, 3:266–67.

On September 12 and 13, the front of the Baltimore Museum was "decorated with VARIEGATED LIGHTS, and a TRANSPARENCY 10 by 15 feet in size, representing the death of GENERAL ROSS, at North Point." On September 15, RuP notified the public that the transparency had been "retouched and improved, and is arranged in the lecture room of the Museum," where it remained on view for about two weeks. *American and Commercial Daily Advertiser*, September 12, 15, 23, 1823.

5. Until recent times, almost all lakes (pigments made in a process similar to the dyeing of textiles) were not permanent enough to be used in artists' paints. The bonding vehicle is the liquid in which the pigment is dispersed. CWP appears concerned that the glazes used by ReP, the thin layer of transparent color laid over the dried pigments, would weaken the adhesive function of the bonding vehicle. Mayer, *A Dictionary of Art Terms and Techniques*, pp. 167, 208, 418.

6. It was unusual for the Peales to spend a large amount of money for an exhibit, but popular interest in a large sea creature had been stirred up by the Philadelphia press, perhaps even with the aid of the museum's proprietors. On August 16 an article in *Poulson's* reported a sighting by fifty people of a "sea serpent" off the Massachusetts coast. On the twentieth, the same newspaper printed a letter from Cape May, New Jersey, that provided an interesting connection between the sea serpent story and the museum's "Devil Fish" exhibit:

> . . . Nearly a dozen of boats have just started off in pursuit of some wonderful fishes seen off the Capes*—Sea Serpents for aught I know—if they are curiosities you will hear of them.
>
> * These have proved to be the Devil Fish.—One of which weighing, when caught, three thousand pounds, twelve feet long, and fifteen broad, is now exhibiting in this city. The skin of the other was sent to New York to puzzle Dr. Mitchell.

Advertisements for the exhibit began appearing in *Poulson's* on August 18, warning Philadelphians that the animal was being exhibited "for a few day[s] only" through at least mid-October. *Poulson's*, August 16, 18, 20, 1823; *National Gazette*, October 16, 1823.

7. In November, 1823, Godman began a "Course of Anatomical Lectures" in the "Ana-

tomical Rooms", located on College Avenue "(immediately in the rear of the University of Pennsylvania)." *National Gazette*, September 5, 1823.

150. CWP to RuP
PHILADELPHIA. AUGUST 25,1823

Philada. Augt. 25.1823.

Dear Rubens

Titian could have sent many of the articles wanted by the Merchant for his friend—[1] but the Fish could not be neglected— We were obleged to make all the dispatch possible to remoove all the flesh, it is now in good train and one half stuffed—being 15 feet across and 12 feet long, made it necessary to have it mounted in two pieces. otherwise it could not pass any of our doors, the inside is made of wood—hollow and as light as possible consisting with necessary strength— It cost me in the first Instance 315$ and since considerable expence, but if I can get the East-room below to exhibit it, I may repay myself before is [it] goes into the Museum. we have thought of sending it for exhibition in Baltemore, shall be able to judge on this subject when we see the effect it produces here. I am as deligent as possible consistant with my Determination of making this picture a deception in toto.

I have not got the likeness so far finished as to hear that it is a better ⟨likeness⟩ than that in the Museum. Mr. Sully & family came to see it yesterday, he highly approves all parts of it, and what surprised him, was my carpeting— he said to me that I ought to send you a piece of the same carpeting on the lower steps to supply you when that shall be spoiled—how can I do that, can I send painted steps, painted steps! bless me, I am completely deceived.

The subject of this piece is this, I am desending the steps from my painting room, a full front face alittle inclined to left shoulder and my left foot on the step, the right foreshortioned as leaving the step behind— which gives this line of figure but very gentle. a Saddlers hammer in the step to shew that I have laid down the hammer to take up the pensil, a picture of your mother on the Easel behind me looking with plea- sure on a sleep- ing infant, beyond the Painting- room one step leads into a Spacious Museum ador[n]ed with birds and part of the Skeleton of the Mammoth at the end of the Room, & intend a group of figures as visitors—35 Portraits are in sight over the subjects of natural history—not well defined you must suppose, but

mer[e]ly the effect of pictures at considerable distance, indeed the whole of the Museum must be in a light effect of distance, & this light extended ⟨to⟩ behind my figure by means of the picture on the Easel, for the purpose of giving a greater effect of relief to my black dress. a slight sketch would give you a better Idea of the picture, but none of us have time to make it. I am so anxious to go on with my painting that I begrudge any time spent from it—my friends are now becoming troublesome by their visits. My plan is when I finish the picture to place it I have intended for your Room, and open the Skey-lights and give a general invitation to visitors to see it—having my prices for portraits hung up in a frame, and if the picture is such as I hope to make it, I may have chance of getting business in the portrait line—as it seems absolutely necessary for me to follow some calling in aid of my funds—

I must conclude as I hope to do in the faint & proper stiles 35 portraits, for the Museum representation, at least as many as I can of them, for after this part is brought into its proper effect I shall then proceed to finish the figure.

I have told Moses that he must pay by installments weekly the debt to you,[2] which he promises to do as soon as we can attract company to the Museum by means of the fish exhibition. he is now without money, indeed I am fearful that he is becoming an Idle & dissipated fellow. he too often neglects the Museum. you know the Man.

I am glad to hear your Son is doing better. love to Eliza— Peggy Shippen is here,[3] and is becoming very fatt, yet, I do not think a very healthy woman. She seems to be always in the desire of rambling abroad and talks of paying you a visit when not determined. yrs. Affectionately
CWPeale

Mr. Rubens Peale
 Baltre.

ALS, 2pp.
PPAmP: Peale-Sellers Papers—Letterbook 17

 1. Unidentified.
 2. There is no information about any money transaction between Moses Williams and RuP.
 3. Margaret Shippen.

151. H. D. and R. Sedgwick to CLP
NEW YORK. AUGUST 26, 1823

NYork Aug 26th. 23

Chas. L. Peale Esqr——
 Sir
 Yrs— of th 29th Ult–[1] was recd. We some weeks since wrote to yr—

Father that the Estate of Mr. Depeyster would be sold this day, at the Tontine Coffee-House at Noon—& that unless he employed some person to bid, very possibly the property would not bring more than eno'[ugh] to pay Mr. Remsen who is to be first paid—[2] Not having heard from yr–Father, we fear the letter has miscarried—

The Sale was to have taken place to day—but in consequence of the urgent solicitations of Mr– Depeyster the sale is to be postponed to three weeks from this day at same place & hour— Mr. D urging that by means of a regular survey of the Property, and farther advertisement more may be got for it than it would sell for now.

If you think that it would be desireable to yr– Father to have this information, You will please communicate it—[3] We should have written to him at Phila–, but feared that a letter would not reach him there.
 In haste
 Respully
 Yr obt &c
 H. D. & R.Sedgwick

ALS., 2pp. & add.
PPAmP: Peale-Sellers Papers

 1. Unlocated.
 2. On July 17, 1823, the Sedgwicks wrote CWP that the only personal and real property left to the DePeysters was a thirty- or forty- acre land holding away from the city belonging to Gerard DePeyster. The lawyers recommended that the interested parties, which included CWP's children, not force DePeyster to sell the property immediately, but accept a one-year mortgage on it, at which time it might be sold for a larger amount. However, the property was not expected even at a later date to bring a full return to the creditors. CWP wrote the Sedgwicks later that month that he would inquire of his children as to whether they would be willing to accept the proposition, but since some were out of town, he would write later. Apparently other creditors, perhaps including Henry Remsen, who had first claim on the estate, did not agree to a delay of the sale. H. D. & R. Sedgwick to CWP, July 17, 1823, P-S, F:IIA/69A9–12; CWP to Messrs. Sedgwick, July [?] 1823, P-S, F:IIA/69A8.
 3. If CLP wrote CWP about this matter, his letter is unlocated.

5 Portraits for the Public: September 19, 1823–July 2, 1824

In 1823, Charles Willson Peale undertook the painting of a series of six portraits of the Revolutionary governors of Maryland in a format similar to the paintings in his gallery of "distinguished characters" in the Long Room of the Philadelphia Museum. Peale intended these portraits for the Annapolis Corporation in exchange for a full-length portrait by Herman van der Myn of Charles Calvert, Fifth Lord Baltimore that was deteriorating in the Annapolis city chambers (fig. 34). The series of paintings represented Peale's last attempt to stimulate government interest in art. He hoped that his effort would mark the beginning of an "important collection" for the state of Maryland and, as a contribution to the historical record, result in recognition by the citizens of the state of the value of public patronage of art.

In making this offer, Peale was not entirely disinterested. Even before seeing the van der Myn painting in Annapolis and being reminded of his attraction to the work when beginning his artistic career, he had probably considered the possibility of painting a group of public portraits, especially after experiencing competition from Joseph Delaplaine's *Repository of the Lives and Portraits of Distinguished Americans* in a nearby gallery. He also realized that once cleaned, reframed, and restored, van der Myn's work would become a major attraction in either his own or Rubens's museum—something that both he and Rubens were constantly seeking. Moreover, a group of portraits such as he proposed would surely enhance his reputation as an artist even while becoming "vastly interresting to posterity at a future period." Thus, he devised this ingenious exchange and immediately rationalized its utility.

The Annapolis Corporation, headed by Peale's friend Mayor James Boyle, was easily persuaded to accept Peale's concept of a state-owned collection of art works important for Maryland's history, with Peale's paintings forming its nucleus. On September 17, 1823, the corporation formally agreed to his proposal. The exchange was effected by the summer of 1824, when Peale delivered his last painting in the series and received the promised van der Myn portrait.

Some citizens of Baltimore and Annapolis protested the removal of *Lord Baltimore* from the state. The editor of the Baltimore *Federal Gazette* criticized the arrangement in an article reprinted in the Philadelphia papers: "No blame can be attached to Mr. Peale in this transaction—but we are quite satisfied that the Corporation cannot justify thus bartering away the portrait of the founder of the State." In response, Peale, always eager to maintain harmony, promised to retain the painting in Rubens's Baltimore museum. However, in 1826 Rubens left Baltimore for New York, and Peale carried the portrait back to his museum in Philadelphia, ostensibly for cleaning, where it remained until his death. Not until 1957 was the painting returned to Baltimore.

To make his replicas, Peale first had to locate portraits of the former governors. Some of the men he had painted at an earlier time: William Smallwood (1732–92) (1781–82: *Independence National Historical Park Collection*); Thomas Johnson (1732–1819) (1771–75: *C. Burr Artz Collection*); and William Paca (1740–99) (1772: *Maryland Historical Society, Baltimore*). Rembrandt's portraits of John Eager Howard (1752–1827) (n.d. *private collection*) and John Hoskins Stone (1745–1804) (ca. 1797–98: *Anglo-American Art Museum, Louisiana State University, Baton Rouge*) provided him with images of those officials, but he was unable to locate portraits of Governor Thomas Sim Lee (1745–1819) and Governor John Henry (1750–98). Forgetting that he had painted Lee's portrait in 1776 (*unlocated*), Peale substituted a life portrait of the sitting governor, Samuel Sprigg, for the missing Lee.

While Peale was busily engaged in hunting down original portraits of the former governors and painting his canvases, Rembrandt, facing slim patronage in New York and eager to test his skills in what he believed would be the more hospitable art world of London, also decided to make a bid for public patronage. A move from New York to Philadelphia in the fall of 1823 had not improved his financial situation; although the portraits painted in his "new style" evoked praise from his admiring father for their "highest finish," they attracted few sitters. Without work, Rembrandt focused on federal patronage, stimulated perhaps by the increasing interest being shown in the approaching fiftieth anniversary of the Declaration of Independence. Seizing on the popular admiration for George Washington as the embodiment of the republican ideal, both like and unlike Andrew Jackson, an emerging hero, and seeking an interesting subject for exhibition purposes—his *Court of Death* was now nearing the end of its successful tour—Rembrandt determined to paint a large historical portrait of Washington that he could justify, as his father did with the governors, in terms of public utility.

Rembrandt envisioned an equestrian portrait of the great man in a historically significant setting—the surrender at Yorktown. Before he

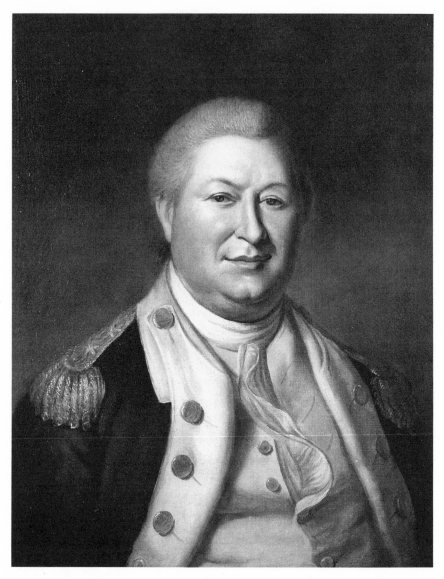

38. *William Smallwood*. C. W. Peale, 1823. Oil on canvas, 29 × 24 ¹/₂″ (74 × 62 cm). Maryland Commission on Artistic Property of the Maryland State Archives, Special Collection 1545–1054.

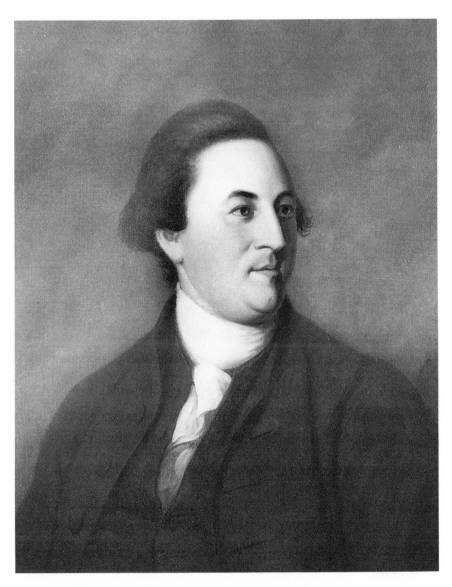

39. *William Paca*. C. W. Peale, 1823. Oil on canvas, 29 × 24″ (74 × 61 cm). Maryland Commission on Artistic Property of the Maryland State Archives, Special Collection 1545–1056.

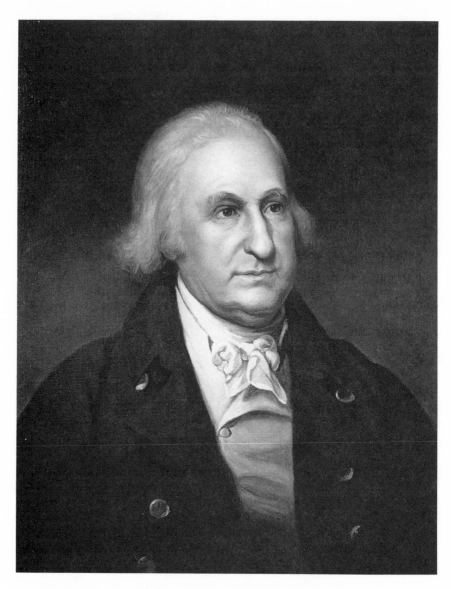

40. *John Eager Howard*. C. W. Peale after Rembrandt Peale, 1823. Oil on canvas, 29 × 24 ½″ (74 × 62 cm). Maryland Commission on Artistic Property of the Maryland State Archives, Special Collection 1545–1053.

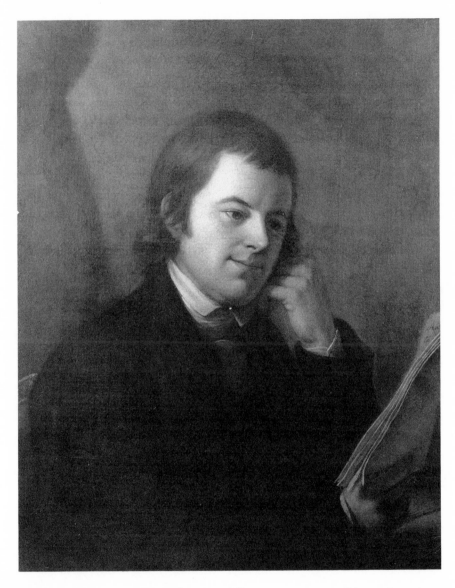

41. *Thomas Johnson*. C. W. Peale, 1824. Oil on canvas, 29 × 24″ (74 × 61 cm). Maryland Commission on Artistic Property of the Maryland State Archives, Special Collection 1545–1119.

42. *John Hoskins Stone*. C. W. Peale after Rembrandt Peale, 1824. Oil on canvas, 29 × 24″ (74 × 61 cm). Maryland Commission on Artistic Property of the Maryland State Archives, Special Collection 1545–1057.

43. *Samuel Sprigg*. C. W. Peale, 1824. Oil on canvas, 29 × 24″ (74 × 61). Maryland Commission on Artistic Property of the Maryland State Archives, Special Collection 1545–1055.

could begin such a major enterprise, however, he had to determine Washington's image. To Rembrandt, wishing perfection in representation as well as idealization, copying either his own or another's portrait of the great leader was out of the question. For his image, he decided to combine the best features of all the important life portraits of Washington that had been produced—mainly Gilbert Stuart's "Vaughan" image of 1795, Houdon's bust of around 1785, his father's 1795 ideal portrait, and his own life portrait of 1795. Such a composite portrait would become, he believed, a "Standard likeness"—an image that would replace all other images of the first president, the *Patriae Pater*. (Fig. 44.)*

*Above, **135**; *Poulson's American Daily Advertiser*, November 26, 1823; Wilbur H. Hunter, Jr., *The Portrait of Charles Calvert, Fifth Lord Baltimore, given to the Peale Museum in Memory of Henry A. Rosenberg, by the Louis and Henrietta Blaustein Foundation* (Baltimore, 1957); *CWP*, p. 410; *P&M*, pp. 113, 123, 154, 195; *Peale Papers*, 1: 105, 115, 153, 237, 504–505; Miller, *In Pursuit of Fame*, pp. 142–47, 279–82; below, **179**, **277**.

152. CWP to Nicholas Brewer
PHILADELPHIA. SEPTEMBER 19, 1823

Philadelphia Sepr.19.1823.
My good friend

The resolution of the Corporation of the City of Annapolis acceeding to my proposition of receiving Six portraits of the Governors of Maryland, for the Portrait of Lord Baltimore, came to hand the day before yesterday,[1] and I would immediately have wrote to you, but I was engaged in prepairing the Exhibition of a Picture which I had nearly finished for the Baltemore Museum. Rubens requested me when I was last at Baltemore to paint for him a Picture of Stair-case on which I should introduce my Portrait, for he said the Stair-case which I painted above 20 years past, in the Philada. Museum always excited much attention of Visitors. This Picture for Rubens is of a large size; 8½ feet high by 6½ wide— I have finished it with with the utmost care, and yesterday the Gallery in which I painted it was opened for public view, and invitations sent to the artists and Amateurs of the fine arts to view it privious to its being sent from this City.

Several of our most distinguished Artists pronounced it to be the best picture from my Pensil. It is a flattering circumstance that I should as I grow older, become a better painter, but the fact is that now my Eyes has become so good that I cannot use Spectacles to paint with them. my judgment of Colours improoved and I find my power to produce better Portraits gives me considerable gratification. In this Picture for Rubens

the design is simply thus. I have painted a Saddlers hammer on the step at my feet, to shew that I laid down the hammer to take up the pensil;[2] I have my pallet & pensils in hand, coming from my painting-room. beyond this room is a view of an extended Museum, at the entrance of which is some Mammoth Bones, for *these* gave rise to the Idea [of] a Museum, from my painting by *one step* assend into the Museum. behind me in the painting is a picture on the Easel of Mrs. Peale my first wife; the Mother of Rubens, looking at her child that had fallen asleep after it was washed and before its mother had put on its cloaths. This Picture gained me much credit with the Poets of that day. I now return to my subject, The Portrait I have of General Smallwood is a faithfull & expressing likeness of him, and I shall in a few days begin my Copy of it in the best head size Canvis, and send it with the Picture for Rubens, before he opens his Annual exhibition of Pictures in October.[3] I am pleased with the Idea that I shall have begun an Exhibition of a collection of Portraits of the Governors of Maryland which will in the end become vastly interresting to posterity at a future period. This Idea is verified by [my] collection of distinguished characters of the American revolution, they are viewed with attention by most of the visitors of my Museum. Be assured my Dear Sir that I will use my utmost powers to make the portraits which I have pledge myself to do for the City of Annapolis, as early as I possibly can, and for that purpose I intend to go in October next to Baltemore and take with me canvis and Paints to make copies of Govr. Johnson Paca &c. I am fearful that I shall not find good portraits of some of the Governors mentioned in the resolution. however my best exertions will secure for me I flatter myself the good estimation of my Work by the Citizens of my native state. I have to request the favor of you to make enquiry of the relatives of the deceased Governors to obtain the portraits in question from which I mean to make all convenient dispatch consistant with my great desire to give full and ample satisfaction to the honorable corporation and, one other request I have to make of you, is, to request Mr. John Shaw[4] (my old friend) to have the Portrait of the old Lord Baltemore, packed up with great care to sent to Ruben's as early as possible, in order that he may have it before his hurry comes on for his Exhibition,

I expect that the frame of the picture is made to be taken to pieces, if not Mr. Shaw will make it so, I need not give him any direction of the manner to do it, as I well know his tallents and care in whatever he undertakes. I expect the picture must be taken off the stretching-frame and rolled on a large rollar &c. I have nothing further to urge ⟨of ⟩ on this subject, and I shall again return to my picture for Rubens.

My intention of exhibiting my portrait is to lead the publick to a knowledge of my intention to again resume my practice of portrait-painting, for

I had so many years withdrew myself from the public as a painter, that it was necessary for me to call their attention to my resolution to persue the art with assiduity, as my Sons Franklin & Titian ⟨was⟩ [are] amply qualified to manage my Museum with my superindendence occasionally. And [my] desire to be distinguished as an artist increases by improvement of my system [of] colouring. and hence by an additional income I may be enabled to do more for my family of Children, than by speculation in other matters.

Please to make my best respects to Mrs. Brewer & the family, & to believe me to be with much esteem your

<div align="right">friend CWPeale</div>

Nicholas Brewer Esqr.
 Annapolis

ALS, 3pp.
PPAmP: Peale-Sellers Papers—Letterbook 17

 1. Resolution of the Corporation of the City of Annapolis, August 11, 1823, to "accede to the proposition made by Charles W. Peale, Esqr. to give in Exchange for the portrait of Lord Baltimore the portraits of the Governors of Maryland, since the revolution . . . the portrait of said Lord Baltimore to be forwarded to Mr. Reubens Peale of the City of Baltimore and that they be authorised to draw on the Treasurer of the Corporation of the amount of the Expences incurred in the transportation of the same." The Corporation acknowledged the completion of CWP's commission on June 28, 1824. Annapolis Mayor, Alderman, and Councilmen, *Proceedings, 1720–1843*, MSA 47 (Location 1/22/1/57), Maryland State Archives, Hall of Records, Annapolis, Maryland.
 2. For CWP's work as a saddler, see *Peale Papers*, 1:32–33.
 3. CWP's "head size" was 23 x 19 inches. *P&M*, p. 18. For his replica of Governor Smallwood, see fig. 38.
 4. John Shaw (1745–1829), Annapolis cabinetmaker, also manufactured fire engines and pumping technology. *Peale Papers*, 2:977n.

153. CWP to RuP

PHILADELPHIA. SEPTEMBER 19, 1823

<div align="right">Philada. Sepr. 19th. 1823.</div>

Dear Rubens

Your account of your and Sarahs labours on the transparency are extraordinary, and you may think your selves very fortunate that you have not brought sickness on you by the exposure to wet and night air. however it appears that you will meet with rewards for your trouble & expence.

I have my Picture now in full Exhibition which commenced yesterday morning and considerable numbers have allready Visited the Gallery— —I sent invitations by the Penny-post[1] to at least 150 persons, the artists not neglected, and I have just left the room where I found 6 artists who

every one agreed in the opinion that it is the best picture I have painted, the likeness perfect, which I consider more extraordinary as I have painted it in as perfect a front view as I could make it, of course no advantage of perspective or profile likeness, as always, or most generally choosen by artists. what is very extraordinary, every Painter is deceived by some part of the picture, all certainly by the Carpet being painted on the real steps. I expect that when it is brought into your Gallery that I may have to make some little difference of shadows of some of the steps—having painted it with more of a side light than is now on it from the Skeylight, which is more perpendicular, of course the shadows less extended.[2]

I have wrote a letter to Mr. Nicholas Brewer[3] to request him to get Mr. Shaw to have the Picture of Lord Baltemore packed up carefully, to make the frame if it is not already done, to take to pieces, and the picture rolled on a large roller and to have it sent to you as early as possible in order that you may have it before your business and hurry of your Exhibition comes on. I have also requested him to make enquiry of the relations of deceased Governors for the Portraits of which I must make copies. I have told him that I shall make that of General Smallwood and send it with your picture of the Staircase. What is the best mode to have your picture sent? The picture will be put on a rollar in one box and the Steps and Door frame in another—which will be a tolerable large one. I mean to carry with me my paints and Canvis to be able to make all the dispatch in my power to complete my engagement with the corporation. I find my powers of painting in no manner decreased, indeed my knowledge of colouring is considerably improved, more especially by the observation of Rembrandt—he has returned to New York, but previous to his leaving Philada. he engaged a House, which was difficult for him to find to his liking—for very few houses are now to be had here, more especially as many families are coming to the City as being much more healthy than in the country. Doctr Godman will take a part of the expence of the House, and thus as Rembrandt has in view, is lessening expences.

Rembrandts plan is if he can sell his Pictures at Boston to advantage, to paint a large Equestrian Picture of Genl. Washington with a view of selling it to the Congress of U. S. to garnish their Gallery at Washington.[4] He does not expect much employment in Portraits in this City & therefore he will travel to get imployment. I have agreed to let him paint in this Gallery on his large pictures, or in my painting-room on smaller pictures if wanted.

I am very unfortunate in not getting the Room below the Museum to exhibit the Devil-fish.[5] The Mayors court are still sitting, although I was led to hope that they would have adjourned for some time past.[6] Therefore I did not apply to the Councils to get the other-rooms, Mr. Burd[7] has

the power & will let me have the court room as soon as the Court adjourns. But if I do not get it this week, there will be too little time left for exhibition before the time of General Election. I have the promise of the Mr. Wharton (Mayor) to sit for his Portrait for the Museum—[8]thus I hope to secure his favor to my views of improvements in the Museum.

Sophonisba has had a trying time with the sickness of Harvy,[9] he is now up, and gaining strength. He was nearly exausted by the fever and suffered a great while. I am glad to hear that your son is like to do well. Although I applied with the utmost deligence in painting your picture,[10] yet I have been favored with good health—altho' I may have lost some flesh, as I am told so, but I neither see or feel it to be the case. with love to Eliza & children

<div style="text-align:right">

I subscribe myself your affectionate
father CWPeale

</div>

Mr. Rubens Peale.
 Baltre.

ALS, 3pp.
PPAmP: Peale-Sellers Papers—Letterbook 17

 1. The penny post was an ad hoc system used in cities for local deliveries of the mail; it gradually died out as the United States postal service (founded 1775) became more efficient. *A Dictionary of American English*, 4 vols. (1938; reprint ed., Chicago, 1965), 3:1713.

 2. In his *Staircase Group* of 1795, CWP had used a similar device, extruding a false step and doorframe into the room to heighten the illusion. *P&M*, p. 167.

 3. See above, **152**.

 4. This is the first mention of ReP's plan to paint an equestrian *Washington at Yorktown*. (Plate 4.)

 5. An eagle ray (*Ceratoptera vampyrus*), which can have a wingspan of up to twenty feet. (*OED*.) Under the heading of "Great Natural Curiosity," CWP advertised the ray as follows: "This extraordinary animal is 12 feet long and 15 feet in breadth and its weight upwards of 2000 pounds—In addition to its enormous size, the striking peculiarities of its structure are such, as cannot fail to gratify the curiosity of the admirers of Nature's wonderful productions." CWP charged a special admissions fee of twenty-five cents to view this exhibit, with children half price. *National Gazette*, October 16, 1823.

 6. The Mayor's Court, chartered April 15, 1789, was a Philadelphia city court with broad jurisdiction over local crimes and misdemeanors. As the name indicates, the mayor of the city served as the presiding officer and judge along with the city's recorder (an office appointed by the city government and equivalent to justice of the peace) and four or more aldermen. The Mayor's Court was abolished in 1838 with the reorganization of the city's municipal courts. Scharf, *Phila.*, 3:1771, 1772; *Dictionary of American English*, 3:1498.

 7. Edward Burd (1751–1833), lawyer and onetime prothonotary of the Pennsylvania Supreme Court (1778–1806), was the uncle of RuP's wife Eliza. Burd was an influential Philadelphia lawyer, but he is not listed as having an official capacity at this time. *Philadelphia Directory* (*1823*); *Peale Papers*, 3:816n.

 8. Robert Wharton (1757–1834), fifteen-term mayor of Philadelphia, serving—albeit not in consecutive terms—from 1798 until 1824. The portrait (*unlocated*) was finished in late December and exhibited in the Museum. The City of Philadelphia purchased it in the sale of the Museum paintings in 1854, but after 1869 the portrait disappeared from city records. *Peale Papers*, 2:236n; *DAB*; *P&M*, p. 246; below, **162**.

 9. Harvey Lewis Sellers.

 10. The *Staircase Self-Portrait*.

154. CWP to Rachel Morris
PHILADELPHIA. SEPTEMBER 19, 23, 1823

Philadelphia Sepr.19.1823.

Dear Sister Morris

What shall I say to excuse myself for so long neglecting writing to you, and I must say that your last affectionate letter makes me feel my shame and mortification that I should from time to time postpone my intentions,[1] but as you say, a multitude of business was in fact the only excuse and a true one, waiving fu[r]ther apologies. I must proceed to give some detail of what I have been doing. After I had painted a whole length Portrait of my self by the request of Trustee's of the Museum I was for a long time almost wholly occupied in my labours to make Porcilean Teeth, tryal after tryal I found still deficiences either in composition or in the Enamel of them, even after making numerous essays, and yet altho' what I had made was not such as I wished to have them, yet they were still greatly superior to those made of Animal substances, and I spent a great deal of time to put togather and into use the best I had made, this of course caused me to do them over again and again. This was a loss of the materials as well as an abundance of labour, for I was still very desireous to serve my friends in the best manner and hastily as possible. I had also some perplexing business in the settlement with Craiger,[2] he appointed Persons to arbritrate in the business, yet always finding himself disappointed in his expectations, he still asked liberty to appoint others in his behalf, and as I never wished to deprive him of any thing he could reasonably expect, I yeilded to repeated tryals for him to get every advantage he might expect through his particular friends, at last it was of necessity that he should be bound to abide by determination of the persons appointed, this being done, the account was settled and he not being able to pay what he was indebted to me I took his note, as rather preferring to wait untill he could pay me. and I also favored him by taking the Rye he had sowed in lieu of 3/4 rent; by this I lost 1/3 of the rent. and now he is not expected to live, and I shall loose 80$ besides some articles he took with him when remooving—for I cannot distress Mrs. Craiger should she be left a widow. My next employment was to write lectures in Natural history with the view of inducing a taste and love for the works of an alwise creator—I thought I had abilities to deliver such lectures to some good effect for the promotion of the interests of the Museum, I wrote and delivered 3 lectures[3] yet I may be mistaken in my abilities of lecturing, but my friends say no, that the public have been tired out with Lectures of all kinds. I then went to Baltemore and to Annapolis for a few weeks relaxation. My perplexity to aid Rubens in his purchase of the Museum from Rembrandt, and I did all I was able to serve him expecting

I could sell his property and repay myself what I had advanced, at last finding I could not sell the House for near its value, and also a difficulty to rent the House and Gallery togather, and my desire to recommence my practice of painting, which I could not do satisfactory in 6th Street, I proposed to Rubens my purchase of this House, and realy I now enjoy many comforts by my various conveniences,[4] in the first place I converted the stable & chaise-house into a printing office and workshop. The dung-hole joining the stable I wawled up one half, brick filled up & put my furnace to fire my porcelain teeth, the other half I made a place to hold my Charcoal, with a trap door to it, the chaise-house doors made a petitician [partition] & door with a small addition of boards, thus I have a shop exclusively for my working at teeth and also as a store room for my Pamphlets &c. This my favorite room, I carry the Key of it in my money-pocket. Now I must give you an account of my last work—When at Bal-temore Rubens requested me to paint for him a view of a Stair-case, larger than that which I painted about 20 years past, and which has long been admired in the Museum, and to make my portrait in it. I have been constant at work at this picture for 5 weeks, and yesterday the Exibition of it commenced for Public inspection, and in order to produce gentele company I had notes of Invitation as the enclosed[5] sent to the all the respectable Inhabitants I could in a short time recolect, and the company is coming in to view the picture, this morning 13 artists[6] came to see it and evry one of them pronounced it to be the best picture which they had seen from my pencil, & what is extraordinary, every one is deceived by some part of the picture, the truth is that I had determined from the commen-cement of it to make as much as I could in it to deceive the Eye of a critical observer. The likeness is very striking, although I took a view of an exact front face, so that to make it like, the utmost power of light and shadow were necessary.

My object in having this picture seen, is to make it known that I am willing to paint Portraits, for I have placed in the Room my prices for portraits, and if a great number of the Inhabitants see my talents in this art I may have a chance of being imployed; at least I may get a few portraits to paint, which will be as it were a clear profit to me, as the Museum will pay all my present expences, yet it is not so productive as to enable me to clear off old scores so fast as I could wish, and I cannot yet find a purchasser for my farm, which would make me clear of all encumbrances, a very desire-able object at my time of life.

23d A great deal of company have been to see my picture, and by all that I can learn, it is thought to be an acstraordinary piece of art. but yet I have no calls for pictures, If I had been so fortunate as to have added to the exhibition a beautiful portrait of a handsome female, it [would] have a

good effect. however in a little time I shall produce some other work of my pencil, for it is much easier to paint a pleasing portrait from another person, than by painting self from a Mirror. Next month I must go to Maryland, for I wish to see this picture placed in Rubens's Gallery, as I may have occasion to retouch some parts of it, to make it suit its situation. And I have also an engagement to paint 6 portraits of the Governors of Maryland elected since the change of Government, they will be copies from pictures which I have formerly painted. One Copy I shall do here, perhaps I may find another in Mr. Delaplaines collection.[7] My Son Rembrandt has taken a House in Philada.[8] and intends to bring his family here in a short time, for he finds that N.York is a much more expensive place to maintain a family, than in Philada. Houseing is immensely high there, and their Markets are also not so cheap as here. He will travel to get employment and perhaps may go to London, for he has long been off the opinion that an Artist that has merrit will meet with more encouragement in London, than in this country, yet it is a risk, to go with his family there, of course he must go without them, And if he is successful, they will follow.

I see Betsey yesterday, and she tells me that her aunt will come to see my picture.[9]

Titians wife & child are both in delicate state of health. My daughter Sophonisba now enjoys pritty good health, and she has gone through a fateaging tryal by nursing her youngest son (Harvy) who had nearly departed this life.

I have not long since purchased a very large fish called the *Devil-fish*, it measures 15 feet across, and is 12 feet long. I have been waiting some time to get the Court room below the Museum to exhibit it, the Mayors court I hope will brake up before the last of the week, so that I have hopes of the use of the room untill the election takes place. I must now conclude in order to be in time for this conveyance. Accept the assurance of ⟨my⟩ the love

<div align="right">and esteem of your brother
CWPeale</div>

Mrs. R. Morris
 harrisburgh.

ALS, 5pp.
PPAmP: Peale-Sellers Papers—Letterbook 17

1. For CWP's last extant letter to Rachel Morris, HMP's sister, see CWP to Rachel Morris, October 16, 1822, P-S, F:IIA/67E12–14. Rachel Morris's letter to CWP is unlocated.
2. Samuel Craiger.
3. See above, **129**.
4. RuP's house on the north side of Walnut Street at the corner of Swanwick's Alley

between Sixth and Seventh Streets was a more comfortable house for an artist than CWP's previous home. It had been built by ReP in 1805 with special attention to his need for a studio and exhibition gallery. When RuP bought the house from ReP on April 22, 1808, he assumed ReP's three existing mortgages on the property and paid cash to ReP to assist him in his visit to Paris, for a total of $3,430. CWP paid RuP $5,600 for the property and immediately began to remodel the dwelling as described here. See *Peale Papers*, 2:881, 1183n; above, **73**.

 5. Unlocated.

 6. These thirteen artists cannot be positively identified.

 7. CWP did not copy any of his portraits of Maryland governors from portraits in Joseph Delaplaine's (1777–1824) collection, "National Panzographia for the Reception of the Portraits of Distinguished Americans," which was open in Philadelphia from 1819 to 1823. Above, **20**; *Peale Papers*, 3:578n.

 8. See above, **153**. ReP rented a residence together with his son-in-law, Dr. John Godman, but Godman is not listed in the *Philadelphia Directory* for 1823, 1824, or 1825.

 9. Elizabeth Morris, Rachel's daughter. The aunt is unidentified.

155. CWP to RuP

PHILADELPHIA. SEPTEMBER 23, 1823

<div align="right">Philada. Sepr.23.1823.</div>

Dear Rubens

 This morning I delivered your letter to Mr. Mead,[1] and told him that I would call again in one or two days to know his determination on the object of your address, he told [me] he had a fine Gallery picture which you might have, a large picture and he said a very fine painting, but it was with out a frame, and he had none to put it into, I told him that you put no picture into your exhibition without frames.

 I am glad that you have sent to Annapolis to prevent the picture from being rolled up, as you have well judged ⟨the⟩ it can very conveniently be sent on the deck of the Steam-boat, and I hope it will be put into a rough packing case—I have given David White directions this morning to make the 2 packing-casses for your picture—I have directed him to make the roller for the picture to be rolled on, 12 Ins. Diameter—and this roller will be very convenient to put the picture of Lord Baltemore on, at the end of your exhibition. Visitors come again & again to see this picture, and I received much praise for the composition and *keeping* of it. Mrs. Gibson[2] was here yesterday afternoon, and she told me that she came with the resolution not to be deceived, as she said she had heard that many were, nevertheless, she was deceived, and confessed it,

 I intend to try if I can mend the head next sunday, as I think I can by making use of a better mirror, a small one will answer my purpose, I dont know that I can materially mend it, *the Ladies say that I have not made it handsome enough.* I take it as a complement, the likeness is good—and

truth is preferable to the Eye of the judicious. I put some mastic varnish on the head last sunday, can I rub it off before I retouch the face?

I am now making Porcelain teeth, and I have moulded the composition in the plaster cast of your mouth, therefore it has a plug to enter into the hole left in your gum. and I put a piece of platina in the back of the tooth, to which I will solder a piece of gold to imbrace the adjoining teeth, they are in the furnace which I have left to cool gradually, perhaps before I close this letter I can examine it, and may add a few words. We are taking Delaplanes' pictures out of the Room and storing them in the Steeple, and Mr. Reed[3] says they may go back again after the Election is over— The Mayors Court is still setting, but I am told that it will be over tomorrow, even if it lasts the entire week, I mean to put the large fish (devil fish) into it and get at least one weeks exhibition of it before the election comes on.

Sophonisba is somewhat indisposed, and Harvy has now an intirmitting fever. I hope they will soon get well again, by taking the prepaired bark. Eliza has been very weak and is now recovering, the Child still unwell.

I have not yet heard from Rembrandt, he promised to write as soon as he could know his success in getting cash at Boston,[4] I am realy fearfull that he will suffer some afflictions before he can get his family settled here.

having examined my furnace I find your tooth well burnt, therefore I will put the spring & send it by the first safe conveyance, I can only add love to Eliza and children, Yrs. affectionately

CWPeale

Mr. Rubens Peale Baltre.

ALS, 2pp.
PPAmP: Peale-Sellers Papers—Letterbook 17

1. Unlocated. Richard Worsam Meade (1778–1828) was a Philadelphia merchant who owned a large collection of European paintings and sculptures. It is not known what painting he was willing to lend to RuP for exhibition, and he may have not lent a painting at all for the reasons CWP gives since there is no listing of a painting from Meade's collection in the extant Baltimore Museum exhibition catalogs. RuP was also hoping to borrow paintings from the collection of Charles Bonaparte of Bordentown, N.J. In a following letter (CWP to RuP, September 29, 1823, P-S, F:IIA/69C9), CWP indicated that RuP should not expect to receive these paintings "of eminant Masters that are esteemed of great value" since the owners of such works would not "relish sending them any distance, least they might meet with injury . . . in which case you [RuP] would not be able to pay the damages." *Philadelphia Directory* (*1823*); *Appleton's*; Baltimore Museum, *Catalogue of the Second Annual Exhibition*, ca. 1823, MdHi.

2. Elizabeth Bordley Gibson.

3. Joseph Reed. (See above, **20**).

4. ReP's *Court of Death* was exhibited in Boston by John Pendleton from August 21 to September 20, 1823. ReP hoped that the proceeds from this exhibition would help support him in Philadelphia while he painted his projected equestrian portrait of Washington. For the Boston exhibition, see above, **147**.

156. CWP to Nathan Sellers[1]

PHILADELPHIA. OCTOBER 5, 1823

Philadelphia Octr 5th.1823.

My dear Sir I have again to ask your aid by drawing a morgage on my farm Belfield. The directors of the Farmers & Mecanick Bank[2] say that as I am now an Old-Man that in case of my death they might have some trouble to recover the monies which I owe them, therefore they call on me to give them some security. my reply was that if I could sell my farm I would pay every Cent I owe in the world, but in the present time I cannot find a purchasher, at the value which I put on it. But I offered to give the [bank] a morgage on it.

It was proposed to me give them a judgement Bond.[3] I answer that I dont like judgement Bonds, for altho', I mean to pay them by a sale of the farm, yet my House in Walnut street in case I might desire to sell it, I could not in such a case—and I might get the sum I owe them by a morgage on the farm, yet I prefer my debt to the Bank because I have the power of paying 100$ at time, as my situation may enable me to do. I constantly keep money in the Bank to pay the Interest as it becomes due on the several notes when discounted.

It was my intention to have made Rubens pay this debt before he left the Museum, however when the offer of the Museum of Baltimore was made him, I wished to give him all the aid in my power to meet his engagements with Rembrandt. and I took on me a debt of 900$ of which I have only been able as yet to reduce to 700$. this is one of the notes in the Bank. and having paid many Bills for Rubens which his engagements with Rembrandt would not leave it in his power to repay me, therefore with a desire to live in a House convenient for my uses and be independent of a Landlord, I made the purchase of the Walnut street property.

And in fact I feel myself much happier so situated, as I have every conveniency for painting, and it is my intention to persue the Art, as being the best employment I can follow for the advantage of the Museum and of course for my family— my other amusement of porcelain Teeth will fill up my vacant hours. I am now prepaired to work for your daughter Ann, & those for Mrs. Sellers have also been ready for fitting, and hope she will soon make good use of them and continue to do so for a long period of time.[4]

Yesterday I sent the Picture of the Stair-case for Rubens on board the Packet. and I am prepairing to follow it to maryland, because I have engaged to paint 6 portraits of the Governors of Maryland for a whole length portrait of Lord Baltimore, (a Valuable picture in my estimation). I have finished one of the number,[5] from a portrait in my Museum most if not all of the other Governors I have painted in former times, and if I can

borrow them to bring with me to Philada. I would prefer it, otherwise I shall coppy them in Maryland as I am now prepairing Canvis to take with me for that purpose. as in duty bound I wish to be as expeditious as possible to complete my bargain with the corporation of Annapolis—who have voted that the portrait of Baltimore be sent to Rubens and ordered the expense of transport be paid.

My debt in notes to the Bank are 1900$ 1550$ 1150$ besides the assumed note of Rembrands debt to ⟨Snyder 700⟩ making a total of $4⟨3⟩600. 4600$

I have long wished to pay you a Visit but the picture of the Stair-case besides other business has keept me constantly employed. but after I have prepaired my Canvis I may probably—yet for the advantage of conveniences of doing the dentist business, I would rather work in my Tooth-Room.

present my respects to the family. yours with

much esteem. CWPeale

PS. as it is my intention to pay off those Notes, by the surpluss monny from the Museum income, or by what I may occasionally earn by painting &c how should I have notes of what I pay from time to time in notes of discount? The note in Snyders name I am most anxious to get rid off, and therefore all the money I can spare shall be applied to its first payment. ought not receipts be made on the Morgage Bond of what I may pay of the princapal, at least yearly? all this is submited to your superior judgement by C.WP—-e.

Mr. Nathan Sellers I wish to finish this business with
 much disptach as may be convenient
 to you. as I have to renew the
 last mentioned notes on the 10th &
 14th. instant.

ALS, 3pp. & add.
PPAmP: Peale-Sellers Papers—Letterbook 17

1. Nathan Sellers (1751–1830), father of Coleman Sellers, had retired in 1817 from his manufacturing and mercantile businesses to his farm Millbank in Upper Darby, west of Philadelphia. Eugene S. Ferguson, ed., *Early Engineering Reminiscences (1815–40) of George Escol Sellers* (Washington, D.C., 1965), p. 89.

2. The Farmers' and Mechanics' Bank was chartered in 1809 to provide financial services and support for Pennsylvania's farmers and artisans. See *Peale Papers*, 3:72n.

3. A judgment bond is a form of debtor's bond in which the non-repayment of a debt because of default or death results in forfeiture of a specific property—in CWP's case the Walnut Street house. *OED*.

4. Elizabeth Coleman (Mrs. Nathan) Sellers (1756–1831); Anne Sellers's dates are unknown. She was a longtime friend of SPS. See *Peale Papers*, 2:856.

5. *General William Smallwood.*

157. CWP to RuP

PHILADELPHIA. OCTOBER 5, 1823

Philada. Octr. 5th. 1823.

Dear Rubens

Last evening I put the picture of the Stair-case on board the Packet, which they told me would sail this morning, I requested the Master to forward them as soon as possible to you, as you wanted the picture for exhibition.

Eleonor and children arrived here yesterday morning, Rembrandt remaining in N.york to finish his Portraits—

To shew Eleonor the picture in the frame she assisted me, and a nail having been put to press the picture close at the top, by her pushing up the picture the nail rubed off some of the paint in the shadow of the upper panneling, Sarah[1] can easily repair it. Eleoner was delighted with the picture and said it is the best picture she ever have seen. Others have been lavish in praise of it—yet you must not expect to see a perfect work, but the best I have been able to give you. should any damage be done to the painting or the steps, by a little trouble it can be repaired at least when I shall be with you, which will be as soon as I can have some shirts made, now in Hands of Rachael Bowen[2] & my Grand daughter Angelica,[3] and some canvis prepaired to carry with me, for it is my intention to complete my engagement as soon as possible with the corporation of Annapolis, ?have you received the picture of Lord Baltemore? and what do you think of it? I had a strip of triangular form made to prevent a dark shadow being on the wainscoting above, which gave it the appearance of a disconnection, said strip is to be sprigged[4] to entrance frame. The Picture is to be placed to the best advantage in the N.W. corner of your Gallery, as the point of sight will be then from the center of the Gallery & I think also as to point of distance, at least the picture should not be seen at less than a sight line from the left of the frame, for passing to the right the entrance on the Stairs become crooked. the higth of point of sight is at my higth from the floor, as generally suiting the higth of other spectators. It is very probable that I may find occasion to alter some of shadows of the Steps when I am with you, for having painted them with more of a side light than was thrown on the picture when lighted by the skey-light here—yet I choose not to alter any part untill I could see it in your room. Miss Shippen[5] when I last see her intimated a disire to pay Eliza a visit, and asked me how long I would stay at Baltemore, my answer was that as I was engaged to paint for the corporation of Annapolis I could not determine, she said she wanted to stay only a few days with you, I told her that if I could not return so soon as she wished, it would be no difficult matter to put her under the protection of some person coming to Philada.

Now it will be well for you to let me know your sentiments of the subject of her visit, as early as possible.

I have not have been able to exhibit the Devil fish owing to the Mayors court being still in session, therefore I cannot exhibit it untill the general Election is over. It is no little mortification to me to find I cannot get the income which might arise from its exhibition to pay the money advanced by Coleman. But when I can get it before the public I will order that all the monies received be daily paid to him, for I have no Idea of placing it in the Museum until it shall have raised all that is due on it. Doctr. Michael[6] has made a flaming account of the fish obtained in N. York, I suspect it is a very exagerated statement, he has wrote a pamphlet on it, which I have not yet seen. However these things may help to call the attention of the Public when I can put my fish to Exhibition.

Moses has not yet paid any of his debt, and I have not pressed him to it, because I told him he should pay weekly when the fish should be exhibited. Mr. Wilson told me he wanted his money, my reply was that I expected to get it from Moses, but if he really wanted it, That I would pay it, he said no, He could wait longer, he was not pressed, but every one wants their own.[7] I am obleged to give a morgage on the farm to the farmer & mechanicks bank, the Managers say I am an old man & in case of my death they might have some difficulty to recover what I owe them, my answer was that I might very probably get the money I owe them but I prefered having the debt in the Bank as in that case I might pay 100$ at a time & thus by degrees pay off the debt. I have this morning wrote to my friend Mr. N. Sellers to draw for me the act of Morgage.[8] Love to Eliza & children.

<div align="right">affectionately yours CWPeale</div>

Mr. Rubens Peale
 Baltre.

ALS, 3pp.
PPAmP: Peale-Sellers Papers—Letterbook 17

1. SMP.

2. Unidentified. CWP employed three people named Bowen—two men and a woman—at Belfield from 1810 to 1820; Rachel Bowen may have been a female relation who sewed or did domestic work for the Peales. Daybook 1; *Peale Papers*, 3:80n, 241n.

3. ReP's daughter, Angelica Peale (Mrs. John) Godman (1800–59).

4. To fasten with sprigs, or light, headless nails. *OED*.

5. Margaret Shippen.

6. Dr. Samuel Latham Mitchill's essay on the devil fish was published under the heading "The Vampire of the Ocean." It related the story of the struggle involved in catching the ray between the capes of Delaware and New Jersey. Mitchill summed up his brief description of the fish with the comment that "the respiratory, motory, generative and sensitive organs present an extraordinary amount of rare and interesting particulars. Incomprehensible as well as wonderful are thy works, O Creator!" *Poulson's*, September 16, 1823.

CWP was influenced by Mitchill's article to change the heading of his newspaper advertise-

ment to read "Devil Fish or Vampyre of the Ocean" and to add the sensational detail that the ray "has a mouth amply sufficient to receive the bodies of two men." *Poulson's*, November 7, 1823.

7. There are no extant personal or institutional accounts for this period to determine the indebtedness existing among and between CWP and his museum workers. The payment and commission arrangements surrounding the exhibition of the devil fish are not known, although it seems to have been expected that Moses Williams would receive a commission, probably based on attendance at the exhibition.Moses had previously been given charge of various special exhibits at the museum, such as the physiognotrace and the perpetual motion machine, which he conducted on a franchise basis. That CWP should have to wait for Williams to make payments on his debt before paying William Wilson, an assistant at the Museum, indicates CWP's straitened financial circumstances at this time; the extent of CWP's indebtedness to Wilson is not known. *Philadelphia Directory (1823)*.

8. See above, **156**.

158. CWP to Joseph Brewer
BALTIMORE. OCTOBER 22, 1823

<div align="right">Baltemore Octr. 22d. 1823.</div>

Dear Sir

Having arrived here with the intention of doing my utmost to fulfill my engagement with the corporation to paint the first 6 Governors since the revolution, elected in Maryland & I have brought with me a faithfull likeness of General Smallwood, and not hearing from you in answer to my Letter[1] requesting to know whether I must send this Picture to Annapolis, or put it into the exhibition, now opened in My Son's Picture Gallery, at the option of the honorable the Corporation of Annapolis, I have borrowed a frame for it and it now is in said Exhibition, and last evening Mr. Graham[2] Son in law of Govr. Johnson promised me to send to me ⟨and⟩ a Portrait of the Govr. which I painted,[3] and said to be a fine likeness, this I shall copy here—and I propose visiting Annapolis ⟨by⟩ next sunday on the Steam-boat in company with Miss Shippen who is on her way to visit a relation at West river.[4] we expect a carriage will be sent for her about the time we shall arrive at Annapolis. otherwise I must hire a hack to convey her to West river, yet I have very little doubt that her relation be anxious for her arrival, and will not put me under the necessity of going with her. It will be very fortunate to find the portraits which I must copy without traveling to different quarters of the State, I expect that I must visit the Eastern Shore (Talbot County)[5] to get the portrait of Mr. Paca, and perhaps Mr. Henry.[6] that of Stone I expect to find in Annapolis.

I am desireous that the Corporation should order frames for these pictures, they ought to be made of a more lasting nature than frames commonly are made, yet they will not cost more, Oil guilding is most proper because they may be washed with water without injuring them,

and handsome frames of the size wanted do not cost more than eight or Ten Dollars each.

This will be the beginning of a very important collection, and I am anxious to make it as valuable as possible and I may hope to add some of my labours from living Charactors, as I now entertain the Idea that my abilities in the art advance in improvements with my age.

Please to make my respects to Mrs. Brewer & the family—with much esteem your

<div style="text-align:right">friend CWPeale</div>

Mr. J Brewer Esqr
 Annapolis.

ALS, 2pp.
PPAmP: Peale-Sellers Papers—Letterbook 17

 1. See CWP to Joseph Brewer, October 5, 1823, P-S, F:IIA/69D11.

 2. John Graham (1760–1833), who married Governor Thomas Johnson's second daughter Ann Jennings (1768–1851) in 1788, was a merchant, planter, and local officeholder who lived from 1788 until his death at Rose Hill Farm, Frederick, Maryland. Sellers gives Graham's middle name as Colin and identifies him as "Major." A modern authority does not list a middle name and gives the highest military rank attained by Graham as that of lieutenant in the Calvert County Militia (1778). *BDML*, 1:370; *P&M*, p. 113.

 3. *Governor Thomas Johnson and Family.*

 4. A bay or inlet on the western side of the Chesapeake Bay just south of Annapolis, Maryland. Edward C. Papenfuse et al., eds., *Maryland. A New Guide to the Old Line State* (Baltimore, 1976), p. 232.

 5. A peninsular county on Maryland's Eastern Shore, bounded to the west by the Chesapeake Bay, the capital of which is Easton. Leon E. Seltzer, ed., *The Columbia Lippincott Gazetteer of the World* (New York, 1952), p. 1867.

 6. For the portrait of William Paca, see figure 39. CWP did not paint a portrait of John Henry (1750–1798), lawyer, delegate to the Continental Congress, senator, and governor of Maryland for one term (1797–98). *DAB; P&M*.

159. CWP to RuP
PHILADELPHIA. NOVEMBER 16, 17, 1823

<div style="text-align:right">Philada. Novr. 16.1823.</div>

Dear Rubens

 The passage as usial short in the Steam boats, and it was not unpleasant, as it was not cold—being alone gave me leisure to recollect what I had done while absent from home and to make ⟨up⟩ out my journal[1] which I had neglected while in Maryland. therefore I sleept little, but amused myself in writing. but when I came to that part of my time employed at Lord Baltemore Picture, I found my memory is not to be trusted. I wrote and had [a]gain to correct what I had written. so much do I esteem the knowledge you gave me in the business of cleaning pictures, that had I

nothing else to induce me to take the journey to Maryland, that alone would be ample recompence for time and expences.[2] yet least I may not have fully described the process, I wish you to write me a letter and in it to repeat the process— Talking with Rembrandt and the necessity of using some active Vehi[c]le to take off the old Varnish and other dark colouring matter,[3] he tells me that the practice is to rub with the fingers, and that persons in the practice rub all their fingers of both hands and with palm of their hands until they often are very sore. They rub and wipe. I put the question, whether ly or soap may not be used with a proper precaution,[4] not leaving it on the picture, but having a spunge in readiness to wipe off, or check the process if found to do injury? you can probably know what Mr. Jones'[5] makes use off as a vehi[c]le.

I mentioned Rembrandt, he is here finishing a number of his Portraits began in New York, several of them are fine. He intends to put them in my picture Galery and I suppose he will invite company to see them, he says that an abscence of 10 years may ⟨be necessary to⟩ show that he is advanced in the art of portrait painting. He seems much more devoted to portrait painting than he used to be, This is natural enough when it happens that when the artist finds his success produces much applause.

The Devel fish was not put to any advantage, and it produced very little more than the expence of shewing it. I have now suspended it on a Gallows & varnished it, and tomorrow will appear an advertizement[6] that it may be seen at 12½ cents each. I have not yet determined whether it can be seen without applying to Wilson, or I may trust to the Hunter woman[7] who shewed Mr. Delaplane's pictures. I have purchased a handsome grate for burning Leheigh Coal and covered the floor with green baise, as preparatory to begining a portrait of the Mayor.[8]

Mr. George Patterson was here yesterday, he says that all is well at Chesnut hill. he wanted me to accompany him home, but the varnishing the fish &c. prevented me. Mary's[9] Work box will [be] sent to her by the next opportunity—James's daughters was too much occupied to finish it.

Titian has a slight attack of pleusery [pleurisy],[10] he has been just blead, and probably will be better tomorrow.

Rembrandts daughters have the Chickin-pox, 3 or 4 of the family are now sick.[11] I have my head stuffed up, but otherwise well. The DePeyster's Estate has given something to my Children about 70$ each[12] some more will be coming after a sale of some land, but they are unwilling to distress the Widow of James DePeyster, Gerard is not worth any thing, I understand that he is a poor miserable being—so much for intemperance, when will men learn wisdom? never while fermented and spiritous liquors possess intoxicating qualities.

I called to see Mr. Burd and he says that he is gaining flesh, that Mrs.

Burd is also mending in health—he inquired very particulary how you went on with the Museum.

Has the picture of Govr. Johnson come to you? and what do you think of it? I see by the criticisms sent to James that the distance to Lord Baltre. is only of a few numbers, I am anxious to know what the author will say on it.

17th. Titian is better this morning, yet not quite free of pain in his side.

I have determined to sell the farm and will be satisfied if I can get for it 12,000$ even includ.g the mill. for I find that Linnius will not mend his condition by keeping it. And now I only wait to know of him whether he wishes to continue a business which he says brings him in debt. I am very solicitous to relief myself from Bank debts— Coleman advises me to apply to Bonsel[13] to obtain money on a morgage on the farm and thus rid myself of Bank debts, for he says it is not a time to sell the farm, in the spring it will more likely sell.

<div align="right">

My love to Eliza and the girls. Yrs &c

CWPeale
</div>

Mr. Rubens Peale
 Baltre.

ALS, 3pp.
PPAmP: Peale-Sellers Papers—Letterbook 17

1. CWP's diary for this period is unlocated.

2. RuP's method of cleaning pictures is not known. CWP was impressed that with his method "the owners scarcely know their pictures." CWP to BFP and TRP, October 23, 1823, P-S, F:IIA/69E3–4 (misdated October 22 on fiche).

3. CWP was seeking an agent that would act as a solvent to remove or clean the layer of varnish that is overlaid on oil paintings to protect and preserve the colors. It is not known what solvent ReP discussed with CWP. *OED*; Mayer, *A Dictionary of Art Terms and Techniques*, pp. 294, 415.

4. Lye and lye-based soaps, common in the nineteenth century, were too strong and corrosive to have been used as cleaning agents for paintings. Mayer, *A Dictionary of Art Terms and Techniques*, p. 227.

5. Possibly William R. Jones, a painter and engraver active in Philadelphia from 1810 to 1824; he exhibited at PAFA. Groce and Wallace, *Dictionary of Artists*, p. 359.

6. See *Poulson's*, December 10, 1823.

7. Unidentified.

8. Robert Wharton. See above, **153**.

9. Mary Patterson.

10. An inflammation of the pleura, the two sacs of serous membrane on either side of the thorax that surround the respiratory system; it is frequently accompanied by fluid build up which probably caused TRP "pain in his side." Later, after he had been introduced by Charles Waterton to new taxidermic methods, TRP attributed this illness, which persisted for a long time, to the arsenic solution he had been using in preserving museum specimens. See below, **200**; *OED*.

11. In a later letter (below, **165**) ReP characterized the disease as the varioloid, a Spanish term for smallpox, so it is likely that his family had the disease itself and not some variant of it. *OED*.

12. See above, editorial note following **32**.

13. John Bonsall.

160. CWP to RuP

PHILADELPHIA. NOVEMBER 23, 1823

Philadelphia Novr. 23d—23

Dear Rubens

Mr. James Griffiths calling on me I am induced to write a few lines to state the situation of the family——Raphaelle has his baggage on board a Schooner bound to Charleston and will sail tomorrow or next day, he has one or two pictures engaged there,[1] this will serve as a beginning, I have been almost the whole of last week occupied in putting his Polygraph and painting apparatus in order he carries with him his frames and may get rid of some of them, tho' I fear many of them will only be a burden to him as of little worth.[2] He says that He now expects to make money, having rid himself of a load, as intends to be very industrous & prudent.[3]

And he will remit to me occasionally money to pay what debts he owes. Patty takes borders and she has 7 at present, but at a low price 2½ & 3$ Pr.week, those finding their bedding the lesser price. making the present amount 19$ p Week. and possibly she may make out to live, yet her Sons Charles & Edmond I much suspect will [be] a burden on her—[4] I told Raphaelle not to give me any trouble with her—as it is my absolute determination to do nothing for her. You know my sentiments of her disposition, and believe think with me that Raphaelle would have been a better man if she had conducted herself with kindness towards him. His natural disposition is affectionate and she had power to win him to noble actions had she willed it. Titian has had a serious illness & now rather in a ticklish state, Not intirely free from pain in his side. James comes & I close with love &c.

CWPeale

Mr. Rubens Peale.

ALS, 1p.
PPAmP: Peale-Sellers Papers—Letterbook 17

1. RaP's Charleston portraits are unidentified and unlocated.
2. These were the stock of frames RaP used for his profiles.
3. As part of his intention to make a new start, on October 18 RaP transferred ownership of his Philadelphia residence at 211 Powell Street and its lot, as well as two lots of land in Maryland, to his son Charles Willson Peale, Jr., (1802–29) for the nominal sum of $10. RaP retained residential privileges in the property, as did his wife Martha (Patty). His intention in making this transfer was to provide for Patty's support by permitting the rental of the property. The deed stated that Charles Willson Peale, Jr., was bound "after payment of the Debts now due and owing by the said Raphael Peale to pay to the said Martha All the Rents issues income and profits of the said Premises for her Support and Maintenance and that of the minor Children of the said Raphaelle." The transfer of RaP's property to his son was probably taken also to protect the family's property from seizure or suits for debts incurred by RaP. RaP, Deed to Charles Willson Peale, Jr., October 18, 1823, P-S, F:V/1E3–10; *Philadelphia Directory (1823, 1824).*

4. RaP's sons Charles and Edmund were twenty-one and eighteen, respectively. Sellers, *CWP*, p. 440.

161. CWP to Commodore David Porter
PHILADELPHIA. NOVEMBER 30, 1823

Philadelphia Novr. 30th. 1823.

Dear Sir

In the belief that you have a fondness for Natural history, I now address you. and your voyages into various and distant parts of the Globe much [must] have afforded you much pleasure in observing the wonderful Works of Creation; the infinite variety of Animal life found in the Air, on the Earth, but still more astonishing those that are found in the Ocean, as yet but little known by the public of mankind. Indeed it appears to me that by the aid of liberal minded men, fond off develloping these extensive productions of the sea's, and giving their assistance to naturalists capable of displaying a world in Minuature, that a new ⟨of⟩ view of the wisdom and power of the Creator will be made manifest, and also have a tendancy to make men wiser & better.[1]

In order to prese[r]ve my Museum from a division and consequently the destruction of it after my decease, I have obtained an Act of Incorporation, consequently it becomes a National Establishment, though located in Philada. Trustee's are annually appointed to see that that it is kept inviolate for the public benefit without injury to my family.

My health continues so good as to enable me to persue my labours of the *brush*, even without the use of Spectacles. and I may yet hope to raise my name as artist as well as a Naturallist, thus leave a monument of industry to my Country.

After this preface I ⟨will⟩ take the liberty to note the method of preserving articles of Natural history for the Museum. No doubt that among the many officers under your command some will take a pleasure in collecting and preserving interresting articles. Skins of Animals having the bones of the head and feet with the flesh taken from them, and some powdered arsenic strewed on them will be secured from vermin & decay. but very large ones may be preserved with Salt.

The skins of almost any birds or quadrupeds from the gulf of Mexico or West Indias, but particularly a bird known by the name of crying-bird,[2] are desireable.

Molluscous Animals & fish are very desireable (the former are commonly known by the names of Sea-flowers or Sea stars, Scuttle-fish, Sea Nettles, Portuguize men of War &c)[3] they abound in the west India sea's,

343

and are to be preserved by putting them into almost any kind of Spiritous liquor, all the larger kind of fish must be skined, but the very small ones keep best in Spirits & are least troublesome preserved in that manner. Shells are very desireable, those that have the Animals in them are preferable, and are best keept'd in Spirits.

Dear Sir, you devote your talents for public good, and may I hope that I do not ask of you an attention to the aid of natural history, that will be peneble [painful] to you? I wish you health and happiness in your ardent persuits for a great length of years, and may every blessing attend you in your perilous voyages is the

prayer of Your friend
CWPeale

Comodore Porter,
Washington

ALS, 2pp.
The Rosenbach Museum and Library, Philadelphia
Copy in PPAmP: Peale-Sellers Papers—Letterbook 17

1. CWP believed that as commander-in-chief of the West India squadron, Porter would encounter curious or exotic specimens that would attract visitors to his museum. He frequently solicited such assistance from sea captains engaged in voyages to distant lands. See *Peale Papers*, 3:635n.

2. The North American courlan, or limpkin (*Aramus pictus*), a long-billed tropical bird similar to the crane and the rail, is found in Florida as well as in Central America and the islands of the Caribbean. *A Dictionary of American English*, 2:692.

3. *Mollusca* are invertebrate animals found in oceans, such as snails and octopi; "Sea-flower" is a type of sea anemone, the name given generically to any of a number of polyps (*Actiniaria*) that resemble flowers because they show extended legs around a central mouth; *sea stars* are starfish (*stella*); *scuttle-fish* is an obsolete term for cuttlefish (*Sepia officinalis*), a ten-armed animal similar to the squid except that it has a calcified shell instead of a soft body; *sea nettle* is a common name for a number of radiate marine animals, similar but not identical to the sea anemone (*Acalphae*), all of which sting when touched; Portuguese Man of War is a large, multicolored *siphonophore* (commonly known as a jelly fish) of the class *Phyalia*, whose long, trailing beard of tentacles is poisonous. *OED*.

162. CWP to RuP

PHILADELPHIA. NOVEMBER 30, 1823

Philada. Novr. 30th. 1823.
Dear Rubens,

devoting a part of this day to writing I will give you some of my concerns & family affairs—

Raphaelle is about this time near the coast of South Carolina. I go, he said to me unincumbered, tho' poor yet with a good prospect before me I will be industrous and prudent and I hope to make money by this

undertaking. I gave him my best advice saying you may yet by temperance restore your powers of body & mind, but otherwise you will soon die in miserey.

Rembrandt has still a sick family one after another are going through a sort of small pox——

He had almost prepaired the Gallery to bring his pictures for Exhibition, when in steping from a ladder he trod on a nail which pointed up from a board which went through his shoe into his foot, fortunately it bent by touching the Sole leather which gave an oblike direction, or it might have been fatal—in the course of this week he will open his Exhibition of Portraits, and invite as I did the lovers of the fine arts to see them. They are of the higest finish, and I hope may invite some wealthy Citizens to encourage the fine arts, as such Portraits have not been seen in Philadelphia before this time.[1] The fish[2] although put at 12½ Cents, brings a[l]most nothing. The time is past that I might have paid myself for cost of it—And Rembrandt thinks it would not produce any thing worth the trouble of sending it to Baltemore—The cost of packing casses and transportation would be considerable, & to send it without being packed up, would be the distruction of the thin parts on the edges. Therefore I meditate puting it in the steeple and mentioning it amongst a collection of fish now prepairing to be put in classical arrangement in some additional Glass cases—now made on the side where the Monkies formerly was placed.

I have in forwardness the Mayors portrait[3] and shall finish it in 2 or 3 days, but the principal part of my time has been employed in prepairing Raphaelle's articles to carry with him, assisting Rembrandt for his exhibition and fitting out my painting-room with a stove for burning Coal, covering the floor with green baise &c &c.

I went yesterday to Mr. Hyle's[4] to ask him whether he would take your cream white.[5] he said he did not know whether it would sell or not. I could not answer either one way or the other, and I went to see Mr. Sully in the evening, and he said that he thought the white was excellent, and he wishd to purchase some of it, but he has no money, the lower pric'd cobalt blue appeared to him as the best, by one test he had made which was that it keept best under water which he said was given as a test for good cobalt he says that he likes those sparkling effects in it. although it is of a lighter colour than No.3.

Mr. Sully had spoken to Mr. Hyles about these colours, but he had not yet seen them, I mean to attend again on this business.

fearful that the Navigation may soon be stoped makes me wish you to send the Portrait of Ld. Baltemore & the other pictures, I mean that of Govr. Johnson & Miss Shippen's mother[6] as early as you can conveniently

345

do it. I will copy that of Johnson & send it to you if possible before the river is closed. I entend to write to Mr. Nicholas Brewer and state my Idea's of the importance of a collection of Portraits of the Governors of the state as exemplified by my collection of Portraits of distinguished charactors of the American revolution. That it will give me much pleasure to know that I have laid the foundation of a gallery of distinguished men in the City where I spent my youthful days.[7]

send me some Cobalt Blue with cream white as will amount to Ten Dollars, and I will pay to your order for that sum.

you may have seen in the papers that the dream of Love[8] and another painting by Rembrandt is burnt at N York, Those pictures Rembrandt had sold.

Tell me whether you can dispose of the frame which is to Genl. Smallwoods picture, as I must pay Mr. Pike[9] for it, at least 5$—for it was my fault the [that] it was injured in the transportation of it.

I do not recollect any thing futher to add at present, therefore conclude wishing you health and happiness, with love to Eliza and the Children.

<div style="text-align:right">subscribing your affectionate
father CWPeale</div>

Mr. Rubens Peale
 Baltre.

ALS, 3pp.
PPAmP: Peale-Sellers Papers—Letterbook 17

1. ReP announced the resumption of his residence in Philadelphia as follows:

<div style="text-align:center">

REMBRANDT PEALE
PORTRAIT PAINTER
</div>
Has returned to this city, after a professional absence of ten years. His Painting Room is at the corner of Swanwick and Walnut, near Sixth street.

Poulson's, December 6, 1823.

2. The "devil fish."

3. *Robert Wharton*.

4. William Heyl owned a drug and paint store at 35 High Street (*Philadelphia Directory, 1823*); for the Peales' previous dealings with him, see *Peale Papers*, 3:700n.

5. Cream white is probably a corruption of Cremnitz White, also Krems white, a variety of white lead pigment whose basic raw material is lead monoxide (litharge). Cremnitz white is a lesser used alternative to the basic opaque white pigment of *Blanc d'argent* or white lead (lead carbonate). Also known as flake white, it is one of the earliest manufactured pigments and the most basic and important pigment for oil painting. We do not know what RuP's mixture consisted of, but RuP long had an interest in developing artists' pigments. In 1810 he had started a company for the manufacture of chrome yellow, but was unsuccessful in its development. See *Peale Papers*, 2:3. Mayer, *A Dictionary of Art Terms and Techniques*, pp. 37, 98, 179, 430–31.

6. Margaret Shippen's mother was Margaret Francis Shippen (1735–94). CWP had painted her portrait in 1772 (*private collection*). When Miss Shippen transported the painting from the West River home of her relatives to Annapolis preparatory to bringing it to Philadelphia, the frame was injured, and CWP promised to repair it. See CWP to RuP, December 28, 1823, P-S, F:IIA/69G4–6; *P&M*, p. 194.

7. CWP's letter to Brewer, if he wrote it, is unlocated, but see above, **152**.

8. ReP's *The Dream of Love (Jupiter and Io)* (1813: destroyed by fire, 1823) was painted, according to ReP, as a challenge to those critics who maintained that no American painter could match the coloring that Adolf Ulric Wertmüller had achieved in his famous nude, the *Danaë* (1787). ReP wrote: "The imputation being chiefly against me, stirred up my pride, and I painted a picture, the size of life, to compete with it, which I thought I had a right to do, as I could not injure the deceased artist." ReP believed that his painting outshone the *Danaë* when the two were exhibited together: "I was satisfied with the result; especially as I found Mr. [Robert] Fulton, no ordinary judge, viewing my picture for more than an hour, and candidly declaring that he had seen nothing done since the days of Titian, to please him so well."

According to ReP, the idea for the painting came from "a slight but voluptuous composition of [Charles] Monnet." Possibly based also on Correggio's *Jupiter and Io* (ca. 1532: *Kunsthistorisches Museum, Gemäldegalerie, Vienna*), the painting depicted the mythological subject of Jupiter seducing the virgin princess Io. Both subject and treatment were so widely criticized that after its initial exhibition, ReP was forced to repaint the work, substituting a naked cupid for the head of Jupiter and retitling it *The Dream of Love.* In early November 1823, Rembrandt sold the painting; and soon after, while on display in New York City, it was destroyed by fire "from the carelessness of the exhibitor." *Peale Papers*, 3:332; ReP, "Reminiscences: Adolph Ulric Wertmüller," *The Crayon* 2 (1855):207; Michael Grant and John Hazel, *Gods and Mortals in Classical Mythology* (Springfield, Mass., 1973), pp. 244–45; Miller, *In Pursuit of Fame*, pp. 117, 141, 142.

9. Marinus Willett Pike, carver and gilder, maintained his shop at 39 North Sixth Street, Philadelphia. *Philadelphia City Directory (1823)*.

163. CWP to RuP

PHILADELPHIA. DECEMBER 18, 1823

Philadelphia 18th. 1823

Dear Rubens

It is now Thursday night and the packet with the 3 boxes not arrived,[1] but there is some hope that she will arrive with the morning tide. my principle object in this scrole is to request you to take care of the fram[e] of Ld. Baltemore's picture, for although you say it is wore thin as not to be worth painting it, yet by means of Putty and art it will be good frame, with guilding an elligant one——[2] I had been praising it to Rembrandt hence you may be sure that I am not alittle mortified to find that I shall not receive it untill the Packets run again. They are this day stoped—But a southerly wind at present may produce a favorable change of weather, giving here an Indian summer, it is a vain hope to expect goods being sent forward at so late a season. Your Exhibition in future ought to [be] held in the beginning instead of the last of October.

Titian is extremely ill, a 2d or 3d attack of Pleurisy. I went for the docter at 10 o'clock last sunday night, so violent was the pain that he could scarcely speak, he was bleed and thus got great relief & repeated the bleeding at noon the next day,—to day he has pain in his left side, the complaints before were on the right side, a blister is now on his side—he was also badly blistered on his right side—fortunately he has no cough.

Rembrandt's family are now well, some of them still confined to the House. His pictures are now on exhibition, but the wheather having been bad, of course but few visitors. I send a letter containing money to Eliza by post yesterday—from her sister Mary.[3] I believe she returned to Chesnut hill yesterday. Enclosed is a two dollar note the deficiency of money from her sister. My portrait of the Mayor[4] is much praised, and I hope that I am still making progress of improovement in my colouring.

We will be pleased in having the cream White—as by washing it to take all the gum out of it, it thuse will be equal to the *blanc d'argent* or silver white of Paris. Doctr. Troust says that the lead of which that white is made has no Iron in it, which is not the case with the other lead of Europe—but they put into the Cream-white a great deal of Gum which makes it as hard as it is generally found.[5] I am fearful that your cobalt blue[6] is not good—I wish to get some that can be prooved of good quality. as I find it is advantageous in the finishing of delicate complections—especially of the fair.

Mr. Wm. Meredith[7] inviting me and also Rembrandt last saterday evening to his *Wister Party*.[8] I thought it prudent to accept his offer, as I am in hopes he meant it to be a mark of consileation, and that he will in future be a friend to the Museum. his attention to me was particular. It is truely a shame that the City of Philada., I mean its public charactors, should so long neglect an Institution of such immence worth as our Philada. Museum realy is.

The income is very small of late owing much as I believe to the bad weather.

No application for portraits to Rembrandt as yet, he is painting a portrait of Genl. Washington that promises to be an impressing picture—my next will probably give you some detail on it. at present I must conclude with giving my love to Eliza & children.

<div align="right">Yrs. Affectionately
CWPeale</div>

Mr. Rubens Peale

ALS, 2pp.
PPAmP: Peale-Sellers Papers—Letterbook 17

1. The closing date of RuP's fall exhibition is not known. RuP was returning the items that CWP had loaned from the Philadelphia Museum. CWP advised RuP to send the paintings and frames in separate boxes. See CWP to RuP, December 28, 1823. P-S, F:IIA/69G4–6.

2. The portrait of Charles Calvert, Fifth Lord Baltimore, attributed to Herman van der Myn, was in its original frame. CWP received public praise for the skill with which he repaired and restored the portrait: "The picture is certainly an excellent one, and owes much to Mr. Peale; who, by dint of ironing, new stretching and cleaning, has rescued it for some years longer from the grasp of decay." *Poulson's*, November 26, 1823; *CWP*, p. 34; CAP.

3. Unlocated.

4. Robert Wharton.

5. White lead, a component of cream white, is refined by a method called the Dutch process, involving the corrosion of lead by acetic acid, or common vinegar. It would have been known to the Dutch mineralogist and geologist Gerard Troost, one of CWP's museum lecturers. Gum from a variety of natural sources is used as a stiffener or binder in holding together pigments. Mayer, *A Dictionary of Art Terms and Techniques*, pp. 37, 98, 179, 430–31.

6. Cobalt blue is a clear, bright blue permanent pigment; discovered in 1802, by 1822 it was widely used by artists. Mayer, *A Dictionary of Art Terms and Techniques*, p. 81.

7. William Meredith (see above, **3**) was the president of the Philadelphia councils; he seems to have been the member who opposed CWP's petitions to have the museum's rent lowered and to extend the institution over the proposed fireproof offices. See *Peale Papers*, 2:846n.

8. From 1815 to his death in 1818, Caspar Wistar served as president of the APS. In addition to his official duties, he held a weekly open house for both the Society's members and visitors to hear a paper and discuss scientific issues. After Wistar's death, the forum he provided for scientific discourse was formalized and continued by the Wistar Association. Attendance at the weekly parties continued to be drawn from the membership of the APS, and the task of hosting the Saturday evening event was rotated among the membership. *DAB; DSB.*

164. CWP to RuP

PHILADELPHIA. DECEMBER 20, 1823

Philadelphia Decr. 20th 1823.

Dear Rubens

Yours of 4th instant received this afternoon & instead of staying to take the receipts of the museum, I have prefered addressing to you a few lines, and you may say to Mr. Paca that I will make a copy of his grand father in the spring, and will do it as cheap as any one could do it, consistant with truth in the execution, that I do not like to leave my home during the winter season. but before I begin the copy I will by letter inform him as to price. I make no charge for my labour in repairing the original, only the cost of the streching frame as being absolutely necessary. The outer frame (Gilt) must depend on breadth of gilding &c. which is a matter of fancy.[1]

With respect to the opinion of Mr. Grayham about Govr. Johnson's portrait—I can put some apropriate obje[c]t for him to look on instead of his family.[2]

Rembrandt this day has opened the Gallery of his portraits, and tickets of invitation are gone forth today, probably he will have many visitors to the room next week—. The plan he addopts will very probably give him some work—in a frame is put his prices vizt, that he will paint portraits from 20 to 100$ and upwards— I should suppose the high finish of his pictures will make a good impression in favor of his portraits.[3]

all his Children have been affected with a disease very like the small-pox. they have passed the cricis and I expect now will in a short time be

well. I had a cape letter from Raphaelle dated this day week,[4] of course by this time he may have reached Charles town. I hope he will now make out better than he has for a long time past—

He promised to me that [he] would. hope is sweet.

Titian is not in good health. he now complains of a pain in his side—a favorable simtom is that he has no cough.

My portrait of the Mayor is approved off, but it will be much more so when finished. I shall work on Mr. Hares portrait tomorrow.[5]

It is now near X o'clock, so shall wish you a good night. Love to Eliza & Children.

<div style="text-align: right;">CWPeale</div>

Mr. Rubens Peale
 Baltre.

ALS, 2pp.
PPAmP: Peale-Sellers Papers—Letterbook 17

1. John Paca had requested a replica of CWP's portrait of his father William Paca (1772), which CWP had painted for the Annapolis Corporation (see fig. 39). There is, however, no evidence that CWP painted such a replica. *Peale Papers*, 1:115n; *P&M*, p. 154.

2. For his portrait of Governor Thomas Johnson CWP took the image of the governor from the family group he had done in 1771. Since the governor would no longer have a wife and children to gaze at, as in the family picture, CWP included a sheet of paper headed by the inscription "An Act/to . . ." in order to indicate Johnson's status as political leader of Maryland. CWP was pleased with the results of his work, and believed that Graham would be "much pleased when he sees the improvements" he made on the picture. He planned to write to Graham to suggest a frame for his painting, since "Pictures however well painted too often get into the garrett, and a picture of little merrit that has has a good frame will maintain its place in the Parlour." CWP to RuP, December 28, 1823, P-S, F:IIA/69F2–4. *P&M*, p. 113. See fig. 41.

3. ReP's exhibition of portraits was apparently not successful, and he seems to have received few commissions. At the turn of the year, he turned his attention instead to composing his Grand Manner portrait of George Washington (fig. 44). See below, **165**.

4. Unlocated. "Cape letter" probably refers to a letter left at either Cape May, New Jersey, or Cape Henlopen, Delaware, framing the mouth of Delaware Bay, the last landfalls reached by ships before they reached the Atlantic for the coastal passage to South Carolina.

5. CWP experienced difficulty in scheduling sittings of the chemist Robert Hare (*Peale Papers*, 2:1142n). The painting of this portrait had proceeded fitfully since it was begun in June 1822 (above, **73**). Hare was professor of chemistry at the University of Pennsylvania who had recently published his *Minutes of the course of chemical instruction in the Medical Department of the University of Pennsylvania*, 3 vols. (Philadelphia, 1822–23). *P&M*, p. 99; *DAB*.

165. ReP to Henry Brevoort[1]

PHILADELPHIA. DECEMBER 30, 1823

<div style="text-align: right;">Philada. Decr: 30: 1823.</div>

Dear Sir

Although I hurried from New York by bringing with me all my unfinished Portraits, my arrival here was not too soon—for scarcely had I got

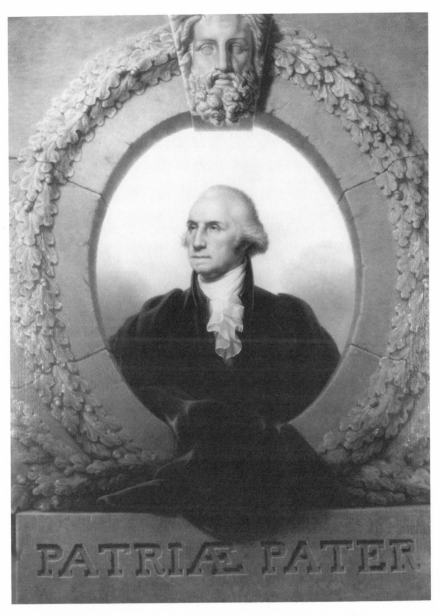

44. *George Washington (Patriae Pater)*. Rembrandt Peale, 1824. Oil on canvas, 59 ½ × 62 ½″ (151 × 159 cm). U.S. Senate Collection, Washington, D.C.

ready to paint at them, when my family, one after another, were seized with the prevailing epedemic, the Varioloid—And our house has been a Hospital for ten weeks past, including myself a great part of the time by a wound from a nail in my foot. Yet I have made out to finish 6 out of the 9 Portraits & to advance the remaining three.[2] But more particularly I have succeeded in making an excellent commencement on my great work, which was my chief motive for returning to Philadelphia—the Portrait of Washington.[3] Had I gone to Europe last spring, I should forever have lamented the omission— As it is, I shall accomplish an undertaking which no one else could or would attempt. There are only five Artists living who have painted original Portraits of Washington. He sat to Stuart, my father & to me in the year 1795. Trumbull did not see him for several years before his death, & my Uncle James Peale is only a feeble miniature Painter.[4] Some years ago I tried the experiment to combine the excellencies of these Portraits, assisted by Houdon's Bust—[5] my recollections of the original, and my Picture (rough & imperfect as it was) received the decided approbation of Judge Washington & other Critics.[6] With encreased ability & even greater ardour, I have begun the present work on an imposing scale—And have already convinced several of those who thought the thing impossible, that I shall fully succeed in producing a *Standard likeness of Washington*. It is my intention to take it to Washington City, with a design which I have sketched for an Equestrian Portrait.[7]

It was my wish & expectation to have finished these works before this time, but my delay in New York & sickness here have not only retarded me, but prevented other works that might have been accomplished. I hasten therefore to state to you the condition of my pencil and to beg the favour of a few lines by return of post, to inform me, what you will be obliged to do in relation to my Picture of the Court of Death in case I should not be able to (as I fear I cannot) remit you the sum, with its interest, for which I shall ever remain indebted to your kindness so promptly shewn. If you could possibly manage the matter so as to leave me the opportunity of reclaiming my Picture, which it would be a pity to have sacrificed, until the month of March, I should then know the amount of my means and my prospects.[8]

I ⟨*shall be*⟩ should be sorry to let it be supposed that the Interest (which is the natural growth of the Ar[t]icle & must be paid) should be considered as any remuneration for the favour—— Nor would I be satisfied that you should suppose me disposed to take advantage, under any circumstance, of your kindness, although I indulge the hope that a measure which will benefit me for a short time may not become disadvantageous to others.

Respectfully, Your much obliged

Rembrandt Peale

ALS, 2pp. & add.
NNF: Charles Allen Munn Collection

1. Henry Brevoort (1791–1874), a member of an old New York family, lived on his inheritance and his investments while pursuing interests in literature, the arts, and civic affairs. A patron of New York's American Academy of Fine Arts, he frequently lent his European paintings to Academy exhibitions. *Appleton's*; Mary Bartlett Cowdrey, ed., *American Academy of Fine Arts and American Art-Union*, 2 vols. (New York, 1953), 2:267, 296, 370, 404, 417.

2. The dating of ReP's New York City portraits is imprecise and, since he does not mention specific paintings, it cannot be determined which of the twenty-two portraits of members of New York's political, social, and cultural elite that he painted during the 1820s he is referring to here. ReP Catalogue Raisonné, NPG.

3. (Fig. 44.) Despite this rationalization for not going to Europe as he had planned, ReP did not abandon the idea of moving to England, where, he believed, he would receive greater recognition and patronage. See below, **178**.

4. The "five Artists living" when ReP wrote this letter included his father, Charles Willson Peale, his uncle, James Peale, Gilbert Stuart, John Trumbull, and himself. In 1795 Washington sat for the following portraits: Gilbert Stuart, *George Washington* (the "Vaughan" portrait, *National Gallery of Art*); CWP, *George Washington* (*New-York Historical Society*); and ReP, *George Washington* (*Historical Society of Pennsylvania, Philadelphia*; replicas, *National Portrait Gallery*, *Detroit Institute of Arts*). Washington also sat to Stuart in 1796. He sat to CWP seven times between 1772 and 1795. JP's portrait from the 1795 sitting has not been identified; he painted miniatures, half-lengths, and full-lengths of Washington, but probably only the 1795 image was from life. He also executed numerous copies of CWP's portraits. Trumbull painted at least four life portraits of Washington from sittings in February, March, and July 1790, which he incorporated in his history paintings: *The Surrender of Lord Cornwallis at Yorktown, 19 October 1781* (1787–ca. 1828: *Yale University Art Gallery*); *The Capture of the Hessians at Trenton, 26 December 1776* (1786–ca. 1828: *Yale University Art Gallery*); *The Death of General Mercer at the Battle of Princeton, 3 January 1777* (1787–ca. 1831: *Yale University Art Gallery*); *George Washington at Verplanck's Point, New York* (1790: *Winterthur*); and possibly *George Washington at Trenton* (1792: *Yale University Art Gallery*). CAP; Irma B. Jaffe, *John Trumbull: Patriot-Artist of the American Revolution* (Boston, 1975), pp. 314–315; John Hill Morgan and Mantle Fielding, *The Life Portraits of Washington and Their Replicas* (Philadelphia, 1931), pp. 115–130.

5. Jean-Antoine Houdon (1741–1828) took a life mask of Washington, as well as his measurements, in 1785. Using these he sculpted a terra-cotta bust (1785: *Mount Vernon Ladies' Association*) from which he made a plaster mold and at least one plaster cast. This cast served as the model for his numerous Washington sculptures in various media, including the full-length statue in the Virginia Statehouse.

ReP may be referring here to the version of the Houdon bust that Joseph Allen Smith loaned to Peale's Philadelphia Museum in 1805. ReP also recounted that he saw either the life mask or the terra-cotta preparatory bust when he visited Houdon's studio in Paris in 1808. H. H. Arnason, *The Sculptures of Houdon* (New York, 1975), pp. 72–77; Morgan and Fielding, *The Life Portraits of Washington*, pp. 89–113, 368–391; *Peale Papers*, 2:1174, 1174n; ReP, "Washington and His Portraits," F:VIB/20A9–10.

6. Bushrod Washington (1762–1829), nephew of George Washington, was appointed to the Supreme Court in 1798 by John Adams and served as an associate justice until his death.

ReP's experiments, previous to the *Patriae Pater*, in painting a portrait of Washington that would "combine the excellencies" of other portraits have not been securely identified. In his lecture "Washington and His Portraits" (ca. 1858), he said that he made sixteen such attempts in Philadelphia, all of which "found satisfied possessors."There is no contemporary documentation of these earlier composites. Numerous copies (undated) of Washington portraits after other artists, such as Pine, CWP, Trumbull, and Stuart, have been attributed to ReP. While some of these are the copies he made to illustrate his lectures on Washington portraits during the 1850's, others may be these early experiments. Eisen has listed eight

"trial portraits" by ReP, a few of which he described as containing elements from the Stuart and Trumbull portraits. One of these trial portraits is at Philipse Manor Hall, Yonkers, New York; another, at Baltimore City Life Museums—The Peale Museum.

Bushrod Washington's praise of ReP's early attempts has not been located. In 1817 ReP wrote that he displayed his 1795 portrait over the door of his painting room, and that Bushrod Washington confirmed his own good opinion of it. See below, **168**, for Bushrod Washington's approval of ReP's *Patriae Pater*. Also see *Peale Papers*, 3:468, 469; CAP; ReP Catalog Raisonné, NPG; ReP, "Washington and His Portraits," F:VIB/20A9–10; Morgan and Fielding, *Life Portraits of Washington*, pp. 368–91; Gustavus A. Eisen, *Portraits of Washington* (New York, 1932), pp. 408–16, plates 129–135.

7. *Patriae Pater* (fig. 44); *George Washington at Yorktown* (Plate 4; preparatory sketch, *private collection*).

8. ReP was not able to repay the loan in March, primarily because Congress postponed acting on the purchase of his *Patriae Pater* and did not commission his larger picture, *Washington at Yorktown*. On April 1, 1824, ReP again wrote to Brevoort asking his "forbearance until the Vote be taken at Washington . . . it will give you less inconvenience & pain than to Sacrifice my poor Court." It is not known when ReP actually repaid Brevoort's loan and redeemed *Court of Death*, but by 1828, the painting was back in his possession and was being offered for sale, through New York merchants Andrew Mitchell and Archibald Watt, at a price of $1,500. ReP to Henry Brevoort, April 1, 1824. Ms. Collection, Morristown National Historical Park, F:VIA/4A12–14; Miller, *In Pursuit of Fame*, p. 191.

166. CLP: Petition to Governor John Andrew Shulze of Pennsylvania 1823.[1]

To his Excellency John Andrew Shulze Governor elect. for the Commonwealth of Pennsylvania

The Memorial & petition of Charles L Peale Respectfully Sheweth That your Memorialist & petitioner from various untoward circumstances, oppressive to manufacturings, having enter'd into that bussiness from patriotic motives, to aid in the consumation of the Independence of his country, by rendering it less dependant on other nations, and to realise the speculative expectations of his ancestors who were propitio[u]s patriots in the Revolution; immersed the whole of his capital in buildings & Stock, for the purposes aforesaid,[2] and meeting with a discomfiture in his patriotic views, & losing much of his property as an officer in the Late war, he is now reduced to the necessity, by loss of Capital to ask of your Excellency, the appointment to the office of Clerk of the Court of Quarter sessions for the county of Philadelphia[3]

Your petitioner is authorized to hope, that the verity of the case as above stated together with the accompanying certificate,[4] subscribed to by his fellow citizens, setting forth his moral & political Character will be sufficient to guarantee the responsibility in the appointment and dignify the office, in the faithfull discharge of the duties thereoff

D, 1p.

PPAmP: Peale-Sellers Papers

1. This petition cannot be precisely dated but its reference to governor-elect Shulze indicates that it was written after the October election and prior to the new governor's inauguration in December. *DAB*.

John Andrew Shulze (1775–1852), governor of Pennsylvania from 1823 to 1829, although originally a Jeffersonian Democrat, tried to steer a neutral course among the contending parties for national political leadership. He was not a partisan of Andrew Jackson and the emergent democracy, however, and he tended to favor appointments of followers of John Quincy Adams. With Jackson's election to the presidency in 1828, Shulze declined to run again for governor and soon thereafter joined the Whig party. *DAB*; Robert Sobel and John Raimo, eds., *Biographical Directory of the Governors of the United States, 1789–1978*, 4 vols. (Westport, Conn., 1978), 3:1299–1300.

2. CLP's involvement in manufacturing was not extensive; the venture he referred to was his unprofitable and short-lived attempt to manufacture razor strops in 1820. How much he had invested in this effort at home manufacture is not known. CLP may also have been referring to the cotton mill enterprise he had carried on at Belfield with BFP in 1815 and later, during the winter of 1823–24, after his Colombian service. *Peale Family Papers*, 3: 342, 409, 723, 813, 824; see below, **169**.

3. CLP did not get this position. Since CLP later entered the Jacksonian fold, he may have been passed over for political reasons.

4. Unlocated.

167. ReP to Thomas Jefferson

PHILADELPHIA. JANUARY 8, 1824

Philada Jany. 8, 1824.

Dr Sir

The Artist who is devoted to his pencil seldom writes with his pen, yet I am induced to take up mine to inform you that my pencil, which of late was employed in the Court of Death, is now performing the mighty act of resuscitating the form of Washington. Although he sat to me for an original Portrait in 1795, and both my father & Stuart painted him in the same year, yet neither of these Portraits ever satisfied me, nor have they satisfied the friends of Washington—— Each possesses something good which the others do not, and each has its own peculiar faults. In addition to those materials, we have Houdons bust, which being made by a mask which was taken from the face of Washington himself, furnishes the exact proportions & the forms of the solid parts, tho it be defective in the expression of the soft parts.

My Portrait[1] is a composition from all these, taking my father's as a base upon which to build—because it is the only one that represents him with his peculiar & Characteristic cast of the head. And I have already advanced so far in it as to satisfy my father that it will surpass everything intended as a representation of Washington. In a few weeks it will be ready to take to the City &, if possible, it is my wish to pay you a visit with it,

355

because if it merit your approbation it not only would afford you some gratification, but your judgment would be of great service in establishing the accuracy of the work which is intended as a National Portrait & standard likeness.

There never was a Portrait undertaken with greater zeal And this is heightened to the extreme point by the conviction that this great work can be accomplished by no one but myself, as I am the youngest of those to whom Washington sat, & the only one who is not prejudiced in favour of his own portrait.

Stuarts portrait is full of dignity & character, but is certainly inaccurate in the drawing & exaggerated—& particularly defective about the mouth, which looks as if it was full of Water. My fathers, tho' expressive in the general Cast of the head & something peculiar about the eyes, is quite unfinished in all the lower part of the face. Mine is more detailed where his is deficient.

The Portrait I am now painting has a grand & imposing aspect & is calculated for public Buildings— But I have designed, to suit the same head, an Equestrian Portrait, with the hope of getting a commission to paint it for the National Hall.[2] This would be particularly flattering to me before I pass to Europe, where I contemplate removing next Summer— —indeed nothing but a large commission from the public can delay me. The Arts are not sufficiently encouraged here, whilst London offers everything to stimulate their professors to the greatest exertions. Three times, after visiting Europe, have I tried to be satisfied with the state of things at home——but commerce engrosses all attention—there is no Wealth, leisure nor fancy for the Fine Arts, And I long for a Society in which they are appreciated, employed & rewarded.

I shall be glad to hear that you approve my plan & shall be delighted to find you in good health, And to exhibit before you the result of my efforts

I remain

With great respect
Your much obliged
Rembrandt Peale

ALS, 3pp., add. & end.
DLC: Thomas Jefferson Papers
Endorsed: Peale Rembrandt. Phila. Jan.18.24 recd Jan.18

1. The *Patriae Pater* (fig. 44). By a "standard likeness" ReP meant a "perfect representation" of an individual that would through the artist's attention to external details reveal the sitter's moral character. Based upon both physiognomical and phrenological principles, ReP's "standard likeness" of Washington was designed to reveal the first president's nobility. See Miller, *In Pursuit of Fame*, pp. 146–47, 281–82.

2. The rotunda of the Capitol.

168. ReP to Bushrod Washington[1]

PHILADELPHIA. JANUARY 12, 1824

Philada. Jany. 12 1824

Sir

As the nearest relative of the illustrious Washington in whose character & fame you are so deeply interested, I have the pleasure to inform you that I am occupied in a work which is to revive the almost forgotten form of your venerated Uncle— Indeed the commendation which you bestowed on a former trial, tho' imperfect & unfinished, has greatly stimulated me to my present undertaking, whilst there are yet living a sufficient number of his relatives & friends who can bear testimony to the accuracy of a likeness which is intended for his Country and posterity.

Never was there a Portrait painted under any circumstances in which the whole soul of the Artist was more engaged than mine is in this of Washington— It has been my study for years, and tho' its final completion has been deferred to this period, it will, I trust, be found the more mature & worthy the approbation of the nation. There is a time for all things, And this is the moment for me, before the opportunity should have passed away for ever, *Now* that my command over the materials of my art is better matured, ⟨ *for the* ⟩ to accomplish⟨*ment*⟩ so difficult and important an undertaking as this National Portrait.

There are only five Painters living to whom Washington sat for his Portrait, the oldest of whom is my father, whose last portrait was painted in the year 1795, immediately preceeding the one executed by Stuart. He sat to me at the same time—and never looked so well afterwards. Trumbull's portrait was painted many years before; And this Artist had not seen him for many years prior to his death. The fifth Painter is my Uncle James Peale, who painted two miniatures of him. These Artists are all in the decline of life & feel no disposition to perform the task which thus necessarily devolves on me—the youngest & most enthusiastic—to correct the popular misrepresentations spread over the whole Country but which fall short of the countenance, character, mildness & dignity of the Father of his Country.

My father, who might be excused for preferring his own, is already satisfied that mine will be the **Standard Likeness**—And his approbation is the more gratifying to me inasmuch as he had studied Washington in painting eleven different Originals, besides a multitude of Copies—[2] Yet I shall submit my Portrait to you & other judges who will on so interesting an occasion pronounce without partiality to the Artist—And their judgment with yours will be the record that shall confirm the authenticity of the document which I am about to offer to the Nation.[3]

It is executed on a scale and in a style suitable for a public Hall—And I trust will be found worthy a place in the Capitol. It will be done about the 1st. of February & I shall do myself the honour to invite your attention to it as soon as it is conveyed to your neighbourhood.

<div align="right">

I remain

Sir

Your humble Servant

Rembrandt Peale

</div>

ALS, 2pp.
DLC: Miscellaneous Manuscript Collections

1. See above, **165**.

2. CWP painted seven life portraits of Washington—in 1772, 1776, 1777, 1779, 1783, 1787, and 1795. Many replicas, miniatures, sculpted busts, and copies were made from these, some of which ReP may have erroneously thought "originals." See *P&M*, p. 217.

3. Bushrod Washington, who was a Supreme Court justice, probably viewed the painting while it was on exhibition at the Capitol. He responded to ReP's letter with a testimonial, dated March 18, 1824, which ReP published in *Poulson's American Daily Advertiser* on March 27: "Sir: I have examined with attention and pleasure the portrait you have drawn of General Washington, and I feel no hesitation in pronouncing it, according to my best judgment, the most exact representation of the original that I have ever seen. The features, as well as the character of his countenance, are happily depicted."

169. CWP to CLP

PHILADELPHIA. JANUARY 14, 1824

<div align="right">

Philada. Jany. 14th. 1824.

</div>

Dear Linnius

I condole with you on the death of your Youngest and favorite Child,[1] I cannot object to your interring it alongside of your Mother,[2] yet I would wish you to think on the best mode of Burial to save expencies—*as*, if we reflect how little consequence it is, where we are laid in our Mother Earth. and in many religious Soci[eti]es we see much folly manifested on such occasions.

I send you five dollars—

<div align="right">

yours Affectionately

CWPeale

</div>

Mr. Linnius Peale—
 at the farm.

ALS, 1p. & add.
PPAmP: Peale-Sellers Papers—Letterbook 17

1. There is no record in existing genealogies of the birth and death of this child. Given the birth pattern of CLP's family, with surviving children born in April 1822 and February 1825, this unidentified baby must have been born in the summer of 1823, and it must have lived for only a few months. Sellers, *CWP*, p. 442; Peale Family Genealogy, Peale Family Papers files, NPG.

2. EDP was buried at Saint Peter's Episcopal Church, corner of Third and Pine Streets, the second church built in Philadelphia (1761). Scharf, *Phila.*, 2:1347.

170. CWP to CLP

PHILADELPHIA. JANUARY 14, 1824

> Half after 6 O'clock-evening January or 1st. Month 14th.1824[1]

Franklin having seen those who have the management of burials at St. Peters church, is informed that 25$ must be paid before they will give an Order to break ground—next comes, I suppose, the funeral charges— The cost of a Hack will not be less than 4$ perhaps 5 or 6. Dear Linnius I wish you to consider whether it is not better to avoid these expenses by burying your Child in the Garden on the South side of the Oblisk, a place which if I hold the farm untill my decease, I shall desire to have my body deposited. This has been my determination ever since I painted those inscriptions. And I now request you and others of my family to remember that I require them to observe this injunction of duty towards me. Connect that S. Distick[2] with your remembrance of your father

CWPeale

To Linnius Peale.
 at Belfield farm.

ALS, 1p. & add.
Recipient's copy: PPAmP: Peale-Sellers Papers
Copy in PPAmP: Peale-Sellers Papers—Letterbook 17

1. Occasionally, when writing to HMP, CWP followed the Quaker custom of denoting months and days by number instead of name. His reason for doing so here is not clear; perhaps he was associating death and burials with HMP's recent death. *Peale Papers*, 2:867, 868n.

2. A *distich* is a two-line verse that is frequently used as a memorial, epitaph, or inspirational inscription. CWP put a number of such verses on the obelisk in his garden. The *S* refers to the southern side of the obelisk, on which was inscribed: "Never return an Injury/It is a noble tryumph to overcome evil by good!" See below, **182**; *OED*; *Peale Papers*, 3:217n; *P&M Suppl.*, p. 39.

171. CWP to Eliza Patterson Peale

PHILADELPHIA. JANUARY 16, 19, 22, 1824

> Philadelphia Jany. 16. 1824.

Dear Eliza

I begin this letter to be in readiness to send by the first favorable private conveyance, as my Scroles are seldom worth postage, yet I endeavor to communicate all that enters my Noddle that occur at the time.

I have received Rubens's letter of 11th. Instant,[1] and as he has not sent the frames for Ld. Baltemore's & Miss Shippens Picture—I think it advisable to have them put into a packing case at the present time, and thus they will be in readiness to send by the french town line, when they will commence runing in the early spring. delays often create trouble. I am now painting Govenor Johnsons picture and it will be a valuable likeness to those who knew him & his worth. a stretching frame is making for Ld. Baltemore. to day I shall be employed to repair the painting of Miss Shippens Mother

A quaker Lady[2] gave me, just before Xmas a profile drawing of her brother, who had died at New Orleans, requesting me to have a profil cut from it. I promised to have it done by Moses— She gave me a great charge to take care of the drawing as it was the only one left of him, like but not so handsome. Rembrandt penciled the out line of it by tracing it. Moses happend to be busey and could not do it immediately, and proposed to me to put it into the money drawer, I put it into the back part of the drawer telling Mr. Wilson to take care of it. somehow or other the drawing was lost, it had been mooved from one end of the drawer to the other end, when the Xmas monies were received, but fortunately the enveloping paper which had the traceing on it was saved. To make all the recompense in my power, for my breach of promise was an imperious duty—I carried the profile cut by Moses to her and requesting her to give me a setting, as I thought I might improove the likeness of her brother, for in general we find the traits of family likeness's striking. The lady consented to set, and she offered to pay me for the profile delivered, and on my declining to receive it, she then said that she would not set. I told her that I wish'd her to allow me the tryal to obtain a better likeness of her brother, that when I had done so, I would comply with her wishes—she has set twice for my painting a miniature profile on Ivory, and it is becoming interesting to her and her friends, some little alterations to be made this day— I have not told her, that I lost the original— thus I hope to make my peace. 19th. having finished the Miniature, I put it into a frame and handed [it] to her, she asked me what she was indebted to me—

I asked her which she would rather have, the miniature or the drawing,—certainly the painting,—then my peace is made, for unfortunately I have lost the drawing, and it has given me much trouble & vexation; oh! she said it was not of much Value and I still claim my part of the bargain, which was that you would settle it to my satisfaction, true I did say so, but I am well pleased to find what I have done is satisfactory & that you pardon my neglect and let me enjoy the pleasure of reparation—she replied that she was very much obleged to me. some other complements passed—I have wrote enough of the subject—and all I mean to say fur-

ther is, that it ought ever to be a maxum with us, that when ever a charge is put on us, that we should not trust to a third person the care, but take special care to prevent what is called accident. for very sildom accidents will happen if we take a little *forecast*. The greater number of accident occur through carelessness.

Linnius has lost his youngest child, I had visited them one or two days before when they told me how good a child it was, always in a good humour—it was fatt and rosey—It complained one day and died the next, on examination by the Doctr it was found to [have] an inward gathering, supposed to have been caused by throwing it up and catching it coming down, as if very often practiced. Linnius wrote a note[3] to me requesting my approbation of his having [it] intered along side of his Mother in St. Peters church yard, I answered him[4] that I could have no objection, but that ⟨all such⟩ he ought to avoid all unnessary expence. after this he told Franklin, to send out a hack, and give notice that it would be buried 4 O'clock next day— Franklin went to give the orders, and he was informed that 25$ must be paid before they would give an order to have the ground opened. I then wrote a note[5] to Linnius with my advice to bury it on the southside of the oblisk, a place where I ment to have my body laid if I possess the farm at my decease, this has been my determination ever since I wrote those inscriptions, and now I request you and others of the family to observe this injunction of of duty towards me. Connect that S. distich with your remembrance of your father C–WP–e. The inscription aluded to is, *Never return an Injury, it is a noble tryumph to overcome evil by good!*

He has complied with my advice. good night. 22d. you see my remembrance of you by my continuance of this scrole from time to time. and by this procedure you will get our transactions as they occur. This evening I expect the printer who has generally assisted us, will pass through the press the 2d and last sheet of a work which I hope will be advantagous to the Philada. Museum.[6]

I might give you the description & Title of it, but as I hope you will receive it with this letter, it is unnecessary to do so, I have sold all the cream white & have only to get the cash from Mr. Doughty[7] and the last delivered to day to Mr. Neagle[8] which is only $3^{1}/_{2}\varpi$. I expect that he will like it so well as to purchase more if Rubens will send it. I mean to send the ballance of Cash for what I have sold by the first oppertunity.

I have taken the Mastic Varnish from Baltemore Portrait and I expected to get much lam[p]black[9] by washing, as it must have been much smoked by the candles in the Ball-room. simply washing it with cold brings away very little of it—and whether I ought to venter to use other means is rather doubtful. Rembrandt has a phamplet directing the french method

of cleaning pictures, when I have perrused it, I shall proceed with the work.[10] one thing I am certain is of importance, in the repairing a picture where there are parts that the paint is wanting, we must only paint in those spots, but never let the new paint pass over the old colour, I have formerly done it with my fingers, for however well it may look at the moment, yet after some time that colour changes darker. & thus it shews that the picture has been repaired. I would not fill your letter with these remarks, but as it is ment for information to Rubens.

We have just completed the printing [of] a journal. we hope it may promote the interest of the Museum, at any rate, this first essay may lead some few to turn their attentions to the subject. And if the subscribers are sufficiently numerous to defray the expence, I shall save the expence of advertizing, which hitherto has been rather oppressive, except in a very few instances.

I find that having it done in this office, it is rather troublesome and is too great a sacrifice of my time. It will be better to give the work to some printer who will do it at a reasonable profit. yet although it is not done here, the employment of another press, it may be considered as coming from the Museum press, as being a press imployed for the service of the Museum.

the other day, he [Rubens] wanted to know the name of the Blue used to paint the bird boxes. *Blue Verditer*, it is a cheap colour and answers very well in water colours though of a light colour. it is easily ground, but where very dark greens are wanted, Prussian Blue & amber is necessary—Dutch Pink is the yellow that we use as it is bright and answers pretty well, yet it is not a lasting colour.[11]

It is so long since I began this letter that now I forget what it contains, therefore I think it time to make a finish of it. I was enquiring of my brother for an opportunity of a safe hand to send what money I had received for the Cream White when he told me that Anna was to send him Cash, therefore I told him to write and I would give him twenty dollars. I hope this find you in good health with an addition to your family. Love to the children yrs. affectionately

CWPeale

Mrs. Eliza Peale
Baltre

ALS, 4 pp.
PPAmP, Peale-Sellers Papers—Letterbook 18.

1. Unlocated.
2. The Quaker lady and her brother are unidentified, and the miniature that CWP painted to compensate for the lost drawing is unlocated. *P&M*, p. 258.
3. Unlocated.

4. Above, **169**.

5. Above, **170**.

6. The first and only issue of *The Philadelphia Museum, or Register of Natural History and the Arts* appeared in January 1824. The publication was designed to appear twice a month, at a subscription price of two dollars a year. In its introductory note the editors (CWP, BFP, and TRP) wrote: "The object of this paper, is to diffuse a taste for the study of Natural History, as well as those delightful arts which contribute so much to the improvement and gratification of the mind" (p. 14). Among the items included in the first issue were "A Sketch of the History of the Museum," a note on the "Maternal Affection of the Bat," "Interesting Facts Relative to the Opossum," "The Fine Arts," and a poem, "The Court of Death." The editors noted that "The appearance of the second number, will depend on the manner in which the first is received." Apparently the public was not receptive, since no further issues were published. DLC, F:XIA/17; *NUC*.

7. Thomas Doughty.

8. John Neagle.

9. Lampblack is a carbon pigment derived from burning substances and collecting the powdery residue. Mayer, *A Dictionary of Art Terms and Techniques*, p. 209.

10. The pamphlet is unlocated, and the "french method" not known.

11. Blue verditer is a light blue pigment made from a mixture of chalk and copper nitrate; it is used especially in watercolors. Prussian blue (ferric ferrocyanide), discovered in 1704, is a deep blue pigment with a green undertone. *Amber* refers to a yellow-gold tint, not to the resin itself, which is not used in painting. Dutch Pink is a golden yellow pigment made from buckthorn berries; it is used in decorative painting. Mayer, *A Dictionary of Art Terms and Techniques*, pp. 13, 121–22, 316–17.

172. CWP to RuP

PHILADELPHIA. JANUARY 18, 1824

Philadelphia Jany. 18th.1824.

Dear Rubens

Having heard that Mr. Mayer[1] goes to your City next Monday, I shall endeavor to give you all the interresting occurrences that come into my Noddle between this & tomorrow forenoon— In the first place, I got through my labour of the transparent painting[2] in good time. having painted a part of the dark ground in the afternoon of the last year, I thought to give it another coat at 2 O clock but I found that my Colours was not sufficiently dry, therefore I determined to rise at 4 O'clock the next morning— I waked at 12, then determined to take another nap, and waked at 3/4 after one, I thought my clock might deceive me, and I went to Titians room to look at it by his night-lamp, that was the time, and feeling indisposition to sleep, I dressed myself and finished what I wanted done in about one hour, I then shaved and changed my linnen, and amused myself in doing several things that I wanted done & thus beguiled the time till daybreak and after breakfast retouched and had Rembrandt to assist me in retouching the picture, and had it carried to the Museum, it did not fitt well to the window it was alittle too wide, with Franklins aid

363

[I] reduced the stretching frame—and finally fitted it nicely—but unfortunately it rained incessantly the whole day and night which doubtless prevented many from visiting the Museum. and considering such a stormy day, I have no reason to complain. I will give you the amount of what I had received that day and also at Cristmas, on the next side, but what I ment to remark by thus giving you these particulars, is, my surprise that I felt not the least fateague during the whole day & night. I realy expected to feel some lasitude or want of sleep, I realy expected that I would have had some uneasiness, but in fact I did not—reasoning it I am more & more convinced of the great importance of temperate living—every day of my experience tells me how important it is to stop eating at the moment the *craving* ceases. masticating the food well which mixes the saliva with it, and thus produces a much easier digestion of it. I find I can [illeg] my [illeg] traction on the best means of preserving health. Christmas Day gave for the day 142$ and at night 195.25. On New Years Day 20—also at night 25—and when the weather has not been extremely bad—the visitation is tolerable.

I have spoken of my situation with respect to my pecuniary affairs [to Rembrandt] with the feelings [illeg] to me, that it distresses me to be in debt that I could not sell the farm without a sacrifise of it and have spoken my mind thus earnestly, that I could not assist any of my Children let their troubles be what they may, [until] I had unencumbered myself from all debts, and my answer for this language was less I might not be called on to aid them. my language being strong I doubt not induced Rembrandt to propose the following, whether he thinks that I am incapable of managing my own concerns I cannot say & that trouble will affect my health. I can appreciate such a motive vizt: 1st. Trustees to be appointed who will zealously & resolutely perform the duties enjoined on them. 2. It is proposed to allow the Trustees [] PrCent on the Income of the Museum. 3. A special power of attorney to be given to the Trustees to [act on?] all the concerns of C.W. Peale. 4. The Trustees shall secure to C. W.Peale [] dollars P Anm. the capital of which to be insured. 5. This capital, on the demise of C.W. Peale, to constitute part of a sinking fund, for the permanent improovement of the Museum. 6. On the above principles the Bond given by C.W. Peale to be cancelled and the Stock to be their property, subject of course to the above regulations & those of the act of Incorporation.

This was given me for mature consideration, and I was requested to, send a note of thanks to the present Trustee's and thank them for their services, and then to appoint others, at least some others. having not some of the Gentlemen who scorned to take the least interest in the Institution. This measure was totally repugnant to my principles and I gave it a rebuff

directly. These Gentlemen I had solicited to accept that Office for me, and as my principle now is, *to offend none*, I think not [to] offend them, by such an abrupt dismissal. some of the 5 Trustees are perhaps more attached to the interest of the University than the Museum and some of them may not like to take much trouble to promote the Interest of the Museum. and if they decline to serve when I shall call for their aid, I may then try to interest [them] in it to be more active— It is surely high time to obtain some aid from the Corporation, if the Museum is of value to this City — I shall make every exertion in my power to render the Museum usefull and attractive, and expect all the help this family can give me, but the management I think will at least for a time, be best in my hands, and also be better for the family generally. I am lessening the demands on me— I have sent word to two old maids at germantown[3] of whom, when on the farm, I obtained 300$ on Interest, that I have the cash to pay off the bond, but at present so much engaged that I cannot leave the City. ⟨at present⟩

Linnius is waiting to know the effect of his application to the Govr. for the clerkship of the mayors court[4] and he tells me if that fails him that he has a chance of getting imploy as a clerk in another quarter worth 6 or 700$ pr.yr. any thing is better than his present situation, for the mill is not going, he says, it brings him in debt. Rembrandt has a prospect of some work—Mr. Strickland[5] has told him that he has the intention of getting him to paint a portrait of himself.

I think it very extraordinary that scarcely any visitors come to see his pictures, although he had sent out many printed invitations.

I have paid 1.50 for the return freight of James Peale's picture[6] also 5$ to Mr. Pike[7] for the frame, you have not told me that you would take it at that price? I mean by letter—I remember your saying you would give that sum for it when I was with you. I am getting some of Moses debt to you, and its' my intention to give you a general statement of both accounts when I have got the cream white.

Doctr. Godman is now putting the printing office[8] in order and very probably I shall have some benefits from the use of it. My portrait of Govr. Johnson will be an excellent likeness, and as soon as it is compleated, if the conveyance is feasible, I shall send it to you.

Rembrandt is painting a portrait of George Washington which will be a very fine and powerful picture. He makes the likeness from his picture and mine painted when the general was *Pealed all round* as Stewart termed it,[9] [also] from Stewarts picture & the Bust of Houdon. It is larger than life, I must not describe the demeanour of the picture and shall only say it is an imp[osing] one.

A desendant of Lord Baltemore was in Rembrandts room the other

day, and told him, that if the picture I had was the old Lord that he would desire to have a copy of it. I suppose this must have been one of Mr. Calverts family, I was intimate with Mr. Calverts family when there was a numerous family of Children, living near the town of Malborough called upper Malborough.[10]

I have now touched on such matters as have occured to my mind and while writing this morning (7 [a.m.?]) and expect daily to hear from you— I have had some little fear that you [would] not be pleased at some of my late letters as they might imply that you had been neglectful of doing what I had desired of you—but it is a fact that you do more work than I thought it possible could be done by an individual, and I believe you often suffer in your health by such close and constant occupation. I wish you could enjoy as much good health as I have.

Further matter must be reserved for another letter

Love to Eliza and the Children
yrs affectionately
CWPeale

Mr. Rubens Peale
Baltre

ALS, 4pp.
PPAmP: Peale-Sellers Papers—Letterbook 18

1. Andrew Mayer, coach and sign painter, whose shop was at Budd and Poplar Streets. *Philadelphia Directory (1824)*.
2. See above, **164**.
3. Unidentified.
4. See above, **166**.
5. In 1824 the architect William Strickland was engaged in a number of projects in Philadelphia, including his important Second Bank of the United States building (now the portrait gallery of the Independence National Historical Park). There is no evidence that ReP painted his portrait. *DAB*; ReP Catalogue Raisonné, NPG.
6. See above, **163**.
7. Marinus Willett Pike.
8. The room that contained the museum printing press, which permitted CWP to publish *The Philadelphia Museum* in-house.
9. Presumably Mrs. Washington described to Gilbert Stuart the scene in CWP's painting room when all the Peale artists—CWP, ReP, RaP, and James—were taking his portrait in 1795. Stuart is reported to have replied that she should look out for her husband, for he stood in danger of being "Pealed all around." *CWP*, p. 276.
10. Unidentified. For CP's and CWP's relationship with Maryland's prominent Calvert family, and especially Benedict Calvert's participation in the group that sponsored CWP's trip to London to study art, see *Peale Papers*, 1:24, 57, 58. CWP painted portraits of two of Benedict Calvert's children, Eleanor (1779: *private collection*) and Charles (1773: *Maryland Historical Society*). See Robert J. H. Janson-La Palme, "Generous Marylanders: Paying for Peale's Study in England," in Lillian B. Miller and David C. Ward, eds., *New Perspectives on Charles Willson Peale* (Pittsburgh, 1992), p. 23; Karol A. Schmiegel, "'Encouragement Exceeding Expectation': The Lloyd-Cadwalader Patronage of Charles Willson Peale," in ibid., p. 54.

173. Thomas Jefferson to ReP

MONTICELLO, VA. JANUARY 19, 1824

Monto. Jan. 19. 24.

Dear Sir

I recd yesterday your favor of Jan. 8.[1] on the subject of the portrait of Gen. Washn. on which you are engaged. from the circumstances of the corrections needed by all those which have been heretofore taken, and the views you give of them, I have no doubt you will produce one peculiarly worthy of the original. The visit you flatter me with would indeed be a most welcome one. I should hope to shew you in turn something in the fine arts not unworthy of being seen. I mean our University, under view from this place, which exhibits some very chaste models of Grecian architecture, and an arrangement ⟨illeg⟩ exhibiting them to good advantage,[2] but that you should take the trouble of bringing the portrait with you, is scarcely admissible; and the less as it could answer no useful purpose to yourself. in the case of historical paintings which few in this country have had oppties of being familiar with, their judgment may be influenced by that of others, but in that of portraits, every one judges for himself, is positive in his judgment and yields nothing to that of another. my opinion of it therefore were I to presume to offer it, could be of no weight with others. I believe you are right in proposing to go to Europe for the exercise of your art. This is certainly not a country for a fine artist. we have genius among us but no unemployed wealth to reward it. the numerous families of our country prevent ⟨the⟩ accumulation ⟨of wealth⟩, and turn whatever we can get into the channel of providing for ⟨our children⟩ them. be so good as to present me affectionately to your father. & to accept my best wishes for your success and welfare.

Th:J

Rembrandt Peale

ALS, lp., add. & end.
DLC: Thomas Jefferson Papers
Endorsed: Peale Rembrandt. Jan.19.24.

1. See above, **167**.
2. By *Grecian* Jefferson meant classical antecedents in general, not just Greek influences. For instance, the Rotunda building, the centerpiece of Jefferson's academical village, was modeled after the Roman Pantheon. In his design and plan for the University of Virginia, Jefferson adopted classical sources as mediated through European architecture of the Renaissance and later. His sourcebook was Roland Reart de Chambray and Charles Errard's *Parallele de l'Architecture Antique avec la Moderne* (Paris, 1766). At this writing, construction at the university was more or less complete. The rotunda had opened in November 1824, completing the plan, which had it flanked by pavilions encompassing the central lawn. *OED*; Richard Guy Wilson, ed., *Thomas Jefferson's Academical Village: The Creation of an Architectural Masterpiece* (Charlottesville, Va., 1993), pp. 16, 29–32, 44–45.

174. CWP to Thomas Jefferson
PHILADELPHIA. JANUARY 25, 1824

Philadelphia Jany.25.1824.

Dear Sir

Although it is a long time since I have wrote,[1] yet be assured that I very often think on the favors you have confered on me at various periods, and could I have been so fortunate as to think I could add a moment of pleasure to you I should have embraced the occasion. But absorbed in the various labours of the Museum, the attentions of duty to a large family, that look to me for aid on every emergency—as being the Elder of a numerous progeny, has very often perplexed me, but now, having viewed life with its blessings & counter parts, I am endeavoring to command my passions as much as I am able, and to be thankful when I can do any good & to disregard the evil which I cannot prevent. which I consider as a very essential means to preserve my health, and I am thankful for the enjoyment of a great share of it. I am often saluted by many acquaintance, as one of the greatest curiosities belonging to the Museum. some of my last portraits are much admired, some Criticks say they are the best pictures they ever had seen, but then come afterwards, *considering as being done by one of my age.* Thus the reward of praise is softened down to almost nothing— It would seem strange indeed to me, if improovment did not get aid, from reflection and long experiance in an art depending so much on mental faculties. But it ought not to be overlooked that I have a Son (Rembrandt) who possesses more knowledge in that essential part of the art of painting, colouring, than any other artist, at least in America, if not all in Europe, but of the latter I can have no knowledge, except by occasionally seeing some essays, and those perhaps by inferior artists. The Journal of the Museum accompanying this, notes his work in likeness of Washington,[2] and I will venture to pronounce it the best portrait ever painted of that great Man, and I realy believe that I have as perfect a knowledge of his visage as any man can have, for he favored me with numerous settings, commencing from the year 1772. If my son can command cash for the expence he will carry this portrait to Monticella for your examination, before he makes any public exhibition of it— I cannot perfectly agree with him in this proceeding, as in all probability if this picture is brought into public notice, I think the manner of it is so impossing and so perfectly adapted for a Public building, or I would say for a chamber of congress, that when seen by men of influence, that there will be a demand for the ⟨*Presidents*⟩ Portraits of the succeeding presidents, in which case he must wait on you. Allow that I have a partiallity for my Sons

talents, yet I much [must] refer you to the opinion of Mr. Bocken-bourough[3] who has seen this Portrait and can describe the manner of it. My Son in law Coleman Sellers introduces that gentleman to us, Coleman being an extraordinary genus in Mechanicks has so improoved the means of extinguishing fires, that the Citizens of Philada. have little to fear from conflagration when duely noticed. His invention carries the water directly into the flames, when by former Engines the water was wasted in air.

I congratulate you on your success in the formation of a great semenary at Charlotteville. I have seen the ground plot presented to my Son Remt. by Mr. Bockenborough, and as far as my conceptions go, it appears to be judiciously planed and doubtless will be a credit to Virginia.[4]

My Museum progresses in utility, yet [I lan]guish in the want of some great influential character, who would be active, to produce a Building capible of being extended with its increasing subjects and usefullness. but as I have said before, I must not be troubled by that which I cannot controle. I have made the beginning, and posterity may build on it to magnificence. The pleasure of tracing the wonderous works of Creation have amply rewarded me for all my labours—

<div style="text-align:right">Dear Sir, that you may long enjoy
Health and happiness is the
prayer of your friend
CWPeale</div>

Thomas Jefferson Esqr
Monticella.

ALS, 3pp., add. & end.
DLC: Jefferson Papers
Endorsed: Peale, C.W. Jan.25.24 recd. Feb.6.
Copy in PPAmP: Peale-Sellers Papers—Letterbook 18

1. See above, **113**.

2. The item on ReP's *Washington* in *The Philadelphia Museum* (pp. 13–14) was a reprint of a notice first published in *The National Intelligencer*, December 19, 1823:

> A letter from a gentleman at Philadelphia, says— "Mr. Rembrandt Peale, the author of the Court of Death, has been for some time engaged in painting a portrait of "the Father of his Country," the great Washington, which in every particular bids fair to give the most admirably correct representation of the *character* and *expression* of this illustrious man, that has ever yet been offered to the world. To understand how he can do this, it is sufficient to know that he is the youngest of the living artists (of whom there are only *five*) that ever painted an *original* portrait of Gen. Washington. Stuart's picture is the only one which has gained much celebrity, and though enriched by markings of the best character, is nevertheless exaggerated and unlike."

The article also discussed the sources of ReP's portrait and concluded by asserting that Washington's contemporaries will find it "the best likeness of *the man*, in all the majesty of his character."

3. Arthur S. Brockenbrough was proctor of the University of Virginia, having been appointed in 1820. Malone, *Jefferson*, 6:370.

4. Probably the plan of the grounds of the University of Virginia, drawn in 1822 and printed by the New York engraver and lithographer Peter Maverick (1780–1831) after a drawing by Jefferson (*Virginia State Library*). A new edition of the engraving was published in March 1825. William B. O'Neal, *Pictorial History of the University of Virginia* (Charlottesville, Va., 1976), p. 47; Groce and Wallace, *Dictionary of Artists*, p. 433.

175. CWP to RaP

PHILADELPHIA. FEBRUARY 1824

Philada. Feby. 1824.[1]

Dear Raphaelle

I recieved yours[2] wrote on your first arrival at Charlestown, and I did hope that it would have been followed soon by another to acquaint us how you succeed in getting imployment of your pensil, the wish of my heart, as without imployment there is no happiness in this life.

I will now give you some intelligence of occurances in the family since your departure, but I do not mean to enter into many particulars untill I recieve an account from you of your prospects, more especially as from your silence it appears doubtful whether you have continued in Charlestown, or whether you have remooved more southerly. Rembrandt has just finished a large head size of Genl. Washington,[3] the head is ⅕ larger than life, in a oval opening of a light ground, Round it are a reath of Oak, and Jupiter's head forms a key stone, all out side of the oval represented of stone (Granite), and beneath a tablet with sunken letters *Patriæ Pater*, anglified *father of his country*. the Gilt frame is 9 Inches wide (flatt) and bundles of rods bound togather, with Stairs in the corners[4] the frame is about 8 feet high & 6 feet wide.[5] This portrait is a composition from my picture, his own, Stuarts and from the bust of Houdon. It is a very fine likeness, and has a rich and impossing effect. Rembrandts object is [to] take it to the City of Washington, in the expectation that Congress will purchase it, and give orders to paint the other four Presidents in the same manner. This picture is not yet varnished, therefore not yet fit for the public eye, but the few who have seen it, speak much in its praise, not only as a fine picture but also a fine likeness.[6] Rembrandt has not received an application for a single portrait, altho' his frame of prices in the Room states, that he will paint portraits from *20. to 100$ and upwards*. I have no applications for portraits and my whole dependance is on the income from the Museum which at this season of the year has few Visitors.

I have painted Doctr. Hare, about a copy of Govr. Johnson, one of those

370

for the Corporation of Annapolis—and I have finished the cleaning and repairing Lord Baltemore, it now only wants Varnishing. It is a very high finished picture but I am uncertain by what Painter, Rembrandt and some others think it was painted by Sr. Godfrey Kneller,[7] be it by whom it may, it is certainly a well painted picture, and I am satisfied with my bargain. more especially as I will have the credit of beginning a collection of the portraits of the Governors of Maryland, ⟨with⟩ which doubtless will be continued with a ceries of Governors, and finally will be a valuable Gallery of Portraits.

Titian has had two attacks of Pleuresy this winter and his health is very feeble, afflicted with a caugh at night, and he is much emasiated, and fearful of going out of the House except on fine days, and never at night—his Physician has advised him to go to a warm climate—and I have made an application to Comodor Porter for his passage to East florida.[8] Patty had boarders, but her price was so low that she got nothing by them, I see her a few days past, and she told me that she would rent a part of the House, and she would keep a school for small children. Edmond is gone to S. America to sell some goods on commission—. Charles I believe is doing nothing—the families now all well—Rembrandts family almost all of them was suffering under a disorder much like the Smallpox. My health is good, some cold since the winter, but nothing to confine me or prevent my usial employment. This day and also yesterday has been much the coldest we have had this winder [winter]. I have published a journal or regester of the Philada. Museum, intend'd to be continued twice in each month, if subscribers can be had to pay the expence. 2$pr Amn. Linneus is doing nothing for the support of his family—He has been the politi[ci]an in the expectation of getting an office, a very bad kind of business, at present he has some hopes of a clerkship[9] if his friend Doctr Hunkle[10] gets a clerk-ship, a very poor prospect this. Linneus says his shou[l]der is so liable to be put out of its joint if he makes any exertion, says that he can only depend on a business that requires no labour.

His youngest child lately died with a short illness, only 2 Days. on opening they found an impostum,[11] supposed to have been caused by tossing the child up and catching it by the loins, and thus produced in-flamation & its consequences. I have often observed that people are too apt to handle children roughly, which must be contrary to nature, espe-cially in very young children.

at a meeting of the Trustee's of the Museum I acquainted them with my necessity of getting the building extended over the fire proof offices—but they replyed that it was not yet a favorable time, for there is yet one member who would make opposition, therefore they advise me to wait a more favorable time.

I am much inclined to think that they are not all of them so friendly to the Institution as they ought to be for my Interest, and as some of them are Trustees of the University, they may think that our experiments clash with that institution.[12] I can see no other cause for their not making some efforts in favor of the Museum.

However if the journal is supported, which I think it ought to be, for the Museum will undoubatably furnish many interristing facts of natural history, and may give a feeling to the Citizens towards it.

Having given you all that I can at present recollect I will conclude with wishing you health and happiness as to advice how to be so, you have had ample advise from your affectionate father CWPeale
To Mr. Raphaelle Peale
 Charlestown S.Carolina—

ALS, 3pp.
PPAmP: Peale-Sellers Papers—Letterbook 18

1. This letter was written sometime between February 1 and CWP's next letter to RaP (see below,**178**), and probably earlier rather than later in the month since ReP had not yet taken his *Washington* to the Capital; he did so after the middle of February.

2. Unlocated.

3. According to CWP, ReP finished the *Patriae Pater* on January 31, 1824. See CWP to RuP, January 31, 1824. P-S, F:IIA/70B10–11.

4. The *rods* were the fasces, symbol of republican unity. In ancient Rome they represented authority or power (*imperium*). *OED.*

5. The actual dimensions of the *Patriae Pater* are sixty-nine and one-half by fifty-two and one-half inches, not including the frame.

6. Before taking the *Patriae Pater* to Washington, ReP exhibited it in Philadelphia in mid-February. He apparently did not advertise its display, however, possibly because he considered it unfinished. That the painting attracted an audience without being advertised was remarked upon in the newspapers: "The splendid portrait of WASHINGTON, by Rembrandt Peale, has been finished within a few days, and such is the interest excited in relation to it that a great number of persons have thronged to see it, although it has not been announced for exhibition." The notice quoted contemporaries as saying that it was "the only picture of Washington, which ever warmed their hearts," noted its fidelity to the subject, and advised that it could be seen "for a few days previous to its removal to the seat of government." *Poulson's*, February 14, 1824.

7. The portrait of Charles Calvert, Fifth Lord Baltimore was the work of Herman van der Myn, ca. 1730. Sir Godfrey Kneller (1646–1723) was a German-born painter who immigrated to England in 1675 and quickly gained the patronage of Charles II, thereby becoming the *de facto* official painter of the English aristocracy; this status was made official in 1691, when he was knighted and named the principal painter to the king. *DNB.*

8. See CWP to David Porter, February 1, 1824, P-S, F:IIA/70C1–2. In his letter to Porter, CWP stressed TRP's talents as a naturalist and collector who would find the Caribbean a rich source of specimens, and minimized his health problems in order to persuade Porter to provide him with passage on a government ship.

9. See above, **166**.

10. Unidentified.

11. A cyst or abscess. *OED.*

12. The only member of the mseum's board of trustees who was also a trustee of the University of Pennsylvania was Zaccheus Collins. Sellers, *Museum*, pp. 239–40; Scharf, *Phila.*, 3:1942–43. William Meredith was the council member believed to oppose the expansion of the museum. See above, **163**.

176. CWP to RuP

PHILADELPHIA. FEBRUARY 11, 1824

Philadelphia Feby. 11th. 1824.

Dear Rubens

I rejoise with you on the safe delivery and health of Eliza & child,[1] blessings which we ought to be thankfull for.

I have much fear that Titians health is so precarious that he will not be able to make a trip to a more warm climate this winter, and the precarious weather of this place, subjects him to relaps of pleurisy from the least exposure— I had 12 days past wrote a letter to Comodore Porter to ask of him a passage in one of his Vessels to Thompsons Island,[2] and have not yet received an answer from him—and was I to have the favor granted, I doubt whether it will be prudent for him to make the journey to Norfolk—a considerable inflamation they say is on his breast this morning, and the doctr. orders him to keep his chamber to day and ⟨not⟩ to speak as little as possible—and to take nothing but gum anaboch[3]—& water that has had a toast of bread in it. He is extreamely weak. He was blead yesterday & by the appearance of his blood the Doctr forms his opinion & advice as above.

I cannot comprehend the nature of your exhi[bi]tions for the 2 weeks mentioned in your letter, perhaps your next will more fully illustrate. You say your exhibiting several times in an evening has a good effect—it may parshally be so—but querry, do you not endanger your health too much by such great and severe tryals of your strength? steady exercise, temperance in all things to keep the body & mind from too great exertion will insure health & long life The following is the state of the account of the Cream-white.

To Daniel Smith[4]	6 ℔		4.50	freight	1.50
Cash for	4 ℔	——	3.00	Stone cask	
for myself	10 ℔		6.25	paid Remb.	3.50
To Mr. Doughty	10 ℔		7.50	Paid J P	20.00
Cash	1 ℔		[.]75		25.00
To Mr. Eckhold[5]	9 ℔		6.75		
To Mr. Neagle	3 1/2		2.62 1/2		
To Mr. Hyle[6]	6 ℔		4.50		
			35.87 1/2		

⟨Mr. Eckh⟩ Mr. Doughty has not yet paid for 10℔, but promisses to pay it shortly. Mr. Neagle wants more of the White, and some other of the artists expects that I will get it for them—I like it so well that I think of adding to my Stock; My Brother says that Sarah ought to get a good store of it.

Before closing my letter I stept into Titians chamber, and he says that he is a good deal better.

Rembrandt Washington is admired by all that have seen it & the visitors are numerous. he will probably be in Baltre. early next week, on his way to Washington.

I called on Mr. Burd yesterday evenng & also on Peggy Shippen to give them the good news—.[7]

Love as usial. yrs. &c&c
CWPeale

Mr. Rubens Peale
Baltre.

ALS, 2pp.
PPAmP: Peale-Sellers Papers—Letterbook 18

 1. William Peale (1824–38) was born February 8. *CWP*, p. 442.
 2. See above, **175**n7. "Thompson's Island" is St. Thomas, Virgin Islands.
 3. Probably gum arabic, or, as it was called in pharmaceutical usage, gum acacia. *OED*.
 4. Unidentified. There are four Daniel Smiths listed in the 1824 Philadelphia Directory, any one of whom might have ordered paint. *Philadelphia Directory (1824)*.
 5. Jacob Eichholtz (1776–1842) was born in Lancaster, Pa., where he was apprenticed to a copper- and tinsmith at a young age. He began to paint profile portraits in 1806, and other than receiving brief advice from both Thomas Sully and Gilbert Stuart, he was largely self-taught. By 1811, he was exhibiting portraits at PAFA. After working in Baltimore in 1820, he moved to Philadelphia in 1823, where he was fairly successful. In 1832, he moved back to Lancaster, returning on occasion to Philadelphia. See Rebecca J. Beal, *Jacob Eichholtz 1776–1842: Portrait Painter of Pennsylvania* (Philadelphia, 1969), xix–xxvii.
 6. William Heyl, owner of a drug and paint store at 35 High Street. *Philadelphia Directory (1824)*.
 7. Edward Shippen Burd and Margaret Shippen, relatives and friends of Eliza.

177. Thomas Jefferson to CWP

MONTICELLO, VA. FEBRUARY 15, 1824

Monticello Feb. 15. 24.

Dear Sir

Altho' writing is a difficulty with me,[1] yet once in awhile I must ask my old friends How they do? your welcome letter of Jan.25. now furnishes an occasion. the most acceptable part of it is that which assures me of your continuance in health, and in the enjoyment of your faculties, insomuch that you can still exercise your art with satisfaction. as long as the eyes retain their acumen, and the hand it's steadiness, experience & judgment will continue to improve your productions. I some time ago re-cieved a letter from your son Rembrandt[2] giving me an account of his work on Genl. Washington, with his native genius, his experience and his philosophical view of what was wanting to compose a moral, as well as

physical, portrait of that great man, I have no doubt of the superlative excellence of his work. your judgment confirms my faith in all this. in his letter he intimated a disposition to bring on the portrait in a visit to me.but in my answer[3] while I expressed the cordial welcome with which I should recieve himself, I besought him not to think of bringing on the painting. this would be attended with difficulties, trouble, expence, and danger of injury to the thing itself, too great to be risked. however sensible the gratification would be to me, the pain of all these considerations would much overweigh it. I reiterate therefore my prayers to him and to yourself that this may not be hazarded, but tell him what he might bring on, much more acceptable, to wit, yourself. I should be delighted to shew you both our rising University, because you have eyes and taste to judge it. greater works may be seen in the US. and in Europe. but you know the difference between magnitude and beauty. in the chastity of it's architecture, it's variety, symmetry lightness and originality you will acknolege it's pre-eminence. it has some things objectionable, which imperious regards to utility forced us to admit. such a journey, in the pleasant days of the spring, would re-animate more than fatigue you. come then, and bask awhile in our genial sun.

I always learn with pleasure the progress of your Museum. it will immortalise your name, and your body must be deposited in it's center, under a Mausoleum, light and tasty, to be designed by yourself or Rembrandt. but far off, in the flux of time, be that day of loss and sorrow. and be it's intervening years and days as many and happy as you can wish.

<div style="text-align: right">Th:Jefferson</div>

To C.W. Peale.

ALS, 2pp.
ViU: Papers of Thomas Jefferson, Manuscripts Division, Special Collections Department
Copy in DLC: Thomas Jefferson Papers

1. Although Jefferson did not appear to have been suffering from any specific ailment, disease, or injury at this particular moment, beginning in 1819 his health had begun to decline with attacks of rheumatism and a violent "cholic." He was frequently unwell during the 1820s, and his health would worsen dramatically by 1825, the year before his death. Malone, *Jefferson*, 6:373, 390, 403–04, 425, 439, 447–48.

2. See above, **167**.

3. See above, **173**.

178. CWP to RaP

PHILADELPHIA. FEBRUARY 21, 1824

<div style="text-align: right">Philada. Feby. 21st. 1824.</div>

Dear Raphaelle

I received your letter of the 11th. instant[1] yesterday, & have now only a

few moments to write by the Vessel going, I spoke to Charles[2] to send you the Guitar, which he will carry to Captn. Canady[3] with this.

I do not think Mr. Pike will like to send the frames you desire without the money being paid before delivery, for he has been a sufferer in some cases of a like transaction— I find the family think that the picture of the Children with the balloons blowing on boats,[4] is not deserving of be[ing] said to come from Rembrands pensil & would be an injury to his reputation to let it go under that appellation— when you write to me say nothing about your drinking only water, as some that see your letters will not give credit to you. It is better to practice and not speak of it, as the result of good conduct will be more powerful than words to do you justice. It will make me happy to hear of your success in business and that you are comfortable which without a family to maintain by a little industry, I could [write] much but Charles waits.

<div style="text-align:right">Affectionaly yours CWPeale</div>

Mr. Raphaelle Peale.
 Charlestown.

ALS, 1p.
PPAmP: Peale-Sellers Papers—Letterbook 18

1. Unlocated.
2. RaP's son, Charles Willson, Jr.
3. Unidentified.
4. Unidentified and *unlocated*.

179. CWP to RuP

PHILADELPHIA. FEBRUARY 21, 1824

<div style="text-align:right">Philadelphia Feby.21.1824.</div>

Dear Rubens

Rembrandt will be able to satisfy all your enquiries respecting me and my concerns, but as you will expect that I would not neglect the opportunity by him to give you some account of what I have on hand, therefore know that I have began a portrait of Count Velliers, which I am obleged to paint at his House, although it is not so convenient as it would be at my painting-room, nor is he a sitter of much patience,[1] yet by my utmost exertions I shall get through my work with some eclaryte [alacrity] for the family seems much pleased with the picture. His daughter who has talent for painting, asked me if I would paint her picture, and said she thought that I could paint a likeness of her. I promised to do it, but requested her to set at my painting-room, as being more convenient—she is to set this week, and on tomorrow I shall take the last setting of her father.[2]

376

I have Govr. Johnson's Portrait before me, and shall occasionally work on it, so that in the end I hope to make it a valuable picture. I wish I could get through my engagements with the remainder of pictures, but I am fearful that I shall meet with some difficulties to get other pictures to coppy from, I suspect that no portraits can be had, my only chance is that of finding a likeness of Governor Stone & perhaps Lee.[3] I have neglected to ask Rembrandt whether he has painted either of them.

do you intend to send any more of the C. white,? have you packed up the frames for Ld. Baltemore & miss Shippen? I expect the stage-boats will soon be in motion. I have not yet got the money from the 10℔ of white sold to Mr. Doughty, perhaps I may call on him this evening, and if I get it will send it by Rembrandt.

you promised to answer the parts of my letter to Eliza,[4] I hope she continues to enjoy good health.

Other Numbers of the Museum journal will be published shortly, one next week and two others immediately after Doctr. Godman has undertaken the care of having it executed, so that he may now be considered as the Editor. I shall furnish him with all that I think is worthy of Notice from the Museum. I received a letter from Raphaelle the other day and says that he is getting into imployment. therefore as he has only himself to support, with very little industry certainly he can make himself at least comfortable in the necessaries of life.

I wish to give Rembrandt as many letters to Washington as my acquaintance there will have any chance of being of the least use to him,[5] and therefore I shall end this with my best wishes for the health of Eliza, children & yourself—with

<div style="text-align:right">affection Yrs. CWPeale</div>

Mr. Rubens Peale
　　Baltre.

ALS, 2pp.
PPAmP: Peale-Sellers Papers—Letterbook 18

1. Napoleon's elder brother Joseph Bonaparte, Comte de Survilliers (1768–1844), the former king of Spain, lived in exile in the United States from 1815 to 1832 and again from 1837 to 1841; his estate was across the river from Philadelphia in Bordentown, N.J. CWP exhibited the portrait (fig. 45) in 1824 at the PAFA. P&M, p. 35.

2. CWP did not paint Joseph Bonaparte's daughter, Charlotte. P&M, p. 35.

3. CWP eventually located ReP's portrait of John Hoskins Stone, governor of Maryland from 1794 to 1797 (ca. 1797: Anglo-American Art Museum, Louisiana State University, Baton Rouge), in the possession of Nathaniel Pope Causin of Washington, D.C., and made his copy there in June (see fig. 42) See below, 193; Miller, In Pursuit of Fame, p. 252. CWP was unable to locate a portrait of Thomas Sim Lee, who served as governor from 1792 to 1794. He apparently forgot that he had painted Lee's portrait in the 1770s (unlocated). P&M, pp. 123, 203–04; Robert Sobel and John Raimo, eds., Biographical Directory of the Governors of the United States, 1789–1978, 4 vols. (Westport, Conn., 1978), 2:646–47.

4. See above, 171.

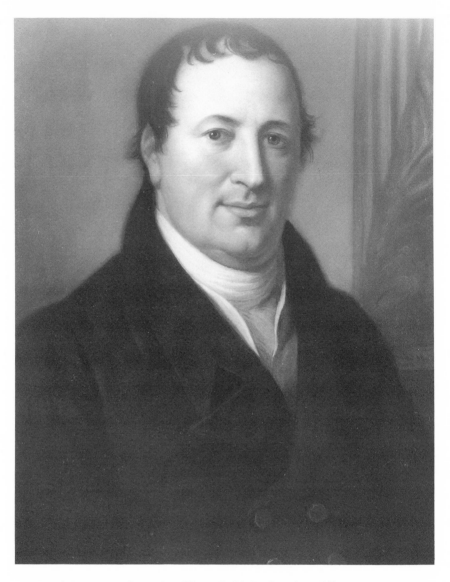

45. *Joseph Bonaparte (Count Survilliers)*. C. W. Peale, 1824. Oil on canvas, 30 ×
24″ (76.2 × 61 cm). Historical Society of Pennsylvania, Philadelphia.

5. In addition to the letters to President Monroe (below, **180**) and Colonel Bomford (below, **181**), CWP also wrote letters on the same day to Andrew Jackson (P-S, F:IIA/70D7); Richard Mentor Johnson (P-S, F:IIA/70D8); and William Thornton (P-S, F:IIA/70C13).

180. CWP to James Monroe[1]
PHILADELPHIA. FEBRUARY 21, 1824

Philadelphia Feby. 21.1824.

Dear Sir

Devoted to the arts I still continue the labours of the Pensil, but all togather in the Portrait line, When looking on a faithful Portrait of a friend, it seems more forcibly to draw our affections to the original, It is assuredly the seal of friendship, which calls to our remembrance passed Sceines— under these impressions I am induced to address you, believing you will be highly gratified on seeing the most correct Portrait of that great and good man George Washington emphatically called the father of his Country—Painted by my Son Rembrandt the bearer of this, and I need not to say that I shall be very much pleased to hear that Congress should request you to set for a like Portrait to adorn the Capital,[2] it is a favorable moment to obtain the striking and high finished Portraits of the favorites of the Americans—and ought not to be lost.

Present my best respects to Mrs. Monroe[3] and believe me with much esteem your friend　　　　　　　　　　　　　　　　　　CWPeale

His Excellency
　　　James Monroe Esqr
　　　　President of U.S.

ALS, lp.
PPAmP: Peale-Sellers Papers—Letterbook 18

1. James Monroe (1758–1831), fifth president of the United States (1816–24). *DAB*.
2. ReP painted two portraits of Monroe around this time, neither of which is dated and neither commissioned by Congress: (*James Monroe Museum, Fredericksburg, Va.* and *Boston Athenaeum*). ReP Catalogue Raisonné, NPG. See fig. 46.
3. Elizabeth Kortright (Mrs. James) Monroe (1768–1830). *Notable Americans.*

181. CWP to Colonel George Bomford[1]
PHILADELPHIA. FEBRUARY 21, 1824

Philadelphia Feby. 21.1824

Dear Sir

My Son Rembrandt will hand you this, He has by great exertions painted a Portrait of Genl. Washington which has excited the Admiration

379

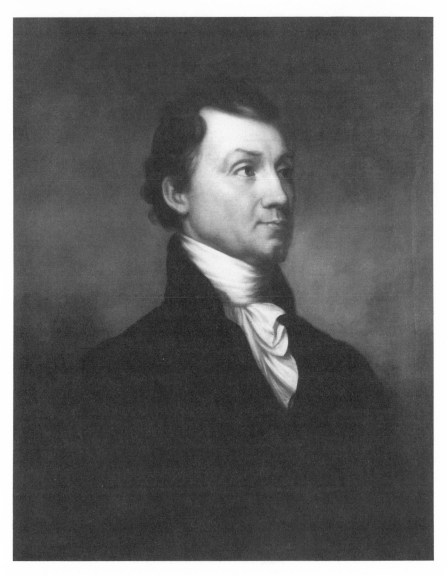

46. *James Monroe*. Rembrandt Peale, ca. 1824. Oil on canvas, 30 × 25″ (76 × 63.5 cm). Boston Athenaeum.

of all the connoiseurs, Painters, and more especially those who have been best acquainted with the General. I need not say any thing about the composition of the picture, you can appreciate it— But I must say that Congress ought not to loose the opportunity of getting the faithful Portraits of all the Presidents in the same stile of this Picture, as Portraits of equal merit may yet be taken from the living characters, by an artist so much distinguised by his talents, not only in making the faithful likeness but also in his colouring & high finish. Rembrandt has not been in your City for many years[2] and your advise will be thankfully received and obleging to me. Your knowledge of arts and Science will be exercised by a converse with my Son, therefore I have a pleasure in introducing him to you.

I continue the use of my pencil, with even more hopes of acquiring excellence, by the aid I have had in colouring from the experience of Rembrandt, for he has gone the round of experiments in the labours of years, this subject makes me regret the departure of your father in law[3] who also had devellopt much curious modes of composition of colours and was a distinguished artist, and Rembrandt will be much gratified in viewing your collection of Pictures.

I am tyed here by duties to encrease and improve the usefullness of my Museum. I wish some wealthy Citizen would take it off my hands, for a price that would give 6 Pr.Cent for its cost, and which by a proper Building and good management would yield 10 Pr.Ct. since I have been left alone, it would be very agreable to visit my friends in distant places, nay I often think that I should delight in visiting the Museums of Europe, more especially that in Paris. I do not think myself too old to undertake almost any thing, enjoying uninterrupted health. with some share of prudence I may yet indure for many years. My youngest Son is a great Naturalist, and a practical man, but in danger of consumption— I wrote a letter to Comodore Porter to to obtain a passage for him to Thompson's Island, but he has not deemed me whorthy of an answer.[4] What must I think of Porter? My Son Rembrandt must supply the deficiences of this scrole, therefore, I will close with presenting my respects to the family. with much esteem your friend

CWPeale

Coll. Bumford
 Washington.

ALS 2pp.
PPAmP: Peale-Sellers Papers—Letterbook 18

1. George Bomford (ca.1780/82–1822), lieutenant-colonel (1815) in the 1st Artillery Regiment, U.S. Army and head of the Ordnance Department, was a well known inventor and designer of weaponry. Bomford named his invention of a new type of cannon the

"Columbiad" after the epic poem of his brother-in-law Joel Barlow, who had married the sister of Bomford's second wife, Clara Baldwin. CWP visited Col. Bomford in December, 1818, while painting portraits of eminent government leaders in Washington, D.C. There he saw Catton's *Noah and His Ark* and arranged to borrow it for copying (1819: *Pennsylvania Academy of the Fine Arts, Philadelphia*). See *Peale Papers*, 3:632, 687.

2. ReP's last recorded visit to Washington was in the spring of 1809. Carrie Scheflow, "Rembrandt Peale: A Chronology," *PMHB* 110 (1986):142.

3. The artist Charles Catton, Jr. (1756–1819), English landscape and animal painter, immigrated to the United States in 1804. He was the father of Bomford's first wife. *Peale Papers*, 3:632, 687–88.

4. See above, **142**.

182. CWP to RuP

PHILADELPHIA. MARCH 7, 1824

Philadelphia March 7th—24

Dear Rubens

Wilson informed me last evening of a Man who offered to take letters to you & would call for them at the Museum on tomorrow, you may know him, I do not therefore I will give you a few lines altho I have little to communicate— yesterday I took the last setting of Count Servilliers—a business I am glad to have made a finish, I have been anxious to make a fine portrait of him, and perhaps I have succeeded as well as any other Painter could do, for a more impatient setter I have not met with, but what has made it more difficult, is my want of conversation for my deafness is a great obstacle to undertake to communicate my Idea's as I cannot make the person I would converse with repeat again & again what they say. Prince Charles,[1] his Son inlaw told me that a hundred pictures had been taken of his Uncle, and not one of them was so like as mine. So far is complimentary, but in fact, I would have made a fine picture of him if he had been a better sitter. He is a handsome man—

He mentioned yesterday having received a letter from you[2] requesting some of his Pictures for your exhibition & he said you should have two, and he wanted me to choose them, my reply was such as he pleased, he was under the impression that you wanted them now, I informed him that your exhibition commenced in October, that I would take care to pack up such pictures as he would lend you.[3] His single daughter[4] asked me if I would take her picture, which I assented to, she said that she thought that I could take a likeness of her. If she is as bad a setter as her father, I will not be sorry if she does not call on me. I told her that I would prefer doing it in my painting-room.

Prince Charles the Son in law of his Uncle Josph Boneparte is very fond of Natural history. he knows more of ornithology than any Man in this

Country he is very often with Titian and I am in some hope that he will benefit the Museum.

My income the whole of last month has been small indeed—we have never had so little company for many years past.

Doctr Godman has undertaken to get the journal of the Museum published, and 3 more numbers will appear soon he tells me. When these are done I may gett more subs[c]ribers. As soon as I get them I will send you what you may want.

The stage boats now run, of course I expect the frames soon.

Titian requests you to purchase for him a Swan. he wants it for Prince Charles, have it put in a packing-case, & if you can have it brought by the Steam-boat as the quickest mode, it will be well—The cost shall be remited to you immidiately. I have to day finished the Portrait of Governor Johnson, and in a manner I hope that will please his friends having it constantly before me, led me to retouch it from time to time & now it pleases me.

I have received a very handsome letter from Mr. Jefferson in which he invites me to visit him & enjoy a warm Sun.[5] I propose being with you in May My love to Eliza & Children

<div align="right">yours affectionately
CWPeale</div>

Mr. Rubens Peale
 Baltre

ALS, 2pp.
PPamP: Peale-Sellers Papers—Letterbook 18

1. Charles-Lucien Bonaparte (1803–57) was the son of the emperor's younger brother, Lucien (1775–1840). Bonaparte married his cousin Zenaide Charlotte Julie, daughter of Joseph Bonaparte, in 1822, and immigrated to the United States soon after his marriage. He worked as a naturalist until 1828, when he returned to Europe, where he combined his scientific interests with a political career in Italy and France. His major work while in the United States was *American Ornithology or the Natural History of Birds Inhabiting the United States Not Given by Wilson*, 4 vols. (Philadelphia, 1825–33), a continuation and expansion of Alexander Wilson's (1766–1813) pioneering *American Ornithology*, 7 vols. (Philadelphia, 1803–13). *DSB; NUC; Peale Papers* 2:108n.

2. Unlocated.

3. RuP borrowed at least one painting from Joseph Bonaparte, a *Magdalen* by Titian. It was shown at the Third Annual Exhibition of the Baltimore Museum and was retained as a special exhibition that RuP advertised as follows:

> This painting is so much thought of in Europe, that ten thousand dollars has been offered for it, and refused by the Count. It is one of the finest specimens of the pencil of that great artist.
> In the evening it is expressly lighted, and is well seen.

Baltimore American and Commercial Advertiser, December 13, 1824.

4. Charlotte Bonaparte.

5. See above, **177**.

183. John Marshall[1] to ReP

WASHINGTON. MARCH 10, 1824

Washington, March 10, 1824.

Sir: I have received your letter of yesterday,[2] and shall, with much pleasure, communicate the impression I received from viewing your Washington.

I have never seen a portrait of that great man which exhibited so perfect a resemblance of him. The likeness in features is striking, and the character of the whole face is preserved and exhibited with wonderful accuracy. It is more Washington, himself, than any portrait of him I have ever seen.[3]

With great respect, I am, sir, your most obedient,

J. Marshall.

Rembrandt Peale, esq.

PrD
Poulson's American Daily Advertiser, March 15, 1824

1. John Marshall (1755–1835), Revolutionary soldier, officeholder from his native Virginia, and statesman, was appointed by John Adams on January 20, 1801, to serve as chief justice of the United States Supreme Court. Marshall's leadership in establishing the principle of judicial review elevated the court to co-equal status with the executive and the legislative branches in the national system of government. ReP painted his portrait in 1834 (*Supreme Court of the United States;* replica, *Virginia Museum of Fine Arts, Richmond*). *DAB.*

2. Unlocated.

3. ReP reprinted this letter in the same format with a heading undoubtedly written by him in Philadelphia and other newspapers as part of his publicity campaign for his *Patriae Pater.* See, for example, *Nile's Register,* March 20, 1824, 3rd ser., vol. 2, no. 3, p. 37.

EDITORIAL NOTE: *The U.S. Congress and ReP's* Washington *Portrait, 1824*

Rembrandt's campaign to persuade Congress to commission an equestrian portrait of George Washington began in February 1824. Traveling to Washington with his imposing *Patriae Pater,* he enlisted the help of senators and congressmen who were friends or acquaintances of his father: Congressman Charles Fenton Mercer (1778–1858) of Virginia, who had risen to the rank of brigadier general during the War of 1812; Senator Richard Mentor Johnson (1780–1850) of Kentucky, a powerful member of the emerging Democratic party led by Andrew Jackson; and Congressman Samuel Breck (1771–1862), a wealthy New Englander transplanted to Philadelphia, who had extensive interest in the city's cultural, artistic, and civic affairs. On March 9, Breck introduced into the House of Representatives, where appropriation bills originated, a joint

resolution authorizing the president "to procure from Rembrandt Peale, of Philadelphia, a Portrait of Washington to be placed in the Capitol: Provided the same can be obtained for the sum not exceeding [blank] dollars." Breck's bill was referred to the Committee of the Whole on March 11, and then to a select committee of the House, who were ordered to clarify the details of the proposed purchase. Rembrandt immediately sent a letter to the committee (below, **184**) designed to provide the members with justification for recommending the commission, and composed a draft of a contract (below, **185**).

On March 20, Breck reported the final resolution to Congress, authorizing the president to "procure from Rembrandt Peale, of Philadelphia, a painting to be placed in the capitol of Washington, on horseback on a canvass, of not less than 18 feet high and 16 wide; the middle and backgrounds to contain a representation of the battle of Princeton, or such other appropriate scenery as the President shall direct." The sum appropriated was not to exceed $3,000, and Rembrandt was to assume responsibility for "a rich gilt frame . . . at least fifteen inches wide."

Three days later, Senator Johnson introduced a similar resolution into the Senate, but he raised the compensation to $5,000. With this first phase of the appropriation process completed, the matter languished until the Second Session of the 18th Congress. Unhappy with the delay, Rembrandt left Washington for Baltimore, where he exhibited his *Patriae Pater* and collected more testimonials to the correctness of his representation of the first president. Then he returned to his studio in Philadelphia, so confident of receiving the desired commission that he set to work at once to paint his grand manner equestrian portrait.*

*Miller, *In Pursuit of Fame*, pp. 144–45.

184. ReP to Committee on the Portrait of Washington[1]
WASHINGTON. MARCH 16, 1824

Washington March 16. 1824.

Gentlemen

The Portrait of Washington which I now offer to my countrymen, to the World and to posterity, is his appearance when he sat to me in September 1795. Being desirous of profiting to the greatest advantage by this occasion, I persuaded my father, C. W. Peale, to paint a Portrait at the same time. From my father's intimacy with Washington (of whom he had previously painted 13 Original Portraits since the year 1772), a conversation was maintained between them which left me entirely at leisure to

study his countenance, during three long sittings. From this my Original Head I soon after made ten Copies which impressed it strongly on my mind.[2] Stuart's Portrait was made public the ensuing Spring,[3] and was not ⟨less⟩ more admired for the splendid tho' unnatural colouring and the beauty of its pencilling, than it was censured by every Artist then living in Philadelphia for its inaccuracy in the drawing and its deficiency in expression.

Convinced that there had not yet been painted a good likeness of Washington, and being equally dissatisfied with my own, with my father's and with Stuart's, I contemplated another trial at Mount Vernon, which, unfortunately was too long deferred. After his death, in 1799, there remained no other resource than to correct these Portraits by means of each other. This task I immediately commenced, but with imperfect success, affording more gratification to others than to myself. Since the death of Washington, I have made repeated trials, but never to my own satisfaction until now—and now I have succeeded (as the public have already decided) by having adopted the *Aspect* of my father's Portrait, correcting its proportion from Houdon's Bust, (which was made by a Mask taken from Washington's own face) and finishing it from my own Portrait, aided by my recollection of the original himself and the Criticisms of his friends. In this manner my attention was finally concentrated on the characteristic touches which I had marked from the living Original, who was thus revived to my recollection in the most lively & effectual manner; and it became possible for me, not only to judge of the character myself, but to execute it with much of the animation of real life, so that it produces a glow of approbation from those who were intimate with him.

There never was a Portrait painted with feelings of higher excitement. No human being could have felt a more devoted admiration of the character of Washington, and no Artist ever found his pride & enthusiasm more strongly excited by the magnitude and interest of his purpose, than mine were to rescue from oblivion the aspect of a Man who would forever be venerated as the "father of his Country."

If it is asked what I would propose to do? I answer— Having succeeded in producing a Likeness of Washington that is preferred to all others, and that is pronounced worthy of him, I am desirous of painting this likeness in a Great Equestrian Picture, in a style at once worthy of the Nation and the Hero it would commemorate. The manner in which I have displayed the mere Bust of Washington gives some idea how interesting a Work of Art may be rendered by the style in which it may be conceived & executed. Greater importance can be given by representing the whole figure, but nothing in Art can be more sublime than a great Equestrian Portrait, in which the Horse and Rider appear in some animated and commanding situation, with all the charms of varied colouring.[4]

Perhaps there is not in the World a Hall of more Grand and imposing proportions than the Rotunda of the Capitol——It is worthy of the Nation. Now, as there has been but **one Washington**, and another may not soon arise with contending claims, let there be placed in this Hall a Magnificent Picture that shall correspond with feelings that have pronounced him "First in War, first in peace, and first in the Hearts of his country men."

The Course of my Career has prepared me for the execution of large Pictures—commencing with the Equestrian Portrait of Napoleon, and followed by the Roman Daughter, the Death of Virginia, the Ascent of Elijah and the Court of Death.[5] An Artist can execute but few great Pictures in his life—They must be chiefly the labour of his own mind and of his own hands, and their final merit must greatly depend upon the devotion with which he applies himself to them. For these his family must be paid so as to leave him without the reproach of sacrificing their comfort to his love of fame.— Therefore, whatever the appropriation may be in reference to me, the painting must in a degree be made to correspond; with this conviction and assurance, that the Picture which I should furnish, will, in any case, be made to surpass the stipulated value.

> Gentlemen
> Your Most obdnSv
> *Rembrandt Peale*

ALS, 3pp. & add.
PPL: Ms. Department.

1. Upon the resolution of Samuel Breck (see below, **187**) that Congress authorize the president to purchase a portrait of Washington by ReP, the subject was referred to a select committee of the House of Representatives consisting of Breck; Duncan McArthur (1772–1839) of Ohio; Charles Fenton Mercer (below, **187**) of Virginia; Daniel Udree (1751–1828) of Pennsylvania; Thomas Metcalfe (1780–1855) of Kentucky; George McDuffie (1790–1851) of South Carolina; and Jonas Sibley (1762–1834) of Massachusetts. *BDAC*; *Gale's and Seaton's Register of the Debates in Congress*, 18th Congress (Washington, D.C., 1825), p. 1763.

2. The original portrait from the 1795 sitting is in the collection of the *Historical Society of Pennsylvania*. Only two of ReP's replicas have been located: *National Portrait Gallery*; *Detroit Institute of Arts*. These are bust length; the original has been cut down to head size. ReP Catalogue Raisonné, NPG; CAP.

3. *George Washington* (the "Vaughan" portrait) (1795: *National Gallery of Art*). Stuart's next portrait of Washington, the "Lansdowne," was not begun until April 1796.

4. ReP may have been thinking of the equestrian portraits of Anthony Van Dyck (1599–1641). The European tradition of equestrian portraiture originated with ancient imperial portraits and continued in Renaissance portraits of rulers and military leaders. Van Dyck brought this tradition to England. Many of his great equestrian portraits were engraved; they became the most influential paintings in this genre. Roy Strong, *Van Dyck: Charles I on Horseback* (New York, 1972); Leo Steinberg, "The Glorious Company," in *Art About Art*, introd. by Jean H. Lipman and Richard Marshall (New York, 1978), pp. 8–9.

5. ReP's equestrian portrait of Napoleon (1811), *The Ascent of Elijah* (1815), and *The Death of Virginia* (1821) are unlocated and probably not extant. *The Roman Daughter* (1811) is at the *National Museum of American Art*; *The Court of Death* (1820) is at the *Detroit Institute of Arts* (see fig. 65). See *Peale Papers*, 3:80, 92, 153, 155, 235, 782, 783.

185. ReP: Draft of Contract for Painting Equestrian Portrait of Washington

WASHINGTON. MARCH 18, 1824

Washington 18th. March 1824

Influenced by emotions which urge me as an Artist to acquire distinction by my pencil—strongly impelled by patriotic feelings as an American—And, in part, for the consideration of Dollars; I will engage to paint on a large scale, not less than 13 feet wide, & 18 or 19 feet high, an Equestrian Portrait of Washington,[1] to be executed with my best abilities, representing the General in his Military dress, mounted on a White Horse—both Horse and Rider in actions of animated movement, character & truth. A Battle in the Back ground to be selected from the Revolutionary scenes, but rendered subordinate to the imposing display of the principal figure. The Picture to be finished without delay—if possible, by the next meeting of Congress.[2]

Rembrandt Peale

ADS, 1p.
PPL: Ms. Department

1. *Washington Before Yorktown* (Plate 4) is smaller than ReP envisioned in this plan; it is 11' 7" high x 10' 1" wide. There is a smaller sketch (36 x 29") in a private collection. See Miller, *In Pursuit of Fame*, pp. 144–45 and color illustration; ReP Catalogue Raisonné, NPG.

2. ReP painted this work on speculation, convinced that Congress would vote for its purchase, but the House of Representatives adjourned without taking the necessary action on the Senate bill authorizing its purchase. When ReP returned from Italy in 1830, he retouched and "improved" the painting and placed it in the rotunda with the permission of the president of the Senate and the speaker of the House of Representatives. There the painting remained, with the intention of "again being offered to Congress." ReP died in 1860, and the Civil War followed soon after. According to the executors of ReP's estate, the family felt it was "their duty to refrain from soliciting the attention of the Congress to the subject of its purchase until the Government should be relieved from the heavy burden of the war." In November 1865, the executors petitioned Congress for either the painting's return or purchase. Not until 1873, however, was the painting removed from the Capitol and delivered to H. N. Barlow, from whom it went to the Corcoran Gallery of Art. See Harriet C. Peale, Rosalba Peale Underwood, John H. Griscom, Executors, to the Hon. the Senate & House of Representatives of the U.S. MH, F:VIB/22D11; Executrix &c of Rembrandt Peale to A. R. Spofford, Esqr., Architect of the Capitol, March 28, 1873. DLC; ReP Catalogue Raisonné, NPG.

186. CWP to ReP and RuP

PHILADELPHIA. MARCH 20, 1824

Philadelphia March 20th—24

Dear Rembrandt

Yours of the 25th.[1] received yesterday and relieved our doubts about your affairs— The Idea occurs to me that the sooner you can obtain the

decission of those great bodies, the better, for if Steward[2] or his friends should write to vindicate his high rank as a portrait painter, it may opperate much against you. The truth of your portrait cannot be doubted, but interested voteries will find fault with your manner of obtaining the approbation of the friends of Washington.

I have been much engaged with my pensil of late and flatter myself that I have done some things superior to my former works. The first is a portrait of Titians Eliza,[3] extreamly like, good expression, and fine colouring. Mr. Hopkinson frequently urging me to give my portrait to the Academy of fine Arts, at last I consented to paint for that purpose. Now a picture to be given by an artist to such an Institution ought to be very good, nay superior as a model for artists, therefore it is presumtion in me in making the attempt. Yet if I have a correct knowledge of Colouring and a correct Eye to see proportions, and faithful to make immitations of the Obje[c]t before me, why should I not (in a simple portrait,) make as good an immitation as any other man, provided I take a resolution to exercise every power to exceel in the task—and with such a resolution, my setter in this case will sett as long and as oftain, and when ever he thinks an improvement can be made. I then have thought the most difficult effect to be produced, should make the picture to be deposited. To produce with reduced colours a forsible likeness and an agreable effect, if I could succeed would be desireable. Therefore my attempt has been to give a full front face with the light behind me.[4]

And believe a more different thing to succed well is not in the scope of portrait painting. working several days, and give great forces of shades, the likeness very strong, and drawing true, yet it had a flatness on front, and very disagreable effect, I laboured again & again still it wanted a rotundance—at last studying what ought to be the tone of colour of each part, it then struck my mind that the parts retireing ou[gh]t not to be warm, I then determined to give them their true debth with cold colours, and to give the prominant their full share of warm tints—and thus I have admirably succeeded— Mr. Hopkinson will visit me this morning and in my next I may give you his opinion. And if this picture is not highly extoled, I shall attempt another.

Dear Rubens I have not heard from you a long while, you must suppose ⟨I⟩ that I wish to hear how you go on with your exhibitions and the state of health of the family. I have been imployed in some preparations of porcelean teeth—but your sister S. has been very unfortunate. I had prepaired to give her a fine sett, prepaired the plates & she was to assertain the length of the teeth in models of wax—when unfortunately she had so violent a toothack, as to induce her to have 3 teeth drawn at once. Thus my work is to be done over again. she has now only two front teeth in her under jaw, and these she says that she has a mind to have them drawn

out. I say no, I would make for her again & again, rather than she should undergo such trouble & pain. Miss Shipping[5] has a cap for your Son (stringer) but whither she can finish it for this conveyance, (I mean by Mr. Snyder Aunt)[6] I know not.— with love to Eliza & children, I subscribe your

affectionate father
CWPeale

Messrs. Rembrandt & Rubens Peale
 Baltre.

ALS, 2pp.
PPAmP: Peale-Sellers Papers—Letterbook 18

1. Unlocated.
2. Gilbert Stuart (1755–1828), who was living and working in Boston at this time, had many admirers in that city, including Congressman Josiah Quincy, whose portrait Stuart painted in 1824. ReP's assertion that Stuart's portrait of Washington, already something of an icon, was not a true likeness would, CWP believed, create hostility among all the public officials in Washington who had been painted by Stuart at various times. See Richard McLanahan, *Gilbert Stuart* (New York, 1986), p. 147 and *passim*.
3. CWP's portrait of Eliza Cecelia Laforgue (Mrs. Titian Ramsay) Peale (d. 1846) is *unlocated*. Sellers, *P&M*, p. 169.
4. CWP's *Self-portrait in the character of a painter* (fig. 47) was commissioned by PAFA to honor one of its founders. The lawyer and man of letters Joseph Hopkinson (1760–1842) was lay president of PAFA. When Hopkinson criticized the lighting in the painting, CWP painted another version which he called *Self-portrait in the character of a naturalist ("for the multitude")* (plate 5). *P&M*, pp. 162–63; below, **190**.
5. Margaret Shippen.
6. Unidentified.

187. ReP to General Charles F. Mercer[1]
BALTIMORE. MARCH 31, 1824

Baltimore March 31. 1824
Sir

Having some business to transact in the City and being quite satiated with idleness at Washington, I have brought my Portrait here to shew it to my friends & to obtain the testimony of CARROLL, HOWARD,[2] & others. In the meanwhile I must leave the merits of my cause entirely to your discretion & kindness. I am certainly very desirous of having an opportunity, before I go to England, to produce a Picture that may do me credit in my own Country—And I cannot but indulge a hope that the Resolution may pass the Senate without mutilation & be honourably received in your house.

I immediately adopted your opinion & found Col. Johnson[3] favourably disposed & prompt to act. May I hope that you will take sufficient interest

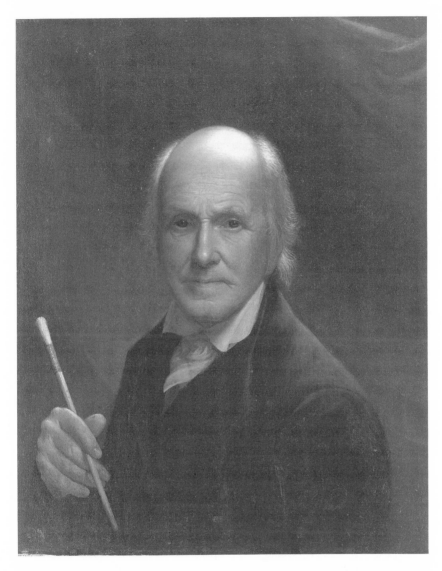

47. *Self-Portrait in the Character of a Painter*. C. W. Peale, 1824. Oil on Canvas, 26 ¼ × 22 ⅛″ (67 × 56.5 cm). Courtesy of the Pennsylvania Academy of the Fine Arts, Philadelphia. Gift of the Artist.

in the measure to endeavour to help it along in the best way, whether it be by hastening its progress or waiting for a favourable moment. As a member of the Committee to whom the Resolution was referred, your opinion will have greater influence in the House to correct the errors that have crept into the Resolution through the timid apprehensions of Mr. Breck,[4] affected as he was by ague & fever. In regard to size, it should be left to me whether it be best to have the Picture 11, 12 or 13 feet wide & 15, 16 or 18 feet long— And as to the frame, I might be tempted to furnish a good frame if 5000 dollars are appropriated, tho' I should make a Picture in itself, worth a greater sum. But above all, for an Equestrian Portrait, not a Battle piece, the choice & arrangement should be left entirely with the Artist, especially as I have already made my Design which requires the Trees & sky of Summer & should have nothing in the Background that would detract from the purposed splendour of my Man and Horse.

May I solicit your kindness in favour of an Act extending to Paintings & Drawings the benefit of Copyrights, which Mr. Lowrie[5] has introduced into the Senate. I do not apprehend that any one can see any objections to such an act of justice to the Authors of Original Designs, when the Engravers, who copy them, are so fully protected.

I am unwilling to trespass further on your time than to say that you will confer a signal favour on

<div align="right">

Sir
Yours
Respectfully
Rembrandt Peale

</div>

ALS, 2pp., add. & end.
DSIAr

1. Charles Fenton Mercer served in the House of Representatives as congressman from Virginia from 1817 to 1839. *BDAC.*

2. Charles Carroll of Carrollton (1737–1832) and John Eager Howard of Baltimore (1752–1837) were prominent Marylanders whose friendship with CWP went back to colonial and early Revolutionary times. As Maryland's delegate to the Continental Congress, a signer of the Declaration of Independence, and U.S. senator, Carroll's testimony as to the true likeness of Rembrandt's portrait of Washington would have been valuable. Similarly, Howard's acquaintance with Washington, both as an officer in the Revolutionary army and as U.S. senator would have also been to ReP's advantage. See *Peale Papers,* 1:57n, 555n.

3. Senator Richard Mentor Johnson became acquainted with the Peale family while having his portrait taken by CWP and ACP in 1819. Later, he visited CWP at Belfield and frequently acted as guide to the capital and to national politics for family members. *Peale Papers* 3:621n; *DAB.*

4. After serving in the Pennsylvania legislature, Samuel Breck was elected to a single term in Congress (1823–25). He failed to win reelection when he put his personal friendship above the interests of the state party and voted for John Quincy Adams in the election of 1824. *BDAC; DAB.*

After introducing the resolution in the House of Representatives to purchase ReP's Wash-

ington portrait, Samuel Breck left Washington for Philadelphia. He advised ReP to enlist the aid of General Mercer. See ReP to "Sir" [Samuel Breck], March 31, 1824, PPL Ms. Dept., F:VIA/4A2–6.

5. Walter Lowrie (1784–1868), a Pennsylvania schoolteacher, was also a member of the state legislature and, in 1819, the U.S. Senate, where he served for one term. A member of the Senate's finance committee, Lowrie had introduced a bill on March 24 to extend to painters and artists copyright protection equivalent to that held by authors. The bill was introduced in response, either directly or indirectly, to ReP's fear that once his portrait of Washington was sold, he would not profit from its reproduction. The bill died in committee after being debated on April 12 because the senators believed it would hinder artistic expression by preventing artists from working on the same subject. ReP himself was criticized for copying Gilbert Stuart's *Washington*. *Gale's and Seaton's*, 18th Congress, 1st Sess.: Senate (Washington, D.C., 1825), pp. 512–13.

188. CWP to William Logan Fisher
PHILADELPHIA. APRIL 12, 1824

Philadelphia. April 12th. 1824.

Dear Sir

I am informed that some time past, the water has been damed on my meadow, and the Grass is now spoiled for the present season.[1]

This very much surprisses me, for I had flattered myself that you would not suffer your workmen to take the advantage of my abscence from the farm to injure my property.

Be so obleging as to remedy this evil and you will confer a favor on your friend

CWPeale

Mr. William Fisher.

ALS, lp.
PPAmP: Peale-Sellers Papers—Letterbook 18

1. The question of water rights in relation to private property and public needs had important economic as well as legal consequences for both agricultural and industrializing communities in the early nineteenth century. Ever since moving to Belfield CWP had been engaged in a constant dispute with Fisher, his Germantown neighbor, over the problem of Fisher's mill pond and stream backing up and flooding Belfield's farmland, thus hindering the operations of its mill. *Peale Papers*, 3:80–82.

189. CWP to Rachel Morris
PHILADELPHIA. APRIL 13, 1824

Philadelphia April 13th.—24

Dear Sister Rachael

Time flies with me, because it somehow happens that I have much work on hand—when I look back on my past labours, I find that mechanicks

has been a great disadvantage to me, as my fondness to do what I wanted made has prevented me from devoting my talents to painting, and although now I find myself better able to produce fine portraits, yet I only find that all my work is for the Museum as no one makes application for portraits, unless they can have them a fo[u]rth part of the price I formerly had for them. Yet under all these disadvantages I am exerting my utmost powers to produce more excellent representations than ever my hand produced. This may appear strange to you, but when I tell you that my sight is so good that I do not want spectacles to finish my pictures in the best manner— and my last pieces, as well as those I have on hand are acknowledged by all that has seen them to be superior to my former work so that it is not an immaginary thing with me, as some would suppose. and in the hopes that what I am now painting to be put into the Exhibition which commences next month,[1] my reputation may be raised as a portrait painter, and to some profit. My Son Rembrandt has acquired great applause by a picture which [he] has painted of General Washington, and I expect that Congress will reward him well, a Bill has been read in the senate, to give five thousand dollers for an equestion picture of the General, He carried his picture to the City of Washington, and was favored with a place for it in the presidents chamber in the Capitol, where it was seen by all the Members & others, approved of by Judge Washington & Marchal[2] and universally allowed to be the best likeness ever made of the General— It is now exhibiting at Rubens's Museum Baltemore.[3]

As Rembrandt has made more experiments on the art of colouring than I believe was ever done by an Individual, of course he has made out the best sistem and thus it is that I have greatly benefited by his observations, as well as by our reflections on the effects produced by our long experience, and the effects of age on the different pigments.

The Museum continues to encrease in its improvements, but my expences is greater than formerly, because I have to support my two Sons who are devoted to labours for its improvement, but the great misfortune is that I have not room to display the additional articles which is continually encreasing on our hands I thought the Trustee's would would have been more active to obtain aid from the Corporation, than they have been—however I must have patience, and shall yet hope to meet with the encouragement which such an Institution deserves.

My labours in forming this establishment is much more estimated by foriegners than by my Countrymen and all straingers cry out shame, when they hear that I pay a high rent for the part of the State-house occupied by the Museum.

I often see Miss Mary Dickenson[4] who very frequently enquire about

you. she complains dreadfully of her Eyes, the least exposure to colds, or much light gives her pain, yet no external appearance shew the weakness of those organs.

I live in the House in Walnut Street, Oh! where do I ramble, you left me here,—— Eliza is kind to me & Titian does his best to please me, but he has been much indisposed all the winter, having suffered 2 or 3 attacks ⟨Rheums⟩ of Phlurecy and still comp[l]ains of a cough & pains in in his breast at times when the least exposed to intemporance of Air.

I am hurrying to fulfill all my engagements in the Tooth making business, and have been very successful in some of my late work, this is one of my mechanical labours, that I must not give up, because I find it very important to my friends as well as myself. hence I esteem this branch of Mechanicks as not so great a folly as the others which have robed me of my time so long. And I have made my daughter Sophonisba happy in her Mouth, and also one ⟨other⟩ or two others of your acquaintance, when I see them perfectly well fitteded & my pictures finished for the Exhibition, I shall go to maryland to complete my engagements with the Corporation of Annapolis, I have painted for them 4 pictures & have two more to do,[5] this is for a fine Portrait of Lord Baltemore painted by Sr. Godfery Kneller. I expect to make this visit to Maryland in the first of May. I am anxious to complete this work in the hopes of Staying at home to make my situation more agreable to myself, as well as friends

altho' I have wrote this scrole in a great hurry, I hope the particulars therein will amuse you for a few moments, ever so little that I can do for your satisfaction ⟨to your friend⟩ wil be a gratification to your friend and
<div align="right">Brother CWPeale</div>

Mrs. Rachael Morris
 Harrisburgh.

ALS, 3pp.
PPAmP: Peale-Sellers Papers—Letterbook 18

1. CWP showed six portraits at the 1824 PAFA Exhibition: a replica of his ca. 1782 portrait of Robert Morris (1824: *Pennsylvania Academy of the Fine Arts*); a portrait of ReP's daughter Eleanor Peale (Mrs. Thomas) H. Jacobs (*unlocated*); *Self-Portrait in the Character of a Painter* (fig. 47); *Joseph Bonaparte* (fig. 45); *Self-Portrait in the Character of a Naturalist ("For the multitude")* (plate 5); and *Eliza Cecilia Laforgue (Mrs. Titian Ramsay) Peale* (*unlocated*).

CWP's contributions were praised in a notice that otherwise decried the lack of quality portraiture in the exhibition: "[The exhibition] is not however so rich in Portraits as heretofore, though they are numerous. The fault is probably in the want of price, rather than the want of talent, if there were but encouragement to exert it. Very few aim at character, or suitable accompaniment, yet the elder Peale is seen with interest, once more, lecturing upon the bone of the Mammoth." Falk, *Annual Exhibition Record*, pp. 163–64; *P&M*, pp. 35, 110, 148, 162, 163, 169; *Poulson's*, June 4, 1824.

2. For Bushrod Washington's approval of the *Patriae Pater*, see above, **168**; for John Marshall's, see above, **183**.

3. The *Patriae Pater* arrived at the Baltimore Museum on March 31, 1824. Extended because of bad weather, the exhibition remained in the city until the first week in May. *Baltimore American and Commercial Daily Advertiser*, March 31, April 28, 1824.

4. Unidentified.

5. CWP had yet to paint governors John Hoskins Stone and Samuel Sprigg. See below, **193**.

190. CWP to Eliza Patterson Peale

PHILADELPHIA. APRIL 18, 1824

Philada.April 18th.1824.

Dear Eliza

As Doctr. Bradford[1] goes tomorrow, I [illeg] not to loose the oppertunity of writing a few lines, as by it I may draw from you a letter in return, in this mode I shall be a great gainer, for one of yours will be of more value to me than any I can scribble. You will excuse me if I make this a short one, for it is now between 8 & 9 o'clock & it does not suit my health to sett up long or write much by candle light. I have been at my Easel the whole day, and you will suppose that I am very fond of my face when I tell you this is the 2d. portrait of myself which I have on hand, but the fact is, that having promised Mr Hopkinson to give a portrait to the Academy of fine Arts, I began one with my back to the light and when Mr. Hopkinson came to see it, he seemed to be better pleased if I had painted it which [with] the light in front, I have therefore painted two portraits, neither of them are quite finished, they will be [e]qually good, The Painters will admire that painted in a reflected light, but the multitude will like the other better, as they cannot conceive how the light should fall on my back without a window was painted behind me.

These are better portraits that [than] have painted heretofore. I have began a portrait of Eleoner,[2] Rembrands daughter, she setts tomorrow for the drapery, the action looking at a Miniture picture, she must be pleased with the picture, but no one will know whether it is of a gentleman or a Lady, as the back of the case is represented, I shall have 4 pictures for the Exhibition, Eliza—Titians consort, Eleoner & 2 of *Pellgarlick*.[3]

I have received the Frames, and David White is repairing that belonging to Miss Shippen, she left it to me to do what I should think best, she was willing to have a new frame, yet I am of the opinion that this will [be] as good as any commonly made at less expence. the repairs will not cost so much as a new frame, it is appropriate to the fashion of the picture.

we are very anxious to know the fate of Rembrandt with Congress. I

wonder he does not write oftener to some of the family. Rubens has also become lazy with his pen.

I shall make every preparation I can to enable me to pay you a visit in May, but how will it do for me to be with you while Rembrandt is there? yet I mean to make what expedian[ce] I can to finish my ingagement with the Corporation of Annapolis, therefore I shall be obleged to go where I can get the pictures to be copied. Coll. (or Genl.) Stone's[4] family is somewhere near Washington, what other I shall do is uncertian.

William & Elizth.[5] was here yesterday—your Sister is well and will be in Philada. soon—William told me.

Coleman have been some time much indisposed—he has a bad cough & sometimes [fe]ver. he has not been able to attend his business for about 2 weeks past. & he begins to think hard of it. Doctr. Bradford will tell you more particularly his state.

Titian goes out in good weather, yet he is far from well, is however able to preserve some small subjects, and is also much occupied with drawing birds for an addition to Wilson's ornithology, to be edited by Prince Charles, Count Suvelleurs Son in Law—alias Joseph Boneparte.[6]

I have given you a longer letter than I intended when I satt down—
My Love to all the family yours affectionally

CWPeale

PS. Mr. Thackara[7] wishes to know if Rembrandt will exhibit Doctr. Michals portrait and others.[8]

Mrs. Eliza Peale.

Baltre.

ALS, 2pp.
PPAmP: Peale-Sellers Papers—Letterbook 18

1. Dr. Richard H. Bradford of Richmond, Virginia, was a friend of the Peale family who frequently visited Philadelphia. In 1815, he attended RaP during his severe illness. See *Peale Papers*, 3:363–65.

2. (*Unlocated.*) The portrait may have been intended as an engagement picture, since Eleanor (1805–1877) married Thomas Jacobs (1800–1863) in 1825. Sellers, *CWP*, p. 441.

3. CWP actually exhibited six paintings at PAFA in 1824. See above, **189**. *Pilgarlic* refers to the naked head of a garlic bulb (peeled garlic), and was a slang reference to a bald man; CWP was referring to his two self-portraits. *OED*.

4. Governor John Hoskins Stone attained the rank of colonel before he resigned from the Revolutionary army following a disabling wound sustained at the Battle of Germantown (1779). *P&M*, pp. 203–04. For CWP's visit to Georgetown to copy Stone's portrait, see below, **193**.

5. At this time, William Patterson and EPP lived in Germantown on his family's farm. *CWP*, pp. 392–93.

6. See above, **182**.

7. The engraver James Thackara (1767–1848). *Peale Papers* 2:109n.

8. CWP is referring to ReP's portrait of Samuel Latham Mitchill (fig. 24). ReP did not exhibit it or any other work in the 1824 PAFA exhibition. ReP Catalogue Raisonné, NPG; Falk, *Annual Exhibition Record*, p. 167.

191. CWP to Eliza Patterson Peale
PHILADELPHIA. MAY 18, 19, 1824

Philadelphia. May 18th—24

Dear Eliza

Your brother George called on me yesterday to inform me of your call on him to aid Rubens with money, and said he can get of Mr. Johnson of Germantown 500$ on loan, provided you send a a bond and Judgement on the Mill for that amount, but that he Mr. Johnson had not the money at this moment but would have it in two weeks— George said he would give of his own Money 200$ and proposed to draw a note for discount in the Germantown bank if I would endorse it. This will not in my circumstances be proper, for I have long since determined never to indorse a note, let the urgency of the case be what it may, this I have declared to several of my family & also to Mr. Tagart (President of Mechanick bank) where I am much in debt and have at present credit with them by my punctuallity of paying interest. This statement will excuse me with Rubens. I have too great expences on my shoulders to prevent me speedily getting out of debt with the said Bank, and cannot get money on the farm or sell it in this time of depreciation of property. my mind would be much harrist [harassed] with such circumstances as occur in the family and my ⟨*difficulty*⟩ deficiency of relief for them & ⟨*my*⟩ also myself, if I did not contrive to give myself a constant employment, even to hurry. And I had hoped that I might add to my income by ⟨*either*⟩ painting portraits, that I find is not my lot to make profitable, for I have after a long period, got only, one picture to copy, which is now in hand, this, of the late Mayor Mr. Wharton, having painted his portrait for the Museum which pleases his friends, and thus induces him to give me the chance of earning 50$.[1] My next recourse is to the porcelain teeth, which I think I may command in a little Time full imployment, and rather than want money, I am willing to relinquish a more favorite art. I have now made myself more perfect in this business, and at present doing some that I shall receive payment for. one lady that I used to work for is not so well off as she used to be, and therefore I have not received from her any Cash for my last work. Teeth I have made for my Daughter Sophonisba pleases all that see them & she is not backward to shew them, and thus, without any other means I shall be known as capable to aid the ladies with these useful as well as beautiful things. I have put 4 pictures in the Exhibition how they will be approved off, is yet to be seen.—and if I have any credit by them it is well, if not then my tooth business must be my resorse,

I cannot visit you in less than 2 weeks, but that time fully imployed will soon pass away.

I have in hand the altering my rooms. The painting room is now square, my bed room the width of a door smaller—The first coat of plaster now putting on— The alteration is thus: The proportion of the lines not correct, otherwise you would be struck with this improvement.

George will accompany me to visit you, as he expects to get the money you require within the 2 weeks—love to the family (in haste) I subscribe

your affectionate father
CWPeale

Mrs. Eliza Peale baltre.

19th. Rembrandt arrived here yester morning and is pleased with my alteration of the painting room.

I have on hand teeth for Peggy Shippen, and succeeding well with them will I am confident be known to many who probably will also want my aid. She was suddenly & voilently attacked with inflamation of the chest & throught, is now recovering from it, says she thinks she will be able to go out muffled to day if the weather permits. It is not fit weather for her this morning.

I thought to [illeg], but find the painting-room so damp that I fear staying in it.

C P_____e

ALS, 3pp.
PPAmP: Peale-Sellers Papers—Letterbook 18

1. There is no record of CWP's painting a replica of Wharton for Wharton's "friends." CAP; *P&M*.

192. CWP to TRP and Eliza Laforgue Peale

PHILADELPHIA. MAY 21, 1824

Philada. May 21st. 1824

Dear Titian & Eliza

By Mr. Lukins[1] I must give you a few lines, but indeed I have no time to write a long letter, suffice it to say that the first coat of plastering is on, yet

the weather has been very unfavorable, only one day of dry weather since it was laid on, to day is fine & probably the plasterer will give it a 2d coat on tomorrow.[2] Rembrandt is returned[3] and about to begin painting an Equesteren Portrait of Washington— Congress was too much engaged with the tarif and electionering about a New President to do any thing else—[4]therefore his friends in Congress advised him to wait for the next sitting of that body. and having a well executed work, in their view, will ensure him a handsome sum— The example of Trumbuls Pictures makes many members unwilling to vote money for expected work.[5]

Margaret[6] goes on smoothly, and I have all the comforts a *lonely life*, can give. My time is now wholy employed in my tooth room, and I shall do some good and handsome work. I am gaining experience daily & now execute with greater certainty.

Franklin has preserved a *large trout* very handsomely. your mother[7] is better, yet complains of want of an apetite. Mr. Lukins will furnish you all the news.

<div align="right">Yrs. Affectionately CWPeale</div>

Titian Peale at Egg harbor.[8]

ALS, lp.
PPAmP: Peale-Sellers Papers—Letterbook 18

1. Isaiah Lukens.

2. For CWP's account with the plasterer who was helping him remodel his painting room, see CWP, *Receipt*, May 21, 1824, P-S, F:IIA/70E12.

3. Upon his return from Washington, ReP put his *Patriae Pater* on display and published an announcement on May 26:

PEALE'S WASHINGTON.

This Portrait, which was much visited in this City in the few last days during which the Author was still employed in a series of progressive improvements, has just returned from the Seat of Government, where it has passed the ordeal of criticism and comes out with a reputation of the highest character. Chief Justice Marshall, Judge Washington and many others who were intimate with the great original, having pronounced it the most exact, expressive and living portrait they have ever seen.

It received its last retouches in Washington, and has not yet been seen in this City since it was entirely finished. but it is now placed in the room where it was painted and may be seen every day after two o'clock.

The exhibition continued until June 21. *Poulson's*, May 26, June 14, June 19, 1824.

4. The first session of the 18th Congress ended May 27, 1824; the second began December 6. During this session, the tariff emerged as an issue of supreme political as well as economic importance, signalled by Henry Clay's speech of March 30–31 in which he called for the establishment of an "American system" of protective tariffs and national improvements. Clay's speech highlighted the emerging differences in the Republican party that eventually resulted in the formation of two new parties, the Democratic Republicans and the National Republicans (Whigs). In the interval between the breakdown of the old party system and the coalescence of the Second American party system, Congress became the locus of presidential politics. Much of the year was spent in convoluted politicking among the five presidential contenders; John Quincy Adams eventually emerged as president following the so-called Corrupt Bargain with Henry Clay. *BDAC*; *The Encyclopedia of American History*.

5. John Trumbull's (1756–1843) paintings for the Capitol had been commissioned in 1816, but were not installed in the rotunda until late in 1824. Congress was not pleased by the long delay, and many members were disappointed in the paintings themselves. *Peale Papers*, 2:1027n; see below, **245**; *DAB*; Lillian B. Miller, *Patrons and Patriotism: The Encouragement of the Fine Arts in the United States, 1790–1860* (Chicago, 1966, 1974), pp. 45–48.

6. RaP's daughter Margaret (1810–47) was keeping house for CWP while TRP and Eliza were vacationing. *CWP*, p. 440.

7. Bridget Laforgue, Eliza's mother.

8. A seaside resort on the coast of New Jersey, about fifteen miles north of Atlantic City. *Columbia-Lippincott Gazetteer of the World*.

In June 1824, Peale was close to fulfilling his agreement with the Annapolis Corporation to exchange likenesses of the Revolutionary governors of Maryland for the portrait by van der Myn of the fifth Lord Baltimore that was languishing in the Statehouse. Having completed replicas of his earlier portraits of Governors Johnson, Paca, and Smallwood, and having decided to substitute portraits of Governor Howard, who had been painted by Rembrandt in 1797, and the recently retired governor Samuel Sprigg for Governors Henry and Lee, for whom no portraits seemed to exist, by the spring of 1824 Peale needed only portraits of Governor John Hoskins Stone and Sprigg to complete the bargain. For these, he determined to travel to Washington, D.C., where he had heard that a portrait of Stone was available at the home of Dr. Nathaniel Pope Causin, the governor's son-in-law, and to Sprigg's Northampton estate in Prince George's County, where he planned to paint the former governor's portrait from life. (See figs. 38–43.)

193. CWP: Diary 24. Philadelphia to Baltimore and Washington, D.C.
JUNE 9–JULY 4, 1824

<center>Expences—</center>

Delaware Steam boat with breakfast.	3.50
including stage to F. Town[1]	3.75
Boy with a Barrow	25.
3 yds. Guaze flannels	1.50
Silver smith Soldering Teeth	25
Making 5 buttons & for do.	75
Barrow at N. Castle	12 1/2

1. During his trip to Baltimore CWP used the familiar combination of steamboat and stagecoach that he had taken in 1818–19. He made stops at New Castle, Delaware, and at Frenchtown on the Elk River. *Peale Papers*, 3:655.

Stage to Washington & Box of Canvis	4.75
Dinner on the Road—	75
pr. Buckskin S[h]oes in Balt.	2.00
Soldering Gold Spetacles—	12 1/2
Stage to Washington & Dinner	4.75
—Compasses at Washington—	25
Hack	25
Expences at Browns Tavern[2]	4.25
Hack to Govr. Spriggs—[3]	4.25
Soldering Eliza Clasp—	57 1/2
Packing Case for pictures	2.00
To Servants at Govr. Spriggs	87 1/2
Stage to Baltimore—	3.25
Dinner on the Road	75
Steam Boat to Annapolis.	2.00
Servants ——	75
P[ostage?] ——	6
Steam boat to Baltre.	2.
linnen & servants	90
chesapeake Steamboat & waiters	5.
Delaware & [illeg]	

June 9th. 1824 commenced a journey to Baltemore in the Steam boat which starts at 5 O'clock in the Morning, the passage being made at this season of the year in day light. The day remarkable pleasant. I am introduced to Mr. [] an agreable old Gentleman.

we arrived at New Castle about 9 O'clock and I took my seat in Stage No. 1. our company besides the Gentleman above named were a Lady who had with her a girl about ⟨8⟩6 or ⟨9⟩7 years of age, of a sickly complexion— I remarked that she was very much like the her guardian Lady and I supposed she was her daughter. no she replied, that she was her Niece the resemblance of features were greatly alike— 2 gentlemen attended this Lady, and we had an agreable chat togather, they all knew me and asked my [me] questions about my family, and thus beguiled the time away. Rain & Stormey weather. Wind & tide against us. yet we arrived at Baltre. at 8 O'clock.

2. Brown's Hotel, also known as the India Queen, was located on the north side of Pennsylvania Avenue between Sixth and Seventh Streets, in northwest Washington. The hotel was familiarly known as Brown's after its landlord, Jesse Brown. Visitors to Washington and congressmen lodged at the hotel for $1.75 per day, or $10 per week, or $25 per month. Samuel C. Busey, *The City of Washington in the Past* (Washington, 1898), pp. 310–11; Constance McLaughlin Green, *Washington: Village and Capital, 1800–1878* (Princeton, N.J., 1962), pp. 28, 108–09; *Daily National Intelligencer*, June 22, 1824.

3. See nn. 19, 20, below.

I wrote a letter to Doctr. Casine[4] at Washington which inclosed in one to Coll. Bumford.[5] perhaps it would have been better not to have put it into that Cover, as it is probable that Coll. Bumford may not be at Washington—and the Doctr. being a distinguished medical charactor would more likely be found at this City.

I visited my daughter Angelica Mr. Robinson was in Virginea. When I first see him I was with Angelica at Doctr Waters his Son in law[6]—I rise & spoke to him, but he did not advance and I stoped in my salutation to him— I have seen him several times since, and always speak to him, yet he scarcely replies— It would be my fault if I neglected to address him—and if he does not make any return of sevilities the fault lays with him, not with me. Therefore I am content and I do not conceive that I am unworthy of Notice. at least I endeavor to fulfill my duty not only to him, but to every human being—.[7]

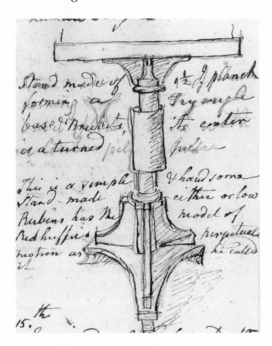

4. See below, **194**. Dr. Nathaniel Pope Causin (1781–1849) graduated from the University of Pennsylvania Medical School in 1805 and practiced in Port Tobacco, Maryland, until 1818. Moving to Washington, D.C., he married Eliza Stone, daughter of Gov. John Hoskins Stone. *Washington City Directory (1824)*; Eugene Fauntleroy Cordell, *The Medical Annals of Maryland, 1799–1899* (Baltimore, 1903), p. 345.

5. See CWP to George Bomford, June 12, 1824. P-S, F:IIA/70F2; above, **181**.

6. Dr. Horace Wesley Waters married Alverda Robinson, fifth child of APR and Alexander Robinson, in 1820. The couple lived near Pearl Street in the south side of Baltimore. *Baltimore City Directory (1824)*; CWP, p. 440.

7. For Robinson's hostility toward the Peales, see *Peale Papers*, 2:121, 522, 719, 750, 816.

Stand made of 4 ½ I planck forming a Tryangle base & Brackets, its center is a turned pillar.

This is a simple & handsome Stand—made either [high] or low Rubens has the model of Redhuffers perpetuall motion as he called it[8]

15th.

I received a letter from Doctr. Casine acquainting me that he had a Portrait of Govr. Stone painted by my Son Rembrandt which I was welcome to the use of it. & requesting to know if it must be sent to me at Baltemore—this determine me to go to Washington rather than having it sent here.[9]

16. took the Stage to Washington & what I conceive is extraordinary is the day is so cold that I found it necessary to keep on my Cloak the whole day— arriving at Washington when the Sun was some height— I went in quest of Doctr. Casine—he was not at home, I then went to Mr. Kings Painting-room[10] and was much surprized to See so many Pictures ⟨and he had⟩ painted in Portraits Landscapes & Still life— then returning to the Doctrs. I see him & the picture which appeared to me as very young for Govr. Stone, yet I know the likeness—though it does appear to me as done by Rembrandt—[11] I took it out of the frame & told the Doctr. that I would call for it tomorrow after I had paid some visits— Then went to Mr. Shoemakers[12] & took Tea with them & now returned to the Tavern (Browns) where I make these notes before retiring to rest. Friday morning I visited the President, who very politely invited me to dine with him— when it was convenient to me—[13]That his hour of dining was 4 O'clock I then went to Coll. Bumfords & was entertained with the sketches of his

8. Charles Redheffer's "perpetual motion machine." See *Peale Papers*, 3:183–86.

9. See below, **194**.

10. Charles Bird King (1785–1862), portrait painter, studied with Edward Savage in New York and Benjamin West in London. He moved to Washington in 1816, where he experienced some success. In his gallery, which was part of his house on the south side of F Street northwest, one door east of Twelfth Street, he exhibited his collection of portraits of Indian chiefs, many of whom had visited Washington for treaty negotiations. Groce and Wallace, *Dictionary of Artists*, p. 370.

11. In his Autobiography, CWP misread this diary entry and wrote "does not appear to me as done by Rembrandt." Sellers repeated the error, thus perpetuating the mistaken attribution of the portrait to an unknown artist. A(TS):464; *P&M*, pp. 203–04; CAP; ReP Catalogue Raisonné, NPG.

12. David Shoemaker was a clerk in the post office whom CWP knew from his 1818–19 trip to the city, when he lobbied the post office to adopt Coleman Sellers's mail bag. *Peale Papers*, 3:629; *Washington City Directory* (*1824*).

13. CWP's friendship with President Monroe developed in the fall of 1818, when CWP and HMP traveled to Washington and CWP took the president's portrait (*New York State Office of Parks, Recreation, and Historic Preservation, Philipse Manor Hall State Historic Site*). At a presidential levee on November 24, 1818, Mrs. Monroe "Paid a marked attention" to HMP. See *Peale Papers*, 3:620–23.

father in law Mr. Caton.[14] Returning to the Tavern I began my Copy of Govr. Stone at one Oclock after sketching it in I began ⟨to⟩ painting and not hearing the dinner Bell I continued my Work until ¼ past 4 Oclock, & then finding my stomack craving food, I went below to enquire for my dinner, the whole of the viands was not remooved from the table, I eat heartily, rather mixing too much Cream with my strawberries, it did not set easy on my Stomack, It appears to me that we ought never to eat our food hastily because in so doing we do not mix with it sufficiency of Saliva, an essential ingregent [ingredient] to promote digstions, and my experience prooves that when any uneasiness occures after eating, the best mode of cure, is to drink a little water and moove about gently, This sildom fails to promote the cure—otherwise, the stomack ought to be relieved by throwing up the contents, which with some persons may be easily affected, yet with my self, the straining to vomit is severe. In this present instance ⟨of⟩ using the water altho' I continued my work of ⟨the⟩ the pensel, and was soon releived, and continued with such rapidity that I almost covered in the whole picture, which might have done had I brought my Prusian-blue, that night I bought an ounce of it at an apothecarys shoop, and before breakfast after ⟨changing⟩ shaving & changing my ⟨lit⟩ linnen I painted in the blue coat before breakfast, and completed the Copy in the course of the day, except that I retouched the face before breakfast, by mending the expression. I should have noted that last evening, I took a hack and went to Mr. Kings[15] (a clerk in the treasury office) and with him I visited Mr. Ringold,[16] who had married a daughter of Govr. Lee to enquire where I could find a picture of him— I had been advised to go to Mrs. Digges,[17] who possessed a large collection of family portraits, and I had previously to my visit to see Mr. Ringold made up my mind to hire a Hack and wait on her, for it was said that there could be little doubt that this Lady must possess the Portrait I wanted, but to know by whom painted and at what time were important enquiries—But to my

14. The Bomfords lived at their estate, Kalorama, northwest of Washington, which was a gathering place and salon for Washington's elite society. See Corra Bacon-Foster, "The Story of Kalorama," *Records of the Columbia Historical Society* 13 (1909):98–119.

For Catton, see above, **181**.

15. James D. King was a clerk in the fifth auditor's office, on the second floor of the State Department. *District of Columbia City Directory (1822)*; *Washington City Directory (1824)*.

16. Tench Ringgold, marshal of the District of Columbia, was married to Lee's daughter Mary Christian. His office was on the south side of F Street, between Nineteenth and Twentieth Streets, northwest. *Washington City Directory (1822)*; *BDML*, 2:529.

17. Thomas Sim Lee was related to the prominent Digges family of Maryland by both blood and marriage; his wife was Mary Digges (1745–1805), the only daughter of Ignatius Digges of Prince George's County. The woman mentioned here was the widow Mrs. Digges, a resident of Capitol Hill, about whom no other information is available. *Washington City Directory (1824)*; *BDML*, 2:529.

surprise Mr. Ringold and his daughter assured me that no picture was made of Govr. Lee,[18] that he never would consent to his likeness taken. Mr. Ringold said that he had some faint Idea that a miniature was made & therefore called his daughter to know if it was so. His daughter replying in the negative, I lossed all hopes of painting his portrait, my next resourse was to paint from the life a likeness of Govr. Sprigg,[19] who from the charactor I had heard ⟨of him⟩ he was a Gentleman of amiable manners, and I of course concieved he a favorite of the People, therefore I engaged a hack to carry me to his farm, said to be about 15 miles distant—[20]I engaged a Hack at 4 dollars for the journey. and sett out at 9 O'clock from Washington, The driver not knowing the road said he could easily find it by inquiry, yet very unfortunately he was advised to go a road which was almost impasible whether it was supposed to be shorter, or more easily found I cannot say—but we were very much perplexed, in the first instance we took the wrong road and had proceed[e]d 1½ miles when meeting a Negro man, he told us that we ⟨had⟩ must return & he would go with us to where we should turn, out—thus, in this first instance we lost 3 miles—this was triffling to our other difficulties. The roads had been washed into deep gullies by late rains, and within one mile we found 4 bridges broken done [down] or rather carried off by the floods, so that with extrieme labour to the horses, and emminant danger of breaking the Carriage I could get on— at the last of the broken Bridges after geting over the run the Hill was too steep for the Horses to drag the carriage up, the baggage was taken out to lighten it, and trying to assend, the wheels got locked in an old trac[e] In short the difficulties was appeared so insumountable that the Driver went to house at a considerable distance to inquire what he must do, they told him, that he must get on in the best way he could, and not to reguard the destruction of the Corn through [which]

18. Ringgold's daughter is unidentified. Governor Lee was reputed never to have had his portrait taken. CWP wrote to John Lee (1788–1871) of Frederick, Virginia, youngest son of Governor Lee, on June 15, inquiring about a portrait. On June 28, 1824, John Lee wrote to James Boyle, mayor of Annapolis, that he had never seen a portrait of his father. However, in 1775 CWP recorded a miniature (*unlocated*) of a "Mr. Lee," who may have been the future governor. Heinrich E. Buchholz, *Governors of Maryland: From the Revolution to the Year 1908* (Baltimore, 1908); *P&M*, p. 123; CWP to John Lee, June 15, 1824, P-S, F:IIA/70F12.

19. Samuel Sprigg (1783–1855), a Democratic Republican, was a political neophyte when he was elected to the Maryland governorship in 1819. He was reelected twice, serving until 1822, profiting in both elections from the domination of the state's House of Representatives by the Democratic Republicans. Sprigg's administration was marked by his strong support for internal improvements, and particularly for the efforts of the Chesapeake and Ohio Canal Company. Sobel and Raimo, eds., *Biographical Directory of the Governors of the United States*, 2:655–56.

20. In 1815, Sprigg had inherited Northhampton, the family estate of more than one thousand acres in Prince George's County. He retired to the farm after his third term as governor. Buchholz, *Governors of Maryland*.

he must go. Here the Carriage was in some degree broken, and we were above an hour detained before we go into the road again, at the bridges we had passed we were obleged to go through thick woods, accomplished with difficulty—at one time we was informed that the distance to the Govr. was only 5 miles, yet after traveling miles other persons said we [had] 5 or 6 miles to go—at last it [was] only 2 miles & in that distance we were twice in the wrong way, and in the conclusion of our rout, we passed the Gate, that led to the Governers House & went about ½ a miles beyond it when we were stoped by another broken down bridge, and in this difficulty we determined to go back to make inquiry at a House about ½ a mile from the road, and on returning the Carriage was locked between two Gullies, and after staying some time trying to get it extricated, I left the Driver to get out as well as he could and walked on to the Gate we had passed, from which I could see a Barn & some small buildings— concluding that some Inhabitants might be found near it— Going fortunately the right way I found Govr. Spriggs habitation— He was setting with some Gentle[men] under a Tree before his House. I was not acquainted with him & my enquiry was joyfull to me— Mr. Sprigg was glad to see me & expressed a great deal of satisfaction that I should have visited him, I told him the reason of my visit, and he replyed that he would do anything that required of him. It was now past 4 O'clock P.M. and dinner was directly ordered for me and servants sent to help the Driver to get the carriage out of the ditch.

I was introduced to Mrs. Sprigg, to her daughter & Son—[21] I knew that my son Raphaelle had painted the Portraits of the family, and they were shewn me Mr. Sprigg remarked that each of the portraits were esteemed very like, but that of Mrs. Sprigg the least so—he said Raphaelle remarked that a beautiful Woman was most difficult to make a likeness & thus he excused himself. I found the right Eye was rather larger than the other, and they said the likeness appeared good, when that part of the face was hidden—I told Mrs. Spriggs that I would endeaver to improove the picture. 21st. I rose early as usial & got one of Mr. Spriggs Negroes to make me an Easell and I began my picture of Mr. Sprigg and finished it & make the the likeness of Mrs. Sprigg much to the satesfaction of Mr. & Mrs. Sprigg.[22]

21. Violetta Lansdale (1788–1865), daughter of Thomas Lansdale of Prince George's County, married Samuel Sprigg on January 1, 1811. At the time of CWP's visit, the Spriggs' daughter Sarah (1812–?) was twelve years old and their son Osborn (1813–?) eleven. Sarah eventually married her cousin William Thomas Carroll, and in 1840 Osborn married Caroline Lansdale Bowie, daughter of Robert W. Bowie. Christopher Johnson, "The Sprigg Family," *MHM* 8 (1913):83–94.

22. RaP's portraits of Samuel and Violetta Sprigg are privately owned; the portrait of Osborn Sprigg (fig. 48) is at the Maryland Historical Society; *Sallie Sprigg* is unlocated. RaP

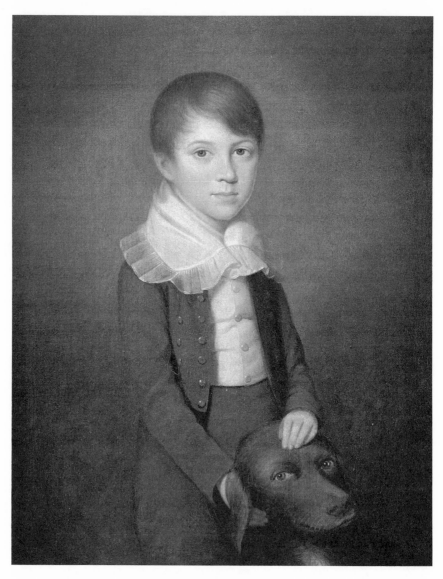

48. *Osborn Sprigg and Dog*. Raphaelle Peale, ca. 1820–21. Oil on canvas, 30 ¼ × 24 ½″ (77 × 62 cm). Maryland Historical Society, Baltimore. Bequest of Mary Bradley Anderson through Julia Anderson Stout.

This family possess immence wealth yet Mr. Sprigg attends deligently to all the concerns of his farms— I see a field of 150 acres in Wheat in a prospect of produsing a fine Crop—he told [me] that he had another in which he had sown above 100 Bushel of Sead wheat.

He has lately got a thrashing Machine—[23]it is to operate by rubing out the Grain. A cilender of about 4 feet long is covered with cast Iron in which are a great many holes—I should rather call it a frame of a cilender. the Sheet Iron are 3 Inches wide with holes of rather more than 1/2 In. diameter thickly placed, above this Cilender is another Iron with like holes in it. which is fixed with Screws to regulate its distance from the Cilender—and the wheat is drawn to this Cilender by a roller, there are two of the rollers, each of them about 2 1/2 or 3 Inches of diameter, The Cilender being turned by a Strap from a wheel of 6 feet diameter—this receiving it[s] Motion ⟨ *from and*⟩ by a lantern in a long shaft, fitted to cog wheel of 8 feet diameter mooved by a single Horse. It is said that with proper attendance more than 100 bushels in [is] got ready for the fan in one day. The Strap that turns the rollers recieves it power by the end of the Cilender, having for that purpose a plain part serving as a pulley of the same diameter as the Cilender

—this Machine is said to be also good to get out Clover seed, by having a hopper over the ⟨ *first*⟩ top of the rollers—and I suppose they must close the Iron that is over the Cilender ⟨*down*⟩ then when thrashing Wheat. Mr. Sprigg has 2 of the these Machines. the 2d. to be worked by a coupeling box to the first, so that by additional hands a double quantity, may be thrashed at one time[24]

having finished my portrait of Govr. Sprigg on wednesday morning, I then make such alterations on the Portrait of Mrs. Sprigg (painted by Raphaelle) in the afternoon & packed up. I had passed a very agreable time with this family.

His carriage carried me to Bladenburgh[25] where I took the stage to Baltemore and arrived there early in the evening of the 24th.

painted these portraits during his travels in Annapolis, Baltimore, and Prince George's County from 1819 to 1821, while Sprigg was serving as governor of Maryland. See Phoebe Lloyd, "Raphaelle Peale's Anne-Arundel Still Life: A Local Treasure Lost and Found," *MHM* 87 (1992):1–9; *Maryland Historical Society News and Notes* 21, 3 (1992):2; *Peale Papers*, 3:818–19, 832–33; Peale Family Papers files: Raphaelle Peale, NPG.

In 1808, ReP painted a portrait of Violetta Lansdale before her marriage to Sprigg (*private collection*). *Peale Papers*, 2:1112, 1138; ReP Catalog Raisonné, NPG.

For CWP's portrait of Governor Sprigg, see fig. 43.

23. For CWP's threshing machine, see *Peale Papers*, 3:225.

24. For CWP's clover harvesting machine, see *Peale Papers*, 3:226.

25. A Maryland town located six miles northeast of Washington. Leon E. Seltzer, ed., *The Columbia Lippincott Gazetteer of the World* (New York, 1952), p. 227.

I finished my portraits & varnished them, and took the steamboat to Annapolis on Sunday the 27th Eliza & her 3 children,[26] she had been invited to Mr. Wm. Brewers,[27] whose House is far from the Dock, therefore I sent for a Hack The driver told me that Mr. Brewers family was gone into the western country for the recovery of his health, I then advised ⟨Eliza⟩ with Eliza whether we ought not to go to a Tavern to get our dinners, as if we [went] to any other of the family, they might be put to some trouble to provide for so many ⟨of us⟩

we went to the best Tavern & ordered dinner, but before it was ready I thought it necessary to get my Trunk &c from on board the Steam-boat, least they might be carried back to Baltemore.

I went to Mr. Nicholas Brewers to get his Servant to go for my Trunk & the case of Pictures. and when I told that I must return to Eliza who was at the Tavern he said she should not stay there, I beged him to let us stay to get the dinner I had ordered, No, No, we must come & dine with him and he went and brought Eliza and her children bag & bagage.

after dining I told Mr. B that I had the 6 portraits of the Governors which I painted, They were in the packing case in the Piaza, supposing he might desire to see them, but he did not intimate any such desire, and I asked his approbation to put them into his spare Parlour. this he consented to, and before Breakfast I unpacked & placed them in proper order to be seen, then went to Mr. Boyle's[28] who is Mayor of the City to acquaint that I had finished my ingage[ment] if the Corporation would be satisfied with the 2 portraits I had painted instead Govr. Lee & Henry of whom no Portrait had been made Mr. Boyle came to see the pictures and as I was desireous to finish my business with the Corporation Mr. Boyle said he would give notice for them to meet in the Evening. We went to Mr. Nicholas Brewers Junr.[29] to dine & spend the afternoon— returning in the evening Mr. Boyle informed me the Corporation had accepted my Paintings— I should have noted that I drew up a short address to witt.

"To the Honorable Corporation of the City of Annapolis

Gentlemen. The subscriber with the utmost of his powers has complied with the resolution of your honorable board—he has to regret that no Portraits of the Governors Henry and Lee have been ⟨paint⟩ made, There-

26. RuP's wife Eliza and their children, Charles Willson (1821–71), George Patterson (1822–58), and William (1824–38), accompanied CWP to Annapolis. *CWP*, p. 442.

27. A relative of CWP's first wife, Rachel Brewer, but otherwise unidentified.

28. James Boyle (1790–1850).

29. Nicholas Brewer, Jr. (1795–1864), a graduate of St. John's College, was trained in the law. He became judge of the Second District, Anne Arundel County. J. D. Warfield, *Founders of Anne Arundel and Howard Counties, Maryland* (1905; reprint ed., Baltimore, 1973).

fore he has substituted those of Govr. Howard and Spriggs If the portraits now presented meets with worthy approbation of your honorable board, it will give infinite pleasure to an old Inhabitant and a friend to the City of Annapolis CW Peale

June 28th. 1824 To James Boyle Esqr. Mayor of the City of Annapolis.["]

we are invited to dine with Mr Maccubens of Strawberry hill.[30] 29th. This morning was ushered in with a tremendous Thunder Gust, followed by a 2d. this made it necessary to hire a Hack, the walking otherwise would have [been] preferable as Mr. Maccubbins was to send his boat to carry us across the Creek. This farm possesses some beautiful Views, and the building especially the Mantion House is a fine task of Architecture disigned by Mr. Buckley for Mr. Sprigg a wealthy friend.

remarkable that last night the[re] was 3 Thunder Gusts succeeding and a continual blaise of Lighting & 2 this morning. I visited ⟨many⟩ several of the old Inhabitants of this City many of whom formerly were wealthy now much reduced. It appears to me that Annapolis if the Legeslature and Courts should be remooved from it, having no working Inhabitants it would become a deserted Village.

July 1st. Before I rose from my bed I reflected on effects which might follow in consequense of the Corporation parting with the Portrait of Lord Baltemore, as I had often heard them censured for parting with it— and some had said that it was expected that the Legeslature would annul the Bargain on ground that they did not possess the power to dispose of it. Mrs. Brice[31] a Lady of superior understanding exclaimed much against the Measure, I said to her that I suppost the Picture had been presented to the City, and therefore they in their executive faculty could dispose of it. she replied no, not without having the consent of the Citizens, and she [was] sure that they would never have parted with it.

It gave me concern that any blame should fall on them, and I had made

30. Samuel Maccubbin (d. 1838) was related to CWP's first wife, Rachel Brewer, whose mother had been a Maccubbin, and to the Howards, Hammonds, and Brices of Annapolis. The Maccubbins were also related to Charles Carroll, Barrister, James and Nicholas Maccubbin—who were Carroll's nephews—having inherited Carroll's estate upon his death and changed their name to Carroll. In 1788, Samuel Maccubbin became a member of the elite South River Club, suggesting that he was a man of property and social standing. See *P&M*, pp. 50, 51; *Peale Papers*, 1:498n, 504n; Warfield, *Founders of Anne Arundel and Howard Counties*, pp. 71, 202.

Strawberry Hill was an estate on the West River, designed for Richard Sprigg (1739–98) by William Buckland (1734–74), a prominent colonial architect, whose portrait CWP painted in 1774 *(Yale University Art Gallery)*. *Peale Papers*, 1:556; Rosamund Randall Beirne, "William Buckland, Architect of Virginia and Maryland," *MHM* 41 (1946): 199–218.

31. Julianna Brice (d. 1837), widow of the lawyer James Brice (1746–1801), lived on Prince Street in Annapolis. Warfield, *Founders of Anne Arundel and Howard Counties*, p. 157.

so great an offer for it, which at the time I conceived might be a great temtation, yet doubtfull whether they would accept my offer of Six portraits, some doubtless were amongst their best friends—and I knew that several Gentlemen had said that it ought to [be] left at Baltemore.

Unwillg to be the cause of contention and strife, I wrote as follows immediately after I rose from my bed.

CWPeale to his friend & kinsman James Boyle Esqr.

I am now leaving the City ⟨of Annapolis⟩ where I spent my youthful days, perhaps never to see it ⟨more⟩ more! My parshality for the place is very great, and ought to imbrace my love and respects for its Inhabitants. The Corporation of your City do me a great favor by accepting my offers for a picture, the first I had seen of any Merrit, and which long excit[ed] my admiration of the art of painting and thus created my desire to possess it.

But my offer of Six Portraits had another motive, in some measure selfish, for I wis[h]ed to be the founder of a collection of Portraits, which has the promise of becoming a rich and highly valuable Gallery of distinguished men elected to the highest office in a free Government.

The sentiment of Gratitude has been communicated to me through several channels, it created pleasure and pain. But, by my conversations with the Citizens of Annapolis, I have found, that if I present the Portrait of Lord Baltemore to the Baltemore Museum, that all censure will be done away to the Corporation for parting with this picture, therefore I have resolved to do so, and I feel much pleasure in the belief that I am performing my duty to them, and at the same time giving aid to the praiseworthy industry of my Son Rubens, who to his other merits possess[es] much taste in his labours to make his Museum a blessing to the Public, by a defussion of knowledge of the *Wonderful works* of an all *wise Creator*! CW Peale

July 1st. 1824

This[32] I carried and presented to Mr. Boyle after breakfast, and desired him to shew it the Corporation, this he promised to do—and he said he much approved it wished to know if I wanted the corporation to be called togather, No, at anytime when they meet— He said they would make a reply and perhaps I might wish to take it with me. This I can have sent to me. He proposed having it put into their Newspaper, the reply may accompany it.

I accidently meet with the Editor of the Annapolis paper[33] & told him

32. See CWP to James Boyle, P-S, F:IIA/70E13–14.

33. Jonas Green (d. 1868) assumed the editorship of the (Annapolis) *Maryland Gazette* in 1811. He was the grandson (and namesake) of the founder of the paper, and his father, mother, and uncle had been its editors before his tenure. Clarence S. Brigham, *History and Bibliography of American Newspapers*, 2 vols. (Worcester, Mass., 1947), 1:219–20; *NUC*.

nay shewed a copy of what I had written so that I expect it will be in his paper of Saterday 3d of July.

I went to take leave of several of my friends this morning, among them my venerable friend Jeremiah Chase.[34] He has become very feeble, and on the account of loss of health, lately has resined his office of chief Justice and other offices—giving up about 2000 $ pr. Annm. Altho, somewhat younger than myself, yet he is more feeble and his head disorded.

His Complextion florid and he has a tolerable suit of beautiful pure white hair, of very fine hairs.

I obtained 2 pictures of Mr. Malydear for Rubens Exhibition[35] they wanted mending, and I told Mr. Maleydear that I would repair them when I got to Baltre. which would save Rubens the trouble of doing it, more especially as just before his Exhibition he would have very little leisure. one of them by Sir Peter Lilly the other Sir God[f]ry Kneller. both very much abused and the canvis very rotten.

We went into the Steam-boat at ½ past 2 O'clock & arrived at Baltre. at ½ past 6 O'clock.

Rubens did not expect our return so soon—and had alittle before my arrivel enclosed letters to me from my family in one to Eliza I went in haste to the Post office, but too late the office shut. I put a note in the box requesting the Post master to detain the letters & I would call for them in the morning. The letter[s] were from Eliza. Franklin & Titian.[36]

3d. assisted in repairing the pictures brought from Annapolis. Visited Mr. Machenry[37] & took leave of Angelica and settled some small accounts with Rubens—went on board the Steam-boat at 5 O'clock A.M. arrived at Frenchtown alittle before 12 O'clock. and at New Castle 1/2 past 3. on board the Steam-boat fell into conversation with a young man who told me his father was a painter Name [] He said he was very fond of the art & practiced alittle he asked me if I was born at Annapolis—no, in Queen Anns County. he said he was born in Annapolis, and his parshality

34. Jeremiah Townley Chase (1748–1828), chief justice of the Maryland Court of Appeals since 1806, retired from that position in 1824. In 1783, he served as mayor of Annapolis and then was elected to the U.S. House of Representatives, serving from 1783 to 1789, when he became a judge. In 1824 he served on the committee welcoming Lafayette to Maryland. *NCAB*.

35. Colonel Henry Maynadier (1758–1849), officer in the Revolution, was married to Elizabeth Ross Key (1760–1832). They lived near Annapolis at Belvoir, the estate originally built by John Ross on Wyatt's Ridge. Since there is no extant catalog for the 1824 exhibition at the Baltimore Museum, it is not possible to identify the subjects of the paintings by the German-born portraitist Sir Peter Lely (1617–1680) and by Sir Godfrey Kneller (1646–1723), Lely's rival at the English court. Warfield, *Founders of Anne Arundel and Howard Counties*, p. 154; *DNB*.

36. Unlocated.

37. Possibly the husband of Martha Hall McHenry, Mrs. Nathaniel Ramsay's sister. See below, **274**.

to the place made him wish it was the place of my Nativity. he was pleased to say one of exalted genus. I boughed and thanked him for the complement.

He was sociable with me all the rout.

4th. a fine day & pleasant passage to Philada.

[memoranda at end of Diary, transcribed in order from back of book (book was reversed when written); five illegible lines written in pencil on back cover]

[in pen:]

In visiting Mr. Jefferson take the steamboat from Washington to Fredericksburg landing—which place is about 10 miles from Fredericksburg—from which city there is a stage that runs to Charlottsville (4 miles beyond Mr. Jeffersons house) perhaps the driver may be induced to drive you there.

Be particular when at Fredricksburg to see the Stage & horses that are to convey you.[38] T. Sulley

in the fall of 1784 I painted a Portrait of Genl. Washington, Coll. Tilghman & the Marquis de Lafayette in it for the State of Maryland.[39]

Octr. 1784 painted of whole length of Genl. Washington, for the State of Virginea.[40]

AD, 31 pp.
PPAmP: Peale-Sellers Papers

38. The directions given to CWP by the artist Thomas Sully, who had visited Jefferson in March 1821 in order to take a life study for a full-length portrait (*U.S. Military Academy, West Point*), would have taken CWP to Fredericksburg in Spotsylvania County, at the head of the Rappahannock River, about fifty miles south of Washington, and from there to Charlottesville and Secretary Ford's Road, which led to Monticello. Monroe H. Fabian, *Mr. Sully, Portrait Painter* (Washington, D.C. 1983), p. 14; Seltzer, ed., *Columbia Lippincott Gazetteer*, pp. 375, 640; William Howard Adams, *Jefferson's Monticello* (New York, 1983), p. 46.

39. (1784: *Maryland State Archives, Hall of Records, Annapolis*). IAP.

40. (1784: *Fogg Museum, Harvard University*). IAP.

194. CWP to Nathaniel Pope Causin

BALTIMORE. JUNE 12, 1824

Baltemore June 12th.1824.

Dear Sir

By direction of the honorable the corporation of the City of Annapolis I

have to paint a Portrait of my *friend* the former Governor of Maryland, *Coll Stone*. My Son Rembrandt painted a portrait of him, and probably other painters have also painted his likeness.[1] Genl. Smith[2] informs me that you married a daughter of Governor Stone—since I am led to hope that you possess the likeness which I am very desireous to hand down to posterity in a Collection of Portraits of the Governors ellected in the State of Maryland since the revolution. I have now finished four of them i, e, Johnson, Paca, Smallwood & Coll. Howard. In the order I had from the Corporation, was the name Henry, but unfortunately no portrait was made of him, which his Son, now greatly regretts.[3]

If you possess the Portrait in question, and will permit me to make a copy of it, I shall be very thankful, or if you do not possess one, it will be very obleging to inform me by a few lines as early as possible & convenient to you, where I shall make application,[4] and you will confer

<div align="right">
a favor on your friend

CWPeale
</div>

PS. Please to Director. at the
 Museum Baltemore
 Doctr– Casine Washington

ALS, lp.
PPAmP: Peale-Sellers Papers—Letterbook 18

1. No other artists painted portraits of John Hoskins Stone, as far as can be determined. CAP; IAP.
2. General Samuel Smith (1752–1839) had entered politics after ending his military career. Following the War of 1812, he was a member of Maryland's delegation to the House of Representatives, and, in 1822, he was elected to the Senate, serving there until 1833. *Peale Papers*, 3:259; *DAB*.
3. John Henry (1750–98) was active as a patriot and as a legislator during the Revolution and during the early national period. He served in the Continental Congress in 1778–79 and, a Federalist, subsequently served in the United States Senate from 1789 to 1797. In 1797, upon his election as governor of Maryland, he resigned his seat. He served only one term, retiring for reasons of health. Sobel and Raimo, eds., *Biographical Directory of the Governors*, 2:648–49.
4. For Causin's reply, see above, **193**.

195. CWP to Coleman Sellers
BALTIMORE. JUNE 14, 1824

<div align="right">
Baltemore June 14th. 1824.
</div>

Dear Coleman

My passage here was tolerably pleasant, exactly 15 hours. I surprised them at the Museum as I had not given them notice of my coming.

Doctr Casine an eminant Phisician in the City of Washington, married a daughter of Col. Stone, and I know his Portrait was painted by

Rembrandt—therefore I expect to get that picture to Copy, being one of the Governors that I have had orders to paint—I have wrote to the Doctr. and expect an answer tomorrow. probably I shall go to Washington to make the copy, and it is my wish to make what dispatch I can in order to return home——and if I take 5 pictures to Annapolis, and the Governor should be there, perhaps I may be admitted to make the 6th Portrait from a living subject, the present incumbent.[1]

Angelica is in good health, except a horseness from a [bad] cold. I have something to do to her teeth, and very little else to keep me in Baltemore, having seen the family of Rubens in good health, they must not to expect me to spend any idle time with them.

This afternoon commences the exhibition of the Mummy, Rubens having engaged to pay Mr. Pendleton 600$ for its exhibition for a limited time.[2] I wish it my [may] yeild a profit to him, he knows much better to speculate than I do. and if he fails in this, it will be the first bad bargain he has made. I have seen Mr. Robinson[3] 2 or 3 times and have always spoken to him, yet he scarcely replies—This gives me no concern, but I begin to think my freedom of speaking to him, may not be altogather proper, he may think it an insult—far be it from me to give offence to him or any one else—let their behaviour to me be what it may. I am not accountable for the conduct of others, but my feelings would be an affliction to me, if I should hurt any human being.

Andrew Summers has just arrived here, & will return tomorrow evening and Mr. Pendleton will follow him the next day, therefore by them I mean to attend to each of my aids at the Museum, as very probably I may not have the chance so favorable to write again for some time. my letters may not be worth paying postage for them, as this present scrole prooves— I should have more pleasant feelings ⟨by⟩ in being absent from my friends, if I knew that my services were not wanting, this applies to you Mother & sister—give my love to all the family, and believe me with high reguard &

Affection yrs.
CWPeale

Mr. Coleman Sellers.
Philada.

ALS, 2pp.
PPAmP: Peale-Sellers Papers—Letterbook 18

1. Samuel Stevens (1778–1860), a Democratic Republican, served in the Maryland House of Representatives before being elected governor in 1822. He was reelected twice without opposition, serving until 1826, when he returned to private life. Among the important measures passed during his administration was a law enfranchising Maryland's Jews. Stevens also played a prominent public role in LaFayette's visit to Maryland during his 1824

tour. CWP did not paint his portrait. Sobel and Raimo, eds., *Biographical Directory of the Governors*, 2:656–67; *P&M*; CAP.

2. At this time, John Pendleton was managing the exhibition of an Egyptian mummy in various American cities. He left the United States for Paris later in the year in order to study the new technique of lithography; subsequently, he and his brother William established a lithography firm in Boston. The mummy was exhibited in Philadelphia in April and at the Peale Museum in Baltimore in June.

The advertisement for the mummy exhibition read as follows:

<div align="center">

For a short Season
The Public are respectfully informed that
THE EGYPTIAN
MUMMY

</div>

Together with its singularly ornamented double SARCOPHAGUS, or Coffin, which was received from Ancient Thebes by the Boston Medical College, has now arrived, and is exhibiting in the

<div align="center">

BALTIMORE MUSEUM

</div>

Baltimore American and Commercial Daily Advertiser, June 16, 1824. Groce and Wallace, *Dictionary of Artists*, p. 497; *Peale Papers*, 3:842; *Poulson's*, April 20, 1824.

3. Alexander Robinson, APR's husband. See above, **193**.

196. CWP to BFP and TRP

BALTIMORE. JUNE 15, 1824

<div align="right">Baltemore June 15.1824.</div>

Dear Franklin & Titian

I am in expectation of a letter from a Doctr living in Washington, who married a daughter of Col Stone, one of the Governors I am to made a picture off. I wrote to that Gentleman on saterday.[1]

The exhibition of the mummy commenced yesterday afternoon. and a respectable company came to the Museum last evening.[2] Rubens takes infinite pains to please the Citizens of Baltimore, or would otherwise find it a hard task to get through his engagements. His Museum is in elligant order, and it appears wonderfull to me when I see so much work done since I was here last fall. He has now an elligant display of Minerals, well arranged and places left for those still wanting, gives the name with black lead pensil so that the arrangement of additionals cause no labour.

His Birds and Insects encrease fast. Instead of cork for Bodies of Birds, he takes wheat or Rye Straw, tying a cord round a part of the thickness of the bird to be mounted, then cuts it to the length and rounds off each end to the proper form, if the bird has a flat body the straw is pressed to that shape—This body in [is] light, and the wires hold admirably well when pushed into it. This Method I understand is practiced by Mr. Bullocks artists.[3]

I ⟨have⟩ am still alittle afflicted with a *Tenesmus*. and think it neceesary to

<div align="right">417</div>

have recourse to Caster Oil & flax-seed injections. before I go further South.[4] If I do not entirely & speedily perfect a cure, will not think of visiting Mr. Jefferson.[5]

I hope you will put the Museum in good order during my absence from home, I shall not undertake to mention what ought to be done as I am confident you are eminantly quallified to the task—And it will give me infinite pleasure to know that a perfect harmony prevails throughout the Establishment.

The Eyes of the Citizens are upon us, and every thing depends upon the approbation they intertain of our conduct

We cannot be independant of public opinion, and must be not only good & virtuous but our works must shew that we are so. or envy and jelousey will rob us of our deserts. such is the World! May you have the Wisdom to bear the follies of the inconsiderate, offending none, and to use every laudeable exertion to obtain the love, admiration & veneration of *all*.

I have some imployment to make teeth comfortable to my Daught[er] Angelica—and since I have been here have had much to do for myself, now tolerably comfortable in this respect. Sarah wishes to go to Annapolis with me and I am waiting to know how to fulfill my ingagements with the Corporation of that City.

I have nothing more to communicate at present, therefore conclude with presenting my love the [to] all my friends in the families— your
affectionate Father
CWPeale

Messrs. Franklin & Titian Peale
 Philada. Museum.

[reverse of envelope] I have just now seen Mr. Graham who lent me the picture of Governor Johnson—and who will inform me if Mr. Lee, 18 miles from Fredricktown has a portrait of Govr. Lee, in which case I shall go there to make a copy

ALS, 2pp.
PPAmP: Peale-Sellers Papers
Copy in PPAmP: Peale-Sellers Papers—Letterbook 18

 1. See above, **194**.
 2. See above, **195**.
 3. William Bullock (fl. 1808–28), an English traveler, naturalist, and museum keeper, published books on his travels in North and South America. He was also the author of *A Concise and Easy Method of Preserving Objects of Natural History* (London, 1817), from which CWP and RuP learned of his methods of preserving specimens. Bullock issued an American edition of his treatise in 1829 (New York). *DNB*; *NUC*.
 4. An irritation of the rectum or bladder; a symptom of dysentery; cystitis with stricture of the urethra. *Century Dictionary and Cyclopedia*.
 5. See above, **193**, n.38.

197. CWP to ReP
BALTIMORE. JUNE 15, 1824

Baltemore June 15th. 1824.

Dear Rembrandt

Yesterday evening I received a letter from Doctr Casine of Washington, who married a Daughter of Govr. Stone, and says he has portrait painted ⟨of the Gov.⟩ by you, of ⟨the⟩ Govr. Stone which he so obleging as [to] lend me & would send it to Baltemore if I required it. But my determination is to go to washington by tomorrows Stage, and shall have this advantage, if I chuse to use it, i, e. taking the Portrait of Govr. Sprigg, who resides a short distance from Washington. as soon as I have finished this scrole, I shall write to Mr. Jno. Lee who resides near to Fredricktown, to know if he has a picture of Govr. Lee, in which case I may take the Stage from washington to Fredricktown and make a copy, if such portrait can be had. The distance from Washington to Fredricktown about 40 miles. and thus I may save that distance by not returning here to go to Fredricktown.[1] perhaps when in that quarter, it may be advisable to take the 2nd Stage to visit Mr. Jefferson. but whether I shall feel myself so well as to undertake so long a journey I cannot say, as I have some little of a tenesm[us] still on me—yet better than it was with me in Philada. but I am almost in doubt, whether I should indulge so far as in the present time to make so long a stay from home, knowing that I ought to haste to serve some of my friends who want teeth.[2]

I called on Genl. Smith, and he informed me that the picture he alluded to in his note to you[3] was a picture painted by Stewart for the Marquess of Lansdown,[4] and he said if you wished it, he would write another and make that addition, I told him that I did not conceive this being necessary— I may be mistaken but I think he said that Steurt was to receive $1000 for the picture. Mr. Carrol[5] had gone to his country seat & would not be in Baltemore again, and I suppose you do not require me to make a journey especially for that purpose, had I been one week sooner in Baltre. I might have seen him.

Mr. Pendleton will inform me of all the news of the family, and refering to him for further particulars

I conclude with love to all your family

Affectionately yrs. CWPeale

Mr. Rembrandt Peale
 Philada.

ALS, 2pp.
PPAmP: Peale-Sellers Papers—Letterbook 18

1. See below, **198**.
2. CWP did not visit Jefferson at Monticello. See above, **193**; below, **200**.
3. Unlocated.
4. Gilbert Stuart (1754–1828), American portrait painter, painted Washington three times from life. The second portrait (1796: *Pennsylvania Academy of the Fine Arts*) was a full-length commissioned by the banker and legislator William Bingham (1752–1804) to hang in his mansion Lansdowne, upriver from Philadelphia on the Schuylkill. Thereafter, it became known as the "Landsdowne type," from which Stuart made replicas. The first replica was Bingham's gift to William Petty, first Marquis of Landsdowne (1737–1805); it is now at Carlton House, London. *DAB*; *DNB*; Lawrence Park, *Gilbert Stuart: An Illustrated Descriptive List of His Works*, 4 vols. (New York, 1926), pp. 854, 864; CAP.
5. Charles Carroll of Carrolton, from whom ReP wished to have a statement certifying the correctness of his likeness of Washington in the *Patriae Pater*. See above, **187**.

198. Richard Peters to ReP[1]

PHILADELPHIA. JUNE 24, 1824

Belmont June 24th 1824.

Sir

I comply very cheerfully with your request to give my opinion of *General Washington*. You have so many & so respectable testimonies of its excellencies that nothing I can say will add weight to them; or encrease the celebrity it has most justly obtained. No ⟨person⟩ one had more frequent opportunities of observing both his features & his person, than I had. To enumerate such opportunities, as you desired, would be an endless task. I have seen him during very many years, from an early period of my life, in every situation calculated to imprint on my mind, accurate recollections. Perhaps there is no person now living who had more frequent occasions to know both his person & his character, in his private as well as public capacities. I have seen all, or most, of the Portraits of this venerated Father of our country. The painters of several were respectable as artists, but they failed in the Likeness; & I have never been satisfied with any of them.[2] I was therefore most sensibly impressed with the superiority, in this regard, of your portrait; which, I think placed all others in the shade. Without pretending to nice discrimination in the execution; I judge from its effect on *my heart*. You have, most happily, caught the lineaments of his face, the air of his person, & the character of his mind. I have seen him, a thousand times, as he is represented by your able & fortunate pencil, and do not hesitate in pronouncing yours to be (in my opinion) the only faithful likeness of this great & good man, yet exhibited. You have done yourself great honour; & presented to your country an inestimable gift. Those of this day, & future generations, may view & venerate, in your performance, the true portrait of him to whom they so much owe the blessings they enjoy. Meritorious as were all other revolutionary patriots; without a <u>Washington</u>, their exertions would have been vain.

I confine myself to the *Portrait*; which is enough for an ardent admirer of the eminently distinguished original. I have heard some objections to the imitation of massive massonry surrounding it. Your idea, that the strong & splendid light in which the principal figure is seen, requires a contrast; has certainly much weight in it. I do not deem myself competent to settle a mere question of *Taste*. Whether this criticism be just, or fanciful & overnice; I am neither disposed nor qualified to determine. From my schoolboy days, I have followed the benevolent & laudable example of *Horace*,—

Ubi plura nitent in carmine, non ego paucis offendar maculis.
Did I deem this apothegm applicable to your Portrait, I would say
Ubi *plurima* nitent.[3]
Believe me very sincerely yours,

Richard Peters.

Mr. Rembrandt Peale.

ALS, lp.
MHH: Autograph File

1. This is the published testimonial requested of Peters by ReP. For a draft of Peters's letter, which contains a more balanced appraisal of Washington's temperament, see Richard Peters to Rembrandt Peale, June 21, 1824. P-S, F:VIA/4B13. Richard Peters (1744–1828), a graduate of the College of Philadelphia, was a youth when he first met General Washington during the latter's visit to the family home at Belmont, an estate outside Philadelphia. His acquaintance with Washington continued through his work as a member of the board of war during the Revolution and later, during the early national period, as a result of his public activities as a lawyer and a judge. Peters's interest in scientific farming also brought him into Washington's circle, as the two men exchanged ideas concerning agricultural methods and especially the breeding of sheep and cattle. *DAB*; *Peale Papers*, 3: 663–64.

2. In his draft, Peters mentioned his half-length crayon portrait "on a small scale" of Washington executed by James Sharples (ca. 1750–1811), an English-born painter of pastels and miniatures who came to New York in 1796 with his wife, also a portrait painter, and their children. Using pastels, or crayons, as they were called—dry pigments ground in a medium and mixed, usually, with water—he painted from life for Judge Peters a profile portrait of Washington that was reproduced many times by Mrs. Sharples and their daughter (*Independence National Historical Park*). John Hill Morgan and Mantle Fielding, *The Life Portraits of Washington and Their Replicas* (Philadelphia, 1931), pp. 395–410; James Ayres, *The Artist's Craft: A History of Tools, Techniques, and Materials* (Oxford, 1985), pp. 59, 102–03.

3. Peters's quotation is from Horace, *Ars Poetica* (ca. 13 B.C.E.) and may be translated as "Where many things in a poem are brilliant, I won't be offended at a few faults." *Oxford Latin Dictionary* (London, 1983). Peters's addendum to Horace's phrase may be translated, "where most things are brilliant."

199. CWP to John Mortimer
PHILADELPHIA. JULY 2, 1824

Philada. July 2d. 1824

Dear Sir

Finding that I must practice economy of time as well as of monies, it is

therefore I withdraw my subscription to the Christian, not that I can find any fault with the publication, for my opinions accord with the society of Unitarians in their sentiments of Christianity, and I admire their liberality to other denominations of Christians, as expressed in several passages in the Christian, the publication of which I hope has fully accomplished the object intended.

I am with respect your friend

CWPeale

Mr. J. Mortimer
No. 74 South 2d St. Philada.

ALS, lp.
PPAmP: Peale-Sellers Papers—Letterbook 18

1. John Mortimer was a Philadelphia bookseller and stationer who published a Unitarian newspaper, *The Christian. A Weekly Paper, devoted to religion, morals and literature*. The journal was short-lived, beginning publication on January 24, 1824, and ceasing on July 24; only the first edition is extant (PHi). *Philadelphia Directory (1824, 1828)*; *NUC*.

200. CWP to Thomas Jefferson

BALTIMORE. JULY 2, 1824

Baltemore July 2d.1824.

Dear Sir

It was my intention to have paid you a visit when I left Philada. I had proposed to myself to commence this journey in the first of May as the better season, but my youngest Son Titian was so much indisposed that he could not attend to the business of the Museum, and another call for his improvement now obleges me to return to Philadelphia. A Gentleman from England by the name of Chas. Waterton[1] told me that he came to North America on purpose to see my Museum, that hearing that I had the Skeleton of the Mammoth, and Wilson's ornithology[2] inform.d him of my Birds, that he was about making a Voiage to South America, and choose to come here first, and he expressed great satisfa[c]tion in this Museum, and was pleased to say that it surpassed most of the Museums in Europe, for it contained a greater variety of subjects, that he had seen all the Museums in Europe, and was so fond of the art of preserving animals that he had made it his Study and had ⟨dis⟩invented a mode much superior in practice, which Sir Joseph Banks[3] said was superior to any in common practice. His method he said was to take out all the Bones of Quadrupedes and to model the Skins into their true form, and that he neither used Wires or stuffing to support them in their proper form and attitude. He showed me a Cats head and a bird from South America in the preservation like

life. Before he left Great Britain, he told me that he delivered a lecture at Leeds in which he discribed all the methods that has been practiced and concluded with discribing the mode he had invented, and shewed the audience some specimens, that this lecture took him from 6 to 10 o'clock to get through with it, I supposed that he had tired his audience, he replied not in the least, they would have staid longer. He appears to be well learned in Science, and in his proceeding with my Son very liberal,[4] supposed to ⟨be a Man⟩ possess wealth.[5] when I came from Philada. he had gone to New York with the intention to teach his Method of prese[r]ving to a young man in the Hospital, but the Professors would not allow him a month to be absent from the Hospital, and he then wrote a letter to me, saying that he would return to Philada. to teach my Son, but he must give him his undivided attention and they must go to some place where they could get fine birds— Titian went with him to Selum[6] in N. Jersey and I have to day received a letter from Titian, in which he says this new method is beautiful in practice, so clean that they eat their meals on the same table that they preserve their Birds. Titian says that he is now convin[c]ed that the use of Arsenic must have injured his lunges, for it eat holes in his fingers. And a letter from my Son Franklin says Titian has sent us two Birds beautifully mounted. Mr. Waterton says that Titian is an apt Scollar, but he will not allow him to attempt mounting Quadrupedes untill he is perfectly master of preserving Birds.

Mr. Waterton told me that his Method of preserving large Animals, was to put a Stick in the Skin after all the flesh and Bones was taken out then with strings tyed to this Stick support it from the cielling of the higth that the feet shall touch the ground, the head also suported, then filling the Skin with cut straw, he could put his modelling stick through the straw with ease, & thus model out the Skin. at first it would be unsightly, but as the work advanced the skin would readily take the true form, and when perfectly dryed, would be so stiff that it would not only support itself but also a considerable weight. That he used corosive sublimate[7] to poison the outer and inner Skin—The sublimate mixed in alcohol.

Thus, my dear Sir I have given a sketch of my sons imployment & which obliges me to return to Philada. and not to do myself the pleasure of Visiting you at present, Possibly I may be permited to do it towards the last of the summer season.

The letter enclosed shews its destination.[8] My Son Rembrandt now begin.g an Equestrian Portrait of General Washington—a Bill was read in the Senate of the United States provinding payment for such a picture, laid on the table, and he was advised not to have it called up, but to execute the painting and bring it to Washington at the beginning of the next session.

423

I had made an offer of Six Portraits of the Governors elected since the revolution, for a whole length picture of Lord Baltimore, this trip into Maryland was to complete my engagement, It is done, the Corporation of the City of Annapolis approoves & accepts my Work. I could not find any portraits of 2 of the number named to me, therefore I substituted others, one of them which I chose to make, was from the life, Govr. Sprigg— I believe my powers to produce good Portraits is greater than formerly, Altho' the immagination of an aged man, may not be so sprightly, yet the judgement may be better, besides having the advantage of years to observe the change of colours— My Eyes are growing better, I cannot use spectacles to paint in oil. very little encouragement for the fine arts in Philada. Therefore I will not seek to get employment, & shall only paint a Portrait occasionally for the Museum. and very probably I shall have much to do in making Porcelain Teeth for those who are so unfortunate as to loose their natural teeth. This I consider a very important work. I can make many Ladies beautiful, which to them is of great import, yet the easey mastication of food is essential to obtain good health & therefore of more importance. I hope your teeth continue to be sound and good, my impression is that you enjoyed a good sett. my Scrole contains a variety of subject I wish it was more important—however I will continue to lengthen it, not in the expectation that I can increase your knowledge. I received a letter from Mr. John Hawkens of London,[9] he wished me to give him my observation on the means of preserving health, he said that he had thought of publishing on that subject, he said his practice was to wash with a coarse towel of a foot square, then rub dry with another coarse towel and lastly to wash his feet. If he had caught a cold to do so night & morning sildom failled to make a cure.

When he traveled he carried an oil cloath bag in which he put his Wet Towels, and thus he always had his bath at hand—I have begun the same practice, and find it very convenient, also very refreshing. I do not believe we can take too much trouble provided we gain an increase of health. That you may long enjoy a large share of it is the ardent wish of your old friend

<div align="right">CWPeale</div>

Thomas Jefferson Esqr.

ALS, 4pp., end.
DLC: Thomas Jefferson Papers
Endorsed: Peale. Chas W. Baltimore July 2.24 recd July 6. Under CWP's signature TJ indexed the subjects included in this letter.
Copy in PPAmP: Peale-Sellers Papers—Letterbook 18

1. Charles Waterton (1782–1865) was an English explorer and naturalist who received his early training in the field during his travels, initially undertaken for reasons of health, to

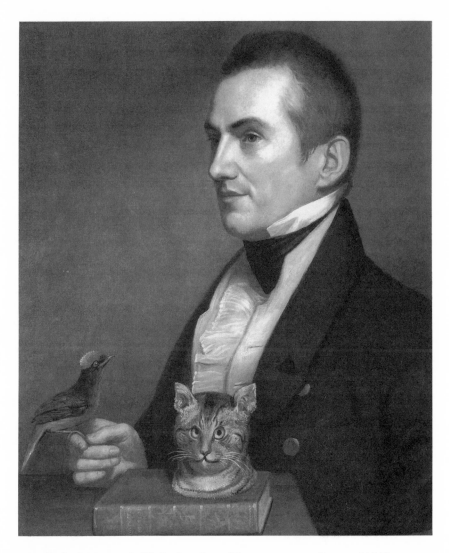

49. *Charles Waterton*. C. W. Peale, 1824. Oil on canvas, 23 ³/₄ × 19 ³/₄″ (60 × 49.7 cm). National Portrait Gallery, London.

Central and South America. He came to the United States in the summer of 1824, and later published *Wanderings in South America, the North-west of the United States and the Antilles in the years 1812, 1816, 1820, 1824* (London, 1825). Waterton was a pioneer in taxidermy. His home in Yorkshire, Walton Hall, was renowned for the size and development of his garden and for his collection of specimens, many of which are still extant. *DNB*.

2. Alexander Wilson's *American Ornithology* had keyed many of its entries to specimens displayed at Peale's Museum, thereby creating an inventory of the museum's holdings. *Peale Papers*, 2:108on.

3. Sir Joseph Banks (1743–1820) was a friend and patron of Waterton's who had endorsed his method of taxidermy. He was a correspondent of CWP's and had befriended ReP and RuP in 1803 when the two young men were exhibiting the mastodon in London. See *Peale Papers*, 2:99–100; *DNB*; *DSB*.

4. Waterton's appendix to his *Wanderings in South America*, entitled "original instructions for the perfect preservation of birds, etc. for cabinets of cultural history," summarized the methods of taxidermy that he apparently first outlined in his lecture at Leeds. Waterton's method basically consisted of carefully eviscerating the specimen from the inside, soaking it in a hardening and preserving agent, and then molding the animal into the pose in which it would be fixed. The method produced exceptionally life-like and long-lasting specimens. The preserved cat's head may be seen in CWP's portrait of Waterton (fig. 49); this portrait served as the basis for an engraving used as the frontispiece of Waterton's *Natural History Essays* (London, 1838). *NUC*; *DSB*; *DNB*.

5. ReP described Waterton's extensive estate when he visited the scientist at Walton Hall in 1833. See ReP to TRP, April 13, 1833, Baltimore City Life Museums: The Peale Museum, cat. no. ML3056, F:VIA/8A7; Miller, *In Pursuit of Fame*, p. 218.

6. Salem is a town in southern New Jersey about thirty miles southeast of Philadelphia, located on the Salem River just before it empties into the Delaware. It is prime territory for marsh birds and seabirds. Seltzer, ed., *The Columbia Lippincott Gazetteer*, p. 1650.

7. The corrosive sublimate used in Waterton's taxidermy method was perchloride of mercury, an extremely poisonous substance. *New Columbia Encyclopedia* (New York, 1975), p. 1751, *DSB*.

8. Unlocated. It is not clear what this letter contained or to whom it was addressed. Given the context of the paragraph, it is possible that it was a lobbying letter from CWP or ReP to Congress, or a member of Congress, regarding the purchase of ReP's *Washington*.

9. Unlocated. There is no record that CWP's friend, the polymath John Isaac Hawkins (*Peale Papers*, 2:232), published any separate work on health. He did, however, edit *The Journal of Human Nature and Human Progress: Designed to contribute largely to public improvement, physically, mentally, morally, and spiritually. NUC*.

6 Lafayette's Return to America: July 16, 1824–December 7, 1825

During the summer of 1824, while Charles Willson Peale and Rubens continued to exert themselves to improve the financial situation of their respective museums, Rembrandt remained in Philadelphia to work on his equestrian portrait of Washington in anticipation that Congress would commission the work during its next session. Upon hearing of Lafayette's expected arrival in America, he had expanded his composition to include the young Frenchman who had risked his life and fortune in the cause of liberty, together with other major players in the events preceding the surrender of the British at Yorktown in October 1781: Alexander Hamilton, General Henry Knox, and the Comte de Rochambeau. Rembrandt's timing could not have been more opportune, and he, as well as other members of his family, hoped to participate in and profit from Lafayette's visit.

The Marquis de Lafayette arrived in the United States on August 15 to begin a triumphant thirteen-month tour that would take him to all twenty-four states of the Union. Lafayette had visited America for five months in 1784, but that visit was insignificant compared to this one. Coming as it did in the midst of the 1824 presidential campaign, his visit and the elaborate panoply of public celebration and civic ritual that accompanied it soon overshadowed partisan politics because of the myriad of meanings his presence embodied. In particular, the reappearance of the hero of the American Revolution—a symbol of the high moral purpose of the revolutionary generation—became an occasion for celebration because it touched on prevailing fears that the country was in danger of losing the moral and political values associated with the Declaration of Independence and the Constitution. Coming soon after the enunciation of the Monroe Doctrine (1823), Lafayette's visit contributed to the popular outpouring of expressions of American nationalism. In the celebrations that accompanied Lafayette's tour, Americans went to great lengths to extol the success of republicanism in establishing a viable nation-state out of revolutionary beginnings. Lafayette, more modestly, presented

himself as an advocate of freedom, as a symbol of the meaning of both the American and French revolutions, and as a critic of the institution of slavery. His visit, then, developed into a transcendent moment of civic enthusiasm because of the number of important personal, political, and cultural chords it struck for Americans.

Lafayette's visit had resonance and meaning for Charles Willson Peale as well. Peale was also a member of the fast-disappearing revolutionary generation. He had known Lafayette personally during the Revolution. And he may have suspected that this would be the last public celebration he would experience.

Philadelphia, and particularly Independence Hall (the old Statehouse building renamed to signify its importance in the nation's history), became the centerpiece of Lafayette's American visit. Now eighty-three years old, Peale, in company with his family, expended great effort to welcome his old comrade. He helped to decorate Independence Hall, painted nine transparencies honoring Lafayette, met with him several times, and possibly drew a portrait of him (unlocated).

Rembrandt, too, took advantage of the occasion by offering his Grand Manner portrait of Washington to the city as part of its decoration, hoping thereby to bring it before the public once again. Having painted a portrait of Lafayette many years earlier, he now anticipated that he would be called upon to paint a commemorative portrait of the aging general. As cities throughout the country girded up to welcome Lafayette, in Philadelphia and Baltimore the Peales readied their institutions and their brushes to receive him. Raphaelle, James, and Sarah Miriam, along with numerous other artists hoping to benefit from Lafayette's presence, prepared to take his portrait. Rubens began to make preparations of another kind; in October 1825, he would move his museum from Baltimore to New York City.*

*Below, **249**; Fred Somkin, *Unquiet Eagle: Memory and Desire in the Idea of American Freedom, 1815–1860* (Ithaca, N.Y., 1967); Anne Loveland, *Emblem of Liberty* (Baton Rouge, La., 1971); Marc Miller, "Lafayette's Farewell Tour of America," Ph.D. diss., New York University, 1979; Miller, *In Pursuit of Fame*, pp. 147–48; *DAB*.

201. CWP to RuP

PHILADELPHIA. JULY 16, 1824

Philada. July 16. 1824.

Dear Rubens

Mr. Barney[1] called on me as you had desired him, and he told me that you had wrote by a Gentleman coming in the Steam boat with him, No

letter[2] has yet been presented, and if it should contain matter requiring an immediate answer you might complain of neglect in me Therefore in future I would prefer paying posstag—rather [than] be liable to have the delivery of your letters neglected. Franklin has gone to N. York of course I could not advise with him about the practibi[li]ty of packing up the Machinery for fire works. The Cask is a difficult article to make sufficiently tight to hold the Gasses and rather a dangerous apparatus for the inexperienced to meddle with.

Franklin had a narrow escape of his life by it. an explosion shivered the 2 Inch thickness of the head and broke the stairs above. Mr. Pendleton has given you the particulars of my hurry on my first arrival here—and now I am very much engaged in my work for the Ladies— Mr. Pendleton carried a memorandom to you, can you obtain the book on Teeth[3] to be sent here? half of a day will [be] sufficient for me to have it. and I will be careful to entrust its return by a safe hand.

Doctr Godman told Rembrandt that Mr. Calvert[4] had said that if I would have a frame of the most superb made executed that he would pay for it. If I can be assured of receiving the cost of an elligent frame, I would order it without delay and exhibit the picture one week and then send it on to you.

A Man who is appointed to collect [taxes] of the nothern liberties has this moment left me he says that Mr. Carmack[5] had paid the Tax for 1823, but will not pay that of 1822. the amount is 3.38 I told him that I was writing to you and would probably have an answer in the course of a few days.

Sophonisba has gone to long branch (Sea shore) her Son Harvey is very much benfited by the sea bathing. I write in haste.

<div style="text-align:right">Love to Eliza & children. Yrs.
CWPeale</div>

Mr. Rubens Peale
 Baltre.

ALS, 2pp.
PPAmP: Peale-Sellers Papers—Letterbook 18

1. Unidentified. There were many individuals named Barney in Baltimore; this may have been John H. Barney, proprietor of a mail stage line between Baltimore and Philadelphia. *Baltimore Directory (1824)*.

2. Unlocated.

3. An unidentified book on dentistry that was being forwarded by the dentist Dr. Horace Henry Hayden of Baltimore; see below, **203.**

4. George Calvert (1768–1838), grandson of Charles Calvert. *Peale Papers*, 2:1026. The frame was intended for the van der Myn portrait that CWP had received from the Annapolis Corporation. See above, **135**; below, **203**.

5. Caleb Carmott, Jr.

202. Thomas Jefferson to CWP
MONTICELLO, VA. JULY 18, 1824

Monticello July 18.24.

Dear Sir

I do not wonder that visitors to your Museum come from afar. if not equal to some in Europe it possesses much which they have not. of the advantage of Mr. Waterton's mode of preserving animal subjects with sublimate instead of arsenic you are the best judge.[1] I greatly wish success to Rembrandt in his new enterprise of the equestrian portrait of General Washington. he is no doubt however aware of the partialities of the public functionaries to economy and that with some it is the first object. he may meet disappointment at that market, but at that of the world I presume he is safe. among your greatest happinesses must be the possession of such sons. so devoted to the arts of taste as well as of use, and so successful in them. and the continuance in the same powers at an age so advanced as yours is a blessing indeed. my eyes are good, also. I use spectacles only at night; and I am particularly happy in not needing your teeth of porcelain. I have lost one only by age, the rest continuing sound. I ride every day from 3. or 4. to 8. or 10. miles without fatigue, but I am little able to walk, and never further than my garden. I should indeed have been happy to have received the visit you meditated in the Spring. yet in the fall it will be more gratifying to you, in as much as our central and principal building will be more advanced, that which is to unite all into one whole, and give it the unity, the want of which has hitherto lessened its impression.[2] we shall want a fresco painter for one of the apartments, which however is not yet ready and perhaps may not be until the next year. I asked by way of postscript in a letter to Mr. Vaughan[3] whether there is such an artist in the US. his answer leaves it doubtful, and our job is too small to think of inviting one from Italy where they are as plenty as oil painters with us. your letters give me great pleasure, altho' my difficulties of writing do not always permit me to count letter for letter. I do not the less preserve you ever & constantly in my affections and great respect.

Th:Jefferson

C. W. Peale

ALS, 1p.
TxU: Hanley Collection
Copy in DLC: Thomas Jefferson Papers
Published in Horace Wells Sellers, "Letters of Thomas Jefferson to Charles Willson Peale," *PMHB* 28 (1904):136–54, 295–319, 403–19

1. See above, **200**.
2. The exterior of the rotunda on the University of Virginia campus, which Jefferson

modeled after the Pantheon to act as the linchpin of his architectural plan, was completed in the fall of 1823, but work continued on the interior even after Jefferson's death. Malone, *Jefferson*, 6:394–95.

3. John Vaughan (1756–1841), Philadelphia merchant and longtime officer of the APS, was a member of Jefferson's circle of correspondents. Although the precise nature of Vaughan's response is not known, the absence of fresco painting in any part of the rotunda suggests that it was negative. Fresco is mural painting utilizing inert pigments on freshly laid plaster walls so that the picture becomes part of the wall. By the nineteenth century, the technique had largely disappeared, although it was still practiced by Italian-trained artists. The subject of Jefferson's intended fresco is not known, and there is no documentary evidence that fresco painting decorated any part of the rotunda. *Peale Papers*, 2:39; U.S. Congress, comp., *A Calendar of the Correspondence of Thomas Jefferson*, 3 vols. (Washington, D.C., 1900); Ralph Mayer, *A Dictionary of Art Terms and Techniques* (New York, 1969), pp. 15–56; Communication to the editors from Carolyn Laquatra, Administrator of the Rotunda Building, University of Virginia, July 13, 1993. Peale Family Papers files, NPG.

203. RuP to CWP

BALTIMORE. JULY 20, 21, 1824

Baltimore July 20.th 1824

Dear Father

When you were in Baltimore last, I told you of the manyfold writing instrument[1] and regretted that you could not see it—I have Just obtained one, which costs me 4 dollars, and this is my first essay with it, I therefore will will be able to say what I think of it after it has been more used—thus far I am well pleased.

I have just given notice to the public that the Cactus Grandiflora,[2] belonging to Henry Schroeder Esq[3] will bloom this evening, the notice is very short and every body are going to the examination at St. Marys College,[4] so that I must not expect much Company. I find that Franklin has just returned from New York, or is on his way—if he or anybody else has the least ⟨of⟩ objections to my having the loan of the Apporatus obtained from Dr. Hare, I should not like to have it— you spoke of the wooden gasholder—I should prefer using my Copper holders, which having a considerable pressure on them making them very safe to the operator.[5]

You mentioned that Mr. Calvert would pay for the frame of Lord Baltimore, as though I knew which of the Calverts he ment—I think it very likely to be one that Rembrandt painted.[6] 21st. I have just received a letter from Franklin[7] and he asks me whether it would be worth my while to have the apporatus for so short a time—and on reflection I hardly think it would be, especially if it would be necessary to have a gas holder made. John Pendleton thinks mine not large enough.

I have been so much occupied since you have requested me to call on

Dr. Haden about the book that it [was] quite out of my power to do so—[8] but will take the first moment of liesure to call on him. I [have] written this letter only becaus I aught not to neglect writing but there is so much bustle and confusion that I scarcely know what I have written. The last of the week I shall be able to give you an idea of the success of the Mummy exhibition, it has turned out rather better than was expected it would. I have already received upwards of 1600 dollars and still tolerably well attended. Give our love to all and believe me ever your affectionate

<div style="text-align: right">Son

Rubens Peale</div>

ALS, 2pp.
PPAmP: Peale-Sellers Papers—RuP Letterbook

1. The "Manifold Writer," or "R. Wedgwood's Patent Manifold Writer," was a copying machine that used the first form of commercially produced carbon paper. It was the invention of Ralph Wedgwood of London, who received an English patent for it on October 7, 1806; an American patent was granted in 1810 to Joseph Hartshorne of Philadelphia for a similar device. The manifold writer used paper impregnated with carbon and a stylus to trace a copy under the original letter. CWP had learned of the manifold writer (and corresponded with Jefferson about it) as part of his interest in the polygraph and the copying machine. This letter indicates that improvements had been made to the machine. There is no listing for such an improved version around 1824, however, in the records of patents issued. *Peale Papers*, 2:1030–31; Silvio A. Bedini, *Thomas Jefferson and His Copying Machines* (Charlottesville, Va., 1984), pp. 156–57, 172; M. D. Leggett, comp., *Subject Matter Index of Patents of Invention*, 3 vols. (1874; reprint ed., New York, 1976), 3:1725.

2. See above, **94**.

3. Henry Schroeder, Jr., of the mercantile firm of Schley and Schroeder, New Church and St. Paul's Lane, Baltimore. *Baltimore Directory (1824)*.

4. St. Mary's College, Baltimore, was established in 1799 to provide a secular higher education for Baltimore's Catholic population. Scharf, *History of Baltimore City and County*, pp. 234–35.

5. Robert Hare pioneered the development of illumination technology. The devices referred to here were gasometers, which held flammable gas before combustion. The older method, used in museum demonstrations and for gas lighting, utilized a wooden cask to store the gas under hydrostatic pressure. The new technology, favored by RuP, used metal (copper) containers. *DAB*; *Peale Papers*, 2:1069, 1142–43.

6. CWP was sending van der Myn's *Lord Baltimore* to RuP's museum for exhibition in part to allay criticism directed against him and the Annapolis corporation because of the exchange of this portrait for six governors' portraits. CWP wrote to George Calvert that he hoped "to take off the censure from the Corporation of the City of Annapolis—as I think the Citizens of maryland will be gratified in knowing that the said Portrait will thus be preserved at the place named after his Lordship." In this letter, CWP also stated his understanding that Calvert would pay for the restoration of its frame. No response from Calvert has been located. ReP did not paint a Calvert portrait; rather, he painted a portrait of George Calvert's father-in-law, Henri Joseph Stier, in 1799 (*private collection*). CWP to George Calvert, July 21, 1824, P-S, F:IIA/71A10; ReP Catalogue Raisonné, NPG; *Peale Papers*, 2:1026; Miller, *In Pursuit of Fame*, p. 87.

7. Unlocated.

8. See above, **201**. Horace H. Hayden (1769–1844) was a pioneering American dentist who learned the profession through apprenticeship. He established a practice in Baltimore in 1800. He taught both informally and at the University of Maryland, and in 1840, he established the first dental college in the world, the Baltimore College of Dental Surgery. The book referred to was not written by Hayden, who did not publish any books about

dentistry, although later in the century he did contribute to professional journals. Hayden resisted publication of his papers and lectures because he wanted to control the dissemination of the knowledge he had obtained through his experience and practice. ReP painted his portrait (ca. 1812: *Medical and Chirurgical Faculty of Maryland, University of Baltimore*). *DAB*; *NUC*.

204. Charles L. J. L. Bonaparte[1] to TRP
POINT BREEZE, PA. JULY 25, 1824

Point Breeze[2] July 25 1824

Dear Sir

I received your kind letter of yesterday and the enclosed note and am to thank you for it.[3] I send you back the note book, the letter, and your copy of the expedition, having copied in mine all the marginal notes.[4] I join a specimen of the Testuda scabro[5] which is the only fine one that I can spare at present, but in a few weeks I shall be able of sending you as many as you please. You may besides probably get Mr. Say's[6] speciman wich is very fine after he will have described it.

The account you gave me of the two Flycatchers are all what I wanted; be so good now as to give me the same accounts of the Tyra[]um[?] Merticati[?] of Mr. Say and of that undescribed flycatcher allied to the Pewee wich is in so bad a state. Be very particular especially in respect to the latter, place, season, length, colour of the eyes &c, &c, &c. Please to tell me also from what author is taken the name of Ruby-crowned Flycatcher given to the species in your museum.[7] From where did you get the specimen? That is very essential.

Let me know how our drawings are coming on.[8] A. Lawson can give a proof[9] send it to me if you please. The man who will bring you this letter will call on you the next morning to get your answer and the things you may have to send me.

Please also to let Dr. Hays[10] know that I am starting for New York on thursday and that I shall not stay but three days in that city, so that he must send me the proof by my man, (he may leave them at your house) or the latest on wensday; after that he must not send me any thing and must do for the better with Mr. Say.

Mr Audubon[10] has promised me to leave for me at your house some papers before he starts. When you hear of his going and if he forgets it, be so kind as to put him in mind.

Excuse the trouble I give you and my awkward English and believe me your good friend

Charles L. Bonapart

My compliments
to Mrs. Peale.

ALS, 3pp.
PPAmP: Peale-Sellers Papers

1. See above, **182**.

2. Point Breeze was the estate of Charles Lucien Bonaparte's father-in-law, Joseph Bonaparte, located along the Delaware River near Bordentown, N.J. Charles and his wife Zénaïde resided on the estate during 1824. Charlemagne Tower, "Joseph Bonaparte in Philadelphia and Bordentown," *PMHB* 42 (1918):289–309.

3. Unlocated.

4. Edwin James, *Account of an Expedition from Pittsburgh to the Rocky Mountains Performed in the Years 1819 and '20*, 2 vols. and atlas (Philadelphia, 1822–23). *Peale Papers*, 3:696–97; *DAB*; *NUC*.

5. Bonaparte is referring to some kind of terrapin (*Testudinata*). *The Century Dictionary and Cyclopedia*, 7:6253.

6. Thomas Say had been named professor of natural history at the University of Pennsylvania in 1822. The first volume of his *American Entomology* (3 vols. [Philadelphia, 1824–1830]) appeared in 1824, when Say was assisting Bonaparte in the publication of the latter's *American Ornithology*. *Peale Papers*, 2:554–55; *DAB*; *DSB*.

7. Bonaparte seems to have been referring to the American flycatcher of the family *Tyrannidae*, one of the large family of small, perching songbirds (*passerines*); Say's Flycatcher, named after the naturalist (*Musciapa saya*), which inhabits the Rocky Mountain region; and the pewee (or peewit) flycatcher (*Musicapa fusca*). The flycatcher allied to the pewee may be the Wood Pewee Flycatcher (*Muscicapa rapax*), which was similar in form but not in behavior to the pewee. The "Ruby-crowned Flycatcher" may be a relative of the crested or tufted flycatchers, but there is no flycatcher with this name. There is a ruby-crowned kinglet (or wren) (*Regulus calendula*), which is similar in size and function to the flycatchers. It is possible that the museum misidentified a wren or kinglet as a flycatcher, thereby leading to Bonaparte's series of questions about the identification of the specimens. The kinglet received its name from George Louis Leclerc, Comte de Buffon, who called it "Le Roitelet rubis" in his *Histoire naturelle des oiseaux*, 10 vols. (Paris, 1770–86). The flycatchers were depicted by TRP in plate 2 of Charles Lucien Bonaparte's *American Ornithology*, 3 vols. (Philadelphia, 1825). For definitions, see *A Dictionary of American English*, 4 vols. (1940; reprint ed., Chicago, 1960), 2:677, 1023.

8. TRP was completing the colored drawings that were engraved for inclusion in Bonaparte's *American Ornithology*. In documenting and describing American birds, Bonaparte drew heavily on the observations and specimens collected on the two exploring expeditions in which TRP participated: Say's Florida mission and the Long Expedition. Bonaparte frequently included summaries or paraphrases of TRP's descriptions of the birds in the wild in his accounts. More important, it was TRP who drew the birds in their natural habitats so as to provide the basis for the color plates in volume one. As Bonaparte wrote in his Foreword, the accurate replication of the birds was secured "through the happy pencil of Mr. Titian Peale, who has invariable drawn from the recent bird, and not from the preserved specimens." Bonaparte noted TRP's success while on the Long Expedition in procuring and drawing "on the spot almost all the new birds contained in this volume." TRP's drawings of twenty-three specimens for Bonaparte established him as a reputable naturalist/artist. *DSB*; Bonaparte, *American Ornithology*, 1:iv-v. (see figs. 50, 51; Plate 6)

9. Alexander Lawson (1787–1879), a Scottish-born engraver who immigrated to Philadelphia in 1792, engraved the plates for both Wilson's *American Ornithology* and Bonaparte's. *Appleton's*.

10. Isaac Hays (1796–1879), ophthalmologist and medical and scientific editor, was trained at the University of Pennsylvania, receiving his M.D. in 1820. In 1822 he was appointed to the Pennsylvania Infirmary for Diseases of the Eye and Ear, where he received recognition for his researches into astigmatism and colorblindness. He was a noted editor of medical journals, including the *Philadelphia* (later *American*) *Journal of the Medical and Physical Sciences*. He was also interested in ornithology, and presumably edited an edition of Wilson's *American Ornithology*, although there is no record of this publication. This letter indicates that

434

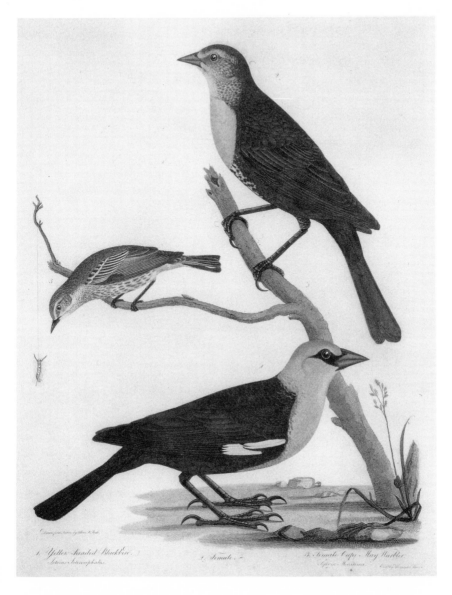

50. *Yellow-Headed Blackbird; Female Cape May Warbler.* Alexander Lawson after
Titian Ramsay Peale, 1825. Engraving, 13 ⅝ × 10 ½″ (34.5 × 27 cm). Plate no.
3 in Charles Bonaparte, *American Ornithology, I* (Philadelphia, 1825). Courtesy
Smithsonian Institution Libraries.

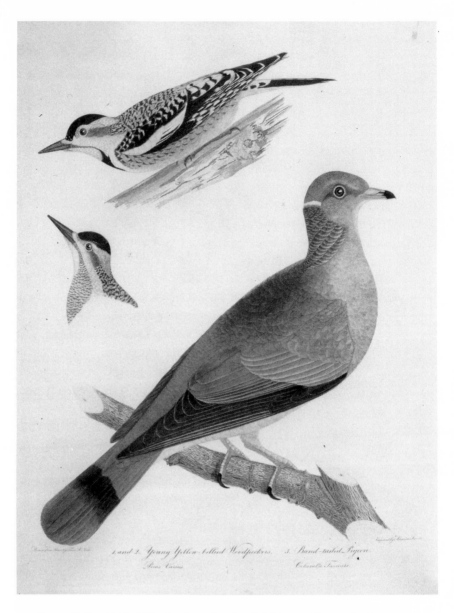

51. *Young Yellow-Bellied Woodpeckers; Band-tailed Pigeon.* Alexander Lawson after Titian Ramsay Peale, 1825. Engraving, 13 ⁵/₈ × 10 ¹/₂″ (34.5 × 27 cm). Plate no. 8 in Charles Bonaparte, *American Ornithology, I* (Philadelphia, 1825). Courtesy Smithsonian Institution Libraries.

Hays was proofreading and editing Bonaparte's manuscript, and it is possible that this task was mistaken by later biographers for the editing of a wholly separate edition of Wilson's *American Ornithology*. *DAB*; *NUC*; *Appleton's*.

11. John James Audubon (1780–1851), the most prominent American artist-naturalist of the nineteenth century, was just beginning his career when he came to Philadelphia from Natchez, Mississippi, in April 1824, seeking patronage and support for his work. According to Audubon, Bonaparte admired his work and engaged him to contribute to the illustrations for his *American Ornithology*. Audubon produced only one plate for Bonaparte, however, for Bonaparte had already engaged TRP to do the illustrations. Audubon was extremely critical of TRP's drawings, writing that "from want of knowledge of the habits of the birds in a wild state, he represented them as if seated for a portrait, instead of with their own lively animated ways when seeking their natural food or pleasure." Audubon's hostility to TRP was evident in his report that on May 30 he "Showed all my drawings to Titian Peel, who in return refused to let me see a new bird in his possession. This little incident filled me with grief at the narrow spirit of humanity, and makes me wish for the solitude of the woods."

Discouraged by his prospects in Philadelphia, Audubon left the city for New York and the northeastern United States on August 1. His *Birds of America* would be published in 1830. James Grant Wilson, ed., *The Life of John James Audubon: The Naturalist* (New York, 1879), pp. 101, 102, 105; Shirley Streshinsky, *Audubon: Life and Art in the American Wilderness* (New York, 1993), pp. 49, 105, 149; Annette Blaugrund and Theodore E. Stebbins, Jr., eds., *John James Audubon: The Watercolors for* The Birds of America (New York, 1993). *DSB*; *DAB*.

205. RuP to CWP
BALTIMORE. JULY 25, 26, 1824

Baltimore July 25th. 1824.

My dear Father

The exhibition of the Mummy closed last night and the receipts during the six weeks were very good as you may judge for yourself 1841,00

The use of the Mummy	650	
other expences——	55	
what the museum would have recd.390——	1095,00	
so that I have gained by this exhibition——	746,00[1]	

I shall be much engaged tomorrow in rearranging the Room if I feel any better than I am at this moment—having been seased with the Cholera this morning.[2] John[3] was taken with it the day before. I have been for a long time trying to make up my mind whether I could be spared for a few days to visit your city and have not yet concluded on it, I must soon as it would be much more convenient than at any other time of the year.

26th. I am today much better than I was yesterday. I have just packed up a collection of Birds to send to Sweeden in exchange for some which I have just received from the person that I sold some to last year. I have just received quite a collection from South America, but they ask 600 dollars for them, which I think is quite too high[4] [in green ink:] My last letter[5] I told you was written with the manyfold writing apporatus. [6]I have used it ever since and I am quite pleased with it [in blue ink:] and this is a sample

of the colours that I have with it—I find but little or no difficulty with it. [in red ink:] The coloured paper is placed between the letter to be sent away and the paper that is kept as the coppey, and with a steel stile I write with [in black ink:] Eliza says it would be of service to george to pay a short visit to Philadelphia and its neighbourhood, her wish is to stay at Chesnut Hill after visiting her city friends—it is possible I may take her with me, if I conclude to visit your City. Mean time I remain your

 affectionate Son

<div align="right">Rubens Peale</div>

ALS, 1p.
PPAmP: Peale-Sellers Papers—RuP Letterbook

 1. The record of the museum's expenses and income for this period are itemized in RuP, Baltimore Museum Account Book, 1822–29, MdHI, F:XIB/3.
 2. RuP was afflicted with the non-epidemical *cholera morbus*, a painful but not fatal gastro-intestinal disorder characterized by pain and vomiting. Common in the summer months, it was brought on by poor diet coupled with the strain of hot weather and fatigue. No outbreak of an epidemic of the usually fatal Asiatic cholera at this time has been recorded. *Century Dictionary and Cyclopedia*, 2:975.
 3. An unidentified museum worker.
 4. Both exchanges are unidentified.
 5. See above, **203**.
 6. This section of the letter was written by the manifold writer in different ink colors as indicated.

206. CWP to John Isaac Hawkins[1]

PHILADELPHIA. JULY 30, 1824

<div align="right">Philada. July 30th. 1824.</div>

Dear Sir

 Your favor by Mr. Sheffield[2] received and it was my intention to have wrote without loss of time, yet having undertaken a new business in which I found my difficulties, still thinking my next tryal would overcome the obstacles & all afterwards would be easey to me, and then allow me time to attend to my other engagements and my wishes— you may wonder what this means, therefore I may remind you that I had for many years been plagued with making artificial teeth, because I made them of various animal substances, which soon decayed, however served very well for the time— The calls in my family for my aid multiplied—at last I attempted to make them of Porcelain, and having no opportunity of obtaining instruction, I have worked to great loss of labour and expence of materials— And still having calls for my pencil made me neglect every call of a different nature. so far for an appology

Your Idea of the means of promoting health I hope you have used with success to your self, as well as to give that blessing to your friends, I wish I could see your Ideas in print—as I doubt not such a work would greatly benefit others on this all important subject.[3] I have practiced your method of washing with the small towel every Morning, and I do assure you that I esteem the practice as highly important. I had for many years past made it my practice to rub with all my strength all my mussels, both at night and on rising—my exertions of rubing fended off the effects of a cold air in winter— how I shall bear the wet towel in the severities of our Winters, I know not, yet I hope I may be able to make it my practice, for begining with the Spring and continueing it regularly as the approach comes to winter may harden me to the practice.

My health is good altho', I have now passed my 83d year, but what surprises me most is that my Eye sight of late has wonderfully improoved— I paint without Spectacles, nay I cannot see to paint with them when using my oil Colours I can read & write tolerably well without them— My passing friends say that I am the greatest wonder of my museum. This may seem strange to many, seeing that I am as active as I have been at any time of my life—yet it seems more strange to me when I see such a multitude of those I had been long acquainted with, who complain of bad health, yet they do not strive to obtain better, by avoiding what they must know is hurtful, how very few men make use of their reason, but gratify any foolish appetite let the consequences be what it will. I use no kind of spices, nor any provocatives to the appetite, such as Vinager, mustard, horse Radish, nay carry it so far as not to desire salt. Our Indians do well without it. I scarcely ever miss a meal, yet eat moderately, and of any thing that comes to the table—but chusing the best dish for health & touch no other, and always rising from table when I could still eat more without oppression—should at any time what I had taken ⟨should⟩ happen to sett uneasey in my stomack, I then drink a little water, which in a little re-mooves all uneasyness—and I then eat very little at the next meal. my [By] a simple mode of living we can have no calls for medicine. Nature is kind to those who use her well, they are soon re[s]tored in all their functions, who follow her dictates, so much for health, when shall I see you in Philada.? and when you come, as I have long heard that you intend it, which of your numerous talents of ingenuity, will be your favorite calling?

My Son Coleman Sellers often talks with me about you & we wish to see you actively employed in some profitable and useful business. Coleman carries on an extensive business of card making, weaving wire, rivited hose and engine making, this last he calls a Hydralick machine of his own invention.

perhaps it may lay in your way to give me some information on making Porcelain teeth, this being my present favo[rite] employment, as by it I can possibly give more comfort to my fellow mortals than by any other work I can undertake, therefore any advice you can give me will greatly oblege me. If you know, or can, find out, any artists that make porcelain teeth, I would like to have a sample of them, with platina in them to Solder to a metallic base. ⟨that⟩ which I make to set easey on the Gums.

My Museum improoves but not in that degree it would, could I have a building to contain the articles already in my possession. However I live in hopes to see it in a better dress. I have got it incorporated so that it cannot be divided, which it was liable to in case of my death, my numerous decendants may have the profits of its exhibitions or dispose their rights in it, but cannot divide it.

It is some time since I have seen our friend Mr. Allison,[4] he is very feeble and probably will not hold out much longer—his Children I believe are chiefly dead, at least I do not know any living, but seeing him seldom I may have neglected to make enquiries about his family.

Rembrandt has painted a much admired portrait of Genl. Washington, it is universally esteemed the best ever made of that distinguished man. and he is now making an equestrian one of him, in full confidence that the Congress of the U. States will pay him a handsome price for it. My Sons Franklin & Titian do everything necessary (or ought to do it) for the Museum, I give them each 600$ Pr.Anm. Should I get the Museum in such train as would enable me to get rid of the management of it, I may then visit Paris & London in a short trip, the expence of a voiage in some of our late Packets are very low, with eligant accomodations. I think it very probable that this care will be taken from my shoulders, as some of my children say, that I ought now to get rid of all care—which they think would prolong my Life. I dont know whether that is correct, for without imployment there is no happiness. make my best respects to Mrs. Hawkins. Coleman desires the same, and believe me with much esteem your old friend CWPeale
Mr. John Hawkins London

ALS, 3pp.
PPAmP: Peale-Sellers Papers—Letterbook 18

1. CWP's last letter to John Isaac Hawkins (1772–1855), English inventor and mechanic, was December 20, 21, 1809. *Peale Papers*, 2:1243–45.
2. Hawkins's letter is unlocated, and Sheffield is unidentified. However, see above, **200**, for a summary of part of its contents.
3. Hawkins may have expressed his ideas on health in the *Journal of Human Nature and Human Progress*, which he edited. *NUC*.
4. The minister and inventor Burgess Allison (1753–1827) spent the last years of his life as chaplain of the Navy Yard, Washington, D.C. *Peale Papers*, 2:108; *Appleton's*.

207. ReP to the Mayor[1] and Corporation of New York

PHILADELPHIA. AUGUST 18, 1824

Philada. August 18, 1824

Gentlemen

The visit of the Marquis de la Fayette to the Nation in whose liberties and independence he took so distinguished a part—heartfelt and disinterested—has revived and excited universal feelings of pleasure, which will be displayed in every mode that gratitude can devise. Permit me to suggest that the Corporation of New York, already an example to others, shall request of the General to sit for his Portrait—and to offer my services in the execution of such a commission.[2] I do this with less hesitation, because it is particularly my ambition to paint a Portrait of Lafayette in the style of, and as a companion to, my Washington, which has already received so distinguished a reputation.

Engrossed as my time now is in painting a large Equestrian Portrait of Washington which is desired for the Capitol, it is not in my power to present for your examination the Original Portrait which has received the unqualified approbation of preference from his most intimate friends;[3] but the style in which it is executed is sufficiently known to your City Delegates & other citizens. I would propose to make a highly finished Portrait of the Marquis de la Fayette in the same style, at the price which I have fixed for Copies of my Washington, one thousand dollars. Being already in possession of an Original Portrait of Lafayette which I painted when I was last in Paris in

1810,[4] it is probable my acquaintance with his physiognomy will enable me to make a valuable & interesting delineation of his character.

<div align="center">

Gentlemen

With great respect

I remain

Your most obedient

Servant & fellow Citizen

Rembrandt Peale

</div>

Transcript of ALS, 2pp. & add.
NNMu, Gift of Mrs. Julian V. N. Whittle

1. Stephen Allen (1767–1852), New York City merchant and politician, was the city's mayor from 1821 to 1824; he then went on to serve in elected and appointed offices at the state level. *NCAB*.

2. ReP was late in making his application for a commission to take Lafayette's portrait, since the general had landed at Staten Island on August 15, and his ceremonial reception at the lower end of Manhattan took place at Castle Garden on the sixteenth. At the time ReP was writing, the Common Council voted to commission an official portrait of Lafayette for its gallery of portraits in City Hall. ReP was one of numerous artists competing for this pres-

tigious commission, which in early 1825 was awarded to Samuel F. B. Morse. Morse received $1,000 for his work (1825–26: *City Hall, New York City*). *DAB*; Paul J. Staiti, *Samuel F. B. Morse* (Cambridge, Engl. and New York, 1989), pp. 116–17.

3. ReP changed his mind, and the following week carried his *Patriae Pater* to New York to demonstrate his skill to the Common Council. See below, **215**.

4. ReP's 1810 portrait of Lafayette, painted in encaustic on the artist's second trip to France, is unlocated. For the portrait of Lafayette that ReP completed in 1825, see below, **218**, n.3 (Fig. 52). ReP Catalogue Raisonné, NPG.

208. RuP to ReP

BALTIMORE. AUGUST 18, 1824

Baltimore August 18.1824.

My Dear Brother

I found my family in good health on my arrival, much surprised to see Uncle and Titians Eliza. Uncle caught a little cold, which gave him pain in one thigh, but he is now quite recovered from it— I am much surprised to hear that my father has taken a long walk &c what can be his motive?[1]

You recollect we had a little conversation on the subject of the additional Eight percent stock, taken by our friend H. Robinson? I am very sorry that he is absent, I have deliberately reflected on the subject, and find that I ought in justice to myself and family, give up the museum entirely, you remember it was my opinion some time since, but a disposition to make the best of every thing, and to give it a thorrough trial, induced me to go on with it—but now that 3700 dollars at 8 percent is added, makes it totally impossible for it to succeed and prosper. I have used every exercion to make the income a good one, and with all this it will not pay its way and give me a moderate living—All that I have saved for many years, you know has been placed in your hands of course is now in this institution and it is a pity that you didnot in the first place seccure me in the eight percent, or in some other way—-

My dear brother it is with the greatest reluctance that I have come to the above conclusion, especially as both you and myself will have some difficulties to encounter, and in my opinion it had better have been done a year ago, and now better than a year hence—- It will be proper for me to place the museum in good condition, so that it will continue to be visited, and also that a suitable person should be obtained to conduct it, when I shall leave it, for it is not like other property, it must not remain an hour without an attendant. When Mr. H. Robinson returns all this must be determined on and the best done that can be done.

If it is offered for sale as Mr. R. thought I fear it will bring but little unless the incumberances were removed from it.

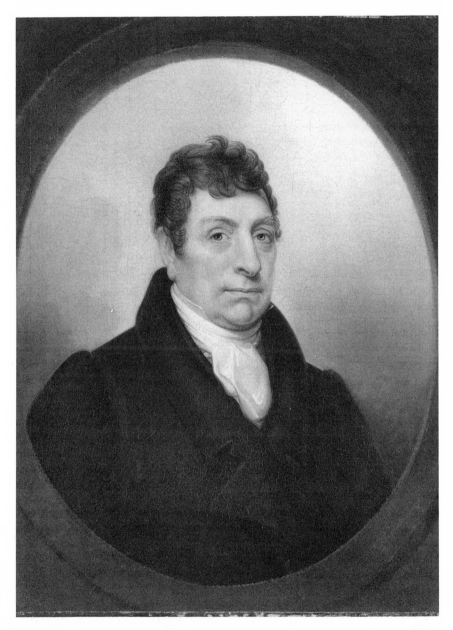

52. *Marquis de Lafayette*. Rembrandt Peale, 1825. Oil on canvas, 34 $^{1}/_{2}$ × 27 $^{3}/_{8}''$ (88 × 70 cm). The Metropolitan Museum of Art, Rogers Fund, 1921. (21.19).

I have been much afflicted with the headache, all yesterday and today, so that I can scarcely see what I am saying, present my love to all the family and believe me your affectionate

brother
Rubens Peale

ALS, 1p.
PPAmP: Peale-Sellers Papers—RuP Letterbook

1. For CWP's "ramble" see below, **214**.

209. John M. Scott[1] to CWP
PHILADELPHIA. AUGUST 19, 1824

Aug. 19, 1824
Dr Sir.

I am directed by the Committee of Arrangements of the City Councils charged with the reception of Gen La Fayette to present to you their thanks, for the permission you have accorded them of selecting from your Gallery of portraits such as the occasion may require.[2]

The Committee will be particularly careful of the portraits while in their possession—and in the Course of a few days will take the liberty to make a selection— I have the Honour to be

Yr. very Obt. St.
John M. Scott
Chr. Pro Tem

C. W. Peale

ALS, 1p. & end.
PHi: Lafayette Reception Committee Papers. Am. 3651

1. John Morin Scott (1789–1858) was an attorney in private practice in 1824; he later served as mayor of Philadelphia for one term (1841–43). Melvin Holli and Peter Jones, eds., *Biographical Dictionary of American Mayors, 1820–1980: Big City Mayors* (Westport, Conn., 1981), p. 322; *NUC*.
2. See below, **211**.

210. John M. Scott to RaP
PHILADELPHIA. AUGUST 19, 1824

Philad. Aug. 19. 1824
Sir.

I am instructed by the Committee of Arrangements, appointed by the Councils of this City to prepare for the reception of Genl. la Fayette, to

express to you their deep sense of the liberality with which you have offered to them for the Occasion, your Splendid likeness of the father of our Country—[1] The Committee are fully aware of the value of the precious charge committed to their Care— It will be applied to a purpose, and placed in a situation, commensurate with its own dignity and excellence— And in making the proper disposition of this master piece the Committee will take the liberty, with your permission, to avail themselves of your friendly Counsel and Assistance—

> I have the honour to be
> Your very Obed. Serv
> John M Scott
> Chairn pro Tem. of the Comee.
> of Arrangt——

Raphael Peale Esqr

ALS, 1p. & end.
PHi: Lafayette Reception Committee papers. Am. 3651

1. RaP's letter is unlocated. There is no record of RaP's painting a portrait of Washington in the mid-1820s. The only recorded *Washington* by RaP is his profile (1795: *unlocated*), taken at the famous sitting during which four Peale artists painted the president. Scott may have intended this letter for ReP, who had offered to lend his *Patriae Pater* to the exhibition. See below, **211**. John Hill Morgan and Mantle Fielding, *Life Portraits of Washington and Their Replicas* (Philadelphia, 1931), pp. 363–66.

RaP's role in the Lafayette festivities has not been documented. RaP painted transparency portraits of Washington and Lafayette for the illumination of Independence Hall, and, although there is no record of Lafayette sitting to RaP during his Philadelphia visit, he may have painted a miniature of the visiting dignitary at this time; however, the curators at Lafayette College have questioned the attribution to him of a miniature (ca. 1824) in the college's collection. Marc H. Miller, "Lafayette's Farewell Tour of America, 1824–25: A Study of the Pageantry and Public Portraiture" (Ph.D. diss., New York University, 1979), p. 119; CAP.

211. Excerpt: Minutes of the Committee for Lafayette Reception

PHILADELPHIA. AUGUST 19, 1824

Peale offers
Portraits &
do. of Washington

Mr. Peale offered to the Committee such of the Portraits in his gallery as they might choose to select, for the purpose of adorning the hall of Audience—and Mr. Rembrandt Peale, tendered his Portrait & splendid painting of Washington—for the same purpose—

Both offers accepted, and the Chairman directed to present the thanks of the Committee to both gentlemen—

Mr. Peale Esq. offered to the Committee the use of the Portrait of Washington—Thanked and accepted.

AD, 1p.
PHi: Lafayette Reception Committee Papers. Am. 3651

212. Eliza Laforgue Peale to TRP with note from SMP to TRP
BALTIMORE. AUGUST 21, 1824

Baltimore August, 21st. 1824

My Dear Titian,

I did not intend to write to day but hearing of an opportunity,[1] I thought I might as well devote 10 or 15 minutes to my Dear Titian, although I have nothing new or interesting to communicate, so that you must excuse the barrenness of my letter.

I am delighted to hear that you are not troubled with the head ache as much you were when I was at home, and hope that in a few days you may be entirely rid of it; so that when I return I will not hear you complain of it again. You do not say how Mother is but I presume from your silence that she is the same if not better. I wrote to Mother and you have not told me whether she has received it or not I should like to know as I am fearful it has miscarried.

I am glad to hear PaPa has returned and hope that he feels better for his ramble which I think was a pretty long one and I am sure not one in fifty of his age could have walk[ed] half that distance in so short a time.[2]

We received the Lens for Dr McCauley[3] by the steam boat, which cost us 62½ cents which is an exorbitant price for so small an artical, but I believe they charge by weight; as it was marked an ounce and a quarter. Reubins thinks it is not the one he alluded to ⟨as it is⟩ the one he meant was the form of the drawing at the head of the letter. However he will go and see

446

Dr McCauley this afternoon to know if he will keep it, if not I will bring it home with me when I come. You must not get the other untill you hear from me again.

Cousin Betsey[4] has been very polite to me, she took me with her on Friday to see several of the Catholic Churches, the one near the seminary is a beautiful little Church built in the Gothic stile; which gives it an appearance of some old chapel that we read of in history.[5] She then went with me to Howard's park, to see the Monument intended for the statue of Washington;[6] which is a very plain one indeed, compared with the Monument commerative of the Battle of North Point.[7] We returned by the way of the City Springs, which I need not describe to you, as you no doubt have frequently seen them.[8] Cousin Betsey says ⟨we⟩ I must be a great deal with her while I am here. The neighbors have all been to see me, and have invited me to come and eat fruit with them; I have accepted some of their invitations: but I assure you it is not with a great deal of pleasure, because I have not you hear to partake with me.

I believe I have not told you that Reubins has some idea of going to New York, and is now wating for Mr. Robinson to come home to decide whether he goes or not.[9] Eliza is very anxious to go; as she thinks R would do better there as all he got would be his own. Give my love to Mother Pa Lewis and Mary and accept the warmest love of your

<div style="text-align:right">Your affectionate Wife
Eliza</div>

Dear Cousen,

Eliza says she is determined to go home next Friday, but you need not expect her until ⟨the nex⟩ we go, which will be the week after.

<div style="text-align:right">Sarah</div>

ALS, 2pp. & add.
PPAmP: Peale-Sellers Papers

1. This letter was carried to Philadelphia by a Mr. Stark, according to Eliza's note on the address sheet.

2. See below, **214**.

3. Patrick Macauley (1792–1849) was a physician who resided at the corner of Lombard and Hanover Streets, Baltimore. Macauley received his M.D. from the University of Pennsylvania (1815) and, in addition to his work as a general practitioner, was active in Baltimore's learned, medical, and civic organizations. He was a founder (1819) and president (1836) of the Maryland Academy of Science, co-editor of the periodical *The North American*, and a member of the Baltimore City Council (1827–30). Philadelphia was a center of early American optical glass manufacture, but it is not known whether Macauley ordered a lens for professional reasons—perhaps for a microscope or a magnifying glass—or for his personal use. *Baltimore Directory (1824)*; Eugene Fauntleroy Cordell, *The Medical Annals of Maryland, 1799–1899* (Baltimore, 1903), p. 481.

4. Elizabeth Polk (Betsey) Claypoole Bend.

5. The increase in the Catholic population of Baltimore during the early years of the nineteenth century required both the expansion of existing churches and the construction

of new ones. The three Catholic churches—St. Patrick's, St. John's, and St. Peter's—that existed in 1806 were insufficient to meet the needs of the city's Catholics. From 1806 to 1821 Benjamin Henry Latrobe's Baltimore Cathedral was under construction, opening uncompleted on May 21, 1821. The cathedral and the diocese were served by St. Mary's Seminary, founded in 1791 by members of the Sulpician order, who were refugees from revolutionary France. The chapel associated with the seminary was St. Mary's Chapel, completed and dedicated on June 15, 1808, and described as "the most elegant edifice of the kind in America." J. Thomas Scharf, *History of Baltimore City and County*, 2 vols. (1881; reprint ed., Baltimore, 1971), 1:234–35; 2:530–33.

6. John Eager Howard donated the land, now Mt. Vernon Square, on which Baltimore's monument to George Washington was constructed. The cornerstone to the monument was laid on July 4, 1815, but the monument itself, a column surmounted by a statue of Washington designed by Robert Mills, was not completed until 1829. *Peale Papers*, 2:1241n. Eliza saw only the base of the column with its dedicatory plaque, which is why she commented on its modest appearance. Scharf, *History of Baltimore City and County*, 1:267.

7. The Battle Monument, which commemorated the victory of North Point on September 12 and 13, 1814, during the War of 1812, was proposed in March, 1815, and the cornerstone laid on September 12, 1815. It was not completed until December 1825, so Eliza saw it in its unfinished form. Like the Washington monument, the Battle Monument was a marble column, carved in the form of fasces and topped with a figure representing Baltimore City. In contrast to Mills's neoclassic monument, it was elaborately carved with decorations and allegorical figures, including urns, wreaths of laurel and cypress, and bas-reliefs depicting the battle. Scharf, *History of Baltimore City and County*, 1:269.

8. Baltimore's water supply initially came from freshwater streams and springs, the most important of which was the City Spring, located downtown near Lexington and Calvert Streets. With the establishment of an organized water company, the City Spring became a decorative feature of the city's most fashionable neighborhood. In 1810 its property was purchased by private developers, who built an elaborate domed structure above the spring and a gothic springkeeper's house next to it. The City Spring was a popular, park-like gathering place for Baltimore's elite society. Scharf, *History of Baltimore City and County*, 1:213.

9. See above, **208**.

213. RuP to Joseph Reed

BALTIMORE. AUGUST 21, 1824

Baltimore August 21. 1824

Joseph Reed[1] Esqr.

Sir-

Yours of the 20th. I have just received and hasten to answer it—— I have also just received one from Mr. Brower,[2] who has an exhibition room in N.Y. which will answer my purpose perfectly well, with some little alterations, I have engaged it until next may a year, and if it suits me, in all probability it may be renewed— I have done this in consequence of our last conversation, you having stated that there would be no difficulty attending my posessing the Delaplain Gallery,[3] I mentioned to your son,[4] that a young man had enquired of ⟨him⟩ my intended doorkeeper, whether he knew of a suitable room, and how he thought Delaplains

collection would succeed &c. that Mrs. D.[5] had desired him to look for a room and had offered him terms &c.

On my arrival in Albany, I found the Legislature in session, which engroced the attention of all classes. I called on Gov. Clinton, who had company with him, I left the letter and returned early the next morning to New York, so that I had not the pleasure of an interview with him—— I was not quite sure whether you had broached the subject of my intended experiment to him or not.[6]

I am willing to take the whole collection on trial—Repair, clense, Varnish and put them in good order—That they be valued by 3 or 5 judges of paintings, chosen by you and myself, and that I should purchase them on their valuation on moderate terms of payment. I believe this is what you wishd, and it meets my perfect approbation.

Although I have determined on commencing with a small collection at once in New York, my Baltimore buisness has not yet been broached to the Stock holders. I find that if they were to let me have it at 5 percent in stead of 8 that I had better get rid of it—and commence a new and with but little debt.

I shall be happy to hear from you, mean time I remain your obediant Serv't—

Rubens Peale

ALS, 2pp.
PPAmP: Peale-Sellers Papers—RuP Letterbook

1. Joseph Reed (1772–1846). See above, **155**. His letter to RuP is unlocated.
2. Unlocated. John H. I. Browere (1790–1834) was a painter and sculptor who was especially well known for taking life masks of famous Americans. Browere's address in New York City was 315 Broadway. Although Browere made New York his home, he frequently was an itinerant, which accounts for the availability of his rooms. RuP's museum ultimately opened at 252 Broadway across from City Hall. *DAB*; *New York City Directory (1823–24)*; *New York Evening Post*, November 1, 1825; see below, **245**.
3. See above, **20**.
4. Unidentified.
5. Jane Livingston Delaplaine. Joseph Delaplaine died May 31, 1824. The previous year he had transferred ownership of his National Panzographia for the Reception of Distinguished Americans to Joseph Reed, recorder of the City of Philadelphia. Therefore, there was no encumbrance on Reed's sale of Delaplaine's collection to RuP. Whether Delaplaine's widow was disputing Reed's ownership of the collection, as is implied here, is not known. *Peale Papers*, 3:578n; Gordon M. Marshall, "The Golden Age of Illustrated Biographies: Three Case Studies," in Wendy Wick Reaves, ed., *American Portrait Prints: Proceedings of the Tenth Annual Print Conference* (Charlottesville, Va., 1984), pp. 32–45.
6. For DeWitt Clinton see above, **122**. The letter, which was probably written by Reed to introduce RuP, is unlocated. RuP's "intended experiment" was the opening of a museum in New York City. He probably was soliciting the recognition, if not the patronage, of the government of New York State. RuP opened the museum October 26, 1825, the day of the opening of the Erie Canal, to take advantage of the celebratory mood of the city. *New York Evening Post*, October 26, 1825.

214. CWP to RuP

PHILADELPHIA. AUGUST 23, 1824

Philada. Augt. 23. 1824.

Dear Rubens

By [My] ramble into the country has been of much service to me, something of Tenismus[1] had long before I went into maryland been troublesome, from what causes this tenismus came I cannot tell, but knowing that nature if not oppressed, will ever tend to heal and restore a disorganised body, and having used according to advice, Laudamum[2] in my engections of flaxseed, I found no advantage, rather I thought injury.[3] I like not any of stimelus, but that of nourishing food taken in small quantities, with exercise in the open air. Ripe fruits are given us to correct the heat of summer, The blackberries brought into our market have many berries amongst them ⟨are⟩ not ripe, those that pick them eat ⟨all⟩ the lucious berries they pick; and fill their baskets with the unripe & ripe mixed. There is also a great difference in the fruit, those bushes that cannot receive the heat of the sun are not so sweet even when full ripe. This is telling you what you know.[4]

I took the frankford stage[5] last sunday morning, and from the Bridge took the road towards the delaware, expecting that along the fences to meet with the object of my wishes, I went into the woods & low grounds without success enquiring of a woman at a farm house, she said that she believed that there were no black berries now, I took my rout along a path to the river and coming to a house of entertainment I got a drink of water & bought 3 Cents worth of Gingerbread—walked along the shore untill I came to the seat of Mr. Jno. Lardner,[6] I was acquainted with him & his family on my first coming to Pennsyla. he was not at home & his wife told me that he would not come untill dinner time, I did not wish to intrude myself on them for a dinner, she told me that they had lost a son 19 Yrs old and she feared that Mr. Lardner would not bear the loss of so promising a youth. they had also lost another Son of 22 years not long since, she was much affected with grief—[7]

I hastened to make a sketch of the Building it being of hansome architecture—[8]⟨a⟩ young men[9] came to me while I was making my drawing, they offered me porter &c I prefered water yet it is not good near the River, I enquired my way to a road leading westward, I made a sketch of the next seat belonging to Mr. Slater[10] (uninhabited), and then found the road & on my way to the frankford Turnpike distant from the river I found plenty of the fruit I wanted & I determined to make the experiment of eating to fullness, and with blackberries and my ginger bread I made a hearty dinner, 3 miles above frankford I left the Turnpike & took

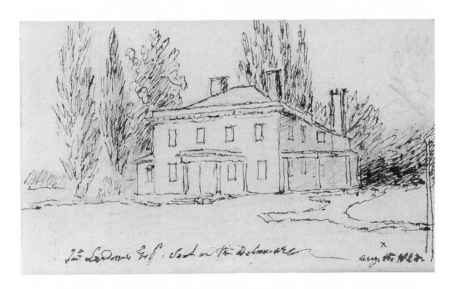

53a. *Seat of John Lardner.* C. W. Peale, 1824. Ink over pencil on paper, 3 ⁵/₈ × 6 ¹/₈″ (9.2 × 15.5 cm). Inscribed, "Jno. Lardner Esqr. Seat on the Delaware. Aug. 15, 1824." From C. W. Peale Diary, 1813–24. American Philosophical Society, Philadelphia. [B/P31.2 no. 21].

53b. *Slaytor House.* C. W. Peale, 1824. Ink over pencil on paper, 3 ⁵/₈ × 6 ¹/₈″ (9.2 × 15.5 cm). Inscribed, on opposite page, "res. of Slaytor." From C. W. Peale Diary, 1813–24. American Philosophical Society, Philadelphia. [B/P31.2 no. 21].

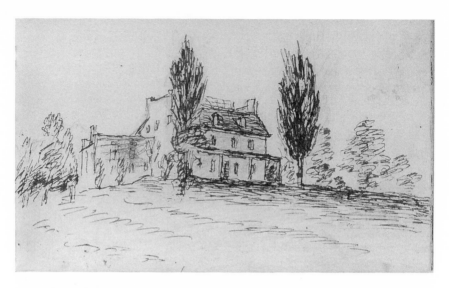

53c. *Miss Swift's*. C. W. Peale, 1824. Ink over pencil on paper, 3 ⁵/₈ × 6 ¹/₈″ (9.2 × 15.5 cm). Inscribed, on opposite page, "⟨*Eddowes (34)*⟩ Miss Swift's." From C. W. Peale Diary, 1813–24. American Philosophical Society, Philadelphia. [B/P31.2 no. 21].

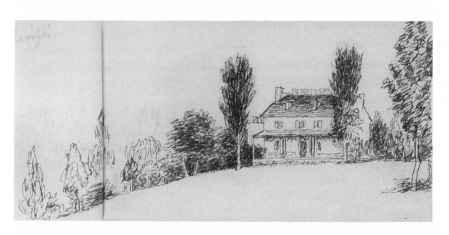

53d. *Miss Swift's*. C. W. Peale, 1824. Ink over pencil on paper, 3 ⁵/₈ × 12 ¹/₄″ (9.2 × 31.2 cm). Inscribed, on opposite page, "Miss Swifts." From C. W. Peale Diary, 1813–24. American Philosophical Society, Philadelphia. [B/P31.2 no. 21].

a road towards Oxford Turnpike—[11] an appearance of a Thunder cloud made me turn into farm house for shelter, as the Sun was hot & being in full persperation I feared being caught in the storm.

The farmer politely asked me to take some brandy with my water—also if I would eat some apple pie & milk, he had some dinner—I declined the acceptance as I had fully satisfied my apetite—we talked on farming etc.[12] The rain being over I walked on untill I came to Mr. Eddows place—[13] here they gave me fruit & I made a slight sketch of their House almost covered with Tree's— Then took directions to Mr. Swifts farm— [14]about 3 miles distant, but finding his maiden sister had her seat close at hand I crossed through the bushes and came to it in a back way. I found her at home & was received politely, I admired the situation of the House and the taste of improvments, made a sketch of the House, on an eminance with a sloping loan [lawn] before it round which is a gravel walk bordered with many hundred flowering shrubs—having finished my drawing, I took tea with Miss Swift & her sisters.[15] I thought then to shape my course towards Germantown, but the Ladies observed that it was growing late—they thought I had better take the morning for my walk. I accepted the offer as I wished to make another sketch which would define what was deficient in the first, and I could have the pleasure of their conversation—I made my sketch before breakfast, and then I said I would visit the Brother—introducing myself as a rambler for Blackberries, he told me he would shew an abundance of fine trees— I spent the day & slept here, he is a widower 3 daughters & Miss [illeg]kley[16] ever busy in prepairing for a wedding— The next day I drew a sketch of Miers Fishers place,[17] returning homeward. I made 2 sketches of Mr. Hartshorns seat[18] then the friends assilun[asylum?]—and reached Philada. as they were lighting lamps— I walked upwards 12 miles that day—and it has not surprised how little when I found myself without fateague. and my health greatly improoved. I have seen Mr. Robinson, but avoid saying any thing to him about your affairs, least I might give offence, for I cannot believe that he is a friend unless for his own Interest. The frame ordered by Mr. Ca[l]vert is with the picture in the Museum, but if you do not keep the Museum I shall not give it to Baltimore— They must incourage your labours, justice to my family say that the picture must remain here, if you cannot be benifited by it. I must close to be in time. I begin to prepair making transparencies this week in honor of the Genl. Lafayate.

<div align="right">Love to Eliza Children, Anne & Sally.

Yrs affectionately—CWPeale</div>

Mr. Rubens Peale
 Baltre.

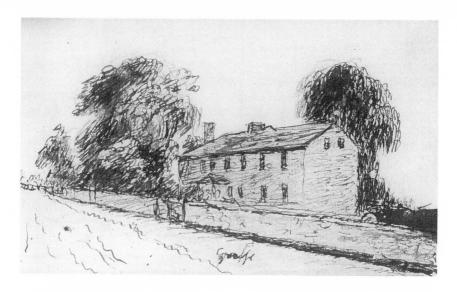

53e. *Unidentified House*. C. W. Peale, 1824. Ink over pencil on paper, 3 ⁵/₈ × 6 ¹/₈″ (9.2 × 15.5 cm). Inscribed below, "grass" and on opposite page (erroneously) "Swifts House (34)." From C. W. Peale Diary, 1813–24. American Philosophical Society, Philadelphia. [B/P31.2 no. 21].

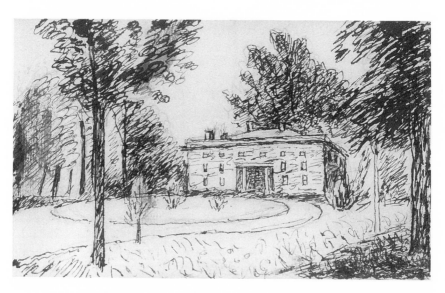

53f. *Miers Fisher's House*. C. W. Peale, 1824. Ink over pencil on paper, 3 ⁵/₈ × 6 ¹/₈″ (9.2 × 15.5 cm). Inscribed on opposite page, "Fishers." From C. W. Peale Diary, 1813–24. American Philosophical Society, Philadelphia. [B/P31.2 no. 21].

53g. *Patterson Hartshorn House*. C. W. Peale, 1824. Ink over pencil on paper, 3 ⁵/₈ × 6 ¹/₈″ (9.2 × 15.5 cm). Inscribed, on opposite page, "Patterson Hartshorn." From C. W. Peale Diary, 1813–24. American Philosophical Society, Philadelphia. [B/P31.2 no. 21].

53h. *Unidentified House*. C. W. Peale, 1824. Ink over pencil on paper, 3 ⁵/₈ × 6 ¹/₈″ (9.2 × 15.5 cm). From C. W. Peale Diary, 1813–24. American Philosophical Society, Philadelphia. [B/P31.2 no. 21].

53i. *Building.* C. W. Peale, 1824. Ink over pencil on paper, 3 ⁵/₈ × 6 ¹/₈″ (9.2 ×
15.5 cm). Inscribed, "Friends asylum." From C. W. Peale Diary, 1813–24.
American Philosophical Society, Philadelphia. [B/P31.2 no. 21].

ALS, 3pp.
PPAmP: Peale-Sellers Papers—Letterbook 18

1. Constipation.
2. Laudanum: a tincture of opium used for many purposes; here CWP used it as a
relaxant of the bowels. *OED.*
3. Flaxseed, taken either orally or in an enema, because of its oily nature was used as an
emollient or demulcent to relieve intestinal problems. *OED.*
4. Fruit, particularly ripe berries, was CWP's usual remedy when mildly ill or consti-
pated. He had adopted it at least as early as 1790 when traveling with RaP in Delaware. *Peale
Papers,* 1:591.
5. The Frankford Stage operated between North Second Street, Philadelphia, and
Frankford, Pennsylvania, a town northeast of the city that has now been absorbed into its
suburbs. Seltzer, ed., *The Columbia Lippincott Gazetteer* (New York, 1952), p. 637.
6. Probably John Lardner (1752–1825), Revolutionary soldier and onetime (1791)
member of the Pennsylvania legislature; his portrait *(private collection)* was painted by Gilbert
Stuart in 1803. His estate was at the confluence of Wissoniming Creek and the Delaware
River. Lawrence Park, comp., *Gilbert Stuart,* 4 vols. (New York, 1926), 1:461–62; *P&M
Suppl.,* p. 51.
7. The son is unidentified. In his autobiography, CWP wrote that in order to console her
he told her of the premature loss of his son TRP[1], explaining that "these were misfortunes
we must expect to suffer." A(TS):479.
8. "Jno. Lardner Esqr. Seat on the Delaware, Aug. 15, 1824." CWP took nine sketches of
houses on this "ramble"; they are included in a sketchbook at the American Philosophical
Society that contains twenty-eight drawings. Numbers 2 to 10 in that book illustrate the
property and houses he mentions in this letter. *P&M Suppl.,* pp. 51–52. See figs. 53a to 53i.

9. In his autobiography, CWP writes that these were John Lardner's sons; they are unidentified. A(TS):478–79.

10. Unidentified.

11. In his ramble CWP turned southwest on the road that ran across the north of Philadelphia to the town of Oxford in Chester County (incorporated 1833), west of the city and some twenty-three miles north of Wilmington, Delaware. This road took CWP back to the Schuylkill. Seltzer, *Columbia Lippincott Gazetteer*, p. 1406.

12. In his autobiography CWP elaborated on this conversation with the farmer, including their discussion about the use of lime and manure for soil preparation and preservation. A(TS):480.

13. Unidentified.

14. Samuel Swift (1771–1847), Philadelphia lawyer. *PMHB* 6 (1882):332.

15. Unidentified.

16. Perhaps the artist Caroline Schetky, who was married to the Bostonian Samuel Richardson at this time. See above, **93**.

17. Miers Fisher had died in 1819; CWP is referring to the Germantown property adjoining Belfield owned by William Logan Fisher, Miers's nephew. *Peale Papers*, 2:28.

18. Patterson Hartshorne's estate, Summer Hill. *P&M Suppl.*, p. 51.

215. ReP to John M. Scott

NEW YORK. AUGUST 23, 1824

<div align="right">New York August 23. 1824</div>

Dr Sir

As your very polite Note was to state the acceptance of my offer of the Portrait of Washington to decorate the Hall of the Declaration of Independence, I did not conceive it immediately necessary to reply to it[1]—— But having subsequently concluded to take my Picture for a few days to New York, it is proper that I should apprize you of this circumstance & to assure you that I shall not fail to bring the Picture back in time to place it in a situation so honourable to it & gratifying to its author. I made several attempts yesterday to see Mr. Strickland[2] without success—and therefore will have to request of him that he will rely on my punctuality in bringing the Picture back in time, and to ⟨request⟩ suggest to him that the outside of the Frame being 7 feet 6, by 6 feet wide, it should be placed on the wall opposite the door, the top of the frame not higher than the base of the Arch of the recess in the Wall, about 12 or 13 feet high.

The Portrait shews to most advantage at the height it stood in my painting Room, where the bottom of the frame stood 2 feet 8 Inches from the floor. Whatever may be the Colour of the Wall, the Picture will look best with green or *purple* Drapery at the sides & over the top of it— somewhat in the Manner of Mr. Wests Picture at the Hospital.[3] With great
<div align="right">respect</div>
<div align="right">I remain Yours</div>
<div align="right">Rembrandt Peale</div>

ALS, 1p.
PHi: Lafayette Reception Committee Papers. Am. 3651

1. See above, **210, 211**. The Declaration of Indpendence Room of the Statehouse was redecorated by the architect William Strickland to serve "as a Levee Room for General La Fayette." *Poulson's*, August 21, 1824.

2. Strickland, who was remodelling the Statehouse (soon to be renamed Independence Hall), was in charge of the arrangements for the Lafayette reception. At the height of his Philadelphia career, Strickland was also busy with the construction of major buildings in Philadelphia's center. In addition to the cosmetic work, some of it temporary, that Strickland was performing on the Statehouse for the Lafayette reception, he also made more permanent structural alterations to the building, finishing a redesigned steeple in 1828. *DAB*; Miller, "Lafayette's Farewell Tour of America, 1824–25," pp. 113–17.

3. It was common practice at the time to place drapery around the frame of history paintings placed on exhibition to suggest the proscenium of a theatre. In his *Artist in the Museum*, CWP mimicked this effect by actually painting the drapery into the picture, thereby creating another level of depth in the viewer's perception of the painting.

Benjamin West's *Christ Healing the Sick* (1815: *Pennsylvania Hospital, Philadelphia*) was commissioned by the Pennsylvania Hospital and installed in a specially constructed exhibition hall on the hospital grounds. *Peale Papers*, 3:360n.

216. RuP to BFP

BALTIMORE. AUGUST 24, 25, 1824

Baltimore Aug. 24. 1824.

Dear Franklin.

Shall I give you the trouble to call on Mr. Joseph Reed at his office or dwelling, and say to him that I should like to have the Delaplain Collection of Portraits, packed and forwarded to N. York as early as convenient.[1]

Then after it meets with his sanction, I shall be under the necessity of calling on you and my father or Titian to have packing cases made and place them in, they neednot be screwed, as they will go by water, a little paper at the corners of the frames will be all sufficient, the boxes may be rough and cheap. If this can be done at once it will save me much time and perhaps a trip to Phila— at any rate will save me much time. If I had made the arrangements about the room when I was in Phila. and have packed the paintings it would have been well, but I hurried home to decide positively, and unfortunately Mr. Robinson has not yet returned, but I find I cannot go on, situated as the museum is— I have just received a letter from Rembt—[2] which is very bitter in his observations, but I have done my part, and the best for him, that could be done, and the only thing that I am sorry for, is, that I am under the necessity of abandoning an institution that I had pride in and throwing not only my self in to difficulties, but also Rembrandt it is possible that I could have gon in

the same manner for a considerable while, but what would have been the advantage of so doing—if any prospect existed of at any moderate period of time, to get it out of debt, I would have been pleased to have continued my exertions here, but unfortunitely there is none.

I have engaged with Mr. Reed to take those paintings on trial and if I find it will do, I am then to pay him the value that, judges shall say they are worth, they aught to be valued before they are packed, therefore will you say to Mr. Reed that, Mr. Sully, C.W. Peale, Mr. Nagle, any [and] any others that he shall name would be fit to give their valuation of them, and this being done and the paintings forwarded by sea to the care of Mr. William Pendleton N. York, I will then follow them, and stop in Phila. to close the arrangement with Mr. Reed—this would be necessisary in consequence of Mrs. Delaplaine having an idea that she had a claim on them. so as to prevent any difficulty with her. 25th. I have jus[t] received a note from Mr. Reed,[3] who approves of my plan, and terms, and will give the order for their delivery &c.

My Room in N.Y. would have been the place for Rems—Washington—but I suppose he would not have it from me. I find that Mr. Robinson has not arrived this morning, in all probability is still in Phila. in all probability, he will receive the inteligence of my intention of leaving Baltimore and as Remt. has some strange notions about it, I may expect a blow up by Mr. Robinson on his return.

I am very sorry to tax you with the trouble of attending to the package of the pictures, but, as much for you, will when required, be done by me with much pleasure. Eliza and Sarah are very desirous of my going on Wednesday next with them, but I had better make one trip answer to visit N.Y. to attend to cleaning and varnishing, and then hanging them, so as to be absent from here as short a time as possible.

Give my love to all inquiring friends,

<div style="text-align:center">

I remain your affectionate
brother

Rubens Peale
</div>

Tell Titian that Eliza is very desirous of hearing from him and to know whether he is well &c and to be particularely remembered to you

<div style="text-align:right">R.P.</div>

ALS, 3pp.
PPAmP: Peale-Sellers Papers

1. See above, **213**.
2. Unlocated.
3. Unlocated.

217. JP: Excerpt: Minutes of Committee for Lafayette Reception[1]

PHILADELPHIA. AUGUST 24, 1824

Mr. James Peale tender'd the Portrait of Franklin[2] which is accepted with thanks, & he is requested to percure at the expence of the City a Frame to Match that of Robt.Morris[3] in the possession of the Union Canal Company.[4]

MsD, 1p.
PHi: Lafayette Reception Committee Papers. Am. 3651

1. At this afternoon meeting all committee members were present except Scott.

2. JP's *Benjamin Franklin* (1772: *American Philosophical Society*) is now considered a joint work by JP and CWP after David Martin's portrait. It is not known where the portrait was hung in Independence Hall. *Peale Papers*, 1:126n; Charles Coleman Sellers, *Benjamin Franklin in Portraiture* (New Haven, Conn., 1962), pp. 332, 335; CAP.

3. At least nine extant portraits of the financier Robert Morris (1734–1806), including CWP's (1782–83: *Independence National Historical Park Collection*) were painted before 1824. The portrait mentioned may have been the most recent—that of Bass Otis, painted in 1824 (*Historical Society of Pennsylvania*). Otis's *Morris*, a copy after Gilbert Stuart, was retouched in 1824 by Thomas Sully. Since Sully headed the artistic arrangements for Philadelphia's Lafayette reception, it is likely that Sully was conserving the portrait for public display at Independence Hall. This would also account for the committee's wish that JP's *Franklin* be framed similarly. CAP; Roland H. Woodward, Gainor B. Davis, and Wayne Craven, *Bass Otis: Painter, Portraitist and Engraver* (Wilmington, Del., 1976), p. 70; Nicholas B. Wainwright, comp., *Paintings and Miniatures at the Historical Society of Pennsylvania* (Philadelphia, 1974), p. 180.

4. The Union Canal Company, incorporated April 2, 1812, was a consolidation of two smaller canal companies that attempted to link the Delaware and Schulykill Rivers with the Susquehannah, thereby opening up Philadelphia to trade with the western part of the state. Robert Morris had no actual connection with the company, but the placement of his portrait in its offices was a tribute to his role as the financier of the Revolution and influential advocate of Pennsylvania's internal improvements. As president of Pennsylvania's Society for Promoting the Improvement of Roads and Inland Navigation, Morris signed the Memorial proposing that the rivers of Pennsylvania be linked to provide transportation by water east and west. Scharf, *Phila.*, 1:549, 611–12; J. Lee Hartman, "Pennsylvania's Grand Plan of Post-Revolutionary Internal Improvements," *PMHB* 65 (1941):446–47; Joseph Jackson, *Encyclopedia of Philadelphia*, 4 vols. (Harrisburg, Pa., 1931), 2:365; *Philadelphia Directory* (*1825*); *DAB*.

218. RuP to ReP

BALTIMORE. AUGUST 25, 1824

Baltimore Aug.[2]5. 1824.

Dr Rembrandt

Yours of the 23d has been duly received,[1] and I am sorry to see by it,

that you have some impressions from my last to you, that I didnot intend. My motives and intentions are all of the purest, and when correctly viewed, will be found to be so. I will now take your letter and answer it, line after line— In the first place you state that you must go emediately to N.Y. to exhibit your Portrait of Washington— the day before the receipt of yours, I engaged a room from Mr. Browere No. 315. Next to the Hospital in Broadway for the purpose of exhibiting the Delaplain Collection in, and have given directions to Wm Pendleton to have a little plaistering done, shall direct to have sashes made for the skylight, and the floor removed &c if you cannot obtain a better room it is at your service. I called on the Mayor Mr. Johnson[2] who says the Councils of Baltimore will require you to paint a Portrait of La Fayette, for the Council Chamber, and that he would write to you, as soon as they have determined on it—[3] I also was told this morning by one of the committees of arrangement that the committee are all desirous of having the likeness.

I have long been of opinion that an exhibition would succeed in N.Y.— and after I saw you I made arrangements with Mr. Reed and since then have concluded them. I have them on easy terms, the Delaplain Gallery, which will require but little of my personal attention, except in fitting up &c—

The difficult⟨y⟩ies of making any arrangement with the stockholders to have this Museum removed, are I fear too numerous to make the attempt, especially when the principal stockholder declaired to Eliza and myself that for his part he would not consent to taking 6 when the law allowed 8 pr. C—and I found that Mr. R.[4] had placed the note into Bank, which I gave him for 300, which he offered and loaned me to pay himself the additional 8 pr C. interest after I had paid the old. In consequence of which I emediately consulted on the subject, and find that in consequence of this additional stock, having been created without my knowledge, is a fair acknowledgement that I am not the owner of this Museum or looked upon ⟨by⟩ as such, that if it can be increased without my sanction, that there may be no end to it, that it breaks any engagement that I have made to you— My intention in my last letter was not to receive any thing from you but that you might make arrangements to part with the Museum or take possession of it, as your own, I am perfectly satisfied that you will find the improvements that I have made will be equal to your expectations and will be worth to you all that I have expended. All that I have expended was the benifit of the institution, and my family have been deprived of much that they stood in need of, becaus I was anxious to pay your debts and those of the Museum. The Ground and 8 pr C. will very soon claim their wrights, in spite of any engagements that you and I have made. Mr.

Mc.Kim[5] is very stiff—so that the "sacred obligations" will all cease when they take possession. I have stopped Mr. Kelso[6] from proceeding for some time yet as well as others. My giving up, is not a volentary thing on my part I can assure you.

The time that I took to decide on the taking [?] of the Museum was sufficient, but if I had spent a little more all my friends would have succeeded in deterring me from making the agreement—and the opinion of Coleman and all others, was that I could have sold without any difficulty, but this having failed, it was unfortunate for us both. You and Mr. Robinson thought I had better commence even under those circumstances, and he has repeatedly told me that it would have been impossible for you to have held it and gon on six months longer, therefore if this was true, you aught not condemn me so severely as you do. I have exerted myself in every respect for the purpose of relieving you when I was much sensured by Mr. R. for paying yours when the stock should have been paid. I this minute have hird a report circulated in Phila. that Eliza & I are extravigant, but this I cannot believe, for it is false in every sence of the word.

The remainder of your letter must be answered in my next, which will be in a few days[7]

And still remain your affectionate brother and friend

<div style="text-align: right">Rubens Peale</div>

ALS, 3pp.
PPAmP: Peale-Sellers Papers—RuP Letterbook

1. Unlocated.
2. Edward Johnson (ca. 1767–1829) was mayor of Baltimore from 1808 to 1816, 1819 to 1820, and 1822 to 1824. During his first term in office, he authorized the Baltimore City Councils' commission to ReP for a group of paintings honoring the city's defenders against the British invasion in 1814. His portrait was included in the group (*Baltimore City Life Museums—The Peale Museum*). See *Peale Papers*, 3:458n; Miller, *In Pursuit of Fame*, pp. 122–23; Holli and Jones, *Biographical Dictionary of American Mayors*, pp. 183–84.
3. The Baltimore City Councils did not vote ReP a commission for a portrait of Lafayette. ReP painted a portrait of the French hero nevertheless, hoping to win New York City's competition for such a portrait. When Morse secured the commission, ReP exhibited his portrait "for sale" at his brother Rubens's New York Museum and Gallery of the Fine Arts (1825: *Metropolitan Museum of Art, New York*). Above, **207**; ReP Catalogue Raisonné, NPG; Staiti, *S. F. B. Morse*, pp. 116–18.
4. Henry Robinson.
5. Probably John McKim, who owned the ground on which the museum was built. See above, **126**.
6. This Baltimorean cannot be positively identified but he was not a stockholder in the museum. It is possible that he was William Kelser, a painter living on Green Street, who was contracted to refurbish the museum. *Baltimore Directory (1824)*.
7. No further continuation of this correspondence has been located.

219. ReP to John M. Scott
NEW YORK. AUGUST 29, 1824

New York August 29. 1824.

Dr Sir

Mr. Strickland informs me that your Committee authorize him to tell me that *a place* will be reserved for my Picture *till* the 4th. of Sept. But as he likewise informs me that the place *allotted* for it is *over* the door, I feel it my duty to give you this earliest ⟨*information*⟩ intimation that it is of too much importance to me to have this Picture in a good situation & light when Lafayette shall see it, to suffer it to be placed in any secondary place where its appearance would be injured & its character undervalued.[1] With this impression I wrote my notes to you and Mr. Strickland, to convey the idea that *no other* spot in that room would be suitable for it.— And from the tenour of your note to me I feel satisfied that you will agree with me. Now as I cannot even wish the work of my friend Rush removed for mine, I must relinquish the pleasure I should have had in contributing to the honours preparing for Lafayette, altho' it is otherwise announced in all the papers of New York.[2]

With great respect
I remain
Yours
Rembrandt Peale

ALS, 1p.
PHi: Lafayette Reception Committee Papers. Am. 3651

1. Angry that ReP had taken the *Patriae Pater* to New York City to be exhibited, the Committee of Arrangements gave the place originally assigned to him to the sculptor William Rush (1756–1833), whose full-length statue of Washington was placed in the central position, facing the main entrance to the Hall. ReP's dissatisfaction with the new position assigned to his portrait can be understood in the light of the pediment on the door that would have overshadowed his painting. Miller, "Lafayette's Farewell Tour of America," pp. 116–17.
The Peales obviously believed that they were being excluded from the festivities surrounding the Lafayette visit. In addition to ReP's dissatisfaction with the arrangements of the official reception room, CWP placed the following item in the paper regarding his portrait of Lafayette (*Independence National Historical Park*):

As the fact does not appear to be generally known in this city, it is deemed proper to state that an original Portrait of Gen. LA FAYETTE is among the collection of Revolutionary Patriots contained in the Philadelphia Museum.
This Portrait was painted at an early period during the war of the Revolution, with all the characteristic faithfulness of his pencil, by C. W. Peale

Poulson's, August 20, 1826.
2. Despite ReP's threat to withdraw his portrait, the difficulties were ironed out and the painting of Washington was placed as he wished it. See below, **223**.

220. CWP to RuP

PHILADELPHIA. SEPTEMBER 3, 1824

Philada. Sepr. 3th. 1824.

Dear Rubens

I can spare only a few moments to write; but must tell you my oppinion on the ingagement with the stockholders and Trustee's of the Baltemore museum, you can not expect to pay a principal when burdened with 8 Pr.Ct. Interest,[1] therefore if they will not let you have it at 5 Pr.Ct. you had better quit it at this moment; and I firmly believe with the same industry as you have for many years practiced will in any other employment make you independant—, remember the like events that have given you large companies of Visitors may very sildom occur—[2] your health may leave you and a helpless family may suffer distress—

The Vallue put on the Museum and House amounts to a Large Sum— you can now leave it and engage in some way to provide for a family & old age, without subjecting yourself to great anxiety— The inseparable [insuperable] fate you must undergo if you engage to keep the Museum.

Having thus stated my belief, I fulfill my duty to you. you ⟨will⟩ are well apprised that I cannot at present help my children should they get into difficulties, I am determined to act more prudently than some Fathers have done within my knowledge. Eliza went in the stage to chesnut hill this morning, in good health; she recd. your letter[3] last night, which she desired before she could think of leaving the City. I cannot say any thing about your having the transparencies, at this moment—[4] The center picture is about 9 feet high & 5½ wide—the others are half that size filling only the lower half of the windows, in my next, I will give you the designs of each—[5] Titian is now suffering under a bowel complaint. he was very ill last night, something better this morning—

Sophonisba has been much indisposed for the last week, is now something better, it will be fortunate if she can hold out for about 4 weeks and be delivered of a living child[6]——

My love to James & Sarah, Yrs. affectionately

CWPeale

ALS, 2pp.
PPAmP: Peale-Sellers Papers—Letterbook 18

1. See above, **218**.
2. CWP is referring to RuP's success in exhibiting an Egyptian mummy earlier that summer. See above, **196, 205**.
3. See RuP to EPP, August 29, 1824, P-S, F:VIIA/5E14-F1; August 30, 1824, P-S, F:VIIA/5G1–6.
4. RuP probably wanted to borrow CWP's transparencies to celebrate Lafayette's ex-

pected visit to Baltimore between October 5 and 10; the museum was illuminated on October 6, 7, and 8, and the general visited the museum on the ninth. Marian Klamkin, *The Return of Lafayette* (New York, 1975), pp. 89–92; Baltimore Museum Account Book, 1822–29, MdHi, F:XIB/3.

 5. Unlocated.

 6. On September 30, SPS gave birth to a daughter, Anna Sellers (1824–1905). *CWP*, p. 442; see below, **226**.

221. RuP to Eliza Patterson Peale

BALTIMORE. SEPTEMBER 5, 1824

<div align="right">Baltimore Sept.5th. 1824.</div>

My dear Eliza

 I received yours of Sept. 1 and 2,[1] also my Fathers of the 3d.[2] therefore this may answer for both of you as I have but little time this morning to write— I have notified the Trustees of the Museum to meet on business of importance, at 4 oclock tomorrow afternoon. and I am much engaged in arranging my papers for their inspection. and we are all to dine with Mr. H. Robinson today. I called on Mr. Long (one of the directors) yesterday & he is perfectly satisfied that I am doing what is right—also Col. Mosher and Mr. Fridge, they all think alike. Mr. Robinson & McKim are the others— Mr. Robinson ⟨took⟩ looked over all the account yesterday afternoon, & was of opinion that I had used every exertion in producing the best income, that I had expended for the Museum very economically that no one could in the least degree complain of it—but that I had expended too much for my family, that in his opinion I did not live expensively but that the amount in hand or spent is too great—but it agreed with common housekeeping in this city—Mr. Fridge, Long, & Mosher, are are of opinion that I could not have lived comfortably on much less than I have estimated it at.[3]

 If the weather is good tomorrow morning Uncle and Sarah expect to start, but I have too much important business to attend to before I can leave home. As the General is expected the 15th. in Phila. I may possibly be there at that time but not sooner unless it is requisite for me. I forgot to state, that Mr. Lorman[4] said the other day that all the stock holders should dock off the arriarage interest that he would for one, and Mr. Fridge said he would also dock off the principal 150$ this is very handsome.

 The size of my windows are 7 feet 6½ high and 3 feet 8½ inches wide. If I can borrow the transparenceys after my father has used them I can bring them with me & place them up altho they are larger than requisite, yet it will perhaps be better than to reduce them, for they will be wanted at the Museum again for some other occasion, and as I cannot go to any consid-

<div align="right">465</div>

erable expence it will be of much service to me. It is expected that there will be a general Illumination in Baltimore.[5]

And now with respect to Mr. Brower, in his letter to me he expresses much surprise that you decline any thing further doing with the premises until I shall arrive, he is willing to remain until wednesday next—he also has made several propositions to join me in the exhibition &c which I will not agree to, for I donot like the Man— I am much surprised that Pendleton has not yet answered my letter to him,[6] he must either be out of town or is very neglectful. I am very well pleased that the money has not yet been paid to him, untill it can be assertained whether it is incumberred or not and it is very likely the trustees may determine tomorrow on something. if they do I will write to you the next day informing you of all that occurred. The general opinion is, that I must not leave Baltimore, that all should aid and relieve the the institution from its difficulties, that it aught flurrish and be unincumbered. The proof of the pudding is in the eating of it. I will not stay unless it is put on better terms than I took it, from Rembrandt, or they to compell me, seems too impossible to think of.

Mrs. Atkinson[7] has been very buisily engaged in putting together and cleaning all the china, glass &c. and will have every thing in the house attended to as soon as Sarah is off. And then think how comfortable I shall be, when I shall visit the parlour or chamber & find not a living being to speak to—and in the dead of the night to look around, and wonder what we are placed on this earth for, then try to slumber, as I have already done.

Present my love and best respects to all enquiring friends. kiss the children for me, I am delighted to hear that they keep well

And beleive me ever your affectionate husband

Rubens Peale

ALS, 4pp.
PPAmP: Peale-Sellers Papers—RuP Letterbook

1. Unlocated.
2. See above, **220**.
3. It is not possible to calculate RuP's personal expenses, but a precise calculation of the museum's income can be made that would suggest how much profit or surplus RuP received at the end of the year. The museum's expenditures for 1824 were as follows:

Gas company on account	753
Oil glass and wicks	27.50
Fuel	82.87 1/2
8 percent interest, taxes & water	867.62
Wages	524.13 1/2
Printing	301.11 1/2

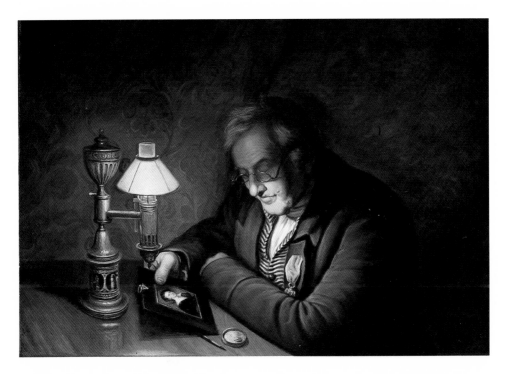

PLATE 1. *James Peale by Lamplight.* C. W. Peale, 1822. Oil on canvas, 24 1/2 x 36" (62.2 x 91.4 cm). The Detroit Institute of Arts, Founders Society Purchase with funds from Dexter M. Ferry, Jr.

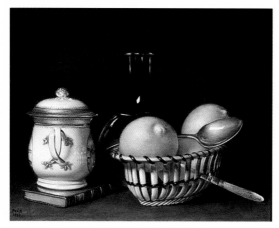

PLATE 2. *Lemons and Sugar.* Raphaelle Peale, ca. 1822. Oil on panel, 12 3/4 x 15 7/8" (32.5 x 40.3 cm). Reading Public Museum and Art Gallery.

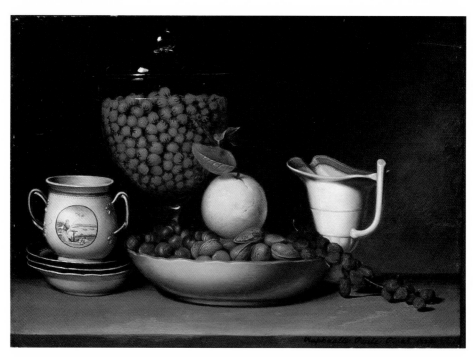

Still Life: Strawberries, Nuts, &c. Raphaelle Peale, 1822. Oil on wood panel, 16 3/8 x 22 3/4" (41.5 x 58 cm). The Art Institute of Chicago, Gift of Jamee J. and Marshall Field, 1991.100.

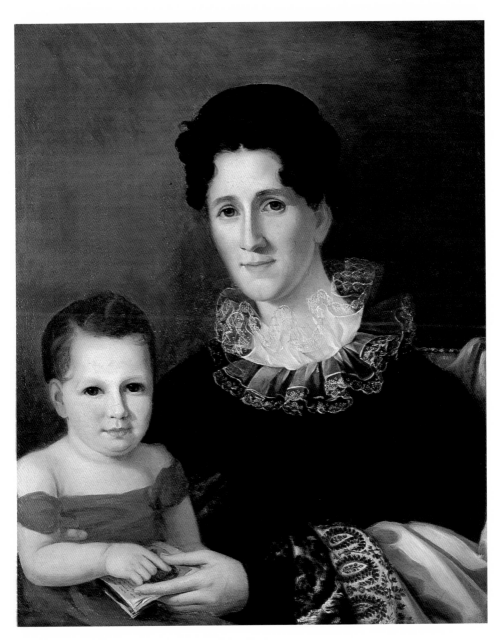

PLATE 3. *Eliza Patterson (Mrs. Rubens) Peale and Son*. Sarah Miriam Peale, ca. 1822. Oil on canvas, 29 1/2 x 23 1/2" (75 x 59.5 cm). The Peale Museum, Baltimore City Life Museums.

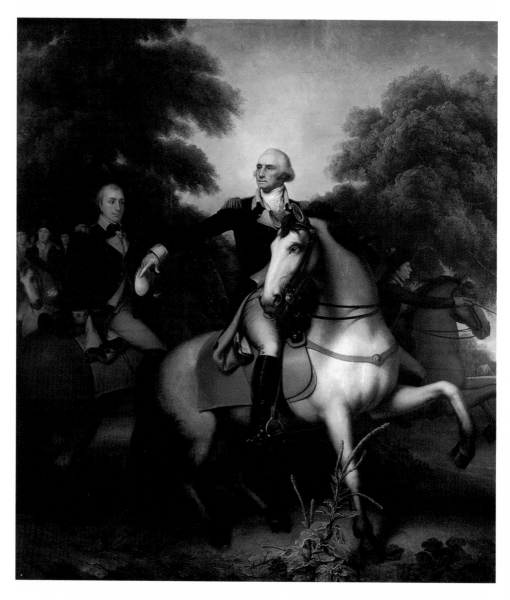

PLATE 4. *Washington Before Yorktown*. Rembrandt Peale, 1824/25. Oil on canvas, 139 x 121" (353 x 307 cm). Corcoran Gallery of Art, Washington, D.C., Gift of the Mount Vernon Ladies' Association.

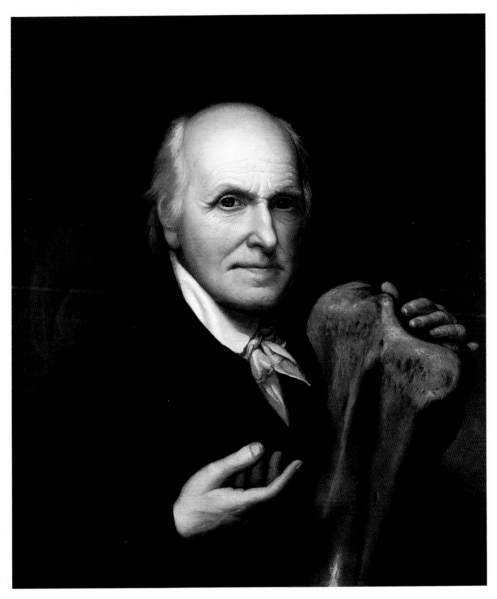

PLATE 5. *Self-Portrait in the character of a Naturalist: "For the Multitude."* C. W. Peale, 1824. Oil on canvas, 26 1/4 x 22" (67 x 55.9 cm). New-York Historical Society.

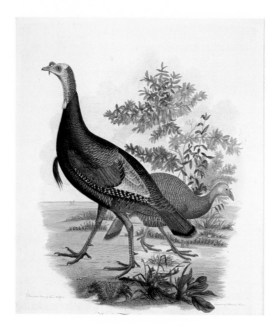

PLATE 6. *Wild Turkey, Male and Female*. Alexander Lawson after Titian Ramsay Peale, 1825. Engraving, 13 5/8 x 10 1/2" (34.5 x 27 cm). Plate 9 from Charles Bonaparte, *American Ornithology*, 1 (Philadelphia, 1825). Courtesy Smithsonian Institution Libraries.

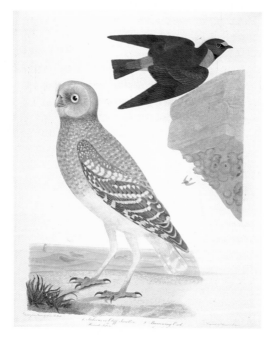

Burrowing Owl, Cliff Swallow. Alexander Lawson after Titian Ramsay Peale, 1825. Engraving, 13 5/8 x 10 1/2" (34.5 x 27 cm). Plate 7 from Charles Bonaparte, *American Ornithology*, 1 (Philadelphia, 1825). Courtesy Smithsonian Institution Libraries.

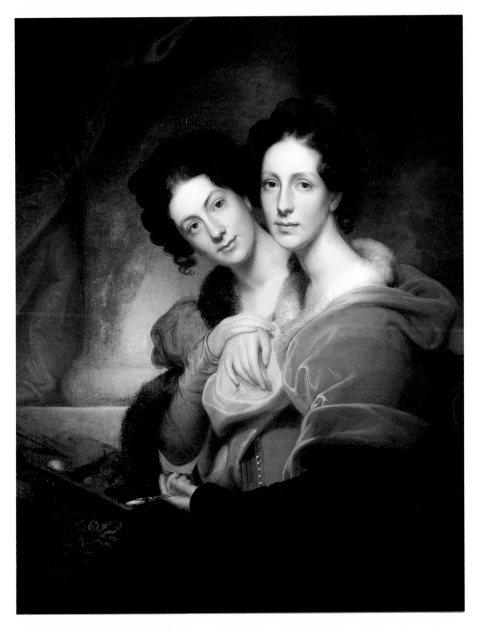

PLATE 7. *Eleanor and Rosalba Peale*. Rembrandt Peale, 1826. Oil on canvas, 42 x 32 13/16" (106.7 x 83.2cm.). The Brooklyn Museum of Art, 67.205.3. A. Augustus Healy Fund

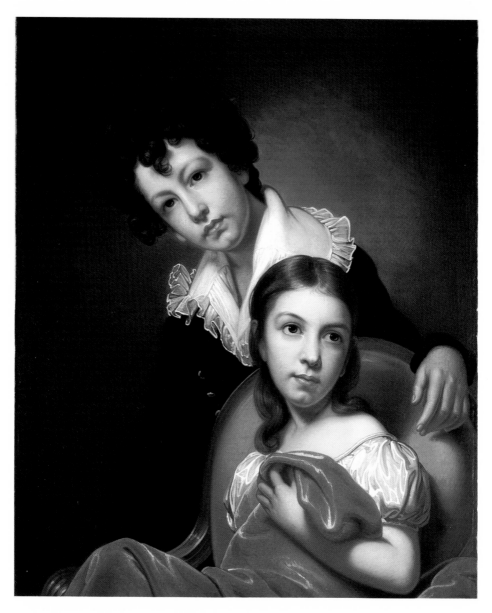

PLATE 8. *Michael Angelo and Emma Peale*. Rembrandt Peale, 1826. Oil on canvas, 30 x 24" (76 x 61 cm). Photograph courtesy Richard York Gallery, New York City.

Permanent improvements	440.17 1/2
ditto the property	78.93
Extraordinary Expenses	1244.10
Repairs	47.03 1/2
Miscellaneous expences	169.27
Omitted 2 looking glasses	190.00
[Total]	$4725.75

The category "Extraordinary Expences" refers to the percentage of income from special exhibitions that RuP paid to contracted entrepreneurs. Subtracting all these expenses from receipts of $5,854.12 1/2, leaves a balance of $1,128.37 1/2. It should be noted that income fluctuated monthly, but expenses remained relatively constant throughout a given year, so that in some months, the museum and RuP ran a deficit. Baltimore Museum Account Book, 1822–29, MdHi, F:XIB/3.

4. William Lorman, a merchant, banker, and railroad developer, owned Baltimore Museum stock. Alexander Fridge was a partner in the Baltimore dry goods mercantile firm of Fridge and Morriss, 12 South Charles Street. *Baltimore Directory (1824)*. See Miller, *In Pursuit of Fame*, p. 116.

5. The Museum illumination commemorated the Battle of Baltimore during the War of 1812 and was advertised as follows:

<div align="center">

Peale's Museum

</div>

Will be brilliantly illuminated on Monday evening—The painting of the DEATH OF GENERAL ROSS, at North Point, will be exhibited in the Lecture room, and a Military BAND OF MUSIC, will attend during the evening.

Baltimore American and Commercial Daily Advertiser, September 11, 1824.

6. Unlocated.

7. The museum housekeeper and attendant.

222. ReP to the Editors of the *American*[1]

NEW YORK. SEPTEMBER 13, 1824

<div align="center">

To the Editors of the American.

</div>

New-York, Sept 13, 1824.

Gentlemen— The love I have ever felt for the art to which I have devoted my life is not stronger than my love of truth; nor did I, at the expense of this, ever wish to receive the breath of praise. What I have at length accomplished, in rescuing from oblivion the countenance of Washington, has excited the approbation of his intimate friends and will be received by their countrymen with respect and attention. If it were nothing more, it is the exhibition of Washington as I knew him—but it is spontaneously acknowledged by his friends, who believe they are discharging a duty they owe to their country and to posterity to express their opinion of its merits. Their rank and character in society will insure implicit confidence in the purity of their motives and the validity of their judgments; nor can any

467

manner of arguing, nor any style of newspaper discusss[i]on arrest the course of conviction, or the irresistible influence of opinion, founded on such authority.[2] Respectfully,

REMBRANDT PEALE.

PrLS, 1p.

1. The founders and editors of the *New York American* were Charles King (1789–1867), merchant and president of Columbia University (1849–1864), who established the newspaper in 1819; James A. Hamilton (1788–1878), lawyer and Democratic party political insider; and Gulian Johnston Verplanck (1786–1870), author and congressman. Clarence S. Brigham, *History and Bibliography of American Newspapers, 1690–1820*, 2 vols. (Worcester, Mass., 1947), 1:607; *DAB*.

2. Although there seemed to have been general approval of ReP's *Patriae Pater*, some voices were raised in dissent. ReP's communication was a response to a series of critical letters to the *New York American* that questioned not only the accuracy of ReP's portrait of Washington, but also his strategy of collecting testimonials from prominent Americans, his treatment of other artists, and his disparagement of Gilbert Stuart. An especially vigorous critic, who styled himself "An Enemy to Quackery," responded to ReP's letter on September 16, further attacking ReP's "air-built vanity of pretence and folly." ReP did not respond and the debate ceased. *New York American*, August 31, September 1, 2, 4, 7, 11, 16, 1824.

223. ReP to John M. Scott
PHILADELPHIA. SEPTEMBER 15, 1824

Philadelphia Sept.15. 1824.

Sir

Having hastened from New York to comply with my engagement with the Committee of Arrangements that my Portrait of Washington should serve to decorate the Hall, if a suitable place could be assigned to it— And having examined the room with Mr. Strickland, who, I find has taken away the uncouth pediment over the door, which would have raised any Picture too high, we have agreed on the Manner in which it should be displayed. I shall therefore be gratified if the Committee will authorize him to make such an appropriation of the Picture as will at once be honourable to it and complimentary to their Guest.[1]

With great respect
I remain Yrs
Rembrandt Peale

J. M. Scott Esq.

ALS, 1p.
PHi: Lafayette Reception Committee Papers. Am. 3651

1. This letter was read into the record of the Lafayette Reception Committee and summarized as ReP "again offering his painting to be placed over the entrance door of the hall of Independence, which Mr. Scott was authorized to say would be accepted." Minutes, September 15, 1824, PHi:Lafayette Reception, F:IIA(Add.)/4F9–10.

The placement of ReP's *Patriae Pater* was favorably noted in the newspaper: "Over the door of the entrance is placed the celebrated Portrait of Washington by R. Peale, relieved on each side by crimson and azure drapery suspended from spears and laurel wreaths." *Poulson's*, September 30, 1824.

224. Philadelphia Museum: Notice Concerning the Arrival of Lafayette

PHILADELPHIA. SEPTEMBER 1824[1]

Philadelphia Museum
Arrival of General Lafayette
The public are respectfully informed that the following regulations have been adopted for the admission of Visitors to the Museum on the day of the procession and will be strictly adhered to on that occasion

Visitors will be admitted at the Back door of the State House, by tickets only until O Clock precisely. at that time the door will be closed and no one admitted.

It will be absolutely necessary that all persons shall remain in the Museum after the doors are closed untill the departure of the General from the State House.

Tickets for sale at the door of the Museum at 25 cts each— Early application is requested as the Number will be limited.

MsD, 1p.
PHi: Lafayette Reception Committee Papers. Am. 3651

1. Lafayette arrived in Philadelphia on September 28. This notice must have appeared a day or two before his expected arrival.

225. CWP to the Marquis de Lafayette

PHILADELPHIA. SEPTEMBER 30, 1824

Philadelphia Sepr. 30th. 1824.
General LaFayette
much esteemed friend,

Before you left this country[1] I began a collection of Portraits of distinguished characters which I have encreased considerably ⟨increased⟩ A few Mammoth bones gave rise to the Idea of forming a Museum, began in 1784.[2] This object has had my unceasing labours for many Years, and, is now in high estimation with the lovers of Natural history—and I doubt not that you will be gratified to see the Animals of America, many of which no other Museum contains, therefore I ask the favor of you to Visit it with

469

your Son and suite,[3] the Governor of Pennsylvania & suite,[4] the committee of arrangement with the Mayor, the Trustee's of the Museum[5] and my Sons, *no other company to be admitted except such as you may invite.*

If this invitation is agreable, please to name your day,[6] and you will much oblege your sincere

<div align="right">friend CWPeale</div>

ALS, 1p.
PPAmP: Peale-Sellers Papers—Letterbook 18

1. Lafayette returned to France after participating in the American Revolution in December 1781. In 1784 he paid a six-month visit to America, returning to France in December. *DAB*.

2. See *Peale Papers*, 2:380.

3. Lafayette was accompanied on his visit by his son George Washington Lafayette (1779–1849), a member of the French Chamber of Deputies, and his secretary, Auguste Lavasseur (d. ca. 1830). Anne Loveland, *Emblem of Liberty* (Baton Rouge, La., 1971), p. 3; *DAB*; *NCAB*; Brand Whitlock, *Lafayette*, 2 vols. (New York, 1929), 2:213,214.

4. The governor of Pennsylvania, John Andrew Shulze (1775–1852), Lutheran clergyman and businessman, entered politics in 1806 with his election to the Pennsylvania state legislature. He was elected governor in 1824 and served three terms, retiring in 1830. Shulze served as the state's official escort to Lafayette. CWP invited Shulze to visit the museum on September 21, 1824 (F:IIA/71B13) but Shulze's reply, if there was one, is unlocated. Raimo and Sobel, *Biographical Directory of the Governors*, 3:1299–1301.

5. There are no extant invitations to the Committee of Arrangements, Mayor Robert Wharton, and the museum trustees.

6. The number of times that CWP and Lafayette met during Lafayette's eight days' stay in Philadelphia cannot be determined precisely. In his autobiography, CWP wrote, "Lafayette visited the Museum and expressed great satisfaction while viewing the Portraits of his associates in arms—but it was immediately after having been in the audience room and shaking hands with hundreds of citizens, of course when he was under much fatigue." This meeting probably occurred on September 28, when Lafayette entered the Statehouse following the procession.

CWP continued, "By this letter [which was reprinted in the Autobiography] it is shewn that he wished to let the general see the museum without a crowd to obstruct his amusement in viewing the revolutionary characters whom he must remember in his military career when he aided to make America independent, and where he [his] own portrait has a place amongst them, as he reminded Peale that he had sat for it 46 years past. If Peale had wished to make money by the exhibition of the General, he would not have given him the foregoing invitation, his wish was to give LaFayette an un[al]loyed pleasure." Sellers cites three other instances of the two old comrades meeting, but there is no documentation for these meetings. *CWP*, p. 418; A(TS):484–85; *Peale Papers*, 1:635; *P&M*, pp. 117–19; CAP.

226. SyMPS to EPP

PHILADELPHIA. OCTOBER 6, 1824

<div align="right">Wednesday Oct. 6th. 1824</div>

Dear Elizabeth

Titian has just given me your letter to read.[1] I was glad to see it as I have been quite uneasy about you. I was in hopes you would have staid at some

of Williams relations untill it was done raining. I am glad you saw Sam Morris[2] when in Harrisburg. I hope they are all quite well Aunt Morris is now at the billet with Thomas[3] she has been in town since you were here. I was wishing you could have been been here a few days ago when General La Fayette arrived. I never saw such a parade in my life[4] there were upwards of 50 thousand soldiers besides the citizens Revolutionary soldiers shoemakers—coopers—Butchers—painters—draymen & carters all elegantly mounted escorted him into town they met him at Frankford—they had an elegant Barrouch[5] and 6 cream coulerd horses—and 2 postillions and a driver with 2 out riders on cream coulerd horses all in buff and light blue livery. the carrige was made at the expence of a young man on purpose for the occasion—by the name of Lockhart[6] only 20 years old— the state house has been intirely new and elegantly painted and done up for his reception The room where independence was declared was splendidly carpetted and scarlet and blue curtains to all the windows and Elegant mahogony chairs and sophas. in front of the museum there is an immense arch the most elegant thing I ever have seen for him to pass under with music new for the occasion (LaFayette ma[r]ch & La Fayete's welcome)[7] there are a great many Triumphal arches throughout the city and libertys[8] in the evening the city was illuminated and a great many very handsome Transparent paintings ex[h]ibited Raphael—Uncle James—Sarah—and *pa* painted several *pa* had one in every window of the museum in the middle was La Fayette's bust in white crowned by the american eagle and decorated with flowers, and surrounded by the French and American flags muskets cannon spears &c&c— he remained in Town a week but will return in the cours of 2 or 3 weeks to lay the corner stone of a monument to be erected to Washington—[9] while he remained in town the gentlemen all mounted the revolutionary cocade—on a badge with his picture, on monday there was a splended ball given in the Theatre which was an imence garden of orange and lemon trees, the Ladies were the most Briliantly drest ever in Philada. on tuesday morning he received all the schools in the state house yard, it was absolutely cramed full and all the streets round—some of the schools spok addresses and some sang songs of welcome and praise he left the city on Tuesday evening amid immence crowds and music from the upper end of the wharfe's down to the navey yard—as he was followed every where he went while in the city he called on *pa*—[10] every body wanted to shake hands with him and immence crowds visited him in his room at the state house—

On Thursday sister Sophy presented us with *a daughter* and is now doing very well with a lovely baby they are all very proud and think it the most wonderful baby ever born. they have not yet found a name for

it—[11] Titian has been at the point of Death with the disentary—but I am thankfull is now quite recovered—and is going to Florida very soon[12] Eliza is as thin an[d] little as ever. all the rest of the family are quite well & send their love remember me to William and kiss Sophonisba for me—you must write by every opportunity, even a few lines to let us know how you come on—and I hope you will like your situation and will do well—

<div align="right">

Your affectionate sister
Sibylla M Summers

</div>

ALS, 3pp. & add.
PPAmP: Peale-Sellers Papers

 1. Unlocated.

 2. Son of HMP's sister, Rachel Morris.

 3. Thomas was another son of Rachel Morris's. *Peale Papers*, 3:220.

 4. Lafayette entered Philadelphia on September 28 to a tremendous parade and civic celebration. SyMPS's estimate of the number of soldiers who participated, however, is probably too high: contemporary accounts gave the total number of people in the parade as approximately 20,000. The city's reception of Lafayette was distinguished from the celebrations of other cities in its use of a combined civic and military procession. The pageant's organizers made a conscious effort to duplicate the popular celebration that had been staged to mark the ratification of the Constitution, in order to emphasize the historical connection and remind Americans of the great achievements of the revolutionary generation. In drawing upon earlier traditions of civic festivals, the Philadelphia procession was a success in itself as well as an influence on the format of subsequent celebrations—both those given for Lafayette during the remainder of his visit and those given down to the Civil War. Miller, "Lafayette's Farewell Tour of America, 1824–1825," pp. 106, 108.

 5. The *barouche* is a four-wheeled open carriage shaped in a shallow open curve, with low sides and a high driver's seat, that was especially suitable for public occasions because of its openness. Its two banks of facing seats allowed for a harmonious grouping of the passengers. Accompanying Lafayette in the parade's lead carriage was Judge Richard Peters (1744–1828), revolutionary patriot and subsequently chief judge of the U.S. District Court, Pennsylvania. *OED*; Scharf, *Phila.*, 1:609n; above, **198**.

 6. Unidentified.

 7. In each city that Lafayette visited, musicians composed marches, fanfares, and other musical pieces to celebrate the hero. The march mentioned is "La Fayette's Grand march. Composed by a Lady of Philadelphia" (Philadelphia, 1824). *NUC*.

 8. As in the civic celebrations of the early national period, the Philadelphia reception was distinguished by its use of the traditional celebratory triumphal arch. Philadelphia had thirteen arches spanning the parade's route. These massive outdoor stage settings were constructed under the supervision of the architect William Strickland, assisted by workers from the New Theatre. Given Strickland's classical bias, the arches were modeled after those used in Roman triumphs and civic celebrations; one of the arches is illustrated in Scharf, *Phila.*, 1:609. The sculptor William Rush contributed allegorical statues and sculptures to these settings, while Thomas Sully helped supervise the painted decorations and added portraits of such notable individuals as Washington and Lafayette. Miller, "Lafayette's Farewell Tour of America, 1824–1825," pp. 107–12.

The suburban Northern and Southern Liberties were municipal units distinct from the city proper. *A Dictionary of American English*, 4 vols. (Chicago, 1965), 3:1417.

 9. Lafayette did not lay the cornerstone to a Washington monument on either of his two trips to Philadelphia. Planned for Washington Square on a classical design of William Strickland, the monument was never built because of inadequate financing and lack of public support. Scharf, *Phila.*, 1:615.

10. See above, **225**; for Lafayette's itinerary in the city, see Scharf, *Phila.*, p. 609.
11. Anna Sellers.
12. TRP spent the winter of 1824–25 on a specimen-collecting trip in Florida to assist in the compilation of Charles Lucien Bonaparte's *American Ornithology*. TRP subsequently drew these specimens to illustrate Bonaparte's *Ornithology*. See below, pp. 473–74; *DSB*.

EDITORIAL NOTE: *Titian Ramsay Peale's Collecting Trip to Florida, October 1824–April 1825*

During the 1820s, Titian Ramsay Peale listed his occupation in the Philadelphia directories as "artist," even though during these years he worked as curator in his father's Philadelphia Museum and, from 1824 on, in the Academy of Natural Sciences. At the academy, Titian also worked on the publications committee, issuing reports on articles submitted to the academy's journal and helping to reorganize and recatalogue its collections and its library. This work was probably not completely satisfying for the young man intent on a career as an artist-naturalist and more interested, it would seem, in the fieldwork aspects of natural history and the artistic demands of illustrating specimens than in the processing of other naturalists' reports.

Thus, when in the winter of 1824–25, Charles Bonaparte, to whose *American Ornithology* Titian was contributing illustrations, decided that he needed information about the birds of Florida and those "belonging to Cuba, and other West India islands [that] may occasionally resort to the southern part of Florida and thus be entitled to a place in our work," and suggested that Titian visit that area at his expense, the young man readily agreed. From Bonaparte's point of view, "a better choice could not have been made," for Titian's "zeal in the cause of natural history" as demonstrated by his activities on the Long Expedition "will warrant us," Bonaparte wrote in the preface to the first volume of his *Ornithology*, "in anticipating much from his exertions in Florida."

Not much is known about this short trip to Florida, since the journal that Titian kept disappeared from public view after its sale in 1913. By November 20, 1824, Titian was in Charleston, South Carolina, "inspecting the Museum of South Carolina and making drawings there," according to the *Charleston Mercury*. By mid-December, he was outside of St. Augustine, according to an observational note included in the manuscript "Sketches. Miscellaneous Notes and Photographs" at the American Museum of Natural History in New York. Titian returned to Philadelphia sometime in April 1825, and in May Bonaparte was able to read a paper to the members of the Academy of Natural Sciences reporting on new species of birds found by Titian in the field.

The illustrations that emerged from Titian's observations on this trip

54. *Key West, Allentown from the Commodore's House Looking North. TRP del. 1826.*
Titian Ramsay Peale, 1826. Ink and graphite on paper, 5 ½ × 9 ⅛" (14.1 ×
23.2 cm). American Philosophical Society, Philadelphia. [B/P31.5d no. 185].

(see Fig. 54) provide some documentation. From Bonaparte's comments
about the "successful zeal of Mr. Titian Peale, whose practical knowledge
(the most important) of North American birds is equalled by none," we
can surmise that the expedition and Titian's work as illustrator were
highly regarded and that Titian had taken an important step in his devel-
opment as artist and naturalist.*

*Charles Lucien Bonaparte, *American Ornithology* (Philadelphia, 1825), 1: iv-v; ibid. (Phila-
delphia, 1833), 2: 25–27; ibid. (Philadelphia, 1833), 4: 109, 114; Jessie Poesch, *Titian Ramsay
Peale, 1799–1885, and His Journals of the Wilkes Expedition* (Philadelphia, 1961), pp. 48–49;
Charleston Mercury, November 20, 1824, in Anna Wells Rutledge, *Artists in the Life of Charles-
ton, Transactions of the American Philosophical Society* 39 (1949): 215. Poesch (p. 49n) quotes the
summary of Titian's journal given in Evelyn and Virginia Keyes, *Catalogue of a collection of
books on ornithology in the library of John E. Thayer*, privately printed in Boston, 1913.

227. CWP to Henrietta Ross[1]

PHILADELPHIA. OCTOBER 26, 1824

Philadelphia Octr.26.1824.

Dear Madam

The remembrance of former times brings with it pleasure and pain, but
Philosophy, independant of religion, teaches us to bear the unavoidable

events of life with patient fortitude, and also to make the best use of present circumstances to obtain a happy result for the future.

I have passed through a variety of vicissitudes in a tolerable long life, and know very well that I might often have acted a better part to procure worldly grandeur, I mean wealth—but following my inclination to make whatever I wanted, made me happy, even in the midst of trouble. and now my constant employment makes time fly impreceptably with me. The disposition above alluded to, has not quite left me, although I daily strugle to conquer it. The Museum ought now to have all my exercians, for the fine arts at present languish in this country, yet I feel some relish to use the pencil since I can paint without spectacles, and perhaps vainly think I can produce something above mediocrity.

If you ever visit this City you will then know whether or not— Intending to send you a miniature picture of my dear friend, your father— which I have had so long in my possission that I cannot remember how I came by it—but I believe I had it from Miss Sarah Turner, why or wherefore I know not.[2] But as it is my wish that those who will most value ⟨it⟩ should possess it,—and thuse I prepare to leave nothing undone before my departure hence. Thurse producing some sentiments from your friend, who wishes you every blessing.

<div style="text-align: right">CWPeale</div>

Mrs. Henerittah Ross.

ALS, 1p.
PPAmP: Peale-Sellers Papers—Letterbook 18

1. Henrietta Maria Bordley (Mrs. David) Ross (1763–1828), the eldest daughter of John Beale Bordley, Peale's early patron and friend, lived in Chambersburg, Pennsylvania. CWP painted her portrait in 1773 (*Honolulu Academy of Arts*). *P&M Suppl.* p. 55; Charles Coleman Sellers, "The Portrait of a Little Lady. Charles Willson Peale's *Henrietta Maria Bordley*," in Lillian B. Miller and David C. Ward, eds., *New Perspectives on Charles Willson Peale* (Pittsburgh, 1991), pp. 83–88.
2. The miniature (*unlocated*) of Bordley referred to here was apparently not by CWP, but by an unidentified artist. Sarah Turner had been a member of the Bordley household and companion to the young Henrietta. CWP painted her portrait (1770–75: *The Chase House, Annapolis*) as a companion piece to young Henrietta's. *P&M*, p. 213; CAP.

228. CWP to RuP

PHILADELPHIA. NOVEMBER 18, 1824

<div style="text-align: right">Philadelphia—Novr.18th. 1824.</div>

Dear Rubens

I send by Anna[1] 4 gross of watch Glasses at 2—50 Pr. Gross one half gross, is off best English, therefore the price of half dollar in addition is making exact amount of the money sent—[2]

Mr. George Patterson I have understood will be married to day[3] he comes to the City with Mary and after the ceremony is over returns to Chesnut hill. I am still much engaged with Porcelain Teeth, and off late have made the process much easier and possibly I may make some profit by the business; but hitherto it has been not alittle expensive to me—yet I will not plague myself with it, for I now think unless I can make my work very profitable, I must quit it in order to devote my time to aid the Museum, more especially as Titian is away. at any rate Those that imploy me must esteem it a favor, and pay me also a high price for my labour. several of my family will want my aid, which I cannot afford unless other customers pay me well. Trumbul is now exhibiting his picture in the state house, east room.[4] I have not time to say more than love to Eliza and the Children.

yrs. affectionatly CWPeale

Mr. Rubens Peale.

ALS, 1p.
PPAmP: Peale-Sellers Papers—Letterbook 18

1. ACP.
2. Since RuP was divesting himself of the Baltimore Museum, although he remained its titular proprietor, and had moved to New York City to open a museum, it is not clear for which institution the glasses were intended. A gross is 144 items. Watch glass was a thin concavo-convex glass that, in addition to being used for pocket watches or miniatures, was used in museum or scientific displays. It was also used as a receptacle (an early form of petri dish) for preserving small objects and specimens. Sellers, *Mr. Peale's Museum*, p. 249; *The Century Dictionary and Cyclopedia*, 8:6836; *OED*.
3. George Patterson's bride is unidentified. *CWP*, p. 442.
4. John Trumbull's paintings of revolutionary scenes, commissioned by Congress for the Capitol rotunda, were exhibited in northern cities before being carried to Washington for installation. The painting exhibited at the Hall of Independence (formerly the Statehouse), under the aegis of the city councils, was *The Resignation of Washington* (*United States Capitol Building*), the last of the series to be completed. Admission was twenty-five cents, with artists admitted free. Trumbull was criticized for exhibiting his paintings for personal profit and thus delaying their delivery. A writer in *Poulson's* blamed the painting's faults on the fact that Trumbull "is now far advanced in years" (November 19, 1824).

229. CWP to RuP

PHILADELPHIA. DECEMBER 7, 1824

Philadelphia Decr 7th.1824.

Dear Rubens

My time of late has been whoaly employed in my Tooth-Room, successful in one instance of firing equal to any thing of the kind, and I can command as much to do as I please to undertake. altho' I wish to do something at painting, I cannot find leisure for it.

Enclosed I send you 4 Silver clasps to fasten on your Sculp, which I

think much preferable to that of using past[e]. each end of them are sewed within the edge of the sculp.[1] I wish to know how your business with the stock holders goes on, whether they will be content with 5 Pr.Cent &c.

also your success with the exhibition? I have no fire in my painting-room. Therefore, I must make a short letter this cold evening, tomorrow in the morning I go to Mr. Nathan Sellers, where your sister Sophonisba is—she every day becomes better in health and her child a thriving one.

I must write a few lines to Angelica which I wish you to contrive to her.[2]

Rembrandt will scarcely finish [t]he equestrean Picture in less than 2 weeks. It is elegant.

Take care to send the pictures belonging to Count Survelleirs as soon as possible, least cold should come and close the rivers.[3]

Love to Eliza & children, I wish to pay George a visit & to see his bride whom I hear is a fine girl.

<div align="right">yrs. affectionately
CWPeale</div>

ALS, 1p.
PPAmP: Peale-Sellers Papers—Letterbook 18

1. CWP was sending RuP clasps for a toupee. He subsequently sent RuP another clasp to help him fix the hairpiece to his existing hair and scalp. According to a communication from Dr. Paul Reinhardt, historian of costume, James Madison University, Virginia, hairpieces for men were revived in the 1820s after a long period of being rejected as aristocratic. The use of toupees to augment natural hair reflected a general transatlantic fashion trend in which longer, styled hair replaced the shorter, simpler hairstyles of the revolutionary era. Peale Family Research files, NPG.

CWP recommended using clasps instead of paste because of "the importance of keeping the pores of the skin free from every obstruction, either of dirt or grime." CWP to RuP, December 18, 1824, P-S, F:IIA/71C14.

2. See CWP to APR, December 7, 1824. P-S, F:IIA/71C11.

3. RuP advertised one of the paintings from the collection of the Comte de Survelliers in the *Baltimore Commercial and American Daily Advertiser* on December 13, 1824:

<div align="center">PEALE'S MUSEUM</div>

The celebrated Magadalen, painted by the great Titian, and belonging to Count Sur-veillier (Joseph Bonaparte) will continue to be seen on Monday, Tuesday and Wednes-day next, after which it will be sent home.—This painting is so much thought of in Europe, that ten thousand dollars has been offered for it, and refused by the Count. It is one of the finest specimens from the pencil of that great artist.

In the evening it is expressly lighted, and is well seen.

230. CWP to APR

PHILADELPHIA. DECEMBER 28, 1824

<div align="right">Philadelphia Decr.28th. 1824.</div>

Dear Angelica

I have hunted in vain for the Tin-box—and I have wrote to Rubens to know if I left it in my bedroom there—and in case he finds it, to send it by

<div align="right">477</div>

some opportunity to me—and also to inform you whether successfull or not— you will of course know whether you must make another impression of your mouth.[1]

I use my cold bath as usial and do not dislike it, how it will be when the weather is more intensely cold, and the water freezes in my bedroom, yet while I enjoy good health I cannot reguard ⟨a little⟩ alittle shivering.

Rembrandt carries this. he is on he way to Washington with an Equestrian Portrait of Genl. Washington, an elegant picture, and I really think it the finest Painting that has been done in this country, it is not only my opinion but of every one who has seen it since finished,[2] there is in it the likeness of Fayette, Knox Hambleton, Knox Lincon & Raushanbeau.[3] These last are distant ⟨figures⟩ The sciene at Yorktown, the moment the Genl. gives orders to break ground. Sophonisba continues to enjoy good health. I write this without spectacles & rather in haste in a cold room

yrs. Affectionately
CWPeale

Mrs. Angelica Robinson
Baltre.

ALS, 1p.
PPAmP: Peale-Sellers Papers—Letterbook 18

1. CWP was seeking a brass mold that he had made of APR's mouth in 1813 for an earlier set of dentures and retained in a tin box.

2. ReP's *Washington at Yorktown* (plate 4) was exhibited at the Capitol, with interruptions, until 1865 but, despite ReP's lobbying efforts (see below), it was never purchased by Congress. Miller, *In Pursuit of Fame*, p. 146; Hevner, *Rembrandt Peale*, p. 17.

3. In addition to Lafayette, the generals who led the Continental Army under Washington's command at the siege of Yorktown were Henry Knox (1750–1806), commander of the artillery; Alexander Hamilton (1755–1804), who had transferred from Washington's general staff to active service; Benjamin Lincoln (1737–1810), who received the British surrender; and Jean Baptiste Donatien de Vimeur, Comte de Rochambeau (1725–1807), the general commanding the French ground forces. *DAB*.

231. ReP to Elijah Hunt Mills[1]

WASHINGTON. JANUARY 13, 1825

Washington Jany. 13.1825

To Mr. Mills.
Sir

As Chairman of the Committee to whom is referred the letter Offering to Congress my Equestrian Portrait of Washington,[2] let me request of you to make the Committee acquainted with a few sentiments in reference to it, which I submit to their consideration.

The design of this Picture was conceived some years ago, and the intro-

duction of *Lafayette* & the other figures was suggested by the arrival in our Country of a Man who possessed the power of carrying back, with affection & gratitude, the minds of millions to a period when the genius & virtue of Washington & the devoted ardour of his adopted son were connected with its salvation & its glory. Washington is represented as having suddenly checked his well-trained Charger, and is in the act of giving command to some one who is supposed to be approaching on his right, towards which point his head, his hand & the head of his Horse are energetically directed, producing a concentration of design & effect required in the language by means of which the Painter addresses himself to the Spectator. The Horse submits to the restraint, but crouches & paws the ground, as if impatient of delay. It is conceived that this action (partly chosen to accord with the peculiar turn of the principal head which could admit of no variation) has the additional advantage of exhibiting, by contrast, the self-collected & resolutely calm countenance of Washington. The Artist did not hesitate to represent the forehead of Washington for a moment accidentally uncovered, rather than be compelled to hide any part of so interesting a countenance by such an object as the cocked hat; which is sufficiently recorded in other parts of the picture.[3] Lafayette is seen respectfully uncovered, turning on his horse, in mild but earnest attention to the Commander in Chief— Whilst Coll. Hamilton, having previously received orders, is galloping off to execute them. Generals Knox & Lincoln & Count Rochambeau are advancing from the distance. This assemblage of Persons is designed to commemorate the events of *October 1781*, before York Town, when the character of Washington as a General was fully & fortunately displayed, and the Youth & condition of Lafayette rendered his services the more memorable. It was supposed that for an Equestrian Portrait of Washington a scene of Greater interest could not have been chosen, nor did it require one of greater life & movement— It is an Historical event of great interest.

The Picture is but recently finished, according to the usual phrase; but has not yet received its last retouches & improvements, which are always the consequence of renewed study, careful examination & judicious criticism; besides the peculiar necessity that remains to adapt it to the character of the light & the situation where it is to be ultimately placed, after being removed from the Artists ⟨study⟩ Room which is generally too small for the final study of so large a composition. Amongst the corrections which are intended in this Picture, one is to render the countenance of Hamilton more youthful.

In offering this Picture to Congress, I am ready to grant that their adoption of it would be highly honourable to my reputation as an Artist, and that this consideration enables me to limit my expectations to a sum

much more moderate than would otherwise be reasonable; especially as the Picture is of a kind to make it popular & profitable by means of exhibition, notwithstanding the *positive disadvantage* that would be experienced should it now, *from any motive*, be rejected by Congress. Yet it should be considered how liberal ought to be the recompense which is to reward the Artist for Years of previous labour & costly study, which are necessary before he can execute a great work; as well as the influence which such a patronage must have in eliciting further efforts and improved talents in every native Artist aspiring to honourable distinction——For it is only by opportunity and encouragement they can demonstrate their ability to assist in adding splendour to our National Glory, or in confirming the influence of principles inseperable from the character & history of our Revolution.

Our public Edifices have been constructed by Native Architects & are beginning to do honour to their genius. It is true the costly Sculpture which decorates them is all from foreign hands—[4] but shall not their walls be animated by the pencils of Americans who, otherwise, must look to Europe for a home? If so much has been done under discouraging circumstances, how much greater talent & more useful demonstration of it may not be expected when excited by the highest emulation for national ⟨*emulation*⟩ patronage. The wealth of Individuals cannot yet afford much to the costly productions of the Arts, yet our public bodies, in the mere furniture of their Halls, have ample means to cherish all the talent in the Country, which could aspire to distinction abroad.[5]

Though I might not be permitted to speak in praise of my own performance as a Work of Art, I am justified by the approbation of distinguished judges, in offering this Portrait as *a true & characteristic likeness of Washington*— And would willingly rest my claim to public favour on the result of an investigation to discover if any recompence, *however great*, could procure a *more satisfactory likeness*. If it could, I would agree to forfeit my Picture—— If not, I should hope that it would admit of but little discussion, whether this National Picture, in becoming the property of the public, should not afford my family a liberal remuneration for my labour—— For myself alone, the honour of such a destination of my work would be a sufficient recompence. With great respect

I remain &c

Rembrandt Peale

Copy of ALS, 5pp.
DSIAr

1. From 1820 to 1827, Elijah Hunt Mills (1776–1829), lawyer and congressman, served as U.S. Senator from Massachusetts before retiring because of illness. Mills had previously served two terms in the House of Representatives as well as a term in the Massachusetts

House of Representatives. Initially a fervent Federalist, he became less partisan during the course of his career, but he left office and died before becoming committed to either of the parties during the Second American Party System. *DAB*.

2. An expert on constitutional law, Mills was chairman of the Committee on the Judiciary, to which the purchase of ReP's painting had been referred because of questions concerning the constitutionality of government patronage of the arts. Mills personally supported the purchase of the portrait, but he made the crucial constitutional point when he said: "If it were desirable for Congress to possess any work of this character, this was the one of all others most desirable." The ensuing debate turned on the question of whether Congress should directly support or commission artists. *Gales's and Seaton's Register of Debates in Congress*, 18th Congress, second sess., February 17, 18, 1825, p. 624.

3. The head was left uncovered to make it accessible to phrenological analysis, which judged character from the shape of the head. See Miller, *In Pursuit of Fame*, pp. 146–47.

4. The architects responsible for the Capitol up to this time were Benjamin Henry Latrobe (1764–1820) and Charles Bulfinch (1763–1844). The foreign artists who furnished sculptural decorations for the Capitol included Giuseppe Franzoni (d. 1815), Antonio Capellano (fl. 1815–27), Giovanni Andrei (1770–1824), Enrico Causici (fl. 1822–32), Nicholas Gevelot (fl. 1820–50), and E. Luigi Persico (1791–1860). See Miller, *Patrons and Patriotism*, pp. 41–42, 58–59.

5. ReP's plea for government patronage of native artists reflected the general concern of American artists throughout the first half of the nineteenth century that they, rather than foreign artists, be called upon to decorate government buildings, and it presages the 1858 memorial to Congress of the Washington Art Association, directed to that end. ReP served as the association's first president. See Miller, *Patrons and Patriotism*, pp. 79–84; Miller, *In Pursuit of Fame*, pp. 233–34.

EDITORIAL NOTE: *The Death of Raphaelle Peale, March 5, 1825*

On March 5, 1825, Raphaelle Peale succumbed to what his doctors diagnosed as "an infection of his lunges," or consumption. His last years had not been happy ones; many artists were without patronage following the Panic of 1819 and the ensuing depression, and Raphaelle, who had never enjoyed prosperity and whose still lifes sold for very little, was reduced, according to family tradition, to writing couplets for a baker to insert in his cakes.

Raphaelle's death was a severe blow to Charles Willson Peale. From the spring of 1805, when he suffered a long illness in Georgia as the result of a tropical disease, until the time of his death, Raphaelle had been a constant concern to his father. His artistic career, which had shown such promise in 1795 when he exhibited thirteen paintings in the Columbianum exhibition, had never attained the level his father expected. During his younger years, Raphaelle produced some charming miniatures, but this art form had to be abandoned when he began to suffer episodes of gout, during which, as his nephew Escol Sellers claimed, his hands "became so distorted that he could not hold or direct the brush." Although some of his portraits are finely conceived, they were not consistently successful (see figs. 55–57); Raphaelle, his father believed, succeeded in achieving "striking like-

55. *Patty Sellman (Mrs. Robert) Welch of Ben.* Attributed to Raphaelle Peale, ca. 1821–22. Oil on canvas, 26 × 22″ (66 × 56 cm). The Peale Museum, Baltimore City Life Museums.

56. *Robert Welch of Ben*. Attributed to Raphaelle Peale, ca. 1821–22. Oil on canvas, 26 × 22″ (66 × 56 cm). The Peale Museum, Baltimore City Life Museums.

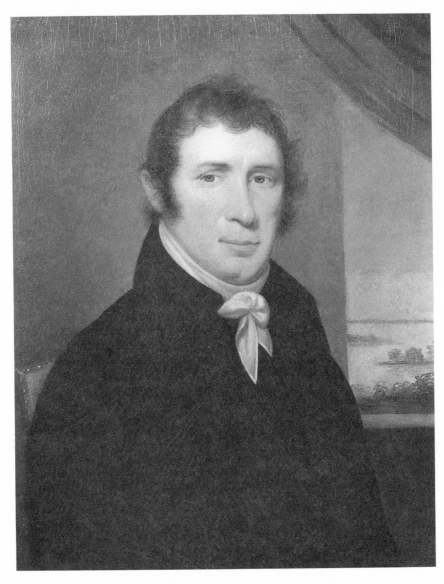

57. *Reverend Nicholas John Watkins*. Attributed to Raphaelle Peale, ca. 1821–22. Oil on canvas, 26 × 22″ (66 × 56 cm). The Peale Museum, Baltimore City Life Museums.

ness," but he did not give his portraits "that dignity and pleasing effects which is absolutely necessary to ensure a great demand for the labours of his Pensil." Painted in full illumination, Raphaelle's portraits lacked the shadowing that not only his father but the taste of the time demanded for "highly finished" portraits. In his still lifes Raphaelle's skills found more consistently successful expression (see plate 2), but in the early nineteenth century, still lifes did not command patronage or income sufficient to maintain the artist. For at least two decades, Peale was burdened with the support of Raphaelle and his family.

More difficult for Peale to accept than the absence of financial success was Raphaelle's "intemperance," the term used for alcoholism up to the mid-nineteenth century. Incapacitated frequently by pain from what his doctors diagnosed as gout, Raphaelle seems to have found relief in alcohol. Given his eighteenth-century belief in man's reason and capacity to control his own behavior, CWP could not understand Raphaelle's inability to follow what to him seemed obvious rules of health. His son's promises of abstinence were followed by bouts of drunkenness and illness. During Raphaelle's many trips away from home to seek patronage for profiles, miniatures, and portraits, rumors of wild living and unsavory companions reached his father, contributing to Peale's worries and frustration.

There are differences of opinion as to the cause of Raphaelle's death, early by Peale standards. A recent medical diagnosis has suggested that Raphaelle's gout was actually "saturnine gout," caused by the ingestion of lead that leached from lead-lined vessels used in wine-making in Portugal and other wine-producing countries. Others have suggested arsenic poisoning caused by Raphaelle's employment in taxidermy in his father's Philadelphia Museum; since, however, Raphaelle worked in the museum for only short periods of time—and not later than 1804—the possibility of arsenic poisoning is unlikely. Still others have attributed Raphaelle's physical debilitation to one or more tropical or other diseases suffered during his frequent travels and careless living. Unfortunately, Peale's letterbook covering the period of Raphaelle's last illness has been lost and with it any description of his symptoms that the correspondence of this period may have contained. Whatever the cause of Raphaelle's death, however, there is no question (as evidenced by the correspondence contained in the Peale archive) that Peale was an affectionate and caring father, bewildered by his son's inability to establish himself professionally or to control his appetites. Raphaelle had, Peale wrote, "great merit as an artist. . . . But what is of equal if not greater importance he [was] an honest good hearted man."*

*Peale Papers, 2:103–17, 960–63; 3:316, 358; Nicolai Cikovsky, Jr., Raphaelle Peale Still Lifes (Washington, D.C., 1988), p. 119; George Escol Sellers, Miscellaneous Reminiscences,

ms. letters to Horace Wells Sellers, PPAmP; *OED*; Phoebe Lloyd, "Philadelphia Story," *Art in America* 76 (October-November, 1988): 155–70, 195–98; Lillian B. Miller, "Father and Son: The Relationship of Charles Willson Peale and Raphaelle Peale," *The American Art Journal* 25, 1&2 (1993): 4–64; Phoebe Lloyd and Gordon Bendersky, "Arsenic, An Old Case: The Chronic Heavy Metal Poisoning of Raphaelle Peale (1774–1825)," *PBM: Perspectives in Biology and Medicine* 36 (1993): 654–665; Phoebe Lloyd and Gordon Bendersky, "Of Peale and Poison," *MD* 38, (February 1994): 27–29; Gerald Weissmann, "Peale's Gout: A Lead-Pipe Cinch," *ibid.* 38 (April 1994):9; Lillian B. Miller, "The Peale Controversy: Not Guilty," ibid., pp. 10, 12; Phoebe Lloyd and Gordon Bendersky, "The Peale Controversy: Guilty," ibid., pp. 10, 12.

232. ReP to the Marquis de Lafayette

NEW YORK. JULY 11, 1825

New York July 11. 1825

Dr Sir

Whilst I am waiting with the hope that You will favour me with a sitting before your departure from this City, permit me to invite your attention again to the subject of my Washington. The Youngest & most enthusiastic of the Artists to whom Washington sat, I have zealously exerted myself to transmit to posterity the character of his sublime Countenance— and I have the gratification to have received the extraordinary approbation of Judges Marshall, Washington, Peters, Tilghman & many other distinguished cotemporaries.[1]

There are but few names more that could be desired to this list. Need I say that yours would be of inestimable value? If I am not mistaken in the meaning of your expressions & if I have not been misinformed by others, you have spoken of my Portrait as one which exhibits more of the ⟨character⟩ countenance and character of Washington than any you have seen. If this be realy your opinion, the simple expression of it in a few lines will be highly esteemed by the nation, and will to me & my family insure an honourable reward for my labours.

I feel that I have a right, in the name of my Country, to ask for your judgment on this subject, so especially connected with your name & reputation. This may offer you a sufficient motive for compliance. But I trust your Benevolence will induce you not to defer to ⟨the⟩ future chances of omission an act that you can perform in a few minutes and which may probably establish the foundation of my fortune & render you the benefactor of my family. I say this under under the conviction that I am rightly informed of your opinion coinciding with that of Judge Marshall &c. for if otherwise I could not for the world desire you to suppress the expression of it.[2]

With great respect & Veneration
I remain
Your Obt Servt
Rembrandt Peale.
No.34 Chatham Row.

ALS, 2pp.
NIC: Lafayette College

1. For John Marshall's, Bushrod Washington's, and Richard Peters's endorsements of
ReP's *Patriae Pater*, see above, **179**, **183**, **198**.

2. Lafayette did not respond to ReP's request.

233. Richard Peters to CWP

BELMONT. AUGUST 24, 1825

Belmont 24.th
Augt. 1825.

My dear Sir

My daughter[1] has taken infinite pains to procure a scarlet breasted
Humming Bird[2] for G.W. Lafayette & Mr Lavasseure who have a strong
desire to take one to France. Hundreds frequent our Trumpet flowered
Virginia Creeper[3] every day; yet every effort to take one has failed. She
wishes to gratify those worthy Members of our friend Lafayette's family,
by sending a preserved dead bird, before their departure from our
shores; & the time of their stay among us will not admit of delay.[4] Can you,
on friday next, inform me where & how such an Article can be procured?
With your adroitness in the case of the palate blower,[5] a dozen might have
been taken in half the time our awkward people have been making abor-
tive efforts to gratify my daughter's wishes to catch these nimble & shy
epitomes of the feathered visitants of our garden; who elude every en-
deavour to capture them alive; & shooting them would defeat every pur-
pose she has in view.

very truly yours,
Richard Peters.

Mr. C. W. Peale.

ALS, 1p. & add.
PPAmP: Peale-Sellers Papers

1. Peters had six children; the daughter is unidentified. *DAB*.

2. The ruby-throated hummingbird (*Archilochus colabri*).

3. Virginia creeper (*Ampelopsis hederacea*) is a climbing vine.

4. Lafayette and his entourage left the United States on September 8, 1825.

5. A blowpipe shooting a small dart so that the hummingbird could be taken without
damaging it. *OED*.

234. CWP to Thomas Jefferson

PHILADELPHIA. SEPTEMBER 10, 1825

Philada. Sepr. 10th. 1825.

Dear Sir

It has for some time past that I have promised myself the pleasure of paying you a Visit[1] yet the situation of my family and the interests of the Museum has not allowed me that indulgence. My Son Titian has not only great skill in preserving all kinds of animals, but also he has acquired an abundance of knowledge in Natural history, I mean of animated nature. And my Son Franklin is possessed of great mechanical knowledge and is not only an able & expert artist; neat & excellent in every thing he undertakes to execute, but he also has a Phylosophical turn of mind.

Having proposed to these two Sons that they should take the whole management of the Museum, and thus releave me from all care respecting it, in order that I may pursue any imployment that fancy would lead too they paying me an Annual Sum, to be paid quarterly.

My view in this proposial is, that they having a greater interest in the improovement to obtain a greater visitation, will exert themselves to advance the usefulness of the Institution, more than they will on receiving a fixt salery. Thus the public will be benifited, the museum much inriched by their united exertions, and I may not loose much income, having a sufficiency to indulge myself in a rational mode of spending the time of the decay of Nature. As yet I am healthy & strong, and I shall endeavor to keep so, by exercise & temperance in all my appetites. I hope you injoy good health. although you cannot walk, yet it will give me pleasure to know that you exercise considerably on horseback. That the progress of diffusing knowledge to a rising generation, by your exertions in the ⟨Colledge⟩ establishment of a Colledge, will give you many pleasing reflections, and that you may live to see the *youth* of your country trained to knowledge and Virtue. I never liked the practice of sending our youth far from their homes to be educated.

Enclosed I send you an attempt I made to deliver lectures, I made a second, but having lent the lecture to some friend, I have lost it, which I regret much as it was more inlarged and opened my views on Natural [History] more fully.[2] I vainly thought I could engage the attention of the public to this pleasing branch of knowledge, my zeal was greater than my powers, so I stoped at my 2d. tryal.

Believe me to be with great esteem
 your friend CW Peale
Thomas Jefferson Esqr.
 Monticellor

ALS, 2pp., end.
MHi: The Coolidge Collection of Thomas Jefferson Manuscripts
Endorsed: Peale CW. Phila. Sep.10.25, recd. Sep.14.

1. See above, **193**.
2. CWP probably temporarily mislaid the second lecture, because manuscripts for both presentations are included in the Peale-Sellers Papers, PPAmP. See above, **129**.

235. Thomas Jefferson to CWP
MONTICELLO. SEPTEMBER 15, 1825

Monticello Sep.15.25

Dear Sir

I recieved yesterday, and with great pleasure, your favor of the 10th.[1] informing me of your good health, which I hope may long continue. for 7. years past mine has been sensibly declining, and latterly is quite broken down. I have now been confined to the house, and chiefly to my couch, for 4 months, by a derangement of the urinary system, which as yet exhibits no prospect of a definite termination.[2] I think your resignation to your sons of the care of your Museum, as your propose, entirely wise. it is now some years since I turned over to my grandson[3] all my worldly affairs. without this indeed I could not have carried on those of our University. for the last 7. years they have occupied the whole of my time; and so far the institution promises all the success I could have expected. we have as yet been only six months in operation, and have 110. Students; and at our next commencement the numbers will be beyond the extent of our ac-comodations. we have great reason to be pleased so far with their order and diligence, which I think will continue.[4] a visit from you, making Monticello your headquarters, would give me great pleasure, and the more should my health improve, so as to enable me to accompany you. your new arrangement with your sons will I hope give you leisure for it.

The excellent Polygraph you furnished me with 16. or 18. years ago[5] has continued to perform it's functions well till within a 12. month past. by the mere wearing of it's joints, as I suppose, it became at last so rickety that I was obliged to give it up; and believing nobody but yourself could put it to rights, I have held it up for a safe hand to whom I could trust it's transportation to you. such an one now occurs, by mr. Heiskell, a mer-chant, and neighbor of mine[6] who sets out for Philadelphia by the stage about the 20th. to procure his annual supply of merchandize. he will deliver it to you on his arrival in Philadelphia and if you could imme-diately take it in hand, it may be ready in time for his bringing it back. he will also pay you the expence of repairs, and of several little things, as spirel chains, inkpots &c. which you have been heretofore so kind as to

489

furnish me for my polygraphs. the beautiful little portable one which mr. Hawkins sent me is now in a similar rickety condition,[7] and I am sorry that, being at a distant place, where I have kept it for use, I cannot send it by this favorable opportunity. I shall have it brought here and forward it to you by some future conveyance. during the 12. months that the one now sent has been disabled, I have had double drudgery to perform in writing which has been very oppressive, and now, I hope will be relieved.

Accept the assurance of my affectionate attachment and respect

Th: Jefferson

ALS, 2pp.
TxU: Hanley Collection
Copy in MHi: The Coolidge Collection of Thomas Jefferson Manuscripts
Published in Horace Wells Sellers, "Letters of Thomas Jefferson to Charles Willson Peale," *PMHB* 28(1904):136–54, 295–319, 403–19

1. See above, **234**.
2. On May 11, 1825, Jefferson was diagnosed as suffering from dysuria, an infection of the urinary canal, brought on by an enlarged prostate gland. Malone, *Jefferson*, 6:447–48.
3. Thomas Jefferson Randolph (1792–1875), who had boarded with the Peales in Philadelphia in 1807–08, assumed responsibility for all of Jefferson's business affairs in 1816. *DAB*; *Peale Papers*, 2:1029.
4. Jefferson may have been trying to convince himself as much as CWP of the continued good behavior of the University of Virginia's undergraduates. The university had had a discipline problem from its beginning, and Jefferson's sanguine opinion of the students' behavior was almost immediately disproved when, beginning September 30, a series of rowdy incidents gave rise to a major disciplinary problem. Malone, *Jefferson*, 6:463–68.
5. Jefferson received his first polygraph from CWP in November 1804. Since it was a prototype, there were problems in making the instrument work efficiently, and it was not until December 1806 that Jefferson was completely satisfied with it. *Peale Papers*, 2:778–79, 992.
6. Unidentified.
7. For Hawkins's portable polygraph and Jefferson's concern with reducing the size of the copying implement, see *Peale Papers*, 2:887; Silvio Bedini, *Thomas Jefferson and His Copying Machines* (Charlottesville, Va., 1984), pp. 117–33.

236. ReP to CWP

NEW YORK. SEPTEMBER 20, 1825

To CWPeale.
On receiving a Present of a Gold Pen.

Parent and Friend! whose gift in early youth
was love of glorious Art and sacred truth—
Thy name, thy pencil have I strove to raise
Up to thy fondest hopes of honest praise—
Thy latest gift this Pen— oh may it prove
The Golden pen of truth and lasting love![1]

Rembrandt Peale.

New York Septr. 20. 1825

ALS, 1p.
PPAmP: Peale-Sellers Papers

1. This copy of the poem ReP wrote to his father is from ReP's "Poetry and Prose" notebook, PPAmP. ReP wrote poetry throughout his life. A collection of his early poems, written between 1796 and 1800, is in a private collection (copy in Peale Family Papers files, NPG). Later poems are included in his *Portfolio of an Artist* (Philadelphia and Boston, 1839), F:VIB/6–9. Also see Miller, *In Pursuit of Fame*, pp. 38, 218, 302 n.54.

237. CWP to Thomas Jefferson
PHILADELPHIA. SEPTEMBER 31, OCTOBER 5, 1825

Dear Sir

When I received your Polygraph, I repaired the springs, then made an essay to write with it, found it stiff—but on putting oil to all the joints, it preformed much better. so that my conclusion was that you neglected to give it oil occasionally. My next opperation was to take the parralells apart in order to examine all the joints— and it does not appear to have worn the pin-holes, indeed I cannot believe they could be sencibly worn in the use of it in a hundred years. ⟨[illeg]⟩ The pivots are steel and the holes are brass the thickness or rather thier length; ⟨of⟩ the width of the wood, consequently so great a surface of contact, that it cannot be the worse for wear, when the motion is so slow in writing.I observed the pieces of quill forming the pen, was long, therfore liable to be mooved from the proper position, also unsteady, therefore I think it preferable to use metal pens, which are made by an artist here who makes an abundance of them. I choose those made of Gold as more serviceable, and they only cost one dollar each. I had that on the left hand made with 3 slots, because then it might be broader and hold more Ink than that mooved by your hand. the advantages must be apparent to you. I have no charge against you & shall only take from Mr. Haskell two dollars for the gold pens. I would be very undeserving of your friendship if I did not feel a pleasure in doing any little service you may require of me. and I begg of you to indulge me in the gratification I have in being able to serve you.

I have wrote this letter with your Polygraph and find it performing as well as I believe can be done with one so compact in all its parts. I shall now pack it up again, and send it to Mr. Haskell.

<div align="right">ever with high respect your friend
CWPeale</div>

Thos. Jefferson Esqr.
Monticello Va.
Although those gold pens will wear a long time with out requiring dress-

ing, yet with great use they ⟨will⟩ must require mending—therefore I send you by Mr. Haskell a piece of wood of this shape: with the pen having its

point inserted in one of the slots. you may observe that the slits have an oblike & opposit direction to fit the different sides of the pen and a small fine file to dress it. doubtless you have among your tools files of all descriptions.

I am flattered with the hope that the substitution of the gold Penns will meet your abbrobation— I have only to add that will make the repairs necessary to your other Polygraf as soon as it come to hand.

<div align="right">CWP_____e
Octr. 5th. 1825.</div>

ALS, 2pp., end.
DLC: Thomas Jefferson Papers
Endorsed: Peale C.W. Phil. Sep. 31.25 recd. Oct. 18

238. RuP to CLP

NEW YORK. NOVEMBER 19, 1825

<div align="right">New York. Nov. 19th. 1825.</div>

Dr. Linnaeus.

Mr. James Bogart[1] has been so obleging as to see Mr. Eckfort,[2] and as I was much indisposed yesterday after his interview with him, Mr. B. wrote the enclosed note to me—[3] this morning Mr. B. called, and informed me in addition, that if there is no vacancy in the Phila. Frigate, that if you could bring credentials from Genl. Brown and any others of known character &c that after he sees you he may offer you a passage in his vessel free of expence—[4] but this he would not do unless he saw you. Mr. B. says you must have an interview with the Captain of the Phia. Frigate & bring

on his recommendation as Mr. E. will not make any appointments unless with his approbation. My love to all & beleave me your affectionate

brother

Rubens Peale

13. Murry Street—

ALS, 1p.
PPAmP: Peale-Sellers Papers

1. James Bogart (1768–ca.1830), whose portrait RaP had painted in 1792 (*Morristown National Historic Park, Morristown, N.J.*), was an old friend of the Peale family. CWP probably met him in 1791 when he visited the Philadelphia Museum with a party of New Yorkers that included Elizabeth DePeyster, who became CWP's second wife. See *CWP*, pp. 246, 248, 249; *Peale Papers*, 1:617n; CAP.

2. Henry Eckford (1775–1832) was one of the most innovative and prolific of the first generation of American shipbuilders. From 1817 to 1820, he supervised the construction of six ships of the line for the United States Navy at the Brooklyn Navy Yard. Thereafter, he returned to his own shipyard, where he specialized in constructing ships for South American navies. *DAB*.

3. Unlocated.

4. The U.S. navy frigate *Philadelphia* was built in 1799 at Southwark. Scharf, *Phila.*, 3:2340. General Jacob Jennings Brown (1775–1828) was the ranking officer and commander of the United States Army from 1821 to his death. For CLP's previous military service, under the command of General Brown, see *Peale Papers*, 3:302–03.

239. ReP to John Quincy Adams[1]

NEW YORK. NOVEMBER 26, 1825

New York November 26. 1825

Sir

Immured in the solitude of my Painting Room, I was ignorant of your arrival in this City[1] till you had left it, and thus lost the opportunity which I had anticipated of inviting your attention to my "Washington before York-Town," as it is now corrected & improved. When it was exhibited at the Capitol last Winter it was fresh from the first impress of my hand. In offering it to the Senate, I wrote to the Committee that it was then unfinished, wanting various corrections, as well as the rich & harmonizing effects of glazing & toning, which could not be done 'till Summer. I should not have presented the work in that state to public inspection, but that I was then preparing to go to Europe & did not think I should be here this winter to have the opportunity of offering my Picture to Congress—and that I believed the Head alone would have found sufficient favour for the whole work. The Picture is now so much improved that I cannot but feel sorry it should have been seen less finished, & particularly so that you did not see it on your return from Boston. Had it met with your approbation, with your known taste & judgement in the Arts, so that you could freely

493

have recommended it to the favourable notice of the Members of Congress, I should have been highly gratified— As it is I can only hope that the acknowledged Merit of the head, as a likeness of Washington; the care with which the work has been revised & corrected; and the interest which should be felt in the circumstance of its being the production of another native American, possessing some merit in itself & being, at least, a specimen amongst others of the actual state of the Arts in our Country—may procure for it a favourable reception.

The names of those Senators who voted for the purchase of the Picture are powerful, & to me flattering, recommendations for the adoption of the Measure— And will, if rightly considered, entitle it to the attention of the House. My ignorance of the business of Congress, and my pride & delicacy which forbid any attempt to procure the favour ⟨able⟩ of Individuals, if they leave me nothing to regret, were certainly a great cause of the delay which finally involved any little Question in the hurry & the overwhelming interest of the business which occupied the House during the latter part of its session last winter, and prevented the Bill from the Senate passing the other house.

Will it be asking too great a favour of you to let me know what would be the best course for me to pursue in prosecuting this affair, that my Picture may have the honour of a place in the Capitol? I cannot again incur the expence of removing it to Washington—nor would my pride feel satisfied (if I did) with the chance of its being rejected. I love my Art too much for the patronage it received in our Country & for myself alone would be satisfied with applause. But the duties which I owe to my family forbid my making my work a gift to my Country & yet I should consider the honour of its location in the Capitol as a large portion of my reward.

A few lines in reply will confer a lasting favour on me.[2]

> With great respect
> I remain
> Yours &c.
> Rembrandt Peale

ALS, 2pp.
MHiA

1. John Quincy Adams (1767–1848), sixth president of the United States (1825–29), had been elected to the presidency by the House of Representatives the previous February in the disputed election of 1824. His *Memoirs* do not mention a trip to New York City in the fall of 1825 or at any time during the year. Adams did visit Philadelphia on October 25, and toured the Philadelphia Museum, where he met CWP and TRP. He was back in Washington the following day. Whether ReP was in Philadelphia during this time, or he confused Adams's trip to Philadelphia with one to New York City, or he was simply using Adams's visit to the museum as an excuse to write to the president, is not known. Charles Francis Adams, ed., *Memoirs of John Quincy Adams*, 12 vols. (1874–77; repr. ed., Freeport, N.Y., 1969), 7:50–51; *DAB*.

2. Adams's longstanding interest in the arts was well known, even in his own time. Having traveled throughout western Europe and Russia as a youth and consorted with Jefferson in Paris, and with European diplomats at the Hague, in Berlin, and in "the capitals of the great European nations," he had, as he wrote in 1809, "acquired . . . a taste for the fine arts . . . which has contributed so much to the enjoyment of my life." Although Adams does not seem to have replied to Rembrandt's letter, in his State of the Union address to Congress the following December, he emphasized the desirability of federal encouragement of education, the sciences, literature, and "the advancement of the Mechanic and . . . Elegant Arts." Later, in 1834, when Adams was serving as a congressman from Massachusetts, he gave Rembrandt at least twelve sittings for a portrait that Rembrandt never completed. See L. H. Butterfield, "Foreword: With Remarks on John Quincy Adams and the Fine Arts," in Andrew Oliver, *Portraits of John Quincy Adams and His Wife* (Cambridge, Mass., 1970), pp. vii-xvi, quote on pp. xi-xii; Miller, *In Pursuit of Fame*, pp. 220–21.

240. Thomas Jefferson to ReP

MONTICELLO. NOVEMBER 29, 1825

<div align="right">Monticello Nov. 29.25</div>

Dear Sir

We want at the University of Virginia a teacher of <u>landscape</u> painting of high qualifications in that line. he would be no otherwise connected with the institution but as a voluntary adjunct without salary lodging or any thing else. his only emolument would be what he should receive from the Students who would engage with him. our present term is near it's close, and the next begins on the 1st of Feb. at that time we expect to have 250. to 300. students. a great part of them will enter if his fees are reasonable. a mr Cornelius Debreet of Baltimore[1] a Hollander by birth is recommended to me as being a <u>landscape</u> painter of the first order, and I am referred to yourself among others as knowing his qualifications. I have chosen to ask information of you rather than others because they might be influenced by favoritism; but on you I can depend for a candid judgment, and that you will consider it more important to render a service to an University than to a single individual. be so good then, dear Sir, as to give me your real opinion of mr DeBreet's fitness for our school and to do it with your earliest convenience. he is uninformed of this recommendation by his friend. I salute you with great friendship and respect.

<div align="right">Th:Jefferson</div>

Mr. Rembrandt Peale.

ALS, 1p.
ViU: Papers of Thomas Jefferson, Manuscripts Division, Special Collections Department

1. Cornelius de Beet (ca. 1772-ca. 1840), a German-born painter working in Baltimore from 1812 to 1832, specialized in still lifes, but painted also in other genres, as demonstrated by his exhibition record at the PAFA's exhibitions of 1812, 1814, and 1832, in which he showed five paintings including two Maryland landscapes. He apparently was not hired by

<div align="right">495</div>

the University of Virginia. E. Bénézit, *Dictionnaire critique et documentaire des peintres, sculpteurs, dessinateurs et graveurs*, 10 vols. (Paris, 1976), 1:575; Groce and Wallace, *Dictionary of Artists*, p. 42; Rutledge, *Annual Exhibition Record*, p. 23.

241. Thomas Jefferson to CWP
MONTICELLO. DECEMBER 1, 1825

Monticello Dec. 1. 25

Dear Sir

Mr. Heiskill delivered my Polygraph safe and in good condition, and when I consider how much time and labor it has saved me since his return I look back with regret to that which I have lost by the want of it a year or two. the gold pens write charmingly as free pens, and I use them for my common writing in preference to the quill. but when applied to the polygraph, I find that they make the shank of the copying pen so long as to warble and be unsteady. I return therefore to the old penpoint as best, but why not make these of gold also, and save the everlasting trouble of mending the pens? as I see no reason to doubt the preference of the golden point, I have cut 2. of quill which exactly suit and fit between the two leaves of the nib of my pen-tube. I shall be very glad if your artist will make me a pair of gold points of the same length, breadth, thickness and form, very exactly. The pentube itself having it's screw so worn as no longer to command motion in the pen, I am obliged to send it to you, for we have nobody here who can do any thing of the kind. whether the old thread can be cut deeper or a new screw must be made you will be best judge. I have stuck one of my model points into the nib of this, & the other is detached. in making a remittance to mr Vaughan[1] of a fractional sum, there will be a fractional balance of 3. or 4. D. over which I pray him to pay over to you to cover these little jobs, and the sooner you can send me the tube & points by mail, the sooner I can resume the use of my polygraph

On the 15th. inst. I shall have an opportunity by a student of our University returning to Philadelphia for the Vacation, to send you my other polygraph, which needs a little rectification only.[2] God bless you and long preserve a life past in doing so many kindnesses to your friends. my health is improving, and I am now able to get on my horse again.

ThJefferson

Mr. Peale.

ALS, 1p. & end.
TxU: Hanley Collection
Endorsed: Peale Chas W. Dec 1.25.
Copy in MHi: The Coolidge Collection of Thomas Jefferson Manuscripts

1. John Vaughan (1765–1841), Philadelphia merchant and secretary of the APS, was Jefferson's friend and correspondent. Vaughan was familiar with polygraph technology, having received a machine on trial in 1805. It is not known what transactions Jefferson was paying Vaughan for. Bedini, *Thomas Jefferson and His Copying Machines*, pp. 129, 180; *Peale Papers*, 2:39n.

2. Jefferson sent the polygraph with a Mr. Millar of Germantown, a student at the University of Virginia. Thomas Jefferson to CWP, December 28, 1825, TxU: Hanley Coll., F:IIA/71E14-F1.

242. RuP to BFP

NEW YORK. DECEMBER 2, 1825

New York. Decr. 2d. 1825-

Dr. Brother.

I have just written to my Father[1] wishing him to request you to have an orery[2] made for me and I will pay all expences with

great pleasure, it can be made under your inspection with much ⟨for⟩ more facility than it could under mine, especially as you have yourse inspection &c— Mr. Haines[3] is just going I therefore cannot say much, you must refer to my Fathers letter for further particulars I have sent a few catalogues[4] which I give to all the visitors. I have just completed my Air Pump Experiments—Made the Hydrogen and Oxygen gasometers, and now go on to get them in good order &c- &c then with the Electrical &c[5]

I remain your affectionate
brother
Rubens Peale

ALS, 1p.
PPAmP: Peale-Sellers Papers

1. Unlocated.

2. Named after Charles Boyle, Earl of Orrery (1676–1731), the orrery represented the motion of the planets in the solar system through a clockwork mechanism; the mechanism was actually invented around 1700 by George Graham (1673–1751). BFP had made an orrery for the Philadelphia Museum, and its success undoubtedly prompted RuP to seek one for his New York institution. In "A List of Articles Constituting Peale's New York Museum," December 11, 1826 (F:XIC/F10) there is no mention of the orrery, but it may have been subsumed in the general category of "Philosophical Apparatuses." See below, **246**; *OED*; *DNB*.

3. Reuben Haines (1785–1831), a longtime friend of RuP's and the first secretary of the Academy of Natural Sciences in Philadelphia. See *Peale Papers*, 3:554.

4. *Peale's New-York Museum and Gallery of the Fine Arts: in the Parthenon* is a brochure that describes the museum's three rooms (for natural history, art, and lectures) and lists the museum's 253 paintings. PPL: Vaux collection.

5. The exact experiments performed by RuP with the air pump, a machine for pumping air out of a receptacle to make a vacuum, are not known. Experiments using the oxyhydrogen blowpipe were a staple at the Peales' various museums; the gasometers were the

497

containers in which the gases were stored before being combined and burned. Joseph Henry (1797–1878), who was later to become a prominent physicist and first secretary and director of the Smithsonian Institution, described RuP's experiments in a diary that he kept on a trip to New York City in 1826, soon after being appointed professor of mathematics at the Albany Academy. Noting RuP's use of heat to burn metals and minerals, he wrote that the "experiments were very neatly performed." Joseph Henry, Diary entry, June 22, 1826, DSIA: Joseph Henry Papers, F:XIC/A14-B2; *OED*; *Peale Papers*, 2:1142–43; *DAB*.

243. ReP to Thomas Jefferson
NEW YORK. DECEMBER 7, 1825

New York Decr. 7. 1825.

Dear Sir

For the purpose of promptly answering your Letter of the 29th. Ult.[1] I sit down immediately to give you my opinion of the merits of Mr. Debreet. For a long while he was engaged in Baltimore ornamenting Windsor chairs for Messrs. Finley, where I became acquainted with him—[2] And it is only of late that he has attempted to make Pictures of Landscapes. I cannot but think his practice on the chairs has been injurious to his taste—

Yet I have seen some small Landscapes by him that were very pretty. I should fear, however, that he might not equal the character you desire.

I am acquainted with a Landscape Painter in Philadelphia, Mr. Doughty,[3] a young man, who has been rapidly rising to great excellence & who, I think, would be much more eligible for the situation if it would be one that he might fancy. Should you desire ⟨to know⟩ it I will write to him on the subject. He draws better than Debreet & his colouring is more natural—besides he is a milder & more amiable man.

I am likewise acquainted with another Artist here in New York, a Mr. Wall,[4] an Irishman, who paints in Water Colours only, in an excellent taste—but he does not draw so well as would be desireable for a Teacher

You say that a great portion of the Students would attend this Class if the charge should be reasonable. What would you say if I should offer myself as a Candidate for the tranquil enjoyments of your College? You k[n]ow of old the vexations of Portrait Painting— Time has not diminished my sensibility to them—Nor can it remove the precarious nature of the ⟨employment⟩ encouragement. So that I have frequently thought of forming a School of Painting— I noted it was the subject of my Meditations when I received you[r] Letter. I cannot but consider myself competent to teach every branch of the Art, because not only have I practiced them all, but I have had Pupils to whom I have taught them—And in particular have instructed my oldest Daughter[5] in Landscape painting. The Landscapes I have painted since my Large One of Harpers Ferry[6]

(which is in the Baltimore Museum) have gained me some Credit, & confirmed my early fondness for this branch of the Art—

If my talents are such as would be desireable to you in your splendid Institution in preference to others whose merits I may frankly, honestly & warmly commend, and you could get about 100 of the ⟨Pupil⟩ Students to give me 10 dollars a Quarter, I should be delighted to become a Neighbour of yours & a resident in your Picturesque Country I might fill up some of my leisure hours in my Historic studies. I say this, however, without knowing the Cost of living at Charlotteville—but having a Wife & family, it would be necessary I should make them comfortable.

I have had serious thoughts of going to Europe next Spring— For if I must tread the paths of emulation, London is a prouder field for me— But my wife is not disposed to leave America, where two of our Daughters are married—Nor does my father wish it.

I shall be pleased to receive your Answer & shall hasten to serve you in any way you may desire. With great respect

Your obliged Friend

Rembrandt Peale

ALS, 2pp., end.
MHi: The Coolidge Collection of Thomas Jefferson Manuscripts
Endorsed: Peale. Rembrandt N.Y. Dec.7.25 rec'd dec 13.

1. See above, **240.**

2. Hugh Finley was the owner of a "fancy furniture warehouse" at 32 North Gay Street, Baltimore (*Baltimore Directory* [*1824*]). Windsor chairs, first made in seventeenth-century England, were a staple in Anglo-American chairmaking. They consist of a solid wood seat with a bowed and spindled back and dowled legs. John Fleming and Hugh Honour, *The Penguin Dictionary of Decorative Arts* (London, 1989), p. 173.

3. Thomas Doughty.

4. William Guy Wall (1792–d. after 1864) immigrated in 1818 from Ireland to New York City, where he established himself as a landscapist in watercolors; many of his paintings of New York scenes were subsequently engraved and published. Groce and Wallace, *Dictionary of Artists*, p. 657.

5. Rosalba Carriera Peale. Little is known about Rosalba's training or work as an artist. She exhibited an *Italian Sunset after Keysterman* at the 1840 PAFA exhibition. *CWP*, p. 441; Rutledge, *Annual Exhibition Record*, p. 169.

6. ReP, *Harper's Ferry* (1811: *private collection*); ReP also painted a small watercolor of the scene (1811: *The Municipal Museums of Baltimore, The Peale Museum*). *Peale Papers*, 3:108.

7 "Journeying through a Long Life." Charles Willson Peale's Autobiography: December 9, 1825–April 20, 1826

Charles Willson Peale began to write his autobiography in December 1825. Once before, in 1790, he had made an attempt at autobiography in order to justify his life to Mary (Molly) Tilghman and her aristocratic Eastern Shore family. With the failure of his courtship and his subsequent marriage to Elizabeth DePeyster, Peale put the autobiography aside, but the seed of writing an overview of his life may have been planted during this early effort.

In 1826, Peale probably believed that despite his anticipation of living more than one hundred years, he was nearing the end of his active life. The death of his son Raphaelle in March 1825 surely deepened the sense of mortality that he had begun to experience even earlier, in 1822, after his severe bout with yellow fever and Hannah's death during that epidemic. With his move from Belfield to Philadelphia, he had begun organizing his affairs and divesting himself of property, sending portraits to former sitters or their relatives, clearing his debts, settling the status of the museum, and attempting to ensure that his sons would have employment. The sense of summing up, rounding off, and celebrating his life is captured graphically in the series of self-portraits he painted, marking the end of his artistic career. Given this mood of valedictory and his earlier predisposition to write an autobiography, it was logical that he should resume the task at this time.

Peale may also have been stimulated to write his memoirs as a result of the increased interest being shown in the American Revolution on the eve of its fiftieth anniversary. The thinning number of living veterans of this great national effort at self-determination made it imperative to capture and communicate the essence of that struggle—its heroic exploits and interesting anecdotes—for future Americans. As Peale began to be more frequently consulted and questioned about the war and his participation in it, short as that was, he became more and more committed to recounting his experiences in the form of memoirs.

During the course of composing his autobiography, Peale changed his ideas about it. He had begun this extensive survey of his life for the benefit

of his children and their posterity, intending it as a supplement to the archive of letters and diaries that he had so carefully maintained throughout his long lifetime. As he proceeded with his writing, his conception, not unexpectedly, expanded. Self-deprecating at first, he began to refer to his work as a "novel," using that term in the picaresque sense that was beginning to be applied to the lengthy fictions of British writers Samuel Richardson and Henry Fielding, and Charles Brockden Brown in the United States. From a didactic treatise intended to guide his family, the autobiography grew into a romantic adventure from which Peale hoped readers would derive entertainment as well as instruction. Peale also began to consider the possibility of publishing his manuscript so that he might profit materially from his efforts.

Peale never completed or published his autobiography. Nevertheless, his was an extraordinary effort. Few of his contemporaries left autobiographies; Benjamin Franklin, John Adams, and Thomas Jefferson were his only counterparts. Franklin's memoirs, which his grandson William Temple Franklin published in 1817–18, may have been in Peale's mind when he began to write his own; Adams's autobiographical fragments were not brought into public knowledge until 1850–56, when his grandson, Charles Francis Adams, edited and published them; Jefferson's draft of an autobiography, begun in 1821, was left unfinished and unpublished until the publication of his papers in the twentieth century. Peale's autobiography (*Selected Papers*, vol. 5, F:IIC/cards 2–13) is a lively record of the life and times of a curious and energetic participant in the stirring events that created and formed a nation in the eighteenth and early nineteenth centuries.*

*Below, **262**; *Peale Papers*, 1:597n; William Temple Franklin, ed., *Memoirs of the Life and Writings of Benjamin Franklin* (London, 1817–18), 3 vols.; second ed., 1818–19, 6 vols.; Charles Francis Adams, ed., *The Works of John Adams, Second President of the United States, with a Life of the Author*, 10 vols. (Boston, 1850–56); Malone, *Jefferson*, 6:341–42; Adrienne Koch and William Peden, eds., *The Life and Selected Writings of Thomas Jefferson* (New York, 1944), pp. 2–3, 4–114; Betty Bergland, "Autobiography and American Culture," *American Quarterly* 45 (1993):445–58; Paul John Eakin, ed., *American Autobiography: Retrospect and Prospect* (Madison, Wis., 1991); Herbert Leibowitz, *Fabricating Lives: Explanations in American Autobiography* (New York, 1989), p. 66.

244. CWP to Thomas Jefferson

PHILADELPHIA. DECEMBER 9, 1825

Philadelphia Decr 9th. 1825.

Dear Sir

I have made all the haste I could to get your pens for your Polygraph, for I well know the uses of that machine, as it has long been my practice to

keep copies of letters, because I have desired to leave to my family as full a knowledge of my transactions as possible, consistant with my other labours— but that you may know why I have been more solicitous on this score, *know* that after the death of my first wife,[1] I paid my addresses to a lady on the eastern shore of Maryland, of a highly respected family, that had been friends to my father, she was 36 years old, of course, reflected what would be the oppinion of the world, if she married a man on [such a slender] acquaintance, my situation did not allow me to make a long courtship, and I told her that I would make her better acquainted with me by a sketch of my life than possibly she could obtain by any long acquaintance, & accordingly I commenced it, and proceeded in the work to the death of my first wife.[2] I told her that I could not give her any other than a true and faithfull relation, as my happiness would depend on it. some of my friends have desired to get it, with the intention of a Publication, but I have always refused saying that it must not be given to the public before my death, and I have preserved journals whe[n] ever I traveled from home, as materials to work from at a future day. But in the last summer I have been called on to know sundry transactions [of] the revolutionary War—this led me to look at [my] journals and also to my Biography, and it has appeared to me, that I shall do justice to myseld[f] by a publication of that part of my life when [I] became a politicion in the early part of the revolution how unintentionally I was led to take a conspicuous part in the transactions of those trouble some times. therefore to endeavor to make such [a] work as may be useful to others I now devote all my time to this one object. and to make it more acceptable I shall make such remarks as I may concive will be in some degree entertaining to many readers— The artists of painting have desired me to give an account of the first painters who have painted in America, this will please the present painters, who have become so numerous that I cannot count them. & I must take care that I may not offend living artists. hence I shall say very little about those living.

I am very glad to hear that your health is restored— the affair of the artist who made the attempt to get a cast, was like to be a very serious peice of business, as it has been published.[3] I have taken many masks from living persons without much trouble to them.[4] I hope you will long enjoy good health, and all the happiness of this world.

<div style="text-align: right">Most affectionably yours
CWPeale</div>

Thos Jefferson Esqr. Monticella

ALS, 2pp., end.
DLC: Thomas Jefferson Papers
Endorsed: Peale C.W. Phila. Dec.9.25 recd. Dec.14

1. Rachel Brewer Peale died April 12, 1790. See *Peale Papers*, 1:583–84.

2. CWP's autobiographical fragment (P-S, F:IIC/1) was written in 1790 during his unsuccessful courtship of Mary (Molly) Tilghman (b. 1753). *Peale Papers*, 1:597–603.

3. In early October, John H. I. Browere (1790–1834) had taken a life mask of Jefferson. Despite Jefferson's relatives' disparagement of him as a "vile plasterer," Browere was a well-known sculptor who assembled an important portrait collection by taking the life masks of famous Americans. He devised a new, improved method of taking casts, but in doing Jefferson's, Browere mistakenly left the plaster cast on his head for an hour instead of the anticipated twenty minutes. The cast hardened so that it literally had to be chiseled off his head, causing Jefferson, who was not in good health, pain and discomfort. This episode became public because of the outrage of Jefferson's household at the way in which he had been mistreated, and an account of the procedure appeared in the *Richmond Enquirer*, November 15, December 13, 1825. Despite this unpleasantness, Jefferson thought the mask and the bust made from it a good likeness (*New York State Historical Association, Cooperstown, N.Y.*). He generously gave Browere a testimonial, which the artist, to repair the damage to his reputation, published. Malone, *Jefferson*, 6:469–70; Groce and Wallace, *Dictionary of Artists*, p. 84; *DAB*.

4. CWP's attempts at sculpture were limited to a few experimental busts he sculpted in London (see *The Peale Family* [ca. 1770–73, 1808: *New-York Historical Society*]) and one of George Washington (see *Robert Goldsborough Family* [1789: *private collection*]). He also fashioned figures in papier-mâché and other temporary materials for triumphal arches and celebrations and for his garden at Belfield (above, **139**). He may have taken life masks on request, but despite his statement here, there is no record of any CWP life masks. *P&M Suppl.*, pp. 9–10.

245. Thomas Jefferson to ReP

MONTICELLO. DECEMBER 16, 1825

Monticello Dec. 16. 25

Dear Sir

I am very thankful to you for your letter of the 7th. for the candid account you are so kind as to give me of mr De Breet, and my rescue from the unworthy Bool,[1] who, unknown himself, was willing to make me a tool to injure a public institution for the sake of an individual friend.

Your offer would indeed be a splendid one for us. the association of your name with our infant, and as yet untried establishment would lift it into view. but in being instrumental to it, I should make myself a Bool also, altho' in the opposite direction, that of perhaps ruining an individual friend for the sake of an untried institution. that it will be something in time I fondly hope. but as yet it is not a position in which I would risk a friend, the son of a most antient and kind friend, and the husband and father of a worthy family. it is yet but in the gristle and too much of a contingency itself for you to risk swimming or sinking with it. I have consulted both Professors[2] and Students who have the best means of judging, to find what would be the prospect for a teacher in drawing, even of your grade. they think that, in the course of a year, 50 scholars might perhaps be engaged, but not at first, nor early in the year, and that these

would not go beyond 30. or 25.D. a year, such being the ordinary tuition fee to our highest Professors. living, that is, articles of ordinary food, are very cheap here but house rent extravagant, as may be expected at a new place, where buildings for newcomers are still to be erected. You see then, dear Sir, that this would not be one fourth of what you call for, and ought to call for, and even that uncertain. I can readily suppose your present occupations may be subject to occasional ebbs and flows in the actual receipt of emolument; but sure in the run, rising as they go, and resting finally on the certain basis of future fame. for our institution therefore I will pre-[fer] taking our chance to find some one who will do for us, and cannot do better for themselves.[3] this will throw on fortune whatever failures may occur and clear us from any disquieting anticipation in it. [A]cting therefore with the candor and sincerity which I would wish towards myself from a friend, this idea shall be sacredly locked up in your breast & mine and I only regret that it does not furnish me an occasion of being useful to you by a positive, rather than a negative act of friendship. I hope you will be not the less assured of my great esteem and respect

ThJefferson

ALS, 2pp.
DLC: Thomas Jefferson Papers

1. Bool, who seems to have been the person who recommended De Breet to Jefferson, may have been Henry W. Bool, a book auctioneer and commission merchant in Baltimore at the time. Otherwise, he is unidentified. *Baltimore Directory (1827)*.

2. There were only five professors on the faculty when the university opened on March 7, 1825. Richard Guy Wilson, *Thomas Jefferson's Academical Village: The Creation of an Architectural Masterpiece* (Charlottesville, 1993), p. 44.

3. Early in 1826 Jefferson offered the position of drawing and painting instructor at the University of Virginia to William G. Wall, but Wall turned the position down because it was not a professorship. Above, **243**; William Dunlap, *A History of the Rise and Progress of the Arts of Design in the United States*, 3 vols. (1834; repr. ed., New York, 1969), 2:321–22.

246. RuP to BFP (?)

NEW YORK. DECEMBER 25, 1825

New York Decr. 25.1825–

My Dear Brother

The Compliments of the Season to you; May you enjoy many happy Christmasses, although this has commenced with a drisselly rain, yet I am in the museum finishing the decorations for tomorrow, we have used a cart load of greens, and a market Basket, of artificial flowers for decorating the inside as well as the outside of the museum, and I can assure you that it has a very handsome appearance, this business has occupied Eliza,

myself, Mr. Atkinson (My preserver) and Mr. Chadwick (my Door-keeper)[1] ever since the receip your letter, it was my full intention to write and send you the money but the post hour slipped away always before I was aware of it, and now I find that I have no Phila. money—so that I have sent you rather more than you mentioned, enclosed are 23 $. I shall be very happy to see you with the Orrery as soon as you can be spared from the museum, and with pleasure pay your expences &c.

If it will be convenient for you to come as you expressed in your letter, I should like to know a day or two before you start, so that you may be accommodated &c. Tell Titian that I have received an Order on him, to deliver ⟨some⟩ a box of Insects from Moscow, directed to Mr. C.W.P. at the Phila. Museum for me, from the Revd. Mr. A. O. Stansbury,[2] who now resides in Connecticut—perhaps it had better be sent under the charge of the Capn. of the Sea Packets? And it will give me pleasure to furnish duplicats. When you come I will give you some superb new minerals (as Mr. Wood[3] says, they will make your mouth water)

Give ⟨my l⟩ our love to all, and I remain you

<div align="right">

affectionate brother
Rubens Peale
</div>

Linnaeus spends almost every evening with us— he has command of the Frigate, until a Captain is appointed, and is now the 3d. Lieutt. with a fair prospect of rising,[4] this must now depend entirely on him self, we have done all we can for him—he now stands a good chance of being the first officer, but must shew himself capable of it. Mr. Eckford, & the builder, & the former Capt. all say they will do every thing to promote him, if they continue to be pleased with him as they are now.[5] His having charge of the Vessel, shews that they are much pleased with him. Last week I received 158..25. cents, it is now two months since I opened the museum and have received 2052..37.cents—so that you may tell those who thinks I am crazy to have undertaken such a thing, that I am aware of it—that I wish them all well, that they may not be more crazy than I am, is the wish of their friend— Rubens Peale

ALS, 3pp. & add.
PPAmP: Peale-Sellers Papers

1. Both museum workers are unidentified beyond RuP's statement. *New York City Directory* (*1824–25, 1826–27*).

2. Abraham O. Stansbury, son of Joseph Stansbury, CWP's old acquaintance from pre-Revolutionary Philadelphia, served as chief administrative officer of the Hartford Asylum for the Deaf from 1817 to 1818 before becoming superintendent of the New York Institution of the Deaf and Dumb. He retired from that position in 1821 and moved back to Hartford. Later this year, CWP would begin to court Abraham's sister Mary (see below, **302**). There is no record in Peale's museum records and accessions of this donation arriving at the museum, and it is also not known how Stansbury obtained these Russian specimens and why he sent them to RuP in care of CWP. *Peale Papers*, 3:518–19.

3. William Wood.

4. CLP was the ranking officer on the *La Plata*, a ship of the Colombian navy being fitted out in New York, and was commanding the ship while it was in port, a customary duty for the third officer on either a warship or a merchantman. When he enlisted, he was fourth officer. In a letter dated February 23, 1826, CWP wrote that CLP was now the second officer (see below, **252**).

5. Eckford's business relations with South American navies would have doubtless helped CLP to secure a higher position on a Colombian vessel. The former captain of the vessel is unidentified.

247. CWP to CLP

PHILADELPHIA. JANUARY 8, 1826

Philada. Jany 8. 1826.

Dear Linnius

I have wrote so fully to Rembrandt and Eliza that I have not any thing material to make up a letter to you.[1] however take the will for the deed.

I suppose that you have a great deal of leisure on your hands, therefore you may give me long letters.[2] Franklin[3] will tell you that I am very deligent in writing my narative, but he does not know my difficulties; for in some of my journals I have wrote the Month & day, but very frequently omitted to put the year. Therefore I must have recourse to books & newspapers for information.

formerly I thought that my journals & letters would be sufficient for some person after my decease to compile a good history of my life, but now I find it not a little difficult to continue a regular connection, and it is impossible for me to be so particular as I would wish to narrate all the little circumstances of my situation at different periods of my life. however it will certainly contain some good precepts for others to avoid the dangers I had fallen into. it shall be my study to make the work if not very entertaining, at least usefull as a *beacon* to put others on their guard not to get into such difficulties as I have experienced on several occasions. this may serprise you, but when I say that I am giving a faithful history of my life, I ought not to hide any of my follies—perhaps some things that I have narrated may offend some families, which I certainly do wish to avoid— and therefore before it shall come before the public I may rub out [names] and only put Initials; and perhaps it might be allowed to give a ficticious name. this will require a good deal of consideration.

however independant I may be with reguard to public opinion on my own account, yet I wish to have a conscience void of offence to others.

It dont appear very probable that Christiana can get boarders to enable her to pay rent, and I am realy uneasy on that score, for the pay day will

soon come around.[4] When you have certainty of your rank & pay, no doubt you can help her— yours most affectionately

CWPeale

Linnius Peale
New York.

ALS, 2pp. & add.
PPAmP: Peale-Sellers Papers—Letterbook 20*

*Ed. note: Letterbook 19, covering CWP's correspondence in 1825, is missing from the archive at the American Philosophical Society and is presumably lost. In his "Index to Letter Books of Charles Willson Peale, 1767–1827" (PPAmP), Horace Wells Sellers indicated that 1806 and 1825 were missing. Since the index was compiled, the 1806 letterbook has joined the collection.

1. Both letters are unlocated.
2. CLP did not sail for South America until the spring. *CWP*, p. 422.
3. BFP was bringing the orrery to RuP in New York in response to RuP's request (see above, **246**). CWP addressed this letter to CLP "per Franklin."
4. In 1828, CLP's residence was at 137 South Tenth Street. Presumably his family was living at this address in 1826, but there is no Philadelphia directory extant for that year. *Philadelphia Directory (1828)*.

248. CWP to Thomas Jefferson
PHILADELPHIA. FEBRUARY 1, 1826

February 1st. 1826.
Dear Sir

Finding that the gallows would not shut down on the Ink holders I therefore cut some of it away, and a jointed piece which I suppose you had made to rest the pens on, was liable to fall and cause a derangement of machinery, to prevent such an accident I have put a piece of spring to keep it up untill wanted— a very little work put the parralels in order, and the supporting springs shortened, or rather others put in their place, has I hope made the Polygraph as ⟨serviceable⟩ corrict as such small machines can be made. almost my whole time has been imployed in writing of late and I find that Gold pens require to be dressed occasionally, and some practice to do it properly. The burnisher and a strap with rotten stone or floor of Emery, to take off all roughness. I have sold my farm for 2 or 3 thousand dollars less then some [time] ago I asked for it.[1] But finding

since I left it that it was depreciating, and I was losing at least 400 $ pr. year, without a prospect of much increase in the value of land, and having purchashed a house in the City to live in, with room to keep my duplicates and articles that I cannot find room for in the Museum, the surplus of money from the farm will go nearly to pay all my debts—which I cannot find myself perfectly happy untill that is accomplished—and it is an important part of my plan to obtain health and long life, to have no care on my mind, and to content myself without some things being done—which ⟨some⟩ many persons may think necessary, yet can very well be dispenced with, if well weighed.

When I look back and see what emmince espences I have paid, and how much time I have spent about triffles, I am astonished. Wisdom comes late, what is past, if done with a good intention is some consolation—

If my young sons will do all that is necessary to support the Museums improvements and take the charge off my shoulders, then I may indulge myself with a visit to see you[r] important labours to promote education which be assured will be a great pleasure to

<div align="right">your friend
CWPeale</div>

Thos. Jefferson Esqr.
 Monticella

ALS, 2pp.
MHi: The Coolidge Collection of Thomas Jefferson Manuscripts

1. The farm was sold to CWP's neighbor William Logan Fisher for $11,000; in 1810 CWP had purchased Belfield for $9,500. Deed, CWP to William Logan Fisher, January 27, 1826, PPDR—Deed Book GWR II, pp. 588–89, F:IIA/71F7–14; *Peale Papers*, 2:1246.

249. CWP to William Patterson and EPP
PHILADELPHIA. FEBRUARY 8, 1826

<div align="right">Philadelphia Feby. 8th. 1826.</div>

Dear William & Elizth.

It is long since we have heard from you and I felt much anxiety about your situation, your letter to Sybilla was very welcome,[1] by it we find that Wm. had got over the hurt of his fall from the waggon—and that although you have difficulties yet you can yet have some comforts in your stove-room. I must now give you as much news as this letter will hold about the family. You no doubt heard of the death of Raphaelle[2] he dyed in March now almost a year since— he had an infection of his lunges, and was nothing but skin & bone before he departed. I was with him

frequently in his last ilness—a short time before he died, he told me that he loved & respected me, therefore he wished me to know that he was perfectly content to die, that he had never injured any Man, and he felt himself easey as to worldly affairs. His family go on without giving me any trouble, the Sons help to maintain the family and I have sometimes heard very satisfactory accounts of their good behavour. I see Patty occasionally, and she expresses her pleasure of seeing me—yet I cannot feel so much for her, when I think that if she had been as kind to Raphaelle as she ought to have been, that she might have made him a much better man than he really was, she might have won him to be a better husband to her—for she had full power over him if she had been always affectionate towards him— Sophonisba has been several times in extreeme bad health, she is now just recovered from the influensa which has been generally prevalent throughout the country I had a spell of it a whole month [high fever] and my head much affected, yet I continued to [s]tick to my table wri[ting the] work that I be[gan after the dea]th of my first wif[e] [illeg] summer I was [asked for] information of som[e][illeg] [revolu]tionary war [illeg] my journals ma[illeg] pi[illeg] [cont]inuation of it this Wi[nter] [illeg] publication of it, not [illeg] wor[illeg] that I have not always done [illeg] [B]ut [I] have told some [trans?]actions which wi[ll offend] some fam[ilies] and I do not desire to offend any one, yet [illeg] of this nature [illeg]th should be told, I shall be able by April next to com[plete] it. Rubens had some difficulties with the persons to whom Rembrandt owed money for the building of his museum, and Rubens found that he could not pay them, and therefore it determined [him] to quit Baltemore, he had made the creditors an offer to pay 5 pr. Cent which they refused, and therefore he went to New York and there made an engagement to form a Museum in a fine situation; and when the Creditors found that he would leave the Baltemore Museum, they agreed to take his offer, & he is oblegated to keep that Museum as well as to continue that at New York. in New York he meets with great encouragement he has since he opened it received 1000$ pr. month, and his experiments please so well there that he will constantly have visitors—and he says that New York will make his fortune, I wish it may, yet I fear that he will have difficulties with that of Baltemore, Interest is hard to pay—and to my cost I have found it so— and therefore I have sold my farm for a less sum than I intended, but I have got rid of some payments of Interest, but [if] I could have got for it 14000$— I would be out of debt and owned this House in Walnut street. I sold the farm for 11000 $ only— the last time I went to see the farm I found that I must make new fences and other things were going to ruin, therefore I agreed to take what I had refused 2 months before, I found myself in a great measure relieved since I owe nothing to the [illeg]

nor any Interest on the debts of the farm. I enjoy good health and I intend to persue some business [for portraits] [to pay my] debts as soon as I can finish my [Biography]
[remainder of letter, about 7 lines, illeg]
[page torn]tterson
[]County

AL, 2pp.
PPAmP: Peale-Sellers Papers—Letterbook 20. Letter badly mutilated and torn. Illegible words that may be guessed at are included within brackets

 1. Unlocated.
 2. See above, Editorial Note following **231**.

250. CWP to D. M. Barringer[1]
PHILADELPHIA. FEBRUARY 9, 1826

<div align="right">Philadelphia Feby. 9th. 1826.</div>

Sir

 Yours of the 3d instant received containing a fifty Dollar note of North Carolina, the discount of which is 3 pr. Ct. a trifle not to be reguarded when such prompt payment is made, and I will make the copy as faithfull and with as much of the character as I can comprehend in the profile Likeness which you also enclosed, but for that purpose I wish to retain it while I am painting from the portrait belonging to my Museum, which is more of a front face, nay almost intirely so.[2]

 Portraits in oil do not require Glass to cover them, they preserve their colour better without. I shall not fail to have the Picture finished early in April, so that if any of the Studients of medicine go about the last of April or sooner it will be ready for its conveyance, and I shall make enquiry for that purpose— 10$ will purchase a good frame. but a very extraordinary one if desired[3] you will have time sufficient to inform your obleged friend

<div align="right">CWPeale</div>

Mr. D.M. Barrenger
 Chapel Hill

ALS, 1p.
NCU: Dialectic Society Papers
Copy in PPAmP: Peale-Sellers Papers—Letterbook 20.

 1. Daniel Moreau Barringer (1806–73), North Carolina lawyer, congressman (1843–49), and ambassador to Spain (1849–53), was a student at the University of North Carolina at the time of this letter. He graduated with honors in June 1826. On January 12, he had written to CWP on behalf of the Dialectic Society, the university's debating and oratory club, seeking to

obtain a portrait of William Richardson Davie (1756–1820), Revolutionary soldier and a framer of the United States Constitution, as a gift from the club to the university. Davie had been responsible for introducing the legislation chartering the University of North Carolina (1789) and for supervising its establishment; the university opened in 1795. Barringer's letter to CWP is unlocated; see CWP to D. M. Barringer, n.d. [1826], NCU: Dialectic Society Papers, F:IIA/71G5–6; *DAB*; William S. Powell, ed., *Dictionary of North Carolina Biography*, 4 vols. (Chapel Hill, 1979), 1:99, 2:28.

2. CWP mistakenly assumed that the portrait of lawyer Joseph Hamilton Daveiss (1774–1811), painted by JP and hanging in his gallery, was a portrait of Davie. When he realized his mistake, he made use of the profile sent to him by Barringer that had been taken with the physiognotrace by Gilles Louis Chrétien (1754–1811) (1800: *University of North Carolina, Chapel Hill*). CWP's portrait of Davie follows Chrétien's profile (fig. 58). CWP finished the portrait in early March and sent it to North Carolina sometime after May, after he had framed it. *P&M*, p. 62; E. Benezit, *Dictionnaire critique et documentaire des peintures, sculpteurs, dessinateurs et graveurs*, 10 vols. (Paris, 1976), 3:16; CWP to Daniel Moreau Barringer, March 10, 1826, P-S, NCU: Dialectic Society Papers, F:IIA/72A10; CWP to Daniel Moreau Barringer, May 30, 1826, P-S, NCU: Dialectic Society Papers, F:IIA/72C1.

3. In his first letter to Barringer, CWP had recommended that the students authorize a special frame, for "a frame to a picture is like dress to a lady." The frame he chose for this work was "a broad frame & to be guilt in all parts seen." He charged $50 for the portrait and $20 for the frame, packing case, and discount. CWP to Daniel Moreau Barringer, [January] 1826, NCU: Dialectic Society Papers, F:IIA/71G5–6.

251. CWP to ReP

PHILADELPHIA. FEBRUARY 12, 1826

<div align="right">Philadelphia Feby. 12. 1826.</div>

Dear Rembrandt

Yesterday I received yours,[1] and now I will give you some particulars of my situation and employment. It is true that I had the prevailing complaint— about 6 weeks past I went to see how things were at the farm, and I took the stage as far as Mrs. Logans[2] gate & walked to her House, she always receives me with politeness, and asked me to dine with her, I carried with me the first part of my Memoirs, wishing to know her oppinion on it, and I left it with her for a slight perusal saying I would call for it next day, she gave me for dinner Salt Pork sassages and mince pie, I ate moderately therefore it was not the quantity but the quality that effected my bowels. for I have not been in the habit of eating any salt meat for a long time—but I went out with my Buckskin shoes, and no over shoes and there had been few days before some snow, it was all gone in the city but I found some on the ground out there, and the ground rather soft. I [went] to the farm and then to Doctr. Betton's[3] where I am always invited to stop. I sleept at the docters, and as before I always found an abundance of bed cloaths. I did not think it needful to speak on the subject, and I had not my usial quantity of covering— the next morning I had too frequent calls backward, I walked to Mrs. Logans but she had

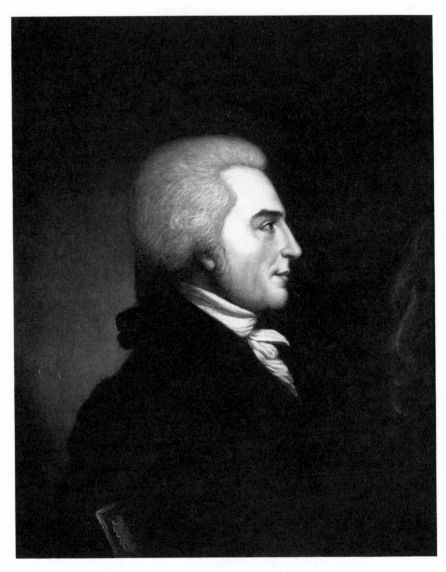

58. *William Richardson Davie*. C. W. Peale, after engraving by Gilles Louis
Chrétien, oil on canvas, 29 ½ × 23 ½″ (7.5 × 59.5 cm). 1826. North Carolina
Collection, Library at University of North Carolina, Chapel Hill.

gone to meeting & to Mr. Johnsons who died at that period,[4] I was disappointed at not seeing Mrs. Logan because I wished to consult on the subject of my writing, she left it folded in a neat manner with her respects and the great pleasure she had received in the perusial wrote on the cover. I then returned to Doctr. Bettons and dined, and finding my bowels much disordered I took the stage going the [to] the city, It appeared to me that the Pork opperated like salts. and I had no objection to it for a few days, but now my head became disordered and I had a sore throught, at first I could with difficulty speak & swallow this continued for about one month, I took only one tea spoon full of sulphur and used some horehound candy, but getting some spanish Liquorish it seemed to act like a charm, I was instantly cured—[5] I did not loose a single hour, but have continued writing, and now I am just entering the rechearch for the Skeleton of the mammoth,[6] I have found that in the several journals I had made that some times I made month & day but omited the year. which has given me some trouble. but what is yet to come I shall not find those difficulties. I suppose this work will make a large volume, and it may be made much larger if some of my introductory lectures are printed in the work, but whether I shall allow it to be printed while I am living has not yet been determined I thought sometime past I would have it published, but in the progress of it speaking of some characters I have told truths which would offend some of the families—instance my courtship of Miss Tilghman where they used that poor girl cruelly—[7] but I may get over that by adopting ficticious names—but when I come to that part of my history where I appointed Visitors and directors to aid me in the improvements of the Museum, and the Gentlemen who consented to be Visitors & directors where of the most distinguished men of that time, Thomas Jefferson, Mr. Maddison, Robt. Morris, Mr. Bordly, Mr. Mifflin, &c and I had put the Bartons amongst those gentlemen which I concieved was doing them great honour, I found by that business I sacrificed a great deal of time and found I must neglect my Museum, which was to be filled with many common animals, but what disgusted me most, was, that doctr Barton arrested articles coming to the Museum, when I found that was the case, I did not trouble those Gentlemen to meet as before—[8] In my history I must tell the truth, and to say that some of them was guilty of this breach of friendship without naming that person would most likely offend others, What say you to this? shall he be named or not? There is such a diversity of my labours and so many trying scenes described with several interesting characters introduced that I cannot help beleiving that the work would excite considerable interest with the Public, in part very much like an Novel. And I see that novels meet with many readers, but then they

are written with fine language, my facts might in the hands of a good penman I am sure can be made very interesting.

I have sold my farm and paid of all my debts to the Bank and all the morgages on the farm and 3000$ towards the payment for my house in Walnut street, but I could not get so much for the farm as would put me out of debt yet I was induced to sell it for I found that I was paying upwards of 600$ annually for the hopes of getting a greater sum for that place—and when I went to see it as before mentioned I found that I must make new fences & other repairs, therefore I was induced to sell it for 11000$ which I had refused 2 months before now I am in debt for this House 2600$ 1100$ to the City for rent of the state house and besides 1200$ to individuals, so that I must still be as saving as possible, and do all I can to get money to pay these debts and the Museum at this season pay all its expences, but this has always been unproductive in January & february. I am urging Franklin & Titian to do all they can to induce more visitors to the Museum. I hear that Mr. Sully and Mr. Neagle have their hands full of imployment, that Mr. Nagle has raised his price.[9]

You say that you have finised a fine Portrait of Prince Charles for this Museum,[10] which I am much pleased to hear, but how is it that I have not got the portraits of Clinton and Doctr. Michel Although I have paid for them.† I have patiently waited for them while I thought you could have any advantage by keeping them can these pictures now be of much advantage to you, I should suppose not, therefore why do yout [you] not send them to be placed in this museum? we very much want things of attraction to help me to pay my debts.[11]

I hope Linnius will soon get a certainty of his pay & a part of it be put in train to support his family. Christiana cannot get boarders and she must be supported by other means, she must get a cheaper rent, and perhaps she might try to get a school of small children to help herself— If Linnius comes here soon I hope these things may be settled to his satisfaction. I waited on a Mr. Barry[12] who told me that orders from Linnius would be paid for the support of his family, and I have also heard that he has the character of being a fine officer, and it is believed that he will do well in that employ.

Afternoon I have just returned from a walk to Doctr Godman to know how they were and if they had any thing to communicate, no, but they are all well, so that I have only to present my love to you all in New York of my family— we here are well, when I wrote to you last I inquired what you

† a mistake [pencilled, possibly in another hand]

expected from your Equestrian Picture, and also of that of Fayette, but when you write you do not look at my letters to know their contents

your affectionate father
CWPeale

Mr. Rembrandt Peale
 New York

ALS, 3pp.
PPAmP: Peale-Sellers Papers—Letterbook 20

1. Unlocated.

2. Around 1814, Deborah Norris Logan, who lived at Stenton, her husband's mansion and scientific farm, had begun to preserve and collect the family papers, which since have become an invaluable source of early American history. It is a significant comment on Deborah Logan's expertise as a historian that CWP would consult her for advice about the assembling of his own memoirs and papers. *DAB*; *Peale Papers*, 3:12n.

3. Samuel Betton, M.D.

4. Unidentified. The Johnsons were a prominent Germantown Quaker family, with many branches. CWP consulted with a Mr. Johnson in the upper part of Germantown in 1815 about a threshing machine. See *Peale Papers*, 3:326.

5. Refined sulphur as flowers (i.e., crystals) of sulphur is taken as a laxative; horehound (or hoarhound) candy is a lozenge crystallized from the herb *Marrubium vulgare* and used as a cough suppressant; *Spanish licorice* was a common name for a candy or lozenge made from the root (*rhizome*) of the plant *Glycyrrhiza glabra*. *OED*.

6. For CWP's famous expedition to recover the bones and assemble a skeleton of the extinct mastodon, see *Peale Papers*, 2:308–76.

7. For CWP's courtship of Mary Tilghman and his attempts to win the approval of her family in 1790, see *Peale Papers*, 1:597–611.

8. For the role of the trustees in the Philadelphia Museum, see *Peale Papers*, 2:12–24. William Barton (1786–1856) and Dr. Benjamin Smith Barton (1766–1815) were both prominent Philadelphia naturalists, but it was Dr. Benjamin Barton who incurred CWP's hostility. CWP believed that Dr. Barton's memoir on rattlesnakes (1799) was based on inadequate observations and experiments; he also resented Barton's use of his work without giving him proper credit. His accusation that Barton had appropriated specimens intended for the museum for his own use, was, however, unfounded: the Swedish birds that were the cause of the accusation arrived later. Still, in his autobiography, CWP did not hesitate to observe that Barton "never scrupled to take the feathers of others to enrich his own plumage." *Peale Papers*, 2:19n, 156n, 202n; A(TS):201–02.

9. Sully's status as Philadelphia's preeminent portrait painter was confirmed by his dominant role in the city's artistic celebration of Lafayette's visit, which included a commission for a life portrait of the general (*Independence National Historical Park, Philadelphia*). In 1822, a year for which prices charged by both Sully and ReP are available, Sully's fees for portraits were about the same as ReP's: $60 for a head, $100 for a bust size. By 1826, Sully's prices had doubtless risen, since in 1837 he charged $150 and $200 respectively. *DAB*; Monroe Fabian, *Mr. Sully, Portrait Painter: The Works of Thomas Sully (1783–1872)* (Washington, D.C., 1983), pp. 12, 23.

John Neagle, who was to marry Sully's niece and stepdaughter Mary Chester Sully in May, was finding such a ready clientele for his portraits that he was able over time to raise his price from $15 to $100 a head. *DAB*.

10. *Charles Lucien Bonaparte, the Prince of Canino* (*unlocated*) was accessioned at the museum in 1828. Philadelphia Museum, Records and Accessions, F:XIA/4–5. ReP Catalogue Raisonné, NPG.

11. See above, **77, 122**.

12. Edward Barry was the consul and commercial agent for the Republic of Colombia, in whose navy CLP was serving; Barry's office was at 151 Pine Street. *Philadelphia Directory* (*1825*).

252. CWP to Richard Worsam Meade[1]
PHILADELPHIA. FEBRUARY 23, 1826

Philadelphia Feby 23. 1826

Dear Sir

I have a Son in the columbian service, Linnius now has the charge of the ship La Plata at New York, he entered her when in the Delaware as a 4th. Officer, he is now the 2d, and I hope his conduct will intitle him to that grade. he seems determined to exert himself to his utmost abilities, some few years past he made some voiages, to south america & to France, and he served in the caveltry in the late War, & I believe to the satisfaction of Genl. Brown.[2] he writes me that a Letter to Mr. Eckford and Mr. Polaccio[3] from you would be of infinite import to him— But my Dear Sir how can I ask you to give letters of recommendation to a young man that you are not acquainted with? I can only say that I believe the profession he has now choosen is that most fitted to his genius—and that I believe that he will exert every nerve to become a good officer. He has an amiable wife & 3 children in Philada. some of his pay must go for their support in his abscence; and he has wrote to her that when he can find it safe and convenient that he will settle his family in South America. If my Son Linnius distinguishes himself by his good conduct, you will I doubt not have a satisfaction in having aided him to get into notice and your favors will be greatfully remembered by

your friend
CWPeale

Richard Meade Esqr.
 Washington City

ALS, 1p.
PPAmP: Peale-Sellers Papers—Letterbook 20

 1. See above, **155**. The extent of CWP's friendship with Meade is not known. It may have been that because of Meade's known interest in collecting art, CWP hoped that he would be influenced by an appeal from an artist to write a letter of recommendation for CLP, whom he did not know. Meade's many mercantile, political, and personal ties with Spain and its empire in South America made him a logical person to apply to for the kind of help CWP was seeking for his son. *DAB*.

 2. General Jacob Jennings Brown. See above, **238**.

 3. J. Palacio was the consul general of Colombia in the United States. *Philadelphia Directory* (*1825*).

253. CWP to RuP

PHILADELPHIA. FEBRUARY 27, 1826

Philadelphia Feby. 27th. 1826.

Dear Rubens

Elizas Letter[1] received saterday, for which I thank her, that, to her brother[2] I left at the Tavern in 4th street where he usually stops. Saterday night last, I was at a Wistar party given by Doctr James,[3] where I meet with Mr Reed,[4] I said to him that I seldom see him, altho' a near neighbour, his reply was that he seldom went to the office, only once in the a day, that he was president of an insurance office which required his constant attention— He said that he intended to go to New York now the Steam boats are beginning to run—that he thought it best as he could see you then—this was a sort of appology for his not complying with your and my request about the paintings— I hasten to give you notice of this in order that you may be prepaired to meet him. Tell Linnius that I waited on Mr. Barry,[5] and he promised that he would write Letters as was desired in his favour— I also wrote a letter to Mr. Meade, at Washington to ask of him Letters of recommendation,[6] but how he can do that, as he has no knowledge of Linnius, I cannot say—however I have done my best for Linnius, and I suppose the business will soon be finished as the Spring season is fast approaching—

two mummies![7] can they give you even the interest of that sum? I cannot help having fears about payments of Interest for it has cost me much trouble in my time—and I shall never be perfectly easey untill I wipe off all such debts, I am still at my memoirs & have 23 years yet to detail, by the 1st of april I may have gone through it, afterwards to retouch the whole. my sight has wonderfully changed, I use concave glasses to look at distant objects—and the youngest spectacles to read small print.
Love to Eliza and others.

yrs. Affectionately
CWPeale

Mr. Rubens Peale
N. York

ALS, 1p.
PPAmP: Peale-Sellers Papers—Letterbook 20

1. Unlocated.
2. The letter to George Patterson is unlocated.
3. Although CWP attended this Wistar party and one preceding it at William Meredith's (see above, 163), he declined further invitations with regret that his deafness made it impossible to participate in the proceedings as he would have wished. Letters of regret were sent to three other parties in March, after which the absence of letters suggests that he was probably

dropped from the guest list. *Peale Papers*, 2:638n; CWP to William Meredith, March 2, 1826, P-S, F:IIA/72A5; CWP to William Tilghman, March 9, 1826, PHi: Meredith Papers, P-S, F:IIA/72A8; CWP to Robert Hare, March 16, 1826, DeWint: Joseph Downs Ms. Coll., P-S, F:IIA/72B1.

4. Joseph Reed, who served as an intermediary between RaP and Mrs. Delaplaine in relation to the Delaplaine Collection. See above, **155**.

5. Edward Barry. See above, **251**.

6. See above, **252**.

7. For the first exhibition of the mummy, see above, **196**.

254. CWP to RuP and CLP
PHILADELPHIA. MARCH 1, 1826

<div align="right">Philadelphia March 1st. 1826.</div>

Dear Rubens & Linnius

Having received the enclosed this evening,[1] I hasten to inclose it to you, beleiving that Rubens would be the most sure direction to get the letter to you. Mr. Meade in his letter to me says, that he is not sufficiently acquainted with Mr. Eckford to write to him, but he advises me to apply to Mr. William Duane[2] and he thinks no man could serve us better, I went directly to Mr. Duane's but find that he is at Harrisburgh, and will not be at home before saterday next, I will write to him immediately, although I have some apprehentions that he will not [receive] my letter in time before he leaves Harrisburgh, for the Post office notice is that the post goes on Friday, yet I hope as the Legeslature is now in Session that the post should be every day.

I wrote to Rubens the other day,[3] which contained almost as much as I can have to say at present, for my occupation is constant at my writing. only that I have finished a picture from a print the size of St Memons, and it is so good that I am proud of it—[4] and it cost me very little trouble to paint it, such is the emprovement of my sight, and if my hearing was equally good I would think myself a young man. My subject in writing to day was on the merit of Portrait painting, and I do not know whether my treating on that subject has not created an enthusiasm to make me try to make a perfect elusion in a Portrait. a perfection that colours can give if the artist has skill enough in applying them. What will Rembrandt say to this? Tell Eliza that I cannot find time very soon to see the fine Widow she mentions as a relation of my second Wife.[5] I pay some attention to the ladies yet as none of them will court me, I shall most probably remain alone to the end of my time—and I cannot yet believe that I am old although I see many changes of men & things— Love to my friends and relations. yrs. affectionately

<div align="right">CWPeale</div>

ALS, 1p.
PPAmP: Peale-Sellers Papers—Letterbook 20

1. Unlocated.
2. William Duane (1760–1835), former editor of the Philadelphia *Aurora*, had served as adjutant-general during the War of 1812. After retiring from the editorship in 1822, he spent two years traveling in South America, an account of which he published in *A Visit to Colombia* (Philadelphia, 1826). Thereafter he became prothonotary of the Pennsylvania State Supreme Court and a writer on military topics. *Peale Papers*, 2:453n; *DAB*; *NUC*.
3. See above, **253**.
4. The posthumous portrait of William Richardson Davie that CWP painted from a profile of Chrétien's (see above, **250**). Charles-Balthazar-Julien Févret de Saint-Memin (1770–1852) was another French pioneer in the art of profile portraits taken with the physiognotrace. *Peale Papers*, 2:479n.
5. Unidentified.

255. CWP to William Duane[1]

PHILADELPHIA. MARCH 1, 1826

Philadelphia March 1st. 1826.

Dear Sir

I received a letter from Mr. Meade at Washington in which he says "that a letter from you to Mr Eckford will have the desired effect."[2] My Son Linnius has entered into the columbian service, he went on board the ship built here called Laplata— when he entered on board her in the Delaware he was given the 4th. in command, his service was such in going to New York that he was raised to the 2d. and all the time that the ship has been at New York he has had the whole charge of her, and I am well assured that his activity has been the cause of his promotion, on the passage to New York his hands and feet was frostbitten yet it did not prevent him from doing all the duties required of him. It is a line of life that seems fitted to his genius, and he writes me that he will rise—he is determined to distinguish himself in the service of that country. He has been a Sailor and a Soldier—I presume that you know him sufficiently to give him a letter to Mr. Eckford; The Captn. that carried the Laplata to New York, I presume got him raised to his present grade, that Captain went out in the frigate which was built at New York, and left Linnius in his present station—

I hope he will get a part of his pay establ[ish]ed here to support his wife and four children, she has attempted to get a maintainance by taking boarders, but has failed to get them—the fact is that we have so many boarding houses, that her chance is nothing because she is not known. I have been obleged to write this late this evening and in haste. I hope I

519

shall see you soon in the city, and that you will see my Son Franklins orery.[3]

I am with much esteem your friend

CWPeale

Mr. Wm. Duane
 Harrisburgh.

ALS, 1p.
PPAmP: Peale-Sellers Papers—Letterbook 20

 1. See above, **254**.
 2. Meade's reply is unlocated, but see above, **254**.
 3. See above, **242**.

256. CWP to Eliza Patterson Peale
PHILADELPHIA. MARCH 13, 1826

Museum March 13th. 1826.

Dear Eliza

Your sister Mary is now with me, and she says least she should not have time to write to you, desires me to tell you that she intends to go home with your Sister Charlotte[1] and spent the summer there and return in the fall, then go to New York and spend the winter with you. Therefore you see that she is determined not to be married this year. I am still constant at my table writing this Novel,[2] I have reached the year 1809—soon I shall be at the farm persueing all my folies there, a pretty numerous list of them, will I suppose close or nearly so this heavy work. I may then begin to paint again, as I find myself more capable than for very many years past.

Wood[3] was here the first of this week. he staid 1 or 2 days. I am fearful that the Museum in Baltimore does not produce any income sufficient to pay its expences. Rubens promised me a long letter I wish I could see it. as soon as the weather is settled I intend to go to Mr. Bryans to paint a Portrait of Timothy Matlock, he now wears a long beard and I am told will make a fine picture.[4]

Love to you all CWPeale

Mrs. Elizth. Peale New York

ALS, 1p.
PPAmP: Peale-Sellers Papers—Letterbook 20

 1. Charlotte Patterson Thompson.
 2. The term *novel* to denote a fictitious narrative had been in use for over a century. *OED.*
 3. William Wood.
 4. Guy Bryan (1755–1829) was the son-in-law of Timothy Matlack (1730?-1829), former companion of CWP's in the radical political group called "Furious Whigs," a colonel in the

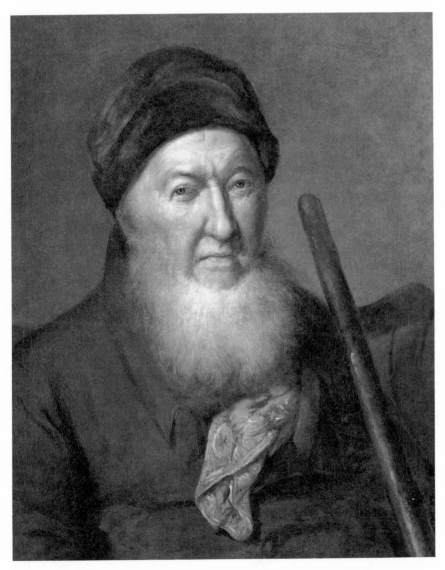

59. *Timothy Matlack*. C. W. Peale, 1826. Oil on canvas, 24 1/$_8$ × 20″ (61.5 × 51 cm). Independence National Historical Park, Philadelphia.

Philadelphia Associates, and secretary of the state's Supreme Executive Council during the Revolution. The elderly Matlack was living at Bryan's estate outside of Philadelphia. Bryan was the president of the American Fire Insurance Company and a director of the Second Bank of the United States. An earlier portrait of Matlack that CWP painted in the 1790s is in a private collection (on loan to the Museum of Fine Arts, Boston). Another, from ca. 1805 at the National Gallery of Art, Washington, D.C., has been attributed to both CWP and ReP; the National Gallery lists it as ReP's. The portrait mentioned here (fig. 59) was painted from life in June 1826. See below, **267**; *Peale Papers*, 1:282–84n; *P&M*, p. 140; National Gallery of Art, *American Paintings: An Illustrated Catalogue* (Washington, D.C., 1992), p. 257; ReP Catalogue Raisonné, NPG; Edward Biddle and Mantle Fielding, *The Life and Works of Thomas Sully* (New York, 1970), p. 110; *Catalogue of American Portraits in the New-York Historical Society*, 2 vols. (New Haven, Conn., 1974), 1:103.

257. CWP to CLP
PHILADELPHIA. MARCH 14, 1826

<div align="right">Museum March 14th. 1826.</div>

Dear Linnius

We have not heard so long from you that it gives cause of uneasiness, we cannot suppose however severe your duty, yet a few minutes might be found to write a few lines— I occasionally call to see Christiana hoping she might have heard from you, she still is without a single boarder and the rent going on, I have paid one quarter but I cannot pay more for my income has lessened so much of late as to bring me in debt instead of giving me a profit, I hope as the spring advances that it will be better or I cannot expect to get out of debt—therefore it is absolutely necessary that you should sent orders for the support of your family, I have done all I can do to get recomdations for you, and enclosed you a letter from Mr. Meade— Mr. Duane says his acquaintance with Mr. Eckford is very little, not sufficient to make him write to him. but he wants to know your Captains name, if he is a person whom he knows he will write, Mr Duane mentioned to me a name which he supposed would be the Captain & I have forgot it. you now can assuredly sent orders of a part of your wages to support Christana—you have undoubtably convinced Mr. Eckford of your merit and need not want any recommendations to him

You must not think it hard that I require you to help Christiana for my situation require it. yours affectionately

<div align="right">CWPeale</div>

Mr Linnius Peale <div align="right">wrote in haste.</div>
 New York.

ALS, 1p.
PPAmP: Peale-Sellers Papers—Letterbook 20

258. CWP to RuP

PHILADELPHIA. MARCH 26, 1826

Philadelphia March 26.1826.

Dear Rubens

Your letter to Mr. George Patterson was delivered to him the same day that I received it, and I had a conversation with him in company of his Brother Burd. & Mrs. ⟨Tomson⟩ Thompson—[1] he said that he would write you a Letter before saterday, and therefore it was not necessary for me to write as I offered to do to save him the trouble—yet I know how neglegent many people are about writing letters, least he may also be neglegent I take up my pen to say what he promised—he said the affair was not at that moment settled, but he would be sure to give you 500$ the first of April, and if you gave him incouragement then, the whole payment.[2]

Mary was here a great part of last week, and had got the painters at work painting her House, she had also choosen paper to cover the passage & 2 lower rooms. she was very much perplexed to chuse her tenants amidst a great number of applicants, Houses being at this moment in great demand. I went on friday to the sale of the machinery at the Mill—it was a tremendous Stormy day & very few purchasers came of course poor sales, 2 men sec[u]red five of every thing, at a private sale they might have brought twice the sum—however Franklin has now got rid of all trouble about them, and therefore he seems satisfied, I intended to sell the mangle but not to sacrifise it—of course it was not put up for sale, and I shall keep it for my own use, at least that is, if I should ever be a house keeper again.

For I often feel uncomfortable that I cannot with perfect freedom ask my friends to take a meal with me. But Titian & Eliza. are very attentive to all my wants when they know them. Still I am like a fish out of water,[3] and nothing but my constant employment would make me bear it— I have just now got to the time of settling the rent of the State-house after the City had puchased it, of course in one or two weeks I shall have gone through my Biographical Sketch. it has been a heavy job—my almost whole imployment of the winter.

I am under some concern about Linnius's support of his family— my Income has been so small that I can not get out of debt, although I have sold the farm and paid off the bank debts & 3000 to Mr. Graff[4] yet if Linnius does not provide for paying the next rent & all[?]—give orders for her & Childrens support she will suffer, as I cannot support them much longer— I mention these things to you with the hope that you will let me know his prospects for he has not written to me a long time— I

hasten to put this in the post office least you may not get it while in N york. Love to Eliza and the Children— yrs. &c

CWPeale

Mr Rubens Peale
 New York.

ALS, 2pp.
PPAmP: Peale-Sellers Papers—Letterbook 20

1. Charlotte Patterson Thompson, Eliza's sister.
2. George Patterson was offering to buy Eliza's, Mary's, and Charlotte's share in the mill inherited from their parents for $1,500 to each. Mary insisted upon receiving $2,000 for her share, to which George agreed provided Eliza accepted $1,500 "as Charlotte has agreed to take that sum." See CWP to Eliza Peale, March 29, 1826, P-S, F:IIA/72B4.
3. The quotation is from Thomas Shadwell's (ca. 1642–92) play *A True Widow* (1679): "I am, out of the ladies' company, like a fish out of the water." Shadwell was an English dramatist and successor to John Dryden as poet laureate during the years following the Glorious Revolution (1688). *The Oxford Dictionary of Quotations* (1941; reprint ed., London and New York, 1964), p. 422; *DNB*.
4. Charles Graff.

259. CWP to Elizabeth Bend
PHILADELPHIA. APRIL 6, 1826

Philadelphia April 6th. 1826.

Dear Betsy

as soon as I received you last letter[1] I hastened to write a few lines to Rubens to hurry him on. I have been expecting him all this month. but I suspect he is waiting to get a sum of money which he expects to receive in Philada. I cannot account for his delay of coming on any other scourse. I have some thoughts of accompanying him to Baltemore in which case I mean to accept the offer of quarters with Mrs. Mchenry,[2] if I find it is perfectly convenient to her. I have now got as far as the year 1823 of my memoirs, of course in one or two weeks I shall have completed the first Sketch—it has occupied me the whole winter, but after this it will require the re-touching to polish it. I find occasionally some pleasure in reading particular parts of it to some of my friends—there seems to be some curiosity with the public to see it, and not very improbable when more of the matter is known, it is to be hoped that the greater will be the wish for publication, if on a perusial of it and the opinion should be that money may be made by the publication, I see no reason why I should not be benefited by the work. but more of this hereafter. I am free of all engage-

ments, and therefore willing to see any Lady you can recommend—and can bare a rebuf for if I cannot please I do not want to be pleased, a similarity of sentiment is all important. I hope to make the evening of my days pleasant.

<div style="text-align: right">yours Affectionately CWPeale</div>

Mrs. Elizabeth Bhenn
 Baltemore

ALS, 1p.
PPAmP: Peale-Sellers Papers—Letterbook 20

 1. Unlocated. Betsy Bend obviously wrote about the condition of the Baltimore Museum in RuP's absence. It would seem that the manager, William Wood, had left it somewhat precipitously and, in her opinion as conveyed to CWP, in bad shape. Yet the museum continued to function with only Mrs. Atkinson and James Griffiths in charge. CWP wrote to RuP this same day indicating that "the account of the Museum at Baltemore that I have received is abominable." See CWP to RuP, April 6, 1826, P-S, F:IIA/72B6.
 2. Martha Hall McHenry.

260. ReP to John Maclean[1]

NEW YORK. APRIL 12, 1826

<div style="text-align: right">New York April 12. 1826</div>

Sir

 I have taken the last sitting of Dr. Hosack, and can assure you that I have made a Portrait upon which I have bestowed as much attention & care as if you had offered me one hundred guineas—because I was desirous of again painting the Doctor, of whom no *good* likeness had ever been taken—[2] Besides, the destination of this Portrait is sufficiently flattering to both parties to induce us to make some effort in rendering it valuable to your institution.

 The Doctor has taken upon himself the charge of a Gilt Frame, and has had a very handsome one made by the best Gilder in this City.[3]

 In commencing this Portrait I did not require of you any attention to my ordinary rule of payment which is "Half-price at the first sitting, the remainder at the last." But I shall now be obliged to you, as soon as possible, to remit me the amount ($100) or an order on some one here for it. I had calculated on receiving it a long time since—but I did not chuse to ask for it till I had taken my last sitting, and I have found it a difficult task to get from the Doctor the requisite number of sittings. He seemed disposed at first to think that I should create his Portrait chiefly by an effort of Genius, rather than submit to the imprisonment of my Room. But the

Dr. is fully sensible of the honour you intend him & has discharged this part of his obligations.

<div align="center">I remain</div>

<div align="right">

Very respectfully

Yours

Rembrandt Peale

</div>

ALS, 2pp. & add.
NJP: John Maclean Papers, Box 1, Seeley G. Mudd Manuscript Library, Department of Rare Books and Special Collections

1. John Maclean (1800–86), was professor of mathematics at Princeton University. He graduated from Princeton College in 1816 and spent the rest of his career there in a variety of academic and administrative posts. In 1829, he changed his field of study to languages and was appointed professor of ancient languages and literature. That year also, he entered the university's administration, and, in 1854, he was inaugurated as president of the college, a position he held until 1868. *DAB*.

2. (*Princeton University*.) Dr. David Hosack's portrait was commissioned by Princeton in 1826 to honor a distinguished graduate (A.B., 1789; Hon. LLD., 1818). In 1826, Dr. Hosack left Columbia College's Faculty of Physicians to found the Rutgers Medical College, which he served as president until 1830. See below, **263**; *Peale Papers*, 2:318n; ReP Catalogue Raisonné, NPG.

ReP's earlier portrait of Hosack was painted in 1823 (see fig. 25). See above, **77**.

3. Unidentified.

261. CLP to Christiana Peale
NEW YORK. APRIL 20, 1826

<div align="right">

Quarantine Ground[1]

April 20th 1826

</div>

Dr Christiana

I have just seen Pah & got your letter[2] when we sailed from New York I wrote to you & enclosed $125.00. which I gave to a Gentleman to give to you— it appears that it has Miscarried or been lost— in 6 or 7 weeks from the time we sail we shall be in Carthagena[3] & you will immediately get from me a draft on Le Roy Bayard & Co. of New York[4] for $175.00. I am sure of being in Service as soon as we get there I believe I give satisfaction, which is my only comfort—bear up our difficulties cannot last forever they shall have an end. send some person to enquire at Judds Hotel[5] for a Mr. Peabody[6] who took my letter.

Pah is in a hurry to return to New York before night, therefore I must finish

<div align="right">

Your Loving Husband—

Chas L Peale

</div>

ALS, 1p. & add.
PPAmP: Peale-Sellers Papers

1. The quarantine station in New York harbor from 1801 to 1861 was at Tompkinsville, Staten Island. Authorities were especially wary about the possibility of ships traveling to and from Central and South America carrying diseases such as yellow fever. Moses King, ed., *King's Handbook of New York City 1893*, 2 vols. (1893; reprint ed., New York, 1972), 1:72–73.

2. The letter is unlocated. The exact date of CWP's arrival in New York is not known, but see **262** below.

3. Cartagena, on the northwestern Caribbean coast of Colombia, is the chief port city of that country.

4. The mercantile firm of Le Roy Bayard & McEvers was founded by Herman Le Roy, James McEvers, and William Bayard (1761–1826) in 1786. *DAB*.

5. Judd's Hotel, at 27 South Third Street, Philadelphia, was opened in 1819 by Anson Judd and managed by James Bradley after 1824. Scharf, *Phila.*, 2:992.

6. Unidentified. See below, **262**.

8 Full Circle. The Relocation of the Museum and the Death of Charles Willson Peale: April 25, 1826–April 27, 1827

In 1826, Charles Willson Peale attempted to effect two large changes in his life and work: to find a companion who would share with him his last years, and to move the Philadelphia Museum into more commodious quarters. Both efforts seem to have emanated from a great need to assert a youthful energy in the face of an obvious diminution of strength. His successful resumption of a painting career, resulting in some impressive achievements, and the completion of his memoirs had reinforced his sense of personal power and made him eager to undertake new challenges. He was, however, to suffer severe disappointments. The courtship that he had hoped would bring an end to his loneliness proved disappointing; and although the building that he looked forward to using would be constructed and his museum would have a new home, he would not live to enjoy its benefits. For, in his confidence in his knowledge of the requirements for healthy living and as a result of the psychic energy produced by his recent achievements, he tested himself beyond his capacity, and within a year he would succumb to physical strain and the inevitabilities of old age.

262. RuP to BFP

NEW YORK. APRIL 25, 26, 28, 1826

New York April 25th. 1826.

Dr. Franklin.

I should have much preferred makeing arrangements with you in regard to the Baltimore establishment, whilst I was in Philadelphia, for any explanation necessary, could be answered at once, and thus prevent de-

lays and misunderstandings which we are all liable to more or less. I should wish both you and the Trustees as well as my Father, Brothers & all concerned, to perfectly understand that I have no wish to deprive the Philadelphia museum of any of its officers— The propositions that I have to offer you, are in consequence of your notice, that you should leave the museum as soon as something better should offer—this was confirmed by your wishing me to let you know what I intended doing with the Baltimore Museum. My wish, if you undertake the management of it, is that you should enter into it with zeal and spirit—to do this you must feel confident of your ultimate success in remuniration. Therefore perhaps you might think it advisable to receive a certain sum per annum? this can be done, the sum I would leave to you, but my decided opinion is, that it would be best for each of us, that you should receive half of the clear receipts over the expences, for then it would stimulate to exercions—for every thing depends on pleasing the visitors, if they are gratified they gratify us with their money. When I last conversed with you in the museum on the subject, you thought you would try it for one year, this I cannot advise you—I think you aught to look forward many years and not be moveing from one thing to another, for a roling stone never gathers moss—[1] Therefore If you undertake this establishment it aught to yieald you several hundred dollars a year over and above all your expences, providing for a rainy day— Instead of depending on the caprices and whims of several, you would be in unizon with one who wishes you well, and to do me justice, is to do yourself justice, for [if] you would do as I should do it will be necessary to give you a power of atterny to act for me in all cases, and have full power as I have to do all that is necessary to be done &c— Your income will be retained by you and my half will be paid to the arrears due by me, untill they are all settled. The following is a statement of expences---

Interest on 16790$ at 5....................	839..50
Interest on 2250$ at 5.....................	112..50
Ground Rent............................	306..00
Taxes & Water..........................	50..00
Mrs. Atkinson...........................	160..00
Servant man's assistance..................	12..00
Gas Light oil &.........................	400..00
Printing & Newspapers...................	350..00
Misselanious expences....................	200..00
Permanent Improvements................	400..00
Fuel...................................	80..00
	$2910..00

My wish and expectation is that the museum will be placed in Market Street,[2] where the income will be much increased. I will give you the amount received since its establishment, I generally leave out the year of gas, for the purpose of making estimates the more correctly.

1814 4[?]months.1755.$——1815–$4871.—1816–$7195——
1817–3630.——1818—4069⁵⁰/₁₀₀——1819—2475⁷⁵/₁₀₀——
1820–3890⁷⁵/₁₀₀——1821–3385.——1822–4196——
1823.4705.⁷⁵/₁₀₀

The total amount received during the Ten years is 44273 dollars 50 cents—it being divided by 10 gives 4427 dollars a year, so that if Rembrandt and my expences had been only what I have given above, the result would be that we at this time aught to have 15,170 dollars. instead of which the expences over run the income &—— Yet you will find some of the items rather too large such as the printing, misselanious and permanent improvements, the difference of interests is considerable, it formerly was 1201 and now 952, a difference of 249 a year——so far when my father arrived.

26th. My Father tells me you are desirous of knowing the amount of arrearages now due, this I cannot at this moment say exactly, but on referring to my papers I can nearly ascertain. Mr Robinson[3] will pay ⟨all the⟩up all, and leave his part until more convenient for me—for which I am to pay him 5 percent. I have settled nearly every item standing, either on Rembrandt's or my account, so that but little difficulty will occur on that head. I pay James Griffiths from this museum. I would wish you to answer this letter fully, especially as I keep a coppy of it. In a few days I will send the book[4] to you.

If you see Wm. Wood[5] say to him that they want the key of the Magic Lantern slides which he may have with him. Their income of Last week was 26$ day and 107 . . 25 night, in all 133 . . ²⁵/₁₀₀ which is doing very well. My Father went with me this morning to see Linnaeus at the Lazaretta,[6] who sent some days since 125$ to Christianna by Mr. J. Peabody at Judds Hotell, Phila.[7] I remain your &c—Rubens Peale

<div align="center">April 28th—</div>

After writing the within, it perhaps will be well to Say that I will garrantee you *800* dollars, even if the half of the receipts would not amount to that sum—by the statement I have given you, it willnot, but it does not follow that the expences must amount to that sum. You must always be governed by circumstances, as Mr. Owen says—[8]

<div align="center">I remain yours &c—</div>

<div align="right">Rubens Peale</div>

ALS, 5pp. & add.
PPAmP: Peale-Sellers Papers

1. This sentiment was originally stated by Publilius Syrus (first century B.C.) (commonly known as Publius) as his maxim number 524; it is found in almost every language. Its negative implication reflects the belief that stasis is preferred because it is more productive than constant change. As Thomas Tusser wrote, "The stone that is rolling can gather no moss / For master and servant, oft changing is loss." In modern times, however, the phrase has been used in the opposite sense to suggest that moving prevents one from stagnating. *Oxford Dictionary of Quotations*, 2d ed. (Oxford and New York, 1953), p. 550; *Bartlett's Familiar Quotations* (Boston, 1980), p. 111; Richard Wolkomir, "Wolfgang Mieder, turner of proverbial stones," *Smithsonian* 23 (1992):118.

2. RuP had long believed that the location of the Baltimore Museum on Holliday Street was not favorable to its success, and that it should be moved to a more central location. See Miller, *In Pursuit of Fame*, p. 294n.

3. Henry Robinson.

4. Probably the museum's account book.

5. The manager of the Baltimore Museum.

6. CLP was in the Quarantine Station at Staten Island; see above, **261**.

7. "James Peabody Esqr." seems to have absconded with CLP's letter to Christiana, the enclosed money, and the journal. On May 24, CWP wrote to Henry Robinson asking him if he knew anybody in Baltimore by that name, detailing CLP's entrusting to the man a letter containing $125 and his journal of seven pages to bring to his wife in Philadelphia. This piece of bad luck seems to typify CLP's business experiences generally. See CWP to Henry Robinson, May 24, 1826, P-S, F:IIA/72B9–10; above, **261**.

8. "Man is the creature of the circumstance in which he is placed" was a phrase of the English socialist and industrial reformer Robert Owen (1771–1858). The sentence embodies Owen's conception of human malleability and the possibility of social reform. It was a common Owenite catch-phrase reiterated throughout his writings, including most prominently *A New View of Society* (London, 1813; first American ed., New York, 1825), the subtitle of which is *Essays on the Formation of Human Character*. Although most literary sources place the phrase in Owen's *The Philanthropist*, which was not published until 1836, it must have appeared earlier in Owen's writings given RuP's quotation of it at this time. RuP may have either read works by Owen—in particular, a pamphlet reprint of his speeches—or actually have heard him lecture in New York City during his American trip of 1824–25. *The Macmillan Book of Proverbs, Maxims, and Famous Phrases* (New York, 1965), p. 356; Frank Podmore, *Robert Owen: A Biography* (1906; reprint ed., New York, 1968), p. 112; *DNB*; *DAB*; *NUC*.

EDITORIAL NOTE: *The Philadelphia Museum: From the Statehouse to the Arcade, 1825–1827*

Tired of continually having to bargain with the City of Philadelphia over the terms of his lease of the Statehouse (or Independence Hall, as it became known after 1824), and eager to continue expanding the museum's collections, in 1825 Peale welcomed the plans announced by a group of developers to construct for commercial purposes a huge building complex to be called the Philadelphia Arcade. Intended to house both offices and shops, the building was designed to occupy an entire central city block between Sixth and Seventh Streets on North Chestnut. The Arcade was modeled after London's fashionable Burlington Arcade. With its extensive frontage of 109 feet and depth of 150 feet and its handsome neoclassical design, the work of architect John Haviland, the

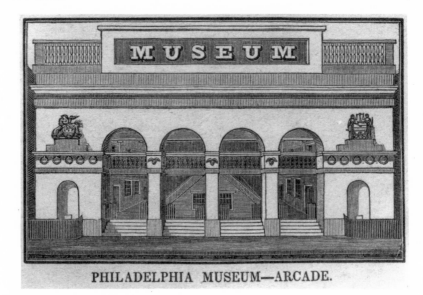

PHILADELPHIA MUSEUM—ARCADE.

60. *Philadelphia Museum—Arcade.* Unidentified artist, ca. 1831. Engraving, 4 ¼ × 2 ³/₄" (11 × 7 cm). Frontispiece to Titian Ramsay Peale, *Circular of the Philadelphia Museum containing Directions for the Preparation and Preservation of Objects of Natural History*, (Philadelphia, 1831). The Historical Society of Pennsylvania.

Arcade offered Peale an entire floor containing five well-lighted rooms and topped by a glass roof or skylight in a fireproof building. The presence of retail stores and offices promised an active center where large numbers would congregate, a situation that would surely benefit the museum. Peale also hoped that the enlarged space would make it possible "to have the articles disposed in classical order, so that it [the museum] shall not only be beautiful, but highly useful for study" (Fig. 60).

A joint stock venture, the Arcade opened its subscription books on October 20, 1825. Negotiations between Peale and the managers were protracted, and agreement was not reached until 1826, when the annual rent was established at $1,500. The cornerstone of the building was laid on May 3, 1826, with completion scheduled for the summer of 1827. Peale's anticipation of the event stimulated him to purchase new collections and make plans for rearranging his exhibitions.

Peale's decision to remove his museum from the Statehouse had a long history. Since 1810, he had been involved in discussions with Philadelphia's Common Councils over rental charges and especially over his wish to extend the museum above proposed additions to the building (see *Peale*

Papers, 3:1–2). It is possible, however, that the impetus for his decision to move to the Arcade in 1826 came from the criticism attending his and the museum's activities during the visit of the Marquis de Lafayette. The debate over private gain and public benefit that had always attended discussion of public support of the museum assumed greater seriousness as a result—at least in part—of Peale's commercial venture of renting viewing space for the Lafayette parade from the museum's windows.

The effort of the managers of the celebration to exclude Peale and his museum as much as possible from participation in the day's events also probably injured the aging museum keeper's pride in his great achievement. Keen on making Independence Hall the shrine of the Revolution, the city authorities could not reconcile the museum, with its conglomeration of exhibits and its private, profit-making character, with their ideal of a hallowed civic space. Peale's decision to move his museum not only signaled the end of his effort to encourage state support of cultural institutions, but it also heralded the new entrepreneurial world of the nineteenth century.*

* C. W. Peale to Mr. Lawrence, May 24, 1826, P-S, F:IIA/72B11; CWP to APR, July 18, 1826, P-S, F:IIA/72C13–14; "The Philadelphia Arcade," *PMHB* 41 (1917):378–80; Sidney Hart and David C. Ward, "The Waning of an Enlightenment Ideal: Charles Willson Peale's Philadelphia Museum, 1790–1820," in Lillian B. Miller and David C. Ward, eds., *New Perspectives on Charles Willson Peale* (Pittsburgh, 1991), pp. 219–36; Marc H. Miller, "Lafayette's Farewell Tour of America, 1824–25: A Study of the Pageantry and Public Portraiture" (Ph.D. diss., New York University, 1979), p. 115; Sellers, *Mr. Peale's Museum*, p.258.

263. RuP to BFP
NEW YORK. MAY 9, 1826

New York May 9, 1826.

Dr. Brother.

My Father yesterday received a letter from Titian[1] who appeared anxious to learn the particulars of his being thrown down by a cart, or carriage in Chatham St. some days since— I didnot hear of it until the next day when he told us of it at the breakfast table, so you may suppose he was not much hurt— Dr. Hosack being in his gig near the spot, insisted on his getting in with him, which he did but was not hurt.[2]

I hope that Coleman, as one of the directors will ⟨close⟩ make the arrangement with the Arcade committee,[3] as my Father intends leaving it altogether to the Trustees, as well as the management of the museum which I think will be perfectly correct, for them to make the appointment of manager &c.

We have commenced house keeping and have nearly got settled in our small house. The museum is doing tolerably well, receiving from 25 to 30 $ pr day.

The last accounts from Balt. was 133$ & 101$ for the two weeks since I left there. And with regard to your letter of the 2d.[4] I have only to observe it was my wish to render you a little more comfort than you at present enjoy and likely to enjoy.

As I have taken the responsibility on my own head, it is my wish, to place it in that situation, that I shall have no uneasiness of mind about it, and this will be better done, by your being there than any other of the name—and the name is of considerable consequence to us. With regard to the sum named by me, ⟨it⟩ I had not fixed it as a sum not to be deviated from but expected you would name one that you would be satisfied with as I said before it would be better that half of the clear receipts, would be the best method of rewarding, yet a stipulated amount would warrent your leaving the present situation, not that I would encourage it in the least degree, but the uncertainty of your permanency, makes it worthy of your consideration. After I wrote my last letter to you,[5] Eliza told me she thought I had done extreamily wrong in naming 800 instead of a thousand dollars, that you would expect it, & it would make no material difference to me, my reply was that I had urged your naming any objection to the proposition, that the sum was not an object with me, ⟨but th⟩ and would not be so considered. Therefore you must not receive the proposition of 8 as my valuation of your time & talents—that if it pleases you to receive 1000 dollars a year certainly it will give me the same pleasure—and herafter, when it shall be removed into Market St, I have no doubt of its yealding a much better profit to us. And with respect to the expence I gave you the extream amount.

I donot want, that you should decide hastely, but that it must necessarily want a head, is very certain. And on that account I would wish an early desission. Mrs. Atkinson says "we go on much better than when Mr. W.[6] was here, that all is quiet and harmony"that James does double the work that he formerly did and is obliging".

I should be very sorry that any one should suppose that I have offered you any inducements to relinquish an Institution which is as dear to me, as to any other member of our family, on the contrary, I would rather let my own institution suffer ⟨rather⟩ than deprive my father's, of any member of it—so that if you see any probability of your being further employed in it to any advantage to yourself donot quitt it on any account, I shall decide very soon to sell all my interest in it, unless you do undertake it.

Last night, the american Museum[7] had their Band of Music for the first time this season, and I think that after deducting their expence of it, that,

their amount of money cannot exceed mine which was 25$. They seem very uncomfortable toward me, they scarcely speak of late, I think their income must be one third less since I have opened than it formerly was.

I think my Father will not be ready to leave N York until the last of this week, he has finished the set of teeth for the lady[8] and has Rembrandt's very forward. He seems decided now, that the buisness of the museum should be placed in the hands of the trustees, especially as there is a prospect of it's being placed in the arcade, and then he will have no care about it or anxiety. which I think will be much the best—for himself as well as for the museum. If it were possible for me to spare a little time, I should like to be with Mr. Haverland[9] to aid him in planning some little matters in the general arrangements—but I cannot anticipate this pleasure. My Father has just come in and has red this and desires me to say that he would have written to Titian but he is so much hurried that he cannot write this day, and he is much obliged to him for his letter—and approves of the above, he has read your letter as well as this and my former ones and thinks I cannot say more on the subject—

Present my best respects to all enquiring friends & believe me your affectionate brother

<div style="text-align: right">Rubens Peale</div>

ALS, 4pp.
PPAmP: Peale-Sellers Papers

1. Unlocated.
2. Dr. David Hosack's residence was at 85 Chambers Street, close to RuP's at 43 Chambers; therefore it is not so unlikely that Hosack would be passing by just as CWP's accident occurred. There are no other details concerning the accident. *New York City Directory* (*1826–27*).
3. Coleman Sellers was a member of the museum's board of trustees. The founding "managers" of the Arcade, who may have constituted its committee, were William Boyd, gentleman; E. S. Burd, lawyer; James Burke, clothier; Thomas Cadwalader, lawyer; John Y. Clark, physician; John R. Coxe, physician; William Davidson, lawyer; Levi Ellmaker, merchant; James M. Linnard, lumber merchant; Josiah Randall, lawyer; Thomas Sparks, plumber and shot manufacturer; and Cornelius Stevenson, city tax collector. "The Philadelphia Arcade," *PMHB* 41 (1917):378; *Philadelphia Directory* (*1825*).
4. Unlocated.
5. Above, **262**.
6. William Wood.
7. The American Museum of John Scudder (1775–1821), located in the Old Alms House as part of the New York Institution, was managed after Scudder's death by a group of trustees headed by Cornelius Bogert. As RuP notes here, the American Museum responded to the challenge of RuP's museum and other cultural institutions in New York City by expanding its permanent collection and by adding popular, sometimes sensational, exhibitions, concerts, and other public programs. While this policy did temporarily increase attendance, in the long run it affected the museum's status adversely by suggesting to the city authorities that it had abrogated its cultural and educational mission for commercial gain. The museum lost the benefits of its status as a municipal museum, and by 1830 it had suffered severe financial losses. The museum petered out through the late 1830s, and,

ultimately, its collection was sold to P. T. Barnum. Loyd Haberly, "The American Museum from Baker to Barnum," *The New-York Historical Society Quarterly* 43 (1959):281–86; *Peale Papers*, 3:493n.

8. Anne Lawrence. See below, **276**.

9. John Haviland was both architect and contractor for the Philadelphia Arcade. *DAB*.

264. ReP to William W. Boardman[1]

NEW YORK. MAY 10, 1826

New York May 10. 1826

Dear Sir

I have to acknowledge the receipt of your kind & polite letter,[2] by which I learn what I should otherwise not have known, that the Session of your Legislature ⟨was⟩ is to be of very short duration, which will render it necessary that I should speedily appear with my *National Portrait* in your city. I have therefore concluded to suspend my labours here and be in N. Haven on Wednesday or Thursday next, together with Your Portrait[3] which will entitle me to the pleasure of a tête-a-tête with you.

I have likewise received by Yesterday's Mail the Herald of tuesday, containing the Governors Message, in which I hold a niche, and an elegantly written highly complimentary paragraph in favour of my Portrait.[4] I shall be much gratified if Gov. Wolcott[5] should approve it equally with Col. Talmadge,[6] who has written me a letter, which it will be well to publish as soon as my Picture is fixed to be seen.

I think likewise of bringing my Fayette to You, with the hope that it may be seen with some interest where he first was received after New York. I shall certainly not be displeased to make a few engagements for my pencil in New Haven, especially as I am about to go to Boston where I shall probably stay some time, chiefly to pursue my Lithographic purposes, near the only press in America from which good impressions have as yet proceeded.[7]

Accept my unfeigned thanks
And believe me

Very respectfully
Yours
Rembrandt Peale

ALS, 2pp.
CtY

1. William Whiting Boardman (1794–1871) was a Connecticut lawyer, judge, and politician who served several terms in both the state and national House of Representatives. Boardman was judge of probate in the New Haven District Court (1825–29) before being elected in 1830 to the state senate. Franklin B. Dexter, *Biographical Sketches of the Graduates of*

61. *William Whiting Boardman*. Rembrandt Peale, ca. 1828. Oil on canvas, 29 ½ × 24 ³/₈″ (75 × 62 cm). The Berkshire Museum, Pittsfield, Ma. Gift of Louise B. Crane, 1994, 5.1.

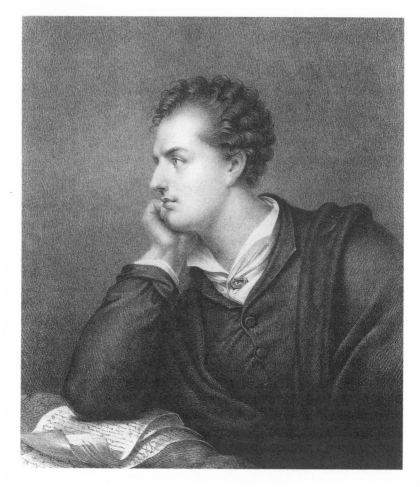

62. *Lord Byron*. Rembrandt Peale, 1825. Lithograph on paper, 9 ³/₄ × 8 ³/₈″ (24.7 × 21.2 cm). National Museum of American Art, Smithsonian Institution, Gift of International Business Machines Corporation.

Yale College, vol. 6: September 1805-September 1815 (New Haven, Conn., 1912), pp. 450–51; *BDAC*.

2. Unlocated.

3. (Fig. 61).

4. Since May 10, 1826, fell on a Wednesday, ReP probably means the edition of the New Haven *Herald* that appeared either the previous day (the ninth) or, more likely, May 2.

5. Oliver Wolcott (1760–1833) of Connecticut served as secretary of the treasury during the second Washington administration and, until his resignation in 1800, in Adams's. After accumulating wealth as a merchant and banker, Wolcott reentered politics and was elected governor of Connecticut in 1817, holding the office until 1827. *DAB*.

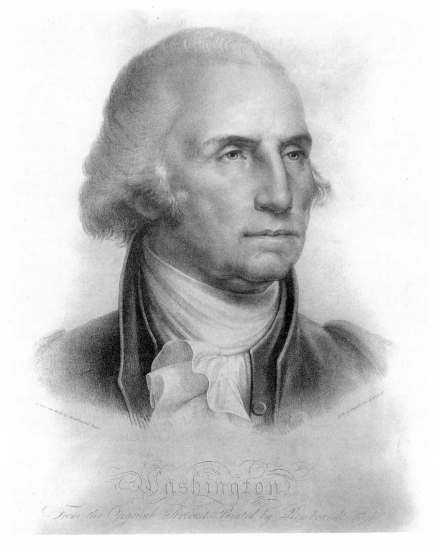

63. *Washington*. Rembrandt Peale, ca. 1832–33. Lithograph, 21 ⁵/₈ × 15″.
Corcoran Gallery of Art, Washington, D.C.

6. Benjamin Tallmadge (1754–1835), Revolutionary soldier and Congressman from Connecticut, saw distinguished service during the Revolution and was promoted to brevet lieutenant colonel on September 30, 1783. After the war, he served (1801–17) eight terms as a Federalist representative to the United States Congress. Thereafter, he lived as a merchant in Litchfield (Conn.). Tallmadge's letter is unlocated. *DAB*.

7. ReP had already experimented with lithography in New York in 1826, producing the lithograph of *Lord Byron* (fig. 62), but was intrigued by the fine prints being produced by the brothers William and John B. Pendleton, with whom he had already been associated in his gas works in Baltimore and through John's management of the *Court of Death*. In the mid-1820s, John studied lithography in France, returning in 1825 with training and materials. With the help of two knowledgeable French assistants he became the first lithographic printer in the United States. He and his brother founded the firm of W.S. & J.B. Pendleton in Boston, and their work began appearing in periodicals in 1825. Apparently, John suggested to ReP that he join them in Boston, an invitation that ReP was quick to accept since he was eager to capitalize on the new technology as a method of popularizing and widely disseminating his image of Washington. Later this year, ReP produced a lithographic portrait of the *Patriae Pater* that won a silver medal at the Franklin Institute the following year (fig. 63). *DAB*; John A. Mahey, "Lithographs by Rembrandt Peale," *Antiques* 97 (1970):236–37, 241–42; Miller, *In Pursuit of Fame*, p. 149; *Peale Papers*, 3:843n.

265. CWP to RuP

PHILADELPHIA. MAY 30, 1826

Philadelphia May 30th. 1826.

Dear Rubens

Mr. Wilsons son in law Mr. Wood[1] going to your City gives me the opportunity of giving you a few lines not worth postage. Mr. Wilson wishes you to give his son *if convenient* what you owe him as it will save him the trouble of writing my mentioning it in my letter. I wish you to send my Magic Lanthorn Slide by some safe hand. Pr.haps Ruben Haines may have a trunk in which it may come safe.

You will find by the enclosed that I have published myself,[2] and some two or three persons have called on me, but they as I suspect were too poor to pay my price, being of the cloath. There is no determination about the museum and the arcade. I told Mr. Burd[3] chairman of the committee to consult with me, that all the upper part must be appropriated to that purpose—and that I had told the Trustee's that I wished them to take the charge of disposing the Museum in such a way as it should be advantageous to Philada. and an honour to the United States, that I was not willing to pay a stipulated sum as rent but a certain pr.centage on the gross income, that Coleman Sellers thought it should be 12 pr.Ct. Mr. Burd reported that rent as not sufficient. he ought not to have acted on my conversation but waited for the determination of the trustee's and I understand that it will be taken up again. they have 12 directers who are to judge on what is best to be done. and several of the acting men say that the

Museum must have a place there. how it will end I know not, for Coleman has another place in view, The House that Wall built at the corner of 6th. & Chesnut, the lot runing back to George street. This House is purchased by Swaine & the cashier of the Trades mens bank.[4] and they agree to build fireproof Stores on 7th. street of one story 40 feet deep, over which to build for the Museum in length 160 feet, to have an entrance in chesnut street of the west wing of the House. The Stable which in George street is perhaps 30 or 40 feet square, to be also appropriated to to the use of the Museum. but I hope it will not, being placed between two stools fall to the ground.[5]

I do not hear what Franklin intends to do. Coleman told him that he thought he ought to accept your offer—and when I came home I told him that you was anxious to hear from him. he replied that he had some serious questions to make before he could determine, I asked him what they were, he said it was whether I would give him the same as I gave Titian, I told him 600 $ Pr year, but that he must pay out of it Eliza's cost at the Hospital, he said he would not, but he would expect his salary— I told my Nephew James to make the settlement of our accounts and to deduct the Hospital bill—thus the matter stands at present—I will not advice— my Children shall not have cause to blame me—as usial, *the young think the old are fools.*

Do the quakers visit in numbers your Museum? can you tell me whether Mrs. Lawrence & her daughter[6] has paid it the long visit as they intended? has Rembrandt come back? & what his success.? I do not know when Betsey Behnn will come here, Rosalba says that she proposes to come by the way of Harrisburgh and mentioned some company that was to be of the party, Sophonisba's Eliza will not visit visit new york untill some time hence.

The South American Gentleman that spoke to me about painting his portrait, I do not recollect if you was present at the time, in your Museum, but I believe he is from Brazil, Consul general, minister or what I know not,[7] nor do I recollect his Name, which I ought to have made a memorandum off and also his place of abode. If I had done this, I would have waited on him *but never mind* as Mr. Bovoise[8] used to say. You may tell Eliza that I am promised the sight of a Lady who is said to be exactly the thing wanted. I long for the sight. yet fear it will not do— If I was 45 instead of 85 there would be some chance in my favor— *I am young, and I am old, I am contented, and not contented, I am alone amidst company.*[9] I told Dr. Maise[10] yesterday, that I hoped to make 100 ladys happy, yet one would be enough for me. If I have no one to please, I have none to be offended with what I do. an accomplished sensible companion, good nature in abundance to forgive all follies, desirous to please & willing to be pleased with

moderate injoyments—are there such to be had? I believe there are, but how to meet and know them? There's the rub.

Titian complains that you have not answered his letter—[11]he says every letter should be answered, if only with a note to acknowledge the receipt of it.

Love to Eliza and the Children— Yrs. affectionately

CWPeale

Mr. Rubens Peale N. York.

ALS, 3pp.
PPAmP: Peale-Sellers—Letterbook 20

1. William Wilson, attendant at the museum. His son-in-law is unidentified. *Philadelphia Directory (1825)*.
2. CWP's advertisement ran as follows:

PORCELAIN TEETH

The Subscriber, during half a century, has practised making Artificial Teeth for his friends, and within the last twenty years for himself, knows experimentally, that they are essential to health and correct utterance of words, as well as ornamental to the individual.

Having within a few years experienced the superiority of PORCELAIN in sweetness, hardness and durability, he has confined his attention to this material, conquered the difficulties of execution, and attained a certainty of success in adapting the Teeth to the mouth, even in cases where few or none of the natural set are remaining, and without regard to the irregularity of the gums.

Convinced that he can render benefits above all price, to those who need his assistance, he informs the public that he shall for a few months devote himself to this business. For terms of operation which will be moderate to those who are sensible of the service, apply to the corner of Swanwick and Walnut streets, opposite the Washington Square.

C. W. Peale

Poulson's, May 27, 1826. See also the *National Gazette*, May 30, 1826.

3. Edward Shippen Burd was one of the twelve managers of the Arcade. "The Philadelphia Arcade," 378.
4. There are four men surnamed Swain in the *Philadelphia Directory (1825)*, all of whom were either artisans or petty proprietors, so no likely guess can be made as to which of them might have engaged in this kind of real estate transaction. The cashier of the Tradesman's Bank is unidentified; CWP may have been using an informal designation of the bank since there was no bank of this name in Philadelphia. He may have meant the Mechanics' Bank, the cashier of which was Thomas Fitch, or the Farmer's and Mechanic's Bank, the cashier of which was Henry Kuhl. *Philadelphia Directory (1825)*.
5. A proverb dating at least to Seneca (ca. 60 b.c.), meaning to lose an opportunity by being unable to make a choice. Burton Stevenson, comp., *The Macmillan Book of Proverbs, Maxims, and Famous Phrases* (New York, 1948), p. 2221.
6. The Lawrences were a New York family who may have resided earlier in Philadelphia. In 1802–03, while in London, ReP and RuP were befriended by a printer and bookseller named E. Lawrence. Lawrence and his family accompanied the young men back to Philadelphia; and to repay Lawrence's loan to his sons, CWP helped him establish a grocery business in the city. This may be the same family.

The daughter to whom CWP refers here was Anne Lawrence of Flushing, New York, for whom CWP was making a set of false teeth. A week before—on May 22—CWP sent her, a copy of "An Essay to Promote Domestic Happiness," together with a warm note addressed to

"Much respected Anne"; later, in September, he offered to make her another set of teeth "in my late improved method" for "the pleasure of serving." See CWP to Anne Lawrence, May 22, 1826, P-S, F:IIA/72B8; CWP to Anne Lawrence, September 29, 1826, P-S, F:IIA/72E8.

7. Unidentified. The chief Brazilian consular officer in the United States at this time was Manuel G. Dos Reis, interim chargé d'affaires and consul general, who was stationed at the embassy in Washington; he could have inquired about a portrait while visiting Philadelphia, but there is no information available to verify this. The Brazilian consul in Philadelphia was not a Brazilian, but an American named James Morrell. *Philadelphia Directory (1825, 1826)*; *Washington, District of Columbia Directory (1827)*.

8. CWP's old friend and fellow naturalist, A. M. F. J. Palisot de Beauvois (1752–1820); the saying was something of a watchword for Palisot de Beauvois. *Peale Papers*, 2:101n.

9. Betsy Bend seems to have been the matchmaker in this instance. See above, **259**.

10. Dr. James Mease (1771–1846) was active in many of Philadelphia's civic and scientific societies, including the APS, which he served as curator from 1824 to 1830. A prolific author, Mease was best known for his *Picture of Philadelphia* (Philadelphia, 1811), a guide as well as a social and cultural history of the city. *Peale Papers*, 2:416n; *DAB*.

11. Unlocated.

266. CWP to TRP[1]

MAY, 1826

You say that you cannot live on the saluary which I give you for your labours to improve the Museum and that I do nothing for its improvement, but choose to follow the profession of a Dentist to serve a number of old Maids—and that I will not allow you to improve the the Museum by which you could give me a comfortable living without any care, and blame me for not resigning my management of the museum, that the Trustee's of it, should be obleged to appoint others.

You know that the corporation of Philada. have oppressed me by making me pay 1200 $ Pr. Annm. Rent for upwards of 3 years and that the Individuals of that body generally told me that the rent should be lowered, and thus I was brought in debt to them to a large amount, and I was obleged to make payments to them by getting discounts at the farmer & Michannick Bank. and finding that year after year my hopes from the promises of the greatest number of the individuals composing each branch of the Corporation I found was not to be depended on, I was obleged to declare to the Boards that I could not pay so heavy a Rent that I must leave the State House, that then they ⟨then⟩ only lowered it to 600 $ P year. but having ordered me to remoove my apparatus for making *Gas* to illuminate the Museum, also to pull down the chimney in the steeple, by which I was enabled to warm the room of marine animals, and also to pull down the room I had built over the Stair-way for the conveniency of preserving animals and keeping those imployed who were to attend the door of the Museum—and that the rent should not be lowered untill all this was performed.

543

Having purchased the House in Walnut Street that I might have a permanant place to keep the articles accumal[at]ing for the Museum and also room to prepare subjects. I have sold the farm for a less sum than would clear myself of the debt of the Museum and the residue of payments for the said House. and still have a debt of 2600 $ to pay for the said house besides a consederable ballance of Rent ⟨to⟩ yet due to the Corporation for arrearages of Rent. Having made this statement of my Situation I shall now state certain questions to you and require answers to them.

1st. Have I not offered you the whole Management of the Museum for $3000 Pr. Year, you taking all the cost of it on yourselves (I mean Franklin with you)

2d. Can I afford to give you a larger sallery than $600 Pr. year with the debts I owe—

3d. have I not said that your Sallery shall be raised when the Museum is remooved into the arcade

4th. are you not oblegated to devote all your time for the improvement of the Museum when I pay you such Salary This question is ment for each of you.

5th. ought I not to be excused from labouring for the museum when I pay each of you to perform that work.

6th. ought I not to do any sort of work that is not dishonorable in order to clear myself of debts

7th. Do you know that I am capable of any other employment more likely to relieve myself of Debt than that of a Dentist

8th. Is it ⟨a⟩ discreditable to me to continue a work in which I believe I am serving my fellow mortals and by so doing I cannot injure any one

9th. have I not done the best according to my judgement and abilities towards all my Children—and

10th. and las[t]ly am I not entitled to live at my ease and to persue such employment as may please my fancy during the remainder of my life, without the censure of any of my family

AL, 4pp.
PPAmP: Peale-Sellers Papers

1. This letter does not have an addressee, and CWP may never have sent it. The draft, however, is clearly meant for TRP, but the comment "This question is ment for each of you" suggests that CWP may have written a similar or identical letter (unlocated) to BFP. At the least, CWP meant to have TRP share this letter with his brother.

The dating of this letter is conjectural. Given the rather sketchy details mentioned by CWP, it could have been written between May 3, when the cornerstone of the Arcade was laid, and May 27, when CWP's first advertisement of his availability to make porcelain teeth appeared. The advertisement sparked much family dissension and demeaning commentary about CWP's role as a dentist. On May 30, CWP hinted at the problem in his letter to RuP (above, **265**) and described his offer to BFP, which was similar to the one made to TRP in this letter. *Poulson's*, May 27, 1826; *National Gazette*, May 30, 1826.

267. CWP to RuP

Philada. June 27th. 1826.

Dear Rubens

as this scrole will cost you nothing I shall write you a letter of nothing account. I went last week to Mr. Guy Brians about 10 miles from the City, to paint the Portrait of Timothy Matlack.[1] I began it on wednesday morning and finished it on friday morning, made a packing case for it that afternoon and returned here on the saterday Morning—found Betsey Behn here, and Mr. Brian & his sick wife desired to see her, therefore on tuesday evening last, we took the Stage which goes within a short distance of Mr. Brians— I do not know if you was ever at his place, but it is one of the most delightful of any that I know in this country, being one mile from the Delaware, which is seen through the tree's at several openings— His Mansion in [is] on high ground which gentley falls on every side, and around are gravel walks, laid out in the highest taste— we feasted on Rasberrys and cream Morning noon and night—His table well stored with great variety of dainties, and for those who love wine he gives a variety— while I had some thing to do I was content to partake of his hospitality and he was so obleging as to offer to bring us to the City on tommo[ro]w or the next day, therefore I left Betsey Behn to come with him, as remarked before, I liked not to be without employment.

My Picture of Mr. Matlack as far as I have yet heard is much admired, his long white beard and Brown velvet cap makes it a singular Picture. his age 93 wrote on the back painted by CWPeale in 1826 of 85 years.[2] Had I made it a practice to put the dates &c on the back of all those I painted in the revolutionary war they would be valuable records. The arcade goes on rapidly & I believe that my Museum will have a place in it—The whole of the upper part to be appropriated for that purpose. The Trustee's have offered them 1500$ Pr. Anm. Rent for 10 years at our pleasure to be renewed for 10 Years more. what other conditions I do not know, it will be ready to receive the Museum in April next, so said— There is some objections to it, such as the expence of warming, and persons to attend the different appartments. I presume you know the model and therefore can form your judgement on the arrangement. but if it is necessary, another letter will more fully detail it.

Love to Eliza and the Children. Oh I had forgot to say that I have not yet learned whether Betsey Behn intends to visit N. York. She had a promise of me when I was in Baltemore to accompany her if she visited N. York, but I have not spoken to her on the subject as yet.[3] I find that I can make whole setts of Porcelain teeth without the metal bottoms, having suc-

ceeded admirably in a sett for myself. but it appears somewhat strainge to me that I have nothing on hand at present although my advertizment has been often in the papers—[4] several have been to inquire my price & some have said that they mean to give me employment. It is not impossible that I shall be able to lower the price of those made entirely of Porcelain, yet I will not offer it untill I have done some of them for others, after which I shall be able to form a judgement of the difficulties as well as all the advantages to be gained. Eleoner is about selling her furniture by au[c]tion, I have not heard on what account—[5] I have not had a line from Rembrandt since I returned home—nor do I know whether Franklin will accecpt your offer—all that I know is, that his female friends wish him to stay in Philda. yrs. affectionately

CWPeale

Mr. Rubens Peale N. York

ALS, 3pp.
PPAmP: Peale-Sellers Papers—Letterbook 20

1. Fig. 59. See above, **256.**
2. If Matlack reported his age accurately, CWP's inscription would indicate that Matlack was born in 1733. Previous biographical authorities have given the tentative date of around 1730. *Peale Papers*, 1:282.
3. To CWP's relief, Betsey Bend decided not to go to New York City. See below, **269.**
4. For CWP's advertisement, see above, **265.**
5. Eleanor (Mrs. ReP) Peale was selling her furniture preparatory to a move to Boston, where ReP was in the process of renting a house for the family. See below, **275.**

268. CWP to RuP

PHILADELPHIA. JULY 9, 1826

Philada. July 9th. 1826.
Dear Rubens,
I could not believe the death of Mr. Jefferson by the first report received—I thought it might be a speculating report, but wonderfully strainge that two of the Committee to report on the expediency of a declarance of our Independance (I believe of the No. 5) should die on the same day 50 years after they had signed & reported it.[1] I wish to know what was your income on the 4th. we had no, or very little parade here, we received a little over 80 $ in both day & night aded togather. Titian with Eliza. and Child, and also Franklin went off for long branch on saterday last intending to spend a week at the Sea shore.
The stock holders of the arcade have not yet acted on the proposition of the Trustee's, The offer of 1500$ rent is the most which they will agree to pay annually—but Mr. Haveland is proceeding with the work on the

supposition that it will be so settled— He drew his plans for the receipt of the museum, and laid it before them (committee), and he tells me that he is carrying on the work on the supposition that the offer will be accepted.

I think it very probable that I shall get work in making solid setts of porcelain Teeth, I have this day finished a sett for my self which promises to give me much comfort, after I have made this kind for others I can then determine whether I can afford them at a lower price than those of metal bottoms. Planteau has returned to Philda. I have not yet seen him, but I under stand that he made nothing of his Steam engine business.[2] I have retained Eliza letter to Peggy Shippen, as I do not know where it will find her.

I have painted the portrait of Mr. Timothy Matlack, it is a good portrait so like as be known by several of his acquaintance in spite off his long *white beard*.

Betsey Behn is still here and the other day told me that she did not intend to visit New York at present. so that my mind is at rest on that score— for I held myself engaged to go with her should she have intended it.

Doctr. Godman has promised me to write something for me on the advantage of my mode of making teeth— It is a matter of much wonder with me that so many people are ignorant of arteficial teeth being of such immence use—very [few] People know that a person having them can masticate their food—I am constantly asked, can I eat with them? Doctr Godman must give you further knowledge of what is doing here.

<div align="right">Love to Eliza & Children.
adieu. CWPeale</div>

Mr. Rubens Peale
 N York.

ALS, 2pp.
PPAmP: Peale-Sellers Papers—Letterbook 20

1. The news of Jefferson's and John Adams's deaths on July 4 reached Philadelphia at the same time and was reported in the Saturday morning edition of *Poulson's* (July 8, 1826). As is well known because of Adams's poignantly erroneous final words ("Thomas Jefferson still survives"), Jefferson predeceased Adams. The news of their passing was received throughout the United States with amazement, and it was frequently asserted that their deaths could not have been a mere coincidence, but rather an act of divinity. On the secular side, an elaborate civic day of mourning was held in Philadelphia on July 24. Scharf, *Phila.*, 1:618; Merrill D. Peterson, *The Jefferson Image in the American Mind* (New York, 1960), pp. 3–14.

The committee appointed by the Continental Congress on June 11, 1776, to prepare a declaration of independence consisted of Jefferson, Adams, Benjamin Franklin, Robert Livingston, and Roger Sherman.

2. The dentist Anthony Plantou had left his practice of dentistry in 1824 to form a joint stock company with the Philadelphia mechanic and inventor Joseph Hawkins (b. 1772) for running a steamboat line between Philadelphia and Cape May, New Jersey. The steamboats were powered by an innovative engine developed by Hawkins in which water was injected

into the piston cylinders and was converted to steam, thus eliminating the separate production of steam under pressure in a boiler. The company failed in 1826. Scharf, *Phila.*, 1:1639–40, 3:2263; Eugene S. Ferguson, ed., *Early Engineering Reminiscences (1815–40) of George Escol Sellers* (Washington, D.C., 1965), pp. 26–27.

269. CWP to ReP

PHILADELPHIA. JULY 9, 1826

Philada. July 9th. 1826

Dear Rembrandt

Having published in the news papers[1] that I would devote a few months exclusively to making porcelain teeth I had expected to get full employment as every one who possesses one grain of sence must know how much they are superior to those made of any animal substance, and as I have not had the applications I expected I will suppose that all the Dentists must have spoken against that substance—it is natural that they should support their practice by argument. Yet with out encouragement I do not slack my labour because I know that by my practice and study I shall level all obstructions and obtain perfection. I have now made a sett for my self without the metal bottoms, which sett perfectly easey on my Gums, and I can masticate any food that I wish to eat with ease and facility. and with this further advantage of having a smoother surface at the base of the teeth, which enables my tongue to remoove the minced food, and rincing with a little water cleans my mouth without the use of the tooth- brush. But my study of the Natural form of the humane jaws and their furniture of teeth I have now overcome a difficulty which has very much perplexed me in many setts that I have made, that is, the twist ing either to the right or left of the upper teeth. In several instances I have made a 2d piece before my work could be acceptable. I do not yet know whether I can make a sett in this new method with the ease which will enable me to reduce the price from 150, to 100$ nor can I assertain what time I shall save by the solid setts, but I know this must be a consequence in this method, that I must very often be heating my furnace which is a hot work, and ought not to take place for single peices. To provide for doing several at one time I have ordered a larger furnace with muffles to hold double the number of teeth that I have usially done. I wish you had said something about your teeth in your letter,[2] I want to know that you find comfort with them.

In a former letter[3] you said that you put in your account of cash received from me, opposite the two portraits, Doctr. Michel and Mr. Clinton without the prices to them, therefore I remind you that you wrote in your

548

letter about Doctr. Michel that you charged 40$ for it—I desired you to paint the portrait of Govr. Clinton for me with the hope that by painting that distinguished Gentleman it would produce you other Pictures, and give you celebrity. One of your letters say the picture of Prince Charles is for my Museum.[4] I wish to have it and I also most earnestly wish that I could get out of debt, I mean debts for which I am paying 6 pr. Ct. If I do not make money by my porcelain teeth, I will get it by painting cheap portraits—I could do them at 25$ and make money by my pencil. Doctr Godman will tell you what you may further wish to know respecting us

<div align="right">affectionately yrs. CWPeale</div>

Mr. Rembt Peale N. York.

ALS, 2pp.
PPAmP: Peale-Sellers Papers—Letterbook 20

 1. See above, **265**. CWP started running a more detailed advertisement in July, probably in response to the competition that he began to experience from Plantou, who had resumed his practice and begun advertising (see *Poulson's*, June 20, July 11, 1826).
 2. Unlocated.
 3. ReP's letter to CWP about the portraits of Samuel Latham Mitchill and DeWitt Clinton, which he painted for the museum in 1822 and 1823, respectively, is unlocated. For CWP's commission of the portraits, see above, **76**, **77**. On December 7, 1822, CWP sent ReP $20, possibly on account (P-S, F:IIA/68A2–3).
 4. See above, **251**.

270. CWP to ReP

PHILADELPHIA. JULY 19, 1826

<div align="right">Philada. July 19th. 1826.</div>

Dear Rembrandt

 You do not inform me how you make out with your teeth—Doctr Godman tells me that he did not see you use them while he was in New York.

 I should suppose if any part of them hurts your Gums, that you are artist enough to remoove the evil. I have succeeded perfectly in making them of each jaw of intire porcelain, and find them comfortable with this advantage that being of a more even surface within, the food is sooner remooved, my tongue can allmost perform the office of a brush. and the first customers to have for whole setts. I shall try my skill to make them in this new mode but I will not engage to do them at a cheaper rate than if made with Silvor plates—yet I am not without hopes that I shall afford them for a less sum by my practice. Yet I must be very often heating my furnace which is not a pleasant work. It appears that I have many applicants since a communication made by Doctr. Godman in the papers—[1]

and the prospect is of getting much to do. but too many apply who cannot afford to pay my price. but the demand of half price on taking the mould will rid me of troublesome customers.

I send you enclosed $ being the ballance due you for the Auction goods—deducting the money I paid to Eleoner—the account of the sale I will reserve for some private conveyance.[2]

I am sorry to hear that you have so little employment, and I am fearfull that the dashing people of New York will make but little work for artists. The first necessaries of life must be abundant before families can afford to have their Portraits painted.

It appears from what I can learn from Mr. Heavyland [Haviland] that the Stock holders will acceed to the offer of the Trustee's to let the Museum be placed in the upper part of the arcade for a rent of 1500 $. The work goes on very rapidly. having now nearly made the arched brick work over the ground floor. I am rather apprehensive that my situation at the topp of the building will be rather hot in the summer season—but I shall urge Mr. Heverland to let me have many openings to let in air.

There is little doubt that the income will be much encreased by the change of place, yet if I could get room over the fireproof offices, that it would be more desireable, a more agreable situation. I have only to add love to Eleaner & children and wishing you health and full imployment as essential to happiness—yours

affectionately CWPeale

Mr. Rembrandt Peale
 New York.

ALS, 2pp.
PPAmP: Peale-Sellers Papers—Letterbook 20

1. See above, **265**.
2. See above, **267**.

271. CWP to Thomas Parsons[1]
PHILADELPHIA. JULY 26, 1826

Philada. July 26. 1826.

Dear Sir

It is only of late, not more than 3 Months since I have determined to follow the business of making Porcelain teeth to serve the Public. upwards of three years I have made them for my particular friends, relations and myself, but knowing, or rather believing, that this labour being of considerable importance more than that of painting portraits or in short any

other imployment that I can do— I am prepairing furnaces to extend the work after which I shall be willing to aid dentists with Porcelain teeth in several forms—but of late I have found it difficult to procure Platina except at ⟨the⟩ a tribble price—but it can be had in Paris & London, and from thence will procure it. At the last time I sent to London for Platina, the Merchant was requested to send a few specimens of Platina teeth for my inspection, but the merchant finding that they demanded the exorbitant of 35/ Pr. Tooth, he did not send them. requesting further order— It was fortunate that he did not send them, as I suppose a sufficient profit may be made at one Dollar Pr. Tooth.

I know Mr. Counsey's[2] method of making teeth, & approve of it more than of other artists— when I have advanced in my work will write to you again, with

respect your friend CWPeale

To Thomas W. Parsons Esqr. Boston

ALS, 1p.
PPAmP: Peale-Sellers Papers—Letterbook 20

1. An English immigrant, Thomas W. Parsons received his M.D. from Harvard in 1818 and practiced both as a physician and as a dentist at 17 Winter Street, Boston. *DAB*; *Boston Directory (1826)*.
2. Unidentified.

272. RuP to BFP

NEW YORK. AUGUST 12, 13, 1826

New York August 12th. 1826.

Dr. Brother.

Will you inquire of Patty, whither she has the Phisiognotrace yet, and if she has, and is desirous of selling it to have it packed up and sent here with the price of it—[1] or any other one you may know of, the price must not exceed 15 dollars. I donot care how cheap it may be got—it is for a person who intends travelling with it, and the amount of it will be sent to you imediately on the receiving of it.

I visited Coney Island a few days ago with the Girls, and found very few shells or crabs. I have been to Hoboken, Staten Island &c.[2] and obtained some good minerals. I did intend going up to North River this morning but Mrs. Chadwick[3] was so unwell that she couldnot attend to the Museum. I have been adding to the minerals to send you and as soon as the *bucket* is full I will forward it.

The long expected box of shells from Tartola[4] has arrived and it con-

tains some fine ones—all the morning has been occupied in putting them in the museum, that is 2 of each kind, the others are for exchange.

Eliza and the children are all recovering slowly, from their caughing spells. Our business is dull in the extreme, I have only received 53,,75 day and night during the week. It has been raining incessantly for three days past and still continues to pour down, but from its thundering I think it will soon stop. Sunday morning 13th. Last evening Mr. Charles Poulson[5] Spent some time with me, he appears to be quite fond of shells and birds, another gentleman of Phila. was with him whose countinance is quite familiar to me. they appeared to be quite pleased with my small collection. Mrs. Atkinson tells me that Dr. Patterson[6] spent some time in the Museum and was more pleased with it than he expected to be, so I suppose he will think more favourable of your accepting the offers made by me.[7] Mrs. Atkinson says she cannot stay unless you will consent to take charge of it— for it is rather too much for her— I am surprised that she has done so well, she received last month 536,,12 1/4. compare it with the Phila. receipts. If on your visiting it you find it to your interest, to make the change, I shall then be induced to take steps to remove it to Market Street, where I have no hesitation in thinking the income will be increased two thousand dollars a year. I refrain from saying all that I think, on the subject, as you very naturally would think that self interest induced it—but my candid opinion is, that it will turn out much better ⟨than⟩ for you than any other prospect before you——besides I should not like that any of the family should say I persuaded you to leave the Phila. Museum— I only know you are not comfortable nor ever will be there, unless some change takes place that I donot forsee. Friends are few and when they profess, let us see how much they are our friends, advice is cheap, it costs nothing.

I remain your affectionate brother

Rubens Peale

ALS, 2pp.
PPAmP: Peale-Sellers Papers

1. Martha McGlathery (Mrs. RaP) Peale. For details on RaP's use of the physiognotrace, see *Peale Papers*, 2. It is not known to whom RuP was going to sell the physiognotrace.

2. Coney Island in southern Brooklyn, a seaside area on northern New York Harbor and the Atlantic Ocean, was already a popular resort at this time; it developed from the 1840s on into New York City's most popular recreation area. Hoboken was laid out as a town in northeastern New Jersey in 1804; Staten Island is a New York City borough some five miles across New York Bay from Manhattan, nearly touching New Jersey. Seltzer, ed., *Columbia Lippincott Gazetteer*, pp. 441, 790, 1823.

3. A worker in RuP's New York Museum.

4. Tortola is the largest island in the British West Indies, in the Lesser Antilles; it was settled in 1648. Seltzer, ed., *Columbia Lippincott Gazetteer*, p. 1933.

5. Charles A. Poulson is listed as "gentleman" at 96 South Fourth Street, Philadelphia. *Philadelphia Directory (1825)*.

6. Dr. Robert M. Patterson (1787–1854), vice provost and professor of natural philosophy at the University of Pennsylvania. *Philadelphia Directory (1825)*; *Peale Papers*, 3:10n. Dr. Patterson visited the Baltimore Museum.

7. See above, **262**.

273. CWP to Mrs. M. Bradish[1]

PHILADELPHIA. AUGUST 12, 1826

Philada. Augt. 12. 1826.

Madam

I hasten to inform you that when there is no teeth in the upper jaw, nor stumps in which pivots could hold up the artificial teeth they must be supported by springs attached to some artificial teeth below— very probably you may have lost some of your Jaw teeth below, and if so, then it is necessary to enquire if there is a vacancy to put in a piece ⟨of teeth⟩ in form of dufftail thus to which I would put the button to hold the lower

end of the Spring, The springs are of so happy a construction as be perfectly easey, and admit the opening of the mouth to its full stretch. Invented by the late John Dorsey formerly of this City—I knew the importance of Mr. Dorseys invention & therefore I have sent springs to Dentists in Europe, to give them this invention.[2] I have made many upper pieces and supported them by back Jaw teeth below (I mean artificial) and put a strong piece of metal to connect them on the inner side of the mouth. in which case I have received the full price 150$

Inclosed is my Card of prices. I ought to remark that many ladies wear teeth which I have made in this mode & masticate their food in comfort— one observation more and I believe I have fully answered your enquiries—in the instances which I allude to those ladies had not jaw teeth below—and their front teeth consisted of several different numbers— one lady with only two front teeth. others with 4, 6 or eight &c. Should you determine to visit Philada. for my service, I should inform you that the time necessary may be about 2 weeks, not longer unless your case should be extreemely difficult.

Altho' my card mentioned the silver plates Yet of late I have succeeded in making porcelain teeth connected togather in one piece. and which promises to become a valuable improovement. I wear a sett of this kind, and have great comfort with them. I think them much better than with the silver plates.

duribility. they never can wear out but may like other chinea be broken by carlessness. respectfully yours

CWPeale

Mrs. M. Bradish
 detroit

ALS, 2pp.
PPAmP: Peale-Sellers Papers—Letterbook 20

 1. Unidentified.
 2. John Syng Dorsey (1783–1818) was an anatomist and surgeon who taught at the University of Pennsylvania and practiced medicine in Philadelphia and at the Pennsylvania Hospital from 1804 until his death. Details about the spring are not known. *DAB*.

274. CWP to William Patterson and EPP
PHILADELPHIA. SEPTEMBER 19, 1826

Philada. Sepr 19th. 1826.
Dear William & Elizth.

 With a desire to give some income in addition to the producks of the Museum I have been devouted to the business of making Porcelain teeth for the whole of this summer, and in consequence of great application and Study, and a vast many expiriments, I have made vast improvements, addressed the publick on the importance of such teeth, at the first publication I had letters from many parts of the U.S. from persons wanting teeth,[1] which letters I answered and inclosed my card of prices, then to save myself the trouble of answering so many letters I made a 2d. address answering all the questions on the subject also stating my prices of Teeth. this measure has stoped the plague of letters, but my prices I suppose has prevented many who had written not to trouble me any further— I know that many people think my charges are too high, but I will not be confined to any such business without I can get a handsome reward for my labour. I get some work but not yet to great account.

 Enclosed I send you a Ten Dollar note of the United States, and I hope it will be some aid in your expence of building, my expences are very heavy on me, and I have yet too much interest to pay—which a hard ship on me, which not deserved from the City of Philada. the 1200 $ rent for the State-house, not being paid as it became due envolved me into my present delema— Rembrandt has gone to Boston & by the last acct. he is like to do well a painting-room & one for exhibition is errecting for him—[2] Rubens labours hard and is much re[s]pected in New York, his Museum is much admired and brings him many visitors, but his expences are very great— Your Sister Sophonisby is again in the family way, her

554

health tolerable, but rather delicate.[3] Linnius went in a ship of war to S. America last may & I have not heard from him since, he told me before he went away that he was determined to raise himself by his exertions—and would write to me in 6 weeks and send money for his family, he has failed to do so. wherfore I know not, but perhaps the government cannot pay their officers.[4] Sybilla well as usial, Titian at present sick but on the recovery. the rest of the family well. You may hear from me again when I can find a private conveyance, therefore if any of your neibours come here give me notice. May you have health and comfort is the prayer of your father

CWPeale

To Wm. & Elizth. Patterson
 Indiana[5]

ALS, 2pp.
PPAmP: Peale-Sellers Papers—Letterbook 20

 1. CWP received inquiries about his porcelain teeth from a number of people; see CWP to George Lauer, July 15, 1826, P-S, F:IIA/72C12; CWP to Mr. Eckbaum, July 22, 1826, P-S, F:IIA/72D5; CWP to John S. Miller, July 30, 1826, P-S, F:IIA/72D7; CWP to J. D. Butler, August 2, 1826, P-S, F:IIA/72D8; CWP to Samuel Batchelder, August 11, 1826, P-S, F:IIA/72D10; CWP to Elias Dawson, August 14, 1826, P-S, F:IIA/72D13.
 2. ReP's studio in Boston was at 2 Graphic Court, near the studio of Boston's preeminent artist, Washington Allston, and other portraitists. He remained in Boston, where he received the patronage of members of the Unitarian elite and professional men, until November 1828 (figs. 64, 65). See Miller, *In Pursuit of Fame*, pp. 149, 151.
 3. SPS would give birth to a son, Coleman, on January 28, 1827 (d. 1907). *CWP*, p. 442.
 4. CLP was a prisoner in Colombia. In the spring of 1826, the U.S. government arranged for his release and passage home, but the person to whom the money was paid absconded. One William Berwin in the consul's office personally paid the money in June, however, and CLP was on his way home when this letter was written. See William Berwin to CLP, June 27, 1826, P-S, F:XD/1E7–8; below, **275**.
 5. No information is available concerning the Pattersons' move to Indiana.

275. CWP to ReP

PHILADELPHIA. SEPTEMBER 24, 1826

Philada. Sepn. 24th, 1826.
Dear Rembrandt
 Your letter of the 17th[1] have given me much pleasure, as it appears that you are now in a good road to arrive at a permanant residence, your board and cost of rooms has for a long time been excessively high and not given you much comfort. and being seperated from your family so long must be grevious—[2] I have devoted myself intirely to making Porcelain teeth and I have made great improvements in my mode of constructing them. Although I had thought that it was impossible to make them in one solid

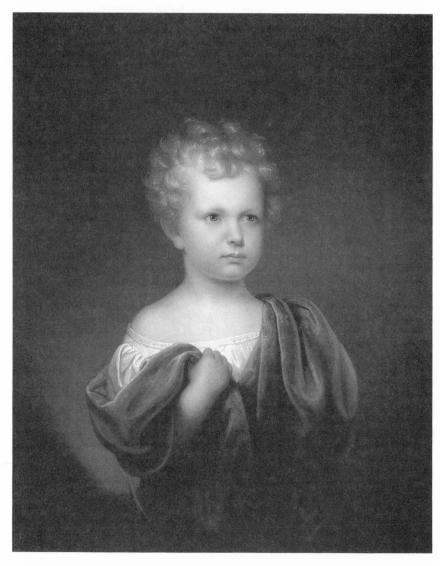

64. *Samuel Atkins Eliot*. Rembrandt Peale, 1826. Oil on canvas, 30 × 25″ (76.2 × 63.5 cm). Boston Athenaeum.

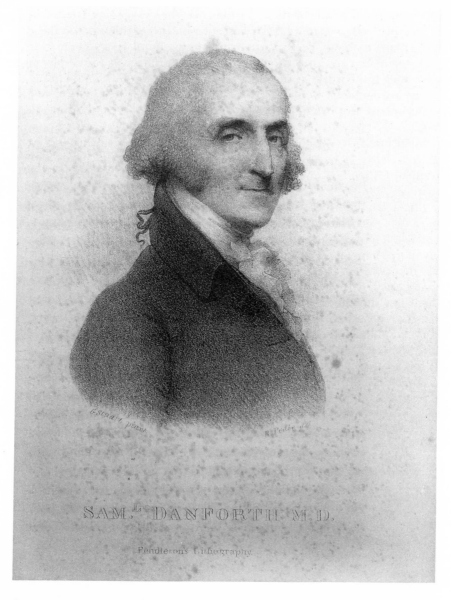

65. *Samuel Danforth, M.D.* Rembrandt Peale after Gilbert Stuart, 1828. Lithograph, 12 ³/₄ × 9 ⁵/₈″ (32.4 × 24.4 cm). Courtesy, American Antiquarian Society.

piece, on the account of their shrinking in the firing—yet I have succeeded perfectly well in several tryals: and now prefer this mode to that of using plates to solder Teeth on them. many have inquired about the use of such teeth, but my price doubtless prevent numbers from employing me—such is the world, if the price was one $ they would want them for a ¼ nay a 5 penny bit would be much— I shall not lower my price, and I shall contrive to work to get a Sufficency of work to keep me from Idleness.

I shall attend to your orders about the baise[3] this week, since the receipt of your letter. I have not had time to enquire about the prints to be framed. I hope Mr. Lucus had received them as you have directed them to him.[4]

I have lately purchased a valuable collection of Indian dresses &c the most complete that has ever been seen in Philada. some Indian traders had taken much pains to collect them, and they must have cost considerably more than what I gave for them—

Their plan was to go to Europe with some Indians to exhibit them, and doubtless they would have made money by such exhibition—but the Indians got discontented, and left them here— Their plan being thus frustrated, they offered me the collection for 200 $ and I think myself very fortunate in the purchase, as in all probability such things will not be had in a few years hense.[5]

It is a settled point that the museum is to be placed in the arcade. It is to occupy the 3d Story. a slight sketch will be sufficient to give you an Idea of the mode.—

This is a floor sketch. the center is 130 feet long by 26 feet having collums 6 feet from the walls to support a gallery. from the floor to the sky lights independant of the sky lights which li⟨t⟩ght the stores below. (noted in the sketch) then we have the rooms all round the plan—that is 100 feet on chesnut street the same on Carpenters street & those on west & east ⟨streets⟩ sides 150 feet each. and 10 ft width. I ought to have made 9 collums on each side. It will have a very imposing effect, more expecially when glass casses is made with glass on each side, so that the objects within will be seen on both sides—These glass casseases placed between the collums and the side walls— But this is not contemplated to be done now, but when the encrease of subjects shall render it necessary. there will

be the most room for a display of articles in the side & end roomes. a future letter may be necessary to illustrate this plan of accomodating the Museum.—in which may be explained the disposition of Articles—also the lecture room which will be large[6]

Titian has just recovered from a bad spell of sickness—I dont know whether it might not be a *stroke of the Sun*, for he went gunning on the river in a hot day before he was taken ill. bled 3 times & twice blood drawn by leeches, has reduced him to feebleness— Your sister Sophonisba is again in the family way—and altho. she looks well in flesh yet she is feeble and apt to be fainty with little exercise.

Christiana has received a short letter from Linnius[7] in which he says, "all his prospects are blasted, he leaves the Columbian Service, he had an abundance of hard work & no pay— "that he is now fishing for the marquet[8] I should have told you it was dated at Carthegena last month— "that he is going to———and will enter into Privateering—that if he cannot mend his circumstances he will never return—& concluding desiring her to kiss his children for him— Thus I have given you all that I can at present think ⟨of the⟩ on family affairs. Love to Eleonor & childn.

<div align="right">yrs. affectionately CWPeale</div>

Mr. Rembrandt Peale
 Boston

ALS, 3pp.
PPAmP: Peale-Sellers Papers—Letterbook 20

 1. Unlocated.

 2. In earlier visits to Boston and before his family joined him, ReP had lived in a lodging house. He now moved to a rented house in Nahant on the North Shore. A notice, reprinted in the Baltimore newspapers, announced that "the distinguished artist Rembrandt Peale, has lately arrived in Boston, with the intention it is said of making it his future residence, if the voice of encouragement shall invite him." Miller, *In Pursuit of Fame*, p. 151; *Boston Directory (1827)*, s.v. "Peal"; *Baltimore American and Commercial Daily Advertiser*, August 4, 1826.

 3. Baize is a coarse, heavy woolen cloth used for coverings, curtains, and linings. Because of its durability, it is especially suited for exhibition walls, such as those in ReP's studio. *OED*.

 4. Probably ReP's lithograph prints. See above, **264**; Miller, *In Pursuit of Fame*, p. 149. Mr. Lucas, the framemaker, is unidentified.

 5. The entry accessioning these items at the museum is dated 1826 and appears after the last dated entry, May 26. The entry reads: "a varyed and complete collection of the Dresses and implements of the Indians of the Missourie and Mississippi was purchased by CWPeale for the Museum from a trader who procured them for the purpose of exhibition here and in Europe—Cost $200." An advertisement in *Poulson's* provides more details about the collection:

<div align="center">Indians of the Missouri</div>

The public are respectfully informed, that an extensive and very complete collection of the dresses, arms, implements, pipes and instruments of musick, &c. of the Sioux, Shienne, Aricaree, Mandan, and Osage Nations of Indians, are now placed for a short time in the

Philadelphia Museum

This collection consists of the male and female dresses of the above nations, ornamented in their peculiar manner with dyed porcupine quills, and is in some of the specimens, extremely beautiful, one of the SKIN LODGES, used by them, is placed in such a manner as to exhibit its use, and is very curious.

Their arms, consisting of bows and arrows, war clubs, &c. and a buffaloe skin, upon which is painted a record of the fight of Colonel Leavenworth, with the Aricaree Indians, executed by themselves, their flag, shield, &c. will give a good idea of their manner of warfare.

In short, this collection contains all their Dresses of War, Ceremony and the Dance, and is the most complete that has ever been exhibited.

Poulson's, September 13, 1826.

Sellers conjectured that the traders were from St. Louis and that their number included one David Delaunay, a "Frenchman" with the rank of major in the territorial militia. Delaunay deceived the Indians "into believing he was officially bringing them to visit the Great White Father in Washington," but actually planned to take them to Paris to put them on exhibition. A second group of Indians, it seems, were misled into accompanying him and toured Europe "with great (but waning) éclat." When profits from their exhibition dwindled, Delaunay abandoned them, and they had to be rescued and returned home. Sellers, *Museum*, pp. 252–54; Philadelphia Museum, Records and Accessions, P-S, F:XIA/4, p. 127.

6. A description of the museum space in the Arcade prospectus simply says that "the third story will be left in one entire room, 150 by 130 feet" and does not provide the architectural details enumerated by CWP. "The Philadelphia Arcade," *PMHB* 41 (1917):379.

7. Unlocated.

8. As the next letter (**276**) makes clear, this is either a misspelling or the use of an obsolete term for *market*; CLP seems to have been reduced to fishing to earn his livelihood. *OED*.

276. CWP to RuP

PHILADELPHIA. NOVEMBER 12, 1826

Philada. Novr. 12th. 1826.

Dear Rubens

This must be short, but the subject is pressing—as it respects the Rhinoserous— Franklin has made the calculation of the average of the Museums income of the last Year, and as far as the present season it is not less productive. The average of Nov. is $15.18cts. and that of December 25 $ Pr. day. the latter being a better season, but in addi[ti]on the holy days makes considerable increase but if the subject is not continued to the holy-days then another calculation of avrage income must be made. As you paid the expense of advertizings I shall do the same and give you the half the income of visitation over those average Statements—and you may send the Rhinoserus as some [soon] as you can. By what rout will you send it?[1] I am at present obleged to be rather too much on the stretch of exertion to please my employers in the tooth line—

Love to Eliza & children. Yrs. affectionately.

CWPeale

NB. My next I hope will be fuller, as I may then tell you what I have done & what I intend to do.

Mr. Rubens Peale

ALS, 1p.
PPAmP: Peale-Sellers Papers—Letterbook 20

1. RuP advertised the exhibition of the rhinoceros at the Museum as follows:

RHINOCEROS
AT PEALE'S MUSEUM & GALLERY OF FINE ARTS

The Rhinoceros Mr. Peale has just placed in the Museum for a short time, being the first specimen ever brought to this country. On its passage from India to England, it died, and was sold for $1600. It measures 10 feet from the nose to the tail, and 9 feet girth. In size the Rhinoceros is only exceeded by the Elephant, but in strength superior. its nose is armed with a formidable weapon, peculiar to this creature, being a very hard and solid horn, with which it defends itself from the most ferocious of animals. It fears not the Lion, Tiger, or Elephant. The body and limbs are covered with a skin so thick and so hard that it turns the edge of a symitar, and even resists the force of a musket ball. It is supposed to be the Unicorn of Holy Writ, and possesses all the properties ascribed to that animal. This specimen is on its way to the South for exhibition.

Baltimore American and Commercial Daily Advertiser, December 11, 1826.

RuP's account of expenditures for December, 1827, indicates that he spent $16.50 to rent the animal from its exhibitor (unknown). The animal was on display at the Baltimore Museum only during December, and there is no record in the Philadelphia Museum's Accession Book of the acquisition or exhibition of the rhinoceros. Baltimore Museum Account Book, 1822–29, MdHi, F:XIB/3.

277. CWP: Diary 25. Visit to New York,
DECEMBER 1826

Man as is the case with all other sociable animals require a companion, & alltho.' I am now in my 86 year of my age, feel the loss of a female of my bosem, to converse, advise, and to partake with me the enjoyments of life. Long habituated to pay attentions to a bosom friend, I now feel as is commonly said, *like a fish out of water*.[1] It is more than 3 years since I lost my dear Hannah,[2] she ever was an endearing companion, I lived about 16 years with her, and in the whole time never a single word of discontent took place between us, it could not be otherwise, for she ever was attentive to all my wants and wishes—my children nothing [noting] this, have oftain said to me that, they would wish me to have such another wife when I have told them that I thought myself lonesome—and I have oftain of late said amongst my friends as well as others that I would marry again and on

1. CWP obviously thought that this phrase appropriately explained his situation; he used it at least once before. (See above, **258**).
2. HMP died on October 10, 1821. *CWP*, p. 438.

the day of December 1826 I meet in chesnut Street, my friend Mr.
Morris[3] he addressed me after enquiring my health and said, he had
heard me say that I wanted a wife, he had thought on the subject and he
knew a Woman that was exactly such as would suit me. she is a most
accomplished woman, sensible, amiable, and would delight in the studies
that I enjoyed, she was chearful and would command respect in all com-
panies, his praise of her was very great, That I knew her father. she is the
youngest daughter of Joseph Stansbury—and now is a Teacher in the
Deaf and Dum institution of New York.[4] I wish you to see her and I am
sure you will be pleased with her, her Person is pleasing and her presence
commands respect—go and see her & if she does not please you, it is *entre
nous*. I replyed that I would pay a visit to N. York with Dr. Godmans
family, the Dr. having having determined to settle there, and was so much
engaged with the new Medical school that he could not come here for
them,[5] But said my friend Miss Stansbury is poor, and with all her fine
accomplishments she is *humble*. This gave me the hope that I might suc-
ceed in the obtaining ⟨*so fine*⟩ such a companion—and I after this meeting
I called at the house of friend Morris, he was not at home but his wife
being a fine Woman, ingenious and very friendly I told her of my inten-
tion to go with my grand children to New York— she told me that she
had scolded her husband for what he had said to me, that he ought not to
make matches nor to brake them— but Madam he wishes to serve me,
and I doubt not has spoken his oppinion of the lady, Yes he did and we
have known her long and she is every thing that he has said of her— but
Madam what is her age, is she fifty, oh yes, her age is 53 or 4— Mrs.
Morrises praise of Miss Stanbury was as high as that of her husband but
says she, suppose she should not like to leave the Institution and you
would suffer a disappointment— Madam my Idea's are that if a lady
does not like me, let her accomplishments and merits be ever so great, I
would not let it trouble me, for if she could not like me, there would be no
happiness in the union. a day or 2 after I called on my friend Mr. Morris to

3. Although there were many Morrises in and around Philadelphia who were relatives or
acquaintances of CWP, the Chestnut Street reference suggests that this was Simpson Morris,
a gentleman, who in 1825 lived at 281 Chestnut. *Philadelphia Directory* (*1825*).

4. Mary Stansbury was the daughter of Joseph Stansbury (1742 o.s.–1809), merchant,
writer, and Loyalist, and sister of Abraham O. Stansbury, who also taught the deaf. *Peale
Papers*, 1:130n; above, **246**.

5. At this time, ReP's son-in-law, Dr. John D. Godman, and his wife, Angelica, had three
children: Steuart Adair (1822–1853), Eleanor Peale (1824–1912), and Henry Robinson
(1826–1878). During the early 1820s Godman and his family moved from Cincinnati to
Philadelphia, and, in 1826, to Rutgers Medical College in New York City, where he held the
chair of anatomy. Because of ill health Godman resigned during the second term and,
retiring from medicine, he and his family returned to Germantown where he wrote his
American Natural History (1826–28). *DAB*; *CWP*, p. 441.

request him to give me a line of introduction to Miss Stanbury, I told him that I only wished nothing ⟨but⟩ more than a desire to see the seminary. and he promised it and when I called for it, he gave it to me open, after reading it I thanked him & said it was to my wish, he offered it to Mrs. Morris, but she declined reading it and said that she would not have any thing to do with it. hence I concluded that she did not much approve of the proceeding—and I took my leave of them—mentioning the time of my departure with Mr. Godman— We took the rout going through in one day, and had an agreable passage.

The next morning I went to the school[6] and presented my letter to Miss Stansbury. When she had read it, she took a Cloak and put on a bench for me to set on in front of the schollers—and told me she would shew their mode of teaching and the progress of her pupels. she shewed me that they obtained first the names of things, then uses, the gramatical part of teaching better understood than by scholars in the schools of speaking pupels. She also made false sentances or rather false gramar which they corrected. Made questions on the Large slate, which each Pupel answered on their slates—she wrote the questions where they were born, in what county &c. all of which they wrote answers to—also they shewed their knowledge of figures—and besides questions of who is God and the redemption of Man by Jesus Christ—comprehending the doctrine of Christanity. That they were without knowledge of all things, before they were taught in this School. and now they were happy. Miss Stansbury put questions of various kinds, all of which they answered on their Slates that once they did wrong, but now that they for sorry for it. I cannot do justice to the examples to shew the advancement of her pupils as I now write this account after my arrival in Philada. therefore make no further attempt of it— we spoke of her father—as she knew I had been acquainted with him— I was much surprized at her abilities and knowlige of the subject of Teaching and more so to see so much exercise, she said it at first fateagued her greatly, but now she was used to it. I staid about 2 hours in the school and when taking my leave, she invited me to take Tea with her & gave directions to her lodgings at Mrs. Strikers in broad way,[7] (a little before 6 O'clock.) I waited on her sooner least I should find it difficult to read the number of the House. I spent part of the evening & in my conversation, told them that I wanted a companion that I found it neces-

6. Incorporated in 1817, the Institution for the Instruction of the Deaf and Dumb opened in 1818 as a free school for New York residents. It received grants from the state. The teaching methods used there were based on those developed by Miss Stansbury's brother Abraham at the Hartford Asylum for the Deaf and Dumb. See above, **246**.

7. Hannah Stryker ran a boarding house at 214 Broadway. *New York City Directory* (*1825–26*).

sary to seek another wife. I gave to Miss Stansbury my Essays on Domestic Happiness, on health, and two of my printed lectures—and as I had brought the drawings of that part of the arcade which which was building for my Museum that I would shew it to them on my next visit—[8] and propossing for them to go with me to my sons Museum, they asked me when, my answer was now or at at any ⟨other⟩ time which would be most convenient— Mrs. Striker was willing to go with Miss Stanbury that evening & off we went to the Museum, where I paid all my attentions to notice them of the most curious and interresting subjects in it. and they seemed much pleased with the Exhibition and expressed their oblegations to me when I waited on them home. a day or two afterwards I asked Miss Stansbury if I might see her at her lodging, and she appointed the hour in the afternoon— in my conversation with her, I told her that I wished to make a bargain with her, which was to teach her to make Porcelain Teeth if she would teach me her Art. she said that she had no genius, that it would be impossible for her to learn it or the art of painting which ever she might chuse, she did not by her answers shew any inclination to assent to my offers, and of course I then thought it would be fruitless to explain my views in more pointed language, or my desire to make her my wife— I took my leave at that time and told her I would return to Philada and take her commands. she said that she would write to her Nephew Mr. Steller who lived in walnut Street.[9] I called on her in the evening and on my taking my leave she accompanyed me part of the way down stairs and put a letter in my hand, which I read on my way to the Museum, it is as follows—(letter directed to CWPeale)[10] I waited on her at the time she appointed, and when I saw her I told her that my heart throbed between hopes and fears—and then I asked if the lady she recommended was good natured, yes she said her letter mentions her amiable qualities I then told her that I would not see that lady, and I said I was

8. CWP included a sketch of a floor plan of the museum section of the Philadelphia Arcade in his letter to ReP of September 24, 1826 (above, **275**). This reference appears to be to architectural drawings (unlocated); no formal drawing by CWP or plan of the Arcade is known to exist. However, see fig. 60. Joseph Jackson, *Encyclopedia of Philadelphia*, 4 vols. (Harrisburg, Pa., 1931), 1:98; "The Philadelphia Arcade," *PMHB* 41 (1917):380; *P&M Suppl.*, p. 51.

9. John Stillé was the son of the founder of the Philadelphia mercantile firm of John Stillé and Company. In her letter to him, Mary Stansbury described CWP: "I have had a visit from Mr. Peale of your City, and find him a rare example of the benefits of temperance in preserving extreme age undiminished mental faculties and corporeal vigour. He will hand you this letter and I think both you and your Harriet would be pleased with his acquaintance. Your [i.e., Philadelphia's] Museum when placed in the Arcade will make a splendid appearance, well worthy of the Nation." Mary Stansbury to John Stillé, December 18, 1826, PHi: Edwin Carey Gardiner Coll., F:IIA/72F4–7; *Eminent Philadelphians*, p. 910; *Philadelphia Directory (1825)*.

10. Unlocated. Perhaps CWP destroyed it.

candid, open, and sincere, and informed that I had expressly come to New Yk. to see her, that I wished to make her happy and myself also — Oh! she said she was not fit to make me so, that altho' she enjoyed good health ⟨ *you* ⟩ her nerves was distroyed that she had spasmatick affections which would soon carry her off, that her father died of the same complaint, that she was sure that she would die soon— for the least change bought on those complaints that her flesh shook or quivired on triffling occasions— I told her that I would be her Phisi[ci]an, her Nurse and her protector, that I had no doubt of my living many years by the care I look [took] to preserve my health and I believed that I could make her happy, that it should be my constant care to please her in every way that was in my power. I urged her to consent to make me happy and she urged me to see the lady mentioned in her letter, I told I would not see her, and I also told her that I would not marry as young a woman let her qualifications be ever so great—she said she was confident that this lady would never have children, I told her that I had fixed my mind of not taking a lady under 50—and she asked what age I thought her, I answered that I had understood that her age was 53 or 4 yes she said she was 53. I entreated her long to consent, but still her reply was that she had devoted herself to the school (⟨*I had forgot to write that the day before*⟩ she said that she received 400$ for her Service pr year) and she thought it was doing her duty to help those poor mutes and although she could not get rich by it, yet she had got 1000$ Miss Stanbury said, that she saw very little company, that when she went to her lodging she retired to her room, that she sildom stayed longer then at meals with the boarders—that she was not able to mix in company for it often brought on those spasyms that distressed her— She said that she would be happy to corrispond with me, my answer was that I could not write to entertain her, that I had not the capasity, oh she said my writing was intertaining and she was much pleased with my publications, they were very interresting, and she hoped that I would correspond with her. I could not promise that I would. having taken her answer that she could not change her situation, I told her that I would return to Philada. on Tuesday. she shewed me her artificial teeth, I offered to make her some of Porcelain, and I desired her to take a mould of her mouth on those parts where she had artifical Teeth, and I told her to take beeswax soften it in warm water, and work it well, and take the mould by pressing against her gums & teeth, and I called on her for the moulds, tuesday morning, and behold she had only taken the shape of the artificial teeth and not of the teeth adjoining, I then told that I would go and get wax, and if she would spare me those artificial Teeth, that to make my work more certain, ⟨*that*⟩ I would make moulds of them in less than one hour if she could spare them so long—oh yes two hours if I

choose it— I hasted then to get some plaster of Paris and Bees Wax—but unfortunately the plaster was old and tardy of setting, I put it on the teeth, and to give it more time to set I did not wait to take the moulds apart and carried it in my hand to the school, and went into the Kitchin and got some warm water to soften my wax, ⟨and then⟩ went into the School, and Miss Stansbury went with me into adjoining-room to be private and hastily I made moulds—⟨then⟩ I asked if she still persisted in her refusal of me, oh! Yes she could not consent to change her situation, I said perhaps I had not given her time for consideration she said she determined to live single.— The day before she told me that she had offers made her & one was of long standing— I did not enquire the cause of that being lost to her. She requested me to make for her a piece of Ivory to fit her gums better than what she had with a natural Tooth in it. having the mould of the places wanting Teeth, I shall endeavor to make of Porcelain, teeth with a duftail base, which I hope she will be able to use, if she can make alterations if necessary. This delay make in this business had like to have made me loose my passage this morning—I hurried to get a carman to take my baggage, and much hurry I reached the Steamboat in time. The cause of this hurrey was in the first place by our going to see the exhibition of live animals in the bowery.[11] Miss Stansbury appointed the hour of 9 O'clock to go there, and the collection of animals being numerous; Elephant, Cammel Lamma, Lyons, Tygers ⟨and⟩ Panthers Bear, Monkies, Coate-Mondie, Civits,[12] &c.&c.- made the time pass quickly and it was 11 O'clock before we reached the School, but had Miss Stansbury made the mould of her mouth as I had directed, I should not have been hurried so much. and finding the Wind blowing fresh at N.W. the air very cold, I became fearful that if I staid longer that the Steamboats might be stoped by Ice.

I reached the Steam boat in good time— enquiring how long before we should reach Brunswick, was answered in 5 hours—but the wind blowed a fresh gale & the tide being against us most of the way, made the passage more than 6 hours, but the greatest misfortune was that we grounded perhaps ¾ of a mile below the landing— was obleged to wait for a boat to take the passengers on shore— I went in the 2d boat, and

11. There is no listing of this zoo in the Bowery in the definitive account of world zoos. Gustave Loisel, *Histoire des Menageries de l'Antiquité a Nos Jours*, 4 vols. (Paris, 1912), 3:179–80. America was slower to organize menageries and zoos than European countries, and those that did exist early in the nineteenth century were run by individual showmen, not by municipalities and states.

12. Coati-mundi are tropical American mammals related to and similar to raccoons, but longer and possessing a long flexible snout, not unlike anteaters.

Civets (*Civettictis civetta*) are small, carnivorous cats native to Africa; the animals' sex organs secrete a musky viscous fluid (also called *civet*) that is used in perfumes.

taking my Trunk with me, rather too heavy to carry any considerable distance—but to add to my difficulties, it was dark and the shore side rough. and to lugue my trunk about ½ mile, was too severe a laybour for me, having my cloak & umbrella— being allmost exhausted one of the passengers was so obleging as to help me—or I might long have laboured to get to the place or stand of the Stage Coach No. 2. I thought myself well off when seated in it. But we were obleged to wait for the other passengers and their baggage a full hour, Then drove on with great speed & reached Trentown about 1 o'clock and was refreshed by a good supper. A waiter waked us at the proper hour, and I had just time to strip off my Night shirt and wash my body, put on my upper garments & wash my feet, but had no time to shave as I usially do before I put on my Coat—and when I got into the yard, Coach No 2 had gone off, but No. 1 was not yet started and I steped into it— on reaching the boat—I thought it would pass away the time most agreable to me, to commence my Journal, for I had been so much engaged while in New York that I had not wrote a script of it. So that as soon as breakfast was over I keept my seat and commenced writing— I did not suppose that I should know any of the passengers and therefore considered myself at liberty to recollect my adventures since I left my home. But when it was anoun[c]ed that we had reached Philada. I put up pen & Ink and looking up, I see Mrs. Matlow[13] standing before me. Why Madam you have been a passenger and I did not know it, why did you not announce yourself to me, I would have been happy to see you— oh! she said I see you was bussey therefore I would not interrupt you— This Lady is much accompli[sh]ed and is a chearming woman, Chearfull and entertaining, she lost all her friends in the Massacres at St. domingue.[14] is Married to a Man much older than herself—and makes him happy by her tender assiduities. they live in Burlington. She asked me if I would not come to see them in burlington oh!yes Madam it will give me pleasure to do so—and very probably you can recommend me to some agreable companion, yes that I can, and I will look out for such, as we do not lack of Many in our City. Then Madam I will certainly wait on you as soon as I can make it convenient. Now it is a fact that I have been recommended to several Ladies, but it is also a fact that very few of those noticed to me have the qualifications, or the attractions that suit my view of the Married state—and I feel myself happy in having escaped being engaged in some Instances, that my warm immagination has sometimes led me. I feel a

13. Unidentified.

14. The bloody slave rebellion and revolutionary war led by Pierre-Dominique Toussaint l'Ouverture resulted in a flow of expatriate French colonists to the United States, and especially to the Philadelphia-southern New Jersey area, in the 1790s. Frances Sergeant Childs, *French Refugee Life in the United States, 1790–1800. An American Chapter of the French Revolution* (1940; reprint ed., Philadelphia, 1978), pp. 11–16; *Peale Papers*, 2:83, 603.

comfort in knowing that I have acted honorably to some to whom my friends had introduced me. I may have paid more attention to some few amongst the Number than on reflection is quite so prudent for me to have done, but it was with the view to sift out their qualifications & to wiegh well whether it would be prudent for me to make any engagement— one Lady in particular I readely see would be willing to make me her companion—and I told her that I would endeavor to know her fully— I should make enquiries about her. But I fear that she is not in all respects such as I should wish to take to my bosom—

If the person I should marry would not enjoy such amusements as pleases me, I would loose much of what would contribute to make me happy. in which case It would be better for me to be as I am forlorn though not miserable. If I have no companion to share in my enjoyments, I have none to trouble myself about, I shall have none to give me trouble or concern.

I may as a single man, go where my fancy leads and my circumstances may be most convenient to spend my time or use the means which my industory may procure—and to drive dull care away I shall always find some imployment for my fingers to perform while my health enables to enjoy life.

Health I well know is a blessing and therefore well worthy the studying how to preserve it— Therefore in all probability I shall not have many other cares to engage my thoughts, at least this is my my present feeling and prospect. Yet I cannot help my wishes of a social life. I must be patient and in the end I may do well.

AD, 25pp.
PPAmP: Peale-Sellers Papers

278. CWP to Allan McLane[1]
PHILADELPHIA. JANUARY 4, 1827

Philada. January 4th, 1827

Dear Sir

very probable you may know my Son Linnius, but if you do not, I will inform you that he is one of the stoutest of my sons, a portly young man, he is a seaman and very active, and I hope perservering in his duties — He went into the Columbian Service, but finding that he could get no pay, he returned home, he has a wife and four Children to mantain—[2] knowing your friendship for the family, therefore I take the liberty of writing to ask your aid to get him into some employment in the

Navy or revenue department on the river delaware in which I presume you have considerable control. If I did [not] believe that he would be deserving of favour, believe me I would not recommend him to your notice and favour. I hope you continue to be active and enjoy an increase of health, you will do me a favour by sending me a few lines on the above subject and much oblege an old friend

<div align="right">CWPeale</div>

Coll. McClane
 Wilmington

ALS, 1p.
PPAmP: Peale-Sellers Papers—Letterbook 20

 1. Colonel Allan McLane (1746–1829), Revolutionary war hero, was collector of the port of Wilmington, Delaware. JP's historical scene based on McLane's exploits during the Revolution, *Ambush of Capt. Allan McLane*, was painted in 1803 (*Utah Museum of Fine Arts, University of Utah*; variant in *private collection*). CWP took his portrait in 1817 (*Maryland Historical Society*). *Peale Papers*, 2:526–27; 3:559.
 2. In 1827, CLP's four children were: Alverda (1818–96), Augustin Runyon (1819–56), Elizabeth (b. 1822), and Simon Bolivar (1825–95). *CWP*, p. 442.

279. CWP to Mary Stansbury

PHILADELPHIA. JANUARY 5, 1827

<div align="right">Philadelphia Jany. 5th.—1827.</div>

Dear Miss Stansbury

 It was my entention to have sent by this conveyance the Porcelain Teeth, but the Gentleman going two days sooner than I expected I had no time to *fire* them. They are modeled sometime past, but the severity of the cold since I left N. York made me fearful to undertake that part of my work. My furnaces being in a small Room in the Yard, and the heat of fire so great that I am obleged to retire from it as quick as possible, the sudden transission would be dangerous to my health.— Being desirous to complete a considerable number of teeth which I have prepaird I had determened to do it this week. more especially as I would thus complete those for you.

 The piece inclosed made of the Sea Cows tooth[1] I hope will be of some use to you. I made it to fitt the mould I took of the larger space, which if I remember right was what you wanted—

 I delivered your letter for your Nephew at the door on my first arrival here.

 I was fortunate in leaving N. York at the time I did, and my passage then was rather uncomfortable— The Steam boat grounded ¾ of a

<div align="right">569</div>

mile from the landings and the delay was such that we did not reach Trentown before 1 O'clock the next morning. When I was in the steam boat on the Delaware, after taking my breakfast I thought to pass my time to most advantage by writing the minutes of my journal, I thought the passage too short when it was announ[c]ed that we were at Philada. and looking up saw a lady from Burlington a very amiable woman for whom I had a short time past done some work remarked to her that if I known she was on board it would have pleased me to have been with her— She said that she see me so busy that she did not like to interrupt me.

Make my respects to Mrs. Striker, and believe me with much esteem your friend

CWPeale

Miss Stansbury
New York.

ALS, 2pp.
PPAmP: Peale-Sellers Papers—Letterbook 20

1. For the use of ivory from the teeth of other mammals in the making of dentures, see above, p.139.
Sea cow is the colloquial name for the manatee, a large aquatic mammal (genus *Sirenia*) found in the shallow tropical waters of the Americas. *OED*.

280. CWP to John D. Godman
PHILADELPHIA. JANUARY 5, 1827

Philadelphia Janry. 5th—27
Dear friend

Dr. [See]miller[1] going two days sooner than we expected leaves me very little time to write & I must beg you to tell ⟨him⟩ Reubens that I recieved his letter respecting the Ostrich[2] ⟨and⟩ that I will attend to it and write to him as soon as I can know any thing about it. I had a very uncomfortable passage from N. York. The Steamboat grounded about ³/₄ of a mile short of the landing, and the passengers was landed in a small boat, of course much time was lost, I carried my Trunk about ¹/₂ a mile in the dark and bad road, and when I got to the Coach was obleged to waite at least one hour for the other Passengers with their baggage and they made it a late or rather an early hour before we reached Trentown (1 o'clock)

A wish you to deliver to Miss Stansbury at the Deaf & dumb Schoole the enclosed—.[3] The School is keept in the upper Story of the long building at the further end—Mr Schudders Museum occupying the West End.[4]

I am very much engaged in my work of Porcelain-Teeth—if it was not

in my expectation to make considerable improvements of the work I would soon quit it Love to the family affectionnately yours

CWPeale

Doctr Godman

ALS, 2pp.
PPAmP: Peale-Sellers Papers—Letterbook 20

1. Unidentified.
2. Unlocated. A living ostrich (the "largest of the feathered tribe") was on display in Philadelphia later in January at 318 Market Street, admission twenty-five cents with children half price; the entrepreneur who showed the ostrich is not known. *Poulson's*, January 29, 1827.
3. Above, **279**.
4. The Institution for the Instruction of the Deaf and Dumb was located in the New York Institute, the old Alms House, on 130 Chatham Street in New York City. John Scudder's American Museum, the Spectaculum, was located on the first floor of this building. *Long-worth's American Almanac*. See *Peale Papers*, 3:493.

281. CWP to Mary Stansbury

PHILADELPHIA. JANUARY 29, 1827

Philadelphia Jany. 29th. 1827.

Dear Miss Stansbury

Yours of the 20th.[1] received while I was confined to my Bed, with a violent spell of Sickness— I will first speak of the peice of Sea Cow sent you, which seems to be of no use—but may probable be made to answer the purpose intended, if a little pains is taken to fix the tooth in its proper direction. The small hole which I made may be in the wrong place, or if the point of the tooth should not be directed forwards or backwards, then the pivot should be bent to give the proper direction. I have relied on your *gen[i]us* to get this done—a small File will readily remoove redundancies on the inner or outer side. and I am persuaded that the peice must fitt the *Gum*, as the Mould is a good one.

My next object to thank you for your f[r]iendly letter, and to assure you that I am anxious to render you any service in my power. I *fired* the Teeth a few days after I wrote and *have packed* them in a small piece of wood to prevent them from being broken—yet my dear Miss this is not all that I have done—for after I had made them, My Son Titian, made an improvement in a mode to tye them to the adjoin[ing] teeth, and I immediatily modeled others, to be sent when I shall be able again to *fire Teeth*. Having now said all that is neccessary about teeth, Will relate some particulars of my Sickness, which has not a little depressated me, in the strentch

[strength] of my Constitution. My excessive fateague in carrying my Trunk at Brunswick I immagined injured my Heart. and after my arrival at Philada. I went through a great variety of the then severe weather disreguarding all its severities, and when greatly exerted I felt the pain of my heart, which would oblege me to lessen my pace, but more frequently occuring I found it became more violent, and at last made me seriously to fear that a weakness was to [be] dreaded, and induced me to be more careful of too violent an exercise, then determining to live on such diet as I supposed most likely to strengthen the animal powers.[2] And I began my Systeem too late the desease was rooted. As was my usial custom I went to the Museum about 8 O'clock every evening. on the 15th. Instant, returning I could scarcely reach to my home being obleged to stop twice in 100 Yards to get my breath. I had on my way ⟨home⟩ got camomile flowers[3] at an apothocaries— I took a pint of Camomile Tea & went to bed— before 12 O'clock I roused up the family, and a Doctr. sent for, who advised a little blood to be taken[4] it was a temporary relief, the desease became more painfull, I was next cuped on my side over my heart, it seemed very considerably to relieve me, ⟨but the most⟩ some days after as well as I can remember my pain became so excessive, as I suppose alarmed the Physician, who was emenant in his ⟨Pho⟩ profession. he ordered a large portion of blood to be taken which reduce me to extreeme dibility. my disorder had the appear[an]ce of a bilious disease, as I threw up much *bile*, of a Pleurisy,[5] as the pain in my side seemed to decend below the heart, but finally it turned out to be in part a *gout*, as from the heart it seized my right heal the pain tho' severe I rubed the greater part of a night it then changed to my left heal, thus fully assertaining the prevalence of gout—I then thought myself perfectly out of danger, which hope remained a few days, but dibilities was so great, that I became extreemely Ill by a stricture on the bowels very alarming. however, at last by powerful medicines I obtained relief, to detail all this to you Miss Stansbury is a miserable subject, it may raise your compassion for my infermities, and is the very reverse of what I ought to write. but you will have the goodness to pardon me, when it has been my desire to comply with your request of a correspondence—and more especially when you know that this is a great exertion for me on the 2d. day on which I have been able to set up and at this moment very weak. My Friends Mr. & Mrs Morris came to see me yesterday afternoon, they seemed to be fearfull that I made too great exertions. I dont know what they would think did they know what I have wrote today. I hope Miss Stansbury to [be] able to write to you soon again with the aditional teeth, but if not, I may send those I have made perhaps with this letter, If I can find a safe conveyance of them.

accept the assurance of my high reguard and beleive me to be every thing you wish.

<div align="right">CWPeale</div>

Miss Mary Stansbury.
 New York.

ALS, 3pp.
PPAmP: Peale-Sellers Papers—Letterbook 20

 1. Unlocated.
 2. Camomile: the dried flower heads of either of the plants of the genus *Anthemis* or *Matricaria*, which when infused into a tea are used as an antispasmodic or digestive. *OED*.
 3. In a letter to ReP the following day, CWP wrote that he took eggs "intending to take them raw with sugar, eating raw oisters with every thing that I supposed would invigorate my Animal Powers." CWP to ReP, January 30, 1827, P-S, F:IIA/72G9–10.
 4. CWP's physician was Dr. Thomas Chalkley James (1766–1835), who attended his second wife, EDP, during her last—and fatal—childbirth. (See *Peale Papers*, 2:638n; below, **283**). Although CWP had medicinal and philosophical objections to the practice of bleeding, he did allow himself to be bled on occasion. In 1810, he made use of leeches to alleviate the pain suffered after he fell from his horse. *Cupping* is the practice of increasing the flow of blood from the patient by the use of a cup to form a vacuum to draw the blood out. *Peale Papers*, 3:317.
 5. *Pleurisy* is an infection of the thoracic cavity affecting the heart and lungs. *OED*.

282. CWP to RuP

PHILADELPHIA. FEBRUARY 2, 1827

<div align="right">Philadelphia Feby. 2, 1827.</div>

Dear Rubens

I have recovered from the most severe and and dangerous sickness I ever had—[1] The foundation laid by too great exertion at Brunswick carrying my Trunk— after arriving here increased it by facing Storms several times. and feeling the consequences by pains at my heart, I became alarmed & determined to recruit my Stamina—but too late, the disease was rooted. It was an accumelon [accumulation] of Deseases—Gout in the Heart, Billious habit and Pleuricy— Doctr James was called in, and he has been kind in his constant attendance, and in good Nursing I am nearly as well as usial—

I was Bled about 6 or 8 Ozs. next cupped over my Heart—large blister over that—[2] The pain seized my right heal—rubed from thence and it went to my left heal—was painful but always releaved by rubing. Pleased to find it had got to my feet & hoped to keep it there by warm covering— yet it would not do. I became much worse, The Phisician and bleeder sent for at the same time, bleed in the other arm in large quantity, the orifice

<div align="right">573</div>

ought be small for they took much time to get as much as they thought necessary— This reduced my strength, I would attempt to go to the Stool and fainted twice in the tryal.

relieved from pain some time I dont remember how many days—but then came a stricture on my Bowels, my distress was extreame—I had taken injections and salts without effectual relief—and being now in ex- tremity of pain—the Doctr ordered a powerful Injection— This gave full relief—and I began to mend. some small degree of weakness remains on my bowels otherwise I am perfectly well—My appetite good, the viands relish highly but I am careful in what I eat, also to quantity. I intended this day to go to Colemans, but Snow prevents me. I shall study to make myself comfortable in all things— I have endeavored for many years to be deserving of it— my judgement may not always be correct, and in consiquence I may suffer some mortifications justly— It is easy to give advice to others, not so easey to be ever correct in what we do— I have wrote a great deal in my time considering the variety of my occupations—and I have said that we ought to be careful of what we say in our conversations, but I know that we ought more particularly be carefull of what we put on paper—least some should see what is written & be feellingly hurt—⟨but⟩ what we part with in either case ⟨belongs⟩ is no longer in our power—lastly as the most important we should be doublely forti- fied in what we commit to the Press. Happiness is certinly a common Plant but the cultivation of it require no little skill. I do not know a better mode than that to place our self in exactly the Identi[c]al situation of those we treat with—perhaps this is not easely done, we must take all their feelings—desires and Passions—weigh all the prooving powers of Nature and customs— In short we must feel our oblegations to make others happy, in order to be fully happy ourselves. So that Self seems to be a mootive for every good action, as self approbation is a powerfull ⟨to⟩ insinsitive [incentive] to good actions. be it so if good comes of it. I have done with this subject at least for the present—but being confined to a room has produced you a tolerable long letter, good or bad, such as it is, it may be little short of the value of the postage, as it give you truely my situation.

I do not hear any thing about the Ostrech when I see it the Plumage was about as good as that in my Museum, the Colour the same, but the Bird is a fine large animal, and if it can be taken care off untill its full groath and in fine feather, would undoubatably be a very valuable object for a Mu- seum. My expences is now beginning for exchange of situation of the Museum—[3] I have hired Wilson to tend and David is making Casses and Sashes, and other additional expences will come towards the Spring.

?Cannot you find some one to take charge of my slides?—James Peale is now on a journey to albany and may call at N. York & see you.[4]

I have made some improovements in my porcelain Teeth, and have some calls in that way—one the other day requesting me to go to New York early in the Spring a whole set. I have too long neglected to send abroad for Platina, and without it I shall have too Much trouble in my work. The other day I broke up 100 teeth to get the Platina to make better and more convenient teeth.

You may tell Eliza that several Ladies have visited me during my sickness, and I feel my oblegations to many of my friends for their attentions to me—and sending me nice things.

accept my love

CWPeale

Mr. Rubens Peale N. York.

ALS, 3pp.
PPAmP: Peale-Sellers Papers—Letterbook 20

1. CWP wrote a similar letter describing his illness with the same details to ReP, January 30, 1827. P-S, F:IIA/72G9–10.
2. Blistering the skin with the application of an irritant such as an ointment or plaster was intended to draw the infection or illness away from the vital organs. *OED*.
3. CWP was referring to the projected move to the Arcade.
4. James Peale, Jr.

283. CWP to APR

PHILADELPHIA. FEBRUARY 8, 1827

Philadelphia Feby. 8. 1827.

Dear Angelica

I will not undertake to give you a long letter, but one containing my late indisposition as correctly as my Memory may enable me to dictate. I went to New York alittle before Xmas intending to stay a few days, as the weather was then fine & I well knew could not last long so. Seeing changes was to take place I determined on my return home, but was persuaided to tarry 2 days longer—and I began my journey on the first day of the Stormy weather—which made a long Passage in the steam-boat to Brunswick, the high winds drove the Water out of the river so much as to ground the Steam-boat ¾ of a mile below the landing, Boats was brought to take the passengers on shore, I went in the 2d boat, and not chusing to leave my Trunk, took it with me, it was not so heavy as to prevent me from carrying it short distance, but ¾ of a mile on the stony shore in a dark

night was too much for my strength, I struggled with it great part of the distance, almost exausted. a gentleman had the goodness to take one end of it, or otherwise I do not know whether I could have reached the Coach—then Obleged to wait one hour for the other passengers & baggage, we reached Trentown at one O'clock next morning—eat my Supper and went to bed as I thought perfectly well—and after getting to the deleware Steam-boat and had eaten my breakfast I began to makes notes in my journal, as I had made none in New York, and thus I promised myself a [to] make a short passage—and when it was announced to me that we had arrived at City, I looked up and see before [me] a married Lady from Burlington for whom I had made some porcelain Teeth. I asked her why she had not announced herself to me, she replied that she see me so busily employed that she did not chuse to interrupt me, I told her I would have been pleased to have attended to her, that I wrote to kill time.[1]

The weather was stormy many days, and I thinking myself Strong many times faced it, and when excercissing hard I felt an aking of my heart, this increasing on each succeeding tryal, I was obleged to moove more slowly for relief. an encrease of this complaint alarmed me, and I had on that day determined to study what could do for releaf. as usial I went to the Museum at 8 O'clock in evening the night was cold and bad, and I hastened home and some Camomile flowers, drank about a point of Tea on going to bed, but I should tell you that I was so exausted on my way home that I was obleged to stop 2 or 3 times to recover before I could go on. I had not been in bed more than an hour before I found myself extreemely ill, with a violent pain at my heart, I allarmed the family by thumping on the floor with my Cain Hercules.[2] Titian & Eliza. instantly was with me, and Doctr. James was instantly sent for, he came and a bleeder in the same moment. It was thought necessary to take blood, 6 or 8 ozs. gave me some relief. afterwards I was cuped on my left side—next a large blister applied over my whole side. some relief—then Blod largely taking all the Blood that could be spared which reduced me to such extreme weakness, that in attempting to go to the chair I fainted twice. the Pain left my heart and seized my right heal leaving that went to my left. I thought myself now in safety, as it seemed to be confirmed gout and care should be had to keep it in my feet by warmth. but rubing soon cured the Gout. I had no swelling caused by the pain.[3] for a few days I seemed to be mending fast and took perhaps too much food. for then come on a stricture of my bowels causing extreeme pain, this was removed by powerful Injections. I was now removed from a small bed room to a larger and seemed to be mending fast. when most unfortunately a Violent Billious collick which keept me in exriuciating pain all night and the following day before relief could be

had— This reduced to great weakness & took all relish of food from me, and also Obleged me to be extreemely cautious in eating— The Violence of my exertions to puke, left a soreness in my Stomack and Bowels 4 days and not totally gone; but begining to take nourishing things my strength is slowly returning to day being pleasant I determined to visit Sophonisba—and although the walk was somewhat fateaging, yet I hope to mend and repeat my Visits there and elsewhere. This letter began before my Visit to her, I have since dinner on a few Oisters made a finish of it.

and I have the pleasure to beleive it will be very acceptable to you. This sickness has much depreciated my opinion of my constitution, and it will indu[c]e me to be much careful of my health in future, for I well know that all this sickness might have been avoided, if I had been more careful of myself. I will now keep a more watchful Eye to all my moovements. yours most affectionately CWPeale

PS. My Physician is Skillful & extremly attentive to me and my Nourses very kind in the whole time of my sickness. I need not name any of them for every one are deserving of praise.

Angelica Robenson. Baltre.

ALS, 3pp.
PPAmP: Peale-Sellers Papers—Letterbook 20

1. See above, **277**.
2. In 1779, while a member of the Constitutional Society, or the radical "Furious Whigs," CWP was assaulted on the street by an angry conservative who opposed the Constitutionalists' efforts at price control. So he could protect himself, a member of the group presented him with a club made of seasoned ash that he called "Hercules" and that he believed saved his life during another attack. Thereafter, he kept the club hanging at the head of his bed. See A(TS):133; *CWP*, pp. 174, 217.
3. In a letter to Rachel Morris the following day, CWP wrote about the "gout" he was experiencing: "The pain at my heart went to my right heel, rubing abated it, next seized the left heal I was pleased to think it was the Gout as I knew that keeping it in my feet my vitals would be relieved. Yet this was a curious Gout for although it mooved from one place to another, yet when the pain was going off no swellings of the parts remained or even weakness." CWP to Rachel Morris, February 9, 10, 1827, P-S, F:IIA/73A5–7.

284. CWP to John D. Godman

PHILADELPHIA. FEBRUARY 13, 1827

Philadelphia Feby. 13th 1827.

My dear friend Godman

This spell of sickness has taken from me much of my animal Spirits. The quantity of Blood taken has greatly lessened my strength, yet at the time of bleeding I was fully sensible it was of absolute necessity to take all

that could be spared, the blood looked very black, and it runed very slow for some time before it was stoped.

soon after I wanted to go to the stool, and the attendant I believe the Doctr was present wished me to use the bed pan—but I would persevere to rise and walk, and behold I fainted. I knew not how I got into bed, it was a very pleasant feeling to me, I thought that they did not so quickly as they ought to have put my fur-cloak round me & that my exertion to help myself made me faint, and I would try it a second time, but this attempt prooved that I had lost my strength for I fainted a 2d time. I have wrote fully discribing my several sufferings to several of my friends, to Rubens amongst others,[1] which doubt not you have seen, therefore will not repeat it in this scrole. I shall only remark that after I had got relief for my heart and freed from pain, my indeavour was to regain my strength by nourishing food, and I know that I carried this system too far, for a stricture took place on my bowels. It was tremendously painfull, but a powerful glister of Salts sera &c relieved me. The receipt I have desired Titian to keep for me. I am now convalascent, and have been 3 times to Colemans walking but find the air so could that I believe it has not been of any service, and once I took an hour in a hack. this I now think must be the better mode to get exercise & fresh air It appears to me that I am more than usial sensible of the cold, for although I burn Lehigh Coal in a sheet Iron stove in my bed room and the fire keept up all night, yet I seem often very chilly. I have at present a small degree of Gout in the joint of my great Toe of my left foot—and in this instance it is somewhat swelled, but when I had the Gout in my heels, as described in my letter to Rubens, I had no swellings. perhaps I have not in this desease of my Toe, persevered in my rubing system as usial. however it has not been so painful as to make me take any trouble about it.

besides my writing to all my friends, I have also for my amusement dome some little work at Porcelain teeth, for to be confined to the House without employment will not agree with my Ideas. In what I cannot well execute myself I obtain the aid of Titian. We are doing every thing in our power to prepare for the change of the Museum. Making new casses, mounting of Animals, Skillingtons [skeletons], and prepairing to make large sashes to preserve the large Animals from Injury by dust &c. Linnius has been making a great number of small Pedestals in Playstre of Paris, 2000 of them.

The building of the Arcade will now progress with great rapedety if the weather becomes favorable. At present they have 60 Carpenters at work, and about 100 men in in all. but if the frost will not prevent the masons and bricklayers working they will drive on lustily. I have read your intro-

ductory Lecture and much pleased with your desc[r]iption of the Stages of Man.[2] The Ladies come to see me, and I am much pleased with their company, but my feelings as not as they used to be some time past, and whether with returning health I shall recover my usial energy, I know not. But at any rate I have determined to disregua[r]d trouble or expence to recover my late Stamina. I will not confine myself so closely as I have done of late to my labours in the Porcelain business, but I will occasionally amuse myself with the Pensil, in that line I can leave off or resume it at pleasure as my Eyes enable me to see without Glasses, I promise myself more pleasure in painting But in my endeavours to get and accomodate teeth to please and be useful, often difficulties occur, which from the nature of mouths, having fine *avelo* bones within the gums, they will often become sore with very little pressure. Beside the capriciousness of some, and the unwillingness to pay a price that give a tolerable profit for the labour and expence, is all a drawback of Teeth making. The expences extraordinary that I must provide for to open the Museum with an ellegant appearance, require me to make what exertions I can by any labour by which I can obtain some of the means is certainly laudible. The borrowing of Money on Interest has too long been a sore in my side— however if necessity should require it, I have full confidence that the income will be all sufficient to meet the additional expences for a good display. I am sory to hear that your health is not strong, I was in hopes that when you had done with the book sellers here, that you would have less writing to go through with.[3] I have nothing further to add but love to Angelica and Children, yrs. affectionately CWPeale
Doctr John Godman
 New York

ALS, 3pp.
PPAmP: Peale-Sellers Papers—Letterbook 20

1. Just before his illness, CWP had had the polygraph placed in his tooth-room so that he could write to a number of friends and relatives, possibly about his recent trip to New York. He had thought, he wrote to his former sister-in-law Rachel Morris, to ask her advice about "a certain lady"—probably Mary Stansbury. Now, however "I am very much deprecated in my own opinion," he wrote. "I can be of no value to any one, and I cannot desire to give trouble to the fair sex who will ever be high in my estimation." CWP to Rachel Morris, February 9, 10, 1827, P-S, F:IIA/73A5–7.

After recovering from his illness, and perhaps realizing that this attack was highly serious, CWP wrote a spate of letters describing his situation to all his children and friends. See above, **281, 282, 283**.

2. *Introductory lecture to the course of anatomy and physiology, in Rutgers Medical College* (1826; 2nd ed., New York, 1827). *NUC.*

3. Godman was in the midst of publishing his *American Natural History*, 3 vols. (Phila-

delphia, 1826–28), which was being produced by the Philadelphia firm of H.C. Carey and I. Lea. *NUC*.

285. CWP to John Paca[1]

PHILADELPHIA. FEBRUARY 19, 1827

Philadelphia Feby. 19th. 1827.

Dear Sir

yours of the 6th. instant[2] received and I might have written sooner but having just recovered from the most severe indisposition I ever suffered, has left me weak and very much infeebled. consequently my letter must be short and indeed I cannot have much to say although I knew your father when he was finishing his studies in the Laws. His person is strong in my remembrance. I have his immage now before me. He was a handsome man, more than 6 feet high, of portly appearance, being well educated and accustomed to the best company, he was graceful in his moovements and complesant to every one; in short his manners were of the first polish. In the early period when the peoples' eyes first became opened to their rights, he was opposed to the Court party, and with his coadjutors Johnson Chase and Barrister Carrol, made the first stand for the independance of the People. and it was a time of great triumph—Voting by *viva voice*. Those who were under *hatches* were obleged to vote as directed, and the office holders, being dependant on the Proprietor, did not spare threats of prosecution against all who should dare to oppose their will but at this noble and noted stand, it was deter[mined] that every canditate for office should be weighed [in the] ballance, and if their talents were found deficient, however high they might hold their heads, and strong their interest, they were rejected by this *band of Patriots*. and now for the first time, men were nominated who were considered as best fitted to be ellected into public office. These early steps to enlighten the People fitted them for the tryals which were soon to follow in our struggles for Independance.[3]

Dear Sir you have the records of the appointmen[ts] of my much esteemed friend your father in the sev[e]ral high stations to which he was ellected by his Country men & in each of those honorable stations his conduct speaks his praise. Early in the revolutiona[ry] war I remooved my family to the ⟨State of⟩ City of Philada. while your father was a member of Congress, coming from the same state we often conversed on the news of those difficult time. Please to accept this humble sketch as the best effort of your friend

CWPeale

PS. I repaired your fathers Portrait[4] and left it at the Baltere. museum—
I have not heard of any print being made from it, except what your letter
states. C. W. P.————.

John Paca Esqr.
 Wye Island
 Maryland.

ALS, 2pp.
PPAmP: Peale-Sellers Papers—Letterbook 20

1. John Philemon Paca (1771–1840), eldest son of the Maryland governor William Paca
(1740–99), pursued no public career, but devoted himself to building and then operating his
ornate estate on Wye Island in Talbot County, designed by John Hoban, architect of the
White House. *BDML*; F. Sims McGrath, *Pillars of Maryland* (Richmond, 1950), pp. 532–33.
2. Unlocated.
3. In 1759–60, William Paca studied law in Annapolis with Stephen Bordley (ca. 1710–
64), half-brother of CWP's friend and patron, John Beale Bordley. Along with Thomas
Johnson (1732–1819), Samuel Chase (1741–1811), and Charles Carroll (1723–83), mem-
bers of the anti-proprietary party in colonial Maryland and activists in the Revolutionary
cause, Paca was a member of the Continental Congress. Chase was also a signer of the
Declaration of Independence, and Johnson would have been had he not been away from
Philadelphia when the Declaration was adopted. CWP is referring here specifically to Sam-
uel Chase's election in the 1764 contest for the seat of the Annapolis representative in the
Maryland Assembly. With the backing of Johnson, Carroll and CWP himself, Chase cam-
paigned against the proprietary candidacy of Dr. George Steuart by appealing for popular
support to reform the political processes of Maryland government. The campaign presaged
the political struggles of the Revolutionary era and marked the beginning of the democratiz-
ation of Maryland politics. David Curtis Skaggs, *Roots of Maryland Democracy* (Westport,
Conn., 1973), p. 23.
4. CWP completed a full-length painting of Paca in 1772 (*Maryland Historical Society*,
Baltimore). In 1823, as part of his arrangement with the Annapolis Corporation to paint the
colonial governors of Maryland, he located Paca's portrait at Jeremiah Chase's farm. Receiv-
ing permission from John Philemon Paca to restore it, CWP brought the painting to the
Baltimore Museum, where it was retouched and rebacked. CWP then painted his copy (see
fig. 39). *Peale Papers*, 1:113; CWP to John Philemon Paca, October 4, 1823. P-S, F:IIA/69D3;
CAP.

286. CWP: Obituary, *Poulson's American Daily Advertiser*,
PHILADELPHIA. FEBRUARY 24, 1827

OBITUARY

DIED, on the evening of the 22d. inst. in the eighty-sixth year of his age,
CHARLES WILLSON PEALE, the Founder of the Philadelphia Mu-
seum.

The Members of the American Philosophical Society, and of the Penn-
sylvania Academy of the Fine Arts, and his friends and acquaintances
generally, are invited to attend his funeral, from his late residence, in
Walnut above Sixth-street, on Sunday morning next, at half past 11
o'clock.

American Philosophical Society
SPECIAL MEETING

February 23d. 1827.

The society having heard, with deep regret of the death of their venerable associate, CHARLES WILLSON PEALE,

It was *Resolved*, That the Members assemble at his late residence, on Sunday next, at 12 o'clock for the purpose of attending his funeral.[1]

GEORGE ORD, Secretary.

PrD, 1 p.

1. CWP was buried in the graveyard of St. Peter's Church (Episcopal) at Third and Pine Streets, in a service attended by members of the scholarly and artistic organizations in which he participated and helped to found. The epitaph on his headstone reads:

He participated in the Revolutionary struggle for our
 Independence.
As an artist, contributed to the history of the country.
Was an energetic citizen, and in private life
Beloved by all who knew him.

APS, *Early Proceedings*, p. 564; *CWP*, p. 433; Scharf, *Phila.*, 3:1880.

287. RuP to BFP

NEW YORK. FEBRUARY 25, 1827

New York Feb. 25. 1827.

Dear Brother

Your letter of the 23d.[1] gave me the melancholy inteligence which had just been communicated to me by a stranger who saw it announced in one of our morning papers—[2] Therefore if you had only given your letter to one of the passengers I should have received it the evening before, in which case I could have left here the next morning, and arrived in P. in the evening, so that I could have seen my dear Fathers remains and attended his funeral.

Although I have been expecting it ever since his first attack, owing to his advanced age, yet the shock was very great and severely felt by Eliza, who was so much attached to him. This event will be severely felt by us all.

I shall if possible get ready to go to Baltimore the last of this week and stay in P. a few hours, and in B. about two weeks. Give my love to all

I remain your affectionate
brother

Rubens Peale

N.B. I had answered your last letter, and in my hurry left it amongst my

papers, and have just discovered it, and now my time does not admit of my opening it to see what I should insert in this. RP————

ALS, 1p.
PPAmP: Peale-Sellers Papers

1. Unlocated.
2. The notice of CWP's death appeared in the *Baltimore American and Commercial Daily Advertiser* on February 26, 1827.

288. Inventory of CWP's Personal Property
PHILADELPHIA. APRIL 27, 1827

Inventory of the personal property of Charles Wilson Peale (deceased) in the house in Walnut Street in the possession of Titian R. Peale

1 Feather bed. .	$12.00
2 Mattrasses. .	7.—
1 Bedstead. . .	1.
1 pr Blankets. . .	7.
1 Fur Coverlise. . .	5.
1 Close[t] Stool. . .	5.
1 Steam bath. .	2.
1 Large travelling trunk	8.
1 Small Do. .	5.
2 Valizes—@5$each.	10.
1 Bolster & pr Pillows.	1.
1 Walnut Washstand	.50
1 Mahogany beareau	5.
1 Do. Washstand	5.
1 Secretary.	12.
1 Carpet 15 yds. @ 75/100	11.25
1 Sopha. .	20.
1 Mantle Clock. .	20.
1 Astral Lamp	12.
1 Small piece of Carpet,	.50
1 Large Polygraph. .	10.
1 Travelling Do.	10.
1 Octagon Worktable	8.
1 Fancy Chair (odd)	4.
1 Fire Screen	.50
Carried up.	18175

brot forward $ 181 75

1 Large Green baize	2.
1 Plaited Cake basket	25.
1 Silver Ear trumpet	15.
1 Cloathes brush	.50
1 Shaving Case	1.
1 Gold Watch	75.
1 Opera Glass.	3.
2 pr. Silver Spectacles	4.
1 pr. Gold Do.	8.
1 Lot of Razors	1.
1 Pen Knife	1.50
1 Patent Pencil	2.
1 Flesh brush.	.25
1 Green silk purse	1.
1 Gold breast Pin	1.00
1 Roll Lythos. Prints	1.50
1 Set brass paint canisters	20.
1 Case paints &"	10.
1 paintbox	1.
1 Paint, Stone Muller &"	10.
1 Large Looking glass	8.
1 Basin & Ewer	1.
1 Worktable	2.
1 Medicine chest	2.

Carried over.	377.45
Brot over.	$377.45
1 Work bench stools	25.
1 Tool Chest (Cong. Sundy.)	10.
1 Engraving. Benjn. West	.50
1 Lot of Books	5.
1 Do. Pamphlets	5.
1 Lot of brass moulds	5.
1 Bandbox	.12 ½
1 Coal Stove	14.
1 Large Lot of Porcelain teeth including all the fixtures & apparatus—	150.—
1 Cloathes press	3.
1 Mall stick & Easle.	1.50

1 Fingered organ	75.
1 Coal Grate	10.
1 Portable Ink Stand	.75
1 Opera Glass	1.50
1 Camera Lucida	10.
4 Silk Hankercheifs	4.
6 Old Do.	3.
8 Linen Shirts	24.
8 Old Do.	8.
7 Flannel Shirts	3.50
2 Muslin drawers	.25

736.57 ½

Brot up. $736.57 ½	
4 Muslin Shirts	1.
5 Do. Night Shirts	3.75
2 Merseille Vests	.50
1 Figured velvet Do.	3.50
4 Flannel Drawers	2.
9 White Cravats	1.45
8 Night Caps	.50
3 Wove Do.	.18
1 pr. Small Clothes	.50
3 Shirts (Silk)	5.
13 Coarse towels	.37 ½
12 pr. Old Stockings all kinds	.50
4 pr Stockings	2.
Large Lot of Old Clothing	5.
Cash/ Farmer & Mechs. bank	401.03

$1165.36

Chas L Peale
Franklin Peale
Appraised sworn & Affirmed
April 27, 1827
Jn. Geyer
Nyork

DS, 2 pp.
PPAmP: Peale-Sellers Papers

289. Coleman Sellers: Account as Administrator of CWP's Estate, 1827–28

Acct. of
Coleman Sellers Adminr.
Estate of Charles Willson Peale–

Note. articles now owned by Horace Wells Sellers
 Cake Basket
 Spectacles Purchased by C. Sellers
 Purse
 Secretary[1] Purchased by Fr. Peale

1827
 To Cash Balance of acct. 401—
 Farmers Mechanics Bank
 Do. from Museum & farm 132.55
 [illeg] house ⟨404⟩
 Do. from Sales 194.67
1828
June 1 Do. Sale of House 7000.00
 amt. of Sundries in Inventory had by & charged the following persons, viz.
 Titian R. Peale: For Sundry furniture &c.
 feather Bed 12.00
 Bolster & Pillows 1.00
 Wash Stand 5.00
 Carpet 11.25
 Sopha 20.00
 Linens 12.00
 4 Chairs 4.00
 Razors 1.00
 looking Glass 8.00
 Handkerchiefs 4.00
 Shirts 24.00

 99.25
 S. Summers
 Matrasses 7.00
 Clock 20.00
 Table 8.00
 &c. 2.00

 37.00

Franklin Peale.	Secretary	12.00	
	Fur Coverlet	5.00	
	Breast Pin [illeg]	4.00	
	Vest 3.50	3.50	
	Camera Lucida[2]	10.00	
			44.50
	Polygraph	10.00	
		Car.d over	7908.74

1827

April 10	By Cash pd note owed at Farmers & Mechanic's Bank		750.00	
	Paid Funeral Expenses viz:			
	Docter James's Bill	25.00		
	Sundries F. Bills	95.00		
	[illeg]	10.00		
	Mrs. Summers' Bill	55.11		
	[illeg]	1.00		
			186.11	
pd.	Wm. Wilson		5.00	
"	Taxes		64.35	
"	Ra[illeg] & Kean		1.28	
"	Letter of Adm.r certificate & fee to Mailman		5.25	
"	Register's Fees		9.50	
"	Clerk of Orphan's Court[3] including Auctioneers commission for Selling House		53.00	
"	Abm. Miller[4]		1.68	
"	Wm. Fry advertizing[5]		6.75	
"	Smith & George[6]		4.50	
"	⟨————————⟩			
"	Entering satisfaction on 2 Mortgages		1.00	
"	Bond with Mortgage to Charles Graff & Interest		2313.83	
"	Do. Jacob Copia		642.80	
"	Ground Rent. C Macalaster		124.86	
"	Rent of Museum to Feb. 22		904.30	
			5074.87	

By cash pd. Water Rent & repairing Hydrant	7.50	
" to J. Kenworthy[7]	6.85	
" to Franklin Peale	494.00	
" to Rowley & Allyson[8]	4.90	
" bonds to Rachal Morris 544.80 & Elizth. Morris 642.20 with Interest [illeg]	1187.00	
" James Coffee[9]	1.25	
" Charles Chauncey Esqr.[10]	75.00	
" Cash pd. Paulson[11]	9.20	
" Cash pd. do.	100.77	
" pr. individual heirs	1089.34	
	8050.00	
Bala. owed from CLP	80.94	
	8129.19	
	8130.81	

	Bal. for.d	7908.74	
[illeg] Sellers			
Plated Bushel		25.00	
Watch		75.00	
Gold Spectacles		8.00	
Silk Purse		1.00	
Lath[illeg]		10.00	
Hone		———	
			120.00
Linneus Peale			
Shaving brush		1.00	
Knife		3.00	
Auction Bill		6.14	
			10.14
Rubens Peale			
Tool chest		10.00	
Opera Glass		3.00	
Rembrandt Peale			
Portable Ink Stand		0.75	
CW Peale's Trunk & Chair		5.20	
Silver Ear Trumpet			
Silver, gold & Platina Scraps		59.98	
Porcelain Teeth			
Cash recd. of S.M. Peale for Paint Canisters ac.		23.00	
			8130.81

AD, 5pp.
PPAmP: Peale-Sellers Papers

1. A writing desk. *OED*.

2. An optical device invented in 1807 by the Englishman William Hyde Wollaston (1766–1828), the camera lucida reversed the principles of the camera obscura and used light and a prism to enable an object to be projected in a reduced image on a plate from which accurate copies could be reproduced. *DNB*; *Encyclopedia Britannica* (11th ed.).

3. Pennsylvania's Orphans' Court, established in 1713, had jurisdiction over wills, probate, and the administration of estates, functions similar to those exercised by other states' probate courts; its name derived from its responsibility for and supervision of minor heirs. *A Dictionary of American English*, 4 vols. (1942; reprint ed., Chicago, 1965), 3:1648.

4. Abraham Miller was a potter at 37 and 39 Zane Street. *Philadelphia Directory* (*1829*).

5. The printer and publisher William Fry (1777–1855) of the firm Fry and Kammerer. *Peale Papers*, 3:383n.

6. Unidentified.

7. John Kenworthy was a painter and glazier. *Philadelphia Directory* (*1828*).

8. Unidentified.

9. James Coffee was a plumber. *Philadelphia Directory* (*1829*).

10. Charles Chauncey (1777–1849), lawyer, educated at Yale and admitted to the Philadelphia bar in 1799, was one of the city's most prominent attorneys. He spent his career in private practice. *Appleton's*; Simpson, *Eminent Philadelphians*, pp. 197–202.

11. Zachariah Poulson (1761–1844), publisher of *Poulson's American Daily Advertiser*. This debt is likely to have been to the newspaper in payment for advertising. *DAB*.

Appendix *Court of Death*

Excerpt, Eliza Champlain[1] to Mary Way, through Mrs. Elizabeth Champlain

NEW YORK CITY. JANUARY 2, 1821

New York January 2d 1821

My dear Aunt

Ten thousand thanks for your letter. It was indeed an *unlook'd*-for New Year's treat. I was invited yesterday morning to accompany Mr & Mrs Fitch[2] to the Academy of fine Arts to see the "Court of Death."[3] I *went, was delighted*, and when I returned found your invaluable letter. I snatched it, flew up stairs, and was crying most *merrily* over it when I was summon'd to dinner. [. . .]

we will now go back to the Court of Death, from which we have travel'd without intending it, as a description of it was what I intended to have commenced my letter with. A *description*, did I say? No, that is *impossible*. I never could convey to your imagination an idea of the *sublimity* of it. But I will enclose the *Catalogue* I brought home for your amusement. It is of course a much more *able* description than could be expected to flow from *my* pen, yet notwithstanding, *we* cannot resist the inclination we feel to make a few comments on the subject. In the first place, imagination cannot concieve of anything more exquisitely beautiful than the face and form of Pleasure.[4] If she *has* a fault it is the *chastity* that breathes through every feature. I at first thought if it *had* a defect, *that* was it; but when I look'd and "look'd again" and thought more *deeply* on the subject, I found it was the *master stroke* of the artist. To attract *virtueous* hearts she must not wear the *semblance* of *vice*, and to the eyes of the beholder always appears in *false colours*. Nothing can be more *chastely* beautiful than the attitude in which she is placed. There is not the least shadow of *indelicacy* in any one *look* or *action*, which, considering the *subject*, I think is something remarkable, as there never was a wider field for the display of *impurity* if the artist had been disposed to represent her in her *true colours*. but he is a man after my own heart. I don't think *Hinkly*[5] could have excell'd him in this respect.

590

As *she* is the most prominent figure in the piece, the light strikes with most force on her face, which I wish to heaven I could sketch upon this sheet; but although it can be *concieved* it cannot be *described*. It is perfectly present to my imagination but not to my *pen*: her hair is the brightest auburn you can imagin, her eyebrows arch just *enough*, and the colour and *expression* of her eyes are inimitable. Her nose is exquisitely turn'd, and her mouth is *perfect*; her form is in profile, her face in front, and rather elevated than otherwise. Her right arm is raised in the act of pouring incense into a vase or something prepared to recieve it, and the shadeing of the arm is beyond anything I ever saw. It is most *Heavenly*! But why should I go on? I cannot paint like *Peale*. I feel I cannot describe the surpassing loveliness of *Pleasure*, and I will leave her without making another attempt. We have been *too* long *strangers* to each other for me to do her *justice*. The next most prominent feature in the piece is "*Virtue*."[6] If I had not seen "Pleasure" I should have pronounced *her* unequalled, but of course she was far eclipsed. Her eyes of "*heavenly blue*" are raised to heaven, she is supporting the figure of *Green old age*. Nothing can be more venerable than the figure she supports—the bald head, the snow white locks that are here and there scattered about it, and the heavenly peace that appears to dwell *within*. Her left arm which supports the stooping form of *age* is finely turned and, tho' not in such strong relief as that of "Pleasure," yet the light which strikes from the Torch of "Desolation" full upon it give a *life* and *soul* to the flesh that I never saw equall'd. The dignified countenance of "Old Age," contrasted with the *seraphic* expression of her, is fine indeed. But I must leave the bright parts of the picture (tho' ever so unwillingly) for the *dark*, with which I must be brief, for I dwelt longer on it already than I intended and am freezing to death into the bargain. Next comes the Warriour.[7] Nothing can be more fierce and terrible, more *heart appalling*, than his countanance as he tramples his victim beneath him. Not a muscle of his ruthless face is relax'd at the woeful sight. Desolation rushes on before him with a torch which, striking on the helmet, the shield of *Medusa*, the blood stain'd sword, and the ferocious countenance of the destroyer, has a fine effect. Close at his heels follows "Want." Nothing in existence can be more wretched. Her meager fingers and the *squalid* misery that speaks in ever[y] part of her is done to the life. "*Dread*" is shrinking behind "*Want*." On the left lie the victims of "Pleasure." The remains of beauty were very conspicuous in the countenance of "*Fever*" and "*Consumption*," but in none other, and the *poverty*, the *forlornness* of their situation compell'd the eye to turn with disgust from "*that part of the picture*." I could go on till the sun set "*did the limits of our opportunity permit*," but I have so much *else* to say, it will not do. To make a long story short, I think we ne'er shall see its like again. We *may*, It's not *impossible*, for the artist has promised to produce *more*

591

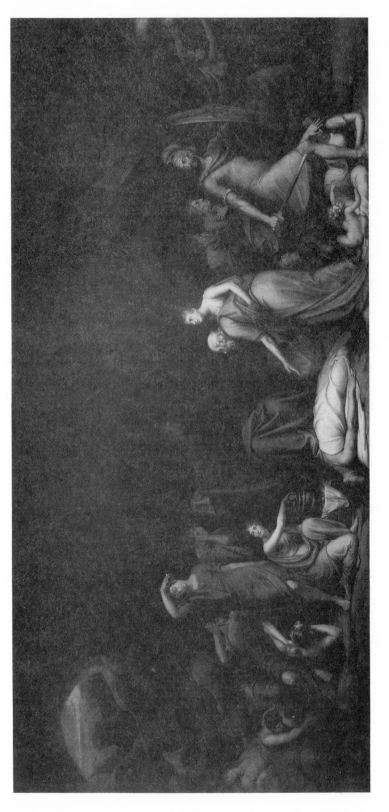

66. *Court of Death*. Rembrandt Peale, 1820. Oil on canvas, 138 × 281" (351 × 714 cm). The Detroit Institute of Arts, gift of George H. Scripps.

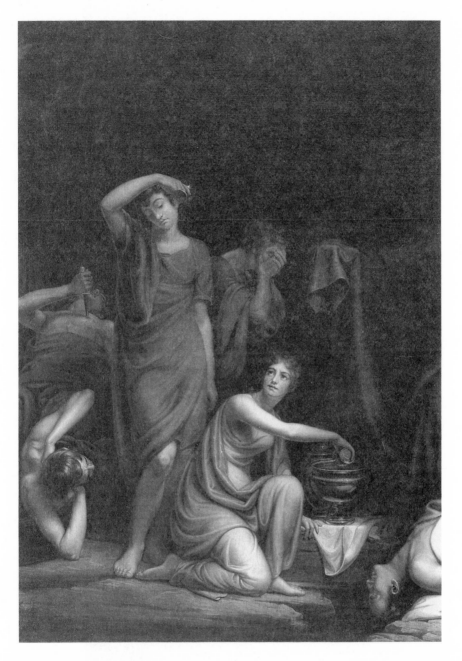

67. *Court of Death*. Detail, *Pleasure serving drink to youth—Intemperance*.

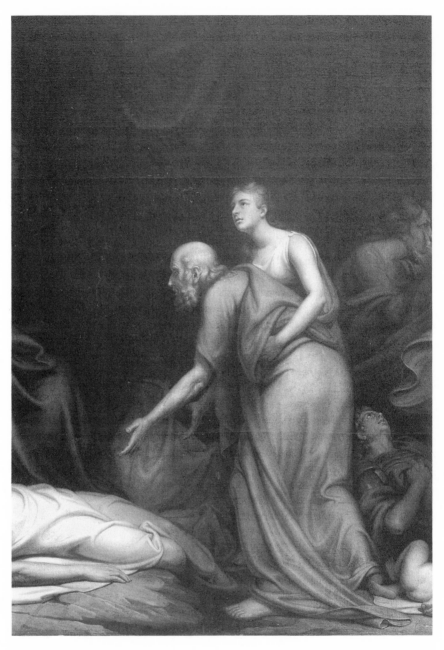

68. *Court of Death*. Detail, *Virtue leading Old Age to Death*.

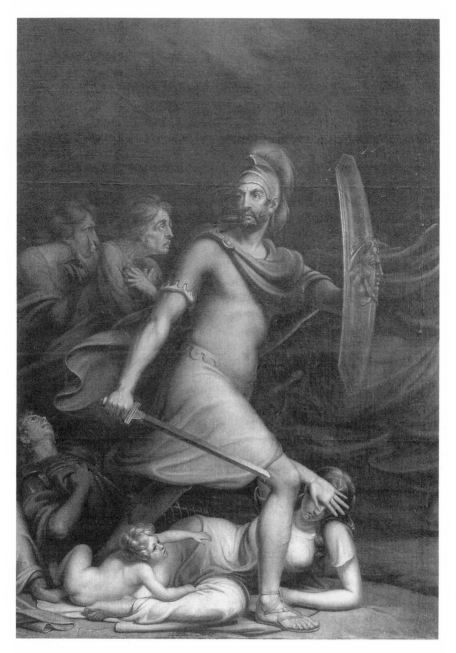

69. *Court of Death.* Detail, *The Warrior (or War) trampling widow and orphan.*

pictures if he recieves sufficient encouragement for *this*; but I think it's doubtful. The common council have interested themselves about it at last and his prospect is more smiling, but I don't know how it will terminate. I hope to heaven such tallents as *his* will be encouraged, particularly as he is a *native artist* and *brother of the brush*. As we were looking at the picture he *enter'd*. The name of Rembrandt Peale was instantly buzzed round the hall and several of our most distinguished characters instantly surrounded him, I suppose to pay him the compliments of the season or, what is much *more*, the compliments due to his painting. As soon as I could discover "*an opening in the thicket*," I looked with all my *might* to see if I could discover those traits of Genius and talents in the countenance of the artist which were so conspicuous in every stroke of his pencil; but I found his Genius was too *mighty* for the eye of the *vulgar*. Except in a very penetrating *blue eye*, there was no appearance of it. He was quite *plain*. I must confess I was somewhat disappointed, as I should suppose such tallents would show themselves in every look and action; for he is indeed a *Great man*. But I suppose if they had he would be *too* perfect. So I will let the subject *rest*.

Since this was written, Mr & Mrs Mitchell[8] drank tea with us, and Mr Mitchell said that at the Academy the other day he had an hour's conversation with *Peale*, who told him that if he recieved sufficient encouragement for *this* picture he should attempt the painting of *Christ*; and if he does not fail *there* (said your *speaker*) he will do more than was ever done *before*. But I must leave the whole of it, tho' I have much more to say, for other subjects.

ALS. Excerpt
MWA

1. Eliza Champlain, her mother Elizabeth, and her aunt Mary Way (1769–1833), to whom this letter is addressed, were miniature painters. Mary Way was probably the most prominent of the three. Although she worked primarily in New London, Connecticut, she lived from 1811 to at least 1819 in New York City, where, in 1818, she exhibited two of her miniatures at the American Academy of Fine Arts. According to a descendant, Mary became blind and moved back to New London, where this letter was sent. Coincidentally, Eliza's daughter Alice married the brother of TRP's second wife Lucinda MacMullen. See Champlain file in Peale Family Papers, NPG; Mary Bartlett Cowdrey, *The American Academy of Fine Arts and American Art Union: Exhibition Record* (New York, 1953), p. 385; William Lamson Warren, "Mary Way's Dressed Miniatures,"*The Magazine Antiques*, 142(1992):540–49.
2. Unidentified.
3. Fig. 66.
4. Fig. 67.
5. Unidentified. An artist named Hinkley (no first name) exhibited a *Portrait of a Gentleman* at the American Academy in New York in 1833. Groce and Wallace list a Hinckley as painting in Charleston, S.C., in 1819, and also list a Hinkley as a portrait and miniature painter with a studio on Nantucket Island, Mass., in 1822.Cowdrey, *The American Academy of Fine Arts*, p. 187; Groce and Wallace, *Dictionary of Artists*, pp. 317, 318.
6. Fig. 68.
7. Fig. 69.
8. John Mitchell, Universalist minister. Peale Family Papers, NPG.

Index

References to portraits and miniatures by CWP and ReP are designated by boldface type under the sitter's name; paintings and portraits by other artists, including JP and RaP, are listed by title and under the artist's name. A miniature painting is indicated by (m). Identification of individuals is designated by italic type.

A.

W.